Praise for *A Flame of Pure Fire*

"Absorbing.... Kahn brilliantly recounts Dempsey's great victories...
as well as the sad defeats in [his] declining years.... Kahn also pro-
vides in Dos Passos–like vignettes a look back at the extraordinary
times in which Dempsey thrived.... This is quite simply Kahn's finest
work since he made *The Boys of Summer* part of the language."
—*Sports Illustrated*

"Without his fan-like enthusiasm, Mr. Kahn might not have portrayed
so vividly the fighter who captured the imaginations of his time—
and is sure to capture those of readers of this engrossing book."
—*The Wall Street Journal*

"One doesn't have to be a fan of boxing to be enthralled by this story of
a nice guy who didn't finish last."
—*The New Yorker*

"Dempsey and his career make for a fine yarn, and when Kahn writes
about fighters and fights, promoters and characters, his book is great
fun."
—*The New York Times Book Review*

"An intelligent look at heavyweight champion Jack Dempsey and the
tumultuous 1920s."
—*The Washington Post Book World*

"Roger Kahn has found material that fits his talents perfectly and written another splendid book about America." *—American Way*

"*A Flame of Pure Fire* is a magnificent piece of work.... Kahn is a superb craftsman." *—National Post*

"[Kahn] makes his social history of Dempsey's 1920s more complete by honoring the related arts of both his hero and his immortalizers." *—American Heritage*

"Kahn is, no doubt, the best writer who ever did a Dempsey biography." *—Boxing Collectors*

"An exhaustively researched and colorful portrait of an American great." *—San Diego Union-Tribune*

"As always, Kahn's prose is impeccable.... *A Flame of Pure Fire* is sports history, true; but you could take the word sports out of that description and still be accurate. Kahn has produced another absolute classic." *—The Fort Worth Star-Telegram*

"Kahn's baseball books, among them the legendary *The Boys of Summer,* are known for their precisely crafted writing and sense of time and content. *A Flame of Pure Fire* is another strong entry in his remarkable lineup." *—Detroit Free Press*

A Flame of
Pure Fire

A Flame of
Pure Fire

JACK DEMPSEY AND
THE ROARING '20S

——•——

ROGER KAHN

A Harvest Book
Harcourt, Inc.
SAN DIEGO • NEW YORK • LONDON

Jack Dempsey obituary on page 437 by Jim Murray.
Copyright 1983, *Los Angeles Times*. Reprinted by permission.

Library of Congress Cataloging-in-Publication Data
Kahn, Roger.
A flame of pure fire: Jack Dempsey and the roaring '20s/
Roger Kahn.—1st ed.
p. cm.
Includes bibliographical references.
ISBN 0-15-100296-7
ISBN 0-15-601414-9 (pbk.)
1. Dempsey, Jack, 1895–1983. 2. Boxers (Sports)—United States
Biography. I. Title.
GV1132.D4K35 1999
796.83'092—dc21 99-15382
[B]

Designed by Ivan Holmes
Text set in Granjon
Printed in the United States of America
First Harvest edition 2000
A C E D B

To Katy, the newest fight fan,
and to the memory of the champion who
won her over

Contents

Prologue xi

Book One THE THORNS OF GLORY

1 When All the Seas Ran Dry 3

2 The Rocky Road to Toledo, Ohio 29

3 A Strange and Violent Heat Wave 49

4 The Left Hook from Olympus 69

5 The Champion and the Whore 100

Book Two LOSER AND STILL CHAMPION

6 Pilgrimage 171

7 Preliminaries 198

8 The Battle of the Century 223

9 Strange Interlude 270

10 The Champ's Best Fight 320

11 Disorder and Sorrow 351

12 Loser and Still Champion 402

Epilogue 427

Acknowledgments 445

Bibliography 451

Index 457

Whenever I hear the name, Jack Dempsey, I think of an America that was one big roaring camp of miners, drifters, bunkhouse hands, con men, hard cases, men who lived by their fists and their shooting irons and by the cards they drew. America at High Noon.

— Jim Murray

The public suddenly saw him in a new light, the two-handed fighter who stormed forward, a flame of pure fire in the ring, strong, native, affable, easy of speech, close to the people in word and deed and feeling.

— John Lardner

Prologue

On a blustery April afternoon in 1960, with much of the country wondering what would happen when Ingemar Johansson, the last white man to hold the heavyweight championship, gave brooding Floyd Patterson the chance to win it back, I walked into Jack Dempsey's Restaurant on Broadway for some expert opinion. Dempsey himself had not been heavyweight champion for thirty-three years but people everywhere continued to call him "Champ." Scores, hundreds, of great boxing figures have swaggered and staggered across the century. Uniquely, and I believe deservedly, William Harrison Dempsey—part Scots, part Irish, part Cherokee, and part Jewish—was our one eternal champ.

More than any other individual, Jack Dempsey created big-time sports in America. The time frame here ran roughly from 1919, when Prohibition began, until 1929, when the stock market crashed and "the era of wonderful nonsense" came to a shattering conclusion. A tumult of our current issues—from racism to heroin, from new journalism to

casual sex—boiled and bubbled through the Dempsey days. Surely he helped make the times what they were, but, in the complexity that is a full-framed hero, Dempsey himself was shaped by the times that he created. *Urgent, restless, roistering* are words that come to mind.

When Dempsey won the championship on July 4, 1919, his fight with mountainous Jess Willard drew 19,650 fans. Dempsey's purse was $27,500. For his final championship fight, on September 22, 1927, the crowd numbered 104,943 and Dempsey and Gene Tunney split $1,540,445. Sports, and indeed being an athlete, had become big business. Dempsey was more prominent than any of his great sporting contemporaries—Bill Tilden, Red Grange, Bobby Jones, Babe Ruth. I knew some of these things on that April afternoon in 1960 when I walked out of the wind and into his Broadway saloon.

It was 3:30, the last lunch customer had left, and Dempsey greeted me with an easy smile and motioned for me to join him in a booth. At sixty-four, he still had blue-black hair. His eyes were dark, over high cheekbones and under thick, arched, intimidating eyebrows. As we talked—his voice was a tenor's, even a little squeaky—the sense of intimidation disappeared. He considered me kindly, listened hard to what I had to say. I began to feel that this towering figure, whom I had been visiting from time to time for about five years, was an old and very close friend. Dempsey had this effect on many men and also on many women.

"How would *you* handle Johansson?" he said at length.

I had seen Johansson win the championship by knocking Patterson senseless with a monstrous right-hand punch that landed between the eyes. Patterson went over backward very hard. Then he got up and walked across the ring, clutching his nose, like a child who doesn't want to fight anymore. Johansson knocked Patterson down six more times before the referee stopped it.

"You've got to watch the big right hand," I said, "so I'd crowd him. Keep moving in close so he has no room to throw the right. Work on his body for a few rounds."

"Pal," Dempsey said, "I can see you know your boxing."

"Thanks, Champ."

"Now I want you to get up. We'll take off our jackets. Then show me how you'd crowd the Swede." Dempsey gestured and a few busboys moved back tables, creating an open space, an informal boxing ring, in the center of the restaurant.

I've done it now, I thought. First I tell Jack Dempsey how to fight. Now I've got to spar with him. But he's always been a genial sort, at least to me. After all these years, he's probably harmless.

"I want you to crowd me," Dempsey said, "and then I'm going to show you my old one-two." I looked at him. Quite suddenly, Dempsey was considering me with no geniality at all. His eyes were pitiless. It was as if he neither knew me nor cared who I was. The knuckles on his fists looked like an eagle's talons.

As ordered, I moved in. The fastest left-hand punch I ever saw up close creased the right side of my face, etching a line along the jawbone. A right I never saw cracked into my midsection.

I spun back and lowered my hands.

Dempsey drove an even harder left along my jaw. "One-two," I said. "One-two. That's three."

"Keep your guard up at all times," Dempsey said, in a cold, flat tone.

Then it was over. He put his own hands down. The menace fled from his face. He patted my back. "Pal, you deserve a drink. This is my place, so I'll be buying."

For the next three hours, until the dinner customers came in, Dempsey told me stories from the saga, the epic poem, of his life. The family left West Virginia for Colorado in the 1880s because there was supposed to be work there in the mines. As the dreams of riches died in the high country, Celia Dempsey converted to the Mormon church. Her son described himself as a "Jack-Mormon," a Mormon who had left the faith.

He decided he wanted to be heavyweight champion when he was eleven years old. After grade school, he found work in the mines and rounding up cattle. "I was a miner and I was a cowboy," he said,

"but mostly I was a hobo. I fought wherever I could, in school halls, outside saloons, anyplace they were putting up a purse. I once walked thirty miles across the desert to a town called Goldfield in Nevada so I could fight for twenty dollars. I got beat a lot. I improved. But I remember the beatings I took. Once I got beat so bad they had to take me out of the ring in a wheelbarrow.

"Later some said I was a killer in the ring. They got that wrong. I killed nobody. But I took out other guys quick. That much *is* true. I got more one-round knockouts than anybody, sixty knockouts in the first round. I beat a good heavyweight in New Orleans once in fourteen seconds. I knocked out Fred Fulton, six-foot-four, 250 pounds, in nineteen seconds. How come? Not because I was a killer. Other way round. I was always afraid that I'd be the one who was killed. Get 'em quick and you live to fight another day."

After a while, Dempsey turned contemplative. "I had great writers covering me. Ring Lardner. Grantland Rice. Heywood Broun. I was lucky they came along the same time I did. I got to star in three movies and in a regular serial they showed the kids on Saturday afternoons. *Daredevil Jack.* All this while I was champion. I even acted, if you can call it that, on Broadway. David Belasco directed me in a play, *The Big Fight.* I got more out of being heavyweight champion than any man who ever lived. I knew some presidents and beautiful women and bank presidents who would have rung the burglar alarm if I'd walked in on them once upon a time.

"But there's the other side. My brother Johnny followed me to Hollywood and turned to dope and killed himself and his wonderful wife. Would that have happened if he hadn't been 'the champ's brother'? I loved beautiful women, I still love beautiful women, but every marriage was a disaster. There was always money to be made, always, but far away from home. The people booed me quite a bit, you know. A story spread that I'd ducked the draft in World War I, that I was a slacker. The same people who said I was a killer, the same people, said I was a slacker. Well, they were wrong. Wrong twice. And then there were the broken ribs, the ear hanging by a shred, the

managers, the promoters, all those lawsuits. I guess I'm glad I was the champ. I'm almost sure I am."

We sat bonded in intense, sudden intimacy. "Pal," Dempsey said, "no one has ever got my story straight. I'm looking for a writer. Want to try?"

"I want to try."

"Okay, but there's some other writer wants to do it, too. Feller is older than you. I promised him first crack. I got to clear it with him first. Understand?"

"Who's the other writer, Champ?"

"Hemingway," Jack Dempsey said.

Nothing worked out for Hemingway, or until now, for me.

Book
One

THE THORNS OF GLORY

1 When All the Seas Ran Dry

Jack Dempsey, the fighter, was infinitely suited to the time in which he fought, which was the time when the United States first felt the throb of its own overwhelming power. For seven years and two months in the days that followed World War I, Dempsey, with his swarthy brow, his fierce good looks, and his matchless dedication to the Kill, was heavyweight champion of the world. He was the wild and raucous champion of the wild and raucous 1920s when Al Capone ran free and jazz men trumpeted a new night music and women bobbed their hair and smoked, they smoked cigarettes in public, and hemlines rose and people talked about free love, and it was against the law to buy a drink.

If, in words originally applied elsewhere, Jack Dempsey had never lived, someone would have had to invent him, invent the man and invent his era as well.

A young writer who had recently discovered William Harrison Dempsey composed this passage thirty-five years ago. Inventing Dempsey surely was a seductive idea. Hobo, roughneck, brawler, fighter, slacker, lover, millionaire, gentleman, and finally—in John Lardner's words—"a flame of pure fire," at last a hero. What a protagonist he would have made for one of those glorious 1930s fictions that so many used to love, the secular, proletarian passion plays called works "of social significance."

But nobody had to invent Jack Dempsey, really. Nobody really could. Jack Dempsey invented himself. If his life were a novel—and it was in many ways—then he himself, William Harrison "Jack" Dempsey, Kid Blackie, the Manassa Mauler, the Champ, was its principal creator and its dominant author.

He was a natural man, he truly was. We have never had so direct and unpretentious a champion, nor perhaps any who fought with such snarling intensity. In the ring, he seemed to enjoy hurting other people, opponents, to be sure, but even sparring partners. He even knocked out the famous sportswriter Paul Gallico, who insisted on going a practice round. Yet outside the fateful squared circle, Dempsey was the kindest of companions. The contrast between the boxer at work and the sporting man at leisure was a wonder.

He was a natural man, but he took the ring name of an earlier boxer, from County Kildare, a dashing, tragic character who called himself Jack Dempsey and who died in terrible poverty on a raw autumn day in 1895. The first Jack Dempsey, born John Kelly, captured the world middleweight championship in midsummer 1884, in the village of Great Kills on Staten Island. After that Dempsey the First won forty-one consecutive fights. During a stretch of six years, when he fought in New York and Philadelphia and San Francisco and up into the Pacific Northwest, winning, always winning, a forgotten journalist nicknamed him the Nonpareil. The word, seldom heard today, describes an individual "of unequaled excellence, a paragon." It is pronounced so that it rhymes with hell. The first Jack Dempsey lost his championship when Bob Fitzsimmons, later the *heavyweight*

champion, knocked out the plucky smaller man in 1891 at a fight in New Orleans. Dempsey was only twenty-nine. His decline was abrupt and unrelieved.

He ended his days in Oregon at thirty-three. Alcoholism played a role and he was broke. Four years later a Portland newspaperman found Dempsey's burial spot and wrote a poem that stirred multitudes. This was a time when narrative poetry, the vigorous, driving cadences of Service, Noyes, and Kipling, seized imaginations and hearts. Light narratives such as "Casey at the Bat" and "The Cremation of Sam McGee" flourished, and such somber narratives as "The Highwayman" held entire families in sway.

"The Nonpareil's Grave," both a narrative and an elegy, is somber as a tomb.

> Far out in the wilds of Oregon,
>> On a lonely mountain side,
> Where Columbia's mighty waters
>> Roll down to the ocean side;
> Where the giant fir and cedar
>> Are imaged in the wave,
> O'ergown with firs and lichens,
>> I found Jack Dempsey's grave.
>
> I found no marble monolith,
>> No broken shaft or stone,
> Recording sixty victories this vanquished victor won.
>> No rose, no shamrock could I find,
> No mortal here to tell
>> Where sleeps in this forsaken spot
> Immortal Nonpareil....
>
> Oh, fame why sleeps thy favored son
>> In wilds, in woods, in weeds,
> And shall he ever thus sleep on,

Interred his valiant deeds?
'Tis strange New York should thus forget
Its "bravest of the brave,"
And in the wilds of Oregon,
Unmarked, leave Dempsey's grave.

It is surely an irony that no one remembers the poet's full name. The best anyone offers is, "He worked as a newspaperman up around Portland. His last name was MacMahon."

"My brothers"—William, Johnny, Bernie, Joe—"my brothers and I all knew that poem," Jack Dempsey, the great heavyweight, told me. "Everybody used to know that poem. We used to recite it. We knew it by heart. So did lots of people in those days. When we were kids around the Colorado mining camps, all of us wanted to be the new Jack Dempsey, the new Nonpareil. When it turned out I could fight the best, I got the name. When I was a kid the family called me Harry from my middle name. I began as Harry Dempsey. It was only when they found out I could fight the best that I got to be Jack."

He was a natural man but not a simple one. At the age of thirty, he had his fierce good looks doctored by a plastic surgeon to please his second wife, a sometime soubrette called Estelle Taylor, who held him in thrall. A natural man with a made-up name and a made-up nose. No, he certainly was not simple. Nor was Estelle, a generally undistinguished actress, who rose up and delivered a performance of great passion and sexuality in Cecil B. DeMille's towering silent movie, *The Ten Commandments*.

Even the times themselves were out of joint.

BOOZE GOES IN WILD ORGY
Cabaret Girls Chant John Barleycorn's
Requiem, As Mourners Weep . . . And Drink

That headline led the *Toledo Times* one very warm day in May. On a sweltering afternoon six weeks later, Dempsey would fight

Willard in a gerry-built wooden arena alongside Maumee Bay. Most of the tickets went unsold, but the three rounds Dempsey fought in Toledo shook the world.

———

Perspective leads to troubling questions about why World War I was fought and to yet more punishing questions about what the fighting accomplished. The long war toppled monarchies but brought no peace. It drew new boundary lines. Hitler erased them all within twenty-five years. So much slaughter, so many dubious battles. Southey's classic lines on the duke of Marlborough's eighteenth-century victory at Blenheim come to mind.

> *"And everybody praised the Duke,*
> *Who did this good fight win."*
> *"But what good came of it at last?"*
> *Quoth little Peterkin.*
> *"Why, that I cannot tell," said he;*
> *"But 'twas a famous victory."*

World War I developed into a horror of trenches, vermin, barbed wire, typhus, deadly clouds of gas, and soldiers by the thousands, soldiers by the millions, bleeding their lives away. Expected to be settled in months, it continued from August 1914 until Armistice Day, November 11, 1918, four summers with the length of four long winters. Statistics from various governments fix the number of "combatant deaths" at 8,528,831. The United States entered the war in April 1917 and eventually sent a million troops to Europe in the American Expeditionary Force. More than 10 percent—116,708—perished. No war had ever killed so many Americans so quickly.

But to the American people the war unfolded in a sanitized, sterilized, glamorized way. Television and transatlantic radio broadcasts did not exist. Photography was relatively primitive. Americans first saw the distant war as a contemporary Iliad—remote, compelling,

who died from Mkville?]

decidedly bloodless. Only in the final stages, with gold stars appearing in the windows of bereaved families and soldiers coming home blind or gassed or maimed, did the horror reach America's heartland.

———

In the words of the notable America war correspondent Richard Harding Davis, the German army was first "a river of steel, gray and ghostlike." Later, German soldiers, simultaneously manic with victory and frightened of snipers, torched the Belgian university town of Louvain and left it blackened. "This," Davis wrote, "is the German Emperor's Holy War."

Soon after that German military authorities in Belgium charged a captured British nurse, Edith Louisa Cavell, with helping British prisoners to escape. Nurse Cavell testified that she had treated English and German wounded with equal compassion at a hospital in Brussels. But she feared for the fate of injured English soldiers in German prison camps. The charges were true. She had indeed helped some countrymen find their way back to their homeland.

Germany military authorities heard Edith Cavell, who was forty-nine and attractive in a prim and proper way. Then they convicted her. Nurse Edith Cavell died before a firing squad on October 12, 1915. She faced death bravely. In one of her last acts she pinned her long skirt tightly around her ankles. Even in a mortal fall, her modesty would be secure.

At once Nurse Cavell became a symbol of innocent, chaste womanhood defiled and murdered. Many Germans outside the military felt that the execution was a punishment beyond the crime. It was also a catastrophic public relations blunder. In a widespread American perception, the Prussians had murdered an "angel of mercy." (Today a breathtaking peak in the Canadian Rockies, rising between Banff and Jasper, is named, with subliminal prurience, Mount Edith Cavell.)

Late in April 1915, as spring came to Flanders, the German army introduced poison gas—greenish iridescent chlorine, choking, vomi-

tory, lung-searing chlorine—into trenches near the village of Ypres. In 1916 the German navy began unrestricted submarine warfare—sinking cargo ships and passenger vessels without warning. The *Chicago Tribune*'s crack reporter, Floyd Gibbons, was a first-class passenger on the Cunard passenger ship *Laconia* when a German U-boat commander, prowling the Irish coast, slammed two torpedoes into her hull. *Laconia* shuddered. Then she sank in forty minutes. Gibbons began his account: "I have serious doubts whether this is a real story. I am not entirely certain that it is not all a dream and that in a few minutes I will wake up in stateroom B 19 and hear my cockney steward informing me that it is a fine morning, sir. But this is not a dream. I am writing this after six hours of drifting and darkness and bailing and pulling on oars and of straining aching eyes toward an empty meaningless horizon in search of help."

American newspaper dispatches soon referred to submarine fleets as wolf packs and to Germans at large as "vicious, rapine Huns." That description would have startled Goethe, Brahms, or the gentle lyric poet Ranier Maria Rilke.

This was war, not marbles. The British army introduced its own weapon of terror, the armored tank, spitting machine-gun and cannon fire, crushing flowers, flesh, bone, everything in its path, the dreaded mythic juggernaut turned real. U.S. reporters applauded "Tommy Atkins' new toy." The German soldiers who found themselves facing the first tanks on September 18, 1916, reacted in an understandable way. They panicked and ran.

Later, in a dissonant echo of the Edith Cavell affair, the French arrested a woman charged with spying for the Germans. The suspect this time was not prim and proper. Americans read that the Dutch woman, Gertrud Zelle, who called herself Mata Hari, was not only a spy but a courtesan. She "had learned to dance naked on a purple granite altar in Java." She was "a serpent in woman's form."

Dark-haired, partly Asian, and sensual, Mata Hari found for lovers a German crown prince, a Dutch prime minister, and a French minister of war. In October 1917, the French military charged her

with enticing high French officers into her bedroom. Working with fine wine and sexual favors, she was said to have obtained French battle plans, which she then sold to the German side. Prosecutors claimed that Mata Hari's wiles had cost the Allies a hundred thousand lives.

"She made a great impression in the courtroom," an American reporter wrote, "standing straight as a ramrod and sweeping the judges with flashing glances from her pale forget-me-not eyes." Her lawyer, Maître Clunet, pleaded that yes, she had been a harlot, but never a spy. She had discussed art and champagne and love with French officers, but never military secrets.

At the end of his summation, Clunet fell to his knees before Raymond Poincaré, the president of France, and began to weep. Speaking through his tears, he said that Mata Hari was enceinte. He himself, the aged lawyer declared, was the culprit. Mata Hari must live, for French law forbade the execution of a pregnant woman. Mata Hari laughed. President Poincaré said to Clunet, "Old friend, I cannot spare her. For France's sake, I cannot."

Still ramrod straight, Mata Hari faced a firing squad of Zouaves at the Vincennes Barracks in Paris on October 18, 1917. A story spread through America that standing there, Mata Hari stared down the Zouave soldiers and slowly opened her fur coat wide. Beneath the coat, she wore nothing. Mata Hari stood naked to her executioners. Perhaps she imagined that the Zouaves, gazing at the coveted breasts and the dark curls of the loins, would recognize that Mata Hari was too beautiful to die. Then they would lay down their guns. Mata Hari would seduce even her slayers. Anyway, that was the story.

Henry G. Wales covered the execution for the William Randolph Hearst's International News Service. He reported that Mata Hari walked to her death wearing a black velvet cloak trimmed with fur, black stockings, and high-heeled slippers, with silk ribbons tied over the insteps. "She was not bound. She was not blindfolded. She stood gazing steadfastly at her executioners.... At the rifles report, Mata Hari fell.... Slowly, inertly she settled to her knees, her head up always

and without a moan or the slightest change of expression on her face, gazing directly at those were taking her life. Then she fell backward." Clearly she did not throw open her coat. Wales, who brought his own sensibilities to the drama, described her black stockings as "grotesque." Mata Hari died with decorum, courage, and modesty. When no one claimed her corpse, it was moved to a Paris hospital. In an operating theater curious doctors dissected the remains of Mata Hari.

Apparently, Edith Cavell was good and Mata Hari was insidious. The German army was brutal and the French poilu and the English Tommy were heroic. In time Woodrow Wilson suggested that World War I was being fought "to make the world safe for democracy." But here on the side of Britain and France stood the czar, an autocrat, a bigot, an unalterable opponent of anything that so much as hinted at popular government. The regime of Czar Nicholas II had few redeeming features. Stripped of irrelevant niceties, the pretty wife, the attractive children, the tailored uniforms, the perfectly trimmed beard, the Fabergé eggs, and the gorgeous palaces, Nicholas Romanov was a brutal dictator. But with time and a little help from his enemies he eliminated himself as a problem.

On Germany's eastern front the czar sent a generation of muzhiks into battle, some armed with nothing more than clubs. Czarist officers, cocking loaded pistols, ordered the muzhiks to charge machine-gun nests. The result was mass murder, ritualized as battle. At length Russian authorities listed 1.7 million soldiers dead in World War I and another 2.5 million "missing." Over four million young lives were obliterated in service to the last Romanov czar. The final victims of the reign fell to Bolshevik bullets on July 16, 1918. These were czar, the czarina, and their children

After Nicholas's forced abdication early in 1917, a liberal government had reigned briefly, but with October came the Bolsheviks. Lenin and Trotsky marched to power, American John Reed reported, under banners proclaiming: "ALL POWER TO THE WORKERS, SOLDIERS AND PEASANTS! PEACE! BREAD! LAND!"

"We have no more government," a Russian soldier boasted to Reed, "and for that *Slava Bogu* [glory to God]!"

Few noticed one small, pockmarked man from Georgia. In the wings stood Josef Stalin.

———

During World War I, Jack Dempsey had an uneven time. He was barely nineteen when the guns of August broke the peace in 1914. He had been boxing as "Kid Blackie," the name he used in the ring until his twentieth birthday. He fought in Salt Lake City but he also had to take matches in bone-dry mining towns around Utah and Nevada. He once walked from Tonopah to Goldfield, a barren Nevada desert stretch where a man could die of thirst. "It was July. Even the cactus was struggling to survive the heat. But I needed the purse," he said. "Twenty dollars. We fought in the back room of a bar." He took on "One-Punch" Hancock in Salt Lake. Fifteen seconds into the fight, Dempsey swung and—almost too droll to be true—knocked out One-Punch Hancock with one punch. Dempsey felt pleased. Hardy Downey, the promoter, did not. "The fans and me got no run for the money. Let's see if I can find someone else for you to fight." Downey cupped his hands and called to the crowd, "Kid Blackie here wants to know if anybody else would like to fight him."

A large man at ringside ripped off his shirt and shouted, "I sure would!" He pointed to One-Punch Hancock still lying unconscious in a corner. "I'm his brother."

It took Dempsey twenty seconds to knock out Hancock II. Downey paid Dempsey five dollars. "When I got five bucks for thirty-five seconds of fighting," Dempsey said, "I felt I was on my way."

But fights were hard to find. He worked as a miner, a dishwasher, a farmhand, a cowboy. He hustled in a pool parlor. For a time he was a porter in the Hotel Utah in Salt Lake City. He boxed whenever he could get a fight. "I didn't mind the mines," he said. "I was the only guy I knew who actually enjoyed going down a shaft and

knocking chunks of ore off a wall. But what I lived for was the fights. I was never happy unless I had a fight scheduled." He fought in the Opera House at Victor, Colorado, and in the Gem Theater at Tenth and Main in Durango. He didn't have much polish, but he punched with a power that broke other men. That was one reason fights were hard to find.

Other boxers began avoiding this skinny black-haired kid who hurt you so much when he hit you. Buck Weaver, a barber and occasional promoter, brought Dempsey to Durango in southwestern Colorado to fight at the Gem Theater on October 7, 1915, during the annual Colorado–New Mexico State Fair. The opponent, Andy Malloy, was twenty pounds heavier and ten years older.

Durango was a county seat, a station stop along the Denver and Rio Grande Railroad, set among mines and a few dairy farms. The Gem Theater, where Dempsey was to fight at 10:00 P.M. on a Thursday, sat in Durango's "saloon block," among the whorehouses, bars, and opium dens along Main Avenue near Tenth Street. Despite that block, Durango had its conservative element. Sheriff Arthur Fassbinder announced before the fight that if either man was knocked out, both would be arrested. The sheriff, cut from a different cloth than Wyatt Earp or Bat Masterson, would permit an "exhibition" of boxing skills, but not a contest. (This sort of uncertain yet aggressive moralizing seemed to say, "Onward, Christian soldiers, but not *too* onward." It led, as we shall see, to a confusing pattern in American boxing legislation.)

Dempsey outpunched Malloy—with uncharacteristic gentleness—over ten rounds. Understandably, there were no knockdowns. Next day the *Durango Herald Evening Democrat* reported that "the audience declared Dempsey the better man." Malloy, near the end as a fighter, promptly proposed himself as Dempsey's manager. "I been around this business for a long time," he said. "I'm a guy who can get you all the fights you can handle."

Dempsey accepted a match Malloy proposed in the village of Olathe, situated among potato farms about halfway between Durango

and Grand Junction. The opponent was a local strongman, remembered as "Big Ed." The arena would be a livery stable. Confident of a quick victory for Kid Blackie, Malloy booked the match as winner take all and checked into a five-dollar-a-week room with Dempsey.

Again a sheriff intervened. This sheriff, Dempsey later insisted, must have been one of Big Ed's relatives. No boxing was allowed in Olathe, the sheriff said. Dempsey would have to wrestle Big Ed.

"You rassle him," Dempsey said. He turned to Malloy. "Let's get out of here."

"Your landlady says you owe her five bucks," the sheriff said, "that you should have paid in advance. We got laws in Olathe about paying rent, just like we got laws about fighting. Unless you wrestle Big Ed, you go to jail."

At the livery, Dempsey lasted less than five minutes. "I could have belted him out with one punch, but the sheriff was sitting right there." Big Ed, an experienced wrestler and a specialist in choke holds, pinned Kid Blackie. There was no purse for a loser, but the sheriff let Malloy and Dempsey go, which may eventually have cost him the vote of a landlady.

Andy Malloy said he knew a pretty girl up in Montana, and he loved her and he was going there. The last time Dempsey saw him, Malloy was standing on the roof of a freight train headed north, silhouetted against a Colorado dawn. Dempsey rode a boxcar back to Salt Lake City. He kept himself cheerful by singing over the noise of the wheels:

> If I was a millionaire and had a lot of coin,
> I'd plant a row of coke and grow heroyn. . . .
> I would have forty thousand hop layouts, each one
> inlaid with pearls.
> I'd invite each old-time fighter to bring along his
> girl. . . .
> Down at the fighters' jubilee. . . .
> We'll build castles in the air,

And all feel like millionaires
Down at the fighters' jubilee.

In Utah he found another manager, an eager character named Jack Price. After Dempsey knocked out "Two-round Gillian" in Salt Lake City just before Christmas in 1915, Price billed him as "the Salt Lake City Tiger." He told everyone that Dempsey, fighting at about 165 pounds, was "light-heavyweight champion of the Rocky Mountains." No such title existed, but boxing managers early learn the uses of creativity and fiction.

In 1916 Dempsey won nine straight bouts—seven with knockout punches. At Ogden, Utah, he took on the Boston Bearcat, a black eastern boxer with good credentials. He hit Boston Bearcat so hard with a right to the stomach in the first round that the Bearcat moaned and fell to the canvas. Then at the count of six, he said, "That's enough, white boy. I got sufficient. No more fighting for me."

Johnny Sudenberg and Jack Downey fell in two rounds. Dan Ketchell lasted three. Cyril Kohn and Bob York made it into the fourth. Nobody boxing in the Rocky Mountain area, no muscled miner, no mighty blacksmith, no brawling cowboy, could long survive in a prize ring with Jack Dempsey. After one rousing victory, Dempsey and Price repaired to a Salt Lake bar where Price told Dempsey that he was one hell of a fighter. As Dempsey later reported, "I didn't give him any argument. And the more he talked the more he gave me an idea."

Dempsey asked Price, "You got any money?"

"Yeah. A little over two hundred dollars."

"That's about what I got, too. Let's go to New York. Let's make some real money."

Startled, Price said, "New York? Are you crazy? They got real fighters in New York."

"I'm a real fighter," Dempsey said.

Price considered briefly. "Okay," he said, "but I won't ride them damned rods with you another foot." (To ride the rods was to cling to

the brake beams under a freight car; no more dangerous way to travel exists.)

"Forget that," Dempsey said. "We'll ride the plush [buy tickets]. And we'll fight our way East. Stop off at a town. I'll flatten some bum. We jump a couple of hundred miles, and do the same thing until we hit New York."

The two shared upper berths on the long train ride. They stopped off at Kansas City, St. Louis, Chicago, and Cleveland. Price carried an envelope of press clippings. He sought out local promoters. He introduced Dempsey as the young tiger who had beaten Joe Bond. One promoter in Chicago said, "Who the hell is Joe Bond?"

"Listen," Price said, "he also knocked out the Boston Bearcat in the first round and the Boston Bearcat was good enough to go ten rounds with the great Sam Langford."

"Heard of Langford, sure, but never no Boston Bearcat. Probably phony as a three-dollar bill. Anyway, your guy looks skinny for a heavyweight."

"I strip big," Jack Dempsey said defiantly. But his speaking voice was high and at tense moments, he tended to squeak. The only work Dempsey found between Salt Lake City and New York was a four-round preliminary. He won, but nobody noticed.

In the late spring of 1916, New York City gave Dempsey a chilly welcome. He looked gangly and bucolic. There was the matter of the squeaky voice. He was never impressive punching bags. New York was crowded with better-looking young boxers. He and Price rented a room near the Polo Grounds, at 155th Street. Price made the rounds of the promoters with the press clippings. Dempsey did roadwork in Central Park and punched bags and sparred at Grupp's Gymnasium on 116th Street. Money was short. Dempsey took to buying nickel beers, which entitled him to a free lunch. Pickles, crackers, cheese. He ate what he could. The free lunches were mostly carbohydrate and Dempsey's weight moved up from 160 to 162. To save money, he and Price gave up the room. They showered at the gym. They slept on benches in Central Park.

On June 24, Dempsey defeated André Anderson at the Fairmont Fight Club in uptown Manhattan. Anderson, fifty pounds heavier, knocked Dempsey down twice in the early rounds. Dempsey recovered, cuffed the bigger man around the ring and, the newspapers reported, won going away. Ned Brown of the *Morning World* wrote: "Dempsey is a great young fighter. There is one thing wrong with him, however. He looks like he needs a square meal." The purse was twenty dollars. Dempsey's share was nine dollars. On July 8 Dempsey fought Wild Bert Kenny at the Fairmont for ten hard-slugging rounds. Every newspaperman gave Dempsey the decision. Dempsey's share of the thirty dollar purse was fourteen dollars. Sportswriters, including influential Damon Runyon, took notice, and the New York boxing crowd suddenly paid attention.

One interested fight man was John Reisler, called John the Barber because he owned a large tonsorium on Broadway. Reisler had begun by clipping hair and soon advanced to clipping people. Reisler faked a telegram to Jack Price. It read: "Come home to Salt Lake City at once. Mother gravely ill."

Price lacked train fare. "I'll buy the fighter from you for fifty dollars," Reisler said. "That will get you home to help your Ma."

"My fighter is a good feller," Price said.

"I'll look after him," John the Barber promised.

Price went West. Reisler proposed that Dempsey travel to New England for a bout with Sam Langford, a great black boxer called the Boston Tar Baby. Langford began boxing professionally in 1902, when Dempsey was six years old. Now thirty-six, Langford was near his peak, tough, experienced, smart, and twenty pounds heavier than Dempsey. Reisler not only managed Dempsey. He also managed Langford. The fight would give him a share of both purses.

"I've seen Langford," Dempsey said. "He's too good for me right now. I need more experience before I take on someone that good."

Having lost a double purse, John the Barber grumpily matched Dempsey against a tough veteran heavyweight named John Lester Johnson, not a championship fighter like Langford, but just a notch

or two below. Johnson, a tall, sinewy black man, was not the ideal opponent for a promising raw boxer from the hinterlands, still working to bring his skills to a big-time, big-town level.

"I don't want him, either," Dempsey said. "I'm not ready for him yet."

"That's the match I made," said Reisler. "We get 25 percent of the gate."

Dempsey observed later that "there is nothing braver than a manager sending his fighter in to be killed." But in the twenty-first year of his hardscrabble life, Kid Blackie, the Salt Lake City Tiger, knew the rules. If he turned down this bout, John the Barber could destroy his career simply by telling boxing people, "The Dempsey kid is afraid to take on anybody good. Dempsey is yellow."

Dempsey and John Lester Johnson fought ten battering rounds at the Harlem Sporting Club on July 14, Bastille Day, 1916. In the second round Johnson hit Dempsey with "the hardest punch I ever took," a right hook into the body. The blow fractured three ribs. Dempsey fought back. He always did. There was never any quit in Jack Dempsey.

When this uptown brawl was done, the crowd gave Dempsey some rousing cheers. The kid from the West had shown flair and style and heart. *The New York World* called the match "a fast ten-round draw." The *Tribune* reported: "John Lester Johnson won over Jack Dempsey," but gave no details. The consensus of sportswriters gave a big hand to Dempsey's courage and a narrow decision to Johnson.

The night before the fight, Dempsey had slept in Central Park. Now, looking over the cheering sold-out arena, he reasoned through pain that he had earned five hundred dollars. He thought of a hotel room. Clean sheets. A hot bath. A cold beer. Maybe he could even buy a suit. While a trainer taped the fractured ribs, John the Barber came into the dressing room. "Here's your cut," he said. He handed Dempsey thirty-five dollars. "Nice fight," John the Barber continued. "Our percentage came to $170. That works out to eighty-five dollars

each. You know I loaned your other manager, that fellow Price, fifty dollars. I gotta get paid back. That comes out of your cut. That leaves you with the thirty-five dollars.

"You bought me from Price," Dempsey said. "That's what the fifty dollars was for."

"Nope," John the Barber said. "The guy just borrowed the fifty against your next fight. Thirty-five, kid, is what you get."

Dempsey remembered thinking, "This comes out to ten bucks for each broken rib, and two-fifty for each black eye." So much for the good life in the big town...

Dempsey caught a freight train going west. He spent a week riding boxcars back to Salt Lake City. Broke again—broke still—he got a job shoveling in a copper mine, shoveling with three cracked ribs. Quite suddenly he married a hard-faced, pretty brunette named Maxine Cates, who played piano in Maxim's, a saloon on Commercial Street in the Gentile—non-Mormon—section of Salt Lake. The street has since been renamed Regent Street, and today runs within sight of the Pony Express Monument. But when Regent Street was Commercial Street in earlier, less self-conscious times, Maxine worked there and did turns as a prostitute. The young and lonely Dempsey was no stranger to whores. He walked into the bar and, as he remembered it, near the piano he heard Maxine say, "Hiya, stranger. I'm Maxine from Maxim's. Who are you?" She leaned forward and her breasts pressed against a thin dress. Dempsey said "something like electricity" ran through his body. Decades later, he explained, "They told me Maxine had another business. I didn't want to believe them. I married Maxine, the piano player. I know I loved her, or I thought I did. Up till then, Maxine was the sexiest woman I'd ever met.

"Why didn't I marry some sweet young graduate? I owned one shirt, one pair of pants, one beat-up pair of boots, and zero prospects. What sweet young graduate would have had me?"

Dempsey and Maxine married in Salt Lake on October 9, 1916. He was not yet twenty. She was thirty-five. They spent their honeymoon,

he said, in "a tacky hotel room." Then, after a day or two, he went back to work looking for fights and, on October 10, outpointed Dick Gilbert in Salt Lake. But fights were hard to come by in the mountain states. By Dempsey's account, he lived by doing "odd jobs, whatever came along." Others have him working as a bouncer in Salt Lake City's brothel-bars. He always denied persistent stories that he and Maxine were so frantic for money late in 1916 that he was reduced to working as her pimp. For nineteen-year-old Jack Dempsey life was mean and murky. In 1917, still armed with hope, he moved on to try his fortune in San Francisco.

Dempsey always worked hard at boxing, drilling, studying, thinking, sparring, punching. He soaked his hands in brine to toughen them. He sloshed bull urine onto his face. That was said to make the skin harder to cut. He was a boxer of extraordinary dedication and great intelligence. What he needed now was a manager who believed in him and beyond that a manager with style and flair.

John Leo McKernan, an implausible, serpentine hustler who called himself "Doc Kearns," became Dempsey's manager in 1917. Kearns had been welterweight fighter, a minor-league ballplayer, a faro dealer, a bouncer, and a bartender before he found his fated trade. He was partial to diamond tiepins, powerful cologne, and jeweled rings. In time his relations with Dempsey came apart, ripped by fusillades of lawsuits, the last for $701,063. Kearns told John Lardner, "When I found Dempsey in San Francisco in 1917, he was a moral, physical, and financial wreck. He wasn't eating steady. He couldn't hold a job. He'd been so broke in Salt Lake that he went out on the streets to find guys for Maxine. Whatever he says now, he sure as hell did pimp for his own wife. I taught him boxing tricks. I showed him how to throw that good left hand. Hook off the jab. The double hook. I got him going. But before I came along, he was a bum."

Dempsey's response: "Sure I rode the rods. Sure I was a hobo. But Kearns has the facts dead wrong. I was a hobo all right. But I was never a bum."

This thorny match between a fighter and his manager, the most extraordinary coupling in boxing's bristling annals, quickly bore fruit. Kearns got Dempsey fights and Dempsey delivered knockouts. Quite suddenly William Harrison Dempsey, now and forever after called Jack, found himself confident and rising, a fighter to be noticed, a person of substance. He would never ride the rods again.

In the spring of 1917, three weeks before America entered World War I, Dempsey swung into a string of rousing performances that began his march toward the championship match against gigantic Jess Willard, the man Jack Johnson said was too huge for anyone to defeat. Starting on March 21, 1917, in Oakland, Dempsey won nine straight fights. The next year, ranging as far as Philadelphia, New Orleans, Buffalo, he won twenty-one of twenty-two. Dempsey did not venture into New York. John Reisler claimed still to be his manager and was demanding half the money Dempsey was winning. "We ain't going near that guy or those New York courts," Doc Kearns decreed.

On eleven different occasions in 1918 Dempsey knocked out his opponent in the first round. Eleven one-round knockdowns in twenty-two bouts. Fighting at 165 pounds, Dempsey punched like Paul Bunyan. "It's not about how much you weigh," Dempsey said. "It's about getting your body weight in motion. That's what a punch is, isn't it? Body weight exploding into motion."

———

The success came against a troubling counterpoint. Beyond the sporting fields, the prize rings, the baseball diamonds, America was being marshaled to fight "the war to end wars." Channeled by a long and skillful propaganda campaign led by such stalwarts as Theodore Roosevelt, war fever and febrile patriotism swept the country. We were going to hang the kaiser. We renamed sauerkraut "liberty cabbage." We called dachshunds "victory pups." George M. Cohan caught the mood with "Over There," the great bugle-tune song he

wrote to a march tempo. In the verse, Cohan urged Johnny to get his gun and to show the Hun he was a son of a gun. "Hoist the flag and let her fly / Like true heroes do or die." Then came a swaggering chorus.

> *The Yanks are coming, the Yanks are coming,*
> *The drums rum-tumming everywhere.*
> *So prepare, say a prayer,*
> *Send the word, send the word to beware,*
> *We'll be over, we're coming over*
> *And we won't come back till it's over*
> *Over there.*

In asking Congress for a formal declaration of war in April 1917, Woodrow Wilson said, "America is privileged to spend her blood and might for the principles that gave her birth and happiness." After wild cheering, the Senate voted for war, 82 to 6. In the House of Representatives the vote for war was 373 to 50.

Some opponents made themselves heard, at least at first. William Jennings Bryan resigned as Wilson's secretary of state to protest policies he said were leading toward war. Robert LaFollete, the Farmer-Labor senator from Wisconsin, commented, "Wilson's declaration was written not on his White House typewriter. It was written when the House of Morgan floated the first Anglo-French Bond issue with the consent of the United States government."

There was big money to be made in banking for warring nations and in selling them arms and munitions. Spending blood and might "for principles" was profitable. But after Congress enacted the Espionage Act of 1917 and later the Sedition Act, it became dangerous to say so. These laws forbade "disloyal" or "scurrilous" language about "the flag, the armed forces, their uniforms, the Constitution or the American form of government." Swarms of district attorneys and judges interpreted these directives like zealots. The eminent and quite peaceable Socialist Eugene V. Debs went to prison for objecting

to the draft. He was convicted of sedition. A woman in Kansas drew a ten-year term for writing a letter that denounced "war profiteers." After Robert Frost's sister, Jeanie, made an antiwar speech, a mob chased her from a platform and threw her into a New Hampshire pond.

George M. Cohan sang, "Pack your little kit, show your grit, do your bit.... Make your mother proud of you, And to liberty be true." Set upon ten million fences, a red, white, and blue Uncle Sam glared, pointed, and said for the armed forces: "I WANT YOU!"

The first army draft, instituted during the Civil War, had led to riots on the streets of New York, even though it was legal to "buy a substitute," to hire someone else to face Lee's army, with all its deadly gunfire and unnerving rebel yells, in your stead. Many thousands of new immigrants were desperate for money. During the Civil War, no young Northerner with means had to go into the army if he didn't want to.

The second Selective Service Act was less forgiving, as were self-proclaimed American patriots. In the war of 1917, hooded Klansmen in the South hunted down supposed draft dodgers, tied them to posts, and lashed their naked backs. Certain Junior League ladies in New York delighted in presenting young men they spotted in civilian clothing a classic emblem of cowardice, a white feather.

Still amid all of this jingoism and bravado, not every American was clamoring to serve. Edsel Ford won an exemption on the grounds that the Ford Motor Company, where he worked for his father, Henry, was an essential industry. Huey Long said he deserved an exemption because he performed vital civilian services—as a notary public. His Louisiana draft board agreed. The most remarkable deferment I can find was granted to writer Conrad Aiken, whose most famous work was a love poem beginning "Music I heard with you was more than music, / And bread that I broke with you was more than bread." His poetry was essential work, Aiken argued. Other poets, Alan Seeger and Joyce Kilmer among

them, served and wrote and died in combat. Aiken's draft board granted him exemption.

But many were jailed. Evan Thomas, brother of the socialist leader Norman Thomas, was sent to Leavenworth for draft evasion. When Evan Thomas went on a hunger strike, the prison doctor cursed him and ordered that he be forcibly fed. Roger Baldwin, later director of the American Civil Liberties Union, refused to serve and spent a year in a federal prison in New Jersey.

The Selective Service Act—the draft—became law on May 16, 1917. Babe Ruth, a Boston Red Sox pitcher who hit with power, enlisted in the Massachusetts home guard. He never missed an inning. Bill Tilden, the great tennis star, joined the Signal Corps and spent two years stationed in Pittsburgh giving tennis lessons to army men, including his own commanding officer. Benny Leonard, the great lightweight champion, enlisted in the army and taught doughboys— the World War I term for GIs—to box. No less a figure than John J. Pershing, tight-buttoned, stiff-backed Black Jack Pershing, the general who commanded the American Expeditionary Force, said that it was important for a soldier to learn how to use his fists. How a firm left jab helped a man charging a machine-gun nest is something the general did not made clear.

Jack Dempsey dutifully filled out his draft questionnaire and applied for an exemption, in classification 4-A. He claimed that his father, Hyrum, his mother, Celia, his widowed sister, Effie, and her three children relied on him for support. In addition he listed as a dependent Maxine, his bride, the comely, dark-haired piano-playing prostitute. If you were the principal supporter of your family, if your induction would impose hardship on your family, you did not have to go into military service.

On his own, Dempsey tried without success to enlist in the navy late in 1918. Before that Doc Kearns put out stories that Dempsey was doing his part for defense by working in a shipyard between fights. Kearns circulated photographs showing the fighter in a work clothes. In one Dempsey sported a leather apron, like the other laborers. Un-

like the others, however, he wore high-gloss patent-leather shoes that protruded into the photograph.

Doc Kearns's misguided public relations campaign and the bitter, poignant, and finally pathetic Maxine Cates Dempsey came close to undoing the greatest of boxing champions.

———

After the armistice and victory, President Woodrow Wilson sailed to France with passionate hopes and a heavy conscience. "There must be a new order of things," he wrote in Paris on his own portable typewriter. "I sent these lads over here to die." He had ridden down the Champs Elysées in triumph like a god. "No one," commented the eminent reporter William Bolitho, "has ever heard such cheers." But at Versailles practical matters intruded. The French, twice invaded by German armies within four decades, wanted a punishing peace. President Poincaré, who had approved Mata Hari's execution, led the French hard-liners. The British intended to make "the Hun pay for the war to the last farthing," and perhaps hang the kaiser as well. And what about those bloody Reds spilling beyond the borders of Russia, with all their explosive agitating about prisoners of starvation and the wretched of the earth?

Wilson, the idealist, said that food rather than artillery might stop the spread of Bolshevism, even roll it back. To the leaders of France and Britain this seemed naive. Besides, some wondered, how could a man presume to lead the world from a country where selling one glass of Chablis constituted a criminal offense?

The Treaty of Versailles failed. Wilson failed. Peace failed. That, of course, is another story.

———

On July 1, 1919, the *World,* probably the most interesting newspaper in New York and the country, ran a headline eight-columns wide:

LID OVER ENTIRE NATION GOES DOWN UNDER
WAR ACT BUT 2.75 BEER IS PERMITTED
PENDING COURT RULING
WHEE! SOME NIGHT,
THAT WAKE OF CITY TO
OLD BOY BOOZE
DRANK THE WET TIME OUT
AND THE SAD DRY ERA IN

To anyone who has enjoyed a chilled martini or sipped deep, red Bordeaux, the coming of Prohibition to the United States is, to say the least, perplexing. Probably Prohibition was, first, an expression of the American puritanism that gained so righteous a voice during the First World War. It was also a strike against what is now termed alcohol abuse, but only afterward.

Drinking, and alcoholism, are rooted profoundly in American life and history. According to John Lardner, Henry Hudson served gin to a party of Lenape Indians on what is now Manhattan Island in the year 1608. The Indians passed out, to a man. Afterward, Lardner reported, the Lenapes named the place Manahachtanienk, which meant, in their language, "the island where we all became intoxicated." "Even the Lenapes," Lardner wrote, "had trouble pronouncing the name and it ended up as Manhattan."

As early as 1700, formal expressions of concern at American drinking appeared. That year Church of England elders sent a directive to Virginia saying that any clergyman drinking with others for more than one hour would be found guilty of intemperance and punished. Later Quaker groups in Pennsylvania published a pamphlet calling drink "the mighty destroyer," even as other Quakers amassed fortunes importing rum from the West Indies.

About 1750, hard liquor began making inroads. Old Monongahela, the first widely popular American whiskey, was prized by the Continental soldiers who shivered through the winter of 1777 at Valley Forge. Mixing with the troops, George Washington sampled a

shot of Old Monongahela. He spat it out. "Stinking stuff," the general said. Washington went back to Madeira wine, which in time stained his dentures. But the hard-whiskey industry had taken hold.

Opposition to drink developed half a step behind American drinking habits and gained steam throughout the nineteenth century. Temperance societies, notably the Women's Christian Temperance Union, focused on excess. Their patron saint was the early American physician Benjamin Rush, who warned that the "habitual use of ardent spirits" led to "fetid breath, disgusting belchings…epilepsy, gout…madness." The Anti-Saloon League, founded in 1893, propounded the idea that drinking, like prostitution, was a scourge that flourished in big cities as a result of alien influences. Soon numbers of rural counties and small towns passed directives against drinking. The various dry movements coalesced into the intemperate campaign to outlaw all drinking in America. The triumph of the dries came during the tumult of World War I.

Congress passed the Eighteenth Amendment, which prohibited "the manufacture, sale or transportation of liquor for beverage purposes," on December 18, 1917. Sponsors called this "the wartime prohibition act" as if to suggest that Prohibition, like World War I, in time would pass. But "wartime" Prohibition outlasted the war. The actual fighting stopped with the armistice of November 11, 1918. Nebraska's legislature cast the thirty-sixth and deciding vote for the Eighteenth Amendment on January 15, 1919, two months after World War I ended.

Actual prohibition took effect in stages. Many regions went dry on their own. But essentially from July 1, 1919, when the amendment became law, until repeal arrived on December 5, 1933, a spell of almost fourteen years, it was unconstitutional and criminal to buy a drink in the United States.

As it happened, A. Mitchell Palmer, the attorney general, was a fanatic. A Pennsylvania man and a Swarthmore graduate, Palmer liked to hear himself described as "the Fighting Quaker." (Detractors called him the Faking Quitter.) He became notorious for the "Palmer

Raids," roundups of Bolsheviks real and imagined. His position on Prohibition was severe. He announced on June 30 that "the law must be obeyed. Anybody selling intoxicants will be prosecuted."

But within the week, Palmer and his press releases, and indeed President Wilson, Versailles, and Prohibition itself, were driven off the front pages by a prizefight.

This, then, was the world into which Jack Dempsey marched with his first strides toward becoming a legend. A world of a great democratic victory and a disastrous peace; a world where America finally achieved world power and quickly embraced isolationism; a world of fast money, fast women, fast living, but where, in America, at least, the puritans still got to write the laws.

2 The Rocky Road to Toledo, Ohio

All wars are planned by older men
In council rooms apart,
Who call for greater armament
And map the battle chart....
But where their sightless eyes stare out
Beyond life's vanished joys,
I've noticed nearly all the dead
Were hardly more than boys.

"The Two Sides of War"
Grantland Rice

T HE AFTERMATH OF WORLD WAR I was like nothing that had occurred across the previous 133 years of United States history. The year beyond the armistice, 1919, gave America a fixed World Series, nationwide Prohibition, and galloping xenophobia, unfortunate anywhere but outrageous in a nation of immigrants. A few lines by the wildly popular midwestern versifier Edgar Guest illustrate the country's righteous, violent mood.

Said Dan McGann to a foreign man who worked
at the selfsame bench,
"Let me tell you this," and for emphasis, he
flourished a monkey wrench,
"Don't talk to me of this bourgeoisie, don't open
your mouth to speak
Of your Socialists and Anarchists, don't mention
the Bolshevik.

For I've had enough of this foreign stuff,
I'm sick as a man can be
Of the speech of hate, and I'm telling you straight
that this is the land for me."

One can imagine what happens next. "I'm still voting socialist," responds the foreign man, a hardworking immigrant from Bratislava. Dan McGann swings his wrench and knocks the immigrant unconscious. That night at an American Legion club situated between Toledo and Detroit, Dan's buddies buy him a half-dozen beers, smuggled across the Lake Erie from Canada on the speedboats gangsters used to outrace the Coast Guard and Prohibition.

Dan's parents were immigrants, his father from County Mayo, Ireland, his mother from Glasgow, Scotland. But never mind. They had made their Atlantic voyages forty years earlier and Edgar Guest was talking about the present. The foreigner suffered brain damage. He could never vote or work again. But Americanism, as defined by Edgar Guest, was preserved.

Counterposed to such dismaying jingoism came both prosperity and literary flowering, a heady mix. Henry Ford flourished with his combination of puritanism, boosterism, anti-Semitism, and good old greed. Nor was Ford alone. Between February and May in 1919, General Motors share prices climbed from $130 to $191. A bull market was gathering strength. With it would come the greatest boomtime in the annals.

Sherwood Anderson published *Winesburg, Ohio* in 1919. Sinclair Lewis' *Main Street* and Scott Fitzgerald's *This Side of Paradise* appeared a year later. Gertrude Stein, who had quit Oakland, California, for Paris, wrote, in *Sacred Emily,* "Rose is a rose is a rose." She left millions discussing what that sentence meant.

———

Grantland Rice is remembered by those who knew him as much for his geniality as for his flowery prose and verse. A soft-spoken na-

tive of Murfreesboro, Tennessee, and a Vanderbilt graduate, "Granny" Rice had a firm literary background, a decent lyric touch, and a classically romantic view of sport. It was Rice who first called a Notre Dame backfield that had run over a strong army football team "the Four Horsemen." He took the reference from the Four Horsemen of the Apocalypse, figures personifying war that appear in the Revelation of St. John the Divine: Conquest, Slaughter, Famine, and Death. Each is depicted astride a rearing warhorse with heaving flanks and flared nostrils, pawing the air with terrible hooves. What a backfield. Not exactly football players, but Rice wasn't much at understatement.

His most famous quatrain extols sportsmanship.

> *When the One Great Scorer Comes*
> *To mark against your name,*
> *He writes not whether you won or lost,*
> *But how you played the game.*

Rice's work yields easily to parody. John Lardner composed a pragmatic response:

> *Right or wrong is all the same*
> *When baby needs new shoes.*
> *It isn't how you play the game.*
> *It's whether you win or lose.*

To a man, surviving colleagues attest to the personal decency and the amiability toward all that emanated from gentle Grantland Rice. "As far as I know," one 82-year-old sportswriter told me, "Rice was kind to everybody he ever met. And the more famous he got to be, the kinder he became. It's a cliché, 'The bigger they are, the nicer they are.' In the case of Granny, the cliché was true."

Yet when the *New York Tribune* dispatched Rice to Toledo in 1919 to cover the championship fight between Jess Willard and Jack Dempsey, the classic geniality disappeared. As I got the story in a later time, Rice spoke to Ring Lardner along these lines: "I covered the

Battle of the Argonne Forest [in northeastern France]. Forty thousand American soldiers died there and only forty newspapermen covered that slaughter, which was as much as I hope I ever have to see of hell. Now we have a couple of brawlers getting ready for a fistfight and we have six hundred reporters cheering them on like heroes here in Toledo. It doesn't make sense, Ring. To make heroes out of these two characters because they're boxers galls me. I saw skinny, four-eyed bank clerks killed when they charged German machine-gun nests. That was courage. These guys can punch, all right, but they didn't have the guts to fight for their own country. So what does a boxing match like this mean? What do you think, Ring?"

Lardner was a tall, bald fellow, silent, except when good whiskey lifted his spirits and led him to sing. "I think Willard," Lardner said. "I think size. Willard is immense. I've bet five hundred dollars on him."

Despite his qualms, Rice was intensely excited by the forthcoming fight. So was much of America. The war was done and the soldiers were tramping and limping home. It was time to get on with the often-pleasant business of peace.

"I think you've made a mistake, Ring," Rice said. "An ox cannot defeat a tiger."

"No," put in W. O. (for William O'Connell) McGeehan, the sports editor of the *Tribune,* "but an elephant sure as hell can." Bill McGeehan had served as a infantry colonel. He had fought in some of the hell that Rice covered. "Not disagreeing with you, entirely, Granny," he said to Rice, "but modern war isn't fought with fists. If that big elephant Willard tried to stand up against a tank, he'd go down as quick as your poor little bank teller. And probably scream louder when he got hit."

This was the first heavyweight championship fight in three years, the first big outdoor fight in almost ten years, and the first in many decades where expert opinion turned out to be evenly divided. McGeehan, a gifted and sardonic character, pointed out on the front page of the *Tribune* that the opinion of boxing experts often was in error.

Experts had given James J. "Gentleman Jim" Corbett no chance

against John L. Sullivan, "the Boston Strong Boy," who was thirty-five pounds heavier when they met in the Olympic Club in New Orleans, on September 7, 1892. Corbett knocked out Sullivan in the twenty-first round. Five years later the experts had given balding Bob Fitzsimmons no chance against the sleek Corbett in San Francisco. Fitzsimmons knocked out Corbett in the eighth with a blow to the solar plexus. Indeed, when Willard, who stood six foot six and weighed 250 pounds, came up against Jack Johnson, the first black champion, in the spring of 1915 at an outdoor arena in Havana, Cuba, experts dismissed him as "a big stiff." Willard won the championship in the twenty-sixth round when he clubbed Johnson to the canvas. Three rousing championship fights. Every one an upset. Whatever happened between Dempsey and Willard on Independence Day in Toledo, half the experts would be wrong.

"To my mind," McGeehan wrote, "Willard should win. He has the advantage of fifty pounds [actually closer to seventy] and a longer reach. He can hit and he can block. If it were not sacrilegious in view of the fact that Mr. Willard was not at all interested in the late war, I might compare him to the American nation aroused. He is a huge person with potentialities.

"William Harrison Dempsey, the contender, is a more romantic figure. Dempsey also is as fit as can be for a man who is twelve years younger and at least fifty pounds lighter than the obstacle that stands between him and the winner's purse and all the glories that the late John L. Sullivan left when he departed this world [in 1918]." (Sullivan, who earned $1,221,320 during a fifteen-year span as champion and subsequent vaudeville tours, left an estate of $3,562. Even though Sullivan turned teetotaler thirteen years before his death, the Prohibition crowd blamed his modest final ledger on whiskey.)

On another page that day the *Tribune* featured a dispatch from Washington quoting Samuel Gompers, president of the American Federation of Labor, on the growth of the Communist party in the Midwest. Gompers blamed Prohibition, specifically Michigan's state-wide ban on alcohol, which had been in effect for fourteen months.

"Oppressive legislation," Gompers told the Senate Judiciary Committee, "begets radical propaganda. Should Bolshevik doctrines obtain a foothold in this country, the prohibitionists will not be free of responsibility."

———

Placing what was one of the most significant fights of the twentieth century in a lively but smallish middle-American community was the brainchild of George Lewis "Tex" Rickard, a gambling man with a surpassing appreciation for the lure and nuances of money and a sense of promotion that might serve as a model for postdoctoral seminars at the Harvard School of Business. Rickard dropped a great fight into a backwater. He chose a time when, one columnist declared, "war has left this country surfeited with violence and blood. We do not need another brutal boxing match." In a climate of frenzied patriotism, he matched two fighters who had declined to go to war.

He then proceeded to build, for this single event, an enormous octagonal arena planked with Michigan white pine in a park beside Maumee Bay, a river mouth that spills into the southwestern corner of Lake Erie. No roof would protect the crowd from the sun or from a thunderstorm. Rain did not come, but the pine oozed sap in the searing summer heat and the sticky-planked arena did not approach selling out. (A number of concessionaires went bankrupt.) The bout itself was brief and flawed almost fatally by a bell that could not ring. Yet to find a germinal, the point of creation, for what sportswriters call big-time boxing, your journey inevitably takes you to Toledo, Ohio, and July 4, 1919, where the spectators in the sixty-dollar ringside seats wore white shirts and straw boaters and, where, under a pitiless sun, the ring ropes looked white as bone.

One of my father's friends, a short, intense, scholarly fellow named Richard Fuchs, had gone to work for Rickard immediately

after graduating with honors from Columbia, a first-job experience from which Fuchs never entirely recovered. He spoke often of Rickard's commercial skills but the admiration was restrained; Fuchs himself never was able to earn much money. He was fired soon after Rickard's death, cut loose to find a new career amid the teeth and claws of the American Depression. When he could not, his wife had to sell china at Wanamaker's to support a growing and gifted family. Fuchs consoled himself by reading and rereading with my father Gibbons' *Decline and Fall of the Roman Empire.*

Fuchs originally entered Rickard's employ because of a passion for the circus. "In those days," "Uncle Dick" told me when I was six or seven, "circus people and boxing men went together. They'll always go together. Pachyderms and pugs," he continued, with a slight grin, offering two words I had not heard before. Like most boys of my generation, I liked to scrap, or at least I liked the idea of a scrap. I listened intently to the fight talk between my father and Dick Fuchs, who both knew quite a bit about the game.

My father, Gordon, had been sent to a gym for boxing lessons at ten, the better to deal with hooligans in the Brooklyn neighborhood where he grew up. Later Fuchs saw my father deck a West Point cadet who came on too aggressively to his attractive dark-haired date. The date in time became my mother. "Your dad dropped him with a left," Fuchs said, standing and throwing a living-room version of a hook. He then showed me the difference between a jab and a hook. "Your father was an amateur, not a professional, but he had a very fast left hook."

"Tell him what I did to Philadelphia Jack O'Brien [a great lightheavyweight champion]," my father said, deadpan, picking up a popular vaudeville routine.

"You want me to tell your son what you did to Philadelphia Jack O'Brien?" Uncle Dick repeated easily.

"Right. Tell him what I did to Philadelphia Jack O"Brien." My father paused before throwing out the punch line. "But don't tell him what Philadelphia Jack O'Brien did to me."

Their fight talk was usually lighthearted but I never heard humorous banter about Dempsey. To both men, Dempsey topped Olympus. He was the champion beyond compare.

As Dick Fuchs unfolded his story, the circus was a steady money-maker, all those acrobats and tightrope walkers, jugglers, jungle cats, and pretty girls in pink, slowly amassing a fortune for John Ringling, the head of the family that ran the show. If the circus did not have the elegance of the Metropolitan Opera—and it did not—it possessed a certain glamour and raffish respectability among the middle class. Since the days of P. T. Barnum, who survived until 1891, the circus had been establishing itself as a national institution, slightly risqué, perhaps, but not seriously threatening to morality. "The circus," Ernest Hemingway wrote, "is the only spectacle I know that, while you watch it, gives the quality of a truly happy dream."

The circus trooped to Hartford, Buffalo, Dubuque, or Louisville and pitched tents. New York City was different. Not a small town. Not a farm town. The circus folded its tents when it came to New York and put on its show in a permanent structure, twice a day for as long as six weeks every spring. An arena that can house a circus can hold a prize ring, which more or less explains how Rickard and Ringling came together. Their focus, their problem, was Madison Square Garden.

Since 1879, no fewer than four buildings in New York have been known as Madison Square Garden. The first two actually were located in Madison Square, originally a four-and-a-half-acre park off Fifth Avenue, extending north from Twenty-third Street. Surely the most dramatic and remarkable was Garden II, designed by the famous architect Stanford White, who topped his pantheon with a 320-foot Italianate tower and topped *that* with a thirty-foot statue of Diana the Huntress. The goddess stood bare-breasted, bow in hand, and wore not much more than a loincloth. Some New Yorkers looking up expressed shock. White established private living quarters in the tower penthouse and relaxed in another apartment nearby by watching a teenage floradora girl named Evelyn Nesbit float back

and forth while sitting naked on another of his designs, a red velvet swing. On June 25, 1906, Nesbit's husband, a moody millionaire named Harry Thaw, approached White, who was watching a show called *Mamzelle Champagne,* at the building's outdoor roof garden. While a tenor sang "I Could Love a Thousand Girls," Thaw shot White in the head three times. Nesbit admitted in court to swinging naked, but claimed she had been drugged. One jury could not reach a verdict. The jury at the second trial found Thaw not guilty of murder by reason of insanity.

The red-velvet history of Madison Square Garden II troubled Rickard and Ringling not at all. To them the elegance, eroticism, and scandal were no more than incidental. Both wanted a bigger arena. Pale red walls enclosed the main auditorium of Garden II, which housed boxing exhibitions, political rallies—Theodore Roosevelt and William Jennings Bryan spoke there—horse shows, and the circus, but held only eight thousand permanent seats. A bigger Garden would mean first and last more money. ("But it ain't just the seats," George Gainford, a later fight manager, pointed out in his clear, inelegant way. "It's the number of asses you got in them seats.")

Boxing cash—at first mostly the potential for boxing cash—forged the unusual alliance between Tex Rickard of the prize ring and the Klondike, a man unsullied by culture, and John Ringling of the circus and Sarasota, a prototypical American arriviste, who built an art museum near his ornate thirty-two-room villa, complete with a full-sized copy of Michelangelo's statue of David. As Stanford White might have pointed out, had he lived, "Yet another nude."

When the *New York Herald Tribune* hired me to write sports in 1950, Dick Fuchs decided to flesh out his portrait of Rickard in an alarming way. "One of my jobs," he said, "was taking care of Rickard's ice. I assume you are familiar with the term." By this time I well knew pachyderms and pugs, but not, in this context, the word *ice.*

"Payoff money," he said. "The big New York City boxing writers came to Rickard's office once a week, usually on a Friday, and I gave them their ice—seventy-five dollars. Farnsworth from the *Journal* and

the feller from the *Telegram* and the men from the *Tribune* and the *Times*. I don't remember all their names anymore, but understand that these rascals were getting paid forty dollars a week from their papers and seventy-five dollars a week from Rickard. So Rickard was their number one employer. Not a man jack of the lot ever turned a penny back. They took the money and they wrote what we told them to write. Rickard always said, 'Buy me the writers. Pay whatever it takes. I'll get my money back at the gate.'"

By this time, broadly the boxing era of Jersey Joe Walcott, a rising Rocky Marciano, and a fading Joe Louis, New York fight writers at the *Times* and the *Tribune,* and possibly elsewhere, were reporting honestly, sometimes defiantly so. When I told that to Uncle Dick Fuchs, schooled in the press by the worldly and cynical Rickard, he shook his head. "An honest fight writer," he said, "is like a good Nazi. There aren't any."

Rickard was born in Kansas City, Missouri, in 1870 or 1871 or 1872. Apparently the birth certificate no longer exists. When he was four his parents moved to Sherman, Texas, about fifty miles north of Dallas. He claimed to have been a working cowboy in Sherman at the age of ten and town marshal of Henrietta, Texas, when he was twenty-three. Old-timers remembered him as a diplomatic marshal, whose quick tongue and calming manner "kept skylarking cowboys from shooting up anybody." But none doubted that Rickard could handle a Colt .45. He was no man to cross, particularly when coins lay on the table.

John Lardner, whose father, Ring, observed the man for years, summed up Rickard as "a footloose gambler." He was indeed, and more than that as well. A buccaneer, a hustler, an adventurer, a fast-dealing baron, and not a bad man, not a bad man at all, if you were willing to overlook a peccadillo or two, such as bribing a generation of newspaper reporters.

Young Rickard quit Texas and made his way to the Klondike during the gold fever of the 1890s. He found no gold, but as Dempsey put it, "Tex found something better. A gambling hall that took the gold the other guys dug." He ran the hall and he dealt faro, a rapid,

dangerous game in which bets are settled after only two cards are dealt. Rickard said he could have grown rich in a hurry except that he ran an honest game, "the only square faro in the Klondike. Many a night I went broke. It wasn't the prospectors beat me. It was the dealers from the other gambling places used to hurt me." Rickard then offered a tip from those rugged Klondike days. "Always gamble where the dealers from the other joints gamble. They know where to find the honest game in town."

At thirty-four, he surfaced in Goldfield, Nevada, running a saloon and possessed of thirty thousand dollars in gold. As Rickard told the story, he put his money, a small mountain of gold coins, in the window. He kept his pistol close at hand, under the bar. (Dempsey said Rickard himself could drink all night and stay steady and clear-eyed.) Then he took advertisements in the *Police Gazette,* a sports and scandal weekly that circulated in almost every barbershop in America, announcing that he was offering the thirty thousand dollars to any two "big-timers" who agreed to box in Goldfield, a town set against the harsh hills of western Nevada. The lightweight champion, Joe Gans, a fast, clever, black man based in Baltimore, and the top challenger, Battling Nelson, a swarming slugger called "the Durable Dane," accepted Rickard's offer. They fought forty-two rounds on September 3, 1906. Gans won when Nelson was disqualified for repeatedly hitting below the belt. Rickard paid his own expenses, paid the fighters, and turned a thirty-thousand-dollar profit, a pleasing 100 percent return on all those gold coins that had sat in the window.

Rickard promoted a fight again in 1910, when Jack Johnson was heavyweight champion and the country had become a tumult of babble about white hopes and white supremacy. Few felt troubled when a black man ruled the lightweight (135-pound) division. Gans even was allowed to fight a championship bout in Arkansas in 1903. But a black as *heavyweight* champion was widely perceived as wrong and widely regarded as threatening. The heavyweight champion stood tall as the greatest warrior in the world, and that warrior was not supposed to be a red Indian or a yellow Chinese or a dark-skinned Negro. The heavyweight champion was supposed to be a white man.

Further agitating this ambient racism, Johnson (unlike the later black heavyweight champion Joe Louis) was cocky, talkative, and determined to express himself, prejudice be damned. He taunted opponents in the ring. He had a gold-toothed smile that many found smug. He came to prefer white women to black women. "Every colored lady I ever went with two-timed me," he said. "The white girls didn't." Such talk and such an attitude inflamed a nation in which all dominant institutions—the Senate, major league baseball, the U.S. Navy, Ivy League faculties, the Supreme Court—were open only to whites.

Johnson won the world championship by knocking out Tommy Burns, a French Canadian born Noah Brusso, on the day after Christmas 1908, in Rushcutter's Bay, a suburb of Sidney, Australia. Burns talked when he boxed, taunting and threatening his opponents. (He ended his days, still talking, as a revivalist minister.) The fight went fourteen rounds, during which Johnson subjected Burns to countertalk and a steady mauling. He knocked Burns down with a heavy righthand punch in the fourteenth. Burns rose at the count of eight and Johnson tore through his defenses with both hands. Burns had stopped chattering by this time. He was tottering. Johnson slugged on. Finally a contingent of Australian police, fearing for Burns's safety, climbed into the ring and stopped the bout. Only then did the referee, Hugh McIntosh, declare the black man the winner and new heavyweight champion of the world. Without the intervention of the police, witnesses said, Johnson might have punched Burns to death.

For the next seven years boxing men and white society at large looked desperately for a white hope "so that," as the novelist Jack London wrote in a newspaper dispatch, "the world champion can once again be what a world heavyweight champion should be—Caucasian."

The brightest white hope, many came to believe, was James J. Jeffries, dark haired and strong jawed, the California Grizzly, who had retired as undefeated heavyweight champion in 1904 at the age of twenty-nine and begun growing alfalfa at a farm near Burbank. London led the agitation for Jeffries's return. "One thing remains," London wrote. "Jeffries must emerge from his farm and remove the smile

from Johnson's face. Jeff, it's up to you." In 1910, Jeffries finally agreed to take on Johnson. The site would be Reno, Nevada. As many as six promoters gathered at Reno to make competitive bids and one came up with eighty-one thousand dollars, the largest guarantee in the annals of the ring up to that time. Rickard said he would put up $101,000. He opened a satchel and on the spot he counted out the money in thousand-dollar bills. "I'll referee the fight myself," Rickard said, "to make sure we get a fair and interesting match."

The men fought on July 4, 1910. White supremacist emotion led bettors to install Jeffries as the favorite, but he was thirty-five, ring rusty, and extremely frightened. His handlers had told him that Johnson intended to take a bribe and lie down like a lamb. On July 2, Jeffries learned that he had been misinformed. Jeffries's wife said her husband spent the night of July 3, 1910, standing at a window in a nightshirt, trembling.

The crowd surpassed fifteen thousand and drew a record gate of $270,755. But the fight was not much of a contest. Johnson pounded Jeffries and when Jeffries clinched, Johnson said with cold sarcasm, "Stop lovin' me, Mr. Jeff." As Rickard looked on inside the ring, Johnson knocked Jeffries semiconscious in the fifteenth round. With the California Grizzly curled in a heap in a corner, Rickard counted him out.

Sometime after that Jack Johnson was charged with violation of the Mann Act, a federal law that forbade "transporting a woman across a state line for immoral purposes." The woman in the case, Lucy Cameron, was white and worked as Johnson's secretary. Johnson married her—she became his third wife and his second white wife—but the charges stuck and he was convicted in Chicago. Johnson responded by leaving the country, disguised as a member of a traveling Negro League baseball team called Foster's Giants. He moved on to Europe by way of Montreal. He boxed exhibitions, bought a white Mercedes-Benz, stayed with Lucy but continued to seduce white women, and later claimed to have become friendly with Czar Nicholas.

The overall prosperity of the boxing business proceeds from the

heavyweight division; the appeal of the heavyweight champion is unique. Simply stated, more or less as John L. Sullivan stated it, the heavyweight champion is the one man who "can lick any son of a bitch in the world." With the heavyweight champion a fugitive, there was no serious money to be made in American boxing. Rickard moved to South America, where he raised cattle in Bolivia and acquired a ranch in Paraguay. He didn't come back to the United States until after Jess Willard had knocked out Johnson in Havana in 1915.

After that defeat Johnson was never allowed to get near the championship again. At length he served a prison term in Leavenworth and boxed sporadically until he was forty-five. Toward the end of his tumultuous life, he went to work as a sideshow attraction in a carnival called Hubert's Museum and Flea Circus on West Fortysecond Street in New York. I was taken to see him in 1940. He was big, courtly, sad-eyed, and while he told fight stories, he sipped red wine through a straw. When he finished talking, he sold autographed photographs for five cents each.

Johnson was not the pure and noble victim politically correct chroniclers have created. But the country treated him shamefully. Twenty-two years followed the end of his reign before a black man was again allowed to fight for the heavyweight championship.

When Rickard returned to America, boxing, with its very large Caucasian heavyweight champion, was edging toward respectability. Bluenose opposition kept the sport illegal in many states, but the military in World War I, from General Pershing on down, had adopted boxing on the theory that good punchers make good soldiers. You could find boxing tournaments in every army base and marine camp and even on ships at sea. Gene Tunney, "the Manly Marine" so prominent in Dempsey's late career, emerged as a serious fighter after winning a series of military tournaments. He became light-heavyweight champion of the American Expeditionary Forces by outpointing Ted Jamison in the Cirque de Paris in France in 1919. Along the way he

had outpointed the heavyweight A.E.F. champion, "Fightin' Bob" Martin, in a four-rounder.

With the return of the doughboys various boxing laws came to approach rationality. New York State had begun the century with the Horton Law, under which fights could be conducted for any number of rounds. Then the Lewis Law, 1901–11, limited boxing to bouts between contestants who were members of New York sporting clubs, effectively precluding heavyweight championship fights. Things loosened up with the Frawley Law, 1911, which permitted fights of up to ten rounds, but prohibited official decisions. (Under this bizarre legislation, people who bet on fights had to rely on newspapers for verdicts.) Finally on May 24, 1920, the Walker Law went into effect. It allowed for bouts of up to fifteen rounds, provided for decisions rendered by a referee and judges, mandated the licensing of boxers, managers, trainers, physicians, and promoters, and provided for overall supervision by a state commission. The Walker Law became the model for boxing legislation throughout the United States.

All this legal stammering was, at least in part, a response to pressure groups. The bluenose contingent, powered by religious zealots, saw boxing as murderous and evil. More people were killed on football fields than in prize rings, but the idealogues viewed fights as instruments of Satan that had to be legislated clear to Hell. On the other side, with support from Pershing and New York's formidable Roosevelt family, a testosterone lobby flexed its muscles. Boxing was manly, virile, a measure of grit, "the one true test between brave men." Brutal? No more than life itself. Dangerous? Not with proper equipment and medical supervision. Pugilism was an ancient and honorable sport that should be allowed to thrive. With the success of the Walker Law in New York State, the debates gradually stilled, although echoes reverberate, even today, notably when thing go wrong in the heavyweight division.

Boxing has always drawn its participants from groups at the low end of the economic ladder. As Dempsey pointed out, it is ferociously

demanding to become and continue to remain a serious fighter. "Your basic training day," he said, "runs fifteen hours, from 6 A.M. to 9 P.M, with fourteen rounds of various kinds of boxing [sparring, light-bag, heavy-bag, shadow], plus your roadwork, running five or six miles." The training is severe and an element of peril persists. "A boxing match," Dempsey said, "is not as dangerous as a fist fight. But if something goes wrong, if you go wrong, you can get hurt."

Almost all the men who take up boxing and *stay* with boxing as professionals have known the hounds of poverty. That is a rule. Ivy League colleges and other upscale schools, Stanford, Vanderbilt, Tulane, have organized boxing teams at various times, but no Harvard man has won the heavyweight championship, or even come close. Those who put up with the grind, the stress, the smelly gyms see life as offering no better choice.

In the first decades of the century the fight roster included heavy representation from the most recent immigrant groups—the Irish, the Italians, and Jews from Eastern Europe. The charismatic champion of 1918, Benny Leonard, was born Benjamin Leiner in New York City. He was a talkative five-foot-five-inch Jewish lightweight and welterweight, billed as "the Ghetto Wizard." Leonard was fast and slick and strong and hard to hit. He held the lightweight championship for seven years. (The names of some Leonard victims illustrate the ethnic nature of the sport: Phil Bloom, Vic Moran, Jack Brazzo, Joe Benjamin. He also knocked out a wild-swinger named Rocky Kansas, who had changed his name from Rocco Tozze.)

Jess Willard, who grew up a poor farm boy, became immediately popular in 1915 for reclaiming the title for the "Caucasian race." But Willard was not a fighting champion. He appeared in movie serials and starred in at least two Hollywood films, playing the heavyweight champion in one and Samson in the other. He made personal appearances with "The 101 Ranch" Wild West show and on the stage, but he defended his title only once in 1916 and not at all in 1917 and 1918. Willard's manner was stiff and pompous. He affected a silver-topped walking stick. His image wasn't helped by several lawsuits filed by

people who said this big prosperous champion refused to pay his bills. Still, Willard, the Pottawatomie Giant, could lick any son of a bitch in the world.

Rickard reasoned he could draw a nice gate for a Willard fight, provided he found an attractive opponent. In January 1919 he signed Willard to a contract, guaranteeing the big man one hundred thousand dollars to defend the championship and putting up an immediate ten thousand dollars. Willard conceded to Rickard the right to chose the opponent and the site.

Rickard told some who were helping with the bankroll that he would match Willard only against a white man. "If a nigger wins the championship," Rickard told one his backers, Frank B. Flournoy, a cotton broker from Memphis, "then the championship ain't worth a nickel. That's what Johnson taught us." Rickard had promoted two fights with black boxers, and the issue here was money, not prejudice. Or anyway money before prejudice. No one argued. This reasoning eliminated Sam Langford, "the Boston Tar Baby," a smallish hellion who boxed at weights ranging from 140 to 180, and Harry Wills, "the Brown Panther," a big, sturdy heavyweight, whom Langford had beaten twice.

Rickard thought the French champion, Georges Carpentier, a war hero, looked "attractive as hell, but he just ain't big enough." The English champion, Joe Beckett, was little known. A more famous British boxer, Bombardier Billy Wells, came with a chin of Yorkshire spun glass. The chin and the Bombardier shattered when struck.

Dempsey, with a string of more than ten knockouts, became the logical contender. He had beaten a string of unknowns, and knocked out good boxers as well: K. O. Bill Brennan, Battling Levinsky, Gunboat Smith, and Fireman Jim Flynn, who was born in Hoboken as Andrew Chiariglione. Rickard summoned Kearns and Dempsey from the West to New York City. "I had a bad time there before," Dempsey said.

"Let me handle this," Kearns said.

"You're the doctor," Dempsey said.

Although the two had amassed little money, Kearns booked

them into the Claridge, an expensive hotel in the theater district. "Jack, it don't matter whether we have money or not. That's nobody's business. I got a big negotiation with Rickard. Going into that, we got to *look* like we have money."

"You're the doctor," Dempsey said. He had just spent five thousand dollars buying a house for his mother in Salt Lake City. It was the first house Celia Dempsey had owned. He was separated from Maxine, moving toward a divorce, and for all his boxing he remained just about broke.

At least two factors prevented the Willard contract from being signed within the limits of New York State. Boxing was going through a brief period when major fights were again, as a practical matter, illegal in New York. (That would last until May 1920.) Then, with Dempsey emerging as the leading contender for Willard's championship, John the Barber Reisler reappeared, announcing that he was still Dempsey's manager and was entitled to a third of everything Dempsey earned. (Doc Kearns was already pocketing 50 percent of Dempsey's purses, plus expenses.)

Rickard brought Dempsey and Kearns to his office on Twenty-third Street and explained that he wanted all the good New York writers to know about the contract, but it couldn't be signed right here. He was going to charter a ferryboat to Weehawken, New Jersey, he said, and bring along the writers and as soon as the ferry left New York State waters, but not before, Dempsey could sign.

"That's okay with me," Dempsey said.

"I'll do the talking, kid," Kearns said. He was preparing to make cash demands.

"But there isn't any contract yet. And maybe there won't be." Rickard said, countering quickly. He stared at Dempsey. "Willard is a big strong man. You look small."

"I strip big," Dempsey said.

"Every time I look at you, you get smaller," Rickard said. "I'm afraid if I put you in the ring with Willard, you'll get killed. I'm afraid Willard will kill you."

"We want a fifty-thousand-dollar guarantee," Kearns said.

"Sure," Rickard said. "Sure, sure. I got to think this over. I'll be in touch."

On January 15 the manager of the Claridge said he would have to ask Mr. Dempsey and Mr. Kearns to vacate by tomorrow unless someone, either of them, paid the hotel at least seventy-five dollars.

"Tomorrow," Kearns said. "You will have your seventy-five dollars. Perhaps more. And that's a promise."

The next afternoon—as Dempsey told me with irresistible relish—he was led to a burlesque house on the lower East Side of Manhattan, a region populated by immigrant Jews. A sign above the box office promised a personal appearance by "Jack Dempsey, Next Heavyweight Champion of the World."

Kearns walked out from the wings and spoke about Dempsey. He could hit. He could block. He could move. He could fight. Kearns went on, "You know I tell people that Jack is one-eighth Jewish. You'd all love to meet his great grandmother, Rachel Solomon. She can't be here. He's got a little Irish blood and some Scottish blood and some Indian blood, but here's the truth. Jack Dempsey is not just one-eighth Jewish. He's easily forty-five, fifty percent Jewish. Jack Dempsey is *mostly* Jewish.

"I give you the man who's going to flatten Jess Willard. I give you the next heavyweight champion of the world." Dempsey walked out to a standing ovation. Then he stood speechless. ("I didn't know how to make a speech.") The cheering stopped. Dempsey stood and gaped. After three minutes of silence, a hook, the old vaudeville hook, collared Dempsey and hauled him off stage.

Mortified, he ducked Kearns and went into a bar and bought a beer. Two men who had sat in the audience came in and ordered drinks. They did not notice Dempsey. One said to the other, "If that Jew can fight, I can make a watch."

Rickard signed Dempsey to fight Jess Willard for nineteen thousand dollars in the ferry station at Weehawken, New Jersey. He gave Kearns five thousand dollars up front. Dempsey fought his way

through Pennsylvania—Harrisburg, Reading, Easton, Altoona—then on to New Haven, Connecticut. Between January 22 and April 3 he fought five times. He won every bout with a first-round knockout. Doc Kearns purchased a big red Buick. "It's your car too, kid," he said.

3 A Strange and Violent Heat Wave

*Has there ever been a fighter quite like the young
Dempsey?—the very embodiment of hunger, rage, the
will to do hurt; the spirit of the Western frontier come
East to win his fortune.*

—Joyce Carol Oates

ALTHOUGH THE POPULATION OF TOLEDO, Ohio, was no greater than 140,000 in 1919, the city was served by more than ten railroad companies, from such trunk carriers as the Wheeling and Lake Erie to the mighty main liners the Pennsylvania and the New York Central roaring westward from Philadelphia and New York. Six steamship companies plied the Great Lakes and connected Toledo with Chicago, Buffalo, Milwaukee, and a dozen other inland ports. If not very many people were resident in Toledo itself, Tex Rickard reasoned, plenty of lively souls in the northeastern United States still would travel a good distance to see the right heavyweight championship fight in a town that was decidedly permissive on such matters as bootleg booze, dance-hall ladies, and pugilism.

Though an unsatisfactory hero in certain ways, Jess Willard remained the undisputed heavyweight champion of the world, white or black. His opponent had to be Dempsey, who could punch harder than anyone else around, and who always delivered a boxing performance

that was vibrant with passion and guts. Outside the ring, Rickard found the black-haired, high-cheekboned kid from the mining camps immensely likable. That meant, Rickard reasoned, that the sportswriters and the public would like him, too. And a likable fighting champion who could punch through a concrete wall...one can hardly blame Rickard for thinking once again of gold.

Although the prospect of Dempsey's death at the hands of a giant continued to haunt Rickard, the idea of a million-dollar gate was irresistible. Publicly, Rickard said he hoped for receipts of four hundred thousand dollars, "give or take some change." Until that time the biggest boxing gate had been the $270,755, for his own Jack Johnson–Jim Jeffries fight in Reno. According to the late ring historian Nat Fleischer, ticket sales for no other boxing match had ever exceeded one hundred thousand dollars. "Willard-Dempsey," Rickard told the sportswriters, "shapes up as the greatest bout and the richest event in the history of sports."

If Rickard was a hustler, and of course he was that, his hustle glows with vision. Before the collaboration with Dempsey came to a sad and unexpected end in 1929, the two men would redefine championship boxing and bring attendance and a panache to heavyweight fights that has not since been equaled.

According to the story, a Roman Catholic priest in Toledo broke his vows by seducing an attractive widow. When he confessed, the priest was ordered to say the *Hail Mary* ten thousand times and to make a pilgrimage to Rome. At the Vatican he was able to gain an audience with the pope where once again he confessed his transgression. Then the lusty pastor mentioned his penance.

"Excessive," the pope said. "Ten *Hail Marys* does it fine."

"How come it was ten thousand *Hail Marys* back home and it's only ten here?"

"Ah," the pope said, gently. "What do they know about sin in Toledo, Ohio?"

"Quite a bit," suggests John Grigsby, a Toledo journalist for many decades. As evidence, Mr. Grigsby, who is eighty-nine at this

writing, produces a clipping from the *Toledo Blade* of August 4, 1904. The headline announces, TOLEDO IS A CITY OF DIVES. Subheads inform the reader that "vice reigns unchecked, hold-up men operate with impunity; the way to ruin [is] made easy for boys and girls." An unsigned, harrowing story follows. Thirty brothels were open every night on Lafayette Street (which today abuts Toledo's historic Saint Clair district). Typically, these were operated in conjunction with saloons, which, also typically, employed female bartenders. Several drinks along, the barmaids led customers upstairs with promises of rousing sex. After a principal stripped, an armed "burglar" appeared. The customer was allowed to keep his clothing, but nothing else.

Few victims took their stories to the police. (As with a raped woman, the element of humiliation implored silence.) Those who did carry a sorry tale to the Toledo police found neither sympathy nor an inclination to investigate. Like the barmaids, the cops were in the pay of whoremasters. The *Blade* commented: "It would be hard to find an equal to these corrupt conditions in our city anywhere outside of Chinatown in San Francisco and the lower part of New York."

Later another *Toledo Blade* story reported, "So-called concert halls have bred vice." Numerous burlesque houses were "used as resorts by harpies and criminals. All the women in these haunts will prance onto the stage and at a moment's notice, do the short-skirt turn, accompanied by a little piano playing by a badlands professor, who can pick his cigarette off the piano without missing a note."

Although the language sounds quaint—even oddly Runyonesque, as with the phrase "short-skirt turn"—these were hard-edged newspaper accounts in the developing tradition of muckraking, a distinctly different pursuit from yellow journalism, and nobler. These stories also contrast sharply with official Toledo histories, which insist that at one period darkened by lurid practices the mayor, a Republican named Samuel Milton Jones, was so honest and sincere "that he gained the admiration of all citizens and was awarded the nickname 'Golden Rule' Jones."

"The real Toledo," Mr. Grigsby said, "was a city of machine shops and foundries and later automobiles. [Chrysler still manufactures

Jeeps there.] Like most other places it experienced cycles of corruption and reform. People sometimes like to make Toledo out to have been a sleepy backwater. It was a lot of things, but not that."

Toledo was a grown-up town. "It was wide open back in '19," Doc Kearns recounted. "You could get a bet down easy. The dames came even easier. It was a hideout for gangland lammisters [criminals on the run] from other sections." Surely Rickard could recognize some of the wild Klondike in the Toledo tenderloin, just as Dempsey saw reminders of his old mining camp scenes, raucous with thugs and harlots. Beyond that, Toledo lies within easy railway distance of New York and Chicago—and the "upper-crust" people Rickard courted, including Vanderbilts, McCormicks, Biddles, Harrimans, Rockefellers. In a sense it sat within sight of Rickard's own Emerald City, the million-dollar gate.

Rickard had considered propositions from promoters in Maryland, New Jersey, and Texas. Blue laws or protests from religious groups drowned out those voices. Organizing support to change the prohibitionary laws was particularly difficult amid the endemic patriotic puritanism. Even moderate politicians were reluctant to speak up for a good fight when the battle matched boxers who had not entered military service.

One Addison Q. Thatcher, who owned a Great Lakes salvage business and a gymnasium called the Toledo Athletic Club, approached Rickard late in the winter of 1919 and proposed his home town. Immediately interested, Rickard asked, "Toledo? What's the politics?"

No law banned boxing in Ohio, but realistically Rickard would need the approval of Governor James M. Cox (in 1920 the Democratic presidential candidate). Cornell Schrieber, the mayor of Toledo, thought the fight would be great for his city. Others did not.

Various versions of the ensuing politicking survive. In the one favored by Doc Kearns, he and Rickard went to the Ohio convention of the Benevolent and Protective Order of Elks, which Governor Cox was attending in Columbus. They talked their way into obtaining ap-

propriate credentials and before much time passed were sitting in at a high-stakes poker game with prominent politicians including the silver-haired and lascivious Senator Warren G. Harding. Rickard and Kearns won large sums. Someone asked if they would like to adjourn to another suite and meet the governor. Taking them to be fellow Elks, Cox greeted them warmly and boozily. Rickard said he wanted to bring the heavyweight championship fight to Toledo. "If you can help us, Governor, I'll be glad to put up a little money, say twenty-five thousand dollars, for your next campaign."

"I'll hear no such talk," Cox said, suddenly sober. "I cannot be bought." ("Buy?" Rickard said years later. "I was only trying to rent the son of a bitch.")

According to Kearns, no blushing violet, it took his own golden Hibernian tongue to save the day. Rickard meant no offense, Kearns said. He didn't understand politics. But the Toledo bout would be a good opportunity for this fine young man, Jack Dempsey. "My father thinks so, too," Kearns said. "That's another reason I want the fight in our home state."

"Where did you say you were from?" Governor Cox asked.

"I didn't say, but near here, sir. My whole family would like to see the fight, sir. It's a big, wonderful Irish family and everybody votes." (Actually, Kearns was a native of Seattle.) Cox said he didn't really believe Kearns, but hell yes, the fight could go on in Toledo, so long as the city collected a fair share of taxes and this conversation stayed off record, so "the bluenose crowd doesn't get on me and cost me the next [presidential] election." The ticket of Harding and Calvin Coolidge would swamp Cox in 1920 by seven million votes. Historians who regard Warren Harding as "a president manifestly unfit for public office" find Cox no more distinguished. Perhaps the highlight of the 1920 campaign was the spirited but ineffective campaigning of Cox's running mate, vice-presidential candidate Franklin Delano Roosevelt.

An alternative version, recounted in Cox's autobiography, *Journey Through My Years,* has Rickard calling on the governor in a New

York hotel suite, where Cox was doing political business. Rickard said he realized that the Democrats would nominate Cox in 1920 and he offered the twenty-five thousand dollars to help secure the nomination. Cox admitted that an offer was made and said that he declined it. But, Cox continued, since Ohio had a "sports-loving public" he would not oppose the boxing match.

Contracts between Rickard and Toledo municipal officials were signed on May 7, 1919. Rickard agreed that 7 percent of the receipts would be donated to a fund "for the poor of Toledo." In exchange, he was given use of Bay View Park, an attractive site on the north side of town, just below Lake Erie, where the Maumee River broadens into Maumee Bay.

Rickard brought in a San Francisco contractor named James P. McLaughlin, who in six weeks constructed the largest boxing arena in history. This flat wooden octagon measured six hundred feet—almost the length of two football fields—in diameter. Within it stretched a total of twenty-four miles of seats. McLaughlin sank forty-eight hundred posts to support the structure. He said the wood he brought in from Michigan weighed eleven million pounds. Concerned with the possibility of gate crashers, Rickard specified that there be only a single entrance to an eighty-thousand-seat arena. A fire during the fight would have brought catastrophe. But that was a small risk, Rickard decided. He was more concerned with the possibility that antiboxing arsonists might try to set the stadium on fire *before* the bout.

As soon as the contracts were drawn up, conservative and religious groups began attacking. The Toledo Ministerial Union presented a petition to Mayor Schrieber asking him to cancel the bout "for the good name of our city." Robert Dunn, a representative from Wood County, just south of Toledo, introduced a bill in the state legislature to outlaw boxing throughout Ohio. The bill failed but Republican legislators passed a resolution calling on Governor Cox to stop the fight because it "would not be conducive to good morals." As

late as June, Charles H. Randall, a Californian in the House of Representatives, proposed a congressional resolution to "protect the Nation's birthday against the desecration of a prize fight." Randall called a press conference and asked, "Why should a fight between bruiser slackers, who were not brave enough to join that war against German murderers, be permitted?" He telegraphed a protest to Governor Cox. The governor ignored him.

Much of this moralizing can be dismissed as politics, an effort to embarrass a powerful Democratic governor and prospective presidential candidate. As New York State law illustrates, movements to outlaw boxing come and go, and never work. Make public boxing illegal and the sport appears in "private clubs." Ban it on the mainland and some promoter stages a big fight on a barge. Governmental efforts to dictate propriety become a greater evil than whatever it is the government wants to abolish, from adultery to Bolshevism to witchcraft.

Rickard possessed a practical man's respect for the dangers of a lunatic fringe. He heard threats from fundamentalists to burn his mighty octagon to the ground. "Then let them hold that accursed fight on ashes, and let the Devil himself, no less, be referee." Bravado aside, Rickard hired a dozen security guards to patrol Bay View Park round the clock. He ordered Jim McLaughlin to hose down the growing arena every night. Hose down the arena and the great stacks of Michigan white pine.

The fight was on.

Willard rented a substantial home at 2465 Parkwood Avenue, a stone house with a Greek-pillared portico in a quiet residential neighborhood. He established a training camp on Maumee Bay and commuted from home to camp in a large chauffeured touring sedan. Willard always left the Parkwood house looking like an outsized businessman, wearing jacket and tie and carrying a walking stick, accompanied by a trainer and a state trooper. He towered over both, a formal, stiff-striding man who did not smile easily. He didn't care for

the rugged boxing crowd, or for the generally hard-drinking sports-writers. Evenings, after his workouts, he sat on the porch of the stone house and exchanged small talk with neighbors.

"What about the war?" someone asked.

"I could not become involved in that," Willard said. "I'm supporting a wife and five children. Even if I had tried to enlist, the army would have turned me down. I'm taller and heavier than army regulations allow."

Willard broke horses and plowed fields in Kansas obscurity until he was twenty-eight years old. Then an Oklahoma fight man named Tom Jones spotted Willard casually tossing five-hundred-pound bales of cotton onto a wagon. Willard had never worn gloves or even seen a boxing match.

Jones told him, accurately, that wealth awaited the white man strong enough, brave enough, and skilled enough to upset Jack Johnson. Willard sold what property he had and moved to Oklahoma, where Jones starting teaching him the rudiments of boxing. Willard's first professional bout took place on February 15, 1911, when he was twenty-nine years old. He lost to Louis Fink in Sapulpa, Oklahoma, forty miles southwest of Tulsa. The referee ruled that Willard had hit low. Six weeks later Willard knocked out Fink in three.

Willard was a stand-up boxer with a giant's reach. He threw long left jabs and then leaned back, a tower too tall to hit hard unless you charged him. But charging this enormous man was dangerous. Willard's power punches were a straight, clubbing right and a right uppercut, which startled, hurt, and wore down onrushing opponents.

No one doubted his tremendous physical strength but the full measure of his might did not come clear until August 22, 1913, in the middle of Willard's third year as a professional boxer. He had lost to the durable journeyman Gunboat Smith that spring, then come back with two victories by decision. Tom Jones, now the manager, matched Willard in Los Angeles for a fight against a youthful hope, John "Bull" Young, the son of a prosperous rancher in Glenrock, east of Casper in Wyoming. Noah Young, the rancher, did not want his

son to box and at length exacted a promise: If Bull lost to Willard, the boy would give up boxing and come home to the ranch.

In the eleventh round, Young walked into one of Willard's monstrous right uppercuts. He fell unconscious and lay in a sprawl so awkward that some thought Willard's punch had fractured Bull Young's spine. It had not, but the force of the punch drove the base of Young's jaw into his brain, with terrible effect. He died in a hospital next day. Physicians listed the cause as "brain hemorrhaging." John Young did indeed return to his father's ranch after losing to Jess Willard, as he had promised. In a coffin. "[John Young] was well and favorably known throughout Central Wyoming," a reporter wrote in the *Casper Press Weekly*. "He counted his friends by his acquaintances."

Los Angeles authorities arrested Willard on a charge of manslaughter, and demanded five thousand dollars bail. A few days later the charges quietly were dismissed. No one can say for certain why the charges were brought or why they were dropped.

Many have questioned Willard's Havana victory over Jack Johnson on April 5, 1915, which won him the heavyweight championship. By this time, Johnson, living a high, wild life in Europe, was a fugitive in America, which had the effect of cutting off income. Is it possible, even reasonable to conclude that Johnson had taken money to lose? A photograph of him down for the count in round twenty-six shows Johnson lying on his back with his right arm raised over his face. Some interpret the picture as Johnson shielding his eyes from the Cuban sun, not really knocked out but, in the argot, "taking a dive," resting supine for fifteen seconds or so while his paycheck is being prepared.

Seymour Rothman of the *Toledo Blade* asked Willard what he thought. The response was brief and convincing: "If Johnson did dive, why did he absorb punishment from me for twenty-five rounds before doing it? I caught him with a quick hard right on the point of the jaw and he went down and his eyes went funny. All you could see were the whites. It was a long, hard fight and an honest one. It made

me champion but it didn't make me rich. My share of the purse was only thirteen thousand dollars. Figuring expenses, I earned less than ten thousand dollars."

In later years telling stories about the "dive"—*selling* stories about the dive—created revenue for Jack Johnson, a man for whom the need for revenue was a way of life. This had the effect of denigrating the reputation of Jess Willard, the strongest man ever to hold the heavyweight championship.

Rothman wrote of Willard: "He was truly equipped to be a champion. He had a long left arm, which held off eager opponents. Both his right hand punches were devastating." But unlike Dempsey, Willard did not enjoy being a boxer. He boxed because that was what made him money. He didn't enjoy punching others. Even before Willard killed Young, he disliked hurting people, or for that matter being hurt himself. "It's easier for me to hit a man after he's hurt me," Willard told Seymour Rothman. "But with my reach and my movements, sometimes it takes seven or eight rounds before he gets to me at all. When I do go after an opponent, I try to finish him off as quickly as possible. I get absolutely no pleasure from punishing a man."

Looking back not long ago at the age of ninety, Seymour Rothman described the Jess Willard he remembered as "a very remarkable person. A shy, gentle, peaceful individual, whose story has never been told." Nor have many recognized how mighty a fighter Willard was. Abruptly on July 4, 1919, Dempsey became one of the few who did.

"I'm in charge of my own training," Jess Willard said in Toledo. "I am my own boss. There isn't a man living who can hurt me, no matter where he hits me or how often he lands. I am better today than when I restored the championship to the white race." He trained hard and seriously. Stripped to the waist, he began by shadow-boxing, moving easily about the ring, throwing huge punches at the air. After that a trainer repeatedly hurled a ten-pound medicine ball into Willard's gut. Willard next moved to a piano bench. While the trainer

clutched his ankles, the big man did a remarkable set of twists and situps. Then he sparred.

Fans were allowed to watch Willard train after paying a twenty-five-cent admission fee. As word of this muscular giant's routine spread, a significant number of women joined the crowd that watched him. "For the big fight," Rickard announced cheerfully, "we're going to set aside a special section just for ladies. Yessir. And we're going to call that the Jenny Wren section." To protect the women from untamed Toledo lust, Rickard ordered his contractor to surround the Jenny Wren section with barbed wire. (When fight day came around, Ethel Barrymore was the most famous female customer. Safe from satyrs, the actress perspired and looked uncomfortable in the afternoon heat.)

Kearns put Dempsey's camp in a rustic and unpretentious site, once called the Overland Swimming Club, directly on the shores of Maumee Bay. Dempsey rose regularly at 6:00 A.M. and began each day's training with a ten-mile jog. Kearns followed in the big red Buick. Dempsey also swam and dug drainage ditches. He sparred ten to twenty rounds a day. He devised a rubbing lotion that he recommended for the rest of his life: three ounces of denatured alcohol, three ounces of witch hazel, one ounce of wintergreen, and one ounce of olive oil. Each night he took a half-hour bath in a hot tub, adding five pounds of Epsom salts to the water.

Haunted by Bull Young, Willard asked Rickard "for legal immunity against a murder charge in case I kill Dempsey." When word of this request—absurd and in a sense pathetic—reached Dempsey, he is reported to have laughed. That afternoon he knocked out all his sparring partners. Years later Dempsey had no recollection of laughing. "Kearns probably wanted to keep that murder stuff away from me," he said, "but there were too many around, hangers-on, reporters. So Kearns talked about it as a cheap publicity stunt. He said Willard was so fat and flabby he couldn't hurt my dad, let alone kill me.

"Then my dad came to town. He went over to Willard's camp. Next thing I find out, he's telling the reporters, 'My boy Harry's a

good boy, but this Willard is just too big and strong for him.' My own *father* picked the other fighter."

Kearns remained ceaselessly persuasive. Willard was slow. Willard was fat. Keep training, Jack. We've got a lock. "I'm even gonna put ten thousand dollars of my own money that says you knock the big bum out in round one." Dempsey had the sides of his head shaved. He thought that made him look tougher. Kearns's alchemy was profound. He got Dempsey to relax.

As the armies of the press converged on Toledo, Kearns organized a spaghetti dinner for Rickard and prominent newspapermen. Rice, Lardner, McGeehan out of New York, and contingents of columnists from California and Chicago converged on the Overland Swim Club, a modest collection of rough-hewn buildings by the bay. Kearns drafted Dempsey's sparring partners to work as bartenders and the fighters poured bootleg whiskey with heavy hands. The journalists grew boisterous, but quieted suddenly when the challenger appeared. Dempsey's entrance was unrehearsed and a thing of beauty. He came walking up the beach, tanned and lean, stripped to the waist and playing "Jellyroll Blues" on the harmonica. Two little girls and two small boys followed, enraptured by the man and the music. (They were children of summer people who had rented waterside cottages.) Watching, Ring Lardner thought, "the Pied Piper of Maumee Bay."

Still, Lardner bet his five hundred dollars on Willard.

Rickard subcontracted the concessions in the new eighty thousand-seat arena to a fight-world character named Billy McCarney, who liked to be called professor, and a theatrical agent named Thomas V. Bodkin. In turn McCarney and Bodkin sub-subleased rights to sell ice cream, lemonade, sandwiches, cigarettes, opera glasses, the mild still-legal potion called near beer, and seat cushions. The heat had started the new pine planks oozing. Sap oozing from the bottom of the benches hung down in sticky stalactites. On the top side enough sap bubbled up to make a man fear for the seat of his

pants. The cushion concession went for a then significant sum, two thousand five hundred dollars. Several thousand cushions would be available in the arena for fifty cents each. But before the day of the fight, most of Toledo had heard about the oozing seats. Almost everyone who showed up brought his own cushion. "While Dempsey and Willard were getting ready to fight," somebody said, "everybody else in Toledo was sewing together cushions."

Rickard, or one of his aides, organized speedboats into an underground ferry to bring good beer and palatable whiskey across Lake Erie from Canada into Toledo. In the days before the fight, no newspaperman who wanted a drink went dry. (This was almost certainly the first major bootlegging operation within dry America.) So here in a city of easy virtue came easy booze. Late in June a violent heat wave struck. After a few days of persistent and withering heat, people began to act strangely.

Battling Nelson, the same Durable Dane who had fought forty-two rounds for Rickard thirteen years earlier in Goldfield, Nevada, drew an assignment to cover the fight for the *Chicago Daily News*. He lacked the money to rent a room in a big hotel, the Secor or the Boody House, so he pitched a tent in Dempsey's camp. It was a blue tent. On the side he painted a white "Bat Nelson." He had boxed for twenty years and was becoming, some said, "strange in the head." Late at night on July 2, unable to sleep in the heat, Nelson left his tent and lifted Doc Kearns's bathing suit from a peg in the main house. Then he set off for a swim in Maumee Bay. Nelson was notorious for poor personal hygiene. Kearns raged and had the bathing suit burned.

Next night Nelson left the tent to swim again, this time in his underwear. Along the way to the beach he came upon six zinc-coated metal tubs. They contained lemon syrup and melting ice. Nelson plunged in.

Soon he was having a bad time. The stuff was sticky and possibly lethal. Someone heard his cries and pulled him out so that Battling Nelson did not drown in lemonade. (He lived until 1954.) But it took a team of several men to revive him and to tear off his underwear in

strips. The word—"Battling Nelson took a bath in the lemonade"— swept through Toledo. "Professor" Billy McCarney said, "The story spread just like wildfire. Did it hurt sales of lemonade? Figure it out. With all the commotion, no one ended up being sure which tub Nelson used. Could of been any one of the six. This may have been the only bath he ever had. Nobody bought the stuff.

"I felt sorry for the guy who paid us one thousand dollars for the lemonade rights. All those concession people—it was like they were hit by some terrible Toledo whammy."

As middlemen McCarney and Bodkin would profit handsomely. The individual concessionaires met disaster. On the day of the fight the temperature in the sun at ringside reached 114 degrees. The ice cream turned to lukewarm soup. The cheese sandwiches rotted. (Sales of ham sandwiches were spoiled by the fact that July 4, 1919, fell on a Friday, a meatless day for observant Roman Catholics.) The Toledo fire chief, noting a huge, inflammable wooden structure with only one access way, banned smoking. You could buy a pack of Sweet Caporals in the arena, but you could not light up.

As Grantland Rice pointed out, the press converging on Toledo numbered as many as six hundred. "The biggest bunch of sportswriters ever at a fight," Rickard said. Rickard scaled the arena at sixty dollars for ringside down to ten dollars for a ticket in the faraway bleachers. The cheap seats sold well. The $60 ringsiders—equal to as much as $750 in today's dollars—moved slowly. The middle-priced tickets moved not at all. Rickard had the press, the fighters, the bootleg whiskey, and a wide-open city. But he was not going to get his million-dollar gate. He blamed the railroad companies for not making enough special trains available. He blamed stories that Toledo was overpriced and overcrowded; that once you got there you'd be fleeced and wouldn't be able to find a place to stay. I suppose Rickard was right, but if he had staged a big Dempsey fight in Toledo a few years later, people would have swarmed into town on bicycles and roller skates, if necessary, and slept outdoors or on the tops of bars. By then, of course, Dempsey was changing the era.

Among the crowds of sportswriters, the most notorious was Bat Masterson of the *New York Morning Telegraph*. William B. Masterson was sixty-six in 1919, but fame from his young gunslinging days still clung to him. He had been an army scout, an Indian fighter, a buffalo hunter before he became deputy sheriff of Dodge City, Kansas, in 1876. There he sometimes took on special assignments for the federal marshal, Wyatt Earp. When Dodge City quieted down, Masterson moved to New York, where he became a newspaperman in 1902. Tough, dour Bat Masterson liked his heavyweight boxers large. In 1919 he derided Dempsey as scrawny and picked Willard.

The *New York World,* still memorialized as a great and literate newspaper—it did not survive the Depression—sent a team of six writers, led by Ring Lardner, who had become renowned in 1916 with the publication of his epistolary baseball novel, *You Know Me, Al.* The work appeared first in serial form in the *Saturday Evening Post.* "Almost as soon as the *Post* began to publish the letters," John Lardner wrote, "they made my father as famous as the President of the United States."

Lardner may have been the most gifted contemporary chronicler of Dempsey, but he worked subtly, even mysteriously, moving from journalism to fiction, from doggerel to writing plays. The baseball book is told through the eyes of semiliterate, vain, yet oddly attractive boob of a ball player. In much of his journalism, Lardner adopted a semiliterate persona for himself. The critic Edmund Wilson rebuked Lardner for writing short stories for the middlebrow *Saturday Evening Post.* "Will he ever go on to his *Huckleberry Finn?*" Wilson asked. T. S. Mathews, another critic and later editor of *Time* magazine, grouped Lardner with Chekhov and Shakespeare in a passionate defense. "They wrote pot-boilers too; their attitude was as unpretentious and their aims as sensible."

Here is Lardner in the *World* three days before the fight:

> Well, gents, I stood outside and bought a souvenir program of the big riot and set down under a shade tree and read what it had to say. "In the last two years Dempsey has

met and defeated fifty of America's leading heavyweights, some of whom were as large as Jess Willard."

Well, gents, I hold no brief against Jack Dempsey, but I want to challenge you gents to name fifty of America's leading heavyweights and when you get through with the trivial task, I want you to tell me the names of SOME who was as large as Jess Willard.

Another striking paragraph says "Like Bob Fitzsimmons, Jack Dempsey says the larger they are the harder they fall." Gents I never thought that adage originated with old Bob and I thought it was sprung by David after he gave Goliath the rush, but a person hears something every day, especially in Toledo.

Lardner then set down in conventional journalism an interview with Walter Monahan, one of Willard's sparring partners, who told him, "Jess is in terrific shape. This bird Dempsey come running out at [six foot six inch heavyweight Fred] Fulton back in Harrison, New Jersey a year ago and knocked him for a goal with two socks, one in the stomach and in the jaw. Well, let him come running out at Jess like that and the fight may last twelve rounds but Jack won't know nothing about the last eleven of them."

Hype Igoe of the *World* offered another evaluation. Willard had driven mule teams through a number of Kansas summers. "If ever a bloke had to be able to stand the heat and the dust, it was a mule driver in that Kansas summer heat." Nonetheless, Igoe was impressed by Dempsey's punching power. At the end of one sweltering session, Jimmy DeForest, Dempsey's trainer, ordered Big Bill Tate, Dempsey's biggest, strongest sparring partner, to stand behind the heavy bag and hold it while Dempsey attacked. "Jack cut loose like a madman fighting his way out of an upholstered stall. Left, right. Two lefts. A right. Two more left hooks. The massive contraption holding the 100-pound bag shivered before Dempsey's assault. Even though he was standing behind the bag, Big Bill Tate seemed about to call for mercy when DeForest barked, 'That's enough, Jack.'"

Countering Lardner, Tex O'Rourke of the *World* wrote that Dempsey would win the fight on the bases of youth and conditioning. "No one has greater respect than I for Willard's superhuman strength," O'Rourke wrote, "and I do not believe there is any man outside of Dempsey who would even have a chance against him.

"Willard is big enough to hold Dempsey off, as long as he does not tire. In fact, I expect the first three rounds will find Dempsey standing up in the champion's powerful arms, with most of his punches going wild....But in this heat Jess cannot go over half a dozen rounds without tiring. And when he slows down, he's gone.

"I am willing to stake whatever reputation I have as a judge of fighting men that Jack Dempsey will be champion before the sun sets on July the Fourth."

The *New York World* promised readers that the morning editions on Saturday July 5 would carry photographs of "Friday's Big Fight." This front-page boast, offered in a time before wirephotos, suggested an unprecedented exercise in transmission. The *World* had leased a versatile Italian biplane called the S.V.A. and engaged an American army pilot, Lieutenant Raymond B. Quick, to fly it. "She's the best little ship I ever handled," Quick said. He calculated that to meet the *World* deadline with the fight film, he would have to cover the 521 air miles from Toledo to New York in four hours and fifteen minutes. Quick planned to average 125 miles an hour, which was within the capacities of the aircraft. He said he would take the first part of the solo journey at 130 miles an hour, before a slower climb to ten thousand feet, which would spare him turbulent thermal currents bouncing up from the mountains of western Pennsylvania. The flight plan was not put to the test. Practicing takeoffs in Toledo on Thursday, July 3, Lieutenant Quick crashed the aircraft. He survived. The *World*'s photo scheme and the Italian S.V.A. biplane did not.

A newsreel company contracted with the U.S. Army for the use of a captive hot-air balloon as a camera station. The balloon could be maneuvered but remained tethered to earth by an enormous length of rope. On the day of the fight, Sergeant Joseph Marquette piloted the balloon to a height of two hundred feet, directly over the arena. A

newsreel cameraman named Frank Delevan started shooting. Then a cable snapped. Wind blew the balloon out over Maumee Bay.

Delevan yelped. He later reported Marquette told him, "There's nothing to worry about. I'll work this little valve here and we'll come down nice and easy."

As the balloon descended toward the water, Delevan shouted, "I don't know how to swim."

"Stay in the basket," Marquette said. "You're in no danger."

From a height of fifty feet, Marquette leaped out of the basket. He swam about for a while trying to reach one of the trailing ropes. He was going to kick his balloon all the way to shore. Suddenly, because of a cramp, sudden fatigue, no one knew exactly, the sergeant disappeared beneath the surface. A motorboat rescued the photographer, who stayed in the basket. Sergeant Joseph Marquette, the brave balloonist, drowned.

With neither rented balloons nor leased Mediterranean airplanes, the New York *Tribune* still was hardly modest in its appeal for readers. In a featured box the editor wrote, "The *Tribune* has sent not only two real fight experts, but a couple of real fighters to handle the attraction of a decade in fistiana. Sports editor MAJOR W.O. M'GEEHAN, formerly of the 50th Infantry, and Sportlight columnist LIEUTENANT GRANTLAND RICE (115TH FIELD ARTILLERY), who scrambled right into the line-up against Kaiser Bill are on the ground.... The *Tribune* will receive direct ringside service, having leased a special wire to transmit the reports of Rice and McGeehan. If you have red blood in your veins, you cannot afford to miss tomorrow's issue of the *Tribune*."

Bill McGeehan was a hard-drinking man who could write awfully well, awfully quickly. He insisted that his sports section would cover the fight without overblown prose about

a battle between troglodytes and abysmal brutes. [World War I] has surfeited the world with fighting and bloodshed.

To all who realized what was happening in the last few years, this thing tomorrow is a puny thing. It is just a quarrel between a big boy and a little boy, in an isolated back lot. But these things have always interested men, grown and half grown.

The town is now decidedly cluttered up.... There are men from Alaska; there are men from Wall Street; there are men from the stock yards of Chicago, and from the oil fields of Texas. The type is bull-necked and paunchy, but among the fat men prowl the rat-eyed and the lean. All the crooks and confidence men have come here for a farewell to the old wild alcoholic days....

Tonight Dempsey will dream dreams because he is a gypsy, a nomad of the brake beams. Willard will not dream much. He is a small town business type and not a dreamer. But Willard will win the fight.

Grantland Rice wasn't sure and avoided making a prediction:

> *When Homer smote his bloomin' lyre*
> *When Nero set his town on fire...*
> *They got their space between old jokes—*
> *But think of all the litrrychure*
> *Now written on two simple blokes...*
> *A million words upon this fray!*
> *And when I see two low-browed men*
> *Grab all this space—I rise to say*
> *The Punch is Mightier than the Pen.*

Once they had met their deadlines, Rice, Ring Lardner, McGeehan, and some other sportswriters repaired to a local club for a round of golf. The men filled their bags with woods and irons and bootleg whiskey. Soon they were walking down the greens singing a lament Lardner composed:

I guess I've got those there Toledo Blues,
About this fight I simply can't enthuse.
I do not care if Dempsey win or lose,
Owing to the fact I've got
Toledo Blues.

No one completed eighteen holes.

A fresh rumor of reformers' violence swept Toledo on the night of July 3. At least ten strong men guarded the arena, but toward nine o'clock Rickard drove up personally to check his security guards and the police detail. Bat Nelson had not yet invaded the lemonade. All seemed quiet.

Willard was chauffeured up in his town car a few minutes later. He alighted in the hot night wearing a vast silk shirt. He chatted for a bit with the policemen and the bystanders. "The real hero here," someone said, "is Jim McLaughlin for building this great arena."

Willard pointed a large hand toward Rickard. "There's the man who rates the bows. He paid me a hundred thousand dollars, didn't he? Where he got it, I don't know."

"What's going to happen tomorrow, Big Jess?" asked one of the trailing press.

"I've killed a man," Willard said. "I never want to do that again. I intend to carry this boy Dempsey for the full twelve rounds, not hurting him any more than I absolutely have to. Then I'm quitting the fight game and going back home to run my farm." The huge man in the silk shirt stepped back into his Cadillac touring car in his stately way and was driven off, as befit a champion and a squire.

4 The Left Hook from Olympus

I was afraid he was going to kill me. I wasn't just fighting for the championship. I was fighting for my life.

— JACK DEMPSEY on JESS WILLARD

LATE ONE NIGHT DURING THE 1960s, Jack Dempsey stepped out of a taxicab in front of his apartment house on East Fifty-third Street, after a long evening of presiding at his Broadway restaurant. He had passed his seventieth birthday. His deep-black hair had gone gray.

Two muggers, seeing an elderly party who looked well dressed and well walleted, sprang out of the darkness. Dempsey spun and flattened both. He stood over them and waited while the taxi driver called police. Having felt Dempsey's fists, the assailants refused to get up until the police arrived to protect *them.* As a number of people, myself included, remarked joyously at the time, "Those two bums sure picked the wrong guy to mug."

Pretty much anywhere—street, gutter, barroom, brothel, beachhead, prize ring—Dempsey could handle himself. But Dempsey would make the corollary point, and often did, that his bout with Willard was a world away from a sidewalk brawl. It was not, he declared, a brawl at all. It was a championship prizefight, with rules and

limits and regulations, referees, corner men, and judges, an event that required, and to which he brought, highly specialized skills and majestic artistry. At its highest level, boxing, rough, sweaty, pounding boxing, surely is art. "The manly art," someone once wrote, "of modified mayhem."

Because Dempsey hit so hard, moving in, always moving in, sportswriters described him in jungle terms. Many saw a tiger closing for a kill, attacking with an instinct beyond human understanding. Dempsey tolerated such analogies—he was not an argumentative fellow—but at length refuted them with a flourish. He set down what he called "the log of my mental journey from Manassa to Toledo" in careful, painstaking longhand. He was, as W. O. McGeehan observed, a nomad. He wrote on trains, in planes, in hotel rooms, and at his principal home in Los Angeles. A nomad, to be sure, and also a thoughtful and introspective man. What happened in that blazing-hot Toledo ring makes sense if one leaves the tigers to the Bengal jungles and recognizes that, whatever his instincts, Dempsey was a thinking boxer, a man who studied, who learned and planned. He told me that he worked on the log for years and finally, about the time of his fiftieth birthday, felt he was finished. He had reached longhand page 384.

"You wrote this to explain yourself as a champion?" I said, offering a statement as a question.

"Not really. I wrote it because there is such ignorance about boxing. When I began bringing in those million-dollar purses for Rickard, I started a gold rush and that brought in the bums. As soon as Tex and I made the big money, here came the amateurs. The amateurs wanted to promote fights and manage fighters and even teach boxing, but mostly they wanted to get rich in a hurry. All of a sudden you get a new crowd—grocers, dentists, butchers, racket guys, doctors, bookies, pool-hall hangers-on. They were all of a sudden boxing experts. People who had never boxed a round became trainers. They misinstructed a lot of boys in a lot of gyms. Then these kids went out and fought for a while and when they stopped, *they* became instructors. You know what I call these fellows?"

"What do you call them, Champ?"

"Palooka experts. They give us fighters who can't punch, and they give us fighters who can't defend themselves." The big man leaned forward intently. "Most of the boxing I see today is just embarrassing."

Dempsey showed me only a few pages of his manuscript. He told me that he had learned from the process of writing it. "I'm not much of a schoolbook student," he said. "I remember George Wintz, one of my teachers in the Lakeview School in Provo, Utah, telling me, 'Harry Dempsey, you are not only the oldest kid in this school, you're the dumbest.' Mr. Wintz had a point. I never cracked a book. All I wanted to do was to be a fighter.

"But I've got a strong memory and I've got a good way of picking things up and working things out, so long as I'm not in a classroom. When I was fighting, a lot of the writers called me instinctive. Sure, maybe a little. But I studied boxing. I learned from a hundred other guys. Technique. Tactics. How to move and how not to move. By time I got to Willard, they were writing that I was a tiger. I don't mind. But that don't really make a lot of sense. If a tiger had come jumping at Willard in Toledo on July 4, 1919, he might have caught the animal and tossed it out of the ring to the boys in the press rows. Big Jess was that strong. You couldn't *fight* Jess Willard. No man could. Maybe not the tiger, either. You had to *box* him."

Dempsey began boxing with his brothers—starting at the age of seven. He always was formidable, a lean and muscular kid with a terrifying punch. But he began seriously to learn only after graduation freed him from school and Mr. Wintz. Working in mines, on ranches, in lumber camps, he boxed, as he put it, "on the side. I couldn't make real money when I was just beginning to be a boxer." He got pointers from every old-time fight man he came across. The trainers, the managers, the veteran fighters all had individual ideas and special techniques, dating in some cases clear back to the bare-knuckle days. Dempsey absorbed information from everybody. He retained what worked for him and discarded what did not. "I absorbed so much information," he said, "I was like a blotter on legs."

He was twenty when he made his first trip to New York, in 1916. With the beating he took from John Lester Johnson and the fleecing he took from the despicable John Reisler, the trip at the time appeared disastrous. But in his persistently cheerful way, Dempsey came to see his few months of working out at Grupp's Gymnasium in uptown Manhattan as an important learning experience. He remembered fighters he met at Grupp's: sandy-haired Frank Moran, a powerful heavyweight out of Pittsburgh who went twenty rounds with Jack Johnson for the championship but lost the decision. (After that 1914 fight in Paris, someone remarked that the only time Moran touched the clever Johnson "was when they shook hands before the bell that started the fight.") He spoke warmly of K. O. Bill Brennan, out of Chicago, a powerful crowd-pleasing slugger who came to a tragic end; Billy Miske, another mighty midwestern heavyweight who did not live to see the age of thirty. "It was like a kind of fraternity," Dempsey said. "If a young feller seemed eager to learn, the veterans were willing to teach him." Although Dempsey's relationship with Doc Kearns eventually bogged down in lawsuits, he credited Kearns with being an outstanding "postgraduate ring instructor." His Toledo trainer, a bald, peppy cigar chomper named Jimmy De-Forest, had been working with fighters since the days of John L. Sullivan.

Dempsey not only recalled the scores of fight people from whom he learned, he remembered the places where he absorbed their lessons. There was Manassa and Montrose in Colorado; Provo, Ogden, and Salt Lake City in Utah; Goldfield and Tonopah in the parched flats of Nevada; there was San Francisco and Oakland, Milwaukee and Memphis, New York and New Orleans, Altoona and New Haven. All his life Jack Dempsey was a traveling man.

Dempsey fought at least sixty professional bouts on the long journey to Toledo. He may have fought as many as one hundred; records are imprecise. After all that hard-bought experience, Dempsey, the prizefighter, was not a tiger or a wildcat or a puma. He was a cold professional, a gorgeous craftsman. Call him a tiger? You might as

well call him a watchmaker. He was neither. He was a great fighter at the top of his glorious form.

The single greatest distinction between a boxing match and a fistfight, Dempsey maintained, is the element of anger. He was driving the red Buick on a hot country road outside Toledo late in June 1919 when he was cut off by a big man racing a Cadillac, spraying dirt and road gravel on Dempsey's windshield. The other driver was Willard. "I was angry when it happened," Dempsey said. "I yelled, 'Why don't ya go to driving school, you big baboon?' Then Kearns and Jimmy DeForest got all over me. 'Forget it, Jack. Don't pay that bum no heed.' The very last thing Doc and Jimmy wanted was to have me angry in the ring." For raw anger in the ring, Dempsey said, is a boxer's serious enemy. "Once you get mad, you're going to forget technique and tactics and you'll be wide open for the opponent who stays calm. You know what I call an angry boxer. I call him a lost-head. He's lost his head and now he's going to lose the match."

A fistfight begins with anger. If at least one of the parties isn't angry, there is no *causa belli* and no fight. Typically combatants in a fistfight charge and rear and throw wild roundhouse, haymaking right-hand punches. You see this style reenacted in a hundred old cowboy movies, where hero and villain club each other back and forth through the swinging doors of a gritty Old West saloon, the one with the painting of the reclining pleasingly plump naked woman beckoning from above the bar. (An outstanding movie brawler, the late actor Dane Clark, once told me, "The only time in my life that I ever won a fight was when it was written into the script.") Such "fights" are fun to watch, and they have no bearing on reality. When a real roundhouse right lands, it breaks a nose and uncaps a geyser of blood. Wild punches that do land, as opposed to movie punches, re-sculpt faces in unpleasant ways.

Fistfights, as Dempsey said, are extremely dangerous, and not in artful ways. Try a roundhouse right-hand haymaker against a professional and you will neither land the blow nor remain upright through

the next minute, let alone the round. The pro will beat you to the punch with a short left that he drives quickly and clinically inside your wild right. Should you retain consciousness, the professional's right cross will immediately alter that state.

Dempsey cited four other significant distinctions between boxing and fighting. A referee enforces rules in boxing. This precludes, or anyway minimizes, some appalling aspects of a brawl: low blows, eye gouging, hair pulling, kicking, strangling, biting. (Mike Tyson chomping on Evander Holyfield's ear reinforced Dempsey's point. He was disqualified and later dispatched to a psychiatrist's office.) In the ring, when boxers clinch, a referee moves them apart. When angry street fighters fall into a clinch, Dempsey pointed out, "There's no one to separate them. They get to wrestling. A feller gets thrown to the pavement. He can be punched when he's down, or be kicked in the face, unless some humane bystander interferes." Dempsey knew how to use a significant pause. He waited a bit before adding, "You can't count on bystanders."

Another major difference between a fight and a boxing match, Dempsey suggested with a nod toward Tex Rickard, is that boxing matches are planned according to a professional measuring of the contestants' abilities and weights. That skill is called matchmaking and a good matchmaker tries to set up closely contested bouts. Flyweights, who can weigh no more than 112 pounds, battle other flyweights. Lightweights, 130 to 135 pounds, fight other lightweights. Welterweights, 135 to 147, match against other welters. And so on up to the heavyweight class, which today officially starts at 195 pounds (fifteen pounds more than Dempsey's real weight in Toledo). Formal weight classifications trace to the mid-nineteenth century, as do the so-called Marquis of Queensberry rules, the overall code that governs prizefights, first published in 1867. Boxing promoters and those government officials who were involved accepted eight weight classifications in Dempsey's time. There are thirteen today. These groupings exist not only to provide interesting matches, but also to prevent strong, heavy boxers from injuring, maiming, or killing lighter men.

Pressing for larger purses across the decades, many great fighters have moved from class to class. Stanislaus Kiecal of Grand Rapids, Michigan, who fought as Stanley (or Steve) Ketchel, is a middleweight champion remembered for "tumultuous ferocity." He fought at about 155 pounds and seemed always intent on not simply knocking out his opponent but killing him. (The same was later said of Jack Dempsey.) In the second year of his middleweight reign, Ketchel challenged Jack Johnson for the heavyweight championship. Pleased with a purse, Johnson accepted the challenge and the men met at Colma, California, twenty miles south of San Francisco, on October 16, 1908. Johnson was about forty pounds heavier and before the match both sides, the fighters, the managers, and the rest, agreed to box an exhibition, with fast sparring and splendid footwork, an interesting, nonviolent match between a great large man and a great little man. In the interests of Ketchel's safety, neither boxer was to hit the other hard.

In the twelfth round, Ketchel saw an opening and drove a hard right that knocked down Jack Johnson. The big man rose in indignation. He had been betrayed. Johnson then hit Ketchel in the face so hard that the Ketchel's lips became impaled on his teeth. He was unconscious for an hour.

Sam Langford, "the Boston Tar Baby," a superlative black boxer for the first twenty years of the century, fought as a welterweight, a middleweight, a light heavyweight, and even as a heavyweight. His announced ring weights ranged from 142 pounds to 180. Langford didn't lose often, but when he did, it was a heavyweight who defeated him. The only man who ever made the prideful Langford actually quit in the ring was a boxer named Fred Fulton, billed as the Giant of the North. Fulton, who came from Kansas, stood six feet four and weighed 215. Langford stood barely over five feet seven.

More recently, Sugar Ray Robinson, "a lean and especially muscular black panther," in Red Smith's enthusiastic, politically incorrect, and compelling description, had been Golden Gloves champion as a featherweight and as a lightweight. At twenty-six, in 1946, he beat

Tommy Bell and became world welterweight champion. Five years later, he knocked out Jake LaMotta and became world middleweight champion.

In 1952, Robinson, whom sportswriters were now calling "pound for pound the best fighter who ever lived," challenged a good but hardly great light-heavyweight champion out of Cleveland, Giuseppe Antonio Berardinelli, who boxed under the name of Joey Maxim. They met on a sweltering June night at Yankee Stadium and drew a crowd of 47,983. Although Robinson was giving away about fifteen pounds, he was favored in the betting line, 7 to 5.

"Fighting out of a crouch, ignoring the weight handicap, Robinson blazed through eleven rounds," James Dawson reported in the *New York Times*. "He punched Maxim almost at will, with left jabs to the body and face, with left hooks and right crosses, with solid lefts to the head and body. In the third, seventh and eighth rounds, Robinson jolted Maxim's head and he kept up a two-fisted fire to the midsection."

Robinson won eleven of the first twelve rounds. In the twelfth he drove a hard right into Maxim's jaw, and the bigger man shook briefly but recovered. That was all that was left in Robinson's fighting frame. He began to stagger about the ring, as though suddenly drunk. After twelve rounds, seconds applied ice packs to his head and neck and groin. They held smelling salts under his nose. He got up for the thirteenth round, moving woodenly. Near the end he missed a wild left swing and fell down. He could not stand up when the bell rang for round thirteen. "Heat exhaustion," announced the ring physician. A thermometer showed the temperature in the ring, under hot lights, was 104 degrees. And it was humid. Robinson had to be carried from the ring. Maxim was credited with a fourteenth-round knockout. This was the first time Sugar Ray Robinson had been knocked out in 137 fights—in more than twelve years of professional boxing. He refused hospitalization, but a physician took him home and spent the night.

It had been fiercely hot all day. "City pavements melted and blistered yesterday," Meyer Berger wrote in the *New York Times*. Fewer

than half of the teams scheduled to compete for the Westchester County Mixed Foursomes Golf Championship even showed up at the Sunningdale Country Club in Scarsdale. The heat was unexpected and punishing and in the ring the bigger man had the physical reserves to contend with it. After that, in the sporting restaurants, the "21" Club, Toots Shor's, and Mama Leone's, you heard people repeating a canon of the ring: *A good big man will always beat a good little man.* Giving away fifteen pounds proved too much for the great Sugar Ray Robinson.

In similar heat at Toledo, Dempsey gave away not fifteen pounds, but fifty.

Dempsey's final point was that boxing matches have a term and fistfights do not. In Dempsey's years, as today, the limit to the number of rounds was usually ten, twelve, or fifteen. Three minutes of fighting. Then one minute of rest. A fifteen-round championship fight cannot last longer than fifty-nine minutes, in what the astrophysicists call "real time." (If you have ever boxed at all, you will remember that the simplest act, holding your gloves up in proper position, tires your arms within three rounds.)

A generation before, John L. Sullivan knocked out Jake Kilrain in a bare-knuckle heavyweight championship fight at Richburg, Mississippi. It took quite a while. Sullivan could not knock out Kilrain until round seventy-five. The rules were somewhat different then but someone timed the bout from beginning to end. It lasted two hours and sixteen minutes, which defines a staggering feat of endurance for two big men, notably Sullivan, who was one of the premier whiskey drinkers of his age.

From Dempsey's days onward boxers have been trained so that they develop the strength, stamina, and wind to go fifteen rounds. Given the fifteen-round limit, there are reasonably precise formulae for how many miles a boxer in serious training should run every day and how many rounds he should spar each afternoon. (Dempsey recommended a six-mile run and fifteen rounds; that is, fifteen three-minute intervals, of sparring, shadow-boxing, hitting bags, and skipping rope.)

People don't train for street fights and once begun, a street fight simply goes on. As Dempsey said dryly, "You don't win a street fight on points. There's no letup until someone is knocked out or beaten up so badly that he quits. Sometimes bystanders or the police break up a street fight. I told you, you can't count on bystanders. You can't rely on the police either.

"No one knows what can happen in a street fight. The footing is bad. On a knockdown your head can slam a sidewalk or a concrete curb. Who's around to stop the bleeding? A street fight is a helluva lot more dangerous than a boxing match, but one big fact that applies to both of them is this: The longer they go on, the more chance you have of getting hurt."

———

"Bobbing and weaving," John Lardner wrote, "is a phrase that is likely to be associated with Jack Dempsey until the end of time." When one bobs in the ring, as when a schoolchild bobs for apples, the head moves up and down. Weaving is a side-to-side motion. As Dempsey bobbed and weaved, his head was always in motion. Up. Down. To the left. Down. Down. Up. Right. Down. Left. Up. Left. "Hell," he said, "you don't have to be a genius to know that it's harder to hit a moving target than a sitting duck."

A beginner who bobs and weaves falls into a regular pattern. Bob. Weave right. Bob. Weave left. Bob. Weave right. And so on. A pro will pick up that pattern and the beginner shortly will bob or weave face first into a knockout punch.

"Bobbing," Dempsey said, "might be called glorified ducking. A bob is a kind of artistic duck. To most people the word *duck* means a frantic dodge down, and that's what a duck usually is. But there is nothing frantic about the bob. When you execute it properly, the bob in the ring is as graceful and controlled as a bow from the hips at a formal dance in Paris, although it goes a little quicker."

Dempsey described the weave as "a series of slight imaginary slips. As you shuffle forward toward your opponent, you roll your left

shoulder slightly; then your right; then your left and so on. Nearly all fighters use the bob and weave to some extent. The genuine bob-and-weaver—and I was one of those—uses it fully. A deep bob and a wide sway.

"I used that to slide in under an opponent's attack. Once in close I threw my left hook. I had a good one. I'd continue with rights and left hooks, uppercuts—what the sportswriters called 'a barrage.'"

The image of Jack Dempsey moving in gracefully, light-footed, a Parisian dancer gliding forward to kiss a countess's pale hand is a bit of poetic license on his part. Dempsey in the ring scowled and snorted. He did box with great technique and a remarkable rough grace. But after a bit, the grace of Dempsey's dance was submerged in the overwhelming power and ferocity of his rushes.

"The best and really the only way to protect yourself with your fists," Dempsey said, "is this. You must become a knockout puncher." With his own hard-bought knowledge he maintained that he could take "a normal chap, anywhere between twelve and thirty, and by normal I mean healthy and sound, not ailing or crippled, and make him a knockout puncher in six months."

That statement is best taken lightly salted. It stands up best as an expression of Dempsey's self-confidence and enthusiasm, since a cold analysis of a fight must include the element of fear.

Long ago a very serious counselor called "Uncle Bill" ordered me into boxing lessons at a New England summer camp called Robinson Crusoe. I was ten. I had good foot speed and my hand-to-eye coordination was sharp enough for me to play third base for the varsity baseball team. I was not afraid of baseballs thrown near my head, nor hard smashes cracked down to third. I'd played a few years of junior prep football and there I swept end or ran hard off tackle without experiencing fright. I had scuffed a bit, as boys will scuff, but never before Uncle Bill and Robinson Crusoe had I boxed. As I was commanded into my first formal boxing match, dread abruptly dominated me. In a manner that never entered my play in other sports, I thought over and over: "Willickers. I can get *seriously* hurt."

"You're a little faster than Harvey here, but smaller," Uncle Bill

told me in his drill-sergeant way. "So you move around Harvey. Circle to the left. Stay low. Stick Harvey with your left. Stick his ribs. Stick his ribs. Kill the body and the head will die."

Harvey, large and fleshy, went wide-eyed, "What about me?" he asked Uncle Bill.

"We'll get to that in a minute," Uncle Bill said.

Like most right-handed boys of ten, I had no left. My strongest left-hand punch was, in the argot, "a powder puff." But like most reasonably athletic right-handed boys, I did have a righthand punch of some power, which I threw by drawing back the fist and indeed the arm and shoulder, then launching body weight into a thrusting punch toward the jaw or nose. Uncle Bill had observed as much watching bland scuffles on the lawn outside our wood cabin, in the hills above Sturbridge, Massachusetts, that were home for summers of sports.

Under hurrying white clouds full of puff, by the lake, the one place at which the boys' and girls' camps commingled, I gaped from time to time at a junior counselor named Edie, dark, slight, with warm Spanish eyes. The day before my bout with Harvey, Edie approached in a two-piece white bathing suit and said, "Uncle Bill says he's starting you boxing. If you win, when the girls go to sleep, I might come up to the boys' camp tonight and tuck you in and give you a kiss good night. But we would have to be quiet."

"I can be very quiet."

"And this is only if you win."

Two gods now reigned in Camp Robinson Crusoe in Sturbridge, Massachusetts. Dempsey and Priapus.

Uncle Bill showed me how to tape my hands. "You want to hit with the knuckles. How many knuckles do you have, not counting the thumb? Four? That's right. You want a power line from the shoulder. You get that if you hit first with the pinky. Except the pinky breaks easy. I want you to hit first with the next finger, the ring finger."

"How can I hit with one finger when my whole hand is inside a glove?"

"Lead with one finger. Lead with your left. Lead with your ring finger. You'll get the hang of it. Punch straight. Punch up. Keep your left hand high."

"What about me?" Harvey said, across the cabin.

"You're bigger and stronger, maybe a little awkward. I want you to crowd him, Harvey. Keep your hands high. Cuff. Left, right. Left. Cuff him. Shove him back. You're stronger. The second his left hand goes down, cross with a right. Hard. Knock him down.

"I'll just chalk out the lines of the ring. Okay. Ready, boys? Two-minute rounds. I'm the referee and the timekeeper and I'm the bell.

"Bong."

Harvey, a department-store owner's son, was downright chubby. There was no denying his bulk. I tried to remember what the counselor had said. Mostly, though, I did not want to get hurt.

I stayed away from Harvey's right glove and moved around him to the left with my head down. An uppercut would have damaged me. But bulky Harvey, facing his own terrors, was trying to throw straight left-hand punches at my ribs. He missed a few and stumbled. Both his hands were low. I drew back my right glove and threw my hardest lunging punch into Harvey's nose.

Harvey plopped down on his butt and began to cry.

"You're okay," Uncle Bill said. "Come on, Harvey. Get up."

"It's bleeding. I know my nose is bleeding. I can taste the blood."

"You're okay, Harvey. Get ready for round two."

I began to unlace a glove, using my teeth. "What are you doing?" Uncle Bill demanded. "What are you doing, dammit?"

"I don't want to fight anymore."

"It's not fighting. It's boxing. Get that glove back on."

"I don't want to hit him anymore," I said. That was sheer bravado. Actually I was thinking, *If this fat kid gets up, he'll be so mad at me for popping his nose, he'll take my head off. He's stronger than I am. He can do it. I will get* seriously *hurt.* Harvey crying, Harvey not crying, was secondary. I didn't want my jaw, my belly, in fact my own nose pounded by a bigger, heavier kid.

When Harvey did not stop crying, Uncle Bill pronounced me the winner. At 9:30 that night, Edie, the pretty junior counselor, knelt by my bed and gave me a brief good-night kiss. Even this moment was finally disappointing. Afterward she rose and moved quietly to Uncle Bill's room in a far corner of the cabin. I watched her silhouette disappear as she closed the door. Dempsey and Priapus continued to reign.

Remembering this incident makes me think harshly of Uncle Bill, to be sure, but the relevance here is something else. Boxing, going into the ring and putting on gloves, is, before anything else, terrifying. At least it was for me. I'm sure it was forever after for poor plump, bleeding Harvey, the department-store heir.

Perhaps under a better boxing coach, one who provided the right coaching plus large portions of emotional support, I might have conquered the terror and come to enjoy boxing, as I enjoyed other rough sports—football and in later years hockey. But perhaps not. Before any boxing teacher, even Dempsey himself, could make a knockout puncher out of anybody, he first has to encourage the prospective boxer to bury, or at least to channel, fright. Taking a liberty and correcting, or anyway editing, Dempsey on boxing, the great champion could convert a "normal chap" into a "knockout puncher" only if the fear in the normal chap did not run so wild as to make planned punching and tough defense impossible. It is hard to punch crisply and methodically while trembling.

Many good athletes, normal chaps, can't hit strong pitches because the curve ball makes them cringe. Others spurn football. They don't like being blocked, much less being hammered to the ground by tacklers. My guess is that an even higher percentage of normal people never could become knockout punchers. Put simply, it hurts too much to learn.

———

Dempsey said that his attack began with a "falling step" forward. He pointed his left great toe toward his target and took a long, falling

step toward the target with his left foot. That started the weight transfer, which was, as he put it, "the power source." He then described "a power line," running from his shoulder down the length of his arm to his gloved fist. To quote from his instruction book, "As you take your falling step forward, you shoot a half-opened left hand straight along the power line, chin high." Then, "as the relaxed left hand speeds toward the target, suddenly close the hand with a convulsive, grabbing snap. Close that left fist with such a terrific grab, that when the knuckles smash into the target the fist and the arm and the shoulder are frozen steel-hard by the terrific grabbing tension. That convulsive, squeezing grab is the explosion." This explosion was Jack Dempsey's left lead. No one who felt the punch forgot it.

He fought out of a semicrouch. Not upright like the great nineteenth-century boxers, Daniel Mendoza of England to John L. Sullivan of Roxbury, Massachusetts, nor the deep crouch that makes one's movements crablike. The deep crouch is a good defensive stance, but Dempsey pointed out that it places your weight too far forward for you to take the falling step that starts the explosive left. Your weight is also too far forward to permit fast retreating footwork. "If," Dempsey added with dry, regal scorn, "you want to retreat."

Footwork was a treatise unto itself. You could fall forward or shuffle forward, sidestep right or sidestep left, even shuffle backward. Dempsey drew diagrams of the requisite footwork. The patterns are as precise as those in a saraband, the formal and stately court dance of Mozart's time.

"Under no circumstances," Dempsey said, "take any little half step or hippety-hop when you decide to punch. And never, never draw back the punching hand before you throw it." Here he was skewering aspects of amateurism. That little hippety-hop leaves you off balance. Worse yet is cocking your fist—winding up. Cock your left against a professional and he will drive a painfully hard right hand over your jab. In the well-known phrase, you will be beaten to the punch. Cock your right against a pro and that classic of punches, the left hook, will promptly end the bout and your consciousness. Finally,

Dempsey said, "Here's another never. Never throw a light punch. Any time you swing, you're going to leave yourself open to some extent. If you're going to be open, make it worth it. Punch hard. Light leads don't impress me at all. Punch his socks off."

Prizefighting is a business of mobility; boxers are never stationary, unless hurt. Dempsey grouped the distances between opponents into three categories. "Long range"—about a yard apart—was ideal for explosive sharpshooting, the left-hand jolt and the right cross. At "medium range"—about half a yard distant—came the rapid-fire exchanges. A fighter has room here to throw straight punches, but there is no space for the falling-forward step. You generate power with a shoulder whirl. Whirl left. Whirl right. Right. Right. Left. It's at medium range that you see what sportswriters call "flurries of punches." It is unusual, Dempsey said, for a man to have such quickness and strength that he could throw a knockout punch with just a shoulder whirl. You get more power with the forward step, the explosiveness driving up clean from the ankles. Few fighters threw knockout punches from just the shoulder whirl. Dempsey did, with either hand.

Close range is where boxers go head to head with hooks and uppercuts. When two men stand chest to chest, there is simply not room enough for straight punches. Powering his hook in close, Dempsey whirled and surged upward, whirled from left to right, driving hooks with a force that Grantland Rice called "tornadic." Close up, Dempsey threw the most devastating left hooks ever seen.

Tornadic in their impact, perhaps, but first precisely engineered. Dempsey gave great thought to creating his classic hook. "A hook," he said, "is a whirl-powered blow, delivered while the elbow is sharply bent." Many mistake a left swing for a hook. In the swing, the left arm is pretty much fully extended. That creates a wide, sweeping blow and leaves a boxer open for the entire time the punch is traveling in its long arc. A sweeping blow is easy to evade and, probably worst of all, traveling that arc robs the swing of explosiveness. In a left swing, you have a long punch dangerous to throw that lands with little impact. "Any one who is so stupid and inexperienced that he can

be hit with a swing is a palooka," Dempsey said. "Just move inside the swing and pound. My message to beginners goes like this: Take the swing, toss it in the slop bucket, and forget it. Then learn to hook."

The left hook is short and sharp. What Dempsey called a "shovel hook" is thrown with the elbows pressed tightly against the hips for a body blow, or with the elbows pressed against the lower ribs for a hook to the head. What he called "an outside hook" is thrown with the elbows a few inches away from the body. The shovel was Dempsey's workhorse hook. He used it to pound opponents who tried to clinch. The properly executed outside hook—kept tight with the elbow sharply bent—is "a pure full-fledged knockout punch, but you have to be careful not to let it degenerate into a swing."

A punch Dempsey particularly favored was something he called the "sneaker hook." This began with Dempsey and an opponent in a clinch. Dempsey kept his chin close to the left side of the other fighter's head. He used his left hand to grab and tightly hold the inside crook of his opponent's right elbow, taking away his righthand punch. He clamped his right hand on the left bicep and held hard, taking away the left. Then, in Dempsey's words: "Suddenly yank him tighter to you with your right hand. Then shove him away hard with both hands. Almost in the same movement whip an outside right hook over his left shoulder and down so that your striking knuckles smash into his left jawbone or left temple. He will drop like a poleaxed steer."

The uppercut is powered by a surge. It shoots straight up along an imaginary line from the floor to the solar plexus or chin. Properly delivered in close quarters, it is difficult to avoid. Good uppercuts drive inside an opponent's defenses with withering power. Dempsey's in-close combinations of hooks and upper cuts made sportswriters think of field artillery. The writers called Dempsey's combination barrages. That they were, lacking only the fallout of shrapnel.

The variety of powerful punches he brought into the ring against gigantic Jess Willard indeed constituted an arsenal. Dempsey's over-whelming power made many people overlook the calculation that went into every punch he threw. In that regard he was a thinking,

even intellectual, boxer. But his *attitude* throbbed with terrifying, ancient instincts. "I never go in confident," he said. "Any sucker can get lucky and give you a crack in the chin. I go in, saying to myself, 'Kill 'im, kill 'im, kill 'im. Otherwise he'll kill me.'"

The long count that a referee named Dave Barry afforded Gene Tunney at Chicago in 1927 was a debacle for Dempsey. It is a point of high drama, still debated today, a drama highlighting suspect "loans," forgotten mobsters, and such well-remembered giants as Al Capone.

Fewer know about the short round in Toledo. Here another mistake in timekeeping lengthened a fight that should have ended in one round and incidentally cost Doc Kearns a sage and daring bet that would have brought him one hundred thousand dollars.

At the beach club at the bayside in Toledo Dempsey trained to a perfect peak, his lean body hardening and his skin turning a deep tan under the relentless summer sun. A few days before the fight, Doc Kearns was convinced not simply that Dempsey would win, but that he would win "in one helluva hurry." As Kearns liked to point out, "I was the first guy that figured Dempsey for the great fighter he was." While the sportswriters were split and uncertain, Kearns sought out a gambler named John "Get Rich Quick" Ryan for a little business. Ryan was handling "action" on the fight. "He'd give you odds on anything," Kearns said, "including whether the sun would come up tomorrow. You could get a real fine price if you bet that it wouldn't."

Kearns met Ryan in the Secor Hotel. If he himself made a big bet, Ryan might suspect that the fight was fixed, or so reasoned the assertively paranoid John Leo McKernan, called Doc Kearns. "I've got this friend who likes my fighter," Kearns told Ryan. "He wants to know what price he can get if he bets Dempsey knocks Willard out in the first round."

With no hesitation, Ryan said, "Ten to one. How much does he want to bet?"

"He's talking ten thousand."

"I can cover that," Ryan said. "Send him around."

"Doesn't want to show himself. Fancy family. He doesn't want to be seen betting. Suppose I bring around the money for him."

"Suit yourself," Ryan said.

There was, of course, no fancy friend. Kearns, never eager to be clear about his financing, said vaguely that the ten thousand dollars came from "shares I had in the fight concessions." Whatever he had, he did put together ten thousand dollars, and made his bet. If Dempsey knocked out Willard in the first round, Doc Kearns would win one hundred thousand dollars.

Generally, W. O. McGeehan reported in the *New York Tribune*, "the betting on the eventual winner seems to be about 10 to 8, Dempsey favored." The final prefight rumor, McGeehan reported, was that Kearns or other Dempsey adherents intended to slip a slow-acting sleeping potion into the iced tea that Willard liked to drink. "This may seem humorous," he wrote, "but one peek at the I'll-take-a-chance men taking a flyer on Dempsey, makes one wonder. In hotels, these birds never use room keys. They go through the transoms just to keep in practice."

Tex Rickard and his mostly silent partner, Frank Flournoy of Memphis, planned a gala Independence Day. Boxing matches beginning at 11:00 A.M. in the colossal octagon of an arena that covered seven acres hard by Maumee Bay. Nonstop boxing from morning to night. There was Rickard's private reserve for women fans, his "Jenny Wren section." After the main bout a giant hard-drinking party would, so to speak, spit in the eye of Prohibition.

Dempsey slept little on the eve of the battle. "I couldn't wait for daylight to come," he said. When it did, he couldn't wait to get to the arena. He spent the morning pacing the grounds of the swimming club–training camp. "How goes it, Champ?" Kearns said.

Normally talkative, Dempsey closed down before it was time to fight. "All right. Just fine." This was, he later said, "the longest morning of my life."

Willard waited inside his three-story stone house, calm and confident. He read the morning newspapers. He was going to dispose of the boy as soon as he could, imposing a minimum of pain. His greatest concern, buried deep, was that he might kill Dempsey as he had killed Bull Young.

Then it was time for both men to proceed.

Preliminary bouts moved along. Wop English knocked out Whirlwind Wendt. Tommy O'Boyle and Solly Eppstein battled to a draw. Johnny Lewis knocked out Tommy Long. The day was cloudless. Heat built in waves. The sun beat down on the fighters and the referees and the men in the stands with their straw Panama hats and the women in long dresses and high collars who sat in the Jenny Wren section. The crowd drifted in by twos and fours and eights. There never was a crush at the entranceway.

Toward three o'clock, Major Anthony Drexel Biddle of Philadelphia led a contingent of Marines into the ring for a display of close-order drill. Biddle was an odd but significant figure in the tableau. He was a Philadelphia Quaker, well connected socially and politically, and an unbridled fight buff. Rickard asked him onto the Dempsey–Willard team as a kind of lobbyist. The Biddle family in Pennsylvania ran back to pre-Revolutionary times and was widely viewed as a symbol of Quaker propriety. Rickard believed that having Anthony Drexel Biddle of the Philadelphia Biddles lobby politicians on behalf of the fight was an important counter to boxing's opponents, practically and morally.

The Biddle fortune came primarily from banking. Anthony Drexel Biddle lobbied well, but for a price: Rickard would have to name him one of the judges. (The other was Rickard himself.) He would have to appoint Biddle's friend W. Warren Barbour of New Jersey as ring timekeeper. Finally Biddle had to be allowed to lead a contingent of marines that he had brought in from Philadelphia in that drill inside the ring.

Professor Billy McCarney, the concession hustler, said that Biddle often liked to go into the ring as a second. "He talked his way

into the corner with me one time," McCarney said, "as a second to Philadelphia Jack O'Brien. It gets crowded in there sometimes, and Biddle kept getting his foot stuck in the water bucket. Maybe he'll be safe as a judge."

The man was unsafe in any ring. Marching about, Biddle and his marines scuffed the canvas so badly that it ceased to be a suitable surface for a championship bout. The proceedings stopped while workmen installed a fresh canvas, then dusted it with resin.

In January 1964, *Sports Illustrated* published an article over the byline of "Jack (Doc) Kearns" and a collaborator, Oscar Fraley, claiming that Kearns had secretly added plaster of Paris—technically hemihydrated calcium sulfate—to the mix that he and the seconds put on the gauze that covered Dempsey's hands. The customary mix applied was powder and, in extraordinary heat, water as a cooling agent. Gauze, tape, powder, water, and then the gloves. On gauze (or anything else) plaster of Paris dries into a solid that is nearly as hard as cement.

He bought the plaster of Paris on a trip to downtown Toledo, Kearns claimed, and poured the stuff into an empty talcum-powder can, which he brought to the arena on July 4. Seconds from each camp watched the others' taping process. Kearns himself observed Willard's hands being taped. "Amateurishly," he noted.

Willard's principal second, Walter Moynahan, watched—in the Kearns version—as Kearns taped Dempsey's hands. Kearns wrote: "I finished with the wrappings. I turned to Jimmy DeForest, my trainer, and pointed to the water bucket.

"'Give me that sponge....I want to keep the kid's hands cool.' The sponge made a sloshing sound. 'Now the talcum powder,' I directed DeForest, and he passed me that innocent-looking blue-lettered can. I sprinkled its contents heavily over the soaked bandages."

No one has challenged Kearns's gifts as a fabulist, but even *Sports Illustrated* showed skepticism of the accuracy of his reporting. The editors preceded the story with "a cautionary note" describing Kearns as a "wily trickster" who presented to the world a face of

"roguish rascality." Kearns was dead when the article appeared. His collaborator, Oscar Fraley, a one-time United Press sportswriter, is more renowned for his collaboration with Elliott Ness, the Prohibition enforcer, on *The Untouchables*. Ness died before that book was published. Working with Fraley seemed fraught with peril. Most students of Prohibition regard *The Untouchables* as an entertainment unburdened with very much accuracy.

The plaster-of-Paris story runs against both physics and logic. A hand ringed with a rockhard substance obviously can inflict damage, but the hand is at great risk. The plaster-of-Paris fist might break an opponent's bones. But impact works two ways; it might just as easily break bones in the puncher's hand. Aside from that, plaster of Paris is heavy. How long a boxer, even in Dempsey's top condition, could hold up loaded gloves is a question. Finally, not Kearns but Teddy Hayes, another of Dempsey's seconds, cut off the tape after the bout. "I snipped it right in front of a whole milling crowd in the dressing room," Hayes said. "Don't you think if there was plaster of Paris, Kearns would have been there, standing guard? And you can't cut plaster of Paris with a scissors. I would have to have had a hacksaw.

"Anyways, by the time I was cutting the tape, Kearns was nowhere around. He was off lifting a few with Damon Runyon. You got to realize when that article was being prepared with this fellow Fraley, Jack was sick. He was dying and he was broke. He would have said anything for money."

Sports Illustrated used a catchy title: "He Didn't Know the Gloves Were Loaded." Mostly because they weren't.

Dempsey entered the ring first, at the center of a small scuttling crowd. He wore white trunks. He looked somber and preoccupied. He made no eye contact with anyone. His biggest sparring partner, Bill Tate, carried an umbrella to shield him from the sun. Kearns had sold local merchants advertising space on the umbrella.

Willard kept Dempsey waiting. "Torture when you're keyed up like I was," Dempsey remembered.

"Relax, Champ," Kearns said. "Take it easy. The fat bum is probably ascared to come out." Dempsey stood stock still, head down, staring at the canvas. Sitting at ringside, H. C. Witwer, author of scores of books with punning titles such as *Bill Grimm's Progress, Don Coyote,* and *The Knights Before Christmas,* described Dempsey as "the coolest and most self-possessed person in the arena."

Willard finally appeared in a dark robe over blue trunks, walking slowly and confidently, a giant advancing slowly on his prey. He stepped into the ring, doffed his robe, turned his back on Dempsey, and held both hands aloft.

"I thought I was going to be sick to my stomach," Dempsey said. "Willard's back was a solid wall. His fists looked like they were twice as high in the air as I was tall. I saw the muscles standing out on his back. Fat? He was in terrific shape. I said to myself, 'This guy is liable to kill me. I'm twenty-four years old, and I might get killed.'"

Willard wheeled and took three long steps across the ring. He extended his right hand toward Dempsey's gloves in a formal, unsmiling, gladiatorial greeting. They touched gloves. Willard looked down at his opponent. Dempsey continued to stare at the canvas.

Willard returned to his corner, where Moynahan held a white umbrella high. No cheap advertising blurbs on this one. Willard turned and offered waves and the suggestion of a smile to people he recognized at ringside. He seemed less a boxer about to battle than a politician about to speak. Willard believed he had a surefire plan. He knew Dempsey's penchant for rushing across the ring at the sound of the bell. Dempsey came into this bout after punching his way through five knockouts in five months, every knockout in the first round. "He'll come tearing at me, but I'm seventy or eighty pounds heavier than the boy. I'll have my left out. He'll have to watch out for my left when he's tearing in. Then I'll hit him with a right uppercut. That will be the end."

Dempsey's focus was first of all intuitive. Don't look at the damn big bastard. He stared down when the ring announcer made formal introductions. Ollie Pecord, the referee, summoned Dempsey and

Willard to the center of the ring and gave the usual instructions. "Keep your punches up. Break clean from the clinches. Good luck to you both." Still Dempsey did not look Willard in the eye. He stared sullenly at a point in Willard's midsection.

The fighters returned to their corners. The seconds left the ring. Pecord signaled W. Warren Barbour, who pulled the ring-bell clapper and started his stopwatch. The bell failed to sound. There was a faint buzzing noise. One of the workmen putting in the new canvas, after Biddle's ill-begotten Marine Corps drill, had left a guy rope stretching between the clapper and the bell. Barbour looked about. Someone threw him a military drill sergeant's whistle. Barbour blew it. Willard looked at the society timekeeper. W. Warren Barbour cried wildly, "Go ahead! Go ahead!"

Ten seconds were gone from the stopwatch when the men advanced to box. In confusion approaching panic, Barbour neglected to reset his stopwatch. With the watch running before the bout actually began, the first round would span not three minutes, but two minutes and fifty seconds. Without malice, Barbour had committed a cruel and unforgivable mistake, particularly for Kearns, but also in a sense for Willard. For technically—if the rules had been followed technically—the bungling would have cost Dempsey the fight.

Dempsey did not rush headlong toward Willard, but showed a sane respect for the big man's strength. He came forward lightly on the balls of his feet, circling left, then right, bobbing, circling, shoulders moving, body twirling, a sun-bronzed dancer with jet-black hair, beautiful in baggy white trunks.

Twice Willard stabbed his long left at Dempsey's face. Neither punch made much impact. Dempsey was keeping his chin tucked inside his left shoulder. Dempsey used the fall step from long distance and landed a right to Willard's heart. Then he clinched, tying up Willard's blacksmith arms. With Dempsey's left glove clamped on the inside of his right elbow, Willard could not throw his dangerous—and once lethal—right uppercut. He shoved Dempsey a bit. But this was not a brawl. It was a boxing match. When the referee broke the

clinch, Willard raised his gloves high and wide, to show that he was breaking fairly, cleanly. His gaze never left Dempsey. Willard was a notorious shover, a stand-up wrestler, so to speak, as Dempsey knew going into the fight. Dempsey conceded he liked to hit on the break, and going into the ring, big Jess Willard knew that.

Dempsey circled and moved and tried to land combinations. But he could not close with the bigger man. Willard's reach measured eighty-three inches, just shy of seven feet. Getting inside his long leads had proved too much even for the redoubtable Jack Johnson. Once, when a foray went wrong, Dempsey spun and made a trotting retreat, briefly turning his back on Willard. But then he spun again and tried to close. For a second time Willard clinched. He wanted to shoot the uppercut inside, but he had sorely underestimated Dempsey's skill. Ollie Pecord broke them again and for a second time Willard stepped back from a clinch with both gloves high.

Willard's style was to wear down opponents. For all his might, he had scored a first-round knockout only once in his career, only one in thirty-one fights. But now he was growing annoyed. When he was wearing down Jack Johnson for the title four years ago this rough-neck kid who moved around him now had been a twenty-year-old tramp, nothing more. He would close with this kid or let the kid close with him and drop him once and for all.

This stage of the bout—sportswriters would say they were "feeling each other out"—lasted for a minute and a half. There were no knockdowns or punishing punches. Some describe the period as "slow," but that description is uninformed and superficial. To call a stalking slow is to miss drama; in this case drama heightened because you could not yet be precisely sure which boxer was stalking the other. Far from being slow, the beginning was rather an awesome prelude, hypnotic and fraught with menace. Two strong, brave men had come a great distance to battle to the finish.

Dempsey circled left, bobbed and circled to Willard's right, then closed, moving toward Willard's right near the center of the ring. Behind the fall step Dempsey landed a left jolt to the jaw and then, in

seconds, he loosed the most devastating combination of punches in boxing history. He crashed a right hook and a left hook into Willard's body and a short right to the mouth. Now a full left hook to the cheek-bone crashed on Willard's face. This was a classic hook, a perfect hook, what Dempsey called "an ideal whirl-powered shovel hook." The blow fractured Jess Willard's cheekbone in thirteen places.

Willard sat down heavily. As Grantland Rice put it, he "wore a dazed and foolish look, a simple half-smile crowning a mouth that was twitching in pain and bewilderment." Has there ever, before or since, been such a punch as the single left hook that destroyed half of Willard's face?

When Pecord's vigorous count reached six, Willard rose slowly, dazed but game. He was asking no quarter and Dempsey was offering none. Another left hook dropped Willard for a second time and hammered six teeth out of his mouth. "Give me one of the big guy's teeth," screamed a woman who had quit the Jenny Wren section and shoved her way to ringside. "I want his teeth."

Willard lay bleeding against the ropes. Blood ran from his face and stained the white canvas. He could not get up without leaning his great weight on the ropes. Dempsey stood over him. Willard rose with his body turned from the ring, turned toward the crowd. Dempsey hit Willard twice from behind, moving him about, and knocked him down for a third time.

At this point, Willard's life was in peril. There was not yet a neutral-corner rule in boxing. Dempsey could not hit Willard when the big man was down, but he could stand over him and batter him as soon as he regained his footing. There was no respite. Willard was now capable of only rudimentary defense, a kind of pawing to keep Dempsey away. Today if there were a fight such as this, it would end right here, after the third knockdown. A good referee would simply stop the fight. Failing that, a good ring doctor would *demand* a halt.

Ollie Pecord did nothing of the sort. He resumed counting. Slowly, wearily, painfully, Willard again pulled himself up by the

ropes. The crowd was on its feet making waves of sound. Some shouted, "Stop it. Stop it." Two images flashed through the poetic mind of Grantland Rice. He had seen a young American soldier take a .45 bullet in the stomach and still lunge forward with his bayonet in a final dying strike. Rice also remembered the bushy-haired Sudanese warriors of Kipling's ballad "Fuzzy-Wuzzy," who soaked up British fire but still broke a British square. Then Rice focused on the ring. As Willard rose for a fourth time, someone else said, "He's become a great fountain of blood."

Up or down, Willard was moving in and out of consciousness. Sometimes he felt his head clearing and then stuck out his long left. But as Dempsey moved through it, Willard realized that he was going to be defeated unless, as he later said, "I landed a lucky blow." Still he fought on.

Dempsey slammed Willard across the ring and into the ropes. He threw hooks into Willard's face and kidneys. Willard went down a fifth time and a sixth. He leaned against the ropes and came upright. Dempsey did not tire and he did not miss. Another combination put Willard on the canvas for the seventh time, sitting against a ring post and quite helpless. Willard's eyes were open, but he did not know where he was. He could not get up and Pecord counted him out.

Doc Kearns climbed through the ropes. He put an arm at Dempsey's back and directed him toward a dressing room. He shouted, "Jack, you're the champ."

The crowd noise was enormous. Men and women screamed in excitement. A reporter named Maria Blanchard wrote in the *Toledo News Bee*: "Ten-buck Jennie and sixty-dollar Geraldine, Jim in the bleachers and James at ringside, all went mad together." Betty Brown of the *Toledo Times* cried out in high delight, "This beats the circus."

Dempsey was not champion. When Pecord's count reached seven, Barbour, the timekeeper, checking his uncorrected stopwatch, blew the military whistle. The round was over. The round ran ten

seconds short, but it was over nonetheless because the timekeeper ruled that it was over.

In the tumult few heard Barbour blow the whistle. Pecord did not. Dempsey did not. (If Kearns had heard it, with one hundred thousand dollars riding on a first-round knockout clearly he would not have let on.) Willard remained semiconscious. Dempsey moved toward his dressing room, seemingly quite calm. Strangers thumped him on the back. Kearns was joyous; the first-round knockout meant one hundred thousand dollars. That is just about a million dollars today.

Willard still sat on the canvas, unable to rise much less walk, when Barbour got Pecord's attention. The fight was still on. Obviously it is inaccurate to say that Willard was saved by the bell. There wasn't any bell. Nor was he saved for anything but more battering. But the fight *was* on. By the rules of engagement round two was to begin precisely one minute after the conclusion of round one. It did not. One minute after round one, Kearns was guiding Dempsey back toward the ring. Kearns had not won one hundred thousand dollars. He had just lost ten thousand dollars, most of his share of the purse. His kid could lose the fight. He was frantic.

At length, with a second holding each elbow, Willard was able to rise and wobble about, eventually reaching a stool in his corner. Ice water revived him somewhat. Then Willard stood up. Since Dempsey was out of the ring and Willard was vertical when round two should have begun, technically Willard had won the fight. Semiconscious, he had won the fight. But like Willard, the rules took a beating this Independence Day in the heat of Toledo, Ohio. Years later John Lardner pointed out, "Critics of Willard argue that his enthusiasm for thrift cost him the championship. Because he refused to hire competent help, which would have been expensive, he had no smart and seasoned second [like Kearns] to insist that Pecord count Dempsey out while Jack was struggling back through the crowd toward the ring. Willard trained himself and managed himself, for which he paid quite dearly."

Some call the succeeding rounds anticlimactic. It is true that Dempsey did not knock Willard down again, but Dempsey's discipline and Willard's courage were both memorable. His tanned back glistening with sweat, Dempsey pursued Willard methodically. Willard put a left lead on Dempsey's chin and tried to snap a right uppercut, but these were the spent punches of a man battered to exhaustion. Dempsey drove Willard about the ring with head and body blows. Willard stumbled against the ropes or leaned his great weight on Dempsey in clinches.

It became increasingly painful to watch Willard in round three. The right side of his face was a smear of blood. His right eye was swollen shut. He bled so heavily from the mouth that during the clinches his blood ran onto Dempsey's body. Dempsey kept pounding away at Willard. When the belatedly repaired bell rang, Dempsey's body was unmarked, but he was dripping with the blood of his opponent.

Willard squatted on his corner stool in shock. The long legs were shaking. He shook his head. At his signal, someone threw a white towel from his corner into the ring, in boxing's classic signal of surrender. The fight was done. The towel fluttered across the ring to Dempsey's feet. Even the towel was stained with Willard's blood.

Dempsey stood and lifted his right fist into the air. He smiled slightly. He was quite composed. Willard rose uncertainly, walked toward the new champion, and extended his right arm in a sporting gesture of congratulation. He sat down again, muttering, "I have one hundred thousand dollars and a farm in Kansas." People swarmed into the ring. Cheering strangers lifted Dempsey shoulder high and carried him toward his dressing room. One sportswriter remarked quite clearly: "Hail the conquering hero comes/Surrounded by a bunch of bums."

An hour later Willard delivered a farewell statement. He had never before been knocked out. No less a boxer than Jack Johnson had said Willard was too big and too strong ever to be knocked out. "I was fairly beaten and thoroughly beaten," Willard said. "Will I try

to recover the championship? I will not, because I could not. Dempsey is a great fighter. I know that now. I congratulate him and I wish him luck. My plans? They won't interest people anymore. I'm no longer champion. Now I'm just an ordinary guy."

Speculation began at once on Dempsey's next opponent. Most favored Georges Carpentier of France, the European champion. Resigned to the loss of his own five-hundred-dollar bet on Willard, Ring Lardner remarked, "After what we've seen, if I were Carpentier, I'd stay in France until the new champion dies of old age."

Grantland Rice wrote: "In his own way Willard, too, was unbelievable. From ringside it looked as if every one of Dempsey's terrific punches would tear away his head. But for six minutes [the last two rounds] he stood up and took upon his unprotected jaw an almost countless flurry of punches from a man who is the hardest hitter fighting has ever known."

W. O. McGeehan added: "Willard directed his own battle. He had perfect confidence in his bulk and in his strength. There may be those who will argue that he was not properly conditioned. That is utter rot. No man not in the best of condition could have taken that punishment and survived. Only because he went into the ring in perfect shape is Jess Willard still alive."

Dempsey went to bed at the Secor Hotel at 10:00. He was exhausted and fell asleep immediately. About midnight he had a nightmare of such intensity that he fell out of bed. He dreamed that Willard was giving him a terrible pounding, cutting his face around the eyes and finally knocking him out.

He rose, turned on a light, and moved to a mirror. He was not cut, not even bruised. He dressed quickly and went downstairs through the lobby and onto a sidewalk at the corner of Jefferson Street and Lafayette. A boy was selling an extra edition of the *Toledo Blade*.

"Who won the fight, son?" Dempsey said.

The newsboy gaped. "Aren't you Jack Dempsey?"

"Yeah."

"You did, ya big jerk. Look at the paper." The new heavyweight champion of the world grabbed a newspaper and considered the page-one headline.

Then he gave the newsboy a dollar, told him to keep the change, and went back upstairs to bed.

5 The Champion and the Whore

ON JULY 5, 1919, JACK DEMPSEY AWOKE as heavyweight champion of the world. Now it was no longer a case of saying (if only to himself), "I can lick any son of a bitch in this room." Now he knew, and so did everyone else, that he could lick any son of a bitch on the planet.

He let his mind run back to the hard days in the hobo jungles and to the lonely times when he had to ride the rods. He was just twenty-four years old. There should be very good years ahead. Toward noon Dempsey talked to Doc Kearns. It surprised him to learn that one thing had not changed. He still was broke. Ticket buyers had paid $452,224 to watch him fight Willard. Risk his neck, and risk his life, as a matter of fact. Still he was broke.

As Dempsey recalled the conversation, he said to Kearns, "I don't get it."

"While you were training, I needed movement money," Kearns said. "Money to move around with. Keep the sportswriters on your

side. It's important, Champ, to keep the sportswriters on your side."

Dempsey said he understood that maybe some of the purse had gone to entertain the writers, but the numbers still were puzzling. He told Kearns with intensity, "I can read a contract. We were supposed to get $27,500 from Rickard. Are you telling me you blew the whole twenty-seven five on Runyon and Lardner and the other guys?"

"Champ, when I got you this fight, we didn't have no money of our own. I had to borrow all our movement money from Rickard. That come to eighty-five hundred. Rickard held on to that and give us the rest, nineteen thousand," Kearns said. "But then I had to cover the ten thousand dollars we lost on the bet, because you couldn't knock out the big bum in the first round."

Dempsey felt a spur of anger. His voice got high, as it did when he became excited, and words tumbled out in a hurry. "I never told you I could knock him out in one round. The guy was never knocked out before by nobody. It was you who said he was a bum, not me. And he ain't a bum. No bum has guts like that guy." But fast talking was a Doc Kearns forte and he came back rapid-fire, without pause:

"Anyways, Champ, that bet you lost for us cut us down to nine thousand dollars. Then I had to cover your training camp expenses and pay off your sparring partners and your trainer and that come to nine thousand easy. So I got nothing left. Come to think of it, I probably lost money getting you where you are today. But look at it this way, Champ. At least we ain't in debt. And I just booked us into a theater down in Cincinnati where they're gonna pay us five thousand dollars a week just for telling the people how we knocked out big Jess Willard."

In later years, Kearns himself said, "Maybe I was a little fast with a buck and the booze and with the broads. But I was goddamn quick with the ideas, too."

At least three outstanding heavyweight champions died pretty much flat broke. These were John L. Sullivan (who died on February 2, 1918), Joe Louis (April 12, 1981), and Rocky Marciano (August 1, 1969). Dempsey, coming out of poverty, acquired a good sense of how

to handle money as he grew older. Even at the age of twenty-four in 1919 he could recognize, as Louis and Marciano could not, when he, or rather his cash, was being treated casually. But for the moment there was nothing he could do. Dempsey had put so much intensity into the fight that he felt spent. Back in the West, he had agreed to let Kearns handle the money and now there wasn't any money. All right, he decided. Move on.

Still a wormwood seed was sown. Movement money? The only movement he'd been doing, Dempsey thought, was the six miles of roadwork he had run every morning in the heat. He knew Kearns could bend the truth. Now Dempsey wondered how much movement money Kearns had blown on bootleg whiskey and the women he was tramping with around Toledo, the fancy ladies and the dance-hall dames. Dempsey knew a little something about dance-hall dames. That was the kind of woman Maxine was. The pretty dance-hall dames got to be expensive.

Well, to hell with all that, Dempsey thought. He was champion and the world was young. When in time Kearns and Dempsey parted, their split was nothing less than an exceedingly nasty divorce. A few said neither man was ever quite the same afterward.

Something worse than a money quarrel slammed into the new champion on that hot Saturday morning in July. Grantland Rice labored and gave birth to a febrile assault that ran prominently in the *New York Tribune*.

"Dempsey is the champion *boxer*," Rice wrote,

but not the champion fighter.

It would be an insult to every doughboy that took his heavy pack through the mules' train to front-line trenches to go over the top to refer to Dempsey as a fighting man. If he had been a fighting man he would have been in khaki....

So let us have no illusions about our new heavyweight champion. He is a marvel in the ring, the greatest hitting machine even the old timers have ever seen.

But he isn't the world's greatest fighting man. Not by a margin of fifty million men who either stood or were ready to stand the test of cold steel and exploding shell for anything from six cents to a dollar a day.

It would be an insult to every young American who sleeps today from Flanders to Lorraine, from the Somme to the Argonne, to crown Dempsey with any laurels built of fighting courage. He missed the big chance of his life to prove his own manhood before his own soul.

Intemperate, poorly reasoned, badly reported, and jingoist as these paragraphs were, they hurt Dempsey more than anything he could remember suffering in the ring. "I was an active young guy," Dempsey told me, "not a brooder. I liked Granny Rice and what he wrote was a setback. But looking back, I guess I sensed even then that arguing with the press is a chump's game. You never get in the last word. They always do." Anyway, Dempsey recognized that right here and now, in jingoist, prohibitionist, isolationist, anti-Bolshevik, boomtown America, there was a fortune to be made. Hemlines were rising. Ankles, even knees, were being bared. The racy pageboy bob was coming in, and everywhere you saw the napes of lovely necks. Heady times were on the way.

"Forget that war-story stuff, Champ," Doc Kearns said. "I'll set Rice straight and this whole thing will blow over." It is doubtful if Kearns ever "set Rice straight." Far from blowing over, the story proved to be an overture to a firestorm that all but burnt out Dempsey's career.

As Kearns and Dempsey jabbed and bantered in Dempsey's hotel room, Teddy Hayes, the trainer and factotum, knocked on the door. He entered with a well-dressed, dark-haired man who wore a serious demeanor. He was with a company that brewed a tonic that strengthened and purified the blood. It was a fine, healthy concoction, the man said, good for people everywhere, and if Mr. Dempsey would

sign an endorsement the company had prepared, he would be pleased to turn over a five-thousand-dollar cashier's check on the spot.

"What is this stuff?" Dempsey said.

"We call it Nuxated Iron. Nuxated Iron keeps the blood rich with red corpuscles. Those corpuscles increase the blood's oxygen power. Nuxated Iron is the world's number-one master strength- and blood-builder."

Dempsey listened vaguely. He looked hard at the cashier's check. As Hayes recalled, "It took Jack less than ten seconds to open that contract, borrow a pen, and sign."

An hour or so later, Harry Stutz, the president of a prominent automobile company, arrived with a few associates. Outside he had parked a bright red sports car, a Stutz Bearcat, the flaming car of the age of jazz and flappers. He was offering the Bearcat to the new champion. No strings attached. The company would be pleased to have people see the champion driving one of their machines. Dempsey went downstairs, considered the car, and said thanks. He wouldn't have to split the car with Kearns. He commenced to feel a little less impoverished.

He told Kearns he wanted a few days off. He had five thousand dollars in his pocket and a sports car to break in. The Cincinnati people could wait a few days, couldn't they? "Not a few," Kearns said. "One day, Jack. Remember one day ain't a few. You fought yesterday. All right. Take the rest of the day off. But you gotta be working in Cincinnati Sunday night. This is our big chance to grab the gold ring. The easy money is out there now. We can't afford to be lazy."

Dempsey drove his Bearcat to Chicago with Teddy Hayes. He spent a long day visiting boxing friends and driving the sports car at high speed. "Slow down, Jack," Hayes shouted as Dempsey roared down a South Side boulevard. "Slow down and take a look at that sign."

In fighting trim, Dempsey glowered down from a huge bill-board. Red capital letters proclaimed: TIGER OF THE RING JACK DEMPSEY DRINKS NUXATED IRON. "They musta had 'em printed in advance," Hayes said.

Dempsey grinned. "What do you think they did with the ones they printed up for Willard?"

A reporter for the *Cincinnati Enquirer* wrote on Monday, July 7, "Fight fans and sports lovers trod on each other's toes yesterday in their anxiety to see Jack Dempsey, the new heavyweight champion, who opened a week's engagement at Chester Park and Vaudeville Theater. Epicures were intent on enjoying the culinary delights which chef Louis P. Mello had to offer at the Chester Clubhouse. Music lovers thrilled to the new concert program offered by Smittie's Prize Band. There were mermaids and mermen in countless numbers come to enjoy the delights of the Chester Bathing Beach. But what swelled the capacity of the park was the word that Jack Dempsey would be on the program."

A two-column advertisement promised: "JACK DEMPSEY ALL DAY AND ALL WEEK. SPARRING EXHIBITIONS DAILY AT 5 P.M. AND 10 P.M. BETWEEN DEMPSEY AND BIG BILL TATE SHOWING THE PUNCH THAT TOOK THE PEP OUT OF BIG JESS. TICKETS: $1.00, 75¢ AND 50¢."

Dempsey and Kearns alternated tricks on the vaudeville stage. In his turn Dempsey talked about waiting for his chance with Willard and watching out for the big feller's left and most of all watching out for the right uppercut, which had killed another boxer once. And how he looked for an opening and when one came, he sure was ready. He knew he had to get the big feller quick, otherwise Willard's size and weight and all that heat would wear him down. Dempsey felt self-conscious about his tenor, at times squeaky, voice. "Aside from that," he said years afterward, "my grammar wasn't any good. I mean what did I know? The mines in Colorado. Commercial Street in Salt Lake. A run-down chunk of San Francisco we called South of the Slot. Skid Row in Seattle? I'd been there. I was self-conscious about my voice and the way I kind of clipped off my words short and sounded breathless and my mistakes in English and how, when I got nervous, which I did on the stage, my voice got even higher. But the people liked me.

"The Cincinnati promoter paid me one thousand dollars a day, and in a few months Hollywood discovered me and Kearns set me up with the Pathé studio. I did a serial, fifteen-minute shorts, and I played a character called 'Daredevil Jack.' I'll tell you about myself as an actor. I started out bad and I didn't get better." He looked directly at me as he made these comments, winding up with a small and winning smile.

"You know why I'm grinning?"

"Why, Champ?"

"Because bad as I was, whenever I worked in Hollywood I got paid at least one thousand dollars a week. I got to give Kearns that. He said, 'You want my guy, you want the champion? That'll be a grand, a thousand bucks a week. Or maybe more.'"

Economics beyond the ring dictated a champion's life during the early years of heavyweight boxing in America. Purses were relatively small. Dempsey's experience, pocketing nothing for winning the heavyweight title, was galling but not unique. Most champions trooped vaudeville circuits to make money. John L. Sullivan toured with an act he called "Honest Hearts and Willing Hands." This earned him eighty-seven thousand dollars in 1891. His biggest boxing purse was $10,500.

Gentleman Jim Corbett, who defeated Sullivan in 1892, doubled as a Broadway actor in "legitimate theater" [as opposed to the then popular vaudeville and burlesque]. Playing a character called "Gentleman Jim," Corbett earned $150,000 in a season. Jess Willard starred in two, possibly three movies. Dempsey followed the tradition when he moved from the ring onto the stage, off to a circus, and at length into the booming business of motion pictures.

Dempsey worked his week at the theater in Cincinnati and then, in Ring Lardner's term, he beat it hence. With some real cash in his wallet at long last, he "rode the plush"—caught a Pullman sleeper to a city he had come to love, San Francisco. He'd had a nasty time once with Maxine in San Francisco, but he'd connected with Kearns there and won some good fights there early in his journey to the champi-

onship. The Bay Area was where he intended to unwind. Basing himself in Oakland, he visited boxing buddies for about a week, and cruised the bars—speakeasies now—and restaurants of San Francisco.

He was so famous, so suddenly famous, that just about everything he did became news. On July 20, 1919, the *San Francisco Chronicle* ran a headline that all but panted on the page.

JACK DEMPSEY HAS ONE WILD NIGHT OF IT
Heavyweight Champion Breaks Away From
Kearns and Gossip Begins

Charles H. Bliss began in the tinted jargon favored by certain columnists. ("the *Unholy* Jargon," the great sports editor Stanley Woodward commented later.) "Wine, women and song," Bliss wrote, "have been the ruination of many a champion and if Jack Dempsey, the present titleholder, does not behave himself better than he did early yesterday morning in this city, the crown now resting jauntily on the head of William Harrison Dempsey will surely pass along to some other fellow with a willing pair of dukes." (Jargon tends to be inaccurate as well as trite. What champion was ever ruined by song? Not one, going clear back to the day when the wily Odysseus resisted the Sirens. Wine and women, obviously, are something else.)

Bliss reported that Dempsey split from Kearns toward midnight on Friday night, July 18, and then

with some old boxing cronies, visited every café and saloon uptown. His foray remains the talk of Mason Street.

Dempsey bought all the drinks. And paid up several touches he had made before he became champion.

Early in the morning the party went to a room of an Ellis Street hotel. Beer and whiskey flowed freely, it was said. Dempsey touched nothing but the $4\frac{1}{2}$ per cent beer, but partook freely of it. The health of the champion was toasted frequently.

As the story goes, a woman joined the now merry party.

She is a friend of Dempsey's wife. Many people are not aware that William Harrison Dempsey is a married man, but it is a fact. The Dempseys are separated, however.

The woman member of the crowd began to twit Dempsey about his married life and suggested in view of his fast becoming a millionaire that he send [his supposed wife] some money.

Dempsey said something about his right hand being responsible for Willard's defeat at Toledo and remarked that he had not used his trusty right since the Fourth of July, but that he never knew when he might use it again.

It is said that the woman, now thoroughly angry at the veiled threat, picked up a glass of water and dashed the water in Champion Jack's face. Other members of the party hustled the women out of the room and hostilities ceased. But the drinking went merrily on....

Kearns, it was said on good authority, was genuinely "sore" at Dempsey because of his behavior but let the matter drop because he knows on which side his bread is buttered.

It is difficult to determine how much of the *Chronicle* article is accurate. Bliss names no sources. Such phrases as "it was said" suggest that the story came to him second or third hand, then as now a common practice in gossip journalism, which proceeds largely from hearsay. By the time of Bliss's story, in fact, Dempsey and Maxine were no longer married. They separated first in May 1917, after a disputatious episode in a San Francisco hotel. Even the hotel itself came into dispute. "We regarded the Gibson as a house of ill fame," said Charles Goff, head of the San Francisco Police morals squad. "We knew what it was," Dempsey said. "We went there because they'd give us a room very cheap. We didn't have the money for a better place."

At the Gibson, as Dempsey told it, Maxine tripped over a doorsill late one night. A doctor named Joseph Fife examined her and di-

agnosed a dislocated jaw. When Fife reset her jaw on site, without administering an anesthetic, Maxine's screams caused a commotion, which is how the incident became public. Years later Maxine claimed Dempsey struck her. Dempsey denied it, denied that he had ever struck a woman. "One of the first things, maybe the very first thing, a professional fighter learns," he said, "is never, *ever* use your fists outside the ring. Of course, it would be wrong to do that. You can hurt a lot of people who don't match up. Besides, in lots of states the law makes a boxer's fists deadly weapons. If you swing at anybody outside the ring, man, woman, whatever, you can be arrested not just for assault, but for attempted murder. So you learn early and you learn good—swing at nobody, unless you're in a ring and getting paid."

Dempsey certainly sounded convincing. He was a struggling young boxer married to a lady who was, to put it charitably, a handful, and he was doing the best he could. But others disputed his version. Kearns told people that Dempsey and Maxine checked into the Gibson so that "Maxine could bring in money servicing guys. It ain't pretty. Dempsey got her customers and his big fists made sure the customers paid up. Back in 1917, the two of them, Dempsey and Maxine, were one helluva mess, until I came along and began to straighten Jack out."

Maxine left Dempsey in San Francisco in the autumn of 1917, rejoined him briefly in Seattle, where he had gone to look for bouts, and then one day told him she was going off to visit her mother in Yakima, Washington. She never came back. Dempsey learned that Maxine had stayed with her mother for only a few days. She moved on to a river town, Cairo, Illinois, where she went back to prostitution. He sent her money in Cairo from time to time. Shortly before he knocked out Fred Fulton in eighteen seconds, during the summer of 1918, Dempsey and Maxine were divorced. At least, that was his recollection. Maxine said the divorce came through in February 1919. Both agreed they were divorced well before the big fight in Toledo.

The new champion's first chance for sustained cash came from a vaudeville troupe called Jones, Lenich and Schaffer, which offered a

ten-week contract at ten thousand dollars a week. The vaudevillians built an act around Dempsey with a chorus line, comics, and a band. Teddy Hayes, who could talk almost as rapidly as Kearns, sold himself as master of ceremonies. Dempsey would say a few words and spar a few rounds. The show opened in Chicago on July 20. It went broke in seven weeks. Dempsey and Hayes were paid for three. "I was just starting to figure out," Dempsey said, "what Doc Kearns knew when he was a baby. Get your bucks up front."

The next offer came from Otto Floto, the impresario of the traveling Sells-Floto Circus Troupe, which had a solid reputation. Reported figures vary and Dempsey himself was vague, but for something like twenty-five hundred dollars a week, he agreed to join the circus. He marched in the opening parade with acrobats and clowns and a baby elephant named Billy Sunday, after a light-hitting, hard-drinking National League outfielder turned prohibitionist and Christian evangelist. ("He couldn't hit," remarked the great and witty ballplayer Christy Mathewson, "so he decided to pitch.")

Dempsey later appeared in a ring with Big Bill Tate, his rangy Toledo sparring partner. He bellowed out some details of the Willard fight. After that he and Tate sparred. Dempsey never landed a punch, but watching him spar against Tate, people who understood boxing drew some suggestion of the way he had moved when he destroyed Jess Willard. He was a dancer whose every move cried danger. Even when throwing mock punches, the fists flashed with blurring speed.

Later he shook hands with locals and granted interviews to newspapermen. He followed two principles, he told reporters: He tried to learn at least one new thing each day, and he tried always to be honest, to be himself. He didn't smoke. Smoking was bad for the lungs. He didn't drink. In fact, he said, he didn't know what beer or whiskey tasted like. (This was not accurate, but it was politic during Prohibition and, more important, it was well intended. Dempsey had seen ruinous drinking. His own father was an alcoholic, or close.)

As the Sells-Floto Troupe worked its way down the Mississippi Valley, Dempsey, with his easy smile, rough good looks, and genuine friendliness, was popular with the press and the public. Then sud-

denly, in Louisiana Delta country, he found himself again a figure of unpleasant controversy.

In sparring with Big Bill Tate, Dempsey was breaking one of the Deep South's canons of racism. Never mind that the sessions were exhibitions, not contests. Never mind that no punches landed. "Every thinking white man," observed an editorial writer at the *Baton Rouge State Times,* "knows the importance of absolute separation of the races in everything approaching social contact." (To characterize the prize ring as a social arena is absurd; but as Jean-Paul Sartre pointed out after the Nazis murdered six million Jews, bigotry is a passion and like all passions is totally resistant to reason.) Suppose, one southern writer postulated, Dempsey should slip in the ring and fall to the canvas. If that happened a Nigra would be observed standing erect over a fallen white man. The world had seen too much of that in the Jack Johnson years.

Dempsey himself had fought blacks and whites and he was far too much the populist, the supporter of working people against the elite, to sanction racism. "More than anything else, I was surprised," he said. "I figured some of the people might have trouble with my voice and the way I bit off my words, but hell, Tate was one of my guys." Dempsey quit the circus in Hot Springs, Arkansas.

Teddy Hayes, a dapper and beguiling character out of Venice, California, had been a journeyman welterweight and would become a friend of Al Capone, J. Paul Getty, and Eleanor Roosevelt. A remarkably worldly man for an ex-pug, Hayes commented, "Even aside from the racist business, Jack didn't much like working in Sells-Floto, which was mostly a circus for kids. He much preferred moving on to Hollywood. Now there was a circus for adults."

Hollywood in 1920 was a young community, fast, intense, and, by the zippered public standards of the time, loose and wild. Like Prohibition, prudery was a proforma order of the early 1920s and the contrast between Peoria and Hollywood—or perhaps more accurately the *perception* of contrast—was as a virginal dawn to a stygian midnight.

In *The Parade's Gone By,* Kevin Brownlow refers to generic Hollywood as "six suburbs in search of a city." With the coming of movies, Brownlow writes,

> Hollywood was transformed from a cactus Paradise for retired Iowa farmers into a seventh heaven for youth. Catering to the two extremes, Hollywood did not provide those links to the past that give stability to the present: there were no art galleries, few bookshops, no proper theaters or museums, no concert halls....It was a cultural vacuum....But as the capital of an industry [Hollywood was] expected to offer the amenities and traditions of the capital of a nation.

Entertainment was what Hollywood offered in the widest possible variety, as thousands and thousands of pretty girls poured into town, pathetically anxious to find work in motion pictures.

Pathetically few ever did, even as extras. The dreamy nonsense of the famous movie *A Star Is Born* is entertaining, but not finally believable. In it a pretty small-town girl, helped by a brash but softhearted producer, finds stardom over a counterpoint of personal sorrow. Most of the pretty girls who did migrate to Hollywood found not stardom but rejection. Thousands turned to prostitution as a means of survival. One harsh characterization of early Hollywood spoke to that point: "The movies stink, but Hollywood has cathouses with the prettiest whores in the world." (Five or six different people have laid claim to this quote.)

Varieties of movie entertainment included Westerns, biblical epics, rustic dramas, comedies, melodramas, and tales of the high seas, the frozen North, the desert sands, and the mysterious East. The constant marketable commodity was sex. Theda Bara, born Theodosia Goodman in Ohio, was reshaped into a dangerous *femme fatale*. Movies still were silent, but in *A Fool There Was* Bara was given a subtitle that still resounds: "Kiss me, my fool." To the envy of millions,

the European vamp Pola Negri, once married to a Polish count, famously seduced Rudolph Valentino. (At Valentino's funeral, Negri was so overcome that she had to be accompanied by a registered nurse.) Vilma Banky, a lusty import from Hungary, a spiritual godmother of the Gabors, abruptly settled down and married a handsome, lanky leading man who bore a Hall of Fame Hollywood name: Rod La Rocque. This promised to be the California wedding of the decade, which in a way it was. A reporter bit into a nuptial turkey at the wedding feast, but never swallowed. The bird was a prop, fashioned from papier-mâché.

Hollywood was fake, tawdry, amoral, and irresistible. But to America's bluenose contingent, the place was first of all a North American Sodom. Like a plague, Hollywood lust had to be quarantined. While actresses projected arousal in *Dust of Desire, The White Slave,* and *The Woman God Forgot,* a bill before the legislature in Utah proposed fines and imprisonment for any woman seen on a city street wearing "a skirt higher than three inches above the ankle." While Mabel Normand, a comely comedienne, was arranging for the murder of the English director who jilted her, a bill introduced in Virginia prohibited women from wearing "a shirtwaist, frock or evening gown displaying more than three inches of throat." While the popular comedian Roscoe "Fatty" Arbuckle threw an orgiastic party at which a pretty starlet lost her life to "pelvic distress," an Ohio legislator proposed a law that would flat out prevent "the sale of any garment which unduly displays or accentuates the lines of the female figure." While Hollywood producers and performers made their fortunes marketing sex, conservative American politicians were hellbent on legislating women's buttocks, thighs, and busts clear out of sight.

It was no go, of course. Sigmund Freud had lectured to American psychologists as early as 1909. With the end of World War I, Freudian theories and Freudian apostles swept victorious America. The United States, wrote John F. Carter in the *Atlantic Monthly* in 1919, "is not going to accept the standards of a world that has been pretty well ruined by the older generations."

With the war done and the established order vanished, Frederick Lewis Allen observed in *Only Yesterday,* "new words and phrases began to be bandied about the cocktail tray and the Mah-Jong table— sadism, masochism, Oedipus complex. Intellectual ladies went to Europe to be analyzed; analysts plied their new trade in American cities, conscientiously transferring the affections of their fair patients to themselves; and clergymen who preached about the virtue of self-control were reminded by outspoken critics that self-control was out of date and dangerous.... Sex, it appeared, was the central and pervasive force that moved mankind.... If you would be well and happy, you must obey your libido." A nation that expressed fear and loathing lest it be overrun by Marx, Lenin, and Bolshevism was subdued, or at least reshaped, by nonviolent European revolutionaries. They were named Sigmund Freud, Alfred Adler, and Carl Gustav Jung. *Das Kapital* turned out to be less of a problem for the anti-red, pro-bluenose forces than oedipal longings counterposed with penis envy.

In December 1919, Jack Dempsey, hobo, miner, and now heavyweight champion, rented a large Victorian home on Franklin Avenue in the Silver Lake district of Los Angeles, a favorite neighborhood of movie people. His ménage included Kearns, Teddy Hayes, and Big Bill Tate, who underwent a significant change of title. Tate was no longer a sparring partner. In Hollywood, he materialized as a butler. (Bill's wife, Sarah, became housekeeper and cook.) "I thought to be in pictures, you had to have a butler," Dempsey said. "The producer expected it. The actresses expected it. So I told them Tate was my butler. He was working for me, sure, but he was just as much a buddy as a butler. I always liked to have boxing people around."

Fred C. Quimby, the president of Pathé Studios, signed Dempsey for ten thousand dollars up front and an additional one thousand dollars a week to star in a serial called *Daredevil Jack*. The story stretched over eighteen episodes, each about fifteen minutes long. At the start Jack, the hero, and his father are cheated out of a gold mine in Nevada that rightfully was theirs. ("I had a fair claim on that there

mine.") Trying to recover, Jack works his way through college, where he becomes a football star. He also falls in love with the campus beauty queen, played by Josie Sedgwick, who in a remarkable coincidence turns out to be the daughter of the fast-dealing character who stole the mine. Daredevil Jack subdues a wiseacre band of college boys, then singlehandedly knocks out five marauding thugs. That wins him the heroine's love and even the grudging respect of her father. That cad won't steal a mine from Jack and his dad again. Through means never made clear, Daredevil Jack earns enough money at college to go into the mining business for himself, providing the happy ending indispensable to Saturday afternoon serials.

The film cast Dempsey as an All-American boy, which contrasted with reality. After one hundred fights Dempsey no longer looked so All-American. By 1920 movie cameras had become sophisticated, and close up in clear focus, Dempsey's face showed scars. He also had a heavy beard, narrow eyes, and an irregular nose. The real Dempsey, though attractive in a rough-cut way, had to be remodeled for the movies.

W. S. "Woody" Van Dyke, who directed *Daredevil Jack,* was a pragmatic and rugged character who had been a miner, a railroad man, and a mercenary. Speed, not nuance and certainly not art, was his strength. Van Dyke engaged Lon Chaney, "the man of a thousand faces," to remake Dempsey's appearance. Chaney reshaped Dempsey's nose with putty and applied pancake makeup, rouge, and eyeliner with a lavish hand. In the stills that survive from *Daredevil Jack,* Dempsey looks embalmed.

Dominant male stars of the time included that paradigm of Latin lovers Rudolph Valentino, Douglas Fairbanks, the first great movie swashbuckler, and Charlie Chaplin, who played his famous engaging tramplike character. Once Chaplin doffed his tramp clothes and left the set, he became a poised sophisticate whose skill at seducing actresses was extraordinary. All three stars sought the camaraderie of the new heavyweight champion, the man who could lick any son of a bitch in the world. "Especially Fairbanks," Dempsey said years later.

"He was married to Mary Pickford, who everybody knew was a nice girl with curls that they called 'America's Sweetheart.' Not so many people knew that Mary was one smart businesswoman. She was making close to a million a year before the income tax was anything more than a pinprick. Doug and Mary had a mansion they called Pickfair. It was the closest thing to a palace I'd ever seen.

"Anyway, Fairbanks wanted to be my pal and having him as a pal in Hollywood back then was like having a credit card today. Except there never was a bill. If Doug wanted you at his parties, then everybody in Hollywood wanted you at *their* parties.

"People think the life there was one long round of parties. But during the week, people were due at makeup at six A.M. Then you had to do a lot of takes. You worked into the night. Things loosened up on the weekends. But Doug and Mary were never what people would call wild. Mary wanted to make sure that the bootleg wine and champagne—the stuff came in to San Pedro by boat—was right for the food. Doug was a big one for horseplay.

"The sign that you were in Doug's inner circle was if he goosed you at a party, like when you were talking politely to a new lady and accepting a glass of champagne from Mary's English butler. He made a production of the surprise goose. Doug would hide out in the draperies for half an hour, waiting for a shot. Some people got sore. I didn't. I always liked a practical joke myself. I believe I'm the man who introduced the hotfoot to the eastern United States. Did it when I was getting ready to fight Big Fred Fulton in New Jersey in the summer of 1918. I'd hang out under a table for half an hour myself, bending a match, getting into a guy's shoe, and lighting it. Like Fairbanks' goosing, it was in fun."

Wallace Reid—according to Dempsey the best-looking and most reckless of the prominent male stars—also seemed like fun. Reid played clean-cut characters in such movies as Cecil B. DeMille's *The Call of the North*. After work Reid mixed pot smoking, cocaine sniffing, and "shooting up"—pumping heroin into the veins. Drugs killed Reid in 1923, but not before he had introduced Dempsey's brother,

Johnny, to narcotics. In time Johnny Dempsey became addicted and that disaster—so remote from the Hollywood serials with happy endings—led to a devastating Dempsey family tragedy.

Jack Dempsey was not the sort of character who boasted about sexual conquests. Indeed, he tended to downplay reports that he was a champion beau. Typically Dempsey observed, "If I had married every beautiful movie star the papers said I was going to marry, two things would have happened. I would have had a delightful time and I would have been arrested. Bigamy at the least."

Daredevil Jack was budgeted at $330,000, and Frank Spellman, the man who ran Pathé Studios, told Woody Van Dyke that he wanted a complete sequence finished every week. That led to fifteen-hour work days, but Dempsey was young, not yet twenty-five, and he had plenty of energy left for weekends.

He seriously dated Bebe Daniels, a lively, round-faced brunette. She worked in the stable of Cecil B. DeMille, the autocratic producer who was, as he himself put it, "the world's greatest showman." Daniels played the saucy, smiling other woman in DeMille's 1920 antidivorce movie, *Why Change Your Wife?* Dempsey also slept with the debutante-actress Peggy Hopkins Joyce; the dangerous comedienne Mabel Normand; and Marion Davies, later mistress and great love of William Randolph Hearst. Women wanted him and Dempsey was willing.

"Once in a while," he remembered, "the Hollywood life made my head swim. I wasn't too far away from Commercial Street in Salt Lake, or sleeping in Central Park, and now I would be at some fabulous supper club, the Montmartre Cafe, pulling up alongside the Pierce-Arrows and the Dusenbergs, getting a great table and dancing with a gorgeous actress who wouldn't have looked at me the year before. I suppose some of them wanted to be seen with a champion to help their careers. On a bunch of my dates, studio photographers showed up with flashbulbs. The girls had tipped them off. I certainly didn't.

"But some of the women really were interested in me. I got stuck on one or two. And one or two got stuck on me. But nothing really

serious right away. Doc Kearns always told me that women and boxing didn't mix. He used to tell me that whenever a fighter comes inside a woman, he loses his strength. Any man loses strength that way, he said. Doc believed that, but you sure couldn't prove it by the way Doc liked to live himself."

Before Jack Kearns' own high days were through, he took to giving pretty girls an introductory gift of a piano. He and Dempsey bought a Los Angeles hotel called the Barbara as an investment, and every suite at the Barbara came complete with a Steinway baby grand. Dempsey was a harmonica man. Kearns couldn't play a scale. But suddenly they owned twenty Steinways. When an actress perked Kearns's interest, he didn't bother with roses, chocolates, or champagne. Small-time stuff. Kearns sent the woman a baby grand. "Lavish," he recalled, "but very effective."

At the Dempsey household on Franklin Avenue, Kearns assumed a complex role: practical moralist, guidance counselor, and warden. "We seen what trouble women can be," Kearns said. "Maxine showed us that, Jack. Did she ever? Broke your heart in Salt Lake, San Francisco, and Seattle. We know that, Jack. So this is no time for you to get serious about anybody. Keep it cool. We got a lot more fights ahead and believe me, the gates are gonna get just bigger and bigger. We're gonna make millions. You'll be a millionaire when you retire, you'll be a millionaire many times over, and you'll still be a young man. And when you got the millions you can have any woman you want.

"That's the next time you can afford to get serious about a dame, Champ, when you're rich and retired. Believe me, Jack, the heavyweight champion of the world has no business being a married man." Kearns excused himself. He had to see a starlet about a baby grand.

Maxine Cates Dempsey was dark haired, strong jawed, and lively, a passable performer who could sing. Bebe Daniels and later Claudette Colbert, who became another lover to the champion, had soft round faces. Mae West, still another lover, was a butterball. Maxine had the angular look of a pioneer woman.

She was born Maxine Cates at Walla Walla, in southern Washington State, about 1880, only four years after Sitting Bull annihilated Custer's Seventh Cavalry, four hundred miles due east. Her mother's name was Adeline Cates. She never knew her father. Like Dempsey, Maxine left home early and tramped the West. She worked in dance halls around mining camps in Nevada and Colorado. She was a piano player in saloons in Yakima and Spokane. In her late teens she married someone named Gleshof and quickly divorced him. "She'd lived a hard life," Dempsey told me, "but Maxine was a fine woman. I loved her very much."

The female barroom pianist remained popular well into the 1950s, by which time the piano itself had evolved into an ebony adjunct bar, ringed by seats and topped with coasters. The woman who played positioned a large cocktail glass on the piano. If you had a request, you put your money in the glass. In the small hours of a summer night in 1952, I asked for Kurt Weill's "September Song" at a private club in East St. Louis, Illinois, of all places. "Put your money in the glass, dearie," said the young woman, whose name was Jeannie. When she finished the song, she lowered her head in a beguiling way. "Put a fiver in *here,*" she said, "and we can get together when I get off. That's in just twenty minutes." She indicated that I was to place the five-dollar bill inside her bodice.

No one knows when Maxine first crossed the line from pianist to prostitute; not that the line in old western bars stretched very wide. Nor, to find employment, did a pianist have to be Dame Myra Hess or Vladimir Horowitz. In *Impressions of America,* Oscar Wilde described a sign he saw posted in a saloon in Leadville, Colorado, during the summer of 1891. It read: Please do not shoot the pianist. He is doing his best.

Dempsey, who had a good ear, said that Maxine was a marvelous cocktail pianist. "She liked to play piano," he said, "but what she *loved* was the fast life. She was used to action. But when we started out, I couldn't show her a fast life. I was broke and hurting. Fights were hard to come by. We had maybe a forty-eight-hour honeymoon. Then she went back to working in a saloon. I told her I was gonna get

her out of there, give her the life of a real lady, not that I knew what that was. We lived in a little cabin, but when we visited my family, my mom started showing Maxine things, cooking special recipes, scrubbing up, and knitting. So I thought we might as well move in with my mother full time."

Celia Dempsey was a strong woman who had survived a nomadic Rocky Mountain life, given birth to eleven children, and become a serious church-going Mormon. She sensed Maxine's background and she detested it. Her son, her strongest, brightest boy, at the age of twenty-one had gone and married a godless woman and a prostitute. The good Lord always seemed to be sending trials. Well, Celia Dempsey decided, she would pray and try to make the best of it. What else was there to do?

One day Celia said, "I have some sewing you can help me with, dear."

Maxine spoke up. "I don't like these things you're always asking me to do. They're spoiling my nails."

The marriage occurred in the difficult times that followed Dempsey's misbegotten trip to New York, where the veteran puncher, John Lester Johnson, cracked his ribs in Harlem and the manager from Hell, John Reisler, stole him blind. Back West late in September 1917 Dempsey knocked out an opponent named Young Hector in Murray, Utah, south of Salt Lake City. On October 7 he traveled to Ely, in eastern Nevada, and outpointed Terry Keller. Two days later he married Maxine in Salt Lake City.

The week after the wedding Dempsey outpointed Dick Gilbert in Salt Lake City. These were small fights throwing off small purses. Dempsey took odd jobs and hired out as a sparring partner, asking a dollar a round. He was paid "maybe a third of the time." He had to box to make a living. He had to travel to box. He was the principal supporter of a large, and largely indigent, family. When he traveled Maxine was alone and playing her saloon piano. What else was Maxine doing? Dempsey wondered. He never liked discussing his days as a youthful bridegroom. He did say, "I found out I was a jealous person."

One of the oldest shibboleths spoken in the company of men is: They never really change. Marry a hooker and after a while, she'll go back to sleeping around. Marry a librarian and she'll expect you to read books. Know what you're marrying. They never really change.

Harsh stories come out of the Dempseys' time together. He repeatedly urged Maxine to travel with him. "Let's go on the road together. I'll get some fights. I'll make some money."

"Go on the road? You don't *have* any money. I'm not riding in any smelly boxcars with you, Jack. I'm staying in Salt Lake."

Physical attraction bonded them. He was powerful, young, and ardent. She was a sexy older woman who knew some tricks. They lived and made their lusty love in a world of cheap whiskey and noisy dance halls, among pimps and hookers and greedy boxing men. That is a world that looks better at midnight than at dawn. Still, glitter, even cheap glitter, allures. Dempsey moved on. Maxine never could. Their relationship was passionate and ruinous.

On February 13, 1917, Dempsey was knocked out for the only time in his career. He said afterward that he was not fit to fight. While scratching out money as a pin boy in a bowling alley a few days earlier, he hurt his right hand when another pin boy carelessly dropped a bowling ball on it. Dempsey took the bout against Fireman Jim Flynn because, hurt or not, he and his new wife desperately needed money. With his mashed fingers puffed and painful, he was a one-handed boxer up against an old pro. Flynn punched him silly within two minutes.

Maxine told another story. She chattered in saloons in Utah and later in San Francisco about "what really happened." The truth, she said, was that Dempsey threw the fight. "They offered him more to lose than to win and he took it." Dempsey denied it, just as he denied that Maxine's chattering had anything to do with her dislocated jaw.

Maxine surfaced again in January 1920, when Dempsey was shooting *Daredevil Jack* and picking his way through an adoration of movie actresses. Maxine was working for a madam named "Tommy"

Wilson in a "dance hall" in Wells, Nevada, an old silver-mining town set two hundred miles west of Salt Lake City. Once again she had a nasty story to relate. In a letter to the *San Francisco Chronicle,* she wrote that Dempsey was a slacker. He "never supported me...to tell the truth I had to support him.

"I hope you will publish this letter," she wrote. The *Chronicle* obliged. Maxine's letter appeared on Friday, January 23, 1920, in a box on the first page of the sports section, under the popular comic strip "Gasoline Alley." The headline spoke volumes:

Dempsey Slacker, Says Divorced Wife
She Claims to Have the Proofs
Dares Champion to Deny Her Charges

Within ten days, Charles W. Thomas, assistant United States district attorney for San Francisco, was moving toward a criminal indictment. Maxine told reporters that she possessed a great sheaf of letters written in longhand by her former husband documenting how he and Kearns plotted to dodge the draft. Beyond that, Maxine said, the letters were full of dirty words, threats, and demands for sex that was "violent and unclean."

Here surely is a wife out of a screaming nightmare. Yet until the last seasons of his life, Dempsey defended Maxine. "She was a good woman. She just turned out not to be strong enough to fight off all the pressures they put on her in the underworld."

Dempsey's great years, across the bounding and increasingly unzipped days from 1919 to 1927, play in a grand sense against a wild American epoch. Prohibition was wild and the suddenly fast-and-loose stock market was wild and down the road two great show trials blossomed wildly into causes, still well remembered.

John Thomas Scopes, trying to teach Darwin and evolution in Central High School at Dayton, Tennessee, was put on trial in the summer of 1925, essentially for heresy. Clarence Darrow, the most famous of trial lawyers, represented the country teacher and with him

the right of public schools everywhere to instruct children in free and rational ways. William Jennings Bryan directed the prosecution. Once the Boy Orator of the River Platte and later the Great Commoner, Bryan had withered and gone a bit dotty in late-life Christian fundamentalism. Reporters overran the courtroom and most of the rest of Dayton, Tennessee. In this place, "deep in the Coca-Cola belt," wrote H. L. Mencken of the *Baltimore Sun,* "Darwin is the devil, Scopes is the harlot of Babylon, and Darrow is Beelzebub in person."

North in New England, two immigrant workmen fought for their lives across eight years in what some called the "American Dreyfus Case." Nicola Sacco, a shoemaker, and Bartolomeo Vanzetti, a fishmonger, were charged with theft and murder after a payroll robbery in South Braintree, Massachusetts, in 1920. Many thought the two were persecuted for their political beliefs; they were anarchists—*immigrant* anarchists. Major literary figures—Upton Sinclair, Edna St. Vincent Millay, Heywood Broun, Maxwell Anderson—rallied to their support. The Massachusetts governor, Alvan T. Fuller, appointed a special committee to review the case, under Abbott Lawrence Lowell, the president of Harvard. Lowell found no reason to overturn verdict or sentence. As Lowell worked, Alice Goldmark Brandeis, wife of the notable Supreme Court justice, opened her home to the families of the accused. In Paris Anatole France and Romain Rolland wrote passionate appeals. The world focused on Charlestown State Prison and watched as season gave way to season, watched and wondered.

One tends to associate Dempsey's years with great issues and high deeds that reverberate today. But Dempsey himself was apolitical until the Great Depression, when touched by the poverty all about, he became a steadfast Roosevelt New Dealer. He said that he had been poor—actually penniless. Even after he became a millionaire, his heart went out to poor people and his vote went to those who promised to help. He'd had little if anything to say about Scopes or Darwin, Sacco and Vanzetti; in his fighting days he was no social commentator. But he became a towering figure even outside the ring.

And in the third of the great American show trials of the 1920s, Dempsey played a major role. He was defendant.

The Dempsey sex letters, if they existed, have long since disappeared; it is not possible now to determine what passed between Jack Dempsey and Maxine Cates Dempsey eighty years ago. But recollections from Doc Kearns, Teddy Hayes, Dempsey himself, and even from Maxine provide a picture that lacks only details. They were rough, hard people, clawing their way up from poverty. Their abiding common language was cash. After Maxine left Dempsey, ostensibly to visit her mother, and found her way into an Illinois whorehouse, Dempsey stayed in touch with her through the demimonde of pugs and madams, whores and hustlers, in which they both knew characters by the score.

The divorce decree, which was real enough, has vanished like the sex letters no one ever saw. But a provision for alimony existed and Dempsey sent Maxine money from time to time. Under the laws of the early 1920s, her decision to work full time as a prostitute did not affect his alimony obligation. Indeed, in a trial on that issue lawyers would have depicted her as a woman forced into prostitution by a brutish mate.

He visited her on occasion in Illinois. When Maxine moved on to the brothel in Wells, Nevada, his visits became more frequent. The fact that divorce did not end their sexual passion is hardly unique. But after sex, the visits were marred by recriminations, even when he brought money. Her gossip that he'd thrown a fight was goddamn dumb, he told her. It just made it harder for him to get other fights.

"Don't blame me for that. You were a bum when I married you and you still are."

Sometime in early 1919, Dempsey sought solace with Tommy Wilson, the madam who had befriended and employed Maxine. Dempsey and Tommy went off together for parts unknown—"somewhere back East." Spurning Maxine for another woman, one who was supposed to be her friend, Dempsey lit a fast-burning fuse. Doc

Kearns read a recipe for disaster. He pleaded with Dempsey to stay away from Maxine and Maxine's friends. "That's the past. We're moving on."

About a month before the Willard fight, Kearns paid a visit to Maxine in Wells. According to Teddy Hayes, he asked Maxine to "be a good girl and leave the kid alone." If she did, Kearns promised, as soon as Dempsey became champion he, Doc Kearns, would personally send her forty thousand dollars. Like deals that Kearns proposed all his life, it sounded too good to pass up.

Maxine accepted the terms, along with the bottle of champagne Kearns brought along. For a long time Doc had known the saying, "If you want a whore to do something for you, treat her like a lady." Then, after Dempsey won the heavyweight championship, Kearns neglected to send Maxine anything; anything at all. She was now spurned sexually by Dempsey and spurned financially by Kearns. In effect, Kearns was treating her like a tramp. The other girls took to teasing her. She was forty years old and being ragged by kids.

Dempsey himself foresaw no danger. He was young, champion, and the toast of Hollywood. He felt invincible. But Kearns, so calculating with promoters, so cagey with hustlers, should have known better than to underestimate the bolts of fury now gathering within Maxine Cates.

Some time in 1917, when Dempsey began to defeat outstanding heavyweights, Harry B. Smith, a boxing writer with the *San Francisco Chronicle,* asked him to fight an exhibition match at the Dreamland Arena for a charity the newspaper was sponsoring. A college fund for *Chronicle* newsboys.

Dempsey was boxing twice a month, most recently Carl Morris and Gunboat Smith, two of the toughest heavyweights in the country. He told Harry Smith he simply had no time for an exhibition. "That made me an enemy for life," Dempsey said later. "This fellow Smith had told his bosses he could deliver me. The charity was important to the paper and now Smith looked like a blowhard. He looked real

bad. I didn't know this at the time or, hell, I probably would have made myself fight the exhibition. But I didn't and now Smith was out to get me and somehow—you know how these things are—Smith and Maxine got together. That damn near did me in."

On Sunday, January 25, the *Chronicle* published another damning story. This headline read:

Showdown Due
on the Dempsey
Slacker Charge
Attested Copies of Letters
From Jack to Wife Are
Being Prepared

"A showdown can be expected shortly," Harry B. Smith began his *Chronicle* piece, "from Maxine Dempsey of Wells, Nev.,

> as regards the charges she has made against her former husband, Jack Dempsey. Mrs. Dempsey has asserted to the world, through the columns of the *Chronicle,* that her husband wanted to evade the draft and did so by hiding behind her skirts. Kearns and Dempsey have denied this and challenge the former wife to prove her assertions if she can.
>
> There first came word on Friday that Mrs. Dempsey was prepared to submit her proofs. Yesterday there was an additional message from "the woman in the case" in which she states affidavits are being prepared together with attested copies of letters from Jack Dempsey to Maxine Dempsey. This should be ready shortly.
>
> "In her second wire [Smith called Maxine's first dispatch a telegram, not a letter] Mrs. Dempsey says: "Am having affidavits made in addition to copies of original letters from Jack Dempsey attested by a notary. No one got me to send the first letter to you. Mr. Kearns can have proofs any time he wants them."...

This writer has no interest in the case other than to publish the news and to see that straight facts are given. There is no desire or tendency to hound Jack Dempsey.... [But if Maxine] has letters from Dempsey admitting her own assertion that Jack was anxious to evade the draft, her case will have to be made.

Harry Smith's righteous prose has the ring of a vendetta. He made no effort to interview Dempsey or Kearns. Quite beyond Smith, a general tide of superpatriotism was running strong against Dempsey. The January 24 issue of *Home Sector,* a magazine for veterans, carried an impassioned attack by W. O. McGeehan, under whose byline appeared the description "Former Captain in the U.S. Army."

McGeehan drew a punishing contrast between Dempsey and Georges Carpentier, the heavyweight champion of Europe. Carpentier, a spotter in the French air force, rode low over the trenches in open-cockpit planes and won the Croix de Guerre for courage under fire. "Slim narrow-chested boys, with the divine fire in their eyes," McGeehan wrote, "were hurried overseas to die in order that the country might be made safe for Jack Dempsey to achieve his ring career.... Unquestionably he is the most formidable of the heavyweights, the king of the living gladiators.... But what a picture it will be, bringing ironical laughter and derision upon eternal justice—Dempsey, the dullard who could not see the vision of the holy fight, gloating over the prostrate form of Georges Carpentier, allied soldier."

Among the scores of newspapers picking up excerpts of McGeehan's article was the *San Francisco Chronicle.*

The commanders of the California State American Legion demanded a federal investigation of Dempsey's draft deferment, the *Chronicle* reported on January 29. The Department of Justice directed Annette A. Adams, the federal district attorney in San Francisco, to comply with the legion's demand. Adams turned the case over to her most military assistant, Charles W. Thomas, a former adjutant-general of the California National Guard and later a colonel who

served, albeit behind the lines, with the American Expeditionary Forces in France.

Thomas communicated with Maxine in Wells. She reported that two brawny men were following her. She was afraid they were going to take the Dempsey letters by force. Take the letters and beat her. Maybe kill her. She was close to hysteria. Thomas told Maxine to proceed to Ogden, Utah, where he and two federal marshals would meet her. Maxine checked into the Healy Hotel in Ogden accompanied by a young black woman, Beulah Taylor, identified as her maid. No marshals were there. After signing the register as "Miss Maida Rice," Maxine appealed to the hotel manager for protection. W. A. Taylor, an Ogden policeman, arrived and stood guard outside Maxine's room. Shortly after that two men from San Francisco registered at the Healy. One checked in as M. Ryan. The other checked in as F. Ryan. These were the marshals.

Maxine told them she had letters in which Dempsey asked her to sign a statement that he was supporting her, "so that he could avoid the draft." Other letters too. Very dirty ones. She had put the letters in a safe-deposit box, but she wasn't telling anybody where, not even the marshals. If she talked anymore, she would be killed. Maxine became incoherent and began to weep. The marshals summoned a doctor, who prescribed sedatives and said that as far as he could tell, Maxine was undergoing a nervous breakdown. Buoyed by federal protection, she rallied quickly.

Kearns and Dempsey himself had misread the situation. Now as rumors raced about, Teddy Hayes recalled, Hollywood bookmakers were giving 5-to-2 odds that Dempsey would go to jail. The backers of *Daredevil Jack* were not about to let that happen. "We've invested more than three hundred thousand dollars in the serial," said Frank Spellman. "If it turns out that Dempsey was the slacker his wife says he was, all our money is in the goddamn ashcan." Spellman, a short, bald, unintimidating man, maneuvered among the cops and marshals until he was alone with Maxine in the battered old Hotel Healy.

No record of the conversation survives. There is no photograph

of money changing hands. But before Frank Spellman left Ogden, Maxine agreed to change her story. On February 4, the *San Francisco Chronicle* reported receiving a notarized statement in which Maxine repudiated her accusations.

"Jack Dempsey is not a slacker," she declared.

> On two different occasions I know to my own knowledge, Jack tried to enlist. I begged him not to because he had his father and mother and me to support.
>
> If I ever said that Jack was a slacker, or signed anything to that affect, I did so because I was jealous of Dempsey and had been made mad at him by his enemies continually ribbing me. At all times during our married life, Jack Dempsey supported me to his very utmost ability, as he did his old father and mother.
>
> I have no letters nor any writing of any kind nor have I ever have had any to the effect that he was trying to avoid the draft or the war.
>
> I am very sorry and regret very much that I have said or done anything to injure the reputation of Jack Dempsey.

Harry Smith traced Maxine to the hotel. As he reported the conversation, he began, "My editors want to know if you wrote that first letter, the one dated January 23, out in Wells, Nevada."

"I'm worn out," Maxine said. "I don't want to talk about this stuff anymore."

"But Mrs. Dempsey, did you write that first letter, or was it a forgery?"

"The affidavit you got today speaks for itself."

"But we published the first letter over your signature. Can't you tell me whether you wrote that first one, or was it faked?"

"It wasn't faked. I wrote it. Look, if you must know, they told me Jack was running around with a woman I knew in the dance hall. I didn't like her and I didn't like that. Tommy. Her name was Tommy.

A lot of other girls kept nagging me. Dempsey was champion. He was making millions. But he didn't care about me anymore. I ought to be a lady with a mansion. And servants. But here I was playing the piano in a dance hall way out in the desert.

"So I got jealous and the girls kept ribbing me and ribbing me to write a letter that would leave him cooked. That's what I did. Then I found out he wasn't really running around with that woman and I felt terrible for what I had done."

"Is there any possibility of a reconciliation between you and the champ?" Harry Smith asked.

"Jack and I will never be anything more to each other than we are now. I'm so sorry for making trouble, because I consider him a wonderful man. Jack was a wonderful man and husband. He was."

Harry Smith looked hard at the comely dark-haired woman and saw a terrible sadness. He wrote in the *Chronicle,* "It's apparent that Mrs. Dempsey is still very much in love with the man whose name she bears. Unquestionably she would welcome a re-marriage."

She concluded the newspaper interview hastily. Federal attorneys wanted to talk her now, she said.

Harry Smith's story led the sports section of the *Chronicle* on February 5, beside a two-column photo of Maxine, primly dressed, unsmiling. With her denial, the paper published for a second time the earlier note in which she called Dempsey a slacker.

A one-column box appeared amid all the Dempsey news. In this story, datelined Los Angeles, Babe Ruth announced he would not sign a contract to play for the New York Yankees in 1920 unless he received a healthy share of the $125,000 the Yankees had paid the Boston Red Sox for his contract when they acquired him the previous December.

With Ruth striding toward capitalism and Dempsey freed from the furies of a spurned (and spurning) woman, February 4, 1920, in California seemed like a splendid day for this extraordinary pair. But it was, in Hemingway's term, a false spring. The Yankees never paid Ruth the percentage he demanded. Federal authorities refused to ac-

cept Maxine's retraction. For the rest of the decade Ruth would fight the Yankees over money. That summer Dempsey would stand trial during the strange and unsettling week when Warren Harding captured the Republican Convention with an oath to return United States to "normalcy." (Semanticists writhed. The proper word was "normality." The word "normalcy" did not exist. The semanticists writhed in vain. Within a few years "normalcy" made its way into Webster's unabridged dictionary. There it remains to this day.)

Beyond their accomplishments as performers, Dempsey and Ruth, c. 1920, were becoming commercial properties as no athletes had ever been. It was not simply that they earned more money than their predecessors (or their contemporaries); the scale of their earning changed the dimensions of American sport. Ruth finally hammered his way to a salary of eighty thousand dollars a year, when many major leaguers earned four thousand dollars. He was a free-spending, free-drinking oaf who was and probably still is the biggest name in baseball. Ruth's salary only hints at his stature. Some have written that Ruth was the savior baseball needed after the fixed World Series, which is justifiable, although portraying the Rabelaisian Ruth as a Christ figure is not the most fortunate of images.

Dempsey earned $2,655,590 in purses between 1919 and 1928 and, by his own estimate, about a million dollars more in endorsement deals and personal appearances during that time. Through the 1920s, Dempsey was earning about five hundred thousand dollars a year and making a fortune for his backers as well. What went down between Dempsey and Maxine has the feel of a nasty divorce, or perhaps a lovers' quarrel. But with so much money at issue, and a national mood of purblind patriotism, *Dempsey v. Dempsey* became larger than the individuals at its flashpoint.

The mood was notably ambivalent. We had gone back to the European heartland with bravado and stunned the Hun. But we were damned if we wanted to do it again. A murmuring spread. No more foreign wars. We wanted peace, without Bolsheviks, in the security

we had between two shining seas. But at the same time, any eligible American who didn't fight in the *last* foreign war was nothing less than a traitor.

The government's case against Dempsey was as reliable as an affidavit from Maxine. But veteran's groups, militant religious leaders, and much of the American press demanded that the case be made. In a lapse in judgment that was unusual for him, Dempsey blamed his indictment on Harry B. Smith of the *Chronicle.* Smith's reporting was a factor but the main reason Dempsey was indicted was that the superpatriot lobby, the veterans, the militant Christians, and the rest of the radical right wanted him indicted. Under all that pressure Justice went blind.

Federal Attorney Thomas hauled in Maxine, and with two other government prosecutors present, began a battering interrogation. Maxine herself had no lawyer. Thomas said the government possessed evidence that she had engaged in prostitution for many years. Many witnesses, some prostitutes themselves, had sworn to that. If this evidence were turned over to state and local authorities, Maxine could go to prison for a very long time. Other information showed that she had purchased illegal drugs, such as heroin. Lately she had been observed buying and selling liquor. The case for sending her to prison for a very long time was strong indeed, the prosecutor said.

But if Maxine stayed with her story, surely true, that Dempsey was a slacker, the government would not put to use the information it had gathered against her. Nail Dempsey and she would remain at liberty. Back away and she'd find herself in prison.

The threat was sufficient to convince Maxine to appear before a grand jury and repeat all her original charges. After she did, the criminal indictment of the heavyweight champion of the world became pro forma.

A federal marshal arrived at the house on Franklin Avenue in Los Angeles. "I recognize you," the marshal said to Dempsey, and jarred him with a subpoena. "I also got something here for Doc

Kearns." The marshal looked at Teddy Hayes and Kearns. "Which one of you is Kearns?" he said.

Kearns and Hayes pointed at each other and said, "Him."

If Maxine Cates Dempsey was powerless to resist a determined federal prosecutor, Jack Dempsey and the men around him were not. For Thomas was not threatening just Dempsey the individual. Thomas also threatened Dempsey the commercial property. So much was involved on that score—endorsements, cash, a whopping big movie investment, and indeed the golden future of heavyweight boxing—that people around Dempsey took their case clear to a back door at the White House.

At last seriously alarmed, Kearns and Hayes traveled to New York to meet with Rickard and devise a strategy. Rickard said he could not help much personally, but he had been talking to friends, such men as John McGraw, the manager of the New York Giants, a nationally famous sporting figure who was said to understand the political scene. McGraw suggested a meeting with William A. Brady, once manager of Gentleman Jim Corbett and now a successful Broadway producer. Bill Brady's connections ran high up in the White House of Woodrow Wilson.

"The president can fix this," Doc Kearns said.

"Mr. Wilson is not well," Brady said, as Kearns remembered the dialogue. "He's had a stroke. He tires easily. Any energy he has goes to move the country into the League of Nations."

"He could fix this in a minute," Kearns said.

"He couldn't if he were well, and he wouldn't 'fix' it if he were well. I'd prefer that you not use the word *fix*. We're not looking to fix anything. All we want is to provide a fair shake for Dempsey."

Brady telephoned the White House and reached Joe Tumulty, Wilson's man of all trades, officially "the president's secretary and political advisor." Where Wilson was formal, aloof, idealistic on many fronts (but bigoted against blacks), and a man of great intellectual ability and equally great intransigence, Joe Tumulty was the White

House commoner, a smiling, dapper little Irish politician who tempered the boss's missionary manner with practicality and humor. Wilson was a native of Virginia, who earned a doctorate in political science at Johns Hopkins and became the president of Princeton. Joe Tumulty grew up in the Fifth Ward of Jersey City, called "the Bloody Angle" for the hard political infighting waged there by rival Democratic groups. Tumulty's father, Philip, a wounded veteran of the Union Army, owned a grocery store on Wayne Street. "Nights in that store," Tumulty wrote in his memoir, *Woodrow Wilson as I Know Him,* "the Irish and the Germans and the Italians came to sit on barrels and boxes and argue. The ward was like Gaul, divided into three parts. But everybody was a Democrat and we learned how to give a little here, take a little there and how much a favor could mean. In my father's little store in the 'Bloody Angle'—that's where I learned politics." Years later, when President Wilson's political machinery needed oiling, Irish Joe Tumulty was the primary mechanic.

Tumulty told Brady he would meet Dempsey's people at the White House, but he wanted them to use a side entrance. Newspapermen logged visitors who rode in through the main gates. Dempsey and draft evasion was not an issue the White House officially would touch. Indeed, by 1920, Wilson's White House was embattled by angry quarreling over the Versailles peace treaty and the League of Nations. Wilson suffered the stroke in September 1919 after working seven consecutive years without a vacation; some think that his second wife, Edith Bolling Galt, was taking care of the nation's business. Whatever the exact truth of that, Wilson survived his term and lived until 1924.

Joe Tumulty, a street fighter who had risen, admired Dempsey. Tumulty said that he despised "the Reds," but he had no sympathy for the branch of superpatriotism that was inflaming the land against Wilson, his boss and hero. Tumulty welcomed Kearns and Hayes and after some sports talk—was Carpentier really as good as all the Europeans claimed?—he handed Kearns a letter of introduction he had prepared. It was addressed to a San Francisco lawyer named Gavin

McNab. "This man knows the federal courts better than anybody else in San Francisco," Tumulty said. "The judges respect him. He knows how to try a case. If you convince McNab to handle the Dempsey trial, that, at this point, is the best that you can do."

"Mr. Tumulty," Kearns said, "I've also been indicted. The papers say I conspired to help Jack fill out the deferment forms dishonestly. That isn't true."

"Tell Gavin McNab," Tumulty said. "The houseboy will show you out the side door."

"Thanks," Kearns said.

"One more thing, gentlemen," Tumulty said. "Officially our meeting has not taken place." (It is nowhere mentioned in Tumulty's memoir, a book that runs 553 pages long. *Woodrow Wilson as I Know Him* was published in 1921 when the Dempsey trial was still a burning political issue.)

Walking out, Hayes said giddily, "You know, this is the first time I ever been inside the White House."

"Before the Carpentier fight," Kearns said, "remind me to get my friend Joe Tumulty a pair at ringside."

Five days later Dempsey, Kearns, and Hayes walked into the San Francisco offices of Gavin McNab, a tall, theatrical, white-haired man who had recently represented pretty, hard-boiled Mary Pickford when she divorced an actor named Owen Moore. While a clerk took notes, McNab questioned his visitors for five hours. Neither Dempsey nor Kearns ever forgot the scene.

Had Dempsey actually worked in a shipyard? In Seattle, Philadelphia, anywhere?

"Not really worked in one," Dempsey said. "Sort of more like I made appearances in shipyards to encourage other guys to go into defense work."

"Did you charge a fee?"

"Not a dime, Mr. McNab."

"Kearns," McNab said, "putting out photos of Jack in a work

apron was stupid, just stupid. And putting the apron on him in the shipyard when he was wearing patent-leather shoes was stupider still. I thought boxing managers were supposed to be smart."

Kearns sat silent.

"The best we can argue now is the truth, that Jack was appearing to stimulate the recruitment of shipyard labor." McNab puffed a cheroot and let his eyes focus on the ceiling. "Now, and I need the truth again, Jack, who were you actually supporting besides yourself and your manager, here?"

Dempsey said he had sent Maxine money when he could. He had receipts from her for more than two thousand dollars. He was supporting his parents. He had bought each of them a house. "They've split up, Mr. McNab."

"Why is that?"

"My mother said my father was chasing younger women. She said he was hanging around the Mormon Tabernacle picking up pretty girls who sang in the choir."

"That gets no farther than this room," McNab said. "We need them both, your mother and your father, solidly behind you at the trial."

"My brother Bernie has got a bad lung disease. We call it miner's TB. My sister, Effie, had an operation for a female complaint. She never got over it. I've sent them both money when I could."

"I'm impressed with your generosity. Let's hope the jury will be, too." McNab turned to Teddy Hayes. "Where do you fit in here?"

"I was in the navy. I served under Admiral Moffett. I trained the U.S. Navy boxing team. Jack was gonna join the navy and fight on that team. He was starting to fill out enlistment papers, when the navy stopped taking enlistments."

"Technically that isn't germane," McNab said. "That isn't the issue. But practically it would shake the government's sails. Hayes, you're too close to the champion to be credible. Are there any other witnesses to this enlistment attempt?"

Dempsey recalled that the navy lieutenant who had taken his name was "a nice-looking Irish kid" with the later resonant name of

Jack Kennedy (not related to the future president). Dempsey remembered filling out his application after boxing a charity exhibition at the Great Lakes Naval Training station. Hayes, who knew Kennedy through his work with the navy boxing team, was able to report that the lieutenant was now a gunnery officer on the battleship *Mississippi*.

"This isn't going to be easy," Gavin McNab said, "but I accept. I'll take the case. Now gentlemen, I'm going to talk to you in your own language. Win, lose, or draw, my fee is seventy-five thousand dollars. I'll take it now."

Kearns spoke next. "We're a little short right at the moment, Mr. McNab, but this frog Carpentier has been challenging us. He's supposed to be some kind of war hero and with the slacker thing going against Jack, the fight's a natural. We'll fight Carpentier next summer and you'll get the fee you want and maybe a little more then."

McNab rose. He spoke with calm courtesy. "You must excuse me, gentlemen, for I am already due in court." (Kearns later said, "White House or no White House, the guy was telling us this: Give me cash up front or take a hike. Probably he heard from somewhere that some boxing guys were a little unreliable.")

In McNab's office, Kearns recognized that this was no occasion for a hustle. "I'll be back in the morning," Kearns said, "and I'll bring the cash."

Kearns kept his word. He immediately telephoned Rickard. The promoter did not have a free seventy-five thousand dollars, but he in turn contacted John Ringling of the circus. Everyone agreed that Dempsey, the commercial property, was worth a seventy-five thousand dollars investment. Ringling, who did possess seventy-five thousand dollars and a great deal more, telegraphed the huge retainer to Gavin McNab.

By the time the trial began, on Tuesday, June 8, Ringling and Rickard were providing free hotel accommodations for reporters coming to San Francisco to cover the story. They also offered the newspapermen free meals and bootleg whiskey. There is no record of any newspaper, from the *San Francisco Chronicle* to the *New York Times,* reporting the existence of such compromising hospitality, nor is there any

record of a reporter turning down the largesse. "It was not," Dempsey said years later, "as if we were bribing the writers or anything like that. But they had come down on me so damn hard, we were doing everything we could to get their minds open, at least to listen to our side."

The trial lasted a week. Its cost to the Dempsey group, Jack Dempsey, Inc., would run $150,000. That was, of course, a fortune in 1920, when a Mark Cross pure silk lady's handbag, with a change purse and a mirror in a tortoiseshell frame, sold on Fifth Avenue for $11.08. Jack Dempsey, Inc. committed a fortune to a proceeding that offered no guarantee of any payoff. There have always been risks in sport but here in the spring of 1920 sport in America was for the first time becoming a big business. A year earlier the gambler Arnold Rothstein had rigged the World Series for an investment of (accounts vary) probably no more than twenty thousand dollars. That was a dime-store cheap rigging of all the star players on a major-league baseball team, but that was as much money as it took. Now visionary promoters, Ringling and Rickard, were willing to make a $150,000 investment in one athlete, Jack Dempsey, his exoneration and—to use a word less hackneyed in 1920 than today—his image. As Dempsey hammered ahead, the investment came to look like a cross between a bargain and a pittance.

———

As it happened, the press and the country did not focus so blazingly on the Dempsey trial as they did on the Dempsey–Willard fight. When the San Francisco court convened, Bill McGeehan was traveling with the Yankees. He stayed with his baseball beat and wrote a story that marveled at the power of Babe Ruth and the other sluggers he nicknamed "Murderers' Row," as they defeated Detroit, 13 to 6. McGeehan's perfervid patriotism was burned out. Grantland Rice remained in New York, three thousand miles east of the trial scene, and wrote opinion pieces limited to hard-core sports. "Our choice for an All-Star outfield right now would be Babe Ruth, Ty

Cobb, Tris Speaker." (Some would suggest that as an all-star outfield for all time.) Other sportswriters were intrigued by the Brooklyn Dodgers, who were quite suddenly leading the National League. Flatbush blood bubbled with excitement. When a home-plate decision went against the Dodgers in a close game with the St. Louis Cardinals, police had to escort an umpire out of Ebbets Field to safety. "Umpire Rigler," wrote R. J. Kelly in the *Tribune,* "almost lost his life at Squire Ebbets' ball park, at the hands of a howling multitude of Flatbush fans." The cops' sweetheart shift, a stint at a ball game, turned into an exciting afternoon.

Sportswriters seemed to be losing interest in patriotism. Or perhaps there was an awareness that their vindictive attacks on Dempsey had been out of line. No apologies came forth; press apologies appear less frequently than press corrections. Typically, the writers simply turn to another story, Babe Ruth, Ty Cobb, the Brooklyn Dodgers, and an umpire named Rigler.

Beyond that, the Dempsey trial ran up against gaudy competition. The Republican party was gathering in Chicago to nominate a presidential candidate. In the words of Senator Henry Cabot Lodge of Massachusetts, "We are gathered to drive from office Mr. Wilson, his heirs and assigns. They stand for a theory of administration and government that is not American."

Heywood Broun wrote a bemused piece on Republicans looking silly as they tramped about the Loop bearing red feathers and cardboard oranges, the symbols of General Leonard Wood and Senator Hiram Johnson of California, two of their twenty prospective nominees. But to most this was high and serious business, with a huge overriding issue. We'd won the war. What kind of peace would we make?

For the first time since the Civil War, a Democrat had presided at the White House through eight consecutive years. Divided on some issues, the Republicans were united in angry opposition to Woodrow Wilson. Rejecting Wilson's world vision, the Republicans promulgated an ostrich peace, built on an isolationism that paralleled the postwar jingoism, anti-Bolshevism, xenophobia, and anti-Semitism, and

fit beautifully with the insularity of Prohibition. Long after the English, sipping gin, and the French, quaffing Burgundy, had stopped laughing at the Sahara of America; long after sexy, puritan, ambivalent days that e. e. cummings called "an age of dollars and no sense"; long after Prohibition itself was discarded and the last flapper danced one final Charleston on the edge, the very brink, of the Depression, anti-Wilson isolationism remained the order of the American day. Its full and tragic course ran until December 7, 1941, when the battleship *Arizona* sank with all hands in Pearl Harbor. (The hulk of the dreadnought, where fifteen hundred sailors lie imprisoned as barnacled skeletons, to this day leaks oil, drop by drop. Navy men talk of "the battleship's tears.")

On the morning of June 7, the Supreme Court issued a unanimous ruling that the Eighteenth Amendment, establishing Prohibition, was constitutional. In the court of final appeal, the "drys" had beaten the "wets." Republicans insisted that they were pleased. And well they might have been, for the court ruling did not affect their own drinking. (A few years later Andrew J. Volstead, the congressman from Minnesota who wrote the Federal Prohibition Enforcement Act, would admit to the *New York Times* that he himself had taken a drink, although he denied that he ever "drank to excess.")

On that same day, June 7, 1920, Hubert Howard, the Illinois Prohibition administrator, announced, in controlled horror, that along with forty thousand Republicans—delegates, their families, friends, and lobbyists—134,000 gallons of whiskey were "at large in Chicago." Government agents had previously seized the liquor and stored it under guard in the Sibley Warehouse. Now 670,000 bottles had mysteriously disappeared. Watchmen and local police knew nothing. They had heard nothing. Someone had moved more than half a million bottles of whiskey without so much as a clink. This huge hijack—in concert with bribed federal, state, and local law-enforcement people—proclaimed the arrival of the big-time, big-money Prohibition mob. Al Capone, Owney Madden, and the rest of

that crew of brigands was acquiring weaponry and cash and gathering strength.

Hubert Howard declared that he would dispense no more prescription blanks with which doctors could legally authorize "medicinal liquor." Was Mr. Howard suggesting that Chicago's physicians were developing a side practice, dropping stethoscopes and tongue depressors to hustle bootleg booze? "Some seem to be doing this, a few even with good intentions," Howard said. "I have reports of doctors prescribing whiskey to sustain the strength of frail Republican delegates. That will be stopped. Let the weak delegates drink strong coffee. There is nothing better for the nerves." The mayor of Chicago, A.V. Dalrymple, sounded existential. "Every saloon in town is running wide open. We know it and so do the delegates. But what are we going to do? If I employed enough men to handle every local drinking situation, I would bankrupt the city of Chicago."

Constitutional changes were coming in clumps. The Nineteenth Amendment, establishing women's suffrage, was just two months away from taking effect. Come November, American women at last would be allowed to vote for an American president. In Chicago the League of Women Voters, born even before suffrage, pressed for Republican planks affirming "independent citizenship for married women" and "equal status for feminine workers in U.S. service." Mrs. Douglas Robinson made a speech urging better pay for women schoolteachers. Saucy, witty Alice Roosevelt Longworth, Theodore Roosevelt's daughter, drew an ovation when she appeared among the delegates, wearing a black dress laced with white embroidery. "Speech, speech," cried the Republican woman.

"Mrs. Douglas Robinson, my aunt, has spoken," Longworth said. "I believe that is sufficient for one meeting. Anyway, I never make speeches, but I endorse everything that my aunt has said."

At the age of seventy, Henry Cabot Lodge, the handsome, trimbearded Boston Brahmin, was too old to run for president in 1920. But as leader of the Republican majority in the Senate Lodge was

possessed of immense power. Usually courtly and temperate, he was even something of an internationalist himself, until Wilson took up that cause. Then Lodge expressed reservations, mildly at first: Was union of nations worth the yielding of any American rights? Mr. Lodge thought not.

When the two men met at the White House, Joseph Tumulty recorded their disagreement. "By joining the League of Nations," Wilson said, "a country loses not its individual freedom, but its selfish isolation. The only freedom it loses is the freedom to do wrong. Robinson Crusoe was free to shoot in any direction on his island until Friday came. Then there was one direction in which he could not shoot. His freedom ended where Friday's rights began."

"But you concede, sir, that some rights will be yielded."

"There would be no federal union today, Senator Lodge, if individual states had not ceded certain rights to federal government."

On another occasion Lodge suggested that commitment to a League of Nations was needless. "Surely you of all people must acknowledge, sir," he told the president, "that we already have a moral obligation to keep the peace around the globe. All that this league of yours does is convert our moral obligation to a legal one. I see no difference between the two."

"A legal obligation, Senator Lodge, requires that one follow the law. It is a clear, unshirkable mandate. A moral obligation includes the element of judgment. In meeting a moral obligation, as opposed to a legal obligation, one follows one's judgment not a mandate. That is the difference, Senator, and it is a very great difference, indeed."

Lodge's opposition to the League and Woodrow Wilson became an anger that fed itself, ever more fiercely. His keynote speech in Chicago, portraying Wilson as the arrogant opponent of American independence and American safety, was more febrile than rational.

In a San Francisco courtroom, Jack Dempsey sat nervous and haggard. The room was crowded with spectators who wore American Legion buttons. Some legion men had been telling an odd story to anyone who would listen. This Dempsey fellow was not what he pre-

tended to be, a young man of mixed American stock. Actually, the legionnaires said, Dempsey was a Levantine Jew. Notice the dark hair, the swarthy complexion, "the black Mediterranean eyebrows." Was Dempsey a draft slacker? He sure as hell was, but what else could you expect from one of them lowdown, shifty Levantine Jews?

A number of army officers sat in attendance. The prosecutor nodded to them in greeting. "Good morning, Colonel Thomas," a major said. In that setting Dempsey had every reason to feel nervous. Further, *Daredevil Jack* been put on hold. All the money he had made in the ring, on vaudeville stages, in the circus, was now committed to legal expenses. Eleven months after smashing Willard, Dempsey was broke again. Even worse, and he realized this, a conviction could effectively end his boxing career. As a felon, he would surely be stripped of his championship. Thomas was telling reporters that the evidence was very solid and he expected "to send the slacker-boxer to prison." Dempsey slumped in a chair too small for his robust frame.

The prosecutor had prepared a nasty case. One of his investigators, O. O. Orr, obtained thirty-five letters from Dempsey to Maxine, which Orr had proceeded to describe to the press. The Dempsey letters were "scurrilous and salacious." Anyone reading them, Orr said, would recognize that Dempsey was "a sexual beast."

How so? Could you tell us about his bestiality? In some detail? Our readers definitely want to know about that. He's a brute in the ring; that's clear to anyone with eyes. Now we want to hear about his brutality in the bedroom. Could we see the actual Dempsey letters, Mr. Orr?

Charles Thomas spoke up. "Not at this time. They will be introduced in due course as evidence. In the letters Dempsey asks his wife to go along with false statements on support money he claimed to have sent her. That, gentleman, is a felony. The letters will be introduced and Dempsey will be convicted and sent to prison."

The letters might well support the government case, but quite beyond that, they were critical to the government's planned courtroom—and press—strategy: paint Dempsey as a thoroughgoing villain, a brute uncomplicated by redeeming qualities. Argue that the man possessed

neither patriotism nor decency. The adversarial legal system is seldom kind. Had Dempsey gotten a speeding ticket racing the red Stutz Bearcat on the South Side of Chicago, the prosecutor would have leaked that to the press as further evidence of sociopathic behavior.

With Maxine's help, willing or coerced, the government had rounded up four prostitutes who knew Maxine in brothels and probably knew young Dempsey there as well. Some of these brothels kidnaped young working women and dosed them with cocaine, after which rough characters imposed sex on them. Women who resisted were repeatedly raped. After that the brothels "owned" the women, who often were sold by one whorehouse to another. This was the notorious business called "white slavery."

Dempsey knew the brothel world. With his rough background, hadn't he done some whorehouse raping in his time? Thomas and his deputies did not answer that question. They merely raised it for the press to consider. The champion might or not be convicted of draft dodging, but as Thomas set things up, this was a trial that—regardless of verdict—Dempsey could only lose. For how on earth can a man win anything by denying that he has betrayed his country or by protesting that he is not a sexual savage?

McNab's counterstrategy was kindlier, gentler. He brought to court Celia and Hyrum Dempsey and had them sit side by side, although they now lived separately in Salt Lake City and were working out details of a divorce. Bernie Dempsey, the champion's older brother, weakened by lung disease, found a place in the courtroom next to his sister, Effie Dempsey Clarkson, a widow whose health was frail. All the assembled Dempseys could testify to the boxer's strong sense of family. Beyond that, the lawyer felt confident that his cross-examination of Maxine and the other prostitutes would shake both the women and the government's case. They were women who had spent years in the underworld, defying or at least skirting the law. McNab told one of his associates with some irony, "As a general rule, saints make better witnesses than prostitutes."

He was concerned about Kearns, whose swaggering manner and cavalier way with truth could antagonize any jury. But the indicted

Kearns was facing prison himself. "You'll answer as I instruct you to answer," McNab said. Kearns, in one of the most docile episodes of his life, agreed to do as he was told.

According to Kearns, a woman named Annette Adams would have been presiding judge in the normal bench rotation of the federal court. "She hated men," Kearns told his collaborator in 1965 as they prepared the fanciful memoir *The Million Dollar Gate*. "She believed every man should do ten years in the can just for the hell of it." Perhaps so, but Annette Adams was not a judge. She was the chief federal prosecutor in San Francisco, an extraordinary position for a woman as suffrage was just coming in. Adams was Colonel Charles Thomas's boss.

McNab wanted the case to go before a judge named Maurice J. Dooling. McNab's friendship with Joe Tumulty in the Wilson White House may explain why, when the Dempsey trial began, Dooling was sitting on the bench. McNab was drawing a huge fee and working hard at both the law and politics. He also had been given a nice shuffle of the deck. For in the person of the handsome naval lieutenant Jack Kennedy, McNab had what delights gambling men and trial lawyers of all stripes—an ace in the hole.

Thomas led off aggressively. He produced Rudolph Goodman, a notary public in Chicago, who had witnessed Dempsey's signature on the selective-service questionnaire. "I also helped prepare it," Goodman said. "I filled in a lot of blanks."

"By asking questions of Mr. Dempsey?"

"I asked Dempsey," Goodman said, "but he didn't answer. It was Kearns who answered all my questions."

In cross-examination, McNab drew information that Dempsey had "reviewed" the questionnaire and, of course, had signed it. But some jurors looked troubled. Dempsey was literate. Why hadn't he filled out his own draft questionnaire like everybody else?

Thomas read the questionnaire aloud. Through Kearns, Dempsey described himself as an expert miner and pugilist who had also worked "at the carpenter trade." He reported that he was earning twenty-five hundred dollars in 1917, the year draft legislation went into effect. He

described his wife as "sickly" and added that she had never been employed. He listed as dependents his wife, his mother, his father, and his widowed sister. He sent Effie Clarkson forty dollars a month toward the support of her two children. His father, who earned three hundred dollars for all of 1917, needed help because he could find work only at odd jobs from time to time.

The prosecutor swore in H. S. McCann, auditor of Salt Lake City. Hyrum Dempsey had actually earned $472.38 as a laborer in 1917. A. J. Auerbach, who ran a wig company in Salt Lake, testified that Effie Clarkson had worked for him and earned "ten or twelve dollars a week." Cross-examination brought out that she was "too sick to work about half the time." The total Effie earned for herself and her children was about $250.

The first day of proceedings wound down without Maxine making an appearance. She did not even come to court. Reporters gathering in a back room at the Palace Hotel felt that this was a bad day for Dempsey. His fast-talking manager had filled out the draft questionnaire and now the government had proved the questionnaire was full of mistakes. John W. Preston, a lawyer who worked with McNab, politicked the press amid the bootleg bottles. "You gentlemen are getting lost in detail," Preston said. "The draft law didn't say you had to be the *entire* source of support for a dependent. You simply had to be the *main* source. Jack was the main source of income for his whole family."

"What about the dirty letters Dempsey wrote to his wife?" a reporter asked.

"What letters?" Preston said.

In Chicago, General Leonard Wood began publishing an eight-page daily for the Republican delegates called *Wood News*. Wood was campaigning all out for the nomination against the early favorite, Hiram Johnson. Black Jack Pershing, commander of the A.E.F., said he would accept the nomination if it were offered to him. Dr. Nicholas Murray Butler, the president of Columbia, campaigned with an unusual slogan: "Pick Nick for a Picnic in November."

Henry Cabot Lodge spoke up for Calvin Coolidge. Charles Evans Hughes had lost narrowly to Wilson in 1916. Surely this great American deserved another chance. Whiskey flowed in the back rooms and the side rooms. The nominating speeches dragged on. Someone recalled that sixty years earlier in Chicago at the first Republican Convention, Abraham Lincoln's name was placed in nomination with a speech consisting of twenty-six words.

On the second day, Colonel Charles W. Thomas promised associates in the federal attorney's office, "We're going to nail the slacker to a wall." Maxine came to court that morning looking lovely and sloe-eyed, clad in a smartly tailored calf-length black dress with plunging neckline. Her dark coifed hair reached to the nape of her neck; in front bangs fell lightly on her forehead. Her eyebrows were carefully shaped and she carried herself proud and tall and straight. She let her eyes rest briefly on Dempsey. She showed no interest, nor even recognition. Men in court sat spellbound. If this was a harlot, surely she was harlot to the gods.

Thomas moved to introduce as an exhibit, the thirty-five Dempsey letters.

Gavin McNab stood up. "Objection. Such admission would violate spousal privilege [the doctrine that neither party in a marriage can testify against the other]."

"Your Honor," Thomas said. "The government believes there is a substantial question as to whether or not the two actually were married, according to the law, or whether they merely purported to be married."

"We have documents demonstrating matrimony between the parties," McNab said. "Here is a certified divorce decree, issued in Utah, on January 4, 1919. In it we see the finding of the Utah courts. The parties 'are and have been husband and wife,' prior, of course, to the decree."

Judge Dooling studied the document. "We all know the constitutional issue. Each state must give full faith and credit to the legal decisions of other states. Accordingly, regardless of any previous marriages or divorces, valid or invalid, this court now rules that between October

9, 1916 and January 4, 1919, Maxine Dempsey and Jack Dempsey were husband and wife. Therefore spousal privilege does exist."

Thomas protested heatedly and legalistically. "Even if they actually were married, the government believes that their divorce eliminates spousal privilege of any sort. Further, sending money by Western Union wire, as Dempsey did from time to time, is so public as also to eliminate spousal confidentiality. You can't do something in public and claim that it's private."

"Overruled."

"Finally, Your Honor, some of the Dempsey letters relate to money he claimed to have sent. The government feels that allegiance to one's country, conforming with the Selective Service law, is a higher doctrine than so-called spousal privilege. Further, these letters show Dempsey for what he really was. A white slaver."

"Objection," McNab cried. "In addition to everything else, that is irrelevant."

"Sustained. Colonel Thomas, the only question before the court is whether Dempsey evaded the draft, not whether he violated the white-slave law, and certainly not what anyone thinks of his morals. I am going to let the chips fall where they may. Because Jack Dempsey happens to be a prizefighter and the newspapermen are playing up this case does not mean we are going to have any different sort of a trial than if he were plain John Doe."

"The letters," Thomas insisted, "are relevant to the central issue— Dempsey's draft dodging. Therefore they deserve to be admitted."

Maurice Dooling set his lips and sighed. "A final ruling on the letters requires more wisdom than the court possesses at this moment. The court reserves decision. You may proceed, Colonel Thomas."

Helen Goodrich testified in mortified tones that she had worked as a prostitute and befriended Maxine. "We traveled together in the underworld." During their time together, Goodrich said, Maxine had received not a penny from Dempsey. Nannie Coffey, a madam in Cairo, Illinois, said Maxine had been a prostitute in her house under the name of Bobbie Stewart. "She was sort of delicate looking, almost

refined," Coffey said. "She told me she was separated from her husband. She went away and left a lot of unpaid bills."

The spectators and the press sat fascinated, but Gavin McNab had heard enough. "All this testimony is irrelevant."

"What the government is proving here," Thomas said, "is that Mrs. Dempsey was forced to work as a prostitute because Dempsey failed to support her."

"Work?" McNab said. "This is the first time in the history of American jurisprudence that vice has been declared to be work. The United States government has prosecuted that sort of 'work.' Are we now to hear it legitimized by government prosecutors?"

"Overruled. The issue is not what sort of work Mrs. Dempsey was engaged in, but whether she was working at anything or was largely dependent on Dempsey for support."

"We will show that Jack Dempsey was no colleague to Maxine in her underworld life," McNab said. "He vigorously protested against it. We will, however, stipulate that during the periods when Maxine worked in houses of ill fame, she received no money from Jack Dempsey. Most of the time he couldn't even find her." The stipulation had the effect McNab wanted. No more testimony about Maxine's whoring, and Dempsey's supposed pimping, would be admissible. But the government's charges against Dempsey's morals had been aired and so, whether relevant in the courtroom or not, could be reported in the press throughout the country. As indeed they would be.

At last the prosecutor called Maxine. "She walked within a few feet of her former husband as she passed the defense table on the way to the witness stand," the *Chronicle* reported. "She appeared calm and self-possessed. Her eyes rested on him for an instant but to a spectator who did not know their relationship it would seem that the big man, sprawled in a chair scarcely large enough for him, meant no more to her than any one of the crowd of onlookers. Dempsey followed Maxine with his eyes and his big fingers played unconsciously with the fastening of his mother's brown fur collar that lay on the table in front of him."

Maxine testified that she had lived under half-a-dozen aliases but between October 9, 1916, and February 4, 1919, she had indeed been Mrs. Jack Dempsey. Thomas presented her with Dempsey's draft questionnaire. "Do you recognize the signature?"

McNab rose. "Objection. Document was signed during the marriage."

"Sustained."

Without apparent embarrassment, Maxine described her travels. "I have worked in many houses of ill fame." She didn't get much further. Arguments about what was admissible consumed the balance of the day in court.

Drinking the bootleg booze supplied by Dempsey, Inc. that night, reporters felt the trial still could go either way. Thomas had found errors in Dempsey's numbers, but that was relatively minor, bookkeeping stuff. A few hundred dollars here or there would not suffice to send a champion to prison.

Another question reverberated beyond Judge Dooling's courtroom. What kind of person was the man who called himself Jack Dempsey? Clearly Thomas was trying to suggest to the jury that he had been in the white-slave business. That was irrelevant as hell and also damaging as hell. Sordid and sleazy, to put it mildly.

What was in those letters, anyway? the reporters wondered. White-slave stuff? Had he peddled his own wife's body? Or was there material even more noxious, hints that Dempsey had worked in brothels as a professional rapist, forcibly deflowering virgins for a fee? These were not trial issues, but jurors vote their hearts as well as their heads. Regardless of evidence, more brutes than gentlemen are carted off to jail. On the night following the second day of the trial of Jack Dempsey most reporters agreed: The verdict hinged on what Maxine, the comely harlot, had to say, and beyond her testimony on the champion's own words as they appeared in his notorious letters.

In Chicago the Republicans appointed Henry Cabot Lodge as permanent chairman of their convention. "In 1916 Woodrow Wilson won the presidency," Lodge said in an acceptance statement, "on the

cry that 'he kept us out of war.' His policies today inspire another cry. 'Woodrow Wilson has kept us out of peace.' The Wilson dynasty must be overthrown."

At length balloting began. Three of the nominees were future presidents. Some of the names are still remembered. Some are not. Wood. Lowden. Johnson. Sproul. LaFollette. Coolidge. Harding. Butler. Hoover. In all the list of nominees reached seventeen. "We are told," Heywood Broun wrote in the *Tribune,* "that the bad old days when a little group of bosses met in a back room and picked the candidate are gone. This, they say, is an open convention. We believe it. In fact this convention is so open that it yawns.

"Politically the old style must have been an evil thing, yet from the aesthetic point of view there is something to say for it. We doubt if any back room boys ever said, as we heard of one nominee today 'he must be chosen because in his blood there runs the same strain of red that floats so proudly in Old Glory.'"

William Allen White, publisher of the *Emporia Gazette* in Kansas, led the liberal wing of the party, which included a fiery, stumpy character later famous as mayor of New York, Fiorello H. LaGuardia. This group wanted modifications in the way the League of Nations was to be structured. With modifications, they found the league acceptable. A vote on who would chair the Committee on Resolutions, charged with shaping the Republican platform, brought liberals and conservatives into head-on collision. White and La-Guardia supported Ogden L. Mills, a New York moderate and patrician. Hard-core isolationists, Hiram Johnson of California and William E. Borah of Montana, supported an Indiana senator named James Watson. In executive session, Watson won over Mills. The vote was 41 to 3. To the Republican party, the League of Nations was dead.

Americanism, 100 percent Americanism, became the Republican order of the day. As Hiram Johnson put it, "We have no use for foreign"—he pronounced the word *fur-en*—"ideas in this great and free nation of ours." Broun described Senator Johnson as "a dumpy little man" who spoke with a pronounced Irish dialect. "That dialect,"

Broun wrote, "is nothing to boast about, but Johnson doesn't do well with English either."

Buried inside the *New York Tribune,* hidden beneath the political news, were stories of police corruption and the theft—the Sicilian Black Hand Society was suspected—of five hundred thousand dollars in jewelry from the rented Easthampton summer residence of Mr. and Mrs. Enrico Caruso. Deep inside the *Trib* a grim one-column headline appeared.

Mrs. Dempsey Tells
Court Heavyweight
Struck Her on Jaw

Judge Dooling had reached a decision on marital confidentiality. He would consider each charge and each matter separately. A possible punch in the jaw was not confidential, even during a marriage. The doctor named Joseph Fife had been summoned. People at the Gibson Hotel or brothel had observed Fife coming and going. The little black bag identified him as a physician. While Fife set Maxine's jaw, half the hotel heard her cries. Screams of pain in a crowded hotel are not confidential. "He hit me," Maxine said, "because I wasn't making enough money for him." In short, Maxine claimed, Dempsey wanted her to have more sex with more men for more money. Dempsey wanted her to support him with her earnings as a prostitute. He didn't care what she did with other men or how many other men there were as long as they paid cash for her body. As Dempsey listened, his strong face contorted into fury. He began to look as he looked in the ring. He started to rise. His brother grabbed his shoulders and said softly, insistently, "Easy, Champ. Easy. Easy."

McNab rose to object and to calm his client. "We will demonstrate, Your Honor, that Jack Dempsey pleaded with Maxine to honor the sanctity of their marriage bed. Pleaded and begged. Time after

time. Far from encouraging Maxine to whore around in the under-world, Dempsey wanted his wife with him. He wanted Maxine faith-ful to the Dempsey marital bed."

"Overruled. This is not the time for Dempsey's version of events. He will be called in due course."

"Thank you, Your Honor."

The very last thing McNab wanted was for Maxine to drive Dempsey to such fury that he took a swing at her in the very court where he intended to deny that he ever swung at her. His control in the prize ring was matchless, but he was playing in a tougher arena now, a marriage gone all the way to hell. Sitting down, McNab said, "She can say anything she wants, Jack. She's trying to get your goat. The only way we can be hurt is if she succeeds. Just promise me that you'll stay calm." Buoyed by his brother and his attorney, Dempsey settled back into the cramped chair.

That morning, however, McNab had won a major victory. Judge Dooling ruled that all the letters Dempsey wrote to Maxine, all thirty-five Maxine said she possessed, were inadmissible. She could testify against Dempsey, within limits Dooling would impose, but the letters and whatever hard physical evidence they possessed on Dempsey's ef-forts to defraud Selective Service were barred.

Colonel Thomas shouted exception.

"So noted," Dooling said.

McNab rose. "Defense moves for a dismissal of all charges from Dempsey and Kearns."

"Motion denied. Call your witness, Colonel Thomas."

Maxine moved to the stand, again wearing a low-cut black dress. Dempsey told me years later that when he first noticed her, playing piano in a Salt Lake bar, she was wearing a low-cut dress with firm breasts pressed against a thin bodice. In court, he said, he found him-self staring at those breasts again. Damn, he thought, she's going to testify against me and try do me in. But damn, damn, damn, part of me still loves her.

After Maxine made her claim that Dempsey had punched her,

Thomas led her through her travels through the West, from Washington State to Salt Lake City, from Wells, Nevada, back east to Cairo, Illinois, from Denver west to San Francisco.

"And your occupation during that time, Mrs. Dempsey?"

"I worked in houses."

"In what are commonly known as houses of ill fame."

"Yes, sir. That's what I did." She neither blushed nor lowered her head.

The *San Francisco Chronicle* reported: "Maxine Dempsey told the story of her life from the time she met Dempsey until the present. The only thing that made it different from the stories of other women of Maxine's profession was the enjoyment with which she told it. So eager was she to recount the sordid details of her life in one city after another that she ran ahead of the questions to make it clear that when she and Jack Dempsey drifted apart after a few months of life together, she made a bee-line for the underworld where she was most at home."

Maxine's eagerness was defiance. She was defying Dempsey, who always said he wanted her to quit prostitution, and she was also defying white-haired Celia Dempsey, who had tried to make her into a housewife. Maxine was an aberration of a liberated woman. She was independent and—as Dempsey had been a hobo—she was a willing tramp.

Thomas pressed her on the letter that she mailed to the *Chronicle* the previous February, the letter that led to Dempsey's indictment. "I was thinking of the government," Maxine said. "How everybody has to respect the government, you know? And how Dempsey didn't. I wrote the letter to help the government."

"You weren't angry at Dempsey?"

"No. I just wanted to help the government."

"You sometimes supported him?"

"Dempsey made me support him, yes. And when I didn't do it good he knocked me down."

"Did he ever send any support money to you?"

"A little. Very little, Dempsey was cheap."

"How much support money did he send you in 1917 and 1918?"

"Not enough to live. Maybe nine hundred dollars for the two years."

Before cross-examination, Gavin McNab introduced three Western Union men from Salt Lake City who were allowed to testify quickly "so that they can return to their jobs." An office manager, J. B. McCloud, said that he and his men had brought records of monies wired by Jack Dempsey. "Maxine got so many remittances from Dempsey that the people in the office got to know her. Once she got remittances two nights in a row and someone kidded her. 'What happened to the money he sent you yesterday?'

"Maxine said, 'I lost the first lot shootin' lousy craps.'"

R. W. Burton, a Western Union cashier, testified that after Dempsey knocked out big Fred Fulton in July 1918, "Maxine got a remittance of two hundred dollars. I remember that clearly because Maxine told me Fulton must have hit Jack hard to jar him loose from two hundred dollars." On another occasion, testified E. B. Thompson, the night manager of Western Union in Salt Lake City, Maxine told him, "Maybe he's not so bad. Jack really does send plenty of money when he has it." From a variety of sources, McNab demonstrated that Dempsey had sent Maxine about one thousand dollars a year through 1917 and 1918, more than twice what he sent to his sister. With many salaries still as low as ten dollars a week, Dempsey easily met the legal requirement as main supporter of Maxine.

When McNab recalled Maxine to the stand, some of her confidence was gone. "I want to return to the letter you wrote to the *Chronicle,* where you alleged that he never supported you. You actually had some help composing that letter, didn't you?"

Rattled, Maxine looked at the floor. "Speak up," McNab ordered.

Yes, Maxine conceded, she'd gotten help, "from Beulah Taylor. She was a Negress who helped look out for us girls in the house in Wells. Beulah was better at writing sentences than me."

"Didn't you say to Beulah and Peggy Murray [another prostitute

at Wells] that you had read in the papers that Dempsey was going to make $250,000 for fighting Georges Carpentier and that you were going to have $40,000 of it, or drag Jack down to the same level as yourself?"

"There was a discussion," Maxine said. "I knew Jack would never part with no forty thousand dollars."

"Why did you wait to make your charges against Jack public at the time you did?"

"We hadn't written to each other for a long time. Then he sent me a photograph of himself, looking like he was rich. That made me mad. It made me so mad I didn't care what I did. But I was thinking how Jack lied to the government and I got Beulah Taylor to help me write the letter."

"You were shaking him down," McNab said

"I don't know what that means," Maxine said.

"Objection," Thomas said.

"Sustained."

"But during the time you lived together, Dempsey always paid the bills?"

"I couldn't hear the question."

"When you lived together as man and wife," McNab shouted, "who paid the bills, you or Dempsey?"

"Uh, I guess, when we lived as man and wife, it was him."

"So your suggestion that you supported him is hogwash?"

"Objection," Thomas said.

"She doesn't have to answer that," said McNab. "She already has."

General Leonard Wood led all Republican nominees through four ballots. Governor Frank Q. Lowden led from ballot five through ballot eight. Senator Warren Gamaliel Harding of Ohio, running a distant fourth as late as ballot six, came up with a closing rush. One hundred five votes at ballot seven; 133 votes at ballot eight; 374 votes and a clear lead at ballot nine. Then the bandwagon sprouted wings and on the tenth ballot Harding drew 692 votes (out of a possible 984) and the nomination. "There is no rancor and no tears," said

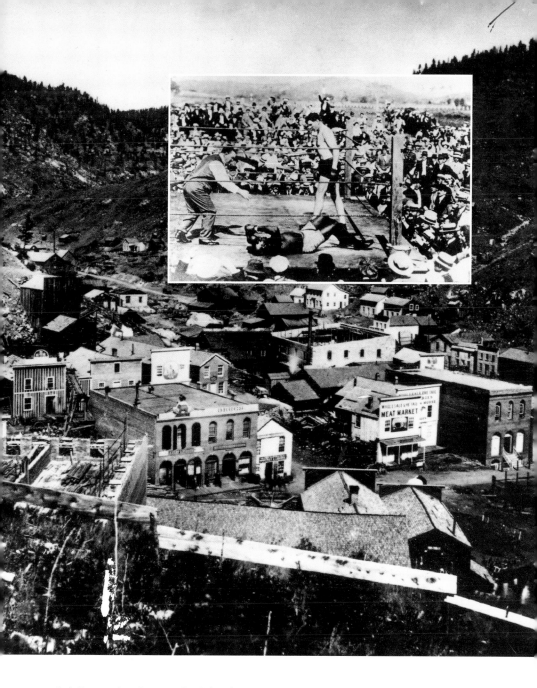

Jack Dempsey's native ground, a Colorado mining town. This one is Black Hawk City. *Corbis-Bettmann*

INSET: Mighty Jess Willard towering over Jack Johnson, whom he has just defeated in the twenty-sixth round at Havana, 1915, winning the heavyweight championship. *Corbis-Bettmann*

TOP LEFT: The champion poses with his father, Hyrum, a gifted, yet vague and indigent man. *The Ring*

RIGHT: Dempsey as a shipyard worker during World War I. The glossy patent leather shoes, not standard workmen's gear, caused trouble. *Corbis/Bettmann-UPI*

BOTTOM LEFT: Jack "Doc" Kearns, Maxine Cates Dempsey and her young husband wearing the checked vest, probably late 1917. *Corbis/Bettmann-UPI*

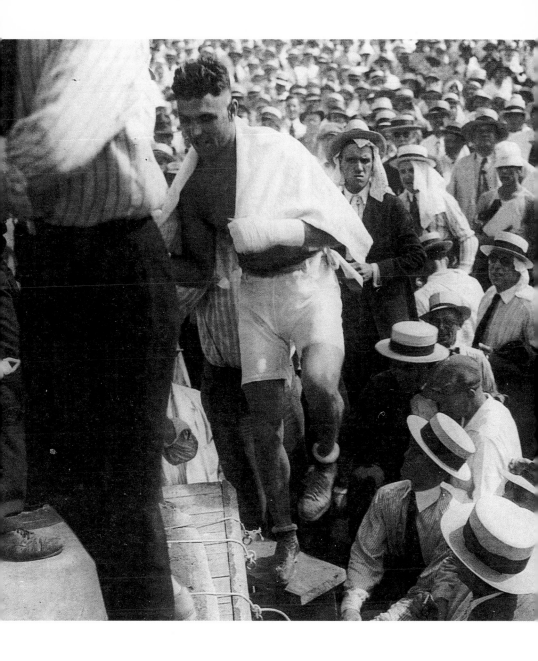

Dempsey entering the ring to face Willard in Toledo, 1919. In this rare and revealing photograph, the wrapping on his left hand shows no sign of plaster of Paris.
The Robert Shepard Collection

Court Bars Letters to Wife in

Confidential Communications To Spouse Ruled Out by Judge Trying Pugilist as War Slacker

Holds Utah Divorce Decree Establishes Marriage Relation Existed; Extent to Which Maxine May Testify to Be Decided Today; Is Pivotal Point in Trial

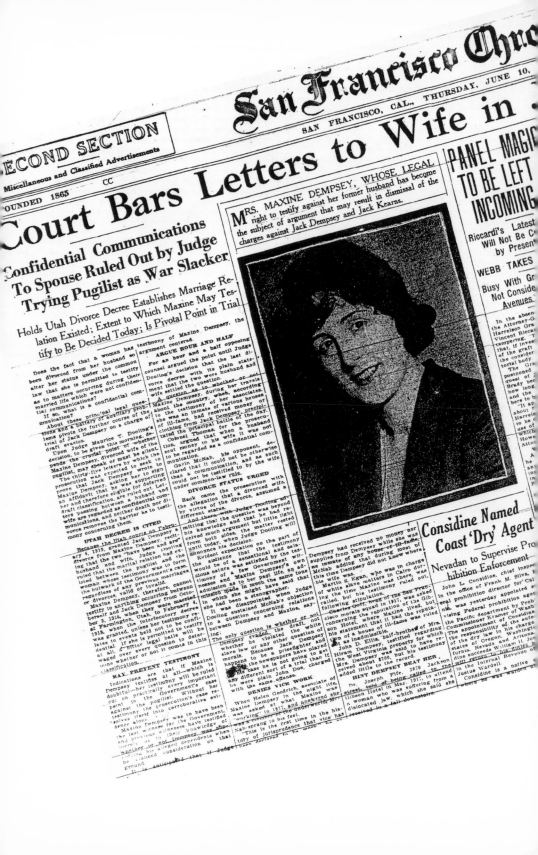

MRS. MAXINE DEMPSEY, WHOSE LEGAL right to testify against her former husband has become the subject of argument that may result in dismissal of the charges against Jack Dempsey and Jack Kearns.

Does the fact that a woman has been divorced from her husband so alter her status under the common law that she is permitted to testify as to matters occurring during their married life which were not confidential communications?

If so, what is a confidential communication?

About these principal legal questions and a battery of auxiliary problems pivots the further course of the trial of Jack Dempsey on a charge of evasion.

Upon Judge Maurice T. Dooling's decision the crucial point or whether Maxine Dempsey, divorced wife of the pugilist, may speak or must be silent.

The thirty-five letters by which the prosecution hopes to seek to prove that Jack Dempsey wrote to Maxine Dempsey, asking her to sign an affidavit that he was supporting her and therefore eligible for draft classification, are ruled out. Letters passing between a husband and wife so regarded as neither death nor divorce removes the barrier as to testimony concerning them.

UTAH DECREE IS CITED

Because the Utah court on February 4, 1919, granted Jack Dempsey a divorce from Maxine Dempsey, reciting that the two have been and are husband and that the marital relation had existed between the pugilist and the woman whose testimony was to form the bulwark of any previous marriages or divorces, valid or invalid.

Maxine Dempsey, therefore, cannot testify to anything occurring between herself and Jack Dempsey from October 1, 1916, when they were married at Farmington, Utah, to February 4, 1919, when the interlocutory decree was granted, unless her testimony relates to events held not to be confidential if she is legally liable to testify at all.

MAY PREVENT TESTIMONY

Indications are that if Maxine Dempsey testifies at all—which is doubtful—her testimony will be ruled out on practically every important point in the Government's case against the pugilist. Without her testimony the prosecution's case resisted itself into corroborative evidence alone.

Maxine Dempsey was to have been the last witness for the Government, and previous witnesses have testified merely as to their knowledge of whether or not Dempsey was supporting his alleged dependents when he claimed consideration on that ground.

ARGUE HOUR AND HALF

For an hour and a half opposing counsel argued the point until Judge Dooling's decision that the last statement that the two were husband and wife settled the question.

Maxine Dempsey, to whether or not she was in the country when travels about the country, when, according to the testimony of web associates she was an inmate of various houses of ill-fame, had received money or clothing from Jack Dempsey, represented the principal battles of the day.

Colonel Thomas, for the prosecution, argued that when a husband sent money to his wife it was not to be regarded as a confidential communication.

Gavin McNab, his opponent, declared that it could not be otherwise a communication and as such could not be testified to by the wife under common-law rule.

DIVORCE STATUS URGED

Back came the prosecution with the allegation that a divorced wife, by virtue of the divorce, assumed a different status.

And there with the question was beyond his knowledge and but little light received much argument but that the matter rested from such side. The matter rested until today, when Judge Dooling will announce his decision.

Evidently expectation on the part of the audience that the sensation would loose a few government witnesses of a sensational and malicious nature was satisfied by the testimony of Maxine Dempsey's own admission made in her past life, an admission that she might have said that she had been a stenographer.

It was disappointed when Judge Dooling sustained McNab's objection to a question concerning relations between Dempsey and Maxine, saying:

The only question is whether or not Dempsey evaded the draft, not whether he violated the white slave law or any other question of morals. Because Jack Dempsey happens to be a prizefighter and the newspapers have played up his case he is not going to get any different sort of a trial than if he were plain John Doe, charged with the same offense.

DENIES VICE WORK

When Helen Goodrich, associate of Maxine Dempsey in the night life, was asked at what Maxine was working in 1917, she answered the question under world Mrs. Nab sprang to his feet.

This is the first time in the history of jurisprudence that vice has been declared to work

Dempsey had received no money nor supplies from Dempsey while she was an inmate of any house of ill-fame, McNab adding that during most of this time Dempsey did not know where she was.

Martin S. Egan, who was in charge of white slave matters in Cairo during the time Maxine was there, was called, but his testimony ruled out, following stipulation.

Charles Goff, head of the San Francisco morals squad in 1917, was asked concerning the reputation of the Gibson Hotel, where Maxine lived, but his statement that it had the reputation of a house of ill-fame was ruled an inadmissible.

John D. Ellis, testified regarding Hiram Dempsey, half-brother of Mrs. Dempsey, said the West Virginia property for which Mrs. Dempsey was said to have received about $700, but his testimony added little to the record.

HINT DEMPSEY BEAT HER

Dr. Joseph Fife, 3870 Jackson street, told of being called to Gibson Hotel in May, 1917, to attend a woman who was suffering from a dislocated jaw, which she said she received, in fall downstairs.

Riccardi's Latest
Will Not Be Co
by Presen

WEBB TAKES

Busy With Gr
Not Conside
Avenues

In the absen
the Attorney-G
Harrelson Gra
Vincent Ricca
tampering,
that, if invest
of the staff
the consider
torial body

The Gra
postponed
quest of C
Brady at
how long
and the
hers to b
about r
Harrelso
to be
use of
McGrs
Howe
Atto

Considine Named Coast 'Dry' Agent

Nevadan to Supervise Prohibition Enforcement

John L. Considine, chief inspec
in the office of Frank M. Silva,
eral prohibition director for Cal
was yesterday appointed a s
vising Federal prohibition age
the Pacific department by Pro
Commissioner Kramer of Oakla
The appointment of Considine
the responsibility of the enfor
of the dry law in the state
states of Oregon, Washington
fornia. Nevada and Arizona.
dine succeeds William H. Jo
din returns to the duties
in the Internal Revenue of
Justus Wardell.
Considine is a native

A banner headline, one of many, during Dempsey's draft evasion trial.
Stephan Sacks, New York Public Library

INSET: Warren G. Harding campaigning for the presidency to a rapt audience in his hometown, Marion, Ohio, during 1920. Harding promised to restore "normalcy," a word coined by the candidate. *Corbis/Bettman-UPI*

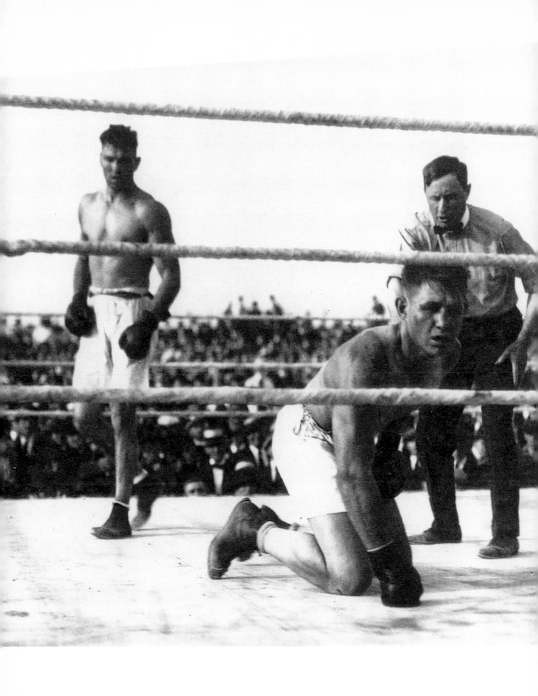

Dempsey defeating brave, doomed Billy Miske in Benton Harbor, Michigan, in 1920.
The Robert Shepard Collection

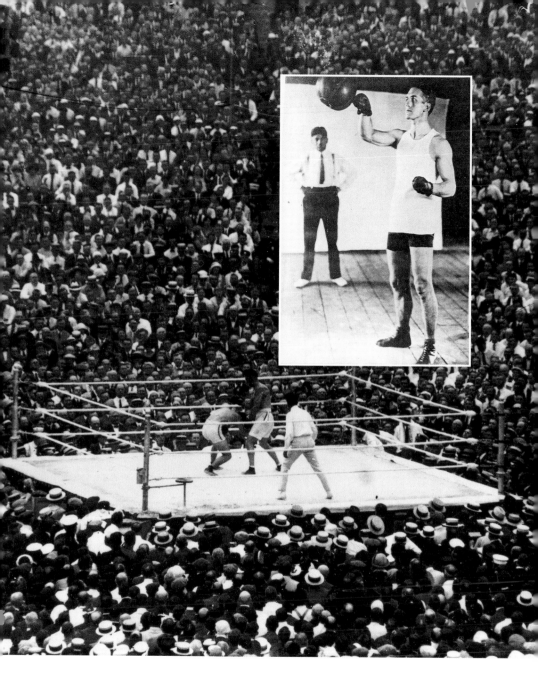

ABOVE: The first million-dollar gate. Dempsey (upright) defeats the crouching Carpentier before 90,000 fans in a green-lumber stadium in Jersey City on July 2, 1921. *Corbis/Bettmann-UPI*

INSET: Handsome Georges Carpentier of France taps the light bag as his manager, Marcel "Evil Eye" Deschamps, watches. American women raved about Carpentier's legs. *The Robert Shepard Collection*

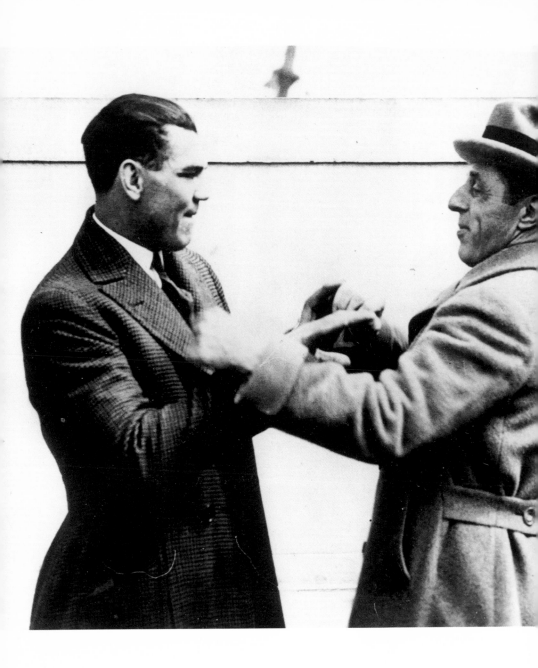

Now a world-famous celebrity, Dempsey playfully spars with the distinguished director
D. W. Griffith on a ship carrying them to Europe. Dempsey swept through Europe in triumph.
Corbis/Bettmann-UPI

Hiram Johnson. "I didn't win and I don't whine." Calvin Coolidge, the governor of Massachusetts, quickly was nominated for the vice-presidency. On the day of Harding's nomination the *Tribune* also reported on its front page: TROTSKY SLAIN. LENINE ESCAPES. SOVIET REGIME FALLS. The date of that report, with its aberrant spelling of Lenin: June 20, 1920.

In a subsequent rhapsodic portrait of Harding, the *New York Tribune* observed: "He likes dogs, reveres [Theodore] Roosevelt and Napoleon. He is the son of a country doctor and grew up on the family farm. He is the proprietor and editor of a fine little newspaper, the *Marion (Ohio) Star.* He went to Ohio Central College now defunct and cut corn and painted barns to earn his way through. The people of Marion who have long known Mr. Harding believe in him with a profound faith. In their eyes this modest, handsome son of the middle border personifies all the virtues of mankind." Of course, you couldn't take literally *everything* you read in the newspapers.

Harding is remembered as a bubbling womanizer and his term in office was to be inglorious. In reviewing Harding's nomination, Gordon J. Kahn, a historian and the author's father, wrote: "When the Republican convention deadlocked between Wood and Lowden, Harding was made the dark-horse nominee on his solemn assertion that there was no reason in his past why he should not be."

It seemed incongruous to the reporter from the *Chronicle* to see a little white-haired woman, looking as though she should be sitting in a sunny window knitting, perched on a witness stand and talking about support payments and prizefights. "My boy, Jack, is a very good boy," Celia Dempsey said. "He's worked hard since he was eleven years old. Since he became eighteen in the year 1913, or thereabouts, he's been supporting all our family. My husband, he had bad rheumatism. Sometimes he gets melancholy and forgetful. He can't do much. We've had to depend on Jack."

John Preston, McNab's associate, guided Celia Dempsey gently, respectfully. "How could you have managed in the years in question, ma'am, 1917 and 1918, if Jack hadn't sent you money?"

"I couldn't have managed," Celia Dempsey said. "We wouldn't have had anything at all."

The family had moved around quite a bit, she said, but wherever they went misfortune seemed to follow. "My daughter Effie, she's needed operations. The doctors have tried but they haven't helped her much. My sons Johnny and Joe, they tried to enlist, you know. But they were in such poor health the army wouldn't take them."

"Did you have another son?"

"Bruce was my youngest, the baby of the family."

"What happened to Bruce, ma'am?"

"It was three years ago. He was just sixteen and Bruce was trying to help us out, selling newspapers on the streets of Salt Lake, where we live. Some gang came up. I don't have all the details. He didn't even know them. They wanted his newspaper money and when he wouldn't give it to them they stabbed my son, Bruce. Stabbed him to death there on the street."

"Do you want a recess now, a little time?"

"No, thank you. I can continue."

Preston asked for details on support. "When Jack fought around here," Mrs. Dempsey said, "he'd bring home his purse and give it to me. He'd say, 'Here, Mother, do what you like with this, but be sure and buy yourself some new clothes.' After he beat Bill Brennan in Milwaukee [in February 1918], he sent me $150 in bills, and he wrapped the bills in a newspaper story about how he knocked out Brennan in the sixth round. He always sent me money. I never even had to ask.

"Then, a while after he won the championship from Willard, Jack came out to Salt Lake and bought us a beautiful twenty thousand dollar home so the whole family could live in a little bit of comfort. Jack is a very good boy."

The armies of the prosecution sat silent. There was no alternative. During a recess, the reporter from the *Chronicle* remarked that Thomas would have to conduct his cross-examination with great care. "It will be a little like cross-examining Whistler's mother."

Next Preston asked Mrs. Dempsey about Maxine. "Do you re-member when Maxine left Salt Lake to go to Wells, Nevada?"

"Very well, indeed. She had been restless for a long time. She said life in Salt Lake was just too slow. She told me, 'I'd rather go back to my old life and smoke hop [pot] than stay in any slow place like this.'"

"Did you try to persuade her to stay?"

"Oh, often. Very often, because I knew Jack cared for her. I used to tell her that as soon as Jack won the championship he'd buy her a beautiful home and she would be the lady of the house. All Jack wanted her to do was learn to cook and to keep house. But she wasn't interested. Finally she went away."

As the *Chronicle* reported, "Cross-examination of Dempsey's mother neither brought out new facts nor shook any of her testimony."

McNab called Tommy Fitzgerald, a boxing roustabout, whom Kearns had dispatched to Nevada to pacify Maxine. Fitzgerald said he learned in Wells that Maxine and Beulah Taylor conceived a plan to shake down Dempsey. The letter to the *Chronicle,* Taylor's flurry of composition, was the first phase. Then, when Dempsey and Kearns reacted, as they did by sending Fitzgerald to Wells, Maxine asserted her demand. She'd return the letters for forty thousand dollars.

"When you informed Jack Dempsey of Maxine's statement," McNab said, "how did he react?"

"The champion said that whatever the women had, they could give to the government or anybody else and they could go to hell."

"No forty thousand dollars for the blackmailers?"

"Objection."

"Extortionists."

"Objection."

"No money for the women shaking him down?"

"Not a penny."

Two prostitutes corroborated Fitzgerald's words. One remembered a fiery discussion in Tommy Wilson's whorehouse. Someone said that even if Dempsey did not come through with cash for Maxine, the letters suggested draft dodging. Maxine had an obligation to

turn them over to the government, anyway. "To hell with the government," Maxine said. "It's the money I want."

Back on the stand, Maxine sat sullen. She didn't remember much about any forty thousand dollars, "except one day up in Wells, Beulah Taylor mentioned something like that."

"You swear you don't remember more than that?" McNab said.

"I ain't swearing to nothing," Maxine said.

"You are aware that Beulah Taylor has disappeared, that the government with all its hundreds, its *thousands* of agents cannot find your confederate, Beulah Taylor?"

Maxine shrugged. "People in the underworld are hard to find."

"Look at this document, please. Is this your signature?"

McNab handed her an affidavit dated October 25, 1918, when Dempsey and Maxine, though separated, still were man and wife. It was a waiver of all her claims of dependency and benefits as a dependent. (This was about the time Dempsey tried to enlist in the navy. Apparently he was trying to foreclose his harlot bride from the benefits due a serviceman's wife.)

"Yes."

"Why did Jack ask you to sign that?"

"He told me he wanted to join the marines."

"Why did you agree to sign it?"

"If he wanted to fight for the country, he had a right to." Maxine began to weep.

Court recessed.

In the *New York World* Ring Lardner offered a paragraph that opposed changes in the tennis scoring system. "The only changes we advocate," Lardner wrote, "is a ball lasting more than two sets and the electrocution of all players who yell 'Ready' just before serving."

Mrs. J. C. Gleason, arrested for jewel theft in her five-room suite at Manhattan's Hotel Pennsylvania, was described as the widow of a Chicago millionaire. "It's poker," she said from her cell. "Society people introduced me to poker when I didn't know an ace from a

jack. I've been losing and losing and now this. Think of it! A well-known woman like me in jail. This will kill my mother!"

Police were continuing to investigate a bigger jewel theft, the one involving Enrico Caruso. "Do not fret," the tenor cabled his wife from Havana, where he was booked for a recital. "I will replace all the jewels."

On Long Island that Saturday only one three-year-old racehorse was entered against mighty Man o' War in the Belmont Stakes. W. J. Macbeth reported in the *Tribune* that "the powerful, irresistible, handsome chestnut colt won in such impressive style as to prompt universal concession that he is the champion of all champions among thoroughbreds past and present." Donnacona, Man o' War's rival, finished twenty lengths behind. After the race, Samuel D. Riddle of Philadelphia, who bought Man o' War for $5,000 at a Saratoga auction, turned down an offer of $260,000. "He's not for sale at any price," Riddle told reporters.

The Republicans in Chicago, whooping it up for Hardin–Coolidge, fell to bickering. "[General Leonard] Wood and the reactionary forces behind him tried to buy the nomination," Nicholas Murray Butler said. "A motley group of stock gamblers, oil promoters, munitions makers, and other like persons were at the center of the scheme. He would have put the presidency in the service of oil promoters and stock speculators."

"A vicious and malicious falsehood," Wood shot back, but the spotlight played on the bland, handsome Warren Harding. Unlike the oil promoters and the stock speculators who came to flourish during the presidencies of Harding and Coolidge, Leonard Wood, a pot-bellied general, was on his way to history's dustbin.

Jack Dempsey made a strong and composed witness. "How long have you been supporting your family?" John Preston began the defense examination.

"Since I was about fourteen years old." Dempsey detailed jobs as a miner, a farmhand, a carpenter. "And I've done some boxing."

"Tell the court about your boxing in 1917."

"In 1917, I fought Fireman Jim Flynn. He beat me. I fought Gunboat Smith twice, Willie Meehan twice, Al Norton, Carl Morris [three times], Bob McAllister; ten bouts as I remember it. I won nine."

"How much did you earn, you, personally, after your manager took his percentage?"

"I made four thousand dollars. I fought ten fights in 1917 and I made four thousand dollars."

"And the next year, Mr. Dempsey?"

"I made about the same."

"But the next year, according to my records, you fought no fewer than twenty-two times. Not ten times, but twenty-two."

"That's about right."

"What happened to the money?"

"I did most of my 1918 fighting for charity."

Preston produced documents showing that Dempsey's matches in 1918 produced $26,000 for the Knights of Columbus War Relief Fund; $73,500 for the Salvation Army; and $197,000 for the Army and Navy War Activities Fund.

"Did you get any money for the charity fights?"

"Travel expenses."

"Anything else?"

Dempsey grinned. "Two wristwatches and a gold pencil."

"How did you make out in the ring?"

"I got careless with Willie Meehan. They said that he outpointed me. The others times I did all right. Seventeen knockouts in the twenty-two bouts."

"What prompted you to fight benefits?"

"I thought I was doing my country some good."

"Were you trying to cover up your trail, make excuses for not being in military service?"

"Absolutely not."

"Seventeen knockouts," Preston said. "Very impressive." Then,

in the same even tone, "Jack, did you ever punch your former wife in the jaw?"

Dempsey looked past Preston toward Maxine. "I never struck my wife. Never."

"Then how did she break or dislocate her jaw?"

"I was asleep at the Gibson. I heard a noise. Maxine was on the floor. Before I called a doctor she told me she tripped over the doorsill. She tripped and fell, she said, and hit her chin." Preston did not ask, because McNab and he believed there was no need to ask, how much Maxine had been drinking, or how much pot Maxine had smoked. They felt there was no reason to let Dempsey speak critically of Maxine, because the point was clear. No vigorous woman falls flat over a doorsill unless she is impaired.

"What were your plans when you married Maxine?"

"Just the same as an other man would have, I guess. I wanted a good wife and a nice family. I knew she had been living a hard life out there all on her own, and I had dreams of leading her to something better. I took her over to my mother's house to live because I figured she could learn housekeeping there. I was always encouraging her to learn. I never did anything to degrade her or send her back to the sort of life she had been living.... Anything she wanted she could have, if I had the means to get it for her."

"If Maxine had behaved herself and had not returned to her old ways, would you have stayed with her?"

"I sure would," Dempsey said. "I loved her. She would have had more than she has today. I told Maxine I couldn't buy the kind of home I wanted to give her until I made more money, but just as soon as I did make more, I would buy her a nice house, furnishings, everything that went with it. A very nice house. But boxing money, it doesn't come in smoothly."

"Then what happened?"

"The boxing business got dull around here in San Francisco, and early in 1917, I had to go to Salt Lake to get some fights. When I came back ten days later—I fought three times in ten days—she'd left the

place I'd rented and was living in some other apartment with her brother. I asked her to come back, and we moved up to Seattle, where I got work in a shipyard. Then she told me she wanted to go on to Yakima to visit her mother. She wanted to go there by herself."

"And she did?"

"That turned out to be good-bye." Dempsey said he lost track of Maxine for months until finally her mother told him she was working in Illinois. He sent several money orders and wrote letters. Maxine cashed the money orders. She never responded to the letters. When Dempsey at last accepted the situation as hopeless, he wrote Maxine that he felt she had deserted him and he wanted a divorce on those grounds.

"Did Maxine respond to that letter?"

"Yes. She wrote or her friend Beulah wrote to me for Maxine. I should go ahead with the divorce, if I wanted." Dempsey's voice dropped. "Maxine," he said, "just didn't care. She didn't hate me. She didn't love me. She didn't care." Dempsey's tenor trailed off as his sad marriage had trailed off, into nothingness.

Lieutenant John F. Kennedy, straight-backed, sandy-haired, and handsome, appeared as the final defense witness. Kennedy was serving as a gunnery officer aboard the *Mississippi,* a thirty-five-thousand-ton battleship armed with twelve sixteen-inch cannon. Each could hurl shells the weight of a sports car twenty miles. The *Mississippi* was at sea when Dempsey's trial began. McNab placed a call to Joe Tumulty and an order went out from SECNAV [the secretary of the navy] directing the battleship to come about and make full speed for San Pedro, near Los Angeles. From there Kennedy proceeded by train to San Francisco. "We were all concerned," Teddy Hayes said forty-seven years later, "that if that big battleship proceeded toward the Golden Gate, she might run into one of those San Francisco fogs and get stalled out there indefinitely. There wasn't any radar back in 1920. San Pedro was the safer port to head for."

Guided by Preston, Kennedy said that in early October 1918, Dempsey put on a boxing exhibition for sailors at Great Lakes Naval Training Station. After that Dempsey said to Kennedy, "All I see

around here are fellows in uniform. If there's any way that I can get into service and have my family looked after, I want to do it."

Kennedy explained that the government issued living allotments to dependents.

"Then sign me up," Dempsey said. "I'm going in."

Kennedy suggested that Dempsey become a navy "artificer," the navy title for those who teach specific crafts to enlisted men. "Artificers work under their own set of rules," Kennedy said. "You can skip the usual training and get right over to France." As a World War I serviceman, Dempsey was going to coach and lead the U.S. Navy's European boxing team.

Dempsey signed papers. The men shook hands. "This will take time," Kennedy said. Release forms from Dempsey's draft board did not arrive until November. Josephus Daniels, the secretary of the navy, ordered enlistments stopped on November 11, Armistice Day.

"Was there any talk of the war ending when Dempsey first approached you about enlisting?"

"No, sir. None at all. Jack said that he thought the war was going to last a long time, and that he didn't want to be left out, and now that he knew that his family would be looked out for, he didn't care what became of him."

Thomas cross-examined Kennedy with great heat. "You spent the war at Great Lakes?"

"Yes, sir."

"You saw no action overseas?"

"No, sir. I did not."

"You're a bit of a slacker yourself, Lieutenant Kennedy."

One juror gasped. An assistant whispered to Thomas that this line of questioning was not going well.

"This witness is excused," Thomas told Judge Dooling.

Gavin McNab was so confident that he announced that he would not address the jury. "The facts are clear. I have no wish to detain these fine people further." Rattled by the blunder with Lieutenant Kennedy, Thomas said he felt no need for a summation, either.

"The question for you to consider in its basic aspect," Dooling

told the jury, "is whether Jack Dempsey sought to avoid military service by falsely answering certain points in the questionnaire and whether, if false statements were made, these were made knowingly and willfully. Everything else you have heard in this court is merely auxiliary to the principal issue."

The jurors repaired to their conference room. They returned within seven minutes.

Not guilty.

———

In New York the press was reporting that the Enrico Caruso home was "infested by the Black Hand." A "positively identified" member of the Black Hand managed to make himself present when police were interrogating Mrs. Caruso's personal maid, Henriquetta. "The maid talked freely," said an insurance company detective, "until this individual made a surreptitious signal. Then she shrieked in terror and she fainted. When we revived her she refused to answer any more questions." But when police made their arrest the next day they charged not a Sicilian Mafioso, but one George Fitzgerald, Caruso's chauffeur for seven years.

Joe Tumulty issued a statement in Washington that President Wilson would "not seek a third term." In Marion, Ohio, preparations began to have the high-school band in which Warren Harding once played trumpet welcome home the Republican nominee. General John J. Pershing said that if the Democratic party nominated him for president it would be his solemn duty to accept. Al Smith, moving up in New York Democratic politics, said, "I could beat Harding running on a laundry ticket." Smith would not be the nominee. Prejudice ran strong and he was Roman Catholic.

Disturbing random violence plagued the country. A mob of five thousand in Duluth, Minnesota, lynched three black men who were being held at police headquarters on the charge that they had raped a white woman. The mob attacked the police station with bricks and

rocks. The police did not fire a single shot in defense of their prisoners. "We were simply overpowered," said the police chief in what he tried to pass off as an explanation.

Mrs. Jack Dempsey simmered with fury. "I'm going to publish Dempsey's letters myself," she said. "I'm going to show the world what sort of man he really is."

"Do you have any other plans?" a reporter asked.

"No, no. I have no plans for the future. I'm leaving tonight for North Yakima, Washington, to make my home temporarily with my mother, Mrs. Adeline Cates. That's the only plan I have."

The press clamored for a statement from the champion. "All I can tell you," Dempsey said, "is that right now I'm the happiest boy in the world."

The *Chronicle,* which had campaigned so hard to put Dempsey on trial, now berated the federal government "for spending $80,000 of the taxpayers' money" to try a bungled case.

The cast dispersed. Hyrum and Celia Dempsey returned to Salt Lake City, where three years later they divorced. Kearns headed east to hunt down "major money" for Dempsey's next fight.

The champion himself drove to Hollywood with Teddy Hayes and rented a small apartment on Van Ness Avenue. The Stutz Bearcat was gone. He was driving a secondhand Marmon. "We'll loaf on the beach and take it easy for a few days," Hayes said. "You know they're going ahead with *Daredevil Jack* again. That will bring in some money. Kearns will get you a helluva guarantee for your next fight."

"Fight?" Jack Dempsey said, throwing a hard look at his trainer. "What are you talking about, Teddy? I don't know if I'll ever fight again. If this is what it means to be heavyweight champion of the world, I don't want the fucking thing."

Dempsey was still confused by Maxine. He really loved her. Into old age, he remembered how she looked at the piano in the Salt Lake City lounge, how she looked and how her breasts pressed against her

blouse and how she brushed her bust and how her nipples were erect before she said across the piano, "Hiya, stranger. I'm Maxine from Maxim's. And who are you?" A line from a B movie, perhaps, but that's what Dempsey told me he remembered. He remembered that first encounter almost every day of his life. He had lost her. She said she didn't hate him, but look what had happened. He had been branded slacker, white slaver, rapist, wife beater, and "lying, devious Levantine kike." And he had lost his girl.

The thirty-five Dempsey letters have disappeared. Dempsey never discussed the contents; some must have been angry. Maxine, whom he loved, with whom he was infatuated, walked out on at least three occasions. It is probable that these multiple rejections fed a rage. Anger is a common immediate reaction to desertion. As one clinical social worker and therapist, Katharine Colt Johnson, points out, "Anger actually may be useful in that situation as a protective mechanism. It masks various other emotions which for the time are simply too excruciating to deal with." What became of the probably angry letters, then? The most reasonable theory is that Kearns and Rickard bought the letters from Maxine and destroyed them in hot haste. Burned the letters and sank the ashes into a deep Pacific hole.

Sometime after the trial Maxine Cates Dempsey resumed a life of prostitution. When a brothel in Juarez, Mexico, caught fire, she was trapped in an upstairs bedroom, and her tempestuous existence came to an end. She burned to death. The year was 1924. Maxine was forty-four years old.

Book
Two

LOSER AND STILL CHAMPION

6 Pilgrimage

Dark hills at evening in the west,
Where sunset hovers like a sound
Of golden horns

—EDWARD ARLINGTON ROBINSON

ONE GETS A SENSE OF THE TRANSIENCE of things in Colorado, 1895, the year of Jack Dempsey's birth, from the story of a particular construction mounted on five acres of plateau near the high-mountain mining town of Leadville, southwest of Denver. That year Leadville merchants erected a fifty-foot-high medieval castle with walls said to be eight feet thick. Visitors who entered found a dance hall, a skating rink, restaurants, peepshows, and glittering displays of ore. But by 1896, the Leadville Castle was gone. It walls had consisted entirely of slabs of ice.

"Leadville," proclaimed a Boston visitor named Charles Francis Adams, is "an awesome spectacle of low vice." At its booming peak, the community numbered fourteen thousand inhabitants. The *Leadville Chronicle* reported that this populace was served by 118 gambling houses, 139 saloons, and 35 brothels. Silver brought men to the place called Leadville. To the east, near both Colorado Springs and Denver, rich veins of gold ran under the uplands. South at Telluride and

Ouray the earth bore a mix of both metals. Prospectors who filled the gambling halls and bars and hired prostitutes called "Straight Edge," "Contrary Mary," "The Irish Queen," and "Slanty Annie" had a common dream—to find the Mother Lode, that mythic heartland where all the earth's veins of precious metals run together. In time the Mother Lode came to bear the Spanish term meaning the gilded: El Dorado.

The United States acquired most of Colorado in 1803, when Thomas Jefferson's deputy, James Monroe, negotiated the purchase of the Louisiana Territory from Napoleon. The emperor thanked Monroe by presenting him with a huge alabaster bust of himself. To this day the bust—Napoleon's business card—dominates the living room of Monroe's historic modest Virginia home.

In June 1806, a party of sixteen to twenty soldiers marched west from St. Louis under orders to explore the tract President Jefferson had acquired. The commanding officer was a young lieutenant from New Jersey named Zebulon Montgomery Pike. In the words of the Colorado historian Marshall Sprague, "Pike's ignorance of the new American West was total." He and his men carried only light summer uniforms. Pike believed that he would finish his survey in three months.

By November 15, the party was still walking west, making its shivering way across high plains. On November 23, from a bank of the Arkansas River, they first saw the Front or Rampart Range of the Rocky Mountains. To the northwest rose an unforgettable vision. Lieutenant Pike guessed that this towering mountain was about as high as Appalachian ridges he had seen in Pennsylvania, perhaps four thousand feet. But a full day's march did not seem to bring the mountain any closer. It took two weeks to tramp to its base. The summit actually is 14,110 feet high and, of course, no mountain approaches that altitude in Pennsylvania or anywhere else in the East. (The highest point in Pennsylvania, Mount Davis, is 3,213 feet above sea level.)

Attempting to climb his newfound mountain, Pike followed a wrong trail. That led him to the top of a high promontory, but the

one next door, now Cheyenne Mountain. Pike never did ascend his great discovery.

Zebulon Pike's shortcomings did not include a lack of courage. Through a biting Rocky Mountain winter, he and his men lived off the land. They shot bear and other game and made themselves fur clothing. The winter sun of the Rampart Range, which today tans oiled and goggled ski buffs, burned blotches on their skin. Frostbite crippled two of Pike's soldiers. Still Pike continued to explore, proceeding generally southwestward As the temperatures moderated late in February, a contingent of Spanish soldiers surrounded and captured Pike's party. The Americans were arrested on the charge of invading "New Spain." Pike was not repatriated until July 1807. Three years later a Philadelphia firm published his book, *Account of an Expedition...and a Tour through the Interior Parts of New Spain.* It sold well and was translated into three European languages.

Pike was promoted to captain and by the War of 1812 he had risen to colonel. Leading American troops in a charge against York— now Toronto—he was struck in the head by a large rock blown into the air by British soldiers, destroying one of their magazines. Pike died on the battlefield at the age of thirty-four, seven years after discovering what became the great symbol of Colorado and the most famous mountain in the United States.

Not many followed Zeb Pike's trail to Colorado. The country was severe and the winter storms were deadly. In small numbers, fur traders, trappers, and adventurers, fewer than a thousand in all, went West. The names of Kit Carson and Jim Bridger live on. But Colorado was sparsely populated on the January day in 1859 when a lanky red-bearded prospector named George Jackson thawed a frozen streambed and panned gravel in Clear Creek, thirty miles west of the new community called Denver. His pan sparkled with heavy yellow flakes. He had found gold. Jackson wrote in his diary, "I dreamed of all sorts of things—about a fine house and good clothes, a carriage and horses and everything you can think of. I had struck it rich! There were millions in it." In fact, the Clear Creek strike

yielded more than $100 million in gold until it played out sixty years later, shortly before Jack Dempsey took on Jess Willard.

The rush for gold and silver in Colorado began with a surge of one hundred thousand Americans just before the Civil War. An enterprising journalist, D. C. Oakes, published a guide for gold-seekers that circulated extensively and made him a relatively easy fortune. The journey to Colorado was not taxing, Oakes maintained, and so much gold lay in the soil around Pike's Peak that to find it, you had only to stick a shovel into the ground. Gold was so plentiful you could pull it from the earth with a pitchfork. And the mountain streams and creeks, just about all of them, were rivers of gold. Just pan the gravel.

In fact the way west beyond the Mississippi and the Missouri was a daunting, terrifying journey of six to seven hundred miles for a family riding a covered wagon behind a yoke of oxen. People cheerily painted their wagons with the slogan "Pike's Peak Or Bust" and rode out toward disaster. Wagons broke down on the endless plains. When there was no longer enough grass to sustain the animals, the oxen starved. Families ran out of food and water. Some perished in botched river crossings, or were trampled to death by stampeding buffalo. As Hollywood reminded America so often in later times, hostile Plains Indians were a persistent menace. Looking backward, we realize that the riches of the West, the gold and silver and copper and coal and oil, belonged to groups called Utes and Arapaho, Sioux and Cheyenne. To them, the people we call pioneers were something else. Invaders.

About half the venturers gave up. They never reached the Rockies. These were called "Go-Backers." Some, in bitter humor, painted over the old defiant wagon slogan with a single word. Busted. Others left dummy tombstones along their trail back east. One bore the epitaph:

HERE LIES THE BODY OF D.C. OAKES,
KILLED FOR AIDING THE PIKE'S PEAK HOAX

But there was indeed precious ore to be found in Colorado, and by the 1870s Colorado had replaced California as the leading pro-

ducer of gold in the United States. People everywhere heard about the Leadville storekeeper Horace A. W. Tabor, originally a Vermont stonemason who gave a seventeen-dollar grubstake to two prospectors in 1878. A year later Tabor sold his share of the mine they found for $1 million.

In West Virginia, a gaunt, weathered man brooded and drank a bit of whiskey. His family had known better times. Hyrum Dempsey was tall and lean at six-feet-one and 150 pounds. He was also willful and moody. Hyrum's father, "Big Andrew" Dempsey, had been a major landowner in Logan County, West Virginia, coal and timber country that runs up to the border of Kentucky. Big Andrew was county surveyor and he possessed sufficient means to send Hyrum off to college—no one is certain which one—for a time. Hyrum tried to teach reading and writing in a Logan County grade school. He hated it. Then he turned to the rolling land his father had given him, three hundred acres of timberland, all his own.

In 1868, Hyrum married Mary Celia Smoot, the slight, blue-eyed daughter of a Virginia shopkeeper. The precise genealogy remains vague; written records vanish—these people were neither royalty nor aristocracy—and Dempsey offered different versions of the family background across his long life. When he was helping me write a magazine article in 1958, he said, "Our family was pretty strongly Irish, with Cherokee Indian blood on both sides and a Jewish strain from my father's grandmother, Rachel Solomon." In a memoir prepared with his stepdaughter, Barbara, when he was past eighty, he makes no mention of the Jewish strain. But he talked of it so often when younger that his second wife, the soubrette Estelle Taylor, devised an unusual pet name for him: "Ginsberg."

One theory holds that Dempsey's response to charges during the slacker trial that he was "a devious Levantine Jew" was to say, in effect, "I will be Jewish and be proud of it." That would have been very like the man. Another theory insists there really was a Jewish strain. Whatever, Estelle Taylor called him Ginsberg. When last I saw the champion in his penthouse apartment around the time of his eightieth

birthday, he had grown rather bumbling and the Dempsey memory, once focused like a laser, was failing. I like to think—no one can be dead certain—that Rachel Solomon was a real person who faded only with the fading of Dempsey's formidable memory.

Hyrum and Celia had their first two children in West Virginia. In about 1880—the Colorado silver rush was in full flight—an itinerant Mormon preacher passed through Logan County. His was a fine religion, the preacher said, where everyone looked out for everybody else, and it was flourishing in the West, a new land, where everybody had a chance to start a new life. Dempsey said, "This was as if my father heard voices. He became a Mormon on the spot. Then he sold his timberland for a dollar an acre and bought a covered wagon, piled the family in, and started West. My father had no head for business. Years later when he found out the Logan County land he sold was rich with coal, he took us all the way back east and started suing mining companies. Then he said he found out he had been left another twenty-five hundred acres of West Virginia in my grandfather's will, and that land really was worth a lot more. That land would be our El Dorado. Except before my father got around to claiming it, the tax collectors impounded every inch. My father told me a lot of stories and they always ended with hard luck. He never struck gold or silver. He never won a lawsuit, either."

As Dempsey heard from his mother, the wagon trip west was harrowing. The plains were dry in 1880 and the frequent carcasses of horses and dried skulls of oxen frightened Bernie and Effie, the first two Dempsey children. Dust storms lashed the wagon. When the water ran out, Hyrum stopped and dug a well. If he found water, he rested for a time. If he didn't, he pressed on and dug again. On this trip or another (family accounts differ), Hyrum drove off a marauding grizzly with an axe. The Dempsey's covered-wagon voyage is not unique. It moves one to respect the bravery and the persistence of pioneers, setting out through wilderness for places unknown, nursing parched children, fighting grizzlies with axes, armed primarily with hope.

Manassa, in south central Colorado, was founded by Mormons during the 1870s. It was rather bland country for the West, rolling rather than mountainous, though more than seven thousand feet above sea level. Game was abundant. The Conejos River ran nearby. The Dempsey family joined the Mormon community in Manassa, built a two-room cabin, and began farming. The soil was dry and clumpy but you could grow alfalfa and potatoes. In 1895 Hyrum Dempsey named his ninth-born child William Harrison, after the ninth president of the United States. The new baby increased the population of Manassa to 643. The Rio Grande Railroad was laying a track the year Dempsey was born, but as yet Manassa was a town without a train station.

Dempsey recounted a story from Mormon Manassa that suggests, in a Calvinist sort of way, that his boxing career was predetermined. On a biting winter day while Celia was pregnant with William Harrison, who became Jack, she heard a knock on the cabin door. A peddler stood outside. He had seen smoke from the wood fire that crackled in the cast-iron potbellied stove. The peddler meant no harm. He asked only to warm himself for a few minutes. Celia took him in, fed him hot soup, and let him nap under a blanket beside the stove. When the peddler awoke, he offered Celia Dempsey a gift. She could take anything she wanted from his sack. Celia liked to read. She chose a book. The peddler thanked her and moved on. When Celia blew dust off the jacket, she saw that she had selected a biography: *The Modern Gladiator, Being an Account of the Exploits and Experiences of the World's Greatest Fighter, John Lawrence Sullivan, Samson of the Prize Ring.* This extraordinary work, both quaint and curious, was published in 1889 without an author's byline by the Athletic Publishing Company of St. Louis. It is a golden realm of bare-knuckled boxing lore.

There are accounts of Sullivan's fast knockouts and a detailed report of his hard-won victory over Jake Kilrain at Richburg, Mississippi, on July 8, 1889. That fight lasted seventy-five rounds; Kilrain could not come out for round seventy-six. (Under the so-called London Prize

Ring rules a round lasted until one fighter went down. An accepted defensive tactic was for a boxer under attack simply to drop. Still, as noted earlier, Sullivan and Kilrain battled in the Mississippi summer heat for two hours and sixteen minutes.)

Sullivan, "the Boston Strongboy," was no mere boxer, the reader learns. He also emerges as a classicist. "If he has been reported at times quoting [ancient] Greek," the author writes, "there is nothing surprising in it, since Boston scholars can do that as naturally as they take to beans." Finally, Sullivan is often seen defending those less fortunate with power and compassion.

"I happened to meet John L. Sullivan in a barber's shop where he was being shaved," the author reports.

> Just inside the door a cripple had a little boot-blacking stand. The man occupying the seat was considerably under the influence of liquor [and refused to pay for his shine].
>
> The little cripple touched him on the arm and said, "Say, mister, I can't afford to black your boots for nothing."
>
> Rudely the drunken loafer pushed him to one side, and the puny limbs of the little crippled bootblack bent beneath him as he fell to the floor. With one stride and a sweep of his hand, Sullivan had the ruffian by the neck. "Here you d———d whelp, pay the boy. Pay him, I say." He made the fellow disgorge not once, twice but three times the price of the job. Then he dropped the trembling fellow as a man would drop a strangling dog to the floor.

Celia later told Jack, "It was fated for you to become a boxer. I read and reread that book about John L. so many times while waiting for you to be born." By his mother's testimony Dempsey weighed eleven pounds at birth. Right from the start he was a heavyweight. The attending midwife charged the Dempseys twenty-five cents.

On June 24, 1895, the day Jack Dempsey was born, during Grover Cleveland's second term as president, America was still discovering

itself. Colorado, which had become the thirty-eighth state in 1876, lurched into an uproar of mining booms and busts, miner's strikes and mine owners' brutal and casual slaughters. Photographs survive of private armies maintained supposedly to keep order, and in practice employed to gun down union men. "Three dollars a day," the mine barons said in effect, "for ten hours or twelve. You'll live in our houses, buy in our stores, and do what you're told. If you don't like it, ten immigrants back East are ready to take your job." Touring one deep gold mine, Ulysses S. Grant said, "This is as close to hell as I hope ever to find myself."

Miners who protested for shorter hours, better pay, and safer conditions underground risked their lives up top. One typical private army, the Silver Queen Guards—employed by the owners of the Silver Queen Mines in Georgetown, thirty miles west of Denver—was better uniformed than the U.S. infantry, and at least as formidably armed. Massacres of union men bloody the pages of history. Dempsey's later populism and passion for social programs such as Franklin Roosevelt's New Deal persisted after he had become a multimillionaire. He said he never forgot, nor did he want to forget, the ferocity with which the mining barons treated working men and their wives and children.

During the early gold strikes, few prospectors bothered to follow up on traces of white ore. The price of silver was one-sixteenth the price of gold. But when a find near Georgetown assayed at twenty-three thousand dollars of silver per ton in 1870, a silver rush began. Investors in Georgetown silver included Jay Gould, the railroad tycoon; Marshall Field, the Chicago merchant prince; and P. E. Studebaker, who later manufactured automobiles. The Guggenheim family and Bernard Baruch are among others who built fortunes speculating on Colorado's "noble metals."

Silver turned out to be riskier stuff than gold. The so-called greenbacks, paper money issued after the Civil War and backed only by federal credit, proved unstable; the greenback dollar fell steadily until its real purchasing power was one-third that of a gold dollar. In

1879, the U.S. Treasury agreed to exchange greenback dollars for coins, in theory either gold or silver. The move was meant to stabilize American currency. For a complex of reasons, including pressure from big European banks, the treasury took in the greenbacks as agreed, but gave back only gold. Then in 1893 the U.S. government stopped coining silver altogether. Bimetallism disappeared. The country embraced a de facto gold standard.

The Colorado silver boom continued briefly, but soon silver fell from almost two dollars an ounce to less than a dollar. It rallied, fell, rallied, fell and collapsed to fifty cents an ounce in the panic of 1893. Suddenly it cost more to get silver out of the earth than the silver was worth in the open market. Unable to make a profit, mine owners closed down. The gaudiest mining king, Horace A. W. Tabor, called the Carbonate Croesus, had earned $42 million in two decades. Now Tabor went bankrupt.

Some miners cheered. But as the mines shuttered, jobs disappeared. The solution, for Colorado, for the nation, many felt, was a return to bimetallism. Mint coins of silver as well as gold. Back paper currency with silver as well as gold. The big eastern interests, increasingly allied with European banks, remained intransigent, and the gold standard continued to work a terrible hardship on Colorado and other areas of the West. That was the frame within which William Jennings Bryan stood at the podium of the Democratic National Convention in Chicago and delivered the most famous of American political speeches. "You shall not press down upon the brow of labor this crown of thorns. You shall not crucify mankind upon a cross of gold."

The year was 1896. In November William McKinley, an Ohio lawyer, won the presidency from Bryan by more than half a million votes, and by a margin of 128 in the Electoral College. William Harrison Dempsey was sixteen months old. McKinley appointed the bankrupt Horace Tabor postmaster of Denver, a thirty-five-hundred-dollars-a-year job. In gratitude Tabor wept. When Tabor died three years later, his last words to his wife, the beautiful and lubricious

Baby Doe, were: "Hang on to the Matchless Mine. Silver is coming back. It will make you rich again."

It never did.

Poor Hyrum Dempsey was unsuccessful even as a gypsy. There was no silver, no copper, no gold, around Manassa, just high plains with the Rockies rising twenty miles west. The village itself was 7,953 feet above sea level and the annual precipitation averaged six-and-one-half inches. Men did not get rich farming the dry high plains, but Hyrum told himself he had not come West for riches. He had come West to make a new life in a new faith. Like his son, Hyrum retained a stated respect for Mormon principles all his life, but he found church rules against drinking and carousing impossible to follow. Nor did he do well with the articles of Mormon faith that required diligence in helping others who were more needy. Hyrum regarded few as more needy than himself. The Mormon theology held few in the Dempsey family for long. In 1919, Florence, the third of the Dempsey children, told an interviewer, "I've become a Catholic myself. Far as I know, nobody else in our family has any religion at all." It was as if the Dempseys had made a perilous overland crusade to faraway Nazareth but decided after arriving that they didn't want to be Christians after all.

Whether Hyrum actually owned farm land in Manassa is uncertain. Dempsey said, "My father was pretty much a day laborer, on the days when he felt like working. He was a farmhand. He hammered in ties for the railroad. He swung a pick. He took whatever came along. He was a pretty strong drinker when he had money to buy whiskey and he was a pretty strong drinker when he didn't. I remember he liked to play the fiddle. My father played 'Turkey in the Straw' so often that we thought it was the national anthem."

As Hyrum's religious faith waned he fantasized about finding wealth, rather than God, in get-rich-quick, boom-or-bust Colorado. Drinking, restlessness, and the pursuit of young women dominated his days. He was a marginal man, the son of a prosperous father and

the father of a prosperous son. Hyrum Dempsey lived to a great age, ninety-two; for all those years wealth was only a dream.

The Mormon families in Manassa helped one another. Village elders regularly checked every family's food stocks and replenished the most meager. No one went hungry in communal Mormon Manassa, Colorado, not even that fiddling, drinking idler Hyrum Dempsey. "If you look back at it today," Dempsey told me in a luxurious apartment hotel suite where he was living between marriages in 1960, "you might say my boyhood was deprived. No toys. Real responsibilities almost from the beginning. Having to work so young. I helped with the food gathering before I was eight years old."

The tame green of Central Park stretched out beyond valenced windows. "Some would say, Champ," I suggested, "that you had no childhood at all."

"Nonsense. It was terrific growing up in the Wild West. I learned to shoot, not for fun, but for food. I liked to go with my father on hunting trips. Sometimes he'd run out of ammunition, but there always was plenty of game. I learned how to set traps. I could follow deer tracks through scrubby brush. I fished in the Conejo River. That was for food, also, but I loved fishing. I could handle horses before I was ten. Sure I had a childhood, but different from most around here. It was as if I grew up in the middle of a Wild West cowboy movie."

Hyrum Dempsey left Manassa in 1902 or 1903 convinced that the place, like Logan County, West Virginia, was unlucky. "All the kids were upset," Dempsey remembered. "Manassa was what we knew of home. There was a Mormon church in town with a white steeple. That was the tallest building I'd ever seen. We thought it was beautiful. But my father had his mind made up. Move on. No plan, really. Move on. Move west up and out toward the Continental Divide.

"We stopped in little towns. My mother heard there was work running a boarding house in Creede. That was in Mineral County, eighty miles from Manassa. You did good making ten miles a day in a covered wagon. We stayed in Creede for a spell and moved on to a

place called Uncompahgre [a name derived from the Ute word *anca-pogari,* meaning red lake]. Then in the winter my father decided to head on up to Leadville. He heard there was a lot of money to be made. That was a terrible trip. Snow all around. We were always going higher. My mother got dizzy spells and fainted. She was a strong woman but the pains in her stomach made her cry out. Then one of the wagon horses—pushed too hard—suddenly lay down on his side and shuddered and died. My sister Elsie cried and cried. It was cold and there were blizzards and we always had to be careful of frostbite, but the worst was having Mother sick. She was the one we counted on. I was helping look after Elsie and Bruce. I was maybe eight years old."

Hyrum at last became alarmed. Celia's illness, he suspected, was a form of altitude sickness. Jack later disagreed. "It wasn't just the altitude that got my mother feeling so sick. My father had a lot to do with that also."

One of the older children, Florence, had moved to Denver—some four thousand feet lower than Leadville—and Hyrum agreed to send his wife there. He dispatched her and the youngest children, Elsie, Bruce, and Harry, who would be Jack, with one ticket. Celia Dempsey boarded the train with a single ticket and three kids. For the rest of his life Dempsey remembered the burly red-faced conductor who said, "You can go to Denver, lady, and so can them two small ones, but this one over here [Jack] looks big. You got to pay half fare for him."

Celia's purse was empty. She wept and begged. She had been ailing. Once in Denver she would get money from her daughter and pay for the necessary ticket. The conductor snapped, "I've seed enough of your kind. Pay the fare when I come back through this car, or I put the boy off at the next station."

Meager circumstances hadn't bothered Dempsey in the little settlements where everyone was struggling. But here he felt humiliation. He became suddenly aware that his clothes were threadbare and that his hand-me-down shoes were stuffed with paper. What

would happen to him if he were thrown off the train, an eight-year-old alone at some unknown station? Suddenly, as if this were a legend, in that ancient railroad car rattling down a single track in high country, a paladin materialized. He was a cowboy, splendidly clad—at least in Dempsey's memory. He wore a pearl-handled pistol at each hip. Silver spurs gleamed on his polished boots.

"Don't worry, sonny," the cowboy said. "If it comes down to it, I'll pay your fare."

Tears welled up in the boy's eyes. When the beefy conductor returned, the gleaming two-gun cowboy shot him a look of such withering outrage that the man simply kept walking. That was how four Dempseys traveled from Leadville to Denver on a single ticket.

By nightfall William Harrison Dempsey was promising himself that when he grew up, he would become a cowboy and sport pearl-handled pistols of his own. It was two more years, maybe three, before he changed his ambition and decided to become heavyweight boxing champion of the world.

Hyrum Dempsey, who had problems living with his family, found life alone even more difficult. "My father got a real fright," Dempsey said, "that my mother would stay away permanently. Mother's health improved pretty quickly in Denver, and that gives me a turn when I think about it. She gets what my father calls 'altitude sickness.' Where does he send her to recover? To the Mile High City. But pretty soon, away from my father, she felt fine again. She must have had a dose of 'Hyrum sickness.' Anyway, my father started sending messages. Come back."

Mary Celia Dempsey decided to return to her husband, who was now working as a laborer in Wolcott, fifty miles west of Denver. This time she would travel, and no nonsense about it, only with a ticket for herself *and* with a half-fare ticket for Jack.

Hyrum sold his surviving horse and wired ample ticket money to his wife. Almost as soon as Celia rejoined him, however, the wandering started again. From Wolcott north to Steamboat Springs. Next

west to Meeker. Then to a town called Rifle. Finally a three-hundred-mile journey south to Delta and just a few miles farther to a Colorado railroad town called Montrose that pioneers named for the protagonist of Sir Walter Scott's novel *The Legend of Montrose.*

Scott told a story of struggle between Royalists and Parliamentarians during the reign of Charles I in seventeenth-century England. This was remote from the American West, but some settlers felt that the rolling southern Colorado hills resembled the rolling Scottish hills in the domain where the marquesses of Montrose flourished. To Jack Dempsey, Montrose, with its railroad station and its storehouses where farmers brought their produce, was a large and sophisticated city. The population in 1905 was 2,134, but that was big enough, Dempsey said, so that "when I wanted to fight, I could always get somebody to fight with me."

Dempsey remembered these vagabond years as a series of cramped cabins, each very much like the last. His mother traveled with a sampler. On a succession of bare walls hung words from Thomas Carlyle:

> MAKE YOURSELF AN HONEST MAN
> AND THEN YOU MAY BE SURE
> THERE IS ONE RASCAL LESS IN THE WORLD

Always—"from the time I was seven or eight"—Dempsey was sent out to work. He was a farmhand in Steamboat Springs, a coal hauler in Meeker, a shoeshine boy on the streets of Rifle. Elsewhere he chopped trees and cut them into stove-length sticks of wood.

With a father who had been a schoolteacher and a mother who read books, Dempsey grew up amid a certain amount of culture. Colorado's public-school system dates from 1861 and by 1903 more than 92 percent of the children in the state were enrolled as students. But with the family's constant shuttling about, Dempsey's early education was haphazard. He loved tracking, hunting, fishing, the outdoors. To a western child of those inclinations, a classroom can have the feel of

a prison. At least, Dempsey said, that's how the classrooms seemed to him.

He was exposed to grade school on a few occasions, but for the embattled Dempseys bringing home dollars was the most important activity, even, or particularly, for a child. It is not clear whether Dempsey learned to read or write in one of his brief sessions at school, or whether his mother taught him at home. But he developed a rough-hewn literacy and in later years became a master storyteller.

His oldest brother Bernie, sometimes called Barney, developed into Dempsey's family hero. Bernie was the first of three Dempsey brothers who tried boxing. He left home when the family still lived in Manassa and worked in the mines and became a determined mining-camp boxer. But not a good one. "Bernie could move and hit pretty fair," Dempsey said. "He couldn't take a punch. He had what the sportswriters call 'a glass jaw.' Soon as he took a good shot, down he'd go. Bernie fought a lot of very short fights."

Bernie was brown-haired—"the one and only blond and blue-eyed Dempsey," the champion liked to say. While mining and fighting around Colorado, Bernie came home for stretches. He showed his kid brothers, Johnny and Harry, how to create a punching bag out of rags and sawdust, using a needle and thread. He taught them to make gum out of pine sap, and told them to chew and chew. That would toughen their jawbones, he said. He should have done that himself when he was younger.

Damon Runyon wrote a story in which Bernie came home to one of the Colorado towns and began to talk boxing with Johnny and Harry. He pulled a pack of cigarettes from his shirt pocket, and as he did a cardboard picture of Jack Johnson fell out. "The three brothers fought for it," Runyon wrote. "Harry, whom we know as Jack, won. He carried that card with him for several years. He wanted to be heavyweight champion and he was convinced Jack Johnson was the man he would have to defeat." Supposedly this happened when Dempsey, twenty years younger than Bernie, was eleven years old. The idea of an eleven-year-old child, even an eleven-year-old Jack

Dempsey, winning a brawl with a thirty-plus professional fighter is absurd.

But Dempsey did see that Jack Johnson card, and Bernie told him that people all over, miners, farmers, ranchers, said a white hope had to whip big, gold-toothed Jack Johnson and restore the supremacy of the white race. The words "white hope" struck home with William Harrison Dempsey. He wanted to fight. He liked to fight. He boxed regularly with brother Johnny. He decided, in one of those implausible and unquenchable fantasies that illuminate boyhood, that he would become America's white hope. From that day in 1905 until he knocked out Willard fourteen years later, Dempsey wanted to do only one thing: Win the heavyweight championship of the world.

Dempsey did not correct the Runyon story. He was always tolerant of the press. It was a harmless yarn, he reasoned, good copy. Why unravel it? Besides, he liked Runyon, a generally difficult and sarcastic character. Let it be. Soon others built on Runyon's account, and magazines and books brimmed with tales of the brawling Dempsey brothers mixing it up in every woodshed in Colorado. The fights started for fun, for grudges, for as many reasons as journalists could imagine. But it didn't matter how the fights started. They invariably had the same ending. The future champion won. By a knockout.

In 1920, closer to the time and to the truth, Dempsey told a reporter from the *Chicago Tribune:* "I never picked up anything much from Bernard. He was a fighter before I was born. I became a fighter after the time he was around enough to teach me anything.

"When Bernie came home and Johnny and I saw his gloves, we put 'em on and mixed it up. In the beginning, Johnny licked me regularly. Gloves. Bare knuckles. Whatever. I was too much a mamma's boy. You got no mamma in the ring.

"I don't know when that changed, but I guess I could focus better than Johnny. I focused on becoming a champion all the time. I did certain things and after a while Johnny, who was older, didn't want to fight me anymore."

Dempsey heard that boxers skipped rope for timing and rhythm.

He made himself a jump rope out of twine. Someone told him that nothing was better to toughen the fists than "a half-hour soak in horse piss." Stink be damned, every day Dempsey soaked his hands in a bucket of horse urine. Cuts could stop a fight. To toughen the skin of his face, Dempsey applied brine. The process was called "pickling your face." Word was that once a face had been sufficiently pickled, the skin could not be cut by boxing gloves. You wouldn't bleed.

A boxer needed speed. Spotting himself a lead, Dempsey ran races against farm and wagon horses. His hands were fast. They could become faster. He had Johnny run at him waving a broom handle back and forth. He practiced landing jabs and hooks against the handle. And wherever he was, wherever the roaming Dempseys paused, he hung his rag bag full of sawdust and practiced punching. One thinks of a Heifetz or a Horowitz, a prodigy whose childhood was an apprenticeship toward the art of the virtuoso. Gloves were Dempsey's fiddle and bow, his Steinway. Prizefighting was the art that he would master.

Montrose, on the western slope of the Front Range of the Rockies, was a major station on the Denver and Rio Grande Railway. Farmers and ranchers brought their crops and cattle to Montrose. Adding to the town's prosperity was work on the Gunnison Railroad Tunnel, a project that bored a route for railroad track through six miles of granite. This became a federal project with headquarters only eight miles from Montrose. Celia Dempsey grabbed fortune by the throat and opened a restaurant in Montrose, the Rio Grande Eating House. Tunnel workers were her core clientele.

Dempsey washed dishes at the Rio Grande, cleared tables, swept, and served railroad construction men the meals his mother cooked. He also had to attend school. There was no tennis or golf at the Montrose, Colorado grade school. But there was one sport the boys started up among themselves after classes: boxing matches. "Not brawls," Dempsey said. "Regular boxing matches. According to the rules as we kids understood them." Dempsey remembered two other families

in Montrose: the Woodses, whom he described as "white and poor like us," and the Pittses, "black and even poorer." His regular opponents were Fred Woods and Tommy Pitts, "about the same size as me." Like Dempsey, Freddy Woods and Tommy Pitts went on to become professional boxers. Their careers ended in obscurity.

When the Gunnison Tunnel was finished, the Dempseys closed down the Rio Grande Eating House. No more railroad construction meant no more customers. Hyrum moved westward into Utah and used the restaurant proceeds to buy a red brick house in the village of Lakeview, about sixty miles south of Salt Lake City. It was a pretty site, mountains to the east with wetlands and the expanse of Utah Lake stretching to the west. "Wetlands and mosquitoes," Dempsey said, "Biggest mosquitoes I ever saw lived in Lakeview. Welterweights, easy."

At Lakeview, the nomadic Dempseys found themselves back in a dry Mormon town. Hyrum idled and dreamed and drank smuggled whiskey. Jack shined shoes and swept out a barbershop and picked whatever harvest was in season. A quatrain by Sarah Northcliffe Cleghorn comments on child labor.

> *The golf links lie so near the mill*
> *That almost every day*
> *The laboring children can look out*
> *And watch the men at play.*

Dempsey retained a vivid memory of his days as a laboring child around Lakeview after the sugar beets came in. He'd crawl into a railroad car, loaded with beets "the size of basketballs," and pitch them into the wagons that carried the crop to a refinery, where the beets were cooked into sugar. Dempsey did not exaggerate. Sugar beets, as opposed to the red beets of borscht, are silvery white and the enlarged upper part of the root, the sugar beet itself, may weigh two pounds or more. He had to crouch in the freight car. The footing, on

mounds of large and slippery sugar beets, was wobbly. This Utah sugar-beet crouch, developed on vegetables shifting beneath his weight, was the origin, Dempsey maintained, of the famous boxing crouch he used when charging down heavyweights, from the forgotten Boston Bearcat to the man who actually did dethrone Jack Johnson, mighty Jess Willard. Dempsey's pay for unloading beets was ten cents a ton. On a good day he could unloaded twelve tons of sugar beets and bring $1.20 home to his mother in the red brick house.

He remembered the barbershop vividly because there he found copies of the *Police Gazette,* a weekly newspaper that covered crime, scandal and sports. Although Dempsey disliked formal classroom reading, he read and reread the *Gazette*'s boxing news and its stories of the old and coming champions—Bob Fitzsimmons, Philadelphia Jack O'Brien, Battling Levinsky, and the great middleweight Stanley Ketchel, who died on the morning of October 15, 1910, shot in the back by the common-law husband of the woman who was cooking his breakfast. Dempsey never forgot what Wilson Mizner, Ketchel's manager, said when they brought him news of the murder. "Tell 'em to start counting ten, and he'll get up."

It was an age as romantic as it was rugged. To a strong, athletic youngster out of the wide-open West, there was nothing quite so romantic as prizefighting and the epic lives and tragic deaths of champions. "My favorite boxer was Bob Fitzsimmons," Dempsey said. "Kind of a funny-looking old guy, I thought, getting bald, and not much more than one hundred seventy pounds. But they wrote that in his prime he could take out anybody in the world with one punch. I wanted to be able to do the same thing."

When Dempsey was fourteen or fifteen, Hyrum moved the family back to Logan County, West Virginia, in hopes of taking over the land that he had been willed. The family made the trip by train. Dempsey described the voyage as "awful" and called the town of Logan "cockroach poor." Hyrum spent months arguing with authorities, but the land was gone for good, seized for back taxes and now sold to others. While his father blundered about, Dempsey worked in

coal mines, drilling holes for powder, setting off small blasts, and shoveling the coal that came loose. "It was hard work and it was dirty and I loved it," Dempsey said. "Kids love dirt and kids love setting off firecrackers. That's kind of what I was doing underground."

Still poor, still vague, Hyrum moved back to Lakeview and there on June 20, 1911, Dempsey graduated from the Lakeview Elementary School. Four days later he reached his sixteenth birthday, and struck out on his own.

———

A poetic form that flowered during the Middle Ages set a young man wandering to seek his fate, his god, his savior, his grail, himself. This period was referred to as the years of pilgrimage. Sometimes, as with Galahad, the saintly knight, or Christian, the protagonist of *Pilgrim's Progress,* the voyager was devout. But not always. A pilgrimage may be sacred or profane, provided only that the wanderer is traveling for an exalted purpose. To sixteen-year-old William Harrison Dempsey, nothing was as exalted as the heavyweight championship of the world.

He assumed the boxing name of Kid Blackie. A vintage copy of *Nat Fleischer's Ring Record Book,* 898 pages of detail in fine print, reports simply, "Early records unavailable." Mostly, until 1914 or so, Dempsey was a barroom fighter. He was lanky with big hands and a dangerous, gliding walk that he said came from his Cherokee forebears. He was thin—130 pounds at the age of sixteen, he said, which is not entirely believable. The few photos that survive from the Kid Blackie days show a lean but muscular young man. Six-feet-one and 150 pounds is more like reality. The larger point is unassailable. Kid Blackie did not have the build of a brawler. That made finding boxing matches easy. He walked about, he walked the West, huge distances, and he remembered from his mother's book *The Modern Gladiator* one of the attention-getting tricks John L. Sullivan mastered. At five-feet-ten and 210 pounds, Sullivan *was* built like a

brawler. His famous, all-but-patented entry into a saloon led him belly up to the bar. There Sullivan declaimed in the loud flourish of his brogue, "I can lick any son of a bitch in the house." The man, the brogue, the build intimidated everyone, even drunks. Seldom, if ever, was Sullivan required to throw a punch.

Dempsey appropriated Sullivan's approach, with different results. He walked into unpleasant mining-camp bars and said in his high tenor, "I can lick anybody in the house." Takers swarmed forward. "For a buck," Dempsey added. Someone almost always wanted to take him. At sixteen and 150 pounds, he knocked out men a hundred pounds heavier. Describing himself years later, Dempsey said, "With that high voice I sounded like a girl. But I didn't hit like a girl." He'd fight and flatten a local tough, often someone who had been bullying others in the bar. The customers then passed the hat. This was how Dempsey made a living for many seasons, tramping into the nastiest saloons on earth and taking on barroom bullies.

In discussing these years with me, he said quietly, intensely, and without self-pity that it was hard, very hard, surviving as a freelance bar fighter, and that the life was dangerous as well. Some local toughs were pretty fair punchers. "Going for a quick knockout was just common sense," he said. "I had a little motto about getting rid of my opponents. 'The sooner the safer.'"

Dempsey had his crouch, his bob and weave, and he had learned to keep his jaw tucked inside his left shoulder and to carry his left high so that fist and forearm also guarded the chin. The majority of knockouts come when a punch to the chin drives the jawbone back toward the base of the skull, cutting off the blood supply to the brain. Usually the affect is brief and transitory. Most of the time most boxers are back on their feet before the count reaches ten.

Some later wrote that Dempsey had "a granite jaw." Perhaps, but his technique of keeping his jaw protected was so sure that across all his decades in the ring only once did anyone land a full-bore punch on his chin. Watching him charge at opponents produced an effect that Ray Arcel, a great trainer who was also a lover of A. E. Housman's

poetry, said was like "watching a volcano erupt. You can't believe the way Dempsey's charges excited the crowds." The charges were fierce but never careless. The fists moved with such speed that many opponents never saw the punch that knocked them out. The charging, snorting, scowling knockouts were the stuff of drama. Few noticed that even as Dempsey charged, he never left his own jaw exposed.

During the 1980s, a reporter named Toby Smith tried to retrace Dempsey's Colorado travels on assignment for the *Albuquerque Journal*. In Durango Smith found a mural of Dempsey standing over a fallen opponent at what may have been the Oxford Bar or the Gem Bar or the El Rancho Lounge. Nobody is certain anymore. Smith later expanded his work into a slim volume called *Kid Blackie*. Rounding up a variety of elderly eyewitnesses, Smith gives us a picture of the young Dempsey as confident, even swaggering. "Did I have a crush on Jack?" comments Susie Osborne, who lived in Uncompahgre. "Sure. I danced with him. Jack was a good dancer. We did the schottische. It's kind of like the polka. Did Jack have a girlfriend? Anyone he wanted. He was such a handsome boy."

Kid Blackie is a gentle book, but Susie Osborne contributes one observation that resounded through all Dempsey's boxing days. "The Jack we knew was peaceable. The Jack who got into that ring was downright vicious."

Dempsey's own account of his wanderings varied a bit, but always developed a hard and brutal edge. After leaving home, Dempsey worked as a "mucker," cleaning up and loading ore in a copper mine at Bingham County, Utah. A burly veteran threw dirt in his face, a kind of underground hazing, and dared Dempsey to respond. The two squared off. Other miners ringed them. A few made bets. Dempsey flattened the bigger man with a right cross. No one tried to haze him after that.

He fought his first professional fight in Montrose, date uncertain, probably 1913, against Freddy Woods, who had inherited a strong-armed build from his father, a blacksmith. Dempsey was passing

through Montrose, looked up Woods, and suggested that they box, the way they had a few years before. This rugged version of "Tennis, anyone?" went, "Hiya, Woods. Let's go back of town and fight."

"No," Woods told him. "I'm through fighting for fun. I have to get paid. We both ought to get paid."

"Sure," Dempsey said, "but who the hell is gonna pay us?"

"All you gotta do is dig up a promoter."

Dempsey tried the Montrose pool room without success. Woods then told Dempsey to promote the fight himself. Everybody remembered his mother's restaurant. "All you need is to rent Moose Hall. On credit. Then after the fight, you pay them off from the profits." Dempsey hustled about and got the little arena. He found a printer willing to run off tickets and a pianist who would play the sturdy upright in Moose Hall. The music was important. Dempsey wanted to advertise both a boxing match and "a refined dance."

On the night of the match, Dempsey sold tickets outside Moose Hall. When there were no more customers he walked inside, took off the trousers he wore over his boxing trunks, and hung them on a ring post. The receipts were in a pocket and Dempsey wanted the pants where he could watch them.

Dempsey remembered starting slowly. In the fourth round Woods hit him in the stomach and Dempsey doubled up and sat down. He got up at eight and instead of retreating charged Woods, weaving in, throwing left jabs and hooks and overhand rights to the face. A right hand knocked Woods unconscious. Dempsey threw a bucket of water over his fallen foe and started to put on his trousers. Woods came back at him, not realizing he had been knocked out. "Take it easy, Freddy," Dempsey said. "They got plenty for their money." He moved out of the ring and with some helpers pushed chairs from the center of the floor. Then the refined dance began.

"I paid Woods his fifteen dollars," Dempsey said. "After expenses I made almost thirty bucks. A fortune. Things didn't usually go that good."

The record books have him fighting his first professional bout as Jack Dempsey on April 5, 1915, in Salt Lake City. He lost a decision to Jack Downey; he would lose only three more times before the July day twenty-five years later when he finally retired from the ring. "I knocked out a fellow named Campbell in Reno three weeks later. I was always looking for fights, but a lot of times there weren't any fights. I kept moving around, doing hitches in the mines. They all had names, the mines. I worked at Golden Cycle, Highland Boy, and Golden Coin. Good work, but I wanted to be the heavyweight champion. I moved around. Sometimes you could bust into a boxcar to go from town to town, but the railroads hired detectives who were looking to use their clubs and crack your skull. And some pretty rotten stuff went on those boxcars." Dempsey was a tall and beautiful young man. He had to use his fists to beat off hoboes intent on homosexual rape "more than a few times."

Riding the rods was a solo adventure. They are the brake beams, the metal rods beneath a railroad car through which the brake shoes operate. No one who clung to a brake beam was in danger of molestation. But if he lost his grip he fell to the tracks and death. There was a solitary quality to Dempsey. He took his chances going alone, riding the rods.

In the summer of 1915, he walked fifty miles across Nevada desert, "hotter than a furnace," to fight a husky heavyweight named Johnny Sudenberg. "I walked because that was the only way to get from where I was to Goldfield, where there was a purse waiting if I could make my way over to where it was. Nobody thought I was big enough for Sudenberg but when somebody else backed out, the promoters got word to me that I could have a chance. They gave me an advance and I hired a sparring partner, a strong Indian, Kid Harrison. I trained hard and after I flattened Kid Harrison, I had to get another sparring partner."

This boxer, Roy Moore, also felt Dempsey's punching power but still suggested, "Don't slug with Sudenberg. He's awful strong. Stay away from him." Dempsey did not. By genes, by disposition, by

training he was not capable of staying away from an opponent. Dempsey walked into the ring and started to slug. Moore was right. Sudenberg was a powerful puncher. The two boxers stood in the middle of the ring, swinging as hard as they could, pounding each other. Dempsey told me that he remembered nothing after round five. "I guess I just kept swinging," he said. "Sometimes I think I saw a face in front of me. Sometimes I didn't. I kept swinging anyway." The fight went ten rounds to a draw, one long-forgotten bout in the furnace heat of Goldfield, Nevada, one more blaze in the fires that forged a champion.

What one sees of his life in these early years are impressionistic pictures, vivid, in certain ways disquieting, unique, and almost all crafted for us by Dempsey himself. His base, as much as he had a base, was Salt Lake City. He didn't smoke, except for an occasional cigar "to be sociable." He drank very little. To become champion, he had to stay in training every day.

Numbers of boxing men have insisted that fighters should live in chastity. I have heard otherwise rational trainers and managers argue that sexual intercourse seriously weakens healthy young athletes. Therefore they insist that during the entire period a boxer trains, he must avoid sex. The first commandment of old boxing men is clear: *Thou shalt not....* Intercourse *immediately* before a fight would be distracting and so questionable. But the night before? To mix sports here, I cite the great baseball man Casey Stengel, who said, "When they're young, it don't matter what they did last night. Just give 'em a glass of milk and they're ready to go." Other boxing men say that a fighter denied sex becomes mean "and that's what you want, one mean bastard in the ring." That would be more persuasive, except that some of the greatest and meanest fighters, from Steve Ketchel through Joe Louis, seemed to thrive on intercourse. The subdued postorgasmic mood wore off even as the lady finished her cigarette.

Dempsey loved women—"all my life I've loved women"—and he found them not at refined dances but in the brothels on Commer-

cial Street. He told Bob Considine, "I spent time with the girls from Commercial Street. They were, let's say, named for the street. We got along." He offered no names and would not be pressed. He had a courtliness about such matters. He said, "I knew some girls and I knew some madams and any time I needed a flop, the madams were glad to have me. If a customer got rowdy, I straightened the guy out."

This then was the life of teenage Jack Dempsey: fighting when he could get a fight. Working in the depths, or as someone fiercely put it, "a Caliban in the mines." Riding the rods. Sleeping in whorehouses. And, when there was no mining work, nor any fights, standing on a street corner. There he begged. In February of 1916, at the age of nineteen, Dempsey met Johnny Sudenberg again in Ely, Nevada. This time he knocked Sudenberg out in the second round. There would be setbacks after that, and pain. But now Jack Dempsey was moving, so slowly it was hard to tell, toward his bright dream and to his rendezvous with history.

7 Preliminaries

THE SLACKER TRIAL LEFT DEMPSEY dispirited and tentative. Teddy Hayes, the trainer, told him he had to resume fighting at once. Hayes repeated the boxing adage: "To rest is to rust." Doc Kearns informed reporters that he was about to sign Dempsey for a rematch with Willard "if the big guy ain't scared to show up." Alternately, Kearns said he would be sending Dempsey into the ring against Georges Carpentier, the dashing and valorous Frenchman who was heavyweight champion of Europe and who had won the Croix de Guerre in the French air force during World War I. Neysa McMein, a popular socialite and illustrator, sketched Carpentier for the *New York Evening World*. McMein was a stunning leader of the smart set, a princess at the Algonquin Round Table. Anita Loos called her "a magnificent young creature, a Brunhilde with a classic face and tawny hair." McMein's customary manner was casual and cool. Men came to her. But after gazing at Carpentier in his training camp on Long Island, McMein gushed in a spasm of passion and

shaky nomenclature, "Michael Angelo would have fainted for joy with the beauty of his profile, which is pure Greek." (Though odd, this version of Michelangelo's name was common enough in the 1920s to survive the *World*'s copy desk.)

Good-looking boxers tend to have an aphrodisiac effect on women. *The Prizefighter and the Lady* has become an old B-movie cliché, but like many hackneyed ideas it proceeded from original truth. (A regal blonde movie star threw herself at Ingemar Johansson, the heavyweight champion from Goteborg, Sweden, with such abandon one day in 1960 that Johansson canceled lunch with me so that he could pay a visit to her hotel suite. I took no offense. Johansson and I had a cocktail instead, during which he talked mostly about Volvos, which he hoped to import into the United States in great numbers. He had quickly come to accept civilized assaults on him by beautiful women as routine.)

Most men respond to imposing fighters with measures of awe and hidden terror. Carpentier knocked out Joe Beckett, the English champion, in London on December 4, 1919, and the spectators at Holborn Stadium included George Bernard Shaw. "I was startled," Shaw wrote on first sighting the French boxer, "by a most amazing apparition. Nothing less than Charles XII, 'the Madman of the North,' striding along in a Japanese dressing gown as gallantly as if he had not been killed almost exactly 201 years before." Charles XII was Swedish. John Lardner described this particular Shavian paragraph as "to put it as respectfully as possibly, babble."

Babble, Neysa McMein, Charles XII, and Michelangelo aside, Carpentier projected extraordinary refinement. Actually he was a coal miner's son from the tiny town of Lievin, near Lens in northern France, where he was born 1894, the year before Dempsey's birth close to the mines of Colorado. Like Dempsey, he first fought for what he could make in village bars. But with some coaching from his manager, François Deschamps, and extensive study on his own, Carpentier developed a presence that appeared to embody Nice, the Champs Elysées, Monet's garden, and the vintage red wines of Chateau

Lafîte. As sportswriters were forever calling Dempsey "tigerish," they constantly described Carpentier as "elegant." This inspired a grand vision within the ranging mind of Tex Rickard, the old Klondike faro dealer, who was coming to covet respectability.

Rickard had no intention of promoting Dempsey–Carpentier as a bout between two rugged characters up from the mines, which is exactly what it was. He was progressing from his own honky-tonk days in Goldfield, Nevada, and even from the disappointing crowd in lively, provincial Toledo, Ohio. He would promote this one on an unimagined scale, or as Rickard put it, "big time." The Mauler against the Boulevardier, a word Rickard had difficulty pronouncing. The American Tough against the Urbane Frenchman. Tiger Jack against the Orchid Man; the Slacker against the War Hero.

Rickard liked Dempsey personally and had, to be sure, arranged for his legal help during the slacker trial. He knew that nothing, not even Maxine's rejections, hurt Dempsey quite so much as the word *slacker*. Rickard knew these things, but the Slacker against the War Hero had a commercial ring. Business was business.

Ronald Reagan remarked at an informal party during his presidency that power had a distinctly upbeat side. "For example," Reagan said, "nobody ever insulted Jack Dempsey." The guests sipping soft drinks and looking out toward the White House Rose Garden laughed at the mot. Accuracy demands a minor edit. After the Willard fight nobody insulted Dempsey *up close.*

"But when that trial was over," he told me, "they'd shout things from passing cars. They'd yell, 'What about them patent-leather shoes?' Or they'd shout 'slacker.' I'm walking down a street in New York. Or I'm on some street out in Hollywood and here comes someone yelling out a car window 'slacker.'"

"They didn't stop?" I asked. "The people who shouted slacker at you didn't stop?"

"No," Dempsey said. "Nobody who shouted slacker at me ever stopped his car. But I still heard them. I heard them all the time.

"Kearns wanted me to fight here. Rickard wanted me to fight there. Myself, I wanted to go back to the mines. It was quiet down in the mines. I could do my work there and be left alone. Nobody would bother me." He paused. We were sitting in his restaurant side by side, our backs toward Broadway. In Montgomery Flagg's stirring mural, Dempsey was young again, bobbing in white trunks, stalking the brave and wounded Willard, stalking the dream. Now he was asking me to understand that when he arrived, the fabric of the dream appeared to have changed. It was not cloth of gold. It was chintz.

"I had to go on fighting, as you know," he said. "There was so much money out there, they wouldn't let me stop. I was twenty-five, a mature fighter, but still a boy really. Before the trial they were always taking me places in New York and L. A. Billy Seeman's parties at his penthouse down on Waverly Place in Greenwich Village. Beautiful actresses there. Madge Evans. Vivienne Segal. A show girl with only one name. Dolores. One name and the most beautiful show girl in town. Or Billy LaHiff's. That's the restaurant where Toots Shor worked as a bouncer. Or up to Harlem and the Cotton Club and Connie's Inn and Small's Paradise."

"Speakeasies?"

"Oh, sure, every one was a speak. I didn't drink much but I began to like a Hungarian wine they call Tokay. Instead of a beer I'd drink a glass of Tokay, maybe with a couple of show girls and Al Jolson." Dempsey smiled at the memory.

"You would have missed that as a miner, Champ."

"I would have missed nasty things as well. Say, have you ever tried Tokay?" A waiter brought a bottle labeled Tokaji Aszu. The wine had an unusual sweet-and-sour tang, something of a cross between sherry and sauterne. After a few sips, I said I was getting to like the taste. Dempsey said, "That's not a wine miners can afford."

He returned to the public scene reluctantly, at his own pace. Teddy Hayes said, "After the trial he was almost always in a growling mood. But I knew he wouldn't quit. Wherever we were, Jack ran six

to eight miles every morning. If he was gonna quit, he would have stopped training."

On July 4, 1920, one year to the day after the fight with Willard, Dempsey woke up at the Hotel Elms in Excelsior Springs, Missouri. For a fee of one thousand dollars he would demonstrate boxing skills for the hotel's holiday crowd. The day broke warm and brilliant. Dempsey and Hayes put on boxing gear and started toward a makeshift ring. "It was in a big garage and when we walked in I counted a crowd of fifty-two people," Hayes said. "Everybody else had gone out to the springs to take the waters."

Dempsey was ready to turn around and pack. Fifty-two people for a champion? Hayes said something upbeat, don't let this bother you, and climbed into the ring and began his practiced patter. "Friends, the champion will now demonstrate some of the punches that have won him fame and the championship of the world. Now the famous Dempsey left hook...Now the Dempsey shift. Now the left hook coming out of the weave..."

Dempsey and Hayes took off their robes and sparred. Hayes, a middleweight, did an imitation of the bob and weave and banged away. In other exhibitions, Dempsey countered lightly, so as not to do harm. This day Dempsey hooked a hard left into Hayes's mouth. Hayes fell bleeding. "It hurt," he said later, "but I was glad. Because the sight of my blood gushing startled Jack and broke his sour mood. A few days later we got on a train to New York to see what Kearns and Rickard really had. It was my blood, his buddy's blood, that got Jack ready to fight again."

The State of New York's schizophrenic boxing history was coming to a point of resolution. For decades prizefights were corrupt and uncivilized, or so a legion of moralists—some ministers, some laymen—swore. "Surely the men who enjoy prizefights the most are the selfsame ones who most savagely beat their wives and helpless children." The evidence behind this statement from a Brooklyn pulpit, c. 1882, remains elusive.

But boxing was exciting, as much an activity of skill as of brute force. Others argued that it was less dangerous to the people of Brooklyn, Manhattan, and points west than easy access to guns or leaky sewage systems, both characteristic of nineteenth-century America.

Legislators, trying to reconcile pro- and antiboxing forces without losing votes, had been forever passing regulations. On July 4, 1892, John L. Sullivan knocked out Jimmy Eliot in Washington Park, the home field of the Brooklyn baseball team that would become the Dodgers. Bob Fitzsimmons, the bald, power-punching champion whom the young Dempsey admired, knocked out Tom Sharkey in Coney Island on August 24, 1900. Both fights drew protests that carried up to the state legislature in Albany, where, following long labor and great screaming, politicians began giving birth to curious and restrictive laws.

After the Frawley Bill passed in 1911, a boxer could win on a knockout in New York State, but not on points. Still, people wanted to bet and bettors despise a draw. The bettors turned to newspaper sportswriters as their judges. When you bet you agreed to accept the opinion of, say, McGeehan of the *Trib* or Runyon of the *American*. This pleased the newspapermen, but was both an abuse of press power and an unsettling temptation. If a big bettor agreed to share a portion of his winnings with a boxing reporter in exchange for that reporter's decision in the paper, who would be the wiser, particularly after a close match? In a time of low newspaper salaries and hefty bets, that was a reasonable question. New York became a great town for "club fighters," semiskilled journeyman who put on rousing brawls. But with rare exceptions, heavyweight championship fights went elsewhere.

In 1920 James J. Walker, a state senator from Greenwich Village, introduced a bill to make professional boxing legal in New York. Jimmy Walker—later "Beau James," the only mayor of New York City booted out of office for corruption—had prepared his proposal with care and apparent honesty. The state would license everyone significantly employed in boxing: promoters, managers, referees, judges, fighters. No mismatches, no crooked decisions, no tickets sold to

fights that never took place. At least in theory. Licensing carried with it the club of discipline. A board of three state commissioners would supervise the sport and they could revoke licenses and, if necessary, call in district attorneys for criminal prosecution. On April 26, this bill went to the desk of governor Alfred E. Smith.

Al Smith was a tough, essentially liberal, whiskey-voiced politician with one ambition that overrode all others: He wanted to become the first Roman Catholic president of the United States. Personally he liked Jimmy Walker's boxing bill. Politically it made him nervous. W. O. McGeehan accompanied Walker into the governor's office, along with Nat Fleischer, who took notes.

"Governor Smith," McGeehan began, "prizefighting is not a sport. It is a gigantic business. As a business, I dare say, it is conducted as honestly as American politics and I venture to say a little more honestly than the stock market. Governor, every profession has its crooks, its gamblers, its undesirables, even the profession of politics. Then why condemn boxing and at the same time whitewash every other business?" He continued with great passion for several minutes.

Fleischer said Smith was impressed by McGeehan's words and by his presence. Other newspapermen were now calling McGeehan "Sheriff Bill." But there was the matter of Smith's own career. Protestant America was uncertain about putting a Catholic into high office, and a Catholic governor who legalized prizefighting put himself in a dangerous corner. Or so Smith believed. At length he told Walker privately that whatever McGeehan said or wrote, he would sign the bill only if he received messages of support from one hundred Protestant clergyman. *Protestants.* He didn't want rabbis. They were fans of the Jewish lightweight champion, Benny Leonard. He didn't want priests; they idolized the Irish-Catholic heavyweights, Sullivan and Gentleman Jim Corbett.

Walker promptly enlisted the support of Anthony Biddle, the prominent Philadelphia fight fan whose marines had caused such chaos in Toledo. Biddle was a contributor to a group called the Protestant Bible Society, to which he now suddenly made a fresh con-

tribution of half a million dollars. Even as the Quaker millionaire's check was clearing, the desk of Governor Smith disappeared under a hummock of messages from Protestant ministers who decided, rather suddenly, that they supported the Walker boxing bill. Smith signed it into law on May 25, 1920.

Most newspapers carried approving editorials. The American Legion issued a statement applauding "the proper return of this manly sport to the Empire State." A Legion spokesman told reporters, "We expect, of course, that no one who failed to fight for the honor of his country in the Great War will be licensed to fight for personal profit in New York."

John Emke, who owned the Elms in Excelsior Springs, was unhappy that Dempsey had failed to draw a crowd. He started drinking and when Teddy Hayes demanded the thousand dollars, Emke told him to keep his shirt on, he'd get his damn money in a while. At length a nervous bellboy appeared and handed Hayes a large box. In it were stacks of small bills and a mountain of change. Dempsey took the box and poured the contents onto the bed. "He thinks he's funny," Dempsey said. "Well, I'm going to count this out."

At about $850 Dempsey and Hayes broke into laughter. They kept counting. The thousand was there. "We signed for everything when we checked out," Dempsey said. "Meals, room, laundry. The works. But believe me, we tipped the waiters and the chambermaids great. Why not? We had a lot of change."

With boxing legal now, both Rickard and Kearns wanted Dempsey in New York. In fact both Rickard and Kearns wanted Dempsey, period. Nor was Teddy Hayes, trainer and buddy, unaware that promoting and managing Dempsey could produce a fortune. Dempsey checked into the Hotel Belmont in Manhattan, but he heard the slacker echoes and that kept him in a scowling mood.

Rickard met Dempsey privately and said that he had signed a ten-year lease with the insurance company that owned Madison

Square Garden, New York Life. "Them insurance guys took some money off me and now I am the exclusive fight promoter for the Garden. Nobody can put a fight in there but me." Rickard said that the Garden was the greatest showplace in the world and Dempsey was the greatest fighter in the world. "You and the Garden go together, Jack. There ain't gonna be trouble about your license. I've seen to that." He said that they both had come a long way from the high western deserts.

Recalling this meeting, Dempsey made several points. "Kearns wasn't there. Rickard didn't want Kearns there. He thought I ought to fire him and find another manager. Then when he was telling me how I could be an emperor in New York, I thought, well maybe, Tex, but just four years ago I was sleeping in Central Park. I was a hobo in New York. But they left me alone then. Nobody called me a dirty slacker then. Am I better off now than I was?"

Dempsey was in no emotional shape to fire Kearns. Fighting itself is so demanding that boxers depend on managers to organize training, find opponents, hire sparring partners, plan menus, run the finances, and coach them during bouts. A break with a manager often leaves a boxer feeling depressed and orphaned. Dempsey's breakup with Kearns was years away. At the moment he had to convince himself to step again into a championship ring. What finally propelled him to do that was tragedy.

Billy Miske, a sturdy heavyweight from St. Paul, Minnesota, had not been knocked out in fifty-seven professional fights. He fought Dempsey twice to "no decisions." Most thought Dempsey won both matches, but Miske was game and brave. "I fought the guy. I loved the guy," Dempsey said. "Hell of a guy, Billy Miske."

In 1919, after five bouts in one month—including a grueling twelve-rounder with Barney Lebrowitz—who fought under the name of Battling Levinsky—Miske felt flushed, feverish, and bloated. His back hurt as though he had been knifed. Doctors at a hospital diagnosed Bright's disease and told Miske he had better give up boxing. His kidneys were failing. His life was at stake.

Miske had made good money boxing. Then he bought an auto dealership and when it failed he lost all his savings. Now sick, perhaps dying, he called Dempsey and pleaded for a fight. Dempsey never forgot Miske's words. "I can't pay my doctors. I can't feed my wife or my kids. Champ, give me a shot. I need a payday. Please."

Once Dempsey made clear that he would fight Miske next, Miske and nobody else, Doc Kearns embraced the idea as his own. Both of Miske's earlier fights with Dempsey had gone the distance, ten rounds. Kearns proclaimed to reporters that Miske was the only boxer on the earth who had gone twenty rounds with Dempsey without being knocked out. The title fight would be a great match. True, Miske had suffered from health problems a year ago, but that was all behind him now and his weight was up to 190 pounds. Miske was in great shape and heavier than the champion. Kearns told Dempsey, "I'll promote this one, Jack, and we'll get a better deal than we ever could get from Rickard." Dempsey did not argue.

With boxing now legal in New York, the logical place for the fight was New York City, the financial, cultural, and sports capital of the country. But Rickard controlled Madison Square Garden and his influence extended to the two major league ballparks, Ebbets Field and the Polo Grounds. Charles Ebbets, who ran the Dodgers, and Charles Stoneham, who owned the Giants, recognized Rickard's skills. Why antagonize today a man who could otherwise cut you in on big receipts tomorrow? (In point of fact, Rickard and his successor, Mike Jacobs, promoted some thirty fights in New York ballparks, which yielded significant rent for the Giants, the Dodgers, and later the Yankees.)

Kearns wanted to show Dempsey that they could flourish without Rickard. He called a Michigan fight promoter named Floyd Fitzsimmons. The two men put together a decent package: fifty-five thousand dollars for Dempsey (and Kearns); twenty-five thousand dollars for Miske. They would fight in a saucer-shaped minor league field in Benton Harbor, a resort city with a population of about fifteen thousand amid the apple orchards of Michigan's western slope.

Two visitors to his Benton Harbor training camp surprised Dempsey. Wearing a wide-brimmed hat and a short-sleeved white shirt and biting hard on a cigar, Al Capone appeared with a grim retinue. His enforcers ordered journalists and tourists to put away their cameras. "Mr. Capone don't want no pictures today." They were taking over the training camp as though it were theirs. Then the mobster walked alone into Dempsey's dressing room. Capone began, "You know who I am, Champ?"

"Sure, I know you."

"I'm a big fan of yours, Champ. I like boxing and I think you're a great fighter. I own a private club in Chicago and I want you to fight some exhibitions there for me." He pulled a roll of bills out of one pocket. "Name your price," Capone said, "and you got it."

Dempsey thought briefly, then said, "I can't do that."

Capone waved his bankroll. "Champ, did you ever see so much money in your life?"

This was the largest bankroll Dempsey had ever seen. But he knew, with his remarkable instinct for survival, that once he started with Capone, he would be on the way to becoming a fighter for the mob. First big-money exhibitions at Capone's club. Then real fights in which Capone was de facto promoter. Then what? A serious betting coup? A fixed heavyweight championship fight? Orders to go easy, even to lie down, from killers and thugs like the ones outside who were bullying the newspaper photographers?

Dempsey shook his head. "Thanks, Mr. Capone. But no."

He was better than Capone could imagine, both as a heavyweight champion and as a man. Personally Dempsey found the gangster interesting; Capone seemed to want his respect not as the Boss of Bosses, but as tough and rugged regular guy. Their paths would cross again dramatically seven years later.

The other visitor came wearing a disguise. It was Tex Rickard, hidden behind prop eyeglasses and an artificial beard. Rickard did not want Doc Kearns to spot him. He told Dempsey that Kearns was faking expenses and cooking the books so that when Dempsey

fought, Kearns in fact was collecting in more than 50 percent of the take. More like 70 percent. "You're doing the fighting, Jack, and this guy is taking seventy cents out of every dollar you make. Kearns has no heartbeat, Jack. He has no blood." As Rickard left, he said, "Whatever you decide, Jack, whatever you do, I'm your friend."

On September 6, Labor Day, the *New York Tribune* reported,

> Thousands of fans began pouring into the twin cities of Benton Harbor and St. Joseph at dawn, swelling the tide of arrivals which flowed in at every gate yesterday and Saturday. Down the bluffs that half circle the two cities by Lake Michigan automobiles coasted by the dozens and long before the fight there was one of the largest assemblages of cars ever seen in the middle west. In midmorning a fleet of giant seaplanes soared over the horizon and dropped swiftly onto the lake to discharge a coterie of officers from the Great Lakes Naval Training Station.
>
> At the arena, Michigan constabulary, husky guards and uniformed soldiers on leave from Camp Custer kept order. There was no repetition of the episode in Toledo last year when hundreds of spectators without tickets made their way into the arena and refused to be ousted.

The orderly crowd reached about fifteen thousand and paid in $134,900. Dempsey, or rather Kearns, scooped his $55,000—plus "expenses"—off the top.

The so-called undercard, the preliminaries bouts, were extraordinary. In one of them Big Bill Tate, Dempsey's sparring partner, outpointed Sam Langford, the Boston Tar Baby, rated by *Ring* magazine as the seventh-best heavyweight ever (behind Joe Louis and ahead of Gene Tunney). Langford was past his peak at forty-two, but still formidable. In another, Harry Greb, the Human Windmill, Ring's "third greatest middleweight," beat Chuck Wiggins of Philadelphia.

As Nat Fleischer, who founded *Ring,* liked to point out, "In that little town in Michigan that Labor Day three of the greatest ever, Langford, Greb, and Dempsey, actually fought on the same card, and you certainly have to give Doc Kearns some credit for helping to organize that."

Kearns's versions of Dempsey fights in his fanciful memoir *The Million Dollar Gate* follow a repetitive scenario. Dempsey is having problems. Kearns says magic words. Dempsey obeys. Fight ends. "Miske looked too healthy," Kearns wrote with his ghost, Oscar Fraley. "I had a feeling we might have been conned. Dempsey was trying to take it easy on him, and Bill started throwing punches that were loaded with pure dynamite. At the end of the second round, we were definitely behind on points. 'Don't play around with this thing anymore,' I instructed Dempsey in the corner. 'Look for an opening and finish it quick.'...Dempsey went out and found an opening for his right hand."

Dempsey himself said he wanted to end the fight as quickly as he could, which was, of course, his way, but particularly so at Benton Harbor because he liked Miske and didn't want to inflict suffering. "And I sure as hell didn't want to cut him up."

The *New York Tribune* on the scene had Dempsey in control all the way. "Half a minute into the fight, Dempsey used his left to the body and jaw almost as he wished. He looked so certain that ringsiders began to try and name the round when Miske would take to the floor for the first time in his career and suffer a knockout."

Dempsey's shovel hook into the body knocked down Miske for a five count in the second round. A right to the jaw knocked Miske down in round three. When he got up another right hand finished him. Dempsey had another knockout. The time was 1:13 of the third. Dempsey kneeled beside the man he had beaten, his friend and antagonist. With great tenderness he helped Miske to his corner.

Dempsey told a reporter, "When I landed that left to his middle my glove really dug in and I knew he was hurt." Miske offered no alibi.

"Dempsey is a better man than I am," he said. "The fellow just hits too hard. That punch in the second round all but caved in my ribs."

"Jack Dempsey is so much in a class by himself that his bouts can no longer be regarded as contests," W. O. McGeehan maintained. "They are stirring exhibitions of the greatest punching machine of all time. No human can withstand a Dempsey onrush."

McGeehan made that observation a week after the fight. During the bout itself, he capped ten days of drinking with a number of deep jolts from his hip flask. As Warren Brown, a Chicago sportswriter, reported, "McGeehan was game. After the fight he made his way by forced march to the press headquarters to finish his story. When he got there the only typewriter available was one of those old-fashioned Olivers on which the key faces were slender ovals. As he thrust his fingers onto the keyboard, all kinds of stalks rose from both sides of the machine and met at the center in an appalling knot. Bill shuddered as he surveyed the scene and made his way unsteadily out of the place.

"He was next heard from when he arrived in the press box in the Cleveland baseball park two days later. His clothes and personal belongings were forwarded to him. Sid Mercer, helping out with publicity for the fight, actually wrote the story that was wired to the *Tribune* under the byline of W. O. McGeehan." That piece is not among McGeehan's best.

The fight brought Miske twenty-five thousand dollars, and with new treatment he maintained his health well enough to box twenty-four more times. He was never again beaten, let alone knocked out. Miske fought on from Brooklyn to Oklahoma City through 1921 and 1922. In 1923 he won his last two bouts with knockouts. Then Bright's disease came raging back. Billy Miske died in St. Paul, his hometown, on January 1, 1924. He was thirty-nine. His widow said that his last words were, "Tell the Champ, tell Jack, I said thanks."

Looking backward, 1920 was a rousing but complicated year for American sports. The chestnut colt Man o' War, bursting out of Kentucky, started eleven races and won them all. That barely hints at the

dominance of the colt they called "Big Red." His groom, Will Harbut, later explained as he stood beside Man o' War: "He broke all the records and he broke down all the horses, so there wasn't nothing for him to do [after two years] but retire. He's got everything a horse ought to have and he's got it where a horse ought to have it. He's just the mostest horse. Stand still, Red."

William Tatem Tilden II won the U.S. Amateur and the Wimbledon Tennis Championships in 1920. (The tennis circuit was supposedly amateur right up into the 1960s.) Tilden was a rangy fellow with chiseled good looks, an elegant manner, huge spinning serves, and beautifully controlled strokes. He won the U.S. Amateur seven more times. "Big Bill" Tilden became the first tennis superstar, courteous, assured, well groomed, and, to the disappointment of a generation of American women, gay. He was direct when he felt directness was called for. Tilden's mixed doubles advice is a wonderful instance of what is now politically incorrect. Tilden said simply, "Always hit to the woman."

The year 1920 also encompassed the baseball season in which Babe Ruth pretty much abandoned pitching. Playing outfield full time for the New Yankees, he swatted fifty-four home runs. Trailing him was George Sisler of the Browns, who hit nineteen. Two years earlier Wally Pipp of the Yankees had led the American League with nine. The emergence of Ruth as a new-age home-run hitter profoundly changed the nature of the way baseball was played but also, and surely this was just as significant, diverted public attention, to some degree, from the most appalling scandal in baseball history.

On September 28, 1920, three weeks after the Dempsey–Miske fight, a grand jury in Chicago indicted eight White Sox ballplayers for conspiring with gamblers and deliberately losing the 1919 World Series to the Cincinnati Reds. In a city like Chicago, where racketeers, politicians, and judges all drank at the same bootleg fountains, conviction of the crooked ballplayers, the Chicago Eight, proved impossible. Key evidence, including confessions by certain ballplayers, disappeared. More documents burned in a courthouse fire. On August 2, 1921, the Chicago Eight, the most famous of whom was the slugger "Shoeless Joe Jackson," were exonerated by a jury. Then the

ballplayers and the jurors who had acquitted them celebrated together in a speakeasy. Overriding the court, the commissioner of baseball, Kenesaw Mountain Landis, announced that the eight were banned from organized baseball for the rest of their days.

Revisionist history, including the earnest motion picture *Eight Men Out,* tries to justify the crooked ballplayers on the grounds that they were underpaid. A bizarre cult movement regularly seeks to smuggle Joe Jackson into the Baseball Hall of Fame. But it is difficult to characterize the behavior of the Black Sox, including Joe Jackson, as anything less than disgraceful. Underpaid? Then get a night job or work winters, or better still take an example from the Colorado miners of the nineteenth century and organize and strike. What these ballplayers and the gamblers were doing, Scott Fitzgerald wrote, was playing "with the faith of fifty-million people with the single-mindedness of a burglar blowing a safe."

Some reporters covering the fixed World Series wrote naive stories about the White Sox's poor play. Two who immediately recognized what was happening were Christy Mathewson, formerly a great pitcher for the New York Giants, and Mathewson's friend Ring Lardner. As the White Sox threw away the first two games Mathewson, a man of great probity, was not fooled. Sitting in the press box, he circled a number of plays recorded on Lardner's scorecard and met Lardner's eyes. No words were spoken. No words were needed.

On the train from Cincinnati to Chicago on October 2, Lardner sang in his fine bass voice:

> *I'm forever blowing ball games,*
> *Pretty ball games in the air.*
> *I come from Chi.,*
> *I hardly try,*
> *Just go to bat and fade and die.*
> *Fortune's coming my way,*
> *That's why I don't care.*
> *I'm forever blowing ball games.*
> *For the gamblers treat me fair.*

Lardner had been a White Sox fan since childhood and his lyric, a parody of the popular "I'm Forever Blowing Bubbles," *was* among other things a cry of pain. John Lardner said the fixed World Series destroyed his father's innocent passion for baseball. "After that the only things he cared about in sport were Dempsey and, later and to a lesser degree, the Notre Dame football team."

The exploits of Dempsey, Ruth, Tilden, Man o' War, Knute Rockne at Notre Dame, the golfer Bobby Jones, and the halfback Red Grange distinguished what came to be known as "the golden age of sports." But the Chicago White Sox, the best team in baseball at the start of the 1920s, were pyrite, iron sulfate, fool's gold. One is left to recall that in a time of increasingly easy money and endemic lawlessness young Jack Dempsey from the hobo jungles and the mining camps told Big Al Capone, on a late summer day in Benton Harbor, Michigan, that no, no matter how big the offer, he would not become a fighter for the mob. Although many continued to vilify him as a slacker, history tells us how important Dempsey's decision and courage really were. For after the Black Sox, the country desperately needed what Dempsey proved to be above all things— an honest champion.

Rickard now pressed for a fight at Madison Square Garden, the so-called Old Garden, actually Madison Square Garden II on Twenty-sixth Street. This was the arena designed by Stanford White with the tower topped by a golden bare-breasted Diana. Dempsey said that Garden II was by far a better arena than its descendants, Garden III, at Eighth Avenue and Fiftieth Street, and the present building near Pennsylvania Station, so poorly designed that its escalators hurl lines of people into one another. Most experts agree with Dempsey. "The Stanford White building was magnificent," says Gordon J. Kahn, A.I.A., this author's family architect. "A crowning achievement of the Beaux Arts school. You could find a Roman arch coming out of a Greek pillar, of course, but that was the nature of Beaux Arts."

Rickard ran Garden boxing and Kearns wanted Dempsey in New York, in the Garden. Pragmatism carried the day; Rickard and

Kearns patched their differences long enough to promote what would be a hard-fought bout. It was also an episode touched with mystery, one that, like the Miske fight, turned out to be a station on a boxer's road to early death.

K. O. Bill Brennan was a tough knockout puncher who had fought more than sixty fights. He won all but four and had been knocked out only once. That was on February 25, 1918, in Milwaukee. Dempsey was his conqueror. The fight ended in round six when Dempsey punched Brennan to the canvas with such force that Brennan's legs twisted and he broke an ankle. He was trying to get up when the referee stopped the fight.

Brennan was born William Shanks in Louisville, Kentucky, and his forebears were German. When he started boxing, at the outset of World War I, he changed his name; the cause of the kaiser was never popular in America. He came up with a fictional life story that made him a native of County Mayo, with parents emigrating to a rough Irish section of Chicago. He did, in fact, move to Chicago in his teens, where he became a formidable street fighter. Later he mixed drinks between bouts and was billed as "K. O. Bill Brennan, the Battling Bartender." That background—a fictitious biography, Chicago, saloons, and speakeasies—spawned rumors that Brennan had underworld connections. One story insisted that Capone, after being spurned by Dempsey, bought an alliance with Brennan. According to this scenario, Capone then dispatched a beautiful mob lady to visit New York City. She was to seek out Dempsey and do everything a smart and stunning woman could to prevent the champion from training properly. That sounds as farfetched as a tabloid headline. Franklin Roosevelt plotted Pearl Harbor; John Kennedy ordered the murder of Marilyn Monroe; Hillary Clinton shot Vincent Foster with a pistol Nancy Reagan left behind in a White House chamber pot. Perhaps this tale belongs in that soapy genre: At the dawn of the golden age of sports, one branch of the mob took over the World Series and another branch moved to capture the heavyweight championship of the world through a pug named Shanks who called himself Bill Brennan.

Perhaps it *is* farfetched, but later events suggest that K. O. Bill Brennan and the mob may not have been total strangers. Kearns insisted in his autobiography: "I'm certain there were sinister influences at work, trying to take the title away from us. Brennan, to my way of thinking, was getting his backing and taking his orders from some mob or other in what shaped up as a gangland betting coup, since Dempsey was a 4-to-1 favorite." Further, Kearns complained, a mysterious dark-haired divorcée appeared—Dempsey's preference for brunettes was becoming widely known—and ran about the New York speakeasy scene with the champion. "I managed Jack in the daytime," Kearns said, "but the broad was his manager at night. That damn near did him in. Believe me, a fighter cannot train on top of a brunette. Nor a blonde, neither, if there are any real blondes."

Kearns found a large apartment on Broadway and Ninety-seventh Street. He rented the gymnasium aboard the U.S.S. *Granite State,* a retired naval vessel that was docked in the Hudson River at Ninety-sixth. He supplemented Dempsey's shipboard efforts with outdoor workouts at Van Kelton's Handball Courts, on West Fifty-seventh Street. For roadwork, Dempsey went back to his former bedroom, Central Park. Hayes said, "It was too spread out and there wasn't anywhere to get peace. A fighter needs some peace when he's training. Jolson was always showing up with some show girls at the handball courts. He couldn't fight a lick but he said he wanted to spar with Dempsey. Jack hurt his sparring partners. Jolson and the show girls were a distraction. Kearns kept the apartment open to newspapermen who wanted stories or booze twenty-four hours a day."

A *New York Times* reporter, preparing a feature on Dempsey, found no evidence of fast living. "Dempsey," the *Times* man wrote, "is disappointing to those whose conception of the ring champion depicts a careless, carefree type.... Early to bed, early to rise is the motto by which Dempsey lives. Manager Kearns frequently complains half-heartedly about the champion's awakening at daybreak and starting the victrola or player-piano in an adjoining room while the rest of the household is trying to slumber. Every morning Dempsey is off on a

run through Central Park before many residents of the neighborhood are awake. It is this mode of living, with the exceptional care he takes of himself, which keeps Dempsey always in condition, and his appearance clearly reflects his wholesome life."

But there was a dark-haired woman, although her name, like that of the dark lady of Shakespeare's sonnets, is lost. Dempsey trained hard and also lived hard. He later said, perhaps with inward humor, that he "overtrained." That the *Times* sportswriter—he got no byline—missed the story is understandable. Doc Kearns was an early master of managed news.

With tickets priced from twenty-five dollars to two dollars, the fight was an early sellout. "Everybody," the *Times* reported, "wants to see the slashing, tearing titleholder." As tickets vanished, Kearns said to Rickard, "Me and Jack need five hundred more ringside seats."

Rickard told Kearns not to be stupid. There weren't five hundred seats at ringside. Kearns settled for three hundred premium tickets. "Me and Jack" was a figure of speech. Kearns sold the allotment to speculators for ten thousand dollars and kept the money for himself.

Rickard hired a large force of laborers to turn Madison Square Garden into a boxing arena. Immediately before, the Garden had been the scene of a six-day bicycle race, and carpenters attacked the oval cycling track with saws, hammers, and crowbars. A new floor and seats had to be installed. Working around the clock, Rickard's crew moved the Garden from bikes to fights in forty-eight hours.

"Jack's legs were shaking when he come into the Garden ring that night," Kearns said. "I couldn't watch him every minute. I swear Jack come to the Garden that night straight from a hard workout with the divorced broad who had dark hair."

The Garden was packed with 16,948 people, more than it could comfortably hold. The place, someone wrote, "was crowded to suffocation." Brennan entered the ring first. He wore a red sweater, and—symbolic of Ireland—bright green trunks. Dempsey followed in white

trunks, no robe, only a white towel over the sturdy shoulders. The crowd booed. He was still Slacker Jack.

If Kearns saw Dempsey's legs trembling, he was the only one who did. The *New York Times* boxing reporter—again unbylined—studied Dempsey entering the ring and wrote: "The lightly drawn skin over the champion's cheekbones and the clear look in his deepset eyes and his general calm and steadiness proved that Dempsey had worked and worked hard to attain that perfection of condition which has always stood him in good stead."

After an even first round, Brennan caught Dempsey with a full right uppercut under the chin, only a few inches away from the point of the jaw. The punch jarred Dempsey from brow to heels. He shook his head. His legs wobbled. No one disputed that Dempsey's legs shook during round two. Dempsey said later that the only memory he had of the next four rounds was Kearns screaming at him, "He's licking you, Jack. You're gonna blow the title."

The *New York Times*: "It looked for a moment as if Dempsey would go crashing to the floor and be counted out. Brennan seemed surprised. He stepped back to look the champion over. Bill could hardly believe his eyes. He did not seem to be able to grasp the fact that he had the champion in a dangerous way. That brief hesitation enabled Dempsey to regain his scattered senses. Dempsey quickly stepped into a clinch and when the referee finally succeeded in prying him loose, he had so far recovered that he was able to fight back and was giving Brennan as good as he received when the bell sounded and ended the round."

After that Dempsey worked on Brennan's body, following the memorable boxing adage: "Kill the body and the head will die." Dempsey was wearing down K. O. Bill Brennan's rib cage in the tenth round when Brennan cracked a punch into Dempsey's right ear, which began to bleed. Dempsey kept working Brennan's body. Brennan kept punching at Dempsey's bleeding ear, punching as if he wanted to knock the ear clear off Dempsey's head. Before the twelfth round Dempsey shot Brennan a look McGeehan described as "white

with ghastly rage." Brennan was not only trying to win; he was trying to punch Dempsey into ugliness—scar him with a cauliflower ear.

Halfway through the twelfth round, Dempsey drove a right hook to the gut and Brennan winced and doubled up in pain. Dempsey straightened him with a left to the chest and crashed a right behind Brennan's left ear. It was over. Brennan was counted out at 1:57. Dempsey's ear, Grantland Rice wrote, "looked like a cross between a veal cutlet and a bloody sponge." But Dempsey had retained his championship.

The crowd was exultant. They had seen what the *Times* called "one of the most vicious and closely-contested fights in history." Some said that the bout showed Dempsey was less than superhuman. That had never been in question. What the Brennan fight, in the old Beaux Arts Garden ten nights before Christmas 1920, proved was this: Just as surely as Jack Dempsey could dish it out, he could take punishment when it came his way. That quality, a remarkable rawhide toughness, led Gene Tunney and others to assert years later that Dempsey in his prime would have been more than a match even for that other great superslugger of a heavyweight, Joe Louis. "They both were awesome hitters," Tunney said. "Dempsey alone was awesome in his ability to take punch after punch and keep coming, and never flinch."

Including newsreel rights, the fight grossed $208,000. The Kearns–Dempsey share was one hundred thousand dollars. K. O. Bill Brennan made thirty-five thousand dollars, a fortune in 1920. Brennan invested his proceeds in a speakeasy at 600 West 171st Street in the Washington Heights district of Manhattan. He fought through November 7, 1923, when he was knocked out in Omaha. Billy Miske, in his final bout, took down Brennan in four rounds. Brennan retired to preside in peace, albeit illegal peace, at the speak, which he called "Brennan's Club Tia Juana."

The following spring two rough-cut characters visited the club and told Brennan he was buying his beer from the wrong people. He would do better buying his beer from them. Did he understand what

they were telling him? Brennan, a strong and fearless man, threw them out.

A few nights later Brennan was sitting in the club, drinking and chatting with friends, James Cullen, a New York state trooper, and Shirley Sherman, a dancer who had been featured in a Broadway play, *The Lady in Ermine*. The scene was a splendid cameo of the time: an ex-fighter and a show girl, drinking in a speakeasy with a law-enforcement officer matching them illegal drink for illegal drink. At 4:00 A.M. two unkempt men at the front door asked to see Brennan. When he went out to meet them, one pulled a pistol and shot Brennan twice. Bullets lodged in his chest and abdomen. Trooper Cullen hurried out and the gunman shot him fatally through the neck.

Unarmed and badly wounded, Brennan ran after the murderer for a few brave steps, but fell to the sidewalk in agony. Shirley Sherman hurried to help him.

Brennan was moaning. "I'm dying, Shirley," he gasped.

"For God's sake, Bill, you're not," Sherman said. "We'll get an ambulance."

"I know I'm dying," Brennan said. The words came slow and hard between sounds of pain. "My poor wife. My poor child."

"Who was it shot you, Bill?"

"I don't know." Brennan lost consciousness. He died as he was being carried to an ambulance. It was June 14, 1924. The next week Brennan would have been reached his thirty-first birthday. His only child, a daughter, was not yet four years old.

Dempsey sent a telegram to the widow, Mary Brennan. He told reporters that he didn't know a thing about stories that suggested a long underworld tie-in, that the shooting was the culmination of an extended mob dispute. "He was a good fighter and a fine man," Dempsey said.

Police caught the murderers a few days later and when the two were booked into the downtown Manhattan jail called the Tombs other prisoners jeered them. But in the end the trigger man, Joseph

Pioli, alias Frank Rossi, was allowed to plead guilty to manslaughter. His accomplice, Terrence O'Neill, alias James Hughes, was acquitted. The 1920s justice system dealt gently with professional killers. Pioli was sentenced to only twenty years in Sing Sing. Three years later he scaled a prison wall on a foggy night and jumped into the Hudson River. Pioli carried a change of clothing in a rubber sack. After swimming the length of three city blocks, he turned toward shore, changed clothes, and hailed a taxi that took him to New York.

Detectives finally caught up with him in a bar in Elizabeth, New Jersey. The *New York Times* reported that he said, "Yeah, I'm Pioli, the guy that got Brennan. What of it? Just to make it more interesting for you dicks, I'll admit I also bumped off my old man and my brother. But I ain't giving you no more details."

Pioli went back to Sing Sing and the famous warden there, Lewis E. Lawes, announced he had information that Pioli's escape had come with the assistance of a bribed guard. The guard was fired, but not prosecuted. In 1937 Pioli, an unrepentant serial killer, was paroled, but on May 19, 1938, the *New York Times* reported:

VETERAN OF CRIME BACK IN SING SING
PIOLI SLAYER OF BRENNAN IMPRISONED AFTER
BOARD FINDS HIM VIOLATING PAROLE
CRIMINAL RECORD COVERS 34 YEARS

Brennan left an estate of only five thousand dollars. Mary died a few years after the murders, and foster parents had to raise their small orphaned daughter, Mary Shirley.

Dempsey's final comment on the tragic events in the Brennan family was succinct and restrained. "I guess," the champion said, "poor Bill bought the wrong beer."

That fiercely casual comment speaks to his Wild West boyhood and the rods he rode and to the street scene of his murdered newsboy brother. Dempsey's remark also speaks of New York in its Algonquin days, too often described through misty haze, as it really was.

A rugged world loomed out beyond the barkeep. Even as Gershwin played and Parker drank and Neysa painted, as often as not a mob torpedo burst out of the Tombs or Sing Sing. Sometimes he escaped by bribing guards. Sometimes he rode out on gentle bail, free once again to slaughter.

8 The Battle of the Century

*It was simply impossible to root for Dempsey. It
would have been like giving three long cheers for
the guillotine as Sydney Carton went up to meet it.*

—HEYWOOD BROUN

O NE OF BOXING'S STURDIEST MYTHS HAS IT that when Georges
Carpentier stepped into the ring with Jack Dempsey, he never
had a chance. At 175 pounds, Carpentier was not a full-sized heavy-
weight, this reasoning insists, and the form that so roused Neysa
McMein and George Bernard Shaw was altogether too frail to match
the champion. If Neysa felt that Michelangelo would have fainted at
the sight of Carpentier's body, no one, not even Neysa, thought Jack
Dempsey would pass out.

The actual fight, the myth continues, went on as long as it did
only to give the newsreel company that bought film rights something
more than a very short feature to offer movie houses. In essence,
Dempsey carried Carpentier until the newsreel producers had enough.
Then he put away the Frenchman in hot, though belated, haste.

Ring Lardner mocked Dempsey–Carpentier in a short story
called "The Battle of the Century" that the *Saturday Evening Post* pub-
lished three months after the fight, on October 29, 1921. In such works

as "The Golden Honeymoon," "Alibi Ike," and "Haircut," Lardner created masterpieces of the short-story form. "The Battle of the Century," generally passed over by anthologizers, may be a shade below Lardner's greatest work. But it is a lively portrait of the Dempsey–Carpentier promotion and probably the great launching pad for that flight of fancy, *Carpentier never had a chance*. (And it is a flight of fancy, as a study of the old newsreel footage makes surpassingly clear.)

Lardner's story, told in the first person by a narrator whose grammar and spelling are primitive, presents an American heavyweight champion named Jim Dugan who signs to fight a French boxer named Goulet.

Right down to offering boxers with matching initials, Lardner made no effort to hide reality.

Jim Dugan's manager is named Larry Moon. Here is Moon/Kearns talking to Dugan/Dempsey: "Further and more, this guy Goulet is a war hero. He's the idol of Europe and the champion of Europe, and if he was built up right he'd be a great card over here. That's what I'm talking about, a match between their champion and our champion for the championship of the world."

"You don't mean match me with this Goulet?" says Jim/Jack.

"That's exactly what I mean," says Moon/Kearns.

"All right," says Jim/Jack. "You're my matchmaker and I fight who you pick out. But I don't see how you come to overlook Benny Leonard."

Leonard, lightweight champion from 1917 through 1925, retired undefeated. Which is not to say he would have been safe in a ring with Jack Dempsey. Leonard boxed at 130 pounds. Carpentier, boxing at 175, was giving only thirteen pounds to Dempsey, a disadvantage, to be sure, but not necessarily decisive. Carpentier had knocked out a tall, muscular British heavyweight, Bombardier Billy Wells, in four rounds in the Belgian city of Ghent, and again in one round in London. On the night he first impressed George Bernard Shaw, Carpentier knocked out another big, strong, brawling Briton, Joe Beckett, the best heavyweight in Europe. That took seventy-five seconds.

The next year Carpentier fought in Bordeaux, Monte Carlo, and Jersey City. No opponent lasted more than four rounds.

Citing spun glass, cynics questioned the chins of bulky English boxers. In an essay to which he lent his name, Carpentier took another tack. "Bigness, stoutness of heart, brute strength, indifference to pain—all matter nothing," he wrote with an unknown collaborator, "if the science of hitting is properly applied." He had mastered the science of hitting, Carpentier maintained, with analysis and study, pretty much as youthful Jack Dempsey did. The enthusiastic Neysa McMein thought she detected the source of Carpentier's punishing right hand. "His legs!" the tawny artist wrote after inspecting Carpentier as he worked out in Manhasset. "I thought I knew a little something about the anatomy of legs, but this young Frenchman has developed a hundred little muscles that there is absolutely no accounting for."

Dempsey supported McMein's endorsement of Carpentier's musculature, but with a reservation. Bob Edgren, a sportswriter and cartoonist with the *Chicago Daily News,* arranged for Carpentier and Dempsey to play golf on a New Jersey course in May 1921. Dempsey had not before played golf. ("I gripped the club," he said, "the way you grip a crowbar.") Carpentier, a fine golfer, impressed Dempsey with his manners, charm, and command of English. No scores survive, but when the round was over Carpentier offered a gracious comment. "Jack, when our fight is done I hope we can still be such good friends."

Dempsey said afterward, "I though Georges was kind of frail, but in the clubhouse when we stripped down for our showers, I could understand how he knocked out those guys overseas. He had tremendous arms and legs. The sign of a puncher. But," Dempsey told the columnist, Bob Considine, "he wasn't a heavyweight any more than I was King Tut." Perhaps so, but Jess Willard could have said the same thing about Jack Dempsey.

Ring Lardner's narrator goes on: Goulet "was a brittle-looking bird. The first time I seen him, up to one of those roof shows [a Broadway play performed in a theater roof garden], I thought the guy

that pointed him out must be mistaken. But it really was him—a pale, frail boy that if he'd went to college the football coaches would have rushed him for cheer leader. As for him standing up to fight the man that had sprinkled Big Wheeler [Jess Willard] all over Ohio, well, it was just a laugh."

Then why even bother to make the match? Moon/Kearns explains, "Who have we got to pick from? They ain't a man living or dead that's got a chance in God's world to even make this baby perspire, and the worst of it is that everybody knows it. Here I got a champion at a time when everything's big money and he should ought to be worth a million fish to me and himself, and he ain't worth a dime. And he won't be worth a dime, neither, unless I can build something up."

There was, in fact, an acute shortage of suitable opponents for Dempsey. On the way to Willard, Dempsey had already knocked out every good American heavyweight, most in one round. Gunboat Smith had lasted two rounds against Dempsey in Buffalo. Carl Morris, the original White Hope, six-foot-four and 235 pounds, lasted less than one round in New Orleans. Fred Fulton, 6-foot-4½, set a record of sorts: Dempsey knocked him out in Harrison, New Jersey, in eighteen seconds.

The country's frightful behavior toward Jack Johnson now created a distinct backlash: a movement to match Dempsey with the New Orleans–born black heavyweight, Harry Wills. Even today some argue that Wills would have given Dempsey a bad time. Racial prejudice ran rampant in the 1920s, and a black heavyweight champion could have been a commercial disaster for the boxing business. "A black heavyweight champion," Tex Rickard said more than once, "would not be worth a bucket of warm piss."

Considered strictly from a competitive viewpoint, the facts suggest that Harry Wills would have proved to be nothing more than another quick Dempsey knockout. Wills was big, strong, awkward, and not notably fast, just the kind of heavyweight Dempsey devoured. Wills lost a bout to Dempsey's sparring partner, Bill Tate, and in later

years lost to Jack Sharkey, and was knocked out by a Basque fighter named Paulino Uzcudun. As time and legend have shrunk Carpentier's skills, they have exaggerated those of Harry Wills. The suggestion that Dempsey in his prime of youth and sinew was "afraid" of Harry Wills is neither fair nor accurate. Dempsey was ready to fight Wills on at least two occasions. He reneged when promoters missed making scheduled payments. Unawed by Wills, Dempsey was afraid of something else: boxing without getting paid.

Ring Lardner guides his readers through brisk fictional versions of Dempsey's fights with Miske and Brennan, then introduces a French boxing manager named LaChance, modeled on Carpentier's François Deschamps. As the Kearns character meets the Frenchman, a marvelous scene plays out.

"'Listen, Mr. LaChance,' says Moon.

> "If you let me have a free hand I can make some money for you and me both. Supposed I could get your man matched with Dugan. How much would you want for your share?"
>
> "I can't speak no English," says LaChance.
>
> "How about two hundred thousand dollars?" says Moon.
>
> This time he really couldn't speak no English. He'd swooned.
>
> They called the house physician and brought him back and laid him on the bed. "A heart attack," says the Doc. "Don't let him get excited."
>
> Larry started to follow the doctor out.
>
> "Wait a minute," says the sick man of Europe. "My heart's all right now. It was just the first shock. You made mention of a sum of money—two hundred thousand—was it francs?"
>
> "I don't know nothing about francs," says Larry. "I

asked you a plain question. Will your man fight my man for two hundred thousand dollars?"...

The Frenchman sprung at him with a kiss for both cheeks, but Larry ducked away.

Years afterward Doc Kearns said, "Ring was my pal, and he did a terrific job with that short story. Except this, when I mentioned the two hundred thousand dollars to Carpentier's manager, Deschamps, he didn't really have a heart attack. We were at a fancy lunch and he was shocked all right, but all he did was spill a whole glass of vintage champagne over his suit."

Warren Gamaliel Harding swept into the White House in the landslide of 1920 and the Republicans would hold their lock on power through a dozen years of tumult. Harding and his running mate, Calvin Coolidge, the governor of Massachusetts, defeated James M. Cox, the governor of Ohio, and Franklin Delano Roosevelt by six million votes. Their Electoral College margin was 404 to 127. Cox was an undistinguished candidate, but Roosevelt spoke with great energy about the League of Nations, about world peace, about America's future as a global power. This was the last campaign Roosevelt was to conduct as a long-striding man. A year later poliomyelitis crippled him.

In 1920 the American majority spurned Roosevelt's eloquence for the drab and unchallenging message Harding offered. "America's present need," Harding said, "is not heroics, but healing; not nostrums but normalcy; not revolution but restoration; not surgery but serenity."

A significant number dissented from this particular brand of milk toast. Running for president on the Socialist party ticket, Eugene V. Debs came out of prison where he had been sent for sedition and drew 917,799 votes. In a period of jingoism and reaction, almost a million Americans voted socialist. But Harding swept the field. By most accounts Harding was amenable and charming, a wonderful gentleman, said a friend, "to play poker with all Saturday night." His polit-

ical beliefs do not seem to have been passionate. He wanted a government that left big businessmen and wealthy stockbrokers alone. He wanted an America that kept its distance from the problems of other nations. A word frequently used to describe Harding was "commonplace." Although he may not have been personally corrupt, he unquestionably brought crooks into high government places.

In 1891 he had married a wealthy widow named Florence Kling DeWolfe, but by the time he reached the White House, he was a well-established philanderer. "You had to be careful where you went in Harding's White House," someone said, quite seriously. "You even had to knock before you opened closet doors. You never knew behind which door you might find a naked president giving the best of himself to an equally naked young thing." Florence K. DeW. Harding was not amused.

Sport was an additional Harding enthusiasm, and early in his term he invited Grantland Rice to join him for a round of golf. Rice brought along his Long Island neighbor Ring Lardner, whose work was a bit too subtle for Harding's taste. Still, Harding was pleased and wondered amiably what had induced Lardner to come all the way to Washington, D.C.

"I want to be ambassador to Greece," Lardner said.

"Greece?" said the president. "Why Greece?"

"My wife doesn't like Great Neck," Lardner said.

In *Only Yesterday* Frederick Lewis Allen sums up Harding: "A common small-town man, an average sensual man.... His private life was one of cheap sex episodes.... Even as President he was supporting an illegitimate child born hardly a year before his election.... An ambitious wife had tailored and groomed him into outward respectability, and made a man of substance; yet even after he reached the White House, the rowdies of the Ohio gang were fundamentally his sort; it was in smoke-filled rooms that he was really most at home."

Apart from sloppy sex and smoky, boozy card games, what lay ahead were oil and financial scandals that rattled a prospering America and made the Harding presidency a disgrace.

Skirts reached to mid-calf and were going higher. The Round Table crowd was gathering at the Algonquin Hotel, with a northern meeting room at Neysa McMein's studio on Fifty-seventh Street. Sergeant Alexander Woollcott and Private Harold Ross returned from war duty, writing and editing the doughboy newspaper *Stars and Stripes*. As the self-proclaimed town crier, Woollcott became a critic of books, theater, and mores, wielding astounding (and to some, alarming) power. With money from the gin-and-yeast fortune of the Fleischman family, Ross founded *The New Yorker* magazine. Acolytes gathered and gabbed and played poker and performed and wrote about themselves: playwrights George S. Kaufman and Marc Connelly; a great newspaperman, Heywood Broun; a superb clown, Harpo Marx; writer Alice Duer Miller; virtuoso Jascha Heifetz; actress Helen Hayes; and poet/author Dorothy Parker, petite and lovely until hard living spoiled her face. One author called the group World War I and Its Afterwits.

Many of the puns seem labored today and the columns written by Franklin Pierce Adams, the great Algonquin chronicler, were, to put it kindly (Adams and my father were friends), mannered. F.P.A. called one of his formats "The Diary of Our Own Samuel Pepys," after the seventeenth-century English diarist who coined the memorable phrase, "My wife, poor wretch." On July 22, 1660, Pepys concluded his London diary entry, "And so to bed." F.P.A. ended so many of his Pepys-style columns with "and so to bed" that the phrase began to buzz like a dental drill. The Algonquin wits were hardly the foremost American writers of the time. Those would include Eliot, Hemingway, Frost, and Fitzgerald. But they were gifted people who developed a style that sophisticated Americans admired. Sometimes someone, notably Dorothy Parker, was very funny indeed. Of martinis Parker remarked: "With two I am under the table. With three I am under the host." Such self-proclaimed female libertinism was strictly postwar Jazz Age stuff, totally alien to, say, Edith Wharton and even, I suspect, Maxine Cates Dempsey.

One Algonquin apprentice gazed at McMein prettily painting

with pastels in her studio and wondered aloud to Parker, "What in the world would I have to do to get Neysa to go to bed with me?"

"You would have to do two things," Parker said. "Stop at a drug-store and purchase precautions. Then ask Neysa."

The man beamed, then said suddenly, "This will be the first time I've ever been unfaithful to my wife."

Parker: "I assure you it won't be the last."

The dashing Carpentier was obviously an Algonquin sort of boxer, but so in truth was the earthy and completely professional Dempsey. When George Bernard Shaw published a pro-Carpentier fight story in William Randolph Hearst's *New York American,* the rebuttal ran in the *Tribune,* under the byline of Heywood Broun. It was wise, intense, and uproarious. In part because he understood boxing, Broun was a better fight writer than Shaw.

The Rickard–Kearns promotion of what Lardner called "the Battle of the Century" was without precedent. Kearns came to regard it as the great accomplishment of his busy life. If you want to select an exact date when it was proven publicly that American sports had become big business, July 2, 1921, certainly makes sense. If you want to select a date when high-society America, Broadway and Hollywood America, Algonquin America, well-coifed, bejeweled superrich America first came to embrace sports with a passionate hug, again you come to July 2, 1921.

After the Brennan fight, Kearns said, "Dempsey and I were fresh out of opponents." Kearns put out stories about a Willard rematch, but that fight nobody, least of all Willard, really wanted. The big man was not about to step into another prize ring with Jack Dempsey. Anyway, something else was at play. Since Brennan had come reasonably close to upsetting Dempsey, Kearns decided to pursue a safety-first policy. Dempsey could make five to ten thousand dollars a week with personal appearances and more if things broke right for him in Hollywood. He could display his skills without putting his title on the line by boxing exhibitions. Dempsey himself didn't like

Kearns's approach. As Ray Arcel put it, "Jack liked to fight real fights where he was really motivated." But Kearns was calling the shots. He meant for Dempsey to risk his championship as infrequently as the press, the public, and various boxing commissions would allow. Dempsey the contender had sometimes fought five bouts a month. Now that he was champion those days were done.

Bill Brady, the Broadway showman who managed Gentleman Jim Corbett, first suggested Carpentier as an opponent. Carpentier made his American debut on Columbus Day, October 12, 1920, when he knocked out Battling Levinsky in Jersey City. Two years earlier Dempsey had knocked out Levinsky in Philadelphia, but that fight had taken him six rounds. Brady described Carpentier as a splendid boxer with a great right hand, "a handsome devil and a war hero. The talk of Europe. He's managed by a close friend of mine, François Deschamps."

Kearns first imagined a grand bout in London or Paris, promoted by none other than Doc Kearns, with cash flow supplied by European speculators. He began researching and learned to his dismay that European boxing was small-time stuff, which is why Deschamps spilled champagne over his suit.

The logical site was the Polo Grounds, uptown in Manhattan, where the New York Giants played. With the addition of seats around the baseball playing field—a boxing ring pretty much fits between home plate and the pitcher's mound—the Polo Grounds could hold eighty thousand people. No fight on record had ever attracted more than twenty thousand spectators, but Dempsey and Carpentier and an enthusiastic press were creating a new world of boxing. There was one problem with the site. Harding's sweep had carried a Republican named Nathan L. Miller into the governor's mansion in Albany. Miller, well financed by bluenoses on the right, put out word that Dempsey–Carpentier would not be welcome anywhere in New York State. If Kearns tried to put the fight into the Polo Grounds, Miller would organize a drive to repeal the Walker Law. It would be expensive and time consuming to battle a sitting governor. Kearns now had no site for the bout for which he had pledged two hundred thousand dollars.

He also was short in another aspect. He didn't have two hundred thousand dollars. This left him no choice but to turn to his once and future adversary, Tex Rickard. "Just what are you looking for?" Rickard said.

"I promised Deschamps two hundred thousand dollars. But me and Jack are the champion. We got to have three hundred thousand dollars and twenty-five percent of the newsreel rights."

"Lemme think about it," Rickard said.

That was not the answer Kearns wanted. He told Rickard he needed something definite, and fast. He had to respond to an offer of one hundred thousand dollars from "some rich Cubanolas" for Dempsey to box John Sanchez, a popular bullfighter in Havana. It was a good offer, Kearns said, because the bullfighter couldn't "hit a lick and it will be a walkover for us. A hundred grand for a walkover, Tex."

Rickard still said he wanted to think about it

A few days later Kearns appeared at the Hotel Claridge, shortly after noon, with two well-dressed Latin men smoking Havana cigars and a number of sportswriters, including Damon Runyon and John Lardner. As Lardner described it, the two Latins wore "silk hats, Prince Albert coats, gray pants, fancy shirt, and ties that would knock you dead." Rickard regularly lunched at the Claridge. Kearns nodded to him as the headwaiter seated his party. Rickard summoned the headwaiter and asked if he knew who those two fancy-looking guys were with Kearns and what did they do, anyway?

The headwaiter said that they were sugar and tobacco million-aires up from Havana who had come to sign a fight contract. Kearns loved recounting the next moments. "This is Señor Juan Rodriguez," he called to Rickard, "and this is Señor Manuel DeCosta. They're here to offer me a certified check for five hundred thousand dollars to put the big fight in Havana."

"Half a million for Dempsey to box a bullfighter?"

"No, that's all changed, Tex. It's a five hundred thousand dollar guarantee for Dempsey–Carpentier."

"Si, si," said Rodriguez. He waved a piece of paper. "The fight will draw a million dollars in Havana."

Rickard got up to leave. He nodded briskly to Lardner and Runyon. Then he leaned over Kearns and whispered, "See me tomorrow. I'll match their offer."

The truth came out only after Rickard had scrambled about, found backers, and deposited $150,000 as a performance bond, an advance; $100,000 for Dempsey and $50,000 for Carpentier: Rodriguez and DeCosta were waiters. Kearns had hired them, clothed them, and coached them. He had tipped the maitre d' twenty-five dollars to describe them as Havana millionaires. Through the lunch Lardner had stayed silent, as was his way. Runyon said he became suspicious when the two millionaires seemed more interested in the fine food Kearns was providing than in the details of the fight. Whatever. As a sting, a con job, the Cuban-waiter ploy of John Leo McKernan, called Doc Kearns, stands on a peak by itself. Its text is the bible in the Hustlers' Hall of Fame.

But a sting man can himself get stung. Rickard next suggested that the two fighters forget the guarantee and instead share 60 percent of the gross receipts. Dempsey would get 36 percent; Carpentier 24. "No chance," Kearns snapped. In search of money, Rickard approached Mike Jacobs, a ticket broker, who lent him $20,000 and raised $180,000 more among other ticket brokers in New York. They would be paid back in good tickets, Rickard promised, as soon as these could be printed.

As things developed, 36 percent of the gate would come out to $644,125, more than twice the guarantee. "We had no way of knowing the receipts would end up as big as they did," Dempsey said years afterward. "Still, this was one of Kearns's few miscalculations. I remember Rickard coming to me a day or two before the fight when most of the receipts were in. He said, 'Listen, Jack. The public makes the champion and I'm the public's agent. Tell your loudmouth manager not to underestimate me again.'"

If the fight could not be held in New York State, it could be held close by. Offers reached Rickard from promoters in Hollywood (William Fox of Fox Studios) and Europe (a diamond merchant

named Solly Joel) and lesser lights in Nevada and Maryland. The one that interested him was engineered by Frank Hague, the Democratic political boss of Jersey City. Boyle's Thirty Acres was a tract of New Jersey lowland and marsh within minutes of New York City. Boss Hague had the land transferred to Rickard, who brought back the crew he had hired in Toledo and here built the last and largest of the green-wood boxing arenas. Kearns said Hague's fee for brokering the deal was eighty thousand under-the-table dollars.

At first Rickard wanted an oval with fifty thousand seats. Rickard scaled his house carefully: $50 for ringside (perhaps $750 today); $40 and $30 for seats in "the inner circle"; $25 for "the outer circle"; $15 for ordinary (and quite distant) reserved seats; and $5.50—about $80 today—for general admission. Despite these stiff prices, at a time when twenty-five dollars a week was a decent salary, ticket buyers stormed Rickard and his broker partners. Soon orders were accepted only if paid for in cash or by certified check. Rickard told his contractors he needed a larger stadium, one with ninety thousand seats. This created a nine-day wonder among arenas, at a cost, Rickard said, of $250,000. The expansion had the effect of placing the $5.50 locations so far from the ring that as someone commented, "You were damn near sitting in New York City."

In counterpoint to the rising hoopla, guardians of public morals whooped their protests. A group of clergymen in New Jersey said the fight would "brutalize America's youth." Assemblies of Methodist and Presbyterian ministers vied with each other in statements of condemnation. James A. Gallivan, a Massachusetts Republican, denounced Dempsey in the House of Representatives not merely as a slacker but as a "big bum," and added that Carpentier should have volunteered for military service sooner than he did. Gallivan then introduced a resolution to delay the bout until every doughboy who fought in World War I received a bonus. "The millions that this fight will cost the American people could very easily be devoted to adjusting the pay of our real fighting men." Gallivan was vague on how that might be accomplished, and his motion disappeared under the paperweights of the Ways and Means Committee.

Wilbur F. Crafts, who ran an organization called the International Reform Bureau in Washington, D.C., said he was preparing legal papers that would block the bout and lead to the criminal indictment of all the principals. He said that assault was illegal, and what was a boxing match, after all, but a dual assault? Prosecutor Pierre Garvin in Boss Hague's Hudson County declined to take the case.

When Hague and Edward I. Edwards, the Democratic governor of New Jersey, were finally fed up, they formed a new organization, the American People's League, and staged a formal dinner at the Hotel Commodore in Manhattan. (Edwards was governor because the Democratic machine in New Jersey was mightier than a Republican landslide.) The guest of honor was Tex Rickard. "When Tex decided to build his arena in Jersey City," Governor Edwards said, "he knew he had officials there who were regular fellows, who stood for law and order, but would not be browbeaten by raving fanatics." He looked directly at Rickard on the dais. "If there is anything about that crowd of yelpers that I detest, it is their infernal hypocrisy." The tuxedoed crowd of four hundred—including Gentleman Jim Corbett, New York State boxing commissioner William Muldoon, and the ubiquitous Anthony J. Drexel Biddle of Philadelphia—rose and cheered. The fight would go on. More than that, it would become— through alchemies that can be observed more than understood—the biggest story in the Western world.

On July 1, 1921, the Senate passed and sent to President Harding a resolution finally establishing peace between Germany and the United States. More than two and a half years after the fighting stopped, the official arrival of peace was front-page news. But it rated only a one-column headline in the *New York Tribune*. The lead story ran under a head that splashed across three columns:

Dempsey and Georges
Fit for Battle To-day;
Gate Nears $1,500,000

Carpentier's people leased a fashionable property in Manhasset, Gatsby Country, as a training site. The Mathews farm was situated near the estates of Payne Whitney and Louis Sherry and only a few miles distant from mansions owned by Ralph Pulitzer, Herbert Bayard Swope, editor of the *World,* Neysa McMein, and such famous theater and movie people as Leslie Howard, Jane Cowl, Eddie Cantor, and George M. Cohan. This was yacht-club and croquet-by-gaslight territory. There wasn't a coal mine in sight.

Kearns set up Dempsey's first camp in Summit, New Jersey, on property owned by a former lightweight champion, Freddie Welsh. The big attraction was cheap booze: Welsh home-brewed excellent cider and beer. Then Kearns moved the camp to the resort town of Atlantic City, where Dempsey trained in a local boxing hall and out of doors at a dog track near the airport. Kearns and Dempsey both enjoyed a wide-open camp. Atlantic City, of course, was smaller than New York, making it easier, as Kearns put it in his tactful way, "to keep Dempsey under lock and key and away from the dames at night." Kearns started out by charging fifty cents admission for Dempsey's sparring sessions. Daily attendance grew from five hundred to seven hundred to one thousand. Kearns increased the ticket price to a dollar. Still people crowded to see the champion.

In Manhasset, Deschamps, who had just put a lock on two hundred thousand dollars, said that sort of thing was beneath the dignity of Carpentier. "We do not want to take the public's petty cash." Actually, neither Deschamps nor Carpentier wanted the public at all. Carpentier needed privacy, Deschamps said, because he was developing a new and secret punch that would flatten Dempsey. You can't, Deschamps said reasonably enough, perfect a new and secret punch in public. He had the Mathews farm surrounded with surplus World War I barbed wire, hired guards, and brought in a massive Belgian watchdog said to be capable of devouring intruders in two, or at most three, savage gulps. Kearns expressed concern. "I have to admit Jack and I are very worried," he told reporters. "Carpentier is a great fighter and Deschamps is smart as a whip. That guy is really slick. He's a French fox."

Others were less impressed. Damon Runyon and Westbrook Pegler suggested that Carpentier wanted secrecy because his workouts would reveal that he didn't stand a chance. Ring Lardner drove to the Mathews farm from Great Neck with his nine-year-old son, John, and was turned back by the guard at the front gate. "Mr. Carpentier is sleeping," the guard said. A second visit produced the same result and the same excuse. Lardner drove home and wrote a line for the ages: "M. Carpentier is practicing ten-second naps."

On June 2 the *New York Tribune* announced that Carpentier and Deschamps "in Star-Chamber Session" had decided how to knock out Dempsey. The French fighter had developed something the *Tribune* characterized, in the endemic ethnic stereotyping of the 1920s, as "the Frog Punch." How did the Frog Punch work? C. F. Fitzgerald, the *Tribune* reporter in Manhasset, was a little vague. "George Carpentier walked, dog-trotted, pushed, climbed, crawled, rolled and otherwise negotiated his way over eight miles of rough country this morning," Fitzgerald wrote. "This afternoon he was the principal performer in a star-chamber session with François Deschamps, his manager and Paul Journée, the French heavyweight, as the only witnesses.

"There was as much mystery in what went on in the open-air arena behind the barn, with all approaches guarded by hillsides or barbed wire, as there is in the statement of Camille Flammarion, noted French scientist, that Mars is just now trying to signal the earth by means of tele-photography. Flammarion at least makes some attempt to explain the theory back of his surmises. But Georges, never." Fitzgerald speculated that Carpentier might be developing a straight right hand, delivered as he sprang forward "panther-like." By getting both his body weight and the force of his leap behind his right fist, Carpentier could have "an invincible wallop." (In a later time another champion, Floyd Patterson, knocked Ingemar Johansson unconscious for ten minutes with a leaping left hook to the point of the jaw.)

Fitzgerald reported that after sparring with Carpentier, Paul Journée was spotted walking with a dazed expression "and husky Paul [he weighed 220] had the appearance of having encountered a

battering ram." Had the leaping right, the Frog Punch, done the damage? And was that truly the mysterious Frog Punch, a leaping right? Deschamps refused comment. "I can say only that our secrecy in London completely unnerved Joe Beckett at the fight in Holborn Stadium. We have many secrets here that no American can be permitted to know."

On that same day Dempsey and Teddy Hayes organized a pickup baseball game on a sandlot behind the Atlantic City training camp. One team consisted of Broadway actors. The other was made up of sparring partners and newspapermen. Dempsey pitched for the sparring partners. The *Tribune* reported, "The actors pounded Dempsey's offerings to all corners of the lot, getting nine runs off his delivery in the first inning. The sparring partners finally won, 38 to 11, with Dempsey out of the box and out of the game." Kearns showed up in the fifth inning and saw Dempsey tearing around the bases, trying to score.

"Jack!" Kearns's voice was a scream. "For Christ's sake don't you realize you can sprain an ankle sliding? You got to be ready for the big fight."

"You're the doctor," Dempsey said. "What do you want me to do?"

"Take a shower, then go to a movie," Kearns ordered. "You like the picture shows. No dames. Just go with Teddy [Hayes]. You ain't going to get hurt watching no movie."

The best heavyweight fighter in the world, the unconquerable tiger of the ring, did as he was told.

The *Tribune* featured the pickup ball game under an arresting headline:

Jack Dempsey
Knocked Out
In One Round!

Around the world, British colonialism, dominant throughout the nineteenth century, was coming under pressure. The first Indian parliament convened at New Delhi. It didn't do much, but its very

existence was significant. In Persia a general named Reza Khan booted out the British and formed an independent, if autocratic, government. Newspapers reported "clashes between Arab and Jewish workers" in the Palestinian city of Jaffa. At issue was a British promise, in the Balfour Declaration, to provide a homeland for Jews.

Americans, moving toward implausibly prosperous times, were fascinated by electricity and its latest offspring, the radio. Westinghouse opened the first commercial station, KDKA, in East Pittsburgh on November 2, 1920, just in time to report the Harding landslide. Someone in Florida heard signals from Havana. In high excitement, a newspaper observed that now "there is radio music in the air, every night, everywhere." In New York Tex Rickard began negotiating with broadcasters and told the sportswriters that Dempsey–Carpentier would be the first fight ever broadcast on the radio. "People will hear it coast to coast," Rickard announced. His enthusiasm surpassed existing technology. The fight could be carried live only as far west as Buffalo.

Atlantic City was crowded with sportswriters, covering Dempsey, and actors day-tripping down from New York. On June 4, Dempsey told Kearns that he wanted to play one more game of ball against the actors before the onset of his final and most demanding training siege. The men negotiated.

"None of that wild base-running that could turn an ankle," Kearns said, as reporters eavesdropped.

"You're the doctor."

"And no sliding, Jack. Sliding could bust your leg."

"I won't slide."

"And you can't pitch. A line drive up the middle busts your nose and then where are we, Jack? A little bit short, Jack. Around three hundred thousand dollars short, not counting the newsreels and radio rights."

"I'll play third. I can handle a glove. The baseball ain't gonna bust me in the nose or anywhere else."

No newspaper reported the score and years after, when I asked, Dempsey had forgotten. "But," he said with a quick smile, "I know I

hit some shots to left field. Long shots. They tell me I used to hit with pretty fair power."

That same afternoon, disaster stumbled into the Carpentier camp. Sparring with big Paul Journée before a select group of reporters and press photographers, Carpentier clinched. Journée shoved and both boxers fell. C. F. Fitzgerald reported in the *Tribune,* "Carpentier's head hit the padded canvas with a thud that was audible to every spectator, and his arms stretched out full length." Before Carpentier rose, the photographers took twenty or thirty pictures.

Deschamps, Fitzgerald wrote, "became a wild man. He leaped madly through the ropes, waving his arms. Then he turned on the photographers. 'You will give me every plate [press cameras used individual plates, not rolls of film]. Every plate, gentlemen, if you please.'" Meek as the old cartoon character called "the Timid Soul," the press photographers complied. If there was one thing the ticket speculators underwriting this fight did not need, it was a front-page photograph of Carpentier supine. Was he punched or shoved or did he stumble? That didn't matter. The challenger was down. "Canvasback Carpentier," one of the writers sneered. That wouldn't do. This would work as the promoters wanted it to work only with Carpentier as Shaw's "Madman of the North" and Dempsey as himself, the Manassa Mauler.

Tickets moved so quickly that a side business sprang up: counterfeiting Dempsey–Carpentier tickets. Rickard stood in the lobby of the Garden on a rainy June day, chatting with the fight fans who clustered around him. "Mr. Rickard," someone said. "I bought two forty-dollar Inner Circle tickets. Can you tell me sir, are these real tickets or counterfeit?"

Rickard examined the tickets. "Good as gold," he pronounced, "and even more valuable than gold, considering the way tickets for this fight are selling. I have never seed anything like the way these tickets are selling."

"Thanks, Mr. Rickard."

"Hold it." Rickard had spotted something. On valid tickets a line of small type read: "Rain Date, July 3." On the tickets he inspected, the line read: "Rain date, July 3." The counterfeiters had neglected to capitalize the "D."

"Sorry," Rickard said, "but these tickets ain't worth anything at all."

"I paid eighty dollars," the fan said (roughly equivalent to a thousand dollars today).

"Find the man who sold them to you," Rickard said, "and have him arrested. I used to be a marshal myself. Get your satisfaction from the police and the crook who fleeced you."

Rickard buttoned his gray jacket over his vest and started back toward his office. It was getting a bit perilous out front. Then he placed an advertisement in four newspapers.

COUNTERFEIT TICKETS!

Special attention is called to prospective $50 Ringside purchasers for **DEMPSEY-CARPENTIER** contest at **JERSEY CITY TO-MORROW** to marked differences between the genuine and the counterfeit. On the seat check stub in the sentence reading "if postponed," etc., the word "Date" on the genuine is printed with a capital D, whereas on the counterfeit ticket "date" is printed with a small d.

PROTECT YOURSELF!

Counterfeit tickets will not be honored and holders are liable to imprisonment.

TEX RICKARD, Promoter.

Behind Dempsey's immense appeal, other fighters in other divisions began to draw better than they ever had. On June 6, in the baseball park at Harrison, N.J., where Dempsey knocked out big Fred Fulton in 1918, Benny Leonard stepped into the ring to battle Rocky Kansas, born Rocco Tozze in Buffalo, for the lightweight championship. A crowd of twenty-eight thousand paid $101,050 to watch the

bout. Leonard had held the lightweight championship for four years. He parted his hair down the middle, and I remember my father telling me that Leonard was so smooth that he could fight for ten rounds without having his hair mussed. "After ten rounds," my father said, "the part would still be there, even though Leonard's opponent often was not."

Lightweights come in at 135 pounds or less. Buxom beauty-contest winners have weighed more. But a 135-pound fighter, trained lean and hard, fine tuned and taut, is one formidable machine. Leonard, at 133 (dropping the hundred, boxing people say "33") was a classic and quite beautiful boxer with a left jab, a left hook, a straight right, a right cross, an overhand right, and uppercuts with either fist. Kansas, boxing at thirty, was unconventional, sometimes leading with a right jab rather than a left. Heywood Broun, still on the *Tribune,* sized up the men in a literary exercise. Leonard represented Thomas Babington Macauley and all the splendid history of orthodox English writing. Kansas was the Dadaist in the ring. The fight was not close. But that did not distract Broun in his flight of fancy. At one point Kansas launched a right lead. Broun wrote, "Kansas' supporters in the grandstands immediately showed their appreciation by splitting infinitives."

A more detailed, if prosaic (and anonymous) description of the fight summarized the twelfth and final round: "Kansas rushed in blindly, but Leonard brought him up short with a straight left.... Leonard rocked Kansas with a hard right to the jaw.... Leonard hooked two wicked lefts to the wind [midsection], then crossed the right to the jaw. Leonard staggered Kansas with a right to the jaw, but Kansas hung on grimly. Kansas was very weak at the final bell."

New Jersey law counted victories only by knockout. Officially this bout was listed as "no decision." W. J. "Bunk" Macbeth wrote in the *Tribune,* "Leonard clearly established his superiority over the challenger from start to finish. Kansas' effort will be recalled chiefly for the game quality he displayed under repeated and unrelenting hammer blows."

Leonard had won the lightweight championship in 1917, held it for seven years, seven months, and never lost it. He retired in 1925. When the Depression turned his investments bad, Leonard returned as a welterweight—147-pound limit—in 1931. Across the next two years, this remarkable prizefighter, born Benjamin Leiner, won nineteen more bouts. When Jimmy McLarnin knocked him out in the twentieth, he retired for good at the age of thirty-seven. Someone had finally mussed Benny Leonard's hair.

The *Tribune* was advertising Ford, "the universal car," at "reduced" prices. A new Ford Runabout, an open car, listed at $370. This model came with a crank, which you spun to start the engine while someone else pumped the gas pedal. As soon as the engine snarled to life, you let go of the crank. And fast. If you continued to grip the crank, now spun at speed by the engine, you were reasonably certain to break your arm. The Ford Runabout with an electrical starter was more expensive: $465. The top-of-the-line Ford Coupé, with electric starter and "demountable rims"—you wouldn't have to hire a mechanic to change a flat tire—listed at $695, which is probably less than what a well-preserved 1921 Ford is worth in real dollars today.

Most people agreed that Henry Ford put out a good car for the money. Unfortunately Henry Ford also put out a publication called the *Dearborn Independent*. Ford financed this weekly newspaper and became its editorial leader. On May 20, 1920, Ford began a series of what would stretch to ninety-one articles. He called this series "The International Jew: The World's Problem." Pivotal material in the articles was the records of a supposed meeting "of the leaders of world Jewry." These were called "The Protocols of the Elders of Zion." No such meeting had taken place; the "records" were forged by functionaries in Okrana, the secret police of Imperial Russia, to justify the slavering anti-Semitism of Nicholas and Alexandra.

A basic premise of the "Protocols" held that "the Jews" were plotting to dominate the world. At Ford's direction, editors at the

Dearborn Independent depicted Jews as a monochromatic group, united behind the single cause of domination. Jews already dominated finance. Jews had already created pornography to corrupt and weaken Christian youth. "Who are the masters of musical jazz in the world?" the *Dearborn Independent* asked. "Who direct all the cheap jewelry houses, the bridge-head show parks [where Dempsey performed some turns], the centers of nervous thrills and looseness? It is possible to take the showy young man and woman of trivial outlook and loose sense of responsibility, and tag them outwardly and inwardly, from their clothing and ornaments to their hectic ideas and hopes, with the same tag. *Made introduced and exploited by a Jew.*" Ford's cesspool contained the assertion that "in certain Jewish sects" the recipe for matzo, the unleavened bread served during the Passover season, was enriched by the blood of Christian babies. Not only had Jews murdered Jesus Christ, Henry Ford preached, they were murdering Christian infants for their blood. If the 1920s were Dorothy Parker, Red Grange, and Man o' War—and indeed the 1920s were—they also were Henry Ford promulgating what lives in scholarship today as the blood libel.

During the ninety-one consecutive weeks in which the *Dearborn Independent* published these attacks, its circulation rose to seven hundred thousand. Some sold by subscription. Most were given away by Ford dealers. Henry Ford's reasons for terminating the articles were no better than the series itself. Jewish groups protested and some threatened a boycott of Ford cars, to no effect. William Fox, the Hollywood producer and failed fight promoter who owned the booming newsreel company Fox Movietone News, at length got word to dour Henry Ford that he intended to include in every weekly newsreel photographs of Ford automobiles mutilated in accidents. Each newsreel would include pictures of dead victims. Mangled survivors of Ford autos would also appear, screaming (soundlessly; movies still were silent) in horrific pain.

Nailed to a cross of his own making, Henry Ford issued a public statement. "I am deeply mortified that [my] journal has been made

the medium...for contending that the Jews have been engaged in a conspiracy to control the capital and the industries of the world....I deem it my duty as an honorable man to make amends." He then announced that he was budgeting $150,000 to advertise Ford cars in Yiddish newspapers.

The apology did not bowl over everybody. My grandfather, a successful dentist, drove a large, handsome Studebaker. When one of his medical friends, a dermatologist named Mortimer Cantor, said he was going to buy "the best Ford that company makes," I heard my grandfather respond, "Morty! Any Jew who buys a Ford motorcar should be arrested."

Adolf Hitler saw to it that the *Dearborn Independent* articles were reprinted in Germany. That they came from the most successful industrialist in the world gave these stories enormous credence in Munich. It was years before civilized people generally grasped a bitter irony. It was not Jews who were out to dominate the world. The people who wanted domination were the anti-Semites.

Tex Rickard had his own ideas about cars. He told Dempsey that the heavyweight champion had to be first class in every way. He said he didn't want to see Jack ever in "something crummy like a Ford." What did the promoter want him to drive? "I'll show ya, Jack." Rickard took Dempsey to a dealer at 785 Fifth Avenue where the champion might find a suitable gentleman's roadster. Dempsey liked the white one. That Rolls-Royce set him back $14,900.

"Actually," Dempsey told me in high humor decades later, "I got myself a pretty good deal. There wasn't any sales tax back then, and that saved me at least a grand right there."

Gay, gifted Bill Tilden won the world hard-court tennis championships at Saint-Cloud, France, and Suzanne Langlen, balletic and asthmatic, won the women's title. They moved on to England, where each won at Wimbledon. Tilden's grace, power, and good manners captivated the English spectators. A correspondent for the *Evening*

World reported in a League of Nations sentence: "The American, Bill Tilden, is every bit as popular in Great Britain as the Frenchman, Georges Carpentier, is in the United States."

Heywood Broun traveled to Atlantic City and found Dempsey at ease, reading a romantic novel (Broun didn't mention the title) and spending quiet times away from the ring and the pitching mound and the shrieking public, studying French. Dempsey had great devotion to self-improvement. (Like the country, Dempsey was moving toward the philosophy of a small, aggressive native of Nancy, France, who was about to sweep America and vacuum up a significant amount of American riches. Emile Coué established "institutes" in his name where variations of an uplifting sermon flourished. "Day by day," pronounced Coué and his disciples, "in every way, I am getting better and better.") Broun described Dempsey as confident and humble and intent on self-improvement.

"It is very difficult for a newspaperman to get into Carpentier's camp," Broun said.

"You're welcome here," Dempsey said. "So is Georges. I don't have any secrets. If Carpentier wants to watch me work, that's fine with me."

Broun liked this young and open champion. "They tell me," he said, "that François Deschamps has the evil eye. He hits you with it and you get paralyzed. That's why Bombardier Billy Wells and Joe Beckett couldn't even make it to the second round. Carpentier hit 'em, all right, but first Deschamps hypnotized them into a comatose state. Hypnosis is their secret weapon."

The evil eye was medieval nonsense, like alchemy, a warlock's tale. But when July 2 at last came round and Dempsey stepped into the ring at Boyle's Thirty Acres, he never once allowed his eyes to meet those of François Deschamps.

Broun noted in Atlantic City that Kearns' final response to the evil eye was to grab Dempsey's mighty right fist. "Them Frogs can say whatever they want. This is Jack's weapon and that ain't no mystery. His fists ain't no secret at all."

Later, Broun thought he saw a harsher Dempsey. After watching him spar eight rounds, Broun wrote in the *Tribune*:

He comes from the line of Cain, not Abel. His hand is against every man, including the lightweights who were tossed into the ring against him this afternoon [to acclimate Dempsey to speedy fighters]. Carpentier is full of gesture and vivid posture when he practices. He apologizes when he hits too hard and maintains all the rules and graces of the romantic hero of sport. Dempsey scowls and says nothing and cuffs away at his sparring partners as if he were paying off old grudges. Perhaps he is.

There have been many hard knocks in the journey up from the brake beams and Dempsey has forgotten none of them. Even when he shadow boxes he seems riled about something and slashes away as if he wanted to show the air it had better not get in the way of Jack Dempsey. Joe Benjamin, the California lightweight, looked much more like a Russian dancer than a prizefighter. He is even more beautiful than Carpentier. Snorting and grunting, Dempsey caught Benjamin solidly with his left and made him bleed.

In an open sparring session on June 6, Carpentier knocked out Joe Jeannette, a black fighter who was some years past his prime. The *Tribune*'s C. F. Fitzgerald reported: "Carpentier caught the Negro on the jaw with a hard right…[Jeannette] fell backward full length." Now Broun wrote, "Danger lurks in the right hand of this challenger, but he is nothing like the grimacing, snarling champion."

All sorts of journalists clamored about the boxers. Someone wrote that Carpentier "wheezed heavily" while sparring, a supposed flaw. Actually, all boxers breathe noisily when working out. You have to put a big piece of plastic in your mouth to protect your teeth. This leaves only the nasal passages for breathing. A fighter breathes hard and loud to keep the air passages open.

William Randolph Hearst's *New York American* hired George Bernard Shaw to comment on the big fight and Shaw wrote, "Carpentier will knock Dempsey into the Hudson River." The *World* engaged H. L. Mencken, advertising him as "America's foremost critic of men and morals." The *Tribune* countered with James Hopper, "celebrated author and world-renowned war correspondent." Mencken's first piece celebrated the fact that no Negro was involved in a fight for the world heavyweight championship. For his part, Hopper asked if "courtesy, grace and graciousness, concealed within a fragile beauty [Carpentier], could conquer strength [Dempsey]."

"The trouble with hiring literary lions to cover a fight," Stanley Woodward observes in his classic book *Sports Page,* "is that they have no real idea of the subject at hand. At the actual boxing match, should they get that far, they become disoriented by cramped conditions in the press rows, since they have not yet learned that at a heavyweight championship fight you must synchronize your typewriter carriage with those of your neighbors to either side." (On fight day, July 2, 1921, Mencken became so occupied with the neck and breasts of a young woman perched two rows behind him wearing a pink dress with a plunging neckline that he failed to watch the preliminary fights, including one in which a light heavyweight billed as "the Manly Marine" boxed skillfully. The Marine, Gene Tunney, scored a seventh-round knockout over Soldier Jones of Jersey City. Mencken meanwhile wondered if the young woman was well born or if she was moving upward from a chorus line toward society, a journey across five hundred mattresses. He also wondered if she was wearing undergarments.)

At the end of the first week in June, Dempsey left the ball fields for a final stretch of hard training. Fully dressed, he weighed 204. Speed would be important against Carpentier and he intended to drop ten or twelve pounds. Sportswriters noticed the reappearance of ferocity in his sparring sessions. The *Tribune* reported, "Fighting like a trapped tiger, Dempsey showed an inclination to separate his sparring

partners from their heads." He took on Martin Burke, Jack Renault, and Larry Williams, each for two rounds, six rounds in all, with the rest period between rounds reduced to thirty seconds. Dempsey pummeled Burke and knocked out Renault. He missed a right swing at Williams, who ducked forward and butted Dempsey over the eye. A stream of blood flowed, but Dempsey kept going. In the final round, boxing with a bloody smear across his forehead, he punched Williams to his knees. A doctor closed the cut with a single stitch. Still all hands agreed that Dempsey would suspend sparring until the wound healed.

Carpentier's mostly secret training proceeded curiously. He was said to be perfecting the Frog Punch. He also recognized how important speed would be, and he was sharpening up by running down wild rabbits. On June 7, an interpreter reported, Carpentier had snagged a rabbit after an invigorating one-furlong dash through woods and underbrush. "How did he grab it?" a reporter asked. "Why, by the ears, of course," the interpreter said. "He will outrun many more before the fight." A number of reporters said at about the same time that Carpentier's speed was impressive, but Dempsey sure as hell was *not* a rabbit. "Merci," the interpreter said. "This press conference is over."

Grantland Rice reported from Paris, "You may have heard of idols in sports before but nothing to touch the idolatry in which one Georges Carpentier is held by his favorite nation. He come close to filling the gap left by the departure of another fighter known as Napoleon Bonaparte and if he whips Dempsey, he will get a statue in some public place to rival any of Napoleon's bronze remembrances.... To France, Carpentier is the man of destiny. France has never had a heavyweight champion in her entire history. So after all those gray centuries have come and gone, just when sport is in its golden age, a Carpentier arrives, and who can blame France for its ecstasy?"

The ecstasy of Warren Gamaliel Harding was more carnal and more troubling, notably to his wife, Florence, a tall, bespectacled, and strong-willed woman whom the press called the Duchess. Harding courted trouble when he appointed Harry Daugherty—"a third rate

party hack," according to the *New York World*—as attorney general. "The people elected me as a Republican," Harding snapped. "I intend to appoint an all-Republican cabinet." One of Daugherty's principal duties was intimidating all the ambient women Harding bedded so that they would be afraid to blackmail the president.

In Ohio, Harding began an affair with a slim, pretty, jut-jawed blonde named Nan Britton. She was a campaign volunteer, twenty-nine years his junior. Harding surveyed Britton in one of his Senate offices in 1919, then suggested that she strip naked so that "I can visualize you when you aren't here." The young woman took off her clothes. Sometime after that she became pregnant and gave birth to a girl. Nan Britton published a confessional in 1927 called *The President's Daughter* and vividly described the newborn baby. "As she lay in my arms a few hours old, drawing her mouth into comical contortions, and wrinkling her face in what seemed a thousand wrinkles, I saw Warren Harding—oh, I saw him so strongly that it seemed I was holding a miniature sweetheart in my arms!" Britton dedicated her book "with love to all the unwedded mothers, and to their innocent children whose fathers are usually not known to the world." Britton named her daughter Elizabeth Anne, and Harding surreptitiously contributed five hundred dollars a month for the baby's support for the rest of his life.

Other women Harding bedded while president included chorus girls Maize Haywood and Blossom Jones. At a private, which is to say off-the-record, party with reporters at the National Press Club, Harding's candor startled everyone. "It's a good thing I'm not a woman," the president said. "I would always be pregnant. I can't say No."

He left a love poem composed in pencil for a blue-eyed, strawberry blonde bedmate named Carrie Fulton:

> *I love your skin, so soft and white,*
> *So dear to feel and sweet to bite....*
> *I love your poise of perfect thighs,*
> *When they hold me in paradise.*

Republican Albert Fall, the interior secretary, secretly leased an oil reserve at Elk Hills, California, and another at Teapot Dome, Wyoming, to oilmen Edward Doheny and Harry "Sinco" Sinclair. In exchange, Fall took a "loan" of cash and stock worth four hundred thousand dollars and an outright gift of one hundred thousand dollars. Adjusting for inflation, Fall accepted $3.6 million in bribes.

Newspapers complained that Dempsey's three-hundred-thousand-dollar guarantee to fight Carpentier—about $2.7 million today—was "so commercial that it will ruin the sport of boxing." The same newspapers reacted differently to Albert Fall's dirty money. The *New York Evening Post* called senators investigating the scandal "mud-gunners." Others said the oil mess was a conspiracy "of the internationalists, or shall we call them what they are, socialists and communists." Such prattle continued until Fall went to prison.

Daugherty eluded conviction for influence peddling when he told a federal judge: "Having been personal attorney to Warren G. Harding and having been Attorney General of the United States during the time that President Harding served, I refuse to testify and answer questions put to me, because the answers I may give and the testimony I might give might tend to incriminate me." It is no overstatement to assert that for the first years of the Roaring Twenties, the United States was run by a serial seducer and his forty thieves.

One Sunday, June 19, Philadelphia Jack O'Brien came to Atlantic City and sparred a very fast round with Dempsey. "Some say," Heywood Broun wrote in the *Tribune,*

> that O'Brien is fifty, and others set him down as forty-five. At any rate he is very old, but still ambitious.
>
> He jumped in at the champion swinging both hands and Dempsey, who can play only rough or not at all, swung two hands on his own account. Dempsey swung harder.... Finally O'Brien hugged tight to rest a while and bleed a little. It was a splendid showing for a middleaged gentleman

and equal in foot pounds of energy expended to about ten rounds of golf.

In honor of the big Sunday turn out Jack Dempsey shaved and wore purple tights. He even smiled a little until the work-out actually began. After that there was no more conversation. Dempsey simply cannot continue to be either good natured or loquacious once he has the gloves on.

By way of picking up extra cash and showing how formidable French boxers really were, François Deschamps booked Paul Journée, Carpentier's biggest, toughest sparring partner, into Ebbets Field, home ballpark of the Brooklyn Dodgers. Journée's match against Charlie Weinert, the so-called "Newark Adonis," drew a crowd of fourteen thousand. From the French point of view, it was something between a disaster and a catastrophe. Weinert's left jabs and hooks cut Journée's face in the first round, after which Journée, one reporter wrote, "got the worst pasting a ring bruiser ever received in the [ten-year] history of Ebbets Field." Probably only umpires who called a close one for the New York Giants against the Dodgers stood in more physical peril at that site.

Weinert knocked Journée down for a nine count seven times. After a tenth knockdown, in round five, the referee stopped the fight. Journée, the *Tribune* reported, showed "little or nothing of the rudiments of the manly art, except innate gameness." Journée, it turned out, was excellent only at arising from a supine position while bleeding. To spar with Carpentier now, Journée had to wear a face mask covering a bruised eye and broken nose. The writers took to calling him M. Broken-nose Canvasback Journée.

Dempsey would not be up against Journée. He had to fight Carpentier, hero of la Belle France, and Carpentier wrote, or put his name to, an exclusive article in the *New York Tribune*. He provided the paper and its readers with a wonderfully gate-boosting fight story.

He knew he was not as huge as some, Carpentier explained. But size was really nothing more than a state of mind. He made himself

believe than he was bigger than his opponents and he fought bigger than his opponents and beat them badly. Ask Bombardier Wells, Battling Levinsky, or that big English heavyweight, Joe Beckett.

> Beckett said he does not know what happened in the London ring. Well, then, I will tell him.
>
> When he stood up with his head bent and kind of tucked away from the great, massive shoulders and I saw a clear road for my left hand, nervousness left me as though I had been put under a magic spell.
>
> Suddenly I knew. I was positive I would win....I felt an opening as wide as a field for me to carry out the first principles of boxing—to drive in the left hand.
>
> My left went out. I reached his nose....I felt the giant frame of Beckett quiver. I saw stars in those strange-looking eyes.
>
> Beckett tried to send punches to my body but I had ranged my elbows so that he could not reach my body. I jabbed him very hard with my left twice. Again convulsive shivers went through him.
>
> There was his chin. I crushed my right full to the point of his jaw. Down went Beckett as I have seen in war men drop when they are shot. I said to myself, "If he can get up, he is the most wonderful man alive and I will have to walk from London to Paris."...He did not get up.

If this was hokum, and some surely was, it was magnificent hokum. Dempsey–Carpentier advance stories began to dominate newspapers, not just sports sections but front pages, across much of the world. A large European contingent traveled to Atlantic City on June 23. These included Victor Breyer, the editor of *Echo du Sport* in Paris, Jeffrey Farnol, an English novelist who wrote such popular historical romances as *The Amateur Gentleman* (1913), and Benny Bettison of the *London Daily Telegraph*. Dempsey punched around sparring partners for the visiting press, then pinned a wrestler named Bull Montana and

granted a long, cheerful interview. "Charming fellow," Bettison pronounced. "I learned a bit about gold mining, railroad cars and some blooming inland lake that's full of brine. Of course, Mr. Dempsey would not talk about the fight." Bettison picked up but did not understand one of Dempsey's highly reasoned patterns. The closer he came to a championship fight, the less he was willing to talk boxing. The process of internalization was at work, but very much more than internalization as well. "I kept my serious fight plans to myself, as I worked them through," Dempsey said. "I felt that talking about them would be pulling the cork on champagne. Everything would go flat."

The world press made excited comments. The *Manchester Guardian* suggested that the French premier, Georges Clemenceau, was supporting interest in the fight to distract attention from serious postwar problems afflicting France. A Japanese newspaper complained that the fight, on Saturday in New Jersey, would take place in Tokyo on Sunday, a day of rest. Why hadn't the fight promoter taken into account the sensibilities of the Japanese? There had never been anything like this nor, to Rickard's pleasure, had there ever been ticket sales like this. The total passed seventy thousand and kept rising. President Harding would not be there, but who the hell cared? John D. Rockefeller was coming and Henry Ford and Vincent Astor and William Vanderbilt and Joseph W. Harriman and George M. Cohan and ladies, not tramps, real ladies. Show girls and society women were equally and wildly excited by the fight. Over and over the bemused Rickard said, "I never seed anything like it."

Tough old Sheriff Bill McGeehan, sports editor of the *Trib,* broke a New York precedent and—to the horror of the old guard—assigned a female reporter to cover Carpentier's camp. A fight writer in skirts. Harriette Underhill began:

> One day last week our genial sports editor asked us if we would take a day away from Broadway and do a story on Georges Carpentier. Now this isn't exactly out of our province, either, because Georges was once in the "movies," and, Jove, how he can move!

When we were in Mexico we steadfastly refused to go to bull fights. When we are in America we steadfastly refuse to go to prizefights. That is, we did refuse. But not now. We are going to see Carpentier knock out Dempsey. Last week we won a ten dollar ticket to the fight in the copy boy's lottery and we promptly sold it. No matter. Eddie Cantor [a popular comedian] says a ten dollar ticket to this fight puts you in the second row in Newark, and of course, Carpentier and Dempsey will box in Jersey City.

But now I have seen Georges. I saw him along with Neysa McMein, Hope Hampton and Janet Flanner.

The women watched Carpentier spar six rounds and skip rope and pressed so prettily for an interview that Carpentier agreed.

"Where is Mr. Dempsey?" Hope Hampton asked. Someone explained that the Dempsey training camp was about seventy-five miles away and that competing boxers did not train together.

"Mr. Dempsey holds the world's record, doesn't he?" asked Harriette Underhill.

An interpreter translated. Carpentier smiled slightly and responded in French: "Something like that."

Another woman asked if he enjoyed boxing and the interpreter translated.

"Oui," Carpentier said.

"But you have such a gentle disposition," Hope Hampton said, "and such wonderful eyes." Carpentier responded with a wide and pleasant smile. "I'm betting three bottles of l'Origan [perfume] and six pairs of stockings on you," the smitten Hope Hampton announced.

Harriette Underhill, equally aroused, told her readers she was going to the fight and that she would spend a lot of money for a very good ticket "even if this means I have to go without hats until autumn." There is no record anywhere of Carpentier responding to American beauties. He had a wife in France.

As the fight approached, the press grew ever more fervid. Frank Parker Trowbridge wrote in the *New York Times* that Carpentier had the specific advantage of dolichocephalism—he was long-headed—as opposed to Dempsey's brachycephalicism—he was round-headed. This might well have led to a saying: "A good long-headed man will beat a good round-headed man every time." Fortunately it did not, and the science of picking boxers by head shape has long since been discredited.

Parker also reported that Carpentier's great physical balance—he had been knocked out only four times in a career dating from 1907 and knocked out not at all after his seventeenth birthday—came from hours of studying *Discobolus,* the famously restored ancient Greek naked sculpture of a discus thrower that stood in the British Museum. Later art experts pointed out that the restoration was imperfect and that anyone trying to heave a discus in the actual manner of the statue would take a hard fall onto his bottom. Somebody ran down one George Gloria, who had knocked out a fifteen-year-old Carpentier in six rounds on February 19, 1909, in Paris. "Carpentier was a different fighter then," M. Gloria said. "He was smaller and not as clever as he is today. Yes, he can knock out Dempsey but against the fierce Dempsey he can also be knocked out. It will not be a fight that lasts for very long."

"The future of boxing," wrote W. J. "Bunk" Macbeth in the *Tribune,*

will be decided by this fight. The State of New Jersey and in particular Jersey City holds a trust.... There is nothing more sacred than hospitality. Those who have made the long journey with implicit faith in protection... Tex Rickard's name has always been a guarantee of good faith. But Rickard never confronted the problems which will meet him face to face on Saturday.... A man very prominent in Brooklyn politics told me that he and a party of friends arrived at the Harrison baseball park a trifle late to see Benny Leonard

and Rocky Kansas. They found their box already occupied. They asked an officer to eject the usurpers. "Beat it," was all the satisfaction they could get. "Beat it before I bust you in the nose."...Now the fair name of the sportsmanship of the boxing game is on trial. The jury that will sit in on the case at Rickard Stadium will represent the best thought and culture of our red-blooded nation. If any leeway is given to mudslinging [and hooliganism], the reform element will seize on it with avidity. In the proper handling of the crowd rests the fate of boxing throughout the United States.

"The human tidal wave that began rolling over Jersey dikes last night," wrote Grantland Rice, "will pick up impetus this morning as the vanguard starts its big offense toward Mr. Boyle's thirty eminent acres that will be for Carpentier a Waterloo or a Marne. For the greatest single day in the ancient history of an ancient sport has come at last, a day that has caught the imagination of more people, from crowded centers to the remote off-lying places of existence than any single contest since the world's dim dawn."

Six high-powered French army planes were readied on July 1 to fly above the boulevards and flash the news. It would be night in France when the battle began. The aircraft would flash crimson lights to hail a Carpentier victory. If Dempsey won, the plane lights would show white, as in a flag of surrender.

From a guarded gate in Manhasset, Fred Hawthorne, a descendant of Nathaniel Hawthorne, wrote for the *Tribune* that the Carpentier camp had become more secretive than ever.

Outside at the old garden gate listening post, we correspondents swapped yarns and made bets on the number of rain drops that would fall within one minute on a one-foot-square space marked out on a newspaper stretched between us. Carpentier, François Deschamps and all the rest of the camp retinue and the cows and the chickens sat down to

luncheon of broiled lamb chops, rice pudding, soft-bellied eggs and hot cocoa. A pleasant time was had by all....

It was learned on reliable authority that Carpentier is in an irritable frame of mind. He and other members of his household played bridge yesterday and twice Georges openly accused Big Paul Journée of trumping a trick he (Georges) clearly would have won. "Ah, you are zee boob tereeble! Not a brain," is what it is reported that Georges hissed.

Dempsey, unshaven and quiet, moved into a private residence in Jersey City. For once Kearns kept the location secret. (It was the home of retired general William G. Heppenheimer, the president of the New Jersey Trust Company). After a quiet dinner, Dempsey repaired to the billiard room. He went to bed at 9:00.

There was no further need to pour free bootleg booze to jolly the press. Every seat had been sold. In fact with all the counterfeiting, some tickets had been sold several times.

The outstanding prefight literary showdown matched the *Tribune*'s Heywood Broun against Shaw in the *New York American*. "Georges Carpentier," Shaw maintained, "is the most formidable boxer in the world." The three "unmatchable qualities" that Carpentier possessed were "brains, style and character." Shaw cited one Bandsman Rice, a strong puncher, who tried to match Carpentier, righthand punch for righthand punch, in Paris during the winter of 1913. Carpentier knocked out Bandsman Rice in the second round. Shaw had not seen that particular bout, but now he wrote, "I stake upon Carpentier's victory over Dempsey my reputation for knowing what I write about."

Broun was a large, rumpled character who looked, Dorothy Parker said, like an unmade bed. He offered the American response to the words of the Irish expatriate and freelance fight writer: "Probably Mr. Shaw meant well in going on the record that Carpentier cannot

lose. But we wonder if he realized the fearful burden he has placed on the shoulders of Georges Carpentier. Well-wishers of the challenger pointed out the advantage which came to him, back in the days before the Shaw article, from the fact that he had nothing to lose. Dempsey would bring into the ring with him, they said, the whole weight of the heavyweight title. Now that has become a feather. Shaw has staked upon Carpentier 'my reputation for knowing what I write about.' In other words, if Carpentier falls, vegetarianism goes with him and Wagner's music, the drama of Ibsen, the freedom of Ireland, Fabian socialism, disarmament, the superman and creative evolution itself."

(Shaw would have an even worse moment ten years later, following an interview with Josef Stalin in the Kremlin. "Stalin," Shaw wrote afterward, "is simply a party functionary and nothing more. Given one week's notice, Stalin can be removed from office.")

In a classic essay called "They Die in the Dressing Room," W. C. Heinz described the dread that clutches boxers in the moments before they have to enter the ring. He concentrated particularly on those who were about to come up against Joe Louis. One, Max Baer, assured Heinz he felt no terror as he put on one sock and then a boxing shoe. Baer continued to insist in normal tones that he felt calm, even as he pulled on his second gym sock, not over the bare foot, but over the newly laced shoe. Baer, a 220-pounder of exceptional strength, fell to the canvas, in relief some said, during the fourth round.

No similar essay appeared during Dempsey's great years. Dempsey's grasp of sports psychology kept the profile writers of the time off balance. He spoke openly about his own fear, sometimes epigrammatically as in "the sooner the safer," sometimes dramatically as in his statement that when he battled Willard he was fighting not just for the championship but for his life. He was so convincing in maintaining that boxing was a dangerous business for Jack Dempsey that often the writers did not get around to considering the allied point: It was a far more dangerous business for Dempsey's opponents.

Unlike Dempsey, ordinary boxers—Baer, who reigned briefly as

heavyweight champion, was better than ordinary—deny their own fear. They want to pump themselves up, as with John L. Sullivan announcing ad nauseam that he could lick any son of a bitch in the house. A second reason, just as important, is the machismo inclination of fighters and athletes generally to deny fear, even in situations where anyone but a lunatic would feel at least a touch of healthy terror. One such situation is stepping into a prize ring. Even observing from the safety of a ringside seat, when two powerful heavyweights march toward one another some of that terror gives you a clutch at the heart.

As Dempsey the champion had no need to hold forth on sexual triumphs, he never talked up his own courage, either. This was a man so passionate that he tried to domesticate a prostitute. But later, when such famous and beautiful women as Barbara Stanwyck led him to their beds, he didn't have to boast. Similarly, Dempsey never talked about his own courage, not even (or especially) during the wretched slacker trial. To see Dempsey box was, quite simply, to see a brave man going about his business in an extraordinary way. On some profound level the champion knew that. So he was free to talk about his own fears, which any lesser man might not have done, and even exaggerate the fears for purposeful effect.

What, then, were the thoughts, the bounding dreams, and the most secret terrors of poised, formidable Georges Carpentier, the mining-town boxer turned boulevardier? His heroic service in the French air force bespeaks courage. Yet even this brave warrior, when he had to share a boxing ring with Jack Dempsey, felt a certain prudent dread, and that would became significant at Boyle's Thirty Acres in Jersey City, New Jersey, twenty minutes from Manhattan, on the hot afternoon of July 2, 1921.

The Senate and the House of Representatives adjourned early that day. Twelve senators and ninety representatives had obtained tickets to the fight. They did not want to be late. The entire roster of the Newark and Jersey City baseball teams in the International League demanded and got a postponement of their Saturday game.

All the ballplayers were going to the fight. The boxers issued last-minute statements to the Associated Press. "I am proud to represent America against this European challenger," Dempsey said. "I was never more anxious to win a fight than this one. I am ready." Carpentier was brief. "When I go into the ring against Jack Dempsey, I will be prepared to make the supreme effort of my fighting career."

The match was scheduled to follow six preliminaries and start at 3:30. Dempsey was trying to remain calm at the Heppenheimer mansion at 1:00 when a platoon of New Jersey fire and police chiefs came roaring up, announced by shrieking sirens. Rickard had dispatched them. The crowd at the open green-lumber stadium was so huge that the topmost rows were starting to sway. Rickard feared disaster. The stadium might collapse, slaughtering thousands. "Come on," one of the Jersey police chiefs called to Dempsey. "Rickard said we gotta start the fight before the stands fall in."

How many people actually sat in Rickard Stadium in Boyle's Thirty Acres? Officially the attendance was 80,183, four times the crowd at Dempsey–Willard and the biggest boxing crowd ever. Indeed, a bigger boxing crowd than most people, including sportswriters, including ticket brokers, including Kearns, had imagined possible. The actual crowd may have been significantly greater than the announced number. Dempsey told me that there were no empty seats. He was sure that the real attendance was at least ninety thousand. "If Tex was skimming off the top to beat the tax men," Dempsey said, "he would not have been the first fight promoter to do that."

François Deschamps sealed shut the Carpentier dressing room. Dempsey allowed a few friends to enter his quarters. An assistant trainer gave him a rub. Dempsey did not want to talk about anything. He particularly didn't want to talk about the fight.

"The arts, sciences, drama, politics, commerce, and the bootlegging industry have all sent their pink," Irvin S. Cobb, would report in the *New York Times*. All the newspapers ran long lists of famous names: Astor, Jolson, Whitney, Gould, Cohan, tart-tongued Alice Roosevelt Longworth. They came in limousines and yachts and pri-

vate railway cars. Some chartered tugboats. Neysa McMein was there and Harriette Underhill and Heywood Broun and the Algonquin crowd and rich Jake Ruppert, the brewery boss, who just a year or so before had bought Babe Ruth's contract from the Boston Red Sox and brought the big, brash youngster to the Yankees. Tex Rickard personally escorted John D. Rockefeller, Jr. to a better seat than Rockefeller had been able to come by. Rickard later said that "escorting Mr. Rockefeller was the very greatest moment of my life."

The promoter was in a frenzy of joy and fear. The stands would cave in. Or if miraculously they held, something else terrible would happen. He rushed into Dempsey's dressing room and said, "Jack, you never seed anything like it. We got a million dollars in already, and they're still coming. High-class society folks. And dames. I mean classy dames. Thousands of them!"

Dempsey did not respond. He was getting ready to box.

"Jack," Rickard said suddenly. "Don't kill him, Jack. If you kill him, you kill boxing. Promise me you won't kill him, Jack."

Recounting this forty years later, Dempsey shook his head. "You know," he said, "it wasn't as if I had a gun."

I sat silent beside this outgoing, sixty-five-year-old man and thought, "But you did have a gun, Champ. You had two guns. They were called fists."

Carpentier donned a gray silk bathrobe over his boxing trunks and set out for the ring. He had been morose in the dressing room, but now, for the public, he wore a bright and carefree smile. Seeing him, the crowd stood to cheer, rising slowly at first, but then yielding itself to a great wordless roar such as a few especially favored gladiators might have heard in the Flavian Amphitheater—the Coliseum— eighteen hundred years earlier. Carpentier skipped and whirled about the ring, smiling and all but dancing to the cheers.

Dempsey was not a silk-robe kind of fighter. He pulled on a simple crimson cardigan and made his way out of the dressing room. The crowd cheered the champion, too. Dempsey did not smile.

Among the cheers he heard hoots. Some shouted, "Slacker." Dempsey walked into the ring and sat down on a stool in his corner, with his oddly shaved head, two-day growth of beard, heavy-knotted brows, and blank, pitiless gaze. Carpentier looked at Dempsey once, then looked away. He did not want to look at Dempsey anymore.

The fight announcer, Joe Humphrey, intoned: "In this corner, weighing 188 pounds from Salt Lake City, Utah, the heavyweight champion of the world—Jack Dempsey." As Dempsey recalled it, there was a little applause and a low murmur. There wasn't anything much more American than Salt Lake City, Utah, he said, but here this huge, overwhelmingly American crowd declined to cheer the native champion. "Believe me," Dempsey said, "that hurt."

"And in this corner, weighing 175 pounds, the challenger from Paris, France—Georges Carpentier." Ovation. "It was simply impossible to root for Dempsey," Heywood Broun wrote. Then, invoking *A Tale of Two Cities,* "It would have been like giving three long cheers for the guillotine as Sydney Carton went up to meet it where it waited. Romance is silly stuff, but that doesn't prevent it from getting you."

In the heat men peeled off jackets, collars, even undershirts. H. L. Mencken wondered if the pretty woman in pink might also be thinking of disrobing. Just before the bell, Kearns barked at Dempsey, "Don't take no chances with this guy. Belt him out as quick as you can."

Joe Bannon, the timekeeper, clanged the big gong that started the fight of the century. Dempsey moved in, bobbing and weaving, balanced so that he could punch with either hand. For an instant the two boxers looked at each other in deep concentration. Then Carpentier drove a quick left lead into Dempsey's face. Dempsey was weaving away when the blow landed. Carpentier moved in and threw body punches. This was a surprise. The fight men thought he would stay away and try to land his blows from a distance. Dempsey hammered punches into Carpentier's ribs.

The Frenchman was game and durable, or as durable as one

could be against Dempsey in his prime. Breaking a clinch, he landed a right on Dempsey's brow and a quick left to the face. Stung, Dempsey rushed forward, pounding short punches to the ribs. W. J. Macbeth wrote, "The champion kept his two hands going with the rhythm and precision of pistons." From close quarters Dempsey sent a hook into Carpentier's nose, and the Frenchman began to bleed. As well he might. His nose was broken. Another myth died right here. Some later said Dempsey carried Carpentier over the early rounds for the newsreels. But when you carry a man, do you hook him so hard that you break his nose?

Dempsey punished Carpentier through the round, but the challenger kept his poise and sent a pretty fair right into Dempsey's face just before the bell. Macbeth wrote: "The crowd was now mad with excitement. Men and women stood on their chairs cheering in crazy excitement." Don Marquis of the *Sun,* the creator of *archy and mehitabel,* screamed Carpentier's name over and over. Then, as if to calm himself, he poured a clear liquid over his head. Heywood Broun, not usually tolerant in such matters, forgave Marquis that terrible waste of gin. Deschamps and the corner men staunched the blood flowing from Carpentier's nose. Carpentier opened the second round wearing a slight smile. Then he went forth and almost won the championship.

About a minute into the round, with Dempsey pressing and Carpentier circling and slipping punches, the Frenchman delivered his full straight right hand from an unusual angle. This was the punch that had finished Joe Beckett, Bombardier Billy Wells, and Battling Levinsky. It crashed flush against Dempsey's left cheekbone. The champion spun back. It was almost a stumble. His knees sagged. But this was not Bombardier Billy Wells. Jack Dempsey shook his head clear and stayed on his feet. The great punch, the French piston, had missed the chin. Worse yet for Carpentier, the impact of his own glove against Dempsey's face was so fierce that it strained his wrist and fractured his thumb in two places. After that Carpentier had to fight with a damaged right hand. After that, in point of fact, the fight was over.

At one minute and sixteen seconds of the fourth round Dempsey

hooked a left and then hooked a right to Carpentier's jaw. The challenger fell on his face, writhing. Then, face down, his fallen body oddly graceful in the shape of a bow, he lay still. The referee, Harry Ertle, began to count. At six, Carpentier still was motionless. Seven... eight...nine.

With a tremendous effort Carpentier sprang up and while leaping from the canvas, drove his right hand toward Dempsey. There really was a Frog Punch, and now Georges Carpentier was putting it to use.

Dempsey's left arm flicked away the blow as one might flick away a moth. Then he crashed a right hook to the heart and Carpentier went into what Grantland Rice called "the poppy field of unconsciousness."

Dempsey placed his back against the ropes and stared intently at Carpentier. He was ready to make another rush, or another fifty rushes, if he had to. Carpentier never moved. When Harry Ertle's count reached ten and the fight was over, Dempsey strode to the center of the ring and tenderly helped Georges Carpentier to his feet. He half carried the beaten boxer to a corner.

Thousands were breathless. Neysa McMein shrieked and wept. Almost one hundred thousand people were roaring. Dempsey leaned over the ropes and said to the reporters, "I'm sorry that I had to knock out such a good man."

Ammonia water on the neck and ice cubes dropped into his athletic supporter revived Carpentier. "Jack," he called. "Jack." Dempsey walked to the stool where Carpentier sat. "Well done, Champion," Carpentier said in English. "I congratulate you."

Grantland Rice summed up for his magical generation of sportswriters in understandably florid prose: "Human flesh and bone are still softer than iron. At 3:16 Georges Carpentier stood in the center of the ring receiving one of the greatest ovations ever given a fighter. At 3:27 the Lily of France lay stretched out upon the resin, now only one of the Broken Blossoms of pugilism."

Dempsey sent a telegram to Celia, who had raised him across the

years of poverty in the cold mountain places so far away. "Dear Mother: Won in the fourth. Will be home as soon as possible. Love and kisses. Jack."

The next time Carpentier saw Dempsey, he called the champion aside. "When I looked at you in your corner, Jack, you resembled a lion, and I had no intention of getting killed by a ferocious beast." Carpentier fought bravely through his terror. But as surely as that gallant and defiant smile, the terror was there.

The country slowly and reluctantly turned to other things. There now existed what the *World* called "final peace with Germany." The kaiser would not have to stand trial as a war criminal. He was living in Holland under the elegant protective custody of the Dutch government. The new German Republic, the first democracy in all the bellicose centuries of Teutonic history, was trying to cope with extremists on the right and on the left and a wild inflation. Charles Evans Hughes, Harding's secretary of state, suggested that a U.S. trade agreement with Berlin might be in order. "We seek a stable economic world," Hughes said. "We always have. We even sought to help the Czar achieve stability in Russia. Only his tolerance of the terrible pogroms against innocent Jews forced us to abrogate that policy."

Things looked bright in Ireland, where on July 9 British military authorities and two commanders of the underground Irish Republican Army signed a truce. The *Tribune* reported that all evidence of warfare was vanishing "in an amazing drift of sentiment toward understanding."

But to most Americans the politics of Europe had become tedious. In the vernacular, we'd licked the Krauts and saved the Frogs. We'd done enough. Wasn't it time to mind our own business, or in the popular phrase "our own beeswax"? Typically, the *New York Tribune* commented on knee-high skirts with a prominent cartoon. The first panel, depicting "former days," showed five lecherous fellows ogling a pretty girl as she left a bathhouse for a swim. The second panel, "nowadays," showed five lounge lizards still ogling, but now

they have waited until the girl changed into "street garb." This summer you saw more leg and neckline on the street than at the beach.

The estate of Andrew Carnegie, the steel baron said to have given away $350 million to charities, turned out to have survived his generous impulses. The New York State tax appraiser fixed its worth at $12,151,911. An inventor named Miller Reese announced in his office in a tower of the Woolworth building, the tallest in Manhattan, that he had developed a new artillery piece that could shoot a five-ton projectile three hundred miles. Friends of Enrico Caruso reported that the tenor was suffering from a variety of serious ailments. "The great voice of Caruso," the *Tribune* reported, "is a thing of the past." That August 2, at the age of forty-eight, Caruso died.

Dempsey and Carpentier remained prominent in the news. Wilbur F. Crafts of the International Reform Bureau called a press conference to announce he was going "to have Mr. Dempsey arrested for assault and battery upon the person of Georges Carpentier." The reformer's case was not only absurd but decidedly shaky. In the ring at Jersey City it was Carpentier who threw the first punch.

At last Carpentier met the American press for an extended interview. "Dempsey is a fearful puncher," he said through an interpreter. "Every blow he landed on my body hurt me terribly. But the American people were told that I am game and courageous and I could not disappoint them, any more than I could disappoint the people of France. I would not throw in the towel. The fight could end only as it did—with a knockout. I salute Jack Dempsey, the greatest boxer I have ever faced, the greatest boxer in the world." When a reporter asked what was next, Carpentier mentioned Tommy Gibbons, a fast and clever light heavyweight from St. Paul. Would the winner rate a crack at Dempsey? Carpentier said that was too far into the future to say, an answer that was the verbal equivalent of slipping a punch. Carpentier had no intention of taking on Dempsey again.

The champion chatted easily with reporters in his suite at the Hotel Belmont. "Carpentier is a great fighter himself," Dempsey said,

"and as game a fellow as I ever saw. He took his medicine without a whimper. I intend to give every logical candidate a chance to fight me, and if the public wants me to meet Georges again, I will. But I really think he's just too light to beat me. He's a great light-heavyweight champion, and from here on he ought to prove that by taking on the best [Americans] in that class."

Dempsey listed logical contenders. "I told Tex Rickard to get me either Willard or Bill Brennan for Labor Day. Fighting is my trade and I like to keep busy." When a reporter asked about Harry Wills, "the Brown Panther," Dempsey said, "It's the public that runs boxing. If the people want me to fight Wills, I'll make the match."

From 1916 through 1921, Dempsey had fought fifty-six bouts. Along the way, he had beaten every good heavyweight except Wills, but that was the match Kearns and Rickard insisted should not be made. Although Dempsey had no qualms about fighting a black man, Rickard said over and over, "We can't have a nigger heavy-weight champion."

John Lardner's *White Hopes and Other Tigers* is the definitive study of racism in boxing through the early twentieth century. Lardner found a newspaper article, attributed to Luis Angel Firpo, after Firpo went twelve rounds with Wills in a boring match. Firpo wrote, or anyway told his ghostwriter, "The Brown Panther is more of a wrestler than a boxer." Lardner concluded that Dempsey, "a confident champion," was in no way alarmed by Wills and would have dispatched him with ease.

After Kearns, Rickard, and Dempsey finished reviewing prospective opponents, and the lack thereof, an idea began to germinate. Why not take a bit of down time? Let the various contenders sort themselves out. Don't follow the battle of the century with a hasty re-tread. "Take a trip to Europe," Rickard suggested. "You'll pick up good money for appearances and you'll learn a lot, Jack. They tell me the girls are very beautiful in Paris."

"I've never been to Paris," said the heavyweight champion of the world.

9 Strange Interlude

What the hell would I do with fifty thousand sheep in a New York apartment?

—Doc Kearns in Shelby, Montana

Dempsey would not forget the Paris he discovered in the spring of 1922. "You probably think, pal," he remarked one night forty years later, "that in the Roaring Twenties you found the most beautiful women in the world out in Hollywood. The truth is that you found the most beautiful girls in the world in Paris." Dempsey's usually impassive dark eyes softened. "It wasn't hard to meet them if you were young and heavyweight champion of the world." He paused. "And I was young and heavyweight champion of the world…"

A second lasting Parisian memory was the number of people who wanted to spar. By now, at twenty-seven, Dempsey was accustomed to people wanting to put on gloves with him and from time to time he obliged. He had sparred with Douglas Fairbanks and, since Fairbanks was smaller and lighter, he let the actor hit him. "When you punch Dempsey," Fairbanks reported, "it feels like you're punching a tree." Al Jolson insisted on mixing it up a month before the

Carpentier fight. An aggressive sort, Jolson threw a right-hand wallop from the heels. Dempsey's counter—"It was just a reflex," he said—knocked Jolson flat, opened up his chin, and left him with a lifetime scar. Forever after Jolson showed off the scar as though it were a medal, announcing, "Jack Dempsey himself gave me this."

"There were a lot of Americans in Paris and I sparred with a couple, just to be obliging," Dempsey said. "But there was one fellow I wouldn't mix it with. That was Ernest Hemingway. He was about twenty-five or so and in good shape, and I was getting so I could read people, or anyway men, pretty well. I had this sense that Hemingway, who really thought he could box, would come out of the corner like a madman. To stop him, I would have to hurt him badly. I didn't want to do that to Hemingway. That's why I never sparred with him.

"If you write this and you want to hand the people a laugh, tell it like this. Did I duck Harry Wills? Hell, no. They just never offered me a decent purse to fight him. The only man I ever ducked was Ernest Hemingway. I never ducked a fighter, just a writer."

Before Dempsey came to the gaiety of Paris, a distressing scandal had broken in Manhattan. The shock exploded immediately, but it was some time before the real effects became clear. One of these would be the most absurd bout of Dempsey's championship career. Even the *Times,* the most prudish of New York's newspapers, played the scandal on page one. A *Times* headline of January 22, 1922 announced:

ARREST "TEX" RICKARD
ON A GIRLS CHARGE
Boxing Promoter is accused of
inviting 15-year-old child
to 47th Street House
HE HINTS AT ENEMY PLOT

The New York Society for the Prevention of Cruelty to Children had obtained an indictment charging that Rickard had sexually

abused numerous young women. Seven girls made accusations. Rickard was said to have picked them up and taken them to his suite in the tower of Madison Square Garden, then to the private Garden swimming pool. There he helped them undress before a dip. When they were naked he fondled their breasts and genitals. Later the group returned to Rickard's tower suite, where they performed sexual acts "too vulgar to detail," even in an indictment. The Madison Square Garden tower suite in question was the same one that Stanford White had occupied two decades earlier when the naked Evelyn Nesbit cavorted on a red velvet swing. In its lifetime this celebrated suite had many names. Hall of the Vestal Virgins was not one of them.

On several other occasions, the girls said, Rickard had taken them for sexual purposes to his residence at 20 West Forty-seventh Street. The story rumbled and rolled. A few days later investigators told reporters that they were discovering yet more "victims of Rickard's bestial depravity." Mary Horbetch, who was eleven, said she knew about Rickard because "a lot of other girls told me about him." Sarah Schoenfeld, who also said she was eleven, reported having had sexual intercourse with Rickard. Nellie Gasko, who was twelve, reported having had intercourse with Rickard "many times."

The "fifteen-year-old child" of the headline was named Alice Ruck. Her two friends were twelve-year-olds Elvira Renzi and Anna Hess. "The story we have," said Vincent D. Plearra, the chief investigator for the Society for the Prevention of Cruelty to Children,

> is that one night last August, a boy friend gave Alice Ruck and Anna Hess tickets to the swimming pool at Madison Square Garden. They went that night and several times more. One night they met Rickard who they say was always at the pool. They were sure of his identity because various people came up to him and called him "Tex." He talked to them and gave them each a dollar.
>
> All three girls continued talking to Rickard every night they went to the pool. He continued to give them money.

One night he told them to come to the pool when it was closed to the public. When they did, they were undressed by Rickard, who is about 50 years old, and touched in improper ways.

One night he took them upstairs to a suite in the tower. There he offered them wine, but they did not want it. After a while he attempted to attack the Hess girl and he did attack the Ruck girl....More attacks on the Ruck child followed on subsequent nights at Rickard's 47th Street residence. A medical examination at Bellevue showed semen in the Ruck child's vagina.

Newspapermen calling Rickard's home reached his wife, Edith Mae. She told them, "I can just say for my husband and myself that we don't believe a word of these stories. They are fabrications from beginning to end."

Rickard hired Max D. Steuer, a renowned New York trial attorney, and Steuer called newspapermen he knew asking them please to reserve judgement. He then distributed a statement. "I was retained by Howard Lehman, attorney for George L. Rickard, and subsequent to the arraignment I went over the alleged charges with Mr. Lehman and Mr. Rickard and they are utterly and absolutely without foundation. Mr. Rickard is engaged in considerable litigation and undoubtedly has a number of bitter enemies.

"We have not up to this time succeeded in tracing the cause of this horrible accusation. We shall cause it to be thoroughly investigated and as soon as we learn the real facts we will be very glad to give them to the public."

William Muldoon, the chairman of the New York State Athletic [Boxing] Commission, announced that the Rickard charges had nothing whatsoever to do with boxing. But they had everything to do with boxing. Antiboxing bluenoses throughout the country now could trumpet that the sort of man who promoted championship fights was the same sort who molested adolescent girls. "Boxing as an institution

is not directly concerned with this matter," Muldoon maintained. In time W. O. McGeehan took to grouping Muldoon and his two deputy boxing commissioners under a catchy nickname. He called them "The Three Dumb Dukes."

The trial that lay ahead for Rickard could be nothing but a nightmare. As one attorney puts it, "You may get acquitted of the charge of child abuse, but you can never really be exonerated. Patches of doubt always remain. Your reputation is permanently stained."

In the golden age of boxing, the greatest champion had been reviled as a slacker and a coward, and the swashbuckling promoter, the alchemist for the golden age, now faced charges that he was a pedophile.

On February 18 Egypt gained independence from Great Britain, with a final guarantee that the Suez Canal always would remain an open waterway. The British Empire was not dying gently. On March 18, a British-ruled court in India sentenced Mohandas Gandhi, who had been advocating an independent India, to six years in prison for the crime of sedition. In turbulent Soviet Russia, the health of Vladimir Lenin continued to deteriorate from the effects of a would-be assassin's bullet that had bored into his neck. During 1922 Stalin would emerge from shadows and become general secretary of the Central Committee of the Communist party. That proved a solid stepping stone to tyranny. To many, perhaps most Americans at the time, such events seemed inconsequential. They were happening very, very far away. In New York during March, the big news was a strictly local story: *People of the State of New York v. George L. Rickard.*

The trial was brief and harsh. Rickard was charged with six counts of abduction and assault. The sum of the allegations was so serious that the prosecuting attorney, Ferdinand Pecora, demanded that Rickard be confined to the Tombs, without bail, on March 15, the date the trial began, and remain in prison for at least the length of the trial. The court complied. Some doubted that Rickard would walk the streets as a free man ever again.

District Attorney Pecora built his case on stories told by just two of the girls, Sarah Schoenfeld and Nellie Gasko. They proved to be damaging witnesses, but imperfect ones. Schoenfeld turned out to be fifteen years old, not eleven. Gasko, the self-described twelve-year-old, admitted having kited checks from the Echo Cement Company of New York, broken into homes, and stolen money. She conceded that she had been arrested once for begging and once for having robbed an association formed to assist victims of pogroms called the Jewish Relief Fund Bank. She moved around not only as Nellie Gasko, but as "Nellie Hurley." A *New York Times* reporter wrote, "She seems considerably older than her few years."

Still, as Pecora pointed out, the girls' earlier misstatements about age and conduct, "while unfortunate," did not give George L. Rickard or anybody else the right "to molest or assault them." Schoenfeld and Gasko swore that their sexual activities with Rickard had spanned many weeks and reached an undescribable peak at the Garden tower suite on Saturday afternoon, November 12, 1921. They were quite certain that was the date of a memorable matinée.

For two days in March 1922, Max Steuer took apart Schoenfeld and Gasko. Under tough cross-examination, Schoenfeld admitted to having intercourse "on a regular basis" with her "real boyfriend," who was sixteen. Even if Rickard were guilty, Steuer said to the jury, what had he despoiled? A woman, or if you must a girl, long since been despoiled by others with her own lustful consent. As for Gasko-Hurley, Steuer got her to admit that she needed money, she always needed money, and she would do just about anything to get "enough for eats." Over Pecora's objection Steuer told the jury that this needy child had almost certainly taken money to tell a fabrication against Tex Rickard. She was pathetic, to be sure, but also dangerous.

Steuer's defense was memorable. First he had Rickard tell his life story. The jury sat listening and appeared spellbound. As the *New York Times* summarized Rickard's words: "He was born in Kansas City in 1870, raised in Texas and compelled to shift for himself when he was 10 years old, becoming a cow puncher. He once had charge of

a herd of thirty-five hundred cattle. He was Marshall for two years in a town in Texas. The Gold Strike took him to the Klondike. In 1899 he went to Nome and ran a gambling house, making seven hundred thousand dollars, which he lost in mines that failed. He made another fortune with a five-million acre cattle ranch in Paraguay.

"In 1908 he launched himself into the fighting game...Gans-Nelson at Goldfield, Johnson-Jeffries in Reno...Willard...Carpentier...Dempsey...Dempsey."

The district attorney refused to be impressed. Indeed, he had some serious questions to ask this great adventurer. Wasn't it a fact that Rickard made his gambling-hall fortune by stacking decks and running crooked roulette wheels? Hadn't he branched out from gambling and run brothels in Nome, Alaska, and Dawson, Nevada? In those brothels hadn't he employed underage girls? Hadn't he seduced a fourteen-year-old in Rawhide, Nevada, and hadn't her mother sought him out and punished him with a whip? And after that, with her daughter disgraced, hadn't this aggrieved mother committed suicide? Hadn't he been run out of Hot Springs, Arkansas, for cheating at cards?

Pecora concluded: "Were you not, in the long and the short of it, Mr. Rickard, a cad and a cheater, and to get to the heart of this matter, sir, an abuser of young women, a pedophile?"

Rickard's ears reddened. His voice was calm. He said, "No, I was not."

Max Steuer's defense first focused on the afternoon of November 12, 1921. Had Rickard spent that afternoon in the prosecution's vile love nest? Not at all, Rickard said. In fact, that afternoon he had gone to the Polo Grounds and watched a football game between Dartmouth and Pennsylvania. Ike Dorgan, his press agent, and Frank Flournoy, now working in his boxing office, went with him along with the sports editor of *The American,* Bill Farnsworth.

Under cross-examination, Rickard could not remember who won.

Pecora asked, "What color uniforms was the Dartmouth football team wearing?"

"I can't say for sure. I'm a boxing man. To tell the truth that was the first football game I ever saw." Dorgan, Flournoy, and Farnsworth later swore that Rickard actually had been at the Polo Grounds. His chauffeur, Thomas Murphy, swore that he drove Rickard there.

"What color suit did Mr. Rickard wear up at the Polo Grounds?" Pecora asked Farnsworth.

"Damned if I know," Farnsworth said. "I'm a sports editor, not a tailor." (He was also one of the newspapermen who received a cash envelope from Rickard every week.)

Steuer now summoned a platoon of character witnesses. Charles E. Herron, a prominent Alaska businessman, testified that Rickard's reputation in the north country was outstanding. Anthony Drexel Biddle said Rickard had "purified" boxing. He added with unchecked ardor, "Rickard is the finest and noblest sportsman I ever knew." Kermit Roosevelt, son of the late Theodore Roosevelt, said he had known Rickard for years. "For some time he has been associated with my family in running a coffee house on West Forty-fourth Street," Roosevelt said.

"Did you know and did your family members know that the defendant once ran a gambling house?" Pecora asked.

"We did indeed," Roosevelt answered, "and all said it was excellent because everyone was sure of a square deal."

Pecora paused and looked at his notes. The president's son rumbled over him. "I would not say he had a bad character because he ran a gambling house. A man who runs a gambling house isn't necessarily a bad character any more than a man who runs a church is necessarily a good character."

Lean, dark-haired Ferdinand Pecora delivered a bristling summation on the afternoon of March 27. "The complainants," he said, "are not normal girls. Normal girls would never have been lured by the great gambler, Tex Rickard, and sold their souls and virtue for a few pieces of silver.... Whether they invoke your sympathy or condemnation, if you believe that assault was committed on November 12, you must find the defendant guilty or hate yourselves all your lives

because, like Benedict Arnold, you will be unfaithful to your trust. The insinuations of frameup [by Steuer and Rickard himself] are preposterous. Brilliant counsel and alert private detectives have established no frameup because there was no frameup. Gentlemen of the jury, it is your solemn duty to protect children everywhere from a moral leper, for that is what Tex L. Rickard is."

The next day, just past noon, the jury returned with its verdict. The twelve men had deliberated for ninety-one minutes. They found Rickard not guilty of any of the charges. He was a free man.

Rickard gripped the rail and almost sank to his knees. He recovered quickly and turned to the reporters. "I'm far too gratified to say very much. I've shot craps at thirty thousand dollars a throw, but I've never been through anything like this last hour and a half. I didn't have any idea how it was coming out." Bravado flowed back into the man like a transfusion. "Boys, I want to tell you that jury has the greatest lot of poker faces I ever looked into."

Pecora told reporters that the "unfortunate verdict" made it doubtful that it would be worthwhile to prosecute Rickard on the allegations of the other young women.

Steuer said the verdict was a "repudiation of blackmail. Mr. Rickard assures me that he will spend the rest of his life seeking out its instigator." No instigator ever was found and the verdict left many unconvinced. An editorial writer in the *New York Times* observed that professional gamblers, "who as a business exploit the common human tendency to risk money on opinion and luck are and should be objects of condemnation by economists and moralists alike." Dark rumors of Rickard's sexual activities persisted. He had been declared not guilty, which is not to say that he had been found innocent. For a long time his energies and his power as a boxing promoter were significantly diminished.

Warren Harding had taught his Airedale, Laddie Boy, to fetch golfballs. That was front-page news on April 11. "On warm spring

evenings," the *World* reported, "the President has been slipping away from his office at 6 o'clock and taking his driver to the rear grounds, enclosed from the public by a hedge. Laddie Boy, who alone accompanies him, has learned to spot where the balls go and rounds them up and returns them to his master." We can conclude that Harding was no two-hundred-yard driver. A few afternoons later the president threw out the first ball and the Yankees opened the baseball season by defeating the Senators in Washington. (They would win the pennant but lose the World Series, swept by the swaggering Giants of John McGraw.)

That same spring day the *Tribune* featured a special dispatch from Ypsilanti, Michigan. Charles McKenney, president of Michigan State Normal [Teachers'] College, and Bessie Leach Priddy, the dean of women, jointly announced that seventeen coeds had been expelled for excessive smoking and petting. Identical charges landed another thirteen coeds on probation. "Their indiscretions," the proclamation stated, "included attentions from many and sometimes strange men; allowing undue familiarities from men who were casual acquaintances, sometimes several in a single term; constant week-end dates, street pick-ups and numerous other intolerable actions unbecoming to a lady." One shudders to think what would have befallen any of these thirty young women if it had been discovered that she had partaken of intercourse.

Dempsey's departure for Europe on April 11 was also front-page news, with neither bluenose chastity nor moral leprosy anywhere on the scene. No one asked him about Rickard's recent troubles and he was sensible enough not to volunteer a comment. Huge, ebullient Luis Angel Firpo, who had just knocked out Sailor Tom Maxted in Newark, bulled his way through the crowd and gave Dempsey a good-bye kiss on each cheek. "I had no idea who the hell he was," Dempsey said.

Swarms of show girls—Dempsey did know who the hell they were—stormed the gangplank of the Cunard liner *Aquitania,* each passionate to wish the champion well. The arrivals and the sailings of the great ocean liners were major news stories during the 1920s,

covered by aggressive reporters and photographers, and the press corps bellowed and bellowed, "Kiss her, Jack. Kiss him, sweetie. That's it. Keep kissing. Just one more."

In succession, Dempsey kissed Florence Walton, a beautiful dancer; Mary Lewis, a lively Follies girl; and Mary Sherman, an enthusiastic movie actress. Reporters cornered each woman and demanded, "What kind of kisser is Jack Dempsey? How does it feel to be kissed by the champion?"

Mary Lewis said, "Jack's kisses are lovely and very..."

"Very what?"

"Oh, but you must *experience* one to understand. Mr. Dempsey is one of the loveliest gentlemen. He's a great, sweet, overgrown kid. His kiss? It was so sweet, but there was such a crowd."

The Follies girl then discoursed on kisses. There was, Mary Lewis said, the Breakfast Kiss, quite formal and polite, that didn't mean "a doggone thing." The Luncheon Kiss was warmer but rushed. There were a lot of things still to be done this day. Finally there was the Teatime Kiss, "as lovely as that time of day and very promising." Lewis described Dempsey as a wonderful Teatime Kisser, "except that here with such a big crowd around, we had to settle for a Breakfast Kiss." She was disappointed. "But I do hope to see Mr. Dempsey again."

Florence Walton, the dancer, said she really knew Dempsey only slightly. "But he told me the other night that I had to come kiss him good-bye to calm him down. He told me he'd had a bad experience on a small boat going from San Francisco to Seattle and now he was afraid he would get seasick, even though this boat is big. So I hugged him and he took me in his arms and kissed me...like a big brother. I'm sure he didn't *really* mean anything by the kiss."

Mary Sherman said she felt that the kiss Dempsey had given her actually meant quite a lot. "But just what, I can't say. Or, perhaps, I shouldn't. I can just tell you his kiss was very, very wonderful."

The *New York American* published this quaint bussing story around an oval picture of Dempsey locking lips with Florence Wal-

ton. He is concentrating. She looks intense and happy. It is a lovely photograph. What it depicts, far from the sibling contact Walton spoke of, is a fine and gentle passion. The *American's* story concluded: "Miss Walton is a brunette, Miss Lewis a blonde and Miss Sherman has a luxuriant head of Titian hair."

"Dempsey kissing all those beauties," commented Hype Igoe of the *World*, "is only doing what Rickard wishes he could do."

A news item dispatched that spring day from Hammonton, New Jersey, seemed to suit the mood of the Dempsey sailing. It reported in its entirety, "Fruit orchards in this section are in full bloom."

Dempsey was indeed concerned about seasickness. He told Damon Runyon, "They don't have any oceans in the San Luis Valley of Colorado where I was raised. I'm not used to oceans."

"Make sure you get the bed by the window," Runyon said. "You'll feel less cramped."

"Yeah," Dempsey said, brightening. "Maybe I'll see the flying fishes skimmer by."

Dempsey was the celebrity of celebrities. As the ship prepared to cast off, he stood at the rail looking at the crowd on the pier, calling people by name. When at last the propellers turned and the *Aquitania* began to move, he shouted a final message to all: "Give my regards to Broadway." But the young champion was not the only celebrity among the fifteen hundred passengers. "A big crowd sailed on the Cunarder *Aquitania*," the *Tribune* reported, "including bankers, social leaders, editors, dancers and singers. Among them: [the diva] Alma Gluck, [the director] David Wark Griffith, the Dolly Sisters [a popular singing group] and Walter Kinsella, holder of the American professional court tennis title, who will meet George Covey, the English champion for a $50,000 purse, two thirds to the winner."

The Dempsey crew repaired to staterooms C114–116 on the second deck. The group included Kearns, Teddy Hayes, and Joe Benjamin, the handsome lightweight out of Stockton, California, a partner for occasional fast sparring sessions and a general factotum.

The final member, not mentioned in the *Times,* given one line in the *Tribune,* but prominent headline news in the *New York American,* was Damon Runyon.

"Damon Runyon," the *American* announced, "the greatest descriptive writer in the country, left yesterday with Jack Dempsey and a party on a tour through Europe. The folk will visit England, France, Belgium and Germany. Mr. Runyon will handle the situations in his usual inimitable style, which means that readers of the *American* will enjoy his tales."

Who would Dempsey fight next? That question buzzed about the *Aquitania* and appeared on sports pages. There was talk about Harry Greb, "the Human Windmill," out of Pittsburgh, a tough, aggressive, crowd-pleasing fighter. But Greb was a middleweight. He was lighter even than Carpentier. The names of two English veterans came up: Joe Beckett and Bombardier Billy Wells. They were big men, but each had a jaw of fine-spun English glass. Willard again? Harry Wills? Carpentier? South American "sportsmen" wired that they would guarantee Dempsey five hundred thousand dollars to fight Luis Firpo in Buenos Aires. All that meant for sure, Kearns said to Runyon, was that "these Latin characters have enough cash on hand to pay for a cablegram."

In the first hours out of New York, Dempsey explored the *Aquitania.* Runyon likened him to "a big animal investigating a new cage. He went bounding about nosing into every nook and corner. He has never reminded us more of a mountain lion." Dempsey "is not a man of great mental diversion," Runyon commented. "He lacks the maturity that brings the habit of repose. He does read a little and he has started keeping a diary and that seems to afford him considerable pleasure. But after all his amusements are mainly physical."

Portions of Dempsey's diary survive. At the end of his first day at sea, he wrote that he had a fine room, but his quarters were modest compared to those of David Wark Griffith. Joe Benjamin had gotten into Griffith's suite and reported: "Say, Champ. It's got two or three rooms, a couple of baths and a private porch. No kidding. A private porch over the ocean. Can you beat that? I bet it costs him plenty."

Griffith invited Dempsey to the suite. "No one," Dempsey wrote, "would begrudge a great director any comfort, or luxury, either." Over drinks very late Griffith told Dempsey, "Don't let this setting fool you. This is all being paid for by a movie company. Personally, I haven't got any money. I don't ever expect to have any. Outside of my business, I really don't need any, that is any great amount. I can only eat so much. I can only wear one suit of clothes. Give me just enough to support my few material wants and that's all I ask."

As Dempsey walked back to his own stateroom, one of the ship's officers told him that there was fog on the sea and, while he and Griffith were talking, a freighter had narrowly missed the *Aquitania*. "As a matter of fact, Mr. Dempsey, we just escaped being cut in two."

Before going to sleep, Dempsey wrote:

> I'll always remember what Griffith said. I feel the same way about money. Some people seem to think I have a lot, but I haven't. I've bought mother a good home [on Western Avenue and Twenty-fourth Street] in Los Angeles and given it in charge to my brother, Joe, because I know he'll stick around to look after her. I've provided for the rest of my family. I think I could get along if I didn't have a dime.
>
> There are a lot of millionaires aboard and several people with titles, such as Sir-this and Sir-that. I listen to the roar of the ocean and the sound of the foghorn and I think how little titles and money mean when it comes to the big showdown.
>
> Eight years ago tonight, I thought the inside of a box car loaded with loose wheat was a fairly comfortable berth. Here I am in a beautiful room on one of the finest ships afloat lying under a silk quilt, and I have just escaped probable death.
>
> Life is pretty much a matter of luck, isn't it?
>
> If you don't think I think I'm lucky, you've got another think coming.

Dempsey's mental capacity and maturity exceeded what Damon Runyon knew. The diary shows us a thoughtful, introspective young man, and, in a sense, the champion as existentialist.

Each day on the *Aquitania* Dempsey rose early, put on roadwork clothes, and jogged five miles around the decks. Then he repaired to the shipboard gymnasium and lifted weights, skipped rope, and shadow-boxed. After that he sparred three rounds with Joe Benjamin. Dempsey and Benjamin worked at great speed on a floor that was rocking with the motion of the waves. Once Benjamin nailed a corking right to the champion's chin.

"Whoa—I didn't mean that," he shouted. "Now I'll catch it."

He did. Dempsey moved in and whacked Benjamin just as a lift of waves tilted the big ship. The punch and the wave sent Benjamin sprawling and spinning to the floor, part boxer, part cartwheeling clown. He got up and tore into Dempsey, who held him off easily and began to laugh. There is no other record of Dempsey laughing in a ring.

"The rumor spread about the big ship that Dempsey was sparring and there was a general rush of passengers to the gymnasium," Runyon wrote. "Only a few were admitted. No women were allowed, much to the disappointment of many prominent ladies on board....The weather is fine. Yesterday the ship hung up a record run of 553 miles."

Why was Dempsey training so hard with no fights on the horizon? "There was always a possibility," he said, "that one of these Europeans might turn up with an opponent and a pot of gold, and I wanted to be ready." But to promote a fight with Dempsey as champion you first had to deal with Doc Kearns, without going bankrupt. Tex Rickard, on the record the only promoter capable of passing that miracle, was going to work every day, but getting little accomplished. The child-abuse trial had left him depressed. For the time being, the rough-and-tumble, risk-a-million, hypertense frenzy of creating another Dempsey championship fight was quite beyond him.

A crowd—Runyon called it "a curious, jostling, eager mob"—

swarmed about Dempsey's boat train when it arrived in London on April 18. The British press jostled about him in a hotel lobby and someone said, "We hear, Mr. Dempsey, that you not only worked out in the gymnasium on shipboard, but that you spent busy evenings with the Singing Dolly Sisters."

"They're nice girls," Dempsey said. "Both of them."

"Are you going to marry either of the Dolly sisters?"

"I'd have to be Solomon to choose and I'm not Solomon. I'm a prizefighter. Who could choose between the Dolly sisters? I can't. And I can't marry two girls at the same time, under American law."

Gershon Mendeloff, of East London, the world welterweight (not over 147 pounds) champion who fought as Ted "Kid" Lewis, broke through the crowd, identified himself, and shook hands. Lewis had signed to fight Carpentier in London on May 11. He would be giving away almost thirty pounds. "Well, what are you going do with Carpentier, Kid?" Dempsey asked.

"Same as you," Lewis said. "Knock him out."

On May 11, Carpentier knocked out Ted Kid Lewis with a right to the jaw in the first round.

The *New York American* ran a cartoon in which Dempsey, clad in mail, clutched a broadsword outside a redoubt labeled EUROPE. "I'm lookin' for giants," Dempsey says. "Toss me out a couple."

Through a barred window the gatekeeper replies, "Sorry, young man, but I'm afraid we're just out of giants." Carpentier's quick work with Lewis underscored a point. Dempsey had been fighting on one level. Every other boxer in the world labored in valleys far below.

Dempsey was an enthusiastic tourist. He saw Big Ben, the Tower of London, and Buckingham Palace. He liked to walk but the weather was persistently cold and wet and raw. He settled on sleeping late and spending his nights at a variety of London parties. Many Britons expected to meet a crude lowbrow primitive, a kind of gorilla in human form. That was all the more reason Dempsey's grace and

easy wit captured the British Isles. The duke of York, later George VI, asked Dempsey to present the awards at a horse show he was sponsoring. Dempsey found the duke painfully shy. He wondered what "the boys back in Provo and Montrose would have thought if they could have seen me talking to real royalty, a prince of England."

On April 19, Dempsey, Kearns, and the rest hired a limousine to carry them to the races at Epsom Downs. Kearns provided an engaging description. "Jack and the rest of us got fitted in top hats, ascots, spats, and when we got there it turned out that the races at Epsom Downs were really a cowtown carnival, only in England. There were booths selling all kinds of gadgets and high-wheeled gypsy wagons from which black-haired and come-hither-eyed gypsy girls in swirling skirts and bright bandanas sold you anything you wanted."

In *The Million Dollar Gate,* Kearns proceeds into interesting fiction. When he Dempsey and Runyon were seated in their box, he reported that "a dignified gentleman with a beard was ushered in." Kearns said he poked Runyon and said, "Pipe the egg in the lean and fat." This was a correct use of the famous, or notorious, cockney rhyming slang. The egg in the lean and fat meant the gentleman in the top hat.

As Kearns told it, Runyon said, "The egg in the lean and fat is none other than King George V of England."

In the Doc Kearns version, Kearns took a few swigs from a hip flask for courage and advanced on George V. "King," Kearns claimed to have said, "how would you like to meet the heavyweight champion of the world?"

"I'd be delighted," the egg replied.

Kearns waved Dempsey toward him. Then the king and the champion shook hands.

What a nice picture, the American miner-champion standing with the British king. All that spoils the story is the intrusion of truth. Runyon reported in the *American* on the day after the supposed meeting, "King George was present at the races with Queen Mary. The royal party watched with obvious interest as the big fighter made his

way through the jam on the lawn below. But the champion did not meet the king."

Lord Northcliffe, publisher of the *London Daily Mail,* held a luncheon honoring Dempsey two days later. Dempsey put on a cutaway coat and striped pants. Runyon caught up with him in the hotel lobby. "They didn't ask me, Jack, but hell, I'm going with you."

Dempsey thought briefly, then said, "They don't do things like that over here, Damon. It's a private party. If you want to go, go ahead. But I'm not inviting you."

Dempsey settled at the luncheon table beside Northcliffe in the publisher's expensively appointed town house. In time Runyon arrived and presented the butler with a calling card. Northcliffe rose and told Runyon at the front door: "I'm sorry. This is a private party for Mr. Dempsey. Good afternoon." Then the butler closed the door in Runyon's face. America's "greatest descriptive writer" was barred on the edict of a London newspaper publisher. No press.

After a series of tributes to Dempsey as a fighter and a gentleman, Northcliffe called on the champion. Cheerful and confident in upper-class England, Dempsey said, "I feel like the Irishman who was asked to do something special for the guests at a very fancy affair. The Irishman said, 'I can't sing. I can't dance. I can't tell jokes. But I'll fight anybody in the house.'" Dempsey never forgot this day. What he remembered most vividly was not his own amusing speech, but Runyon's being turned away. "Damon couldn't get over what happened to him in London, mostly because in Colorado, he knew me when I was a hobo."

Cruising among the toffs and earls, Dempsey quietly was burning for another fight. But under Kearns's bluster, the manager dreaded putting the championship at risk. Rickard, who might have been setting up a good match, instead was fighting his depression with a Bermuda vacation. In truth, worthy contenders were hard to find. By this time—Dempsey was approaching his twenty-seventh birthday—the champion had matured enough to regard an opponent

as "worthy" not just on the basis of ring skills, but also on a projection of how much box-office cash that particular opponent would draw. He had memorized one professional boxers' adage: Only losing lovers and drunks fight for free.

Just before leaving London, Dempsey got together with Runyon and put his byline on an unusual story for the *American* and William Randolph Hearst's international syndicate, King Features. This was the 1922 equivalent of today's prime-time network television appearance.

"Here are a couple of hopes," Dempsey began.

One is that I'll find someone in Europe who is eager to give me a fight. The second is that by the time I get back to the United States, there'll be a half a dozen battlers who want to take me on. Lots of champions have been satisfied to sit pretty and duck battlers, rather than seek them. I'm somewhat different. This loafing stuff is getting on my nerves. I want action and more action.

Here's an idea. I could meet two fighters on the same night in one ring. I'd try to put away one man in four rounds and the second man in six. This two-fights-in-one-night idea has been tried before in America, around 1898. Jim Jeffries came out of the West that time and agreed to fight Bob Armstrong and Steve O'Donnell on the same night. Jeff took on Bob, the husky Negro, as a starter, and that's as far as he got.

They went ten tough rounds. Jeff got the decision. But when the fight was over, he decided he couldn't take on O'Donnell. That was all because Bob Armstrong had handed out a good pounding. [Jeffries won the heavyweight championship from Bob Fitzsimmons the following year.] It's a tough assignment for a man to fight two good men on the same night. But if I have to do that to get fights, then that's the program. Meanwhile, I'm hoping some promoter can come up with the right guarantee for a match between Harry Wills and myself.

Dempsey against the universe, or anyway against two bruisers, caused enough of a New York buzz for the *World* to contact Kearns. Since Dempsey had been paid for the Hearst article, Kearns directed the *World* to his agent, Christy Walsh, who also represented Babe Ruth. (The idea of Kearns, who was variously carving a third to one-half of Dempsey's income for himself, having an agent of his own, gives pause.) Walsh arranged for a copyrighted article under the byline "Jack Kearns, Manager of Jack Dempsey, World's Heavy-weight Champion." Unfortunately but predictably, the *World* got more fluff than real boxing news. Interesting fluff—Kearns did not know how to be dull—but the stuff contained as much substance as cotton candy.

Kearns wrote that Dempsey had dreamed of seeing kings and queens since his early boyhood and actually standing in sight of King George and Queen Mary had gotten him "steamed up. When Jack was spotted near the King, the crowd began to cheer. 'He's a popular man,' Jack told me. He didn't realize that the cheers were for himself."

But what about another fight? "We have received two tentative of-fers," Kearns wrote, "but they were not substantial enough to consider."

What about fighting two men on the same night? Kearns re-sponded with braggadocio. "There is even a suggestion Dempsey take on *three* men in one night. Jack is willing, but I won't even take that seriously. Anyway, the trouble would be finding three men will-ing to go into the ring with my champion.

"Old-time English sporting men tell us no other American boxer, and few other American individuals, have ever received such a reception here as Dempsey. Compared with Dempsey, [Jim] Jeffries, [Jack] Johnson, and [Tommy] Burns attracted no attention whatever.

"Men whose memories go back to the visit here of John L. Sulli-van say it was nothing like what my champion has experienced.

"We are all looking forward to Paris."

It was sunnier in Paris, and warm. Jack Dempsey, the uncon-querable heavyweight champion and self-improving tourist, made his way to the Louvre. Guides bumped elbows vying to show him

about. A dapper Frenchman who spoke English led him to the *Mona Lisa*. The Neapolitan noblewoman Madonna (Mona) Lisa del Giocondo smiled faintly at Dempsey from the four-hundred-year-old canvas. "This wonderful work," the French guide said, "was created by Leonardo da Vinci." Dempsey looked serious and blank. The guide said, "Leonardo also invented the wheelbarrow."

"Now that," Dempsey said, in a hearty tenor, "is something I know about. I know about the wheelbarrow."

The Paris Dempsey discovered in the summer of '22 was a cultural carnival like no other. Marcel Proust, who was fifty-one, confined himself to a cork-lined bedroom in his apartment on Boulevard Haussman, revising and re-revising *In Remembrance of Things Past*. Severely asthmatic, rent by anxieties, Proust would not survive the year. James Joyce, at forty, had finished *Ulysses* and was now embarked on his final novel, then called *Work in Progress* and published seventeen years later as *Finnegans Wake*. At forty-eight, Gertrude Stein was running salons, publishing little, and collecting works of art. Monet still was painting—he lived until 1926—and behind the great Impressionist appeared an astonishing young guard: Braque, Matisse, Picasso.

F. Scott Fitzgerald's *This Side of Paradise* had made him famous and (temporarily) wealthy two years before. Now, at twenty-six, Fitzgerald and his bride, Zelda Sayre, were embarked on an implausibly lush life, with homes on the Riviera and Long Island as well as in Paris. His group of Americans, Fitzgerald would write, "had grown up to find all Gods dead, all wars fought, all faiths in man shaken." Gertrude Stein called them "the lost generation."

At the age of twenty-three, Ernest Hemingway was gathering his strength, marshaling his anger, and writing poems that were not very good and short stories that were extraordinary. He talked often with Stein about dialogue and technique, letting the dialogue speak most rhythmically and eloquently, so that you could hear from the words themselves whether the characters were whispering or shout-

ing, angry or making love. Hemingway's first book, *Three Stories and Ten Poems,* was published in 1923. *The Sun Also Rises* and *A Farewell to Arms* lay far in the future.

The biographer Carlos Baker puts Hemingway at the 1935 bout between Joe Louis and Max Baer in Yankee Stadium, and observes, "Ernest's personal interest was heightened by the fact that Jack Dempsey, whom he had disliked for years, was going to serve as Baer's second at ringside." He has Hemingway gloating in a nasty way at Baer's supposed cowardice. By several accounts Baer was indeed frightened of Louis and would not leave his dressing room until Dempsey said, "You either fight Louis in the ring or you fight me right here."

Baker does not seem to have looked for the source of Hemingway's antipathy. Dempsey, who in his later years forgave even Doc Kearns's excesses, would never go into detail about his 1922 Paris encounter with Hemingway beyond his observation to me that to stop Hemingway, "I would have really had to hurt him."

One can create a reasonable scenario. Hemingway imagined that he could fight and more than once described himself to interviewers as "a good semiprofessional boxer." In 1948, he invited some Brooklyn Dodgers, then training in Havana, to visit Finca Vigia, his Cuban villa. After several drinks he challenged Hugh Casey, a 210-pound relief pitcher, to mix it up. Casey knocked Hemingway through a glass-topped cocktail table. Casey had no formal boxing experience, but he was, of course, a professional athlete.

Probably, with a few drinks in him, Hemingway challenged Dempsey in Paris, 1922. Dempsey recognized the mad brutality that was as much a part of Hemingway as writing genius and declined. I can imagine Dempsey dismissing the boxing Hemingway with an easy putdown, and Hemingway persisting and Dempsey, who is now annoyed, sneering or perhaps even laughing in Hemingway's face. On certain matters, it was not a good idea to crowd the champion. Any amateur who threw down a serious challenge was delivering an insult and it is remarkable that Dempsey remained as gentle as he did with such pretenders.

Given Hemingway's personality, his response to scorn—and *physical* scorn, at that—would have been hatred. Dempsey's remarks to me in 1960 suggest the men may have reached a reconciliation in later years, but that is speculation. I can only report that there were just two people I ever heard Dempsey speak of in a dismissive way: Estelle Taylor, whom he had loved, and Hemingway, whose books he admired.

While life in Paris seemed ever faster, ever more brimming with jazz and lust, American academics continued to man the ramparts against feminine sexuality. In late April the *American* reported, "The faculty at Northwestern University has decided that for a pretty coed to display a pretty knee in a picture is 'unfavorable publicity.'" This report came out of Evanston, Illinois, on April 26. Just one night later, Dempsey thrilled the crowd at a Paris nightclub by climbing on to the stage and performing a spirited, jazzy dance with Yancsi, one of the Dolly Sisters. Runyon reported:

> Old Paris babbles today of the terpsichorean efforts of the heavyweight champion. With Irving Berlin, American composer, hammering out the strains of "Everybody Step," on a piano, Jack Dempsey and Yancsi Dolly gave an exhibition of a new American dance. It's called "Chicago."
>
> Berlin came in with Miss Dolly [and went to the piano] and sang "All by Myself" and "When I Leave the World Behind," one of his old songs. A big crowd of men and women in evening dress packed the room. Among the Americans were Earl Dodge, New York millionaire; Muriel Spring, motion picture actress; Mitti French, the dancer, and Leonora Hughes, partner to the French dancer, Maurice.
>
> When Berlin finished playing, Miss Dolly was asked to dance. She said she would if Jack Dempsey would dance with her. The big champion got up blushing and footed it around with the slim dancer.
>
> Berlin played the accompaniment and the big crowd roared its applause. Out in Chicago this particular dance is

known as the "Umbrella" dance, but here Miss Dolly and Dempsey called it the "Chicago" dance. "Chicago" was a tremendous success.

In all likelihood in the climate of 1922, the "Chicago" would have been banned in Evanston.

Carpentier took time off from training for his fight with Ted "Kid" Lewis to show Dempsey a bit of Paris. Then he induced Dempsey to referee a twenty-round bout for the middleweight championship of France, which matched Billy Balzac against Maurice Frunier. There were no knockdowns. When the fight was done, Dempsey lifted Balzac's right arm and announced in his most careful French: "Le victor est Monsieur Bee-ly Balzac." The crowd cheered in a good-natured way. Carpentier patted Dempsey on the back and said, "Jack, if only your right hand were like your French, I would today be heavyweight champion of the world."

Dempsey took to rising early and exploring Paris on long solitary walks. Sometimes he was recognized; often he was not. He remembered stopping early one morning at Le Café du Père Tranquille where the chef was preparing onion soup for those who had walked the night and needed sustenance. Two Americans waved. One was the Algonquinite and playwright Marc Connelly. The other was Jascha Heifetz, who saluted the champion with a brief, inspired performance of Debussy's "The Girl with the Flaxen Hair." Dempsey shook the violinist's hand gently and resumed his unaccompanied walking tour in a city that was miraculous with magic.

Dempsey loved Paris in the springtime. He found the French people warm and approving, even though he had defeated their champion. He visited Nôtre Dame, rode to the top of the Eiffel Tower, and went on a conducted tour of the Paris sewers, where he first learned of Jean Valjean, Inspector Javert, and, indeed, Victor Hugo. As he put it, he went to "reception, reception, reception." He was gaining weight and losing sleep and having the time of his life. Everywhere beautiful women were adoring.

An American actress, Peggy Hopkins Joyce, later famous for finding wealthy husbands and divorcing them at a great profit, had to return to America. She stood on the deck of a liner about to depart from Cherbourg, and wept. "Where is my lover?" Peggy Joyce said among the teardrops. "Where is my champion? Where is my Jack?"

In Paris Dempsey expressed annoyance. "The first time I knew I was having a love affair with Peggy was when she told everybody about it on the boat."

"Did you have a love affair with Peggy?" asked a reporter from *Echo du sport*.

"If holding hands is a love affair, then I did. That's the most there was between us. A little hand holding."

"But you are single," the French reporter said.

"Sure, and if I was going to marry anyone right now, it could be a French girl. I love French cooking and the French girls really know how to please a man." Dempsey smiled at the reporter.

"He ain't marrying no one, American or French," Doc Kearns interrupted, with finality. "If there are two things in the world that don't mix, it's marriage and boxing. Show me a married boxer and I'll show you a guy who's about to get knocked out in round one."

Early in May, Dempsey's group traveled to Berlin to see what he thought would be a comic act, women's prizefighting. "First we went to May Day demonstrations," Runyon wrote. Dempsey watched chanting, singing marchers who bore red banners. Someone translated one of their songs:

> *The people's flag is deepest red.*
> *It's shrouded oft our martyred dead*

Although Dempsey knew miners had been murdered in Colorado, this was probably beyond the immediate understanding of his own steadfast Democratic party liberalism. He had no comment on the May Day parade.

"His reception here," Runyon wrote, "seems founded largely on curiosity. There is none of the warmth shown in England and France. Most of the German people hardly know what it is all about. Few recognize him when, as is his habit, he goes about the streets. But those who do are friendly."

The women boxers worked in a Berlin café. "The ring was pitched in the middle of a dance floor," Runyon wrote.

A dozen girls of different nationalities marched around to music in a preliminary parade. Then the contestants for two bouts were chosen by the toss of a coin.

The girls all wore little athletic tops and short kilts, with their legs bare to the tops of their boxing shoes. Their hair was covered with caps. Spectators put up cash prizes.

The first bout was for six rounds between a pretty sixteen-year-old girl and her older opponent. They wore regular five-ounce gloves and the rounds were a full three minutes each. The Americans present were amazed at the boxing skill and punching power displayed.

The young girl was outclassed for the first five rounds and was bleeding from the nose and mouth. The Americans thought it was a shame that the bout was continued, when Jack Kearns sent Louie Meyer, one of our group here who speaks German, to the young girl's corner and told her to try a left hand body punch.

When the last round started the young girl staggered out of her corner and let fly, according to Kearns' instructions. She knocked her opponent cold.

Dempsey thought the rounds were too long for girls, that their bodies were insufficiently protected and really disliked the entire business.

When a German newspaperman asked for comment Dempsey said, "All I can tell you is I guess I'd rather box myself than watch other people fight."

As the late Otto Friedrich documented in *Before the Deluge,* pre-Nazi Berlin was almost as remarkable as Paris. The city was vibrant with theater, music, architecture, art, and with such intellects as Albert Einstein and Max Planck. Nor was there any shortage of attractive frauleins. Yet the German capital left Dempsey cold. He could not think of it without remembering the sight of young women punching one another bloody and the sound of German men cheering on the carnage.

Back in Paris on the first leg of the voyage home, Dempsey made fresh entries in his diary.

> They had the idea in Europe that I was nine-feet tall and weighed about 500 pounds. Gorilla. They say I look smaller in street clothes than I do in the ring. Europe has seen me walking, sometimes in groups where there are a dozen bigger men. They can't believe, a lot of them, that I'm the Dempsey who knocked out mighty Georges.
>
> Maybe the only way I can show the natives that I really am Dempsey and that I can fight a little bit is to put on my ring stuff some evening and take on some of these European huskies and knock them overboard, one after another, in about one minute each.
>
> Kearns is scared I'll really do that and he tells me even the worst bum can land a lucky punch.
>
> So I won't do that.
>
> So a lot of these Europeans will go to their graves believing that before I took on Carpentier in Jersey City, I had Kearns put poison in his onion soup.

Dempsey sailed for New York on May 13, a considerably more worldly man than he had been when he left the United States. Talk continued about a match with Harry Greb or Harry Wills or a rematch with Carpentier or Willard. But no one in Europe had made a

serious offer. "That left me with a familiar problem," Dempsey told me. "After cruising Europe with Kearns and moving around as though we were royalty, I was pretty close to being busted—again."

———

With no fight in sight, the New York press began to gossip—genially, by current standards—about the women in Dempsey's life. Whenever reporters could corner him, at a steak house like LaHiff's, they had their questions. Wasn't he secretly engaged to Peggy Hopkins Joyce? How could you not be engaged to somebody that beautiful? Wasn't he going to marry his old Hollywood flame, dark-haired, bright-eyed Bebe Daniels? Hadn't he quietly given one of the Dolly Sisters an engagement ring? Come on, Champ. Tell us which one. What about Florence Walton, the gorgeous brunette dancer? We hear you and Florence have taken out a marriage license. What about Bea Palmer, Champ? Sylvia Jocelyn? Helen Worthing?

Dempsey finally told the reporters that he had decided to marry, but it was somebody they never heard of. Helen Rockwell, a nineteen-year-old student at the University of Colorado. When that story made headlines in a half dozen papers, Dempsey broke into laughter. "There isn't any Helen Rockwell," he told Teddy Hayes. "I made her up to get rid of the reporters. Helen Rockwell doesn't exist."

"Are you sure?" Hayes said. Dempsey blinked. Suppose there really was a girl named Helen Rockwell studying at Colorado. Suppose she now came forward and claimed him. Dempsey looked at Hayes and said two words. "Good Lord."

No Helen Rockwell ever appeared. Dempsey left New York on the Twentieth Century Limited at 2:45 P.M. on May 20. He was off to visit his mother in the Los Angeles house he had bought her. Then he and Kearns and Hayes were going to tour theaters on the Pantages Circuit to generate some cash.

"Remember, Jack," Kearns said, "as long as I keep you on the stage, there ain't no way you're going to lose your championship."

Dempsey nodded without cheer. He wanted to fight. Soon he signed a curious contract with Harry Wills.

———

Summer of 1922 brought the finest moment of Warren Harding's presidency. Late in June Harding was golfing in Bar Harbor, Maine, helped by a young caddie he had come to like. The boy, who had caddied for Harding in earlier summers, was slim, soft voiced, courteous, well schooled at his work, and clearly capable of achieving more. When asked about his background, he told the president that his father owned a gardening business. He said, in answer to another question from the president, that he was Jewish. Harding mused that there could not be very many Jewish gardeners working in the rock-bound State of Maine.

"Do you want to be a gardener like your dad?" Harding asked.

"No, sir. I'd like to be a newspaperman."

"I believe I can arrange that," the president said.

Edward "Ned" McLean, who published the *Washington Post,* was Harding's close companion. Later some charged that McLean lined up women for this president, whose lust, unlike the Bar Harbor Golf Course, knew no bounds.

After a phone call from Harding, Ned McLean hired the Maine caddy as Washington police reporter. Two years later the police reporter was promoted. At twenty-one, in 1924, Shirley Povich became the youngest sports editor on any major American newspaper. He wrote columns for the *Post* from 1924 until his death in 1998 and said, but only if asked, that he had known every American president from Harding to Clinton. For more than seventy years, Shirley's dignity and humor, his writing and reportorial gifts, brought honor to the newspaper business

"My father had his favorites," Maury Povich, the television interviewer, says. "He didn't just *like* Jack Dempsey. He loved Jack Dempsey. He loved the way Dempsey handled his championship and

the way Dempsey never got overly impressed with himself. But most of all Shirley loved the champion's marvelous sense of fun."

Harding died in August 1923, leaving behind political scandals and stories of sexual adventures that fill books. Some find it hard to say a kind word about the man. Not I. President Warren Gamaliel Harding put Shirley Povich into the newspaper business.

While waiting for a fight, Dempsey and Kearns made their way through theaters across the country, the one sparring and chatting, the other telling tall tales. At length the two found themselves in Kansas City, Missouri, working for a percentage of the house, at the same time as John McCormack, the famous Irish tenor, was playing a music hall there. The three met in a restaurant. They all missed New York and McCormack told Dempsey and Kearns, "I'm afraid you shall find this a rather dull town."

"We need the money," Kearns said.

"And isn't that the sad song, lads, that everybody knows around the world?"

Someone cracked the safe at the theater where Dempsey was working and the owner said Dempsey and Kearns were going to have to give up some money. "You wanted a percentage of the profits. Now you'll take a percentage of my losses."

Furious, Kearns turned to McCormack. "It's seems to me you need assistance from a political source," the tenor said. "Why don't you contact [Kansas City political boss] Tom Pendergast. He has his offices at the Muelhbach Hotel."

Kearns called and one of Pendergast's assistants invited the group to stop by at noon the following day. Kearns picked up Mc-Cormack in his suite and found him resplendent in a green silk dressing gown, consuming a breakfast of Melba toast and champagne. "The champagne soothes my throat," he said. "The toast takes away any hoarseness I might be having."

Kearns said his own throat felt dry. McCormack shared Veuve Cliquot with his new friend. Later in Boss Pendergast's lair Kearns

made loud introductions. "Meet the great Jack Dempsey, heavy-weight champion of the world, and meet the golden voice from the Emerald Isle, John McCormack."

Prendergast's political flunkies were draped about the room. One, a short fellow in spectacles, had been playing piano.

"John," Prendergast said to the Irish tenor, "could you sing us a little song? I'm sure Harry here will be delighted to play for you."

"I'm truly sorry, sorry indeed, gentlemen, but it's a bit of the hoarseness I'm having today and if I irritate me throat now, I might not be able to perform tonight."

"And that," Kearns told people for the rest of his life, "is how a pretty good country piano player who was Boss Pendergast's flunky missed an opportunity to accompany the great John McCormack. His name? Harry S Truman." (This Kearns tale calls to mind an adage I first heard from the baseball magnate Walter O'Malley. "Only half the lies the Irish tell are true.") The P.S.—there was always a P.S. to Kearns's stories and there was usually a prologue—was that Boss Pendergast later called the theater owner and flexed some muscle. Dempsey and Kearns were paid in full.

Abiding questions remained: When would Dempsey box again, and against whom? Forces that came into play in these decisions—indecisions, really—entered from beyond the squared circle called the ring. Carpentier didn't want to fight Dempsey again. Willard had passed his fortieth birthday; he was incapable of taking on Dempsey again. "Fighting Bob" Martin, heavyweight champion of the American Expeditionary Forces, had lost to Bill Brennan and then been injured in an automobile accident. Sam Langford, the Boston Tar Baby, was at least forty-three. Not a good battle in the bunch.

Many argued, and Dempsey seemed to agree, that the one logical contender was Harry Wills. At six-feet-two inches and 220 pounds, Wills was a powerful, if awkward, fighter. "He didn't hit anywhere near as hard as Dempsey," Ray Arcel said, "and he didn't move any-

where near as smoothly as Carpentier. I would rate Wills as a very good journeyman."

Nat Fleischer started *Ring* magazine in 1922. Fleischer stood five-feet-two and had boundless energy, which he divided among boxing research (excellent), boxing writing (enthusiastic but clichéd), and self-promotion (outstanding). Asked to describe himself once, Fleischer said in a single sentence: "I have received the *Médaile d'honneur d'or d'education physique* from France; the *Constantine ordine militare de San Georgie di Antioche* and the *Commendatore della stella al merito sportivo* from Italy, and the Order of the White Elephant from King Bhumibol Adulyadej of Thailand for my work on behalf of international boxing, and I've done a lot for boxing here, as well."

Within six months *Ring* replaced the *Police Gazette* as the pre-eminent American boxing magazine. As early as *Ring*'s third issue, Fleischer made a case for Wills. He carefully pointed out that Wills was "unlike Jack Johnson," whose sins were swagger and a fondness for white women. *Ring* wrote that Wills was "a clean athlete, a splendid sportsman, a boxer of high ideals who has proved himself a credit to his race." (The "credit to his race" observation presently became overworn and demeaning. It was used so many times about Joe Louis, the so-called Brown Bomber, that the columnist Jimmy Cannon finally said: "Joe's a credit to his race, all right. I mean, of course, the human race.")

Other journalists joined Fleischer's campaign. A few details have been lost but some sort of Dempsey–Wills contract was drawn up and signed on June 11. From Kearns's viewpoint the principal purpose of the agreement was to satisfy sportswriter-matchmakers, one of whom wondered in print if Dempsey intended to box again "before the year 1952." The June 11 contract called for the Dempsey camp and the Wills camp each to post twenty-five hundred dollars in forfeit money. No site was mentioned. Both sides agreed to set a date "within 60 days after a reliable promoter undertook to stage the bout." After the great Carpentier gate, the sum of twenty-five hundred dollars was

not serious money for a Dempsey championship fight and the phrase "reliable promoter" was subject to many interpretations. This was not so much a contract as a press release, but it would later play into a slippery lawsuit Kearns threw at Dempsey.

Twenty-five years earlier, William Muldoon had advertised himself as the strongest man on earth. Large, powerful, and square-jawed, he performed feats of strength and built a rambling structure overlooking Long Island Sound, twenty-five miles northeast of New York City. Here in this place he called Olympia, he established the Muldoon Hygienic Institute, a spa for weight loss and muscle building. From all over the country the rich and flabby converged on Olympia to get into shape. Billy Muldoon, a strong-backed farm boy from the Genesee Valley in upstate New York, had evolved into Professor William Muldoon, "the world's outstanding authority on physical culture." Muldoon wrestled, played road-company roles in Shakespeare, trained John L. Sullivan, and, by the time he became New York State Boxing Commissioner in 1920, appeared to be an icon of athleticism and an authority on practically everything.

For the record, Muldoon supported a Dempsey–Wills match. He was in his late seventies and the idea that a black man might be anointed as the greatest prizefighter in the world secretly troubled the old man. He issued a number of statements deploring commercialism in boxing. It was profoundly wrong, Muldoon said, for a heavyweight to earn more than an American president. It was equally wrong to peg ticket prices at such a level "that good working people cannot afford to buy a ticket." If Tex Rickard wanted to stage Dempsey–Wills at the Polo Grounds (Rickard did not), he would first have to guarantee to price forty thousand tickets at two dollars. Rickard, struggling to regain his old hustling form, shuddered. In the name of good working people, Muldoon was making the match impossible. (Privately Rickard said that if he were somehow forced to promote Dempsey–Willard at the Polo Grounds, he would insist on a floor of ten dollars and no more than ten thousand tickets at that price. The

scale would rise swiftly to sixty dollars. Rickard hoped for a $2 million gate, not in the name of "the good working people" but in the name of free enterprise.)

At length Muldoon called a press conference at Olympia. As boxing commissioner, he announced, he was banning all heavyweight fights in New York State until "honorable financing" was established. He was personally preparing a bill for the legislature to fix the price of ringside tickets at five dollars. "The present attitude of boxers, managers and promoters borders on insanity," Muldoon said. "There will never be a Dempsey–Wills fight in this state while I am commissioner. My opposition is in no way attributable to the boxers involved. They are not to blame for the existing situation. It is the commercialized condition produced by crazy promoters and managers that is responsible."

It is impossible to imagine a commissioner of baseball canceling the World Series because ticket prices, the cost of beer and hotdogs, and television receipts were all too high; because, in short, the series would be too profitable. That commissioner would shortly be fired or sued or both. The always practical Rickard had no comment on Muldoon's propoverty press conference. Instead, Rickard talked to several wealthy men in Montreal. For a few days he thought he had Dempsey–Wills booked into Canada. Then the Montreal backers mysteriously withdrew.

Edward Van Every, whose biography *Muldoon: The Solid Man of Sport,* was published in 1929, provides as good an explanation of these perplexing events as we are likely to get. Rickard told Van Every that "orders came directly from the top of the British Government" prohibiting Dempsey–Wills in Montreal. High government officials said Jack Johnson's victory over Tommy Burns in Australia had sparked trouble "in many of the English provinces that numbered a heavy Negro population." A Wills victory, British officials feared, "would ignite Negro uprisings from South Africa to the West Indies." Van Every maintains that His Majesty's racist government, not Rickard or Kearns and certainly not Dempsey, canceled the big fight in Montreal.

Further, Van Every insists, Muldoon's bizarre behavior in effectively barring Dempsey–Wills from New York was not entirely his own doing. "Orders from a very high place" forced Muldoon to find a way to block the fight, Van Every wrote. Not Muldoon, Van Every, or anyone else ever said or wrote anything more specific, but there is no reason to disbelieve Van Every. The American Establishment of the 1920s loathed the thought of a black champion. In essence, the fight was canceled by no one and by everyone; by the racist times. The coincident furor about boxers' purses led to a New York State law that limited the top price for ringside tickets to twenty-five dollars.

Which is how it came to pass that the matchmaking for Dempsey's next championship bout began on a cold spring night in 1923 in a suite at the Hotel Morrison, Chicago, where Doc Kearns was taking time out from his search for purses to help a show girl remove her brassière. In later times he was not sure whether her name was Alice or Helen, but he always remembered her face, blonde hair, and a body he called "long-legged and kittenish." Then the telephone rang and a hearty voice began, "My name is Loy J. Molumby, Mr. Kearns. I'm the Montana statewide commander of the American Legion and I'd like to meet with you concerning a very big deal."

Kearns regarded his immediate problem as considerable. Long-legged, kittenish Alice or Helen was still wearing her brassière, along with panties, a girdle, and stockings. The telephone interruption annoyed her. She began to rise as if to dress. Kearns grabbed the back of the brassiere and, as he put it, "hauled her back." Then he put a hand over the phone and told her to relax, he'd get rid of this creep in a minute.

Molumby said he wanted to match Dempsey against a journeyman light heavyweight named Tommy Gibbons, who was six years Dempsey's senior, in a booming northern Montana oil town called Shelby. He was in a position to guarantee Dempsey three hundred thousand dollars up front. Kearns recalled that as this conversation continued, the blonde stripped to her "step-ins." At length she walked toward Kearns bearing a drink.

Speaking even more quickly than usual, Kearns told Loy J. Molumby to come to Chicago with serious front money, at least one hundred thousand dollars, and they could talk more. He hung up and turned to blonde, long-legged, kittenish Alice or Helen.

"Or Dolly," Kearns said years later. "Her name could have been Dolly, too."

Kearns had never heard of Loy J. Molumby, or of Shelby, Montana, for that matter, and he moved on to the Hotel Claridge in New York. Molumby tracked him down in Manhattan and said, "I was under the impression we had an appointment in Chicago." Kearns apologized and said that a great offer for Dempsey had forced him to New York.

"Will you see me tomorrow?"

"If you have the front money," Kearns said.

Molumby appeared the next day, a floppy-eared, thick-chested country lawyer from the West who wore cowboy boots. He had been a fighter pilot in World War I and his first swoop here gained Kearns's attention. Molumby opened a satchel containing one hundred thousand dollars in large bills. "I'm here to negotiate," Molumby said.

Kearns considered the money for some time. "Mr. Molumby," he said, "I ain't here to play tennis." Molumby then told Kearns about Shelby. It was situated up near the top of Montana close to the Canadian border, not far from the Sweetgrass Hills. It had been Indian country, just a few years ago, Blackfoot Indian country. After that Shelby became a little country crossroads where three or four hundred cowboys and sheepherders could get together and do some buying and some selling and maybe a little tomcatting, too. Then came the great Shelby oil strike of March 22, 1922. The Kevin-Sunburst field, a tremendous pool of oil lying just to the north of town, shot up so many gushers that geologists said it would produce millions—not thousands, millions —of barrels of the finest sweet (low sulphur content) crude every year. The oil field was producing now, and growing.

Boomtown Shelby had the Silver Grill Hotel, a dance hall, two fine banks, a hot real-estate market, and a population that had hit a

thousand and was heading up. There was good railroad service into Shelby along the tracks of Great Northern. Fight fans could come in on coaches and Pullman cars from Spokane and Seattle and San Francisco, or from Grand Forks and Minneapolis and St. Paul, even Chicago and New York. Shelby was a great little railroad town. In fact the town took its name from a fine railroad man, Peter P. Shelby, the general manager of the Great Northern Railway in Montana. Molumby said his people at Shelby were prepared to build an open-air fight arena, the finest in the West, that would seat at least forty thousand people. "Oil has brought us some money," Molumby said. "Now a Dempsey fight will put us on the map."

Here was the boosterism of the 1920s laid plain. Despite the new Jazz Age sophistication and the emergence of big-money boxing, despite Hollywood, the Algonquin, and Al Capone, it was still possible in 1922 for someone to come out of nowhere and—with a little cash, fast talk, and luck—make something happen. Sinclair Lewis captured boosterism better than anyone else in his 1922 novel *Babbitt,* now a period piece, and its protagonist, a hustling, self-important realtor from Zenith, "the Zip City." Lewis named his character George Follansbee Babbitt. The name Loy J. Molumby was already taken.

Kearns sensed at once that he could deal himself in with this floppy-eared rube as de facto fight promoter. Kearns's dislike for Rickard made that prospect irresistible. He decided that he would show Rickard how you *really* ran a fight. Seeds of disaster never settled in more fertile soil. The realities, the push and pull, the hustle and the con, of big-time fight promotion were beyond Loy Molumby and his Montana associates. But the outlanders were willing to learn the angles of the boxing business from one John Leo McKernan, who called himself Doc Kearns. Kearns himself never grasped the fact that promotion requires a sense of tomorrow as well as today. He proceeded to ravage Montana so savagely that John Lardner would call Dempsey–Gibbons "the Sack of Shelby."

Over many weeks, the behavior of Kearns and the fight novices from Montana was so erratic that many regarded the whole business

as a fraud. Here was a fight in a place nobody knew that—be realistic, boys—never would happen. The Great Northern Railroad took the hoax stories seriously and declined to run special trains into Shelby. To see the fight, everybody except the Shelby locals would have to undertake a long drive on bad roads through hundreds of miles of dry, hot wilderness. Once in Shelby, most would have to sleep in their cars. Before the drama played out, both of Shelby's banks collapsed. So did a bank in Great Falls and another in Joplin, Montana. It is only slightly hyperbolic to say that the Dempsey–Gibbons fight, a Doc Kearns promotion, bankrupted Montana.

Nor was the misfortune only financial. A well-armed crowd of American Legionnaires gathered around Dempsey outside the Shelby Arena in the hours before the fight. There they reprised the slacker charges. From the safety of the mob, men waved Colt revolvers and shouted that Dempsey was a bum, a draft dodger and a coward. With the help of only two bodyguards—"my Chicago hard guys," Kearns called them—Dempsey stood his ground. Suffering abuse is not recommended prefight preparation.

After the fight, all that saved Kearns from being lynched was his wits. He engineered a remarkable escape from Shelby just as a mob began to drink seriously and talk of stringing him up from one of the cottonwoods that grew along the banks of the Marais River. "Lonely-looking trees they were, at that," Kearns said years afterward, in a moment of contemplation.

Tommy Gibbons was a serious light-heavyweight out of St. Paul who had been boxing professionally since 1911. He was fast, clever, and hard to hit. He had split two fights with heavyweight Billy Miske, but lost to the smaller Harry Greb. He was not a perfect contender for Dempsey, but he was quite a reasonable one. Before Molumby's approach to Kearns, a civic group that included Molumby; James A. Johnson, the mayor of Shelby; Sam Sampson, a Montana shopkeeper and landowner; and George H. Stanton, a prosperous banker in Great Falls, had approached Gibbons to see if he

would be willing to fight Dempsey. It took some time to get the attention of Gibbons's manager, Eddie Kane. He hadn't heard of Shelby, either. But the prospect of a Dempsey match anywhere was heady stuff. Every boxing manager knew how much money Dempsey–Carpentier had earned. Gibbons, a decent man who lacked a big knockout punch, said, "I'll be glad to fight the champion. I'm raising a family. I need every cent I can make."

For reasons neither manager would discuss, Kearns and Kane had not spoken for four years. "The reason that I hate the son of a bitch has somehow slipped my mind," Kearns said. In the first stages of the negotiation, Molumby had to act as go-between. Kearns insisted on a three hundred thousand dollar guarantee, the same as Rickard had offered for Carpentier. Probably making another mistake, Molumby quickly said that three hundred thousand dollars was no problem. Kearns said Gibbons could be a tough opponent. Kearns needed one hundred thousand dollars when the contract was signed, another one hundred thousand dollars sixty days before the fight. The final one hundred thousand dollars would have to be paid in full one week before the fight. Molumby moved the satchel toward Kearns and told him the first one hundred thousand dollars was his right then and there.

Kearns put a hand on the satchel and said he wanted to be clear about something else. If the Shelby people missed a payment, if they missed either of the two later one hundred thousand dollar installments, then the contract would be null and void. Kearns and Dempsey would keep everything they had been paid, but the obligation for Dempsey to fight would end. Loy Molumby wanted the fight. He did not object to this overwhelmingly one-sided arrangement.

Boxing has a long history of fraudulent fights, or to be accurate, nonfights. Particularly in the early days of the century, a big fight was announced, sportswriters were bribed to promote it, and tickets were printed and sold. Then the fight was canceled for mysterious reasons, usually beginning with larceny. The promoters moved promptly across state lines, where prosecution was either difficult or impossible. Against this background, a reasonable fight contract had come to re-

quire an appearance bond, posted by both fighters, an arrangement akin to putting money in escrow. A proposed fight was reasonably sure to take place, because if one boxer ran out on the contract, he lost his escrow money.

At the very least, Loy Molumby of Montana should have tried an approach along escrow lines, offering Kearns seventy-five thousand dollars immediately and establishing an escrow bank account in the amount of twenty-five thousand dollars. The other two payments would follow that form. After the bout, the bank would release the seventy-five thousand dollars in escrow. Agreeing to turn over three hundred thousand dollars without strings left Kearns free to dominate the fight or even to cancel it at his displeasure. He would threaten cancellation many times.

Eddie Kane wanted Michael Collins of Minneapolis, a matchmaker who was a friend of Gibbons, to act as referee. If there were no knockout, the referee alone would decide the winner. Kearns said there would be a fight only if Jim Dougherty of Lieperville, Pennsylvania (a good friend of his) got the job. Kane argued and lost.

Kane pressed for rules changes. In clinches, Dempsey delivered a fierce wallop to the back of the neck. This so-called rabbit punch jolted the spinal cord. Kane wanted rabbit punches prohibited. He lost here too. Kane also wanted kidney punches ruled fouls. Dempsey's tremendous hooks into the body were usually propelled into the ribs. Sometimes, when an opponent turned, a Dempsey hook landed flush on the kidney. (A fighter thus struck would find blood in his urine for some time afterward. In the short term he might not want to fight anymore.) Kearns had the champion; Kearns was in charge. Eddie Kane lost another point.

Having won all that he cared about, Kearns acceded to Mike Collins as official promoter and Collins's proposed scale of ticket prices: from fifty dollars for ringside down to twenty dollars for seats high in the rear. This created the possibility, however remote, of another million-dollar gate and raised the issue of money for Tommy Gibbons. He had agreed to fight without a guarantee of any kind. Now Kane demanded 50 percent of the gross receipts from three

hundred thousand dollars to six hundred thousand dollars and 25 percent of everything above that. Kearns said that seemed fine. He and Dempsey had locked up the first three hundred thousand dollars, and as Kearns put it, "that cowtown in the middle of nowhere ain't gonna draw a nickel more than that." He was giving Kane and Gibbons percentages of zero. Kearns, in full crow, caught a train west for Shelby on May 16.

Meanwhile Tex Rickard, recovering his verve, was at most marginally interested in Shelby. He didn't regard Gibbons either as a first-rate fighter or a good draw and his instincts foretold a debacle. For his part, Rickard was quietly negotiating with a mighty Argentine heavyweight, the stranger who kissed Dempsey good-bye, Luis Angel Firpo, whom Damon Runyon would call the Wild Bull of the Pampas. He focused on getting Firpo north to fight Dempsey in the fall and had already lined up a more commercial site than Shelby. Rickard made a deposit with the New York Giants and secured the Polo Grounds, the huge uptown ballpark near the Harlem River. A Dempsey fight outdoors in New York City against a big, strong puncher would be a diamond mine. Further, Rickard, who was pleased to show up Kearns, organized an ideal buildup. He signed Firpo to box Jess Willard, who was now forty-two years old, at Boyle's Thirty Acres in Jersey City on July 12. A slowed-down Willard, Rickard reasoned, would establish Firpo as a hitter.

Stories persisted that Dempsey and Kearns were not serious about Shelby, and that there would be no fight in the wilderness. Dempsey and Kearns simply intended to take as much Montana money as possible, leave the state without boxing and without being imprisoned, then fight the winner of Firpo–Willard. These stories pleased Tex Rickard as much as they angered Doc Kearns. They well might have pleased Rickard; he was spreading them.

Kearns made a rousing speech when he and Dempsey arrived at the Silver Grill, the gathering hall of the Shelby Chamber of Commerce. "I'll talk first," he said, "and then you can hear from the champion. It's going to be a great fight. Nobody hits like the champion but

when it comes to ring technique, what we call *boxing,* Tommy Gibbons is the best boxer in the world. Let me tell you this. It wouldn't surprise me a bit if the winner of this bout fights Harry Wills right here in Shelby on Labor Day. [So much for Rickard's Firpo–Willard match.] When that happens, Shelby will be the fight capital of the world."

The room filled with cheers and bellows. While the locals yelped, Kearns said quietly to Dempsey, "Let's get out of this dump." On a quick tour, Kearns noticed that Shelby had a King Tut Dance Hall, featuring a plump soprano named Patsy Salmon and a chorus line of six. To Kearns, and particularly to Dempsey, the girls looked like light heavyweights. The most prominent sign on Main Street advertised Aunt Kate's Cathouse. Dempsey felt that he had wandered a long way from the Champs Elysées, and even from Hollywood Boulevard, back toward the mining camps of his boyhood.

The tight confines of Shelby made Kearns uncomfortable, and Dempsey didn't like the place at all. He later said it was populated by "a few honest slobs, but mostly oil-stock hustlers. I was a working guy. I couldn't stand those bastards. They were as bad as the mining bosses in Colorado. Plenty of money, maybe, but they didn't know a pick from an axe."

Kearns rented a roadhouse on a border of Great Falls, forty miles south of Shelby, and set up a training camp at Great Falls Park. Great Falls was a mining town. Its Boston and Montana Copper Smelter, with a smokestack 506-feet high, was said to be the largest in the world. There was a high school, a public library, a training school for nurses, a stone courthouse, and a population of about twenty-four thousand. Dempsey had not fought for two years and Kearns brought in sixteen sparring partners, ranging from a seven-foot-two-inch giant named Ben Wray to fast middleweights, who could emulate Gibbons's perpetual-motion style. Dempsey spent most of his time before the fight in Great Falls. He took his unhappiness out on his sparring partners and broke Big Ben Wray's jaw. For some time after that Wray could consume only liquid nourishment, through a tube.

Gibbons, happy enough with Shelby, happy for the fight, moved

into a comfortable frame house with his wife, two sons, and baby daughter, four blocks from where a local lumber dealer was erecting the new greenwood arena. (The lumberman, J. E. Lane, operated on credit arranged by Mayor Johnson through the First State Bank of Shelby.) After Gibbons sparred and skipped rope and had his rub, he liked to push his daughter's perambulator down Main Street. He was a polite man, with pompadoured hair, and he spoke easily with the people of Shelby. Was he going to knock out Dempsey? Well, he couldn't say that for sure. But he'd won his last two fights with knockouts, and he could promise this. Dempsey would get a run for his money.

When Heywood Broun visited him for the *World,* Gibbons spoke of the beauties of nearby Glacier National Park, which he had visited. He said the fishing was great in Montana trout streams. He'd even gotten in a little golf. But Gibbons didn't want to talk about the fight to a reporter. Broun was compassionate. He wrote, "One does not mention rope in the house of a hangman or talk fight to a man who is about to meet Jack Dempsey." (Broun actually meant, "One does not mention rope in the house of *one sentenced to be hanged.*" The whole New York crew was a bit disoriented by Shelby.)

For amusement, Dempsey gathered a menagerie in Great Falls. He obtained a cow, which became a pet, a Hereford bull, a wolf cub, and a bulldog. Hiram Dempsey came up from Utah. Hype Igoe of the *World* visited both Dempseys and wrote an emotional story:

> Old Man Dempsey wiped the perspiration from his brow with a hand that trembled with anxiety, admiration and pent-up belief in a son who can thrash any living man.
>
> As he sat there I looked into his kindly old face and for a moment at least I would rather have been Hyrum Dempsey than President of the United States. His cup of joy must bubble over. He is wrapped up heart and soul with the steel-fisted one, this great man-grizzly who combines all the assets of all the ring heroes since man began.

The first Shelby Crisis struck on June 15, the day the second payment of one hundred thousand dollars was due. Between them, Loy R. Molumby and Mayor James A. Johnson had raised not one hundred thousand dollars but eighteen hundred dollars. They turned to a Great Falls banker, George Stanton, in search of a quick $98,200.

For pay-as-you-go fight financing to work in the 1920s, the promoters had to sell tickets in advance, as Rickard did so skillfully for Dempsey–Carpentier. That need led, in turn, to the demimonde of ticket brokers, and here Molumby and Johnson were lambs in a wolf pack. They dispatched thousands of tickets through the state and the country and expected to be paid as soon as the brokers sold the tickets. They did not think to demand good-faith money in advance. Here the constant rumors that there would be no Shelby fight proved devastating. Brokers were selling very few tickets, and the idea that they would keep accounts current was naive. The temptation to let receipts sit about, ripening and drawing interest, is beyond the resistance of any self-respecting ticket broker.

The $98,200 shortfall led to some remarkable dialogue, according to Kearns.

"In place of the one hundred thousand dollars," Mayor Johnson said, "would you be willing to accept fifty thousand head of sheep?"

Kearns shook his head. "What the hell would I do with fifty thousand sheep in a New York apartment?"

Stanton, the Great Falls banker, then tried a mousetrap. He suggested that Kearns take over the promotion and the ticket sales. Since Kearns would then "own" the fight, Kearns himself would have to find the remaining two hundred thousand dollars due him and Dempsey. You might as well trap rain water in a sieve. Kearns cursed and said he was busy training a fighter. That night Montanans from as far away as Butte formed a consortium. They made the one-hundred-thousand-dollar payment.

What the *New York Times* called "low finance" in Shelby distracted Dempsey. His sparring sessions became alternately lethargic and violent. He could not find the middle ground—sharpening his

timing without unduly punishing his sparring partners. Broun, Run-yon, McGeehan, and Hype Igoe, all of whom slept in a press Pullman car, shuttled between Shelby and Great Falls, and reported that the champion looked ragged. ("Damn right I looked ragged," Dempsey said years later, "but it wasn't only because of the confusion. I hadn't had a real fight in two years.")

Shelby is a cautionary tale, a fragment of an antisaga, a story without a hero. For all that, it led the front pages of the *World,* the *New York Times,* and every other major American newspaper for many days in the summer of 1923. Indeed, the *New York Times* broke with its tradition of anonymous sportswriting and assigned Elmer Davis, the paper's preeminent reporter, to write bylined stories on the fight and the promotion. (Adolph Ochs, who owned the *Times,* thought so much of Davis that he later engaged him to write the authorized family biography.) On July 2, Davis reported that the promoters did not have the final one hundred thousand dollars due Dempsey and Kearns. Only "about forty" tickets had been sold in Los Angeles and "scarcely more than a handful" in San Francisco. Two special trains out of San Francisco were canceled when reports were received that the promoters were having trouble with their finances.

"Shelby's optimism has ebbed," Davis wrote. "It has been ebbing and flowing in the last few days like the waves on the beach just after a big boat has gone up the river....The improvised hotels, tent colonies and automobile parks were beginning to see a few customers arriving at last when suddenly news came from Great Falls, the financial capital of the world, that the international loan which was to have enabled Montana to pay its debt to Jack Kearns had fallen through and that the stern, acrid, undissuadable Kearns was going to proceed with the sanctions provided in the treaty and take his champion out of the state with no fight. It is now hard to tell what the people of Shelby are thinking and if it were possible, it still would be inadvisable to print their exact thoughts."

A day later, July 3, the Associated Press dispatched a bulletin from

Great Falls: SHELBY BOUT CALLED OFF. Stanton told Kearns that there was no money, none at all, for the final one hundred thousand dollar payment. Kearns said that he would settle for fifty thousand dollars now and take the final fifty thousand dollars out of gate receipts. Stanton said there was no fifty thousand dollars now. Kearns walked out and told reporters, "This fight is definitely off."

But Kearns had forgotten one party in this many-sided deal. "In my first years with Doc," Jack Dempsey said long afterward, "I did as I was told. He was the manager. I was the fighter. Doc called the shots. But by the time I got to Montana, I was twenty-eight. I wasn't a boy anymore. I wanted to get back into the ring. I owed that to boxing. I owed that to the fans. I owed that to myself. I told Kearns that whether he liked it or not, I was going to fight Tommy Gibbons."

Elmer Davis made the front page of the *New York Times* on the following morning. "The fight between Jack Dempsey and Tommy Gibbons, which was actually off for a couple of hours early today [July 3], will to all appearances take place at 3 o'clock tomorrow. Jack Kearns, Dempsey's manager, has agreed to take his third $100,000 payment out of gate receipts. It is doubtful under that arrangement that he will get it all...."

"What the promoters and the businessmen of Shelby and Great Falls are getting out of this is not doubtful at all. For that, however, only their own mismanagement and fatuous optimism is responsible." Shelby now had a fight, an unpaid-for boxing arena, and, as the realities of its debt struck home, a gathering rage. Dempsey was the inevitable target.

The champion traveled from Great Falls to Shelby in a private railroad car that pulled onto a siding near the arena. A crowd surrounded it. "There were no cheers," Dempsey told John Lardner. Bill Lyons, one of Kearns's Chicago hard guys, ordered the engineer to run the car up and down the siding until fight time. Only about fifteen hundred people saw the first preliminary bout. Thousands of others swarmed around the arena in an apparently spontaneous rebellion

against the fifty to twenty-dollar prices printed on the tickets. A series of shouts carried to the big sky. We'll watch this fight, the shouts said in effect, but we won't pay any more than ten dollars a ticket.

Musicians were playing inside the arena: the Montana State Elks Band on one side and the Scottish Highlanders of Calgary on the other. Until Kearns, who was now in charge, gave in to the mob, the sportswriters agreed that there were about as many musicians as customers on hand. Finally, at 2:30, every ticket was marked down to ten dollars. Seating became first come first served. Half an hour later another five thousand people overran the gatekeepers and rushed into the arena without paying anything at all.

While the crowd was having its way, Dempsey stood quietly at a soft-drink stand with fewer than a dozen retainers, Chicago hard guys and sparring partners, trying to keep the mob away. Bootleg liquor flowed early that Independence Day. Emboldened by drink, strangers surrounding the soda stand called Dempsey a slacker, a coward, a run-out son of a bitch, and a Jew bastard. (The Levantine rumor had surfaced again.)

Dempsey entered the ring at 3:36. There was some hissing, but mostly unpleasant silence. Gibbons, by now a Shelby hero, appeared at 3:45. He drew an ovation. "The unruly crowd wanted Gibbons to win," Heywood Broun wrote, "because he is pleasant and agreeable, a good churchman and the father of three charming children. When he became an honorary member of the Blackfeet Tribe the other day, the Indians prayed to Mother Earth to make Thunder Chief [Gibbons] as powerful as lightning." Gambling men were more pragmatic. Bookmakers offered odds of 2 to 1 that Dempsey would knock out Thunder Chief Gibbons inside of eight rounds. There were no takers.

The fight itself was anticlimactic. Gibbons's strategy was clinch, clinch, clinch. Dempsey, stale and probably unnerved by the crowd, had trouble landing squarely. Gibbons's left opened a cut over one eye in the second round and Kearns applied a styptic powder to stop the bleeding. He spilled some powder *into* Dempsey's eye; the champion fought half blind until the seventh.

Broun had picked Dempsey to win in two. Back in New York, Tex Rickard doubted that the fight would last six rounds. Gibbons clinched and wavered, pedaled backward and grabbed. But he did not fall. Broun wrote: "The crowd was intensely partisan and Dempsey could not hit his opponent a foot above the belt without cries of 'foul' ringing out....On the other hand Gibbons could not be criticized for holding on. It is a triumph to last against this champion....Dempsey's short punches to the body carried no such snap as they did against Carpentier. At the moment he is not the killing Dempsey the ring once knew. The crown has sobered him. He may yet be dethroned while playing it safe and Louis [*sic*] Firpo might do it."

Jim Dougherty, Kearns's handpicked referee, raised Dempsey's hand in triumph after fifteen rounds. Nobody, least of all Gibbons, protested. Gibbons was groggy and could hardly stand. Dempsey had a discolored eye. Broun wrote a telling epigraph: "Tommy Gibbons was not ashamed to run."

Dempsey left for Great Falls immediately on the private railroad car and moved on to Salt Lake City the next day. Kearns had to remain in Shelby to count the proceeds, which he did, accompanied by three federal tax agents, who would claim the government's 10 percent. By consensus, the paid attendance was 7,202 and the gate was eighty thousand dollars, a net of roughly eleven dollars a ticket. (The Carpentier fight, with an attendance of 80,183, netted twice that, about $22.30 a ticket.) The agents took their eight thousand dollars. Kearns asked the tax men, who were armed, to accompany him to the Shelby railroad station.

With Dempsey having fled, bootleg liquor poured down a thousand Montana throats made Kearns Shelby's preeminent public enemy. Mustering as much poise as was possible under the circumstances, Kearns asked the stationmaster what time the next train was leaving "in either direction."

Told there was nothing until the following day, Kearns mentioned a locomotive and a caboose on the siding. How much would

the stationmaster charge to get an engineer to fire up the engine and take him down to Great Falls? The railroad man said five hundred dollars would do it.

With federal agents standing by, Kearns opened a suitcase and counted out five hundred dollars. So that the stationmaster would hurry, he added a fifty-dollar tip. Kearns boarded the caboose, locked in the suitcases, and, feeling more confident now, moved to the rear platform.

As the locomotive got up steam, Kearns saw Hype Igoe, the *World*'s boxing writer, wandering down a wooden sidewalk along the tracks, playing a ukulele and singing some forgotten song. "Hype was a wonderful ukulele player," octogenarian sportswriter Harold Rosenthal remembers. "He kept the uke in his refrigerator. He thought that protected the wood and preserved the sound."

On this Montana day, Igoe had made his deadline and been drinking ever since. It could be dangerous for an outsider that night in Shelby.

"Hey, Hype," Kearns shouted. "This is the New York Express. Better get on." Startled, Igoe fell face forward. He got up and hurried toward the train as it began to move. Kearns leaned over the observation platform and lifted Igoe, a slight man, into the safety of the caboose. This has been celebrated as Doc Kearns's good deed in Shelby.

With gate receipts totaling eighty thousand dollars, Gibbons fought Dempsey for nothing. His percentage never kicked in. Gibbons did get a two-month vaudeville stint, going on stage and relating how he stood up to the champion for fifteen rounds. This earned him ten thousand dollars and made Gibbons one of the very few people connected to the fight—aside from Kearns and Dempsey—who did *not* lose money.

On July 9, less than a week after the fight, the Stanton Trust & Savings Bank of Great Falls went out of business. There was no federal insurance for customers in 1923; depositors lost their savings. On July 10 mayor Jim Johnson's First State Bank of Shelby stopped pay-

ments to depositors and closed its doors. It never reopened. On July 11 the First State Bank of Joplin, Montana, an affiliate of Stanton's Great Falls Bank, closed. On August 16, the First National Bank of Shelby was shuttered. Shelby had now neither a bank nor significant assets. The oil field played out shortly afterward. The fight arena was torn down. Mortgage holders seized the lumber.

Three months later, Johnson wrote to Dempsey that he was on the track of another oil field. Could the champion see his way clear to lending him twenty five thousand dollars for drilling? Dempsey was innately generous. He wrote a check. The loan was not repaid.

In later years Kearns chattered often of Shelby, a promotional debacle without equal. "I hear you broke three banks with that one," a young reporter told him during the 1950s. Kearns feigned outrage.

"That's a lie," he said. "A contemptible lie. I didn't break three banks with the Shelby fight. I broke four."

10 The Champ's Best Fight

Somehow I feel as though I could go on and on writing about him, and never exhaust the colorful, incredibly fascinating story of a strange man and a full life.

—Paul Gallico on Dempsey

WHEN I FIRST MET DEMPSEY, I had just become sports editor of *Newsweek* magazine. I was not yet thirty years old. By that time, he had passed his sixtieth birthday, which someone described as "a statistic to give America pause."

I wanted to write an unpretentious piece: Dempsey at sixty. I had heard he spoke well, I knew something about his greatest fights, and I realized that he was a legend. The combination seemed more than ample for a basic *Newsweek* sports story, c. 1956, which could run at most six hundred words, less than three typewritten pages. In that straitlaced corset, I meant to give readers a bit of conversation with the champion and let them hear a bar of the music that made the man.

I was a rookie sports editor, however, and that entitled half a dozen men whose names stood above mine on the masthead to issue directives. A writer, David Cort, said that the manifesto of news-magazine journalism begins with one overwhelming demand: Find an eternal truth. Newspapers cover news in comparatively straightfor-

ward ways, but newsmagazines don't reach readers until days after the news breaks. To cover the lag, Cort wrote in the *Nation,* newsmagazines try to make their stories sound fresh by having each offer a new eternal truth. "A new eternal truth every week," he observed, deadpan. "That's the trick." In another world, Socrates winced.

The executive editor told me to ask, "Why are there so many colored boys in fighting?" The assistant features editor told me to see what Dempsey thought he would have done "in his prime" against Joe Louis and Rocky Marciano. The managing editor told me to ask Dempsey why the Ivy League—"which produce leaders everywhere else, certainly here at *Newsweek*!"—has never given us a heavyweight champion.

In time I learned to ignore these flurries and the abiding powers came grumpily to accept my independence. But in 1956, new to the newsmagazine business, I paid too much attention to knee-jerk editorial suggestions. That, plus the prospect of actually sitting down alone with Dempsey, must have made me nervous. After a few minutes at a table by the window in his restaurant on Broadway at Forty-eighth Street, Dempsey said, "I've got plenty of time. Let me show you around this place." He guided me toward the famous portrait by George Wesley Bellows, in which Luis Firpo is knocking Dempsey clear out of the Polo Grounds ring. The picture portrays the combatants with vivid, angular vitality. It also shows sportswriters sitting at ringside, upon whom Dempsey is about to crash.

I thought I would get a self-promoting story about how Dempsey heroically climbed back into the ring and won the fight. I did not yet know my companion. "Let me point out some people," Dempsey said. He indicated the men at ringside.

"That's Ring Lardner. There's Damon Runyon. That's Westbrook Pegler.

"I thought you'd want to know who they are," Dempsey said, "because they've all interviewed me, too."

Not a word about himself. Not a word about the fight. Just what he thought might put a young writer at ease.

He would not match himself against Louis or Marciano. "If I do it one way—pick them—I look silly. If I do it the other way—pick me—then I sound like I'm bragging. Wouldn't you agree with me there?" (In a piece written for *Look* magazine, Gene Tunney picked Dempsey to knock out Louis in one spectacular round. Few thought Marciano would have been able to withstand Dempsey's power for much longer.)

On such matters as the preponderance of black boxers and the absence of Ivy Leaguers from professional rings, Dempsey said he liked to see a broad mix of people in the sport, Irishmen, blacks, Frenchmen, Jews, Poles, whatever. "Boxing is a very tough game," he said, "and not many fellows who grow up with butlers in their homes are willing to put up with all the training and all the punishment you have to take."

I pressed him on the ethnic mix. Dempsey said that boxing was such a demanding business that although any kid, rich or poor, might go into it, only the poor kid would *stay* in it, and that would be because he had no other place to go. A lot of the poor kids today, he remarked, are black. "But the boxing question isn't about black kids or white kids. To get back to what it once was," Dempsey said, "boxing needs more kids of all kinds. For that to happen, the times have to get tougher." He thought briefly then he said, "Right now what boxing really needs is a good depression."

He walked me down Broadway back toward *Newsweek,* then located on Forty-second Street. Passersby stared. Some greeted him. He smiled at the starers and returned every greeting. At Forty-fifth Street, a policeman stopped crosstown traffic. "Come on ahead, Champ," the cop said. "Come on over." Which is how I crossed a Manhattan street against a red light in stride with the great Jack Dempsey.

For forgotten reasons, *Newsweek* declined to publish my story. I visited Dempsey again and expanded the piece into an article that appeared in another magazine. Although I misspelled his father's first name and made some other rookie mistakes, he approved. Four decades later I remember Dempsey's candor, immediate warmth, and

tolerant good sense. Those are recollections that make life sweet. But I remember most vividly the way he walked me to the Bellows mural and showed me not himself, but the sportswriters covering a remarkable moment in a bout that many believe was the greatest prizefight ever fought.

It was not his style to claim heroics. Indeed, over lunch a few years afterward, Dempsey made a decidedly antiheroic point: If the rules had been followed that Friday night in September 1923, Luis Angel Firpo, not he, would have won the fight and the heavyweight championship.

Firpo was a powerful, eccentric Argentine strong man who became what John Lardner called "the most spectacular lone-wolf financial genius...[boxing] has ever known." Managing himself and making his own investments, Firpo accumulated a fortune of more than $5 million. Before his death in 1960, Firpo owned five estancias, sprawling over 205,000 Argentine acres. He grew up poor in Buenos Aires, the son of an Italian immigrant father and a mother of Spanish stock. Before turning to boxing, he worked as a clerk in a drugstore. Runyon's nickname for him, "the Wild Bull of the Pampas," was a triumph of imagery over accuracy. Lardner, to whom Firpo blurted out much of his life story, described him as "parsimonious on a heroic scale." For most of his American boxing career, he owned only two suits, both black. He wore celluloid shirt collars until they turned yellow. When presented with modest income-tax bills on his purses, which would total more than eight hundred thousand dollars, he wailed in agony. During the weeks before the Dempsey fight, when reaching peak physical condition was critical to his chances, he fired Jimmy DeForest, the outstanding trainer who had prepared Dempsey for Willard. DeForest had asked for a raise.

Bill Brady, who managed boxing careers (and lucrative vaudeville tours) for three heavyweight champions—James J. Corbett, Bob Fitzsimmons, and James J. Jeffries—presented himself to Firpo in the kitchen of the small apartment Firpo had rented at 215 West

Fifty-first Street. Firpo summoned his secretary-cook-chauffeur-interpreter-bedmaker over from a stove. Guillermo Widmer had been heating beans. Firpo paid Widmer twenty-five dollars a week. Brady spoke of the champions and what he had done for them for a commission "of only thirty-three and one third percent." Firpo paled. Then he said, through Widmer, "Fitzsimmons is dead. Jeffries has no money. Corbett is through." On his own, Firpo added, "Adios."

Firpo was capable of later spasms of largesse. He invited Dempsey to a party at his principal ranch in Rosario, Argentina, in 1957 and welcomed the entire town population as guests. It surprised Dempsey to find out that Firpo's giant party was in his honor. At the airport the next day, Firpo handed Dempsey an envelope and said not to open it until he landed in New York. Dempsey forgot about the envelope until a maid, sending his suits to a cleaner, found it two days later. Inside Dempsey discovered twenty thousand dollars in large bills. Firpo's note, in English, read: "Just a small token of friendship and appreciation from one old friend to another." The Argentine's generosity, when it surfaced, was on a scale to match his parsimony.

In his youth Firpo stood six feet three inches, with huge shoulders and mighty hands. His head was topped by an unruly crown of jet-black hair. His weight ranged from 215 pounds to 230. He left the drugstore to become a boxer in 1919, when he was twenty-three, and defeated all of his opponents, knocking out most, over the next three years. He fought in Chile, Uruguay, and Argentina. He came north in 1922, claiming for himself the title of heavyweight champion of South America, and continued knocking out people. He took down Italian Jack Herman in five at Ebbets Field in Brooklyn. He knocked out rugged, doomed Bill Brennan at Madison Square Garden in the twelfth round. He knocked out Jack McAuliffe in New York, took out Italian Jack Herman again, this time in two rounds in Havana, and just seven days after that he knocked out Jim Hibbard in the second round at Mexico City.

With these imposing victories and his great-bodied good looks,

Firpo became a Latin American hero. He marketed and sold reasonable quantities of Firpo Form-Fitting Shoes, Firpo Fedoras, Firpo Fantasy Perfume, plus a large variety of nonalliterative products, building his fortune in a thoroughly modern manner. He disliked training in general and he detested roadwork. He didn't care much for sparring either. Lardner, possessor of a sophisticated humor, wrote solemnly in *White Hopes and Other Tigers:* "[Firpo] had hit upon a profound economic truth, appreciated by very few boxers. In preparing for a major fight, you save money—in fact, you make money—by dispensing with training camps and sparring partners and fighting real fights instead."

Rickard matched him against Willard in Jersey City on July 12, just eight days after the debacle in Shelby. He called it "the Battle of the Giants," reasonably enough, since, on the basis of bulk and raw physical strength, these were the two mightiest men ever to fight a major bout. Recovered from his ordeal by scandal and trial, Rickard poured all his promotional skills into Firpo–Willard. Profit, as always, was one of Rickard's motivations, but other elements worked strongly here. Rickard intended to show both Kearns, whom he disliked, and Dempsey, whom he admired, how a big fight should be promoted—how to put it in the right place, how to scale the ticket prices, and how to work the press. What Kearns, who always danced to his own solitary flutist, was willing to learn from Rickard is questionable, but Rickard knew that Dempsey was a practical man. After the barren crowd at Shelby, the champion would focus on how many people two contenders attracted to Boyle's Thirty Acres.

On July 9, after touring various Manhattan ticket agencies, Rickard summoned his sportswriters to Madison Square Garden and said, "In all my promotions, I've never seen an advance sale like this one."

"What about Dempsey–Carpentier?" a newspaperman asked.

The *New York Times* report has Rickard responding stiffly and with perfect grammar; it is a formalized version of what he actually said but the sense, if not the language, is probably accurate. "As great

as was the request for the Dempsey-Carpentier bout, it never equaled the demand that has arisen for the Willard-Firpo battle. An entirely new element seems to have come into the boxing game…and it is due to nothing else than the great work of Firpo, who has won the support of virtually all the people of Spanish and Italian blood in this section. They are all behind him and they are purchasing tickets, not by ones and twos, but in groups.…Society folk also are ordering tickets.… Firpo seems to have drawn the following that was behind Carpentier, besides thousands of new followers in the game.…The Italians are wonderful boxing fans.…There were more than 75,000 paid admissions for the Carpentier bout and I expect the coming battle will exceed that number.…We are preparing for a crowd of 100,000."

Rickard chose not to mention a significant difference between his handling of the two fights, and the sportswriters chose not to press him. He scaled Dempsey–Carpentier tickets from fifty to ten dollars. That, plus, of course, the crowd, is what pushed the receipts to almost $1.8 million. For Willard–Firpo, Rickard priced ringside seats at only ten dollars. Forty thousand general-admission tickets sold for one and two dollars. He would draw less than a third of the gate he had realized for Dempsey–Carpentier. But, as Bill McGeehan commented, "Tex had a point to make after Shelby. He, not Kearns, was the man who knew how to promote big fights and get big crowds. He was going to make that point with mass, not class."

On the eve of this battle, Dempsey was busy in Hollywood, starring in a serial for Universal Pictures called *Fight and Win*. As Teddy Hayes later recalled it to Harold Rosenthal of the *New York Herald Tribune,* "A new world was opening up to Jack and Doc and me. It was beautiful, like a sea shell roasting in the sun. We [it was mostly Dempsey's money] bought the Barbara Hotel in downtown Los Angeles for five hundred twenty-five thousand dollars and we all took suites there. We bought the Wilshire Apartments, a few miles west, strictly as an investment, for two hundred seventy-five thousand dollars.

"But I'll tell you the truth, Harold. A new bitterness was surfac-

ing in Jack toward Doc. Sure Shelby had Jack upset, but it wasn't only Shelby. Jack liked people; he treated people with respect. Doc was a brilliant guy, but he had a contempt for others, and when he got drunk he could be downright mean. Doc didn't stay with us in L.A. long. He headed back East. I knew trouble was coming."

Trouble was dark-haired and gorgeous. She was born Estelle Boylan in Wilmington, Delaware, into a working-class Irish and (reportedly) Jewish family, and left home to marry a banker when she was fourteen years old. Now, at the age of twenty-four, she had metamorphosed into Ida Estella Taylor, and acted in films under the briefer name of Estelle Taylor. She had played prominent roles in *Blind Wives, A Fool There Was,* and *Only a Shop Girl.* Most recently she had played "Miriam, Sister of Moses," in Cecil B. DeMille's astonishing epic *The Ten Commandments.* DeMille kept his actresses clothed, but watching a slit-skirted Estelle writhe in lust beneath the Golden Calf certainly called forth testosterone.

One day Jack Dougherty, who starred in cowboy movies, called Hayes aside at Universal and said, "Would the champion like to meet Estelle Taylor? She's very beautiful." Hayes said Jack was free and not at the moment in training. Dougherty drove Dempsey and Hayes to a Paramount back lot in the San Fernando Valley where Taylor was acting in *Tiger Love.* The group arrived outside Taylor's dressing room at lunch break and she walked straight to the car, smiled at Dempsey, and said, "We have so many mutual friends here and in Philadelphia and Wilmington."

"I'm sure we do, Miss Taylor," Dempsey said. He offered a shy and boyish grin.

That night Hayes dropped off Dempsey at Taylor's duplex apartment on Formosa Street near Hyland Boulevard, two blocks from the Charlie Chaplin studio. Dempsey said he would call when it was time for Hayes to fetch him.

No call came that night. Hayes went to sleep. He woke up to a ringing telephone at 8:30 the following morning. Dempsey said, "Bring me a clean shirt, will you, Teddy?"

After Dempsey climbed into the open car—a handsome Chrysler Imperial sports sedan—he leaned his head back. Then he said, "This is *it*. I'm in love." Dempsey did not journey East for the big fight in Jersey City. He was trying to catch up on a lot of life all at once.

Willard and Firpo prepared prefight statements for the Associated Press. "I am not overly confident," Willard said, "but I think I can win. I'm in better condition than at any other time in my career and I don't think there's anybody who can take my measure today. I hope to whip Firpo. If I do, I'll be ready for a return match with Dempsey the next day."

"I know I can beat Willard," Firpo said. "I'm in the best condition of my life and I can outlast him if necessary. I have all the confidence in the world that I'll be the victor, and then it will be Jack Dempsey and the title."

In Los Angeles, Dempsey told a sportswriter, "I won't make a pick. From my standpoint, it would be better for Firpo to win. I've beaten Willard, so if Firpo wins the public would look to him to beat me. That would probably draw better than a Willard rematch. But my fight with Tommy Gibbons taught me one thing. I must keep fighting. No more long layoffs. It makes no difference whether Kearns signs Harry Wills, Willard, or Firpo to box me. They all look alike to me. I want to fight one of them on Labor Day."

There never was final agreement on the size of the crowd that swarmed into Boyle's Thirty Acres on the evening of July 12. Rickard insisted that twenty thousand gate-crashers swelled the actual attendance to one hundred thousand, which would make it the third largest crowd in American boxing history, and the largest crowd ever for a non-Dempsey fight. The crashers came in flying wedges of five hundred men, storming entranceways and rushing up aisles before dispersing themselves among the paying customers. They overran gatekeepers like Caesar's phalanxes. Not even Rickard had anticipated such highly organized ruffianism. "I'm including the cops and the ushers and the firemen and the concessions people in that one-

hundred-thousand number," Rickard said. "The total beats Dempsey–Carpentier. If you counted the cops and the crashers and the ushers and the rest for that one, you'd get about ninety thousand."

After talking to Willard, Firpo, and associates of Rickard, John Lardner put the number at eighty-two thousand. Federal tax men recorded a paid attendance of 75,712. Whatever, government figures indicated that this great crowd put in only $492,920, or an average of about $6.50 a ticket. Willard's share was $123,113. Firpo drew $79,114, a total for both fighters of slightly more than $202,000. So while the attendance was about the same as Dempsey–Carpentier, this was a bargain-basement special. Between them *both* fighters earned ninety-eight thousand dollars less than Dempsey himself made in knocking out the graceful Frenchman. In the larger picture, however, this is bookkeeping and nuance. The simple weight of the Firpo–Willard numbers, the largest crowd ever to watch a fight with no championship at stake, made the Shelby adventure, and its attendance of 7,202, seem ridiculous and wretched. No one was more sharply aware of that than Dempsey.

Luis Firpo's weapons were mauling, shoving strength, and a huge righthand punch. He tended to rear back before he threw the right. Some boxing men said sure, he tipped his best punch, but Firpo hit the way an elephant charged, and if an elephant tipped his charge that was no help to an unarmed man. Others said that a seasoned boxer, and Willard was that, would mash an opponent who telegraphed his blows. Since it has less distance to travel, a straight left beats a roundhouse right every time. Controversy created a nice climate for the match. Betting was light; Firpo was favored 5 to 3.

The fight began—"on white canvas blazing under the lights"—with Firpo charging Willard, throwing right hands to the head and body. One overhand right drew blood from Willard's left ear. Firpo never stopped charging. The New York Times gave him six of the first seven rounds and rated the other round as even.

In the eighth, the *Times* reported, "a succession of rights and lefts

to the head, ending in a swift right drive which found Willard's jaw, brought the uneven contest to the close after one minute and fifty-five seconds....Sprawled on his hands and knees, his face puffed and bruised, Willard presented a pathetic spectacle. As Referee Harry Lewis started the fatal count, Willard's face worked convulsively. His right hand sought the nearest rope so he could pull himself up. But it was useless. Firpo's savage drives to the body had taken all the strength out of Willard. He frowned once or twice, as if amazed by his own feebleness....at the count of ten he was still on all fours, no longer the great Kansas giant, but merely a tired man who had tried to conquer middle age and failed."

That story led the front page of the *New York Times*. Elsewhere on the same front page came the disquieting news that armed federal prohibition officers had marched into the Berheimer & Schwartz Brewery, at 128th Street and Amsterdam Avenue, and seized 163 oak vats. These contained beer that had been lagering since 1919. To general dismay, the officers poured the beer, which the *Times* said was worth one million dollars, into the sewers of Harlem and into history.

Firpo's record now consisted of nineteen knockouts in twenty-three fights. At ringside, Doc Kearns told reporters, "We'll take him, if he'll fight us. But we're gonna need a million dollars up front. You only get crowds like this because Dempsey has gotten everybody excited about boxing. Look at all the publicity we got for boxing way the hell out there in Shelby. We gotta have a million bucks."

In a competitive press conference, Rickard said that he would match Dempsey–Firpo "for reasonable terms" immediately. "After watching this," he said, "I think everybody has to be convinced that Firpo is capable of taking on Dempsey. He'll make a dangerous opponent. He strikes me as another Jim Jeffries, but better than Jeffries because he's stronger than Jeff and hits harder. He's also got a unique defense style. He'll surprise everybody against Dempsey, if I'm not mistaken."

A reporter asked if it wouldn't be logical to match Firpo next

against Harry Wills, with the winner to fight Dempsey. "I was trying to put together Firpo–Wills for some time," Rickard said. "But it was no go. The colored guy wouldn't fight him." The men did fight in 1924, officially to no decision in a battle without knockdowns. Most reporters called it a victory for Wills, which one attributed "to the fact that Firpo lately has loafed and made investments and eaten himself into a state of near decay."

Warren Harding died unexpectedly and mysteriously on August 2, 1923, in a suite at the Palace Hotel in San Francisco. He was returning from a visit to Alaska. Harding's body was placed on a funeral train, which proceeded across the country to Washington and attracted throngs of mourners in the cities and in the plains. This was a bizarre echo of the funeral train—"a lonesome train, on a lonesome track / seven coaches, painted black" in the words of a stirring folk song—that had borne the corpse of Abraham Lincoln from Washington to Springfield, Illinois. Following the misbegotten theme, editorial writers called Harding "like Lincoln, a martyred president."

"Innumerable speeches," wrote Frederick Lewis Allen in *Only Yesterday,* "expressed no merely perfunctory sentiments. Everywhere people felt that a great-hearted man, bowed down with his labors, had died a martyr to the service of his country. The dead President was called 'a majestic figure who stood out like a rock of consistency.'"

But even as Harding died, scandals were coming to light from within the Interior and Justice departments and the Veterans Administration. After long research, Allen concluded that "proved evidence warrants the statement that the Harding administration was responsible in its two years and five months for more concentrated robbery and rascality than any other in the whole history of the Federal Government." American newspapers and most of the American public elected to gloss over the corruption. The times, after all, were prosperous and, except in forlorn pockets like Shelby, were growing more so. What's a little government graft, or even a lot of government graft, balanced against a new motorcar, a rising bank balance, and a stock market that is beginning to spiral upward?

Over ensuing years lurid accounts of Harding's philandering became public knowledge. He was addictively devoted to seducing younger women anytime or anywhere at all, and not every one of his partners maintained a maidenly silence. He was even caught by a White House staff member copulating vertically with a noisy partner in a closet. Soon various books appeared portraying him as a simpering lover. "Tell me it is possible," he said, while groping young Nan Britton toward bed, "that when I say I love you, you don't utterly despise hearing my words." In a forty-page love letter, the president wrote, "You are my shrine of worship, darling Nan." Alice Roosevelt Longworth, who was said to have slept around enthusiastically herself, did not think Harding was at heart a bad person. Longworth said, "He was just a slob."

Time shriveled Harding's reputation. The public subscribed to build a tomb in Marion, Ohio, immediately after his death, but there was no rush to dedicate the monument. Sensible Republicans distanced themselves from Harding and his legacy. It was not until 1931 that President Herbert Hoover presided at a dedication. By now the martyr motif had been abandoned. The ceremonies were modest and restrained.

Even Harding's final moments were clouded. One story said that the developing scandals drove him to suicide; he poisoned himself and died. Another suggested that his wife, Florence, raging at his adulteries, poisoned him with the connivance of the family physician, Charles E. Sawyer (with whom she may have been having her own affair). Another theory, offered by Carl S. Anthony in his 1998 biograph, *Florence Harding,* suggests that Sawyer's bad doctoring killed Harding, with injudicious mixtures of digitalis and purgatives that caused a coronary. Anthony writes, "Clearly, besides the fatal heart attack, something embarrassing happened in the dying of Warren Harding."

Calvin Coolidge was sworn in as president by candlelight in a Vermont farmhouse. His father, Colonel John Coolidge, administered the oath. Calvin Coolidge was laconic, lean, and dour, an unin-

spiring leader, but he handled the scandals with political skill and the Republican party escaped widespread blame. The country moved smoothly into "Coolidge Prosperity."

On the day Harding died, United States Steel, paying a five dollar annual dividend, sold for eighty-seven dollars a share. The New York Central Railroad, paying seven dollars, sold for ninety-seven dollars. American Telephone & Telegraph, paying $9, sold for $122. Revelations of the Harding scandals had no more effect on the 1920s stock market than did the Clinton impeachment on the booming market of 1998. In the bull-market years that followed Harding's death, U.S. Steel rose to $261; New York Central hit $256, and AT&T touched $304. More and more Americans would agree with an exuberant economics professor named Irving Fisher who told the Purchasing Agents Association that "stock prices have reached what looks like a permanently high plateau." Fisher spoke those words in 1929; two who shared that view were Tex Rickard and Jack Dempsey.

Firpo set up his training camp at the dog track in Atlantic City, where Kearns had based Dempsey for Carpentier. Dempsey moved into a lakeside cabin on the grounds of a hotel in an upstate New York village called White Sulphur Springs, near Saratoga, the resort and racetrack town. Kearns had not gotten a million-dollar guarantee from Rickard. He had to settle for the record-shattering sum of five hundred thousand dollars, at least $5 million today. The anticash boxing commissioner, Professor William Muldoon, had no comment.

Firpo stood to make one hundred fifty thousand dollars boxing Dempsey, and as soon as the contracts were drawn in mid-July Rickard told him to stop fighting and start training. (Rickard's Spanish was fluent.) Firpo, anxious for every purse he could grab, ignored Rickard and fought four opponents (the boxing term for mediocre fighters). But even an opponent could get lucky, land a punch to the point of the jaw, and send Firpo down for ten, which would ruin the setup for the real fight. Firpo said in effect that he was too strong to be dropped, and that no one had ever hurt him in the ring. Rickard

said that he agreed Firpo was the strongest fighter around and that could mean trouble, too. In Spanish, "Luis, you could kill one of these bums. That would be terrible for the Dempsey fight. Believe me, if you kill somebody, they won't only want to call off the Dempsey fight, they'll want to make boxing, all boxing, illegal."

Under the pressure, Firpo folded his road show and agreed to train for a few weeks. At Atlantic City, he rented the dog track for the period of 2:00 to 4:00 P.M. each day and charged fans who wanted to see him pummel sparring partners a dollar. He paid the sparring partners fifteen dollars a session, ten dollars under the going rate offered by other prominent boxers. If Firpo hurt them, they were on their own. He would accept no bills for medical or hospital expenses.

Few could stand up to him. Only John Lester Johnson, the boxer who had broken Dempsey's ribs seven years earlier, extended Firpo. The *Tribune* reported, "In the first round of two, Johnson landed a hard right to Firpo's jaw, which seemed to rile the South American. The Wild Bull snorted and threw the throttle open and from then on Johnson was on the receiving end of many a terrific wallop. Only the heavy gloves used for sparring saved the Negro."

Another sparring partner, Joe McCabb, said, "I've seen Dempsey fight. I know from experience how Firpo fights. I don't think anyone, including Dempsey, can hit Firpo hard enough to stop him." Benny Leonard, the great lightweight, came to a similar conclusion. "He sure is a powerful fellow," Leonard told reporters at Atlantic City, "and he's a terrific hitter. It looks to me as if even Dempsey will wear himself out trying to hurt him."

Grantland Rice called Firpo "the Argentine Plesiosaurus," after a large, extinct marine reptile that had huge paddlelike limbs. Rice rated Firpo as the most dangerous opponent Dempsey had faced. William Chipman wrote in the *Tribune,* "All the gods must have joined in the creation of this modern monster man who more appropriately might have roamed the earth in the dim days beyond the rim of history."

Excitement swelled. Firpo, the strong man, impressed everyone who saw him, but the mood of his training camp was surly. He

seemed motivated entirely by a passion for flowing gold. He had no interest in the reporters, the sparring partners, or anyone around him. At first, he refused to answer questions from sportswriters unless they paid him for the interview. No one did. Rickard had to come down from New York and tell Firpo, in heated Spanish, that newspaper stories build the gate. After that Firpo talked to reporters, but gruffly, and as briefly as possible.

In contrast, Dempsey's camp beside Lake Saratoga was open and relaxed. Paul Gallico, a rookie sportswriter with the *New York Daily News* who visited the place, found sparring partners with bent noses and twisted ears; handsome state troopers in gray and purple uniforms; doubtful blondes who wandered about and blondes about whom there was no doubt at all; Kearns, "smart, breezy, wise-cracking and scented"; and finally "tough Jack Dempsey, slim, dark-haired, crinkle-nosed, dressed in trousers and an old gray sweater, playing checkers on the porch of his bungalow with a sparring partner." Gallico, fresh from the humanities program at Columbia College, called the Dempsey camp "gay, low, vulgar, Rabelaisian and rather marvelous."

Gallico was writing secondary stories about sparring partners, the crowds, the color. He was both gifted and ambitious. He wanted to write a piece that would command notice. "I found myself wondering what boxing is all about." He approached Dempsey, introduced himself, and said that his boss down at the *News* wanted him to box a few rounds with the champion. It was his own idea, but Gallico thought that invoking someone higher up might get Dempsey's attention.

Dempsey grinned. "What's the matter, pal? Don't your editor like you anymore?"

Gallico persisted and length Dempsey said, "All right. I'll take you on next Sunday."

This happened on a Wednesday when Kearns was away, scouting Firpo in Atlantic City. On his return Kearns tried to cancel the fight. Gallico stood six foot three and weighed 192. He had rowed in the Columbia crew for four years. He looked like an athlete.

"He's just a sportswriter, Doc," Dempsey said. "Nobody to worry about."

"Sportswriter, hell," Kearns said. "He's big and strong. I think he's a ringer."

"I promised the kid I'd take him on," Dempsey said, "and I don't break a promise."

As Sunday approached, Gallico felt increasing fear. He was indeed a good athlete but he had never boxed before. Hype Igoe didn't help. He said, "I understand you're going into the ring with the champ."

"Yes, Mr. Igoe. But you know we're just going to fool around and take it easy."

Gallico never forgot Igoe's response. "Son, don't you know that that man *can't* take it easy?"

As Sunday approached, Gallico made one request. "Mr. Dempsey, I'm in pretty good shape, but I wanted to ask you if you could keep your punches up, sort of at my chest and head. I honestly don't think I could take your hooks into my stomach."

"I know what you want," Dempsey said. "A good punch in the nose."

"Yes," Gallico said. "Thank you very much. That would be fine." He retreated and spent the next days fighting down spasms of terror.

Jerome Holtzman, a Chicago newspaperman, tracked Gallico to his estate in Antibes, France, in 1972, when Gallico had reached the age of seventy-six. Gallico had long since left sportswriting, making a memorable exit with his book *Farewell to Sport,* and had become wealthy by composing such popular fiction as *The Snow Goose* and *The Poseidon Adventure.* Holtzman recorded Gallico for his splendid oral history of sportswriting, *No Cheering in the Press Box.*

> "The fight took place on a Sunday.... Three thousand people were there. I had to wait at ringside. I had headgear and was in trunks and an undershirt, a rowing shirt from college. [Dempsey] had about five sparring partners, little ones for speed, big ones for heavy hitting. Three were on the

program ahead of me, and each one was carried out. I said to myself, 'Gallico, you're next!'

Kearns was the referee....He called us to the center of the ring....All I knew was to keep my left arm out... Dempsey came in bobbing and weaving....He walked into my left. It wasn't a hard punch, more of a jab. He looked like a very angry tiger. I retreated and he chased me. I stabbed him again and I thought, "I'm doing all right."

There is one photograph...of which I haven't the slightest recollection. But there I am bent over and Dempsey's left hook is whistling over my head. I have no recollection of ducking that one. But I didn't duck the next one. I found myself on the floor. Everything went black. The ring made one complete revolution clockwise and then went back, counterclockwise.

Kearns was saying, "Six, seven, eight." Like a God damn fool I got up.

Dempsey pulled me in, next to him. By then he knew I was a bum....He whispered to me in the clinch, "Hang on, kid, until your head clears."

But he couldn't stop. That was the nature of the beast. He hit me with six straight rabbit punches on the neck, all perfectly legal, and the next thing I knew Kearns was saying, "Thirty-eight, thirty-nine, forty."

It was as if a building had fallen on me. The whole thing lasted a minute and thirty-seven seconds.

Grantland Rice reported: "At the end, the head of young Mr. Gallico was attached to his body by a shred. We only hope he is not asked next to cover an electrocution." Two months later Captain Joseph Patterson, the publisher of the *News,* who admired bravado, appointed Gallico sports editor.

Dempsey laughed at the episode in later years. Gallico did not. Once he mused, "Could that soft-spoken fellow with the high-pitched

voice, and the perfect manners, be the Jack Dempsey who clouted Willard until he resembled nothing human and pounded all the grace out of that prince of grace, Georges Carpentier? How wonderful to be so quiet and so gentlemanly—and yet so terrible!"

In 1922 Babe Ruth lost his home-run title to a now-forgotten slugger, Ken Williams of the St. Louis Browns. Ruth hit thirty-five homers, but Williams hit thirty-nine and led the American League. (Rogers Hornsby of the Cardinals, the St. Louis Rajah, led the majors with 42.) In that same season sleek George Sisler batted .420 for the Browns, a team that had never won the pennant. For all their great hitting, the '22 Browns still finished second to the Yankees. Now, late in the season of 1923, Sisler was sidelined with a massive sinus infection that defied all treatment. Antibiotics lay years in the future. Ken Williams continued hitting long ones, but the year belonged to Ruth, who would drive out forty-one homers and bat .393, the highest average of his tumultuous career.

But as Friday night, September 14, approached, Ruth had a focus other than baseball. He told his agent Christy Walsh to make sure that another of Walsh's clients, Doc Kearns, "gets us a couple of real good seats up close." The Babe said he *had* to see that damn Dempsey–Firpo fight.

Into the masculine world of boxers, ballplayers, and hustlers danced beautiful Neysa McMein, selling the *Tribune* charcoal sketches of Dempsey and Firpo and throwing in an enthusiastic opinion article as well. McMein wrote that when she heard Dempsey would fight Firpo, she threw a new hat into the air and telephoned for ringside tickets. "If this fight is half as exciting as the Carpentier–Dempsey match, it will be worth all the money I may lose on Firpo. Dempsey–Carpentier was the perfect entertainment. I was delirious with anticipation until the fight began. Then, as the beautiful Frenchman was being hurt, I grew numb and stunned, alive only in one part of my brain.

"The next day, while I was still weak from excitement, people said to me, 'What can you see in boxing?' Aside from my delight in the

sport for the sport's sake, it is a marvelous picture…the arrangement of piercing white light in acres of darkness and two men in the center of everything, their pink strengths pitted, one against the other."

As the fight approached, Firpo withdrew deeper into a shell of reserve. Between rounds on his final sparring day in Atlantic City, two beauty-contest entrants, Peggy Shevlin and Irene Knight, climbed into the ring and drove Firpo toward a corner. (What could the Pampas Bull do, throw overhand rights at Miss America?) Photographers swarmed. Firpo posed between the two beauties. But he would not smile.

Approaching the battle, Dempsey as always turned inward. On the eve of a fight he talked thoughtfully with Grantland Rice; the old slacker charges were now forgotten, or at least suppressed, by both.

"I have had to come up through a very hard school where I was fighting not to win but for my existence," Dempsey said. "I think that's why in the early days, I could come back after being knocked down three or four times. Gunboat Smith hit me squarely on the chin with so much force that all I remember is starting to fall forward. I felt my knees giving way and that is about all I remember. Some instinct from the hard early days kept me going and I won. I don't remember that. I know I won only because they told me.

"Maybe I can't take as much now as I took then. It's much easier, you know, and more fun fighting your way up the hill than it is standing on the top and defending it. Being champion isn't as great as it seemed before I was champion. I have more money and softer living, but there are more worries and troubles and cares than I ever dreamed of before. The glory and even the money don't mean as much as they did in the days when you belonged only to yourself—not to the public."

Rice asked gently how long Dempsey felt he could continue as the champion.

Dempsey said he wasn't sure. "But I know this. When I hit the floor and I can't get up, it will be because a better man put me there. I promise this. After I been down for ten with someone standing over me, I'll never alibi." (It did not end with someone standing over him.)

For me, at least, this calls to mind King Henry before Agincourt. "What infinite heart's ease / Must kings neglect that private men enjoy."

Then the king said, "O God of battles! steel my soldiers' hearts."

When it was done, no one composed a more cogent comment than McGeehan of the *Tribune:* "A pair of wolves battling in the pines of the Northern Woods, a pair of cougars in the wastes of the Southwest, might have staged a faster and more savage bout, but no two human beings."

Dempsey came to New York on the night of September 13 and checked into a suite at the Hotel Belmont. The relaxed mood of his lakefront camp was vanished. As the fight approached, he became grim and silent. Tex Rickard arrived and asked for a few words in private. "Like Carpentier, we got a hell of a house," Rickard said. "Keep this bout going, Jack. Don't let it end too quick."

"Go to hell," Dempsey said. (That's how he recounted his words to me. He really may have said something stronger.) Rickard blinked.

"And something else," Dempsey said. "The check for five hundred thousand dollars goes to me."

"Of course, Jack. You can have it now, if you want. I got my checkbook with me."

"I mean to me, not Kearns, and, yeah, I'll take it now."

Rickard gave Dempsey a five-hundred-thousand-dollar check. That covered the guarantee. Dempsey thanked him and put the check in one of his suitcases. A reporter from the *World* asked Dempsey to byline a prefight story. "Let Doc do it," Dempsey said. Kearns predicted that Dempsey would win inside six rounds. "There is one mystery about Firpo," Kearns (and his ghostwriter) wrote. "No one knows what he will do when he is hurt. No one has ever hurt him in a ring. He has always let his opponents come to him and he has taken all their punches. Suddenly he starts to go after them, and he bangs away until they collapse. Dempsey will hit Firpo and hurt him and when Firpo starts to clinch...well. That's where Dempsey is Dempsey—*in close.*"

Firpo moved into an apartment at Ninety-fourth Street and Riverside Drive. With the help of a reporter who knew Spanish, Firpo wrote a matching, but more intense, story for the *World*.

> During the afternoon yesterday, one of my friends said, "Firpo, if you are indeed as unafraid as you seem, you are a courageous man, and if you are only seeming to be unafraid, you are a remarkably great actor."
>
> I do not understand why so many think I should be afraid. I smile to hear that anyone believes I would be afraid to fight a man in a ring with gloves on his fists. Once I crossed the Andes in midwinter on foot. That was indeed danger. I had then not the gloved fists of a man to fear but the might of snowslides, and I say with truth that I was not afraid then. Why should I fear now?
>
> If you read the North American boxing writers, would you not think that the odds against me should be 50 to 1?... If they know I cannot win, it is funny that they do not take advantage of their knowledge to bet every cent they can get from any source and so become rich without risk of loss.
>
> Tomorrow we shall know. There will be an end of guessing. The hour is near and I am ready.

At 10:45 on the night before the fight, the first bleacher fans arrived outside the Polo Grounds at 155th Street and Eighth Avenue. These were Charles O'Brien, a day laborer from Boston, and Jack Farman, an oil-well driller from Port Arthur, Texas. They brought food, binoculars, and sweaters. "We were buddies in Europe in the A.E.F. Same outfit. This is our reunion," O'Brien told newspapermen. By morning hundreds more were lined up. People came and did not stop coming. They took the Sixth Avenue El, the Ninth Avenue El, and the West Side subway line of the IRT. By 7:00 on the evening of the fight, police estimated that 125,000 people were swarming within and around the Polo Grounds. Forty-three thousand had to be turned away.

This was a bad night for gate-crashers. At Rickard's urging and for some under-the-table cash, the New York Police Department dispatched three troops of mounted officers to keep order. When Rickard arrived, by limousine, someone who could not buy a ticket or force his way into the Polo Grounds threw a melon rind at the promoter. It missed. With all those mounted troopers, no one dared do more. The *World* reported, "The police, mounted and on foot, charged the swirling masses, and kept order using their clubs and their choicest vocabularies. Men and women fainted by the score. Many offered five or ten dollars for a chance to mount a truck or a wagon and escape the swirling mass. The real violence this night broke within the ropes."

Archibald and Kermit Roosevelt sat in ringside tickets near Florenz Ziegfeld and Henry Payne Whitney. John J. McGraw and Jess Willard took their seats quietly. The ample form of Babe Ruth edging his way into the eighth row caused a stir, but only briefly. When Firpo walked into the ring, he was wearing a yellow-and-black-checked dressing gown over his huge frame. The robe's cuffs matched the color of Firpo's trunks. Sitting in an upper grandstand box, Neysa McMein pronounced the color scheme satisfactory and gave a cry of pleasure at the sight of his 216-pound frame. "If I ever should draw anything besides girls' heads [the magazine covers she painted for *McCall's*]," McMein would write in the *Tribune*, "I should chose a scene like last night's. Thousands packed in semidarkness in geometrical patterns, bordered by thin aisles. The people shouting, smoking, watching, waiting for two giants. The lights, the flesh, the darkness....Oh, but to paint that one would need the genius of Goya."

Dempsey came into the ring wearing white trunks and a hooded white sweater. Kearns, Joe Benjamin, and Dempsey's handsome, light-haired brother Johnny entered with him. Dempsey weighed 192, his highest ever for a fight. Firpo weighed twenty-four pounds more.

"Where's the maroon sweater?" Jack Lawrence of the *Tribune* called. "Jack told me that was his lucky sweater."

"The champ doesn't need it tonight," Johnny Dempsey shouted. "He's got plenty of confidence." Johnny Dempsey, one year older than Jack, had been exploring Hollywood in his brother's wake.

The referee, Jack Gallagher, instructed the fighters to keep their blows above the belt. In the center of the ring, Firpo looked half a head taller than Dempsey. At every knockdown, Gallagher said, he wanted the standing fighter to go to a neutral corner "right away." That would soon become a universal boxing rule. This night it was simply what the referee wanted, as much a request as a command.

At the bell, Dempsey rushed across the ring and threw a high left. He started a right, but Firpo beat him to the punch. His quick left, an impure punch but a hard one, a kind of hooking jab, knocked Dempsey to one knee. This was the first time anybody had knocked down Dempsey since the strange fight with Fireman Jim Flynn, six and a half years earlier in Murray, Utah. ("And that happened before I took him under my wing," Kearns liked to say. "When I was running things, nobody but Firpo ever floored Jack.")

With Dempsey down, the crowd jumped to its feet. A row of temporary ringside seats toppled and a porky man swung wildly at someone who landed on him. "I turned," said Mickey Walker, the welterweight (and future middleweight) champion, "and I was gonna deck the stupid, fat son of a bitch who swung at me. But when I saw his face I pulled my punch. Hell, I was a Yankee fan and I wasn't about to bust up Babe Ruth."

Dempsey leaped up quickly, even before a count began, as if to deny that he had been floored. He moved in, throwing whirling hooks at Firpo's ribs. *Kill the body and the head will die.* Body punches make a man lower his guard; then the aggressor goes for the jaw, the head, the kill. Dempsey's body punching was a thing apart. He hooked and hooked and body-punched Firpo to the canvas. No man before had knocked down mighty Luis Firpo, let alone knocked him down with a blow into that oak tree of a chest.

"This isn't a boxing match," Bill McGeehan said at ringside. "This is a fight!"

Firpo got up at eight, without expression. He still was fresh. He had taken a terrible blow, but showed no fear. Firpo threw his big wide right into Dempsey's body. Dempsey kept coming. That was Dempsey's way, the two-handed fighter who stormed forward. He closed with Firpo and hooked a right to Firpo's face. This time the Argentine took a count of four. From the corner, Doc Kearns shouted, "Now, Jack. Go get him now! Now!"

Dempsey rushed. Firpo grabbed. Dempsey worked his right arm free, and hooked Firpo's jaw. A third knockdown. Firpo got up quickly. Hard as Dempsey was hitting, the big man still seemed unhurt. Grantland Rice decided that he was watching "a melodramatic thriller beyond all words."

Dempsey knocked Firpo down again and as soon as he rose, the boxers clinched. The referee ordered, "Break!" As they did, Dempsey drove an uppercut into Firpo's chin. Firpo fell awkwardly, as if unconscious. He lay motionless, face down. Someone at ringside said, "The whale is dead." Another writer cursed Dempsey and said that hitting on a break was dirty stuff, "worse than what Cortez did to Montezuma."

Firpo rolled over slowly. He rose at nine, barely getting to his feet, before Dempsey knocked him down again, with an uppercut to the heart. Dempsey stepped over Firpo, who spun on the canvas and this time came up swinging. He hit Dempsey with a long overhand right that crashed into Dempsey's head, behind the left ear. Dempsey fell to all fours and took a three count. He had now gone down twice in a single round. Dempsey down twice, Firpo down five times, and all within two minutes. The Polo Grounds crowd was shouting and bellowing.

Back on his feet, Dempsey bobbed and weaved and smote Firpo with a right. Again Firpo went down. Dempsey said in later years that hard as he was hitting, "the lust to kill still kept burning in Firpo's eyes. That was what I was trying to put out."

After Dempsey scored a seventh knockdown, he stepped into a corner, puffed air, and relaxed. He thought that finally Firpo was fin-

ished, that the fight was over. He was wrong. Firpo rose again, marched through a Dempsey hook to the chest, and threw the overhand right. Heywood Broun in the *World* memorably described the next moments:

> It was Firpo's right, the great swinging right, which moved in a circle like the scythe of death.
>
> In the Book of Fate, where entries are made concerning even prize fights, it was written that this blow should land. It not only swept the champion off his feet, but tumbled him heels over head across the middle rope. There hung Dempsey, horizontal for a split second and then he fell on the heads of the front row of sporting writers....
>
> The timekeeper began to count while Dempsey lay as helpless as he did on the day he received his first spanking. But the fighting instinct of the champion was functioning. He crawled back [at the count of three or four] and clinched. At this moment the conscious mind of Dempsey was not functioning. He did not know where he was or what was happening. But in some deeper layer of his brain the memory stuck that he was champion and must not go down. And so he hung on.
>
> His head lolled and his mouth was open. We saw his eyes wandering about hopelessly in search of something to remind him of what this fearful thing was all about.
>
> Even when the bell rang nothing clicked in Dempsey's mind. He kept on punching away at Firpo, the referee tugged at his arm and slapped him on the back and still he tried to hit the Argentine. It was not until the crowd started to boo this punching after the bell that Dempsey shook his head, blinked and seemed to wake.

As Broun perceived, Dempsey was fighting while semiconscious. For the rest of his days he had no memory of being knocked out of

the ring. Indeed, Firpo's punches had been separating Dempsey from memory for most of the round. Later Dempsey said, "There was just this fog before my eyes and this big guy getting up every time I knocked him down and the crowd screaming so loud it made it even harder for my brain to try to think."

Nor did Dempsey himself know how he got back into the ring. "I have no memory, none at all," he said, "of the most spectacular moment in my career. To find out about it, I had to look at pictures." Dempsey had fallen neck first on the typewriter of Hype Igoe of the *World* or Jack Lawrence of the *Tribune* or Eddie Neil of the Associated Press, or onto Perry Grogan, a Western Union Telegrapher, or one of the fight judges, Billy "Kid" McPartland. ("I sort of hope it was Eddie Neil," Dempsey said. "He was a terrific kid and he got killed covering the Spanish Civil War.")

As Dempsey fell, his feet became entangled in the lower rope. Twisting and crashing downward, he jammed a hip on the wooden board where the reporters had placed their typewriters. (Like a war wound, the hip plagued him more with time). A doctor named Walker, employed by the New York State Boxing Commission, said that the Dempsey he checked before the Firpo fight was the best-conditioned human specimen he had ever examined. The remarkable pitch of his conditioning is the only explanation for Dempsey's surviving the skeletal jarring and the fierce pain of his fall.

Supine, he said, low, intense, "Push me back. I gotta get back." In later years two dozen people, writers, telegraphers, boxing officials, claimed to have shoved Dempsey up and into the ring. The newsreel cameras, focused on the ring itself, not the front row of seats, provide no resolution. But someone, or several people, did as Dempsey asked and pushed him back into the ring. Article Four of boxing's governing code, the Marquis of Queensberry Rules, decrees, "If either man fall through weakness or otherwise, he must get up unassisted." Referee Jack Gallagher never did explain why he ignored the rule, why he did not stop the bout and declare Luis Angel Firpo heavyweight champion.

In Dempsey's first memory after the fall, he found himself sitting on a stool in his corner. Kearns and Joe Benjamin were slapping him and cursing one another. Kearns poured a bucket of ice water over Dempsey's head. He could not find the smelling salts. That's what the cursing was about. Finally, Kearns located the bottle—in his shirt pocket—and pushed it under Dempsey's nose.

"What round was I knocked out in?" Dempsey said.

Kearns snapped, "You slipped. You're coming out for the second. Now!"

Dempsey charged forward and crashed home a right. Firpo clinched. As they broke, Dempsey hooked a left to the face. Firpo clinched again. They wrestled briefly and then Dempsey, in a phenomenal feat of strength and balance, hurled the huge Argentine to the canvas.

Firpo rose swinging. They wrestled some more. Working free from a clinch, Dempsey threw a left hook to Firpo's chin and as Firpo began to fall, followed with a right cross. Two great blows to the jaw, too fast for most human eyes to follow.

Firpo rolled and writhed on the canvas. Gallagher counted him out at fifty-seven seconds of the second round.

Dempsey rushed across the ring. The fight was done. The Mauler vanished. The gentleman appeared. Tenderly, but with enormous strength, Jack Dempsey lifted Luis Firpo to his feet.

Grantland Rice reported that he had just watched "the most sensational fighting ever seen in any ring back through all the ages of the ancient game." Broun wrote, "It is not possible that there has ever before been such a battle for the heavyweight championship." Ring Lardner, playing the rube, commented, "There was a big question as to whether or no the Wild Bull could take it. He took it and took it plenty and come back for more. Dempsey was on the receiving end of four or five of the most murderous blows ever delivered in the prize ring. He never lost sight of the main idear, that he must get this guy and get him quick. He came back after every one and fought all the

harder. But Firpo. Listen, they ain't nobody living could take what Firpo took before he finally got hit with that left and right in succession and became the tame cow of the pampas.

"This was a *fight*."

Firpo recovered with sufficient speed to consume a huge spaghetti supper at Perrona's Restaurant on West Forty-sixth Street. He walked in, removed his fedora, and proceeded toward a back room, bowing to the other diners, who cheered him as though he had won. He earned $156,250 for his pain. The next morning he was up early completing a deal to import a special sports car, the Firpo Stutz Bearcat, into Argentina. The car was red with the head of a bull painted in white on one side. Firpo became its exclusive importer and dealer. The car sold well.

A year later, now prosperous and out of shape, Firpo fought Harry Wills at Boyle's Thirty Acres. McGeehan reported, "This was such a dull spectacle, with more pushing and shoving than punching, that one chance onlooker, Mr. Jack Dempsey, yawned in a bored fashion in the seventh round and left the arena." Wills did most of the hitting, but never had Firpo in trouble. Newspapers gave Wills the decision. This fight proved, Grantland Rice wrote, that Firpo was not in condition and that "Wills is not a fighter in Dempsey's class, or even close." Gentleman Jim Corbett told McGeehan at ringside, "In all the forty years I have been watching fights, I have at last, in my old age, gazed on the worst."

Accused of immoral behavior with a dark, buxom friend named Bianca Lourdes Picart, Firpo quit the United States in 1925. He had indeed been sleeping with Señora Picart; they were single consenting adults. One Brooklyn churchman, canon William Chase, a long-time campaigner to outlaw boxing, tried to have Firpo arrested on the grounds that he had brought Picart into the country for "lewd purposes." Firpo said it was nobody's business with whom he slept and retreated to run his wildly successful investments in Argentina. In

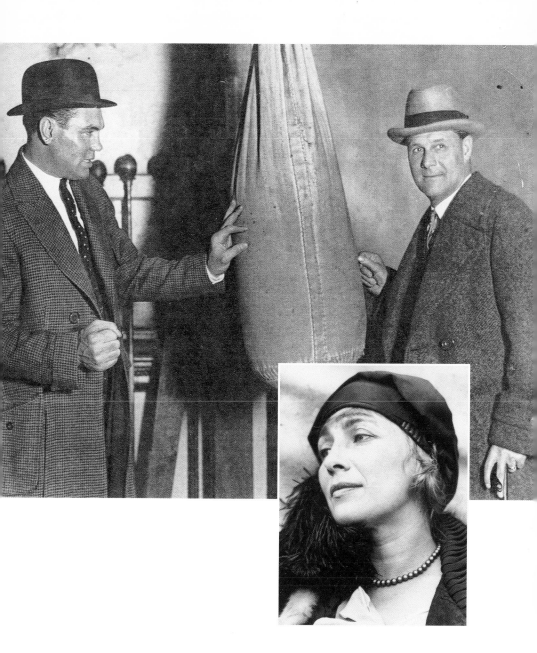

TOP: Dempsey and the great promoter George "Tex" Rickard posing before a heavy bag in 1923. Note the size of Dempsey's clenched right fist. *The Robert Shepard Collection*

ABOVE: Neysa McMein: painter, illustrator, free spirit, and one of the first women to write about boxing for the big New York newspapers. Her prose was colorful, eccentric, and sexy. *Corbis/Bettmann-UPI*

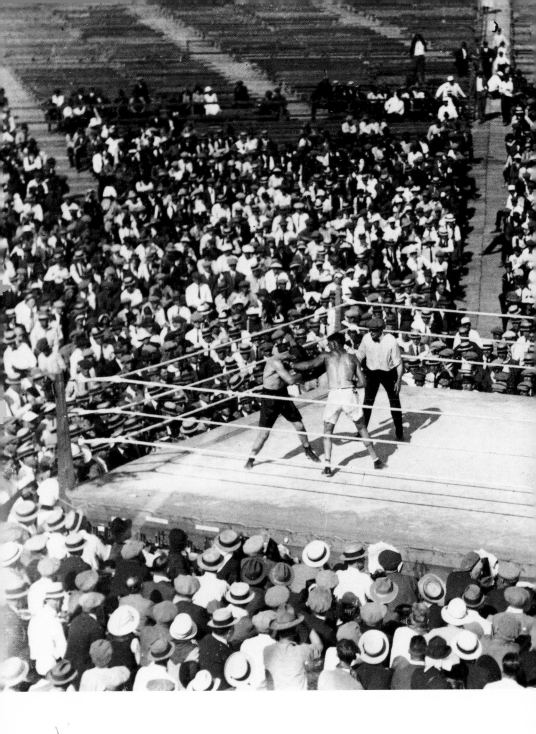

Empty stands at Shelby as Dempsey (in the white trunks) moves toward Gibbons. This fight bankrupted its Montana backers. *The Ring*

INSET: Rare photograph of Dempsey's brother Johnny, in dark suit, with trainer Jerry Luvadis, taken at Shelby, Montana, in June 1923. Four years later Johnny shot his wife and killed himself. *The Robert Shepard Collection*

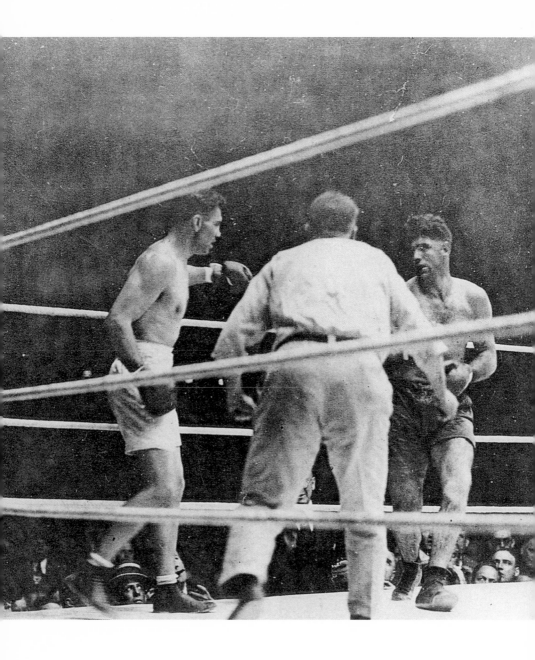

Action in Dempsey's storied fight at the Polo Grounds with Luis Firpo, the Wild Bull of the Pampas. The massive Firpo, coming up from a knockdown, is moving in for more.
The Robert Shepard Collection

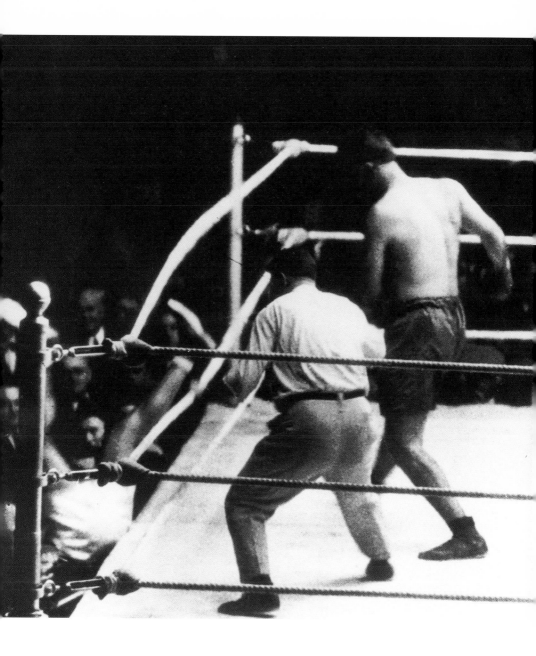

Firpo punches Dempsey through the ropes. Only the helping hands of sportswriters, shoving hard, got Dempsey back into the ring and (illegally) saved his title. *Corbis/Bettmann-UPI*

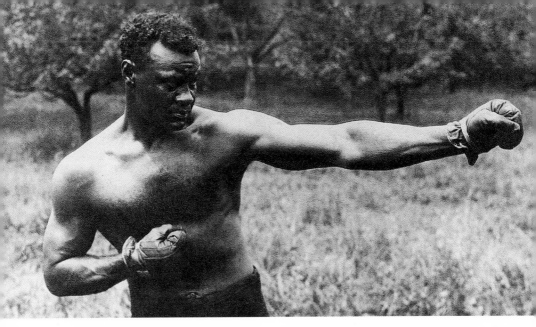

TOP: The challenger who never got a chance, Harry Wills, "the Brown Panther." The rampant racism of America in the 1920s blocked Wills's path to Dempsey. *The Robert Shepard Collection*

BOTTOM RIGHT: Looking well fed, Dempsey devours chips offered by Estelle Taylor during the filming of "Manhattan Madness" in 1925. Dempsey financed the picture as a vehicle for his new wife and himself. *Corbis/Bettmann-UPI*

BOTTOM LEFT: Movie princess of the 1920s, Clara Bow, called "The It Girl." She and Dempsey had at least one interesting encounter. *Corbis-Bettmann*

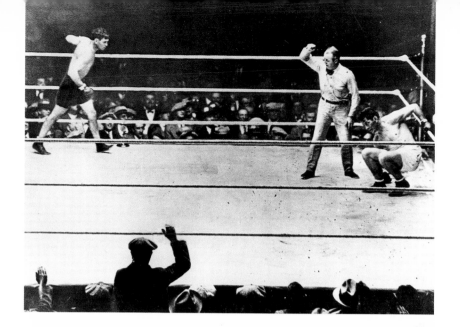

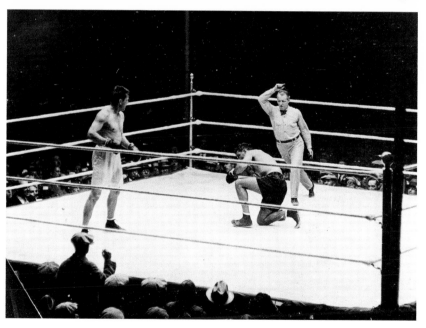

TOP: Tunney rising at nine after the famous long count in the seventh round in Chicago, 1927. Referee Dave Barry, who ran a Chicago speakeasy, may have been in the pay of pro-Tunney racketeers. Some estimate that the long count gave Tunney eighteen seconds to recover from Dempsey's barrage. *Corbis/Bettmann-UPI*

BOTTOM: The short count. With Dempsey down in the eighth round, the referee has started to count, although Tunney is far from any neutral corner. *The Ring*

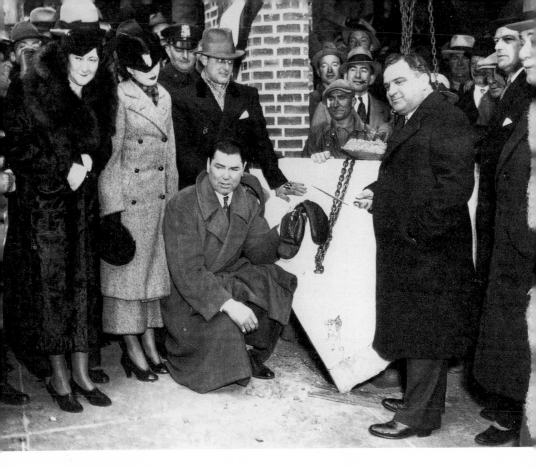

TOP: Dempsey placing a pair of gloves beside the cornerstone of his New York restaurant that opened in 1934. To his left stands Mayor Fiorello LaGuardia. Beside LaGuardia is mustached beer baron, Jacob Ruppert, who owned the Yankees. *The Robert Shepard Collection*

BOTTOM: Commander Jack Dempsey, M1 rifle at the ready, rides in to Okinawa Beach in 1945. At the time, he was 49. *Corbis/Bettmann-UPI*

later years he said that Dempsey was the bravest boxer he had encountered, but he himself had really won the fight. "I won it four times on fouls and bad refereeing," Firpo said. "Once when Dempsey hit me low. Two times when he hit me while I was getting up. And once after I knocked him out of the ring. The rules said you had to get back without help. I saw what happened. So many American writers pushed Dempsey into the ring that it looked like he was getting a back massage." For the rest of his days, Firpo remained the most famous citizen of Argentina, with the dual exception of the infamous Perons.

On September 15, 1923, when Rickard told Doc Kearns he had given the five-hundred-thousand-dollar check directly to Dempsey, Kearns turned furiously on his champion. Dempsey recalled the exchange with amusement.

"What the hell did you do with our money, Jack?"

"I put two hundred thousand dollars into an annuity."

"What interest?"

"I'm not sure. Two, three, four percent."

"I coulda got us fifteen, maybe nineteen," Kearns said.

"But this way," Dempsey said, "we aren't going to lose the principal."

That September 14, the day of the fight, detectives arrested Edith McCahill, the Mardi Gras queen of Coney Island. They had booked her husband for selling alcoholic beverages, and when the beauty queen punched the arresting officers, they charged her with disorderly conduct.

Out in St. Louis, Branch Rickey, who was managing the Cardinals, got into a fistfight with Rogers Hornsby, then batting .390. Rickey asked Sam Breadon, who owned the team, to trade Hornsby. Breadon considered for a year or so. He then removed Rickey as manager. The replacement was Rogers Hornsby.

Everybody was busy throwing punches. Babe Ruth, Edie

McCahill, Hornsby, Rickey. By Dempsey's standards, there was not a real fighter in the lot. Or a real moneymaker either. Ruth's annual salary was fifty thousand dollars. (It eventually reached eighty thousand dollars.) Hornsby and Rickey earned far less.

Any year that he chose to fight, the heavyweight champion could gross a million dollars from his fists and his irresistible persona.

11 Disorder and Sorrow

*I'll take on Dempsey at any time in any street he wants
to name. I'll knock him out for nothing.*

— HARRY WILLS

POOR NO MORE. DEMPSEY REMEMBERED thinking that phrase
the morning after Firpo. Even after settling with Kearns, always
an expensive affair, he was not going to have to worry about money
ever again. Or so he believed. Tranquility was something else. As
long as Dempsey presided as champion, and even beyond, conflict
and controversy clawed at his side.

A September storm broke violently with accusations that Demp-
sey was a dirty fighter and that he had won because the referee failed
to enforce the rules. He had, in fact, thrown punches that landed as
Firpo was rising from the canvas. He had, in fact, been helped back
into the ring. Various state commissions quickly adopted new boxing
regulations. Henceforth, when one fighter fell, the other *must* with-
draw to the most distant neutral corner. Until he did, no knockdown
count would start. Henceforth, when a fighter was punched through
the ropes, a knockdown count would begin immediately and con-
tinue until the fighter returned to the ring *under his own power.* If oth-
ers helped him back, he was adjudged the loser.

At least two prominent New York journalists, Nat Fleischer, who ran *Ring* magazine, and Dan M. Daniel of the *New York Telegram,* argued that Dempsey's brutish tactics had preserved a championship he now should not rightly possess. Dempsey set his teeth, thrust out his jaw, and held his tongue. To his core, Dempsey believed that you neither asked nor gave quarter in the prize ring. That was how it was in the mining camps and the saloons, in Tonopah and Goldfield, Ely and wide-open Reno, when you were fighting for the purse to buy your first hot meal in a week, when you were fighting so you didn't have to beg. Smooth and polished and gentle as the champion's manner became, Dempsey never could re-structure the emotional side of his boxing, nor did he even want to. When Paul Gallico got up in the ring that Sunday afternoon at White Sulphur Springs, Dempsey rabbit-punched him to the canvas. *Don't get up against me, dummy, unless you're looking to go down again.* When I dropped my hands in our brief session at the Broadway restaurant, Dempsey singed one side of my chin with the fastest jab I ever saw. *You better learn this, pal, if you're standing in with me. Keep your guard up at all times…pal.*

In a real boxing match, where he believed his safety and indeed his life were on the line, Dempsey did what was necessary to win. He equated victory with survival. Some have written that his fighting was instinctive and animal. But Dempsey was not a puma; he was a highly trained, superbly skilled professional boxer. Many years later Gene Tunney summed up one boxer's honest creed. "Did Dempsey ever hit me below the belt? He sure did. But when I hit *him* below the belt, Dempsey never complained. He was a fighter. In one way or an-other in this life it will finally come down to this: A man must fight to win the best way he knows how."

To Dempsey "the city" was always New York, which he had come to love. But after Firpo, New York boiled with charges that he had stolen his great victory. The nomad in Dempsey took over and he drafted Teddy Hayes for a hunting trip into high mountain country

in northern New Mexico. There he tirelessly tracked bear, elk, and mountain lion. When the men bunked in a cabin with a telephone, Hayes sent word to the press that Dempsey had shot "the biggest elk seen around here in many a year. Three hundred pounds. Seven prongs on the antlers. That's one big buck. It's almost an elephant." Was the champion happy hunting in the wilderness? "At heart," Hayes said, "he's still a Wild West boy. Jack loves the mountains and the fresh air and the open spaces."

But Dempsey quit the fresh air for New York City in a week. Kearns was arranging exhibition bouts tied to a tour of southern cities on the Pantages Vaudeville Circuit. Dempsey rehearsed and labored with his lines and hit the road and knocked out exhibition opponents. On February 10, 1924, he leveled Dutch Seifert in Memphis. The next night in New Orleans he knocked out Martin Burke and Tommy Marvin. He boxed in Pensacola and Raleigh. He destroyed the biggest, roughest town bullies inside three minutes. They had no more chance against him than Paul Gallico or myself.

Dempsey turned north when Calvin Coolidge invited him to the White House for a meeting on February 22. As Teddy Hayes recalled it, the two shook hands. The president turned to staff members and said. "Here is one who has been before the public even longer than I." (Actually Coolidge became governor of Massachusetts in 1919, the same year that Dempsey destroyed Willard.)

Hayes said, "Mr. President, the champion can knock people out with a punch that travels only two inches."

Coolidge looked at Dempsey. "That is two inches more of a punch than I would like to get from you."

For Coolidge, the most taciturn of presidents, two sentences amounted to a philippic. Silent Cal was gushing. "But the big thing," Hayes said, "was not that Coolidge talked. It was the White House invitation itself. When the president of the United States, no less, who was a very proper and conservative man, went out of his way to shake hands with the champion, it moved the bluenoses and hypocrites who had been blasting boxing clear out of the arena. Or, anyway, it parked

them way the hell back in the bleachers. I mean with the champion in the White House, you knew boxing had arrived."

New York had become Dempsey's shining city. The western mountains and meadows that spawned him remained his native ground. But the money lay in Hollywood. In the months after Firpo, as a practical matter, Dempsey decided to settle in Los Angeles. After that, nothing again was as it had been before.

Kearns continued to base in New York and to collect 50 percent of all the money Dempsey made. He let Teddy Hayes represent him at the studios. He said, "I was never as good with the Hollywood bums as Teddy. He had the contacts. But I deserved what I got because it was up to me to okay all the deals."

Dempsey had bought a mansion—the style was Hollywood Moorish—on Western Avenue and Twenty-fourth Street and installed his mother, now a vigorous septuagenarian, as reigning lady. His brother, Johnny, and his sister, Elsie, often shared the living space as well. For a time, Dempsey turned away from serious boxing and devoted himself to a career in the movies. His affair with Estelle Taylor grew more intense.

After Willard, Carpentier, and Firpo, Dempsey presided as the most famous athlete on earth. It was no trick to find a studio that wanted him to star. Carl Laemmle, the president of Universal Studios and one of Hollywood's eminent early tycoons, proposed a million-dollar deal. He would pay an even million if Dempsey agreed to appear in ten movies and, incidentally, do his training at a facility Laemmle proposed to build for him on the Universal lot. Most of the films turned out to be Saturday afternoon serials with such titles as *Fight and Win*. A thousand marquees would announce: "See the Great Champion Jack Dempsey Starring in *Fight and Win*!"

"Even when I was signing the contract, I couldn't believe it," Dempsey said. "I mean, I'd been a hobo. Then I was fighting for pork and beans. And here I am under the bright lights becoming a million-dollar movie star. You can't imagine how big movies were in those

days. You had theaters running nonstop movies and staying open twenty-four hours a day.

"I always loved the cowboy movies, the Westerns, and my favorite actor was Tom Mix. He wasn't one of those fake Hollywood cowboys. He'd fought in the Boer War and he was a helluva rider and he could handle the lasso. Now they told me I'm going to be making more from the movies than my hero, Tom Mix. Charlie Chaplin was maybe making even more and Doug Fairbanks and Mary Pickford, but not many others.

"It was something, the pork-and-beans fighter becomes a movie millionaire. I walked out of the signing at Universal straight into the fastest-talking rug salesman in California. He knew all about my big house on Western Avenue. In half an hour I bought fifteen thousand dollars worth of Persian rugs. I bought more rugs than we could use to cover the floors. We had to hang some on the wall.

"My mother just shook her head. She said a little cabin in a meadow with some land to farm was all she needed. A couple of times, like with the carpet salesman, prosperity went to my head. But the big money *always* made my mother downright uncomfortable."

Life in the sprawling house was unusual. Dempsey, as gregarious as he was famous, invited friends and acquaintance to visit for dinner or drinks, or a few hands of bridge. His work on the serials at Universal started at dawn when makeup men began powdering, painting, and prettying up the rugged face. Because he had to arise at 5:30 during the week, he usually went to bed by 10:00. Celia Dempsey kept the same hours. But the visitors, old-time boxers, agents, sportswriters, and movie people, did not. When Dempsey started upstairs toward bed, he'd say, "I'm kinda tired. But you folks stick around as long as you want."

Sometimes when Celia came downstairs to prepare breakfast, visitors from the night before still sat in the living room, talking, drinking, or sleeping off their whiskey, with accompanying snores. After a while she asked her son why he was turning their home into an all-night roadhouse. Dempsey said Doc Kearns "taught me the

value of ballyhoo. I need all these Hollywood people and all these sportswriters on my side."

Celia was unconvinced. The press had turned on him, first as a slacker and lately as a dirty fighter. Did it make sense still to court them with hospitality? She became more obsessively religious and insisted that grace be said before each meal. ("Some guys at my table," Dempsey told Bob Considine, "thought God was a cuss word and grace was a babe.") She insisted on cleaning the house herself. Dempsey hired a cook "to handle the people who dropped in kind of late." Celia disliked all the smoking; the casual drinking bothered her even more. This was a pioneer woman who had found a measure of salvation in the Mormon Church. Now she felt her Mormon home was being defiled.

All the while, Dempsey was courting Estelle Taylor, or she him, with ardor and a certain amount of discretion. His work schedule kept them apart most weekday evenings. Celia's presence precluded Estelle's sharing his bedroom on weekends. When they partied together on Friday and Saturday nights, Estelle's apartment was their base. She liked to show off her trophy lover to her friends, mostly writers, directors, and actors. "Some of their talk," Dempsey said, "went over my head. Sometimes with the high-flown conversation, I found myself feeling out of place and lonely. But after a while they'd go away and Estelle and I were alone. It doesn't always show in the still photos, but Estelle was a great beauty. After everybody left and it was just Estelle and me, I wasn't lonely at all."

Within a year Celia said that she could take no more of Los Angeles and the loose, *un-Mormon* life. Dempsey bought her a twenty-two-acre farm outside Salt Lake City. There Celia flourished again in the high-plains quiet, among Mormon neighbors. She was unaware that Hollywood gossips and journalists attributed the departure to her maternal discomfort with Jack's ardent romance. According to Dempsey, his mother actually liked Estelle, a woman possessed of saucy spunk. What Celia disliked, he said, was Hollywood life and Hollywood gossips and Hollywood drunks.

Estelle drove a Willys Overland, an unimposing car, which she had piled up several times. "When she drove off with Jack once," Teddy Hayes said, "the two fenders were flopping so badly that I thought they might give a final flap and the car would start to fly." Dempsey told her to sell the car. He gave her a new Buick, a sturdy and prestigious car associated with prosperous doctors and dentists, depositing a sleek beauty in a square automobile.

If a single flaw diminished Estelle's dark-haired attractiveness, it was her nose. Narcissistic, beautiful women—and Estelle Taylor was both—seem to find flaws in a mirror that no others see. After long gazing they decide that their eyes are too far apart, or that their cheekbones are too prominent. Taylor's nose was slightly more assertive than she wanted and in 1924, she engaged a plastic surgeon to trim the bridge and put a sexy arch into the nostrils. That was common enough, a movie actress hiring a doctor to modify nature. (In a later time doctors surgically rounded the shape of Marilyn Monroe's natural rather square jaw.)

Taylor talked Dempsey into visiting the same surgeon. Behind his back, she had been referring to "Jack's palooka nose." He heard the words repeated by Taylor's friend Lupe Velez, a dark-haired actress billed as "the Mexican Spitfire." His own fling with Velez had ended with rancor, Velez mistaking a few passionate evenings for love. After Velez teased Dempsey about the palooka nose, Dempsey reported to the surgeon. A wrinkle at the tip of the nose was removed. Honorably earned scar tissue was excised. The base between the nostrils, mashed by hooks and jabs, was raised and narrowed. Not to be outdone, Doc Kearns engaged the same surgeon and had his own nose remodeled. Gene Fowler, a Hollywood writer who was close to Dempsey, remarked, "I asked Jack, but he never told me did the doctor give them some kind of rate, like say, three nose jobs for the price of two."

W. O. McGeehan was afraid Hollywood was transforming Dempsey. "The fighter I saw against Willard and Firpo was wild from his toes to his hair," he wrote in the *New York Tribune*. "The

hair bristled like the hair of a wild boar. It lent an appearance of ferocity, which was quite natural when the bell rang. Fancy hairstyling and the new nose have altered Dempsey's naturally ferocious appearance and given him the look of a mooncalf. If that look continues, many contenders will want to take a sock at him, just for the enjoyment of the sock. The movies have softened our champion where Mr. Gibbons and Señor Luis Angel Firpo failed."

Doc Kearns disliked Taylor early, and came to detest her. He thought she was pretentious, vain, and sluttish. Kearns was tolerant of sluttishness, but not in a wife. From the start he sensed that Taylor was out to marry the champion, *his* champion, and that the marriage would spell trouble for the firm of Dempsey and Kearns.

Dempsey was many things to Kearns: champion, gold mine, surrogate son. They traveled separate paths and squabbled. Neither entirely trusted the other. But for years they were bonded by a cactus kind of love, beautiful but spiky. Kearns first saw Taylor as someone who would come between the champion and himself. He suspected that she was a gold digger and that her passion was more for Dempsey's millions than for Dempsey. Finally, Kearns, like most of his contemporary fight managers, believed that sexual activity weakened boxers.

Covering boxing, I heard this spouted by generations of trainers and managers. Women and boxers do not mix. Never have. A fighter in training must remain celibate. Along with keep your right high, this was boxing's first commandment up until 1959, when Ingemar Johansson arrived from Sweden to fight the heavyweight champion, Floyd Patterson, at Yankee Stadium. Johansson imported and displayed his mistress, a lissome blonde named Birgit Lundgren.

John Lardner commented, "This will make Gene Tunney blanch."

"And Dempsey?"

"Dempsey will blink."

After taking steady body punches and losing the first two rounds, Johansson suddenly threw what he called "Toonder," his

overhand right. The wallop landed squarely between Patterson's eyes. Six knockdowns later Johansson had become champion. The reputations of enforced chastity and Floyd Patterson both took a terrible beating that night.

With no serious fight ahead for Dempsey in the winter of 1923–24, Kearns did not expect his fighter to remain celibate. But Kearns believed that boxers, when not in active training, should satisfy themselves with one-night stands. Falling in love was a waste of emotional energy; a serious affair or marriage could amount to disaster. Boxing wives complained about the harsh nature of the business. They worried that their husbands might get hurt, or even killed. Boxing wives consistently urged husbands toward other, gentler lines of work. Besides that, wives and mistresses demanded attention and expressed needs. Sex, sure, but also love and protection and a whole lot more. Kearns wanted a fighter focused only on fighting. He understood one-night stands in the down times. But during training he pressed for celibacy. (Look how Dempsey almost lost the Brennan fight.) A wife and children? They could come only after retirement from boxing.

Dempsey unburdened himself to Teddy Hayes. He'd had his fill of one-night or even two-week stands. He'd known some beauties. Clara Bow, Bebe Daniels, Velez, Barbara Stanwyck, that English noblewoman in London, Lady Something. Very posh. But what *was* her name? Paris too had been fun. Those French girls spoiled you. A terrific all-night workout and they'd get out of bed without a stitch on and make the greatest omelettes for breakfast. It was something seeing those bare bottoms by the stove.

He was properly closemouthed to the world at large about the women he knew, but a director named Eddie Sutherland was telling a story all over town. Sutherland, short and slight, possessed a reputation as a seducer of movie queens. Clara Bow was a wonderfully pretty and fresh-faced actress, famous as "the It Girl," *it* here being a kind of code word for sex. Sutherland and Bow became lovers, but after a time Sutherland noticed a diminution in the It Girl's ardor.

He told her he had to go to New York to scout out plays that might make good movies, and they held hands in the back of a limousine, while Bow's chauffeur drove them to Union Station in Los Angeles. They hugged and wept as they parted. Sutherland rode the train only to Pasadena. There he hailed a taxi, went home, and then drove to Clara Bow's mansion. He had a key to the front door, but upstairs he found the bedroom door locked. He knocked and kept knocking over Bow's cries, "Please go away before I call the police."

At length she opened the door. She wore only a bathrobe.

"There's a man here," Sutherland shouted. "I smell a man."

"What are you?" Bow asked. "A bloodhound?"

Sutherland plunged through closets and finally tried the bathroom, where he found another locked door. "I know you're in there," yelled little Eddie Sutherland. "Come on out, so I can knock your teeth out, you yellow son of a bitch."

The bathroom door opened. Behind it stood Jack Dempsey.

"Just another quiet night for me in good old Hollywood," Eddie Sutherland told drinking companions for years.

"I imagine," Gene Fowler remarked, "that the next thing you said, Eddie, was, 'Just kidding, sir.'"

Dempsey had been champion now for almost five years—there wasn't a good contender in sight—and he was tired of waking up in strange bedrooms. He was coming within sight of his thirtieth birthday. He didn't want any more one-nighters, no matter how beautiful they were. He was ready to settle down. Whether Doc liked it or not, he intended to propose to his new friend, Miss Taylor.

Hayes was neither surprised nor comfortable. Dempsey–Kearns was indeed a firm and he was sort of managing director, but still an employee. He liked Jack and he liked Doc. He couldn't tell Jack to forget the pursuit of happiness. That was everybody's right, even a champion's. At the same time Hayes knew how Kearns would react to Dempsey's most serious romance since Maxine Cates of long ago. Doc Kearns would go volcanic. An Irish Vesuvius. Hayes wished

Dempsey his best, in a noncommittal way. For many weeks, he said nothing to Kearns. Dempsey's habit was to stay in light training all the time, running, skipping rope, and punching light and heavy bags. Enthralled by Taylor, he now abandoned training. "She fascinated me," he later said. "I just lost all my discipline." When Dempsey's weighed pushed above 205 pounds, Hayes finally said to Kearns on a long-distance call, "It's like he doesn't care about fighting anymore. He only cares about Estelle."

Kearns cursed hotly, then turned to ice. He began contacting detective agencies. He wanted a complete background report on the movie star known as Estelle Taylor. Who was she? Where did she come from? Where had she worked? Who had she married? How much money did she have? Who had she slept with? Any history of mental illness or venereal disease?

Details varied from report to report but all agreed that Estelle was a driving, ambitious, sexually charged woman of the world. She was born into a lower-middle-class family in Wilmington, Delaware, on May 20, 1899, and the name on her birth certificate was Ida Estelle Boylan. The father was Irish. Her mother was at least partly Jewish. The mother wanted her to become a typist, but at fourteen, Estelle won a beauty contest and quit school. By lying about her age, she was able to marry a man named Peacock or Pencock, who was a banker or a bank employee or a shipping clerk. Four years later she left, but did not divorce, her husband and enrolled at Sargent's Dramatic School in New York City. She modeled for artists, sometimes nude, appeared in the chorus of two Broadway musicals, and found a sugar daddy in Casper Sharpless, "a big butter and egg man" from the Philadelphia area. He provided a stake so she could go to Hollywood, but he was tired of the affair by then and handed her over to the director, George Walsh. Hollywood gossip made Estelle prominent in Walsh's divorce and then put her into bed with Walter Wanger, the chief of production at Paramount Pictures. Along the way, she had affairs with Charlie Chaplin and the gruff actor Wallace Beery. The men who talked described her as demanding, volatile, and temperamental. As Kearns

summed up the detectives' dispatches, "Dempsey wasn't getting no maiden."

Dark-haired, worldly Estelle Taylor surely was reminiscent of dark-haired Maxine Cates, worldly too in her sad setting of shreds and patches. As Maxine had moved confidently through honky-tonks and brothels, Taylor knew her away around studios and casting couches. Modern psychology suggests that both women may have been sexually abused as children. Fleeing home early and then embarking on a promiscuous life can signal early sexual abuse. A third sign would be sexual frigidity, and there is some indication of that in both women Dempsey chose to marry.

What Kearns learned from detectives convinced him that Estelle was, to put this tactfully, a handful.

After Firpo, Dempsey stood at an absolute peak. Solid boxing men, Ray Arcel, Gene Tunney, had long recognized the ferocity of his charges, the swirling hooks that drove mighty men gasping to their knees. "Against Firpo," Tunney said, "Dempsey showed me something else; that he could take it. I don't believe any other human alive could have absorbed all those full-arm blows from Firpo and remained upright or even conscious, let alone win the fight."

In his old age, Kearns said, "I still think a fighter shouldn't have home ties. You have to stay hungry and keep on the go if you want to make it big in the fight game, and here was Estelle looking to move in on Jack and his money and settle him down. My champion was at the top, but I felt in my heart that Estelle Taylor was doom."

Back East, Kearns had kept busy in a new role, managing the welterweight champion, flashy, handsome Edward Patrick "Mickey" Walker, the Toy Bulldog—the man who declined to flatten Babe Ruth at ringside during the Firpo fight. Careful in this instance, Kearns asked Dempsey if there was any objection to his taking on another fighter. There was none. Then Walker sought out Dempsey, who told him that Kearns was expensive, always insisting on 50 percent, and the best manager in the business.

Walker had lost to middleweight Harry Greb, the Human Windmill, at the Polo Grounds in the summer of 1925. Negotiating for himself, Walker accepted a twenty-thousand-dollar guarantee. The Greb fight drew a four-hundred-thousand-dollar gate. He had fought for only 5 percent of the gate. The two crossed paths later in a restaurant and continued their fight on the sidewalk. Walker won the unofficial bout, flattening Greb against the fender of a parked car. "Stop it, you guys," Kearns yelled. "Stop it right now. You ain't even getting paid for this."

Later he told Walker, "From here on we ain't fighting nowhere for less than one hundred thousand dollars."

That September Walker outpointed Dave Slade in New York and pocketed forty-eight thousand dollars; half the guarantee had gone to Kearns and another two thousand dollars paid training expenses. It was easily the biggest payday of Walker's life. Walker wanted to become an architect; he took night classes in design at Columbia. His hobby was painting and he sold some of his canvases as primitives. Kearns enjoyed this interesting character, with whom he relaxed as he was never quite able to settle back with Dempsey. Kearns and Walker romped through Prohibition New York, feted by bootleggers and embraced by show girls, carefree, prosperous, and a bit giddy, until the warning call came from California.

It is a vexing, old question in the company of men. What do you do when you discover that the girl who has captured your buddy's heart is not as she appears? To your buddy, she is the pure and matchless Miss America. To a legion of others, most of whom have known her supine, she is Miss Congeniality. The practical answer is that you do nothing. Tell a man in love that his sweetheart is easy to bed and he will enter denial. At the same time he may start punching. In the end he will do exactly as he wishes, exactly as he would have done, without your advice, for which he did not ask. "Love's best habit," Shakespeare writes in a sonnet, "is in seeming trust." Not trust, but the *appearance* of trust. That is something that is best left alone.

Jack Kearns's strengths, as we know, were formidable. No one was better at organizing a training camp, extracting cash from promoters, getting a boxer ready to go to work, and supervising tactics during a bout. But now, in a matter where the best course was restraint, Kearns came apart.

He wanted to tell Dempsey what he had already told Dempsey: Don't marry or settle down with a woman until you retire from the ring. To this he now felt compelled to add that Dempsey, severely stung by his prostitute-wife in the slacker trial, was getting involved with another tramp. Kearns booked Pullman space to Los Angeles. He knew he was assuming a daunting job and he began serious drinking on the train west. He missed a connection in Chicago. The New York to California trip took five days. At length Kearns caught up with Dempsey at Eddie Branstetter's Montmartre Club on Hollywood Boulevard.

The Montmartre was a large and fashionable place, with white tablecloths, a polished dance floor, and the soothing music of big-name bands. Charlie Chaplin, Douglas Fairbanks, William Randolph Hearst, and his mistress, Marion Davies, a nervous beauty who stuttered, all favored the Montmartre.

Kearns had not stopped drinking. He sat down at a table with Dempsey, Estelle, Teddy Hayes, and Joe Benjamin and said he had been keeping track of things. He knew Dempsey had just one more episode to shoot in the serial *Fight and Win*. Looking at Estelle, Kearns said he had found the perfect costar for the finale. "She's beautiful, Jack. You're going to love her. Blonde dish named Margaret Quimby. I been dating her. You might try yourself. Don't pass up this dame. If you put your shoes under her bed, you'll be glad you did."

Taylor glared. Hayes said, "Doc, now cut that out."

Kearns turned on Hayes and wanted to know "what the hell has been going on out here?"

He was shouting. Hayes asked Kearns to lower his voice and said, "We'll talk about this later."

Kearns took a drink from his flask. Estelle said that she and Jack

had been getting lots of "grand" publicity lately and now that the serial was almost done, it would be wonderful if she and Jack starred in a feature film together. Fairbanks and Mary Pickford owned a screenplay called *Manhattan Madness.* "That would be the perfect vehicle for Jack and me."

Hayes thought this was a bad idea. He believed that Dempsey's acting skill barely got him through serials. A serious full-length part would prove too much, particularly a full-length part against the demanding and egocentric Taylor, fresh from her spirited portrayal of Miriam, Sister of Moses. Hayes kept those thoughts to himself.

Loud and drunk, Kearns said, "Who'll bankroll this thing?"

Taylor said, "Oh, you boys know how to take care of that. And we can get Paramount, my old studio, to release it."

Kearns glared at Taylor. Hayes remembered him saying, "Listen, lady. Jack has been out here putting paint and powder on his face, and that isn't what the public wants to see. They want to see that limousine body and those left hooks and right crosses. So to hell with you and your movie." Kearns proceeded to recount the reports detective agencies had furnished. Hayes said he ended the diatribe by shouting, "I got stuff that can put you and your career right in the city dump."

Dempsey sat stunned. Estelle, accused of being a harlot, said grandly, "My cape, please, Jack." She led Dempsey out of the Montmartre.

Working for peace, Hayes called a cab and followed the couple to Taylor's apartment. The door was open. He heard Estelle screaming: "You! Every night under the sheets you tell me how much you love me. Then you let a drunken slob insult me."

Dempsey said that Kearns was not as bad as he sounded. He was just drunk.

Estelle's fury fed on itself. Soon she was shouting that Dempsey would have to choose, "that slob or me."

"I love you, Estelle."

"Then fire that slob. You're the champion. The big tough champion. Fire that slob who insulted me."

Hayes walked into the middle of this scene. Estelle brightened and her voice softened. "Teddy, why don't you just take over and manage Jack? The public and the news people like you better anyway." Hayes took a step backward. Everybody was making too much of hot words, he said. Tomorrow Doc would send over a roomful of flowers and apologize.

At last Dempsey spoke. Resentment had been building up for months and years. Why did Kearns's bookkeeping always favor Kearns? Why had Kearns wasted all that time in northern Montana and gotten half the country sore for a second-rate fight? Why was Kearns always telling him what to wear, who to see, what to do? Dempsey took 100 percent of the punishment in the ring; why did Kearns get to grab 50 percent of the purse? Dempsey put an arm around Estelle Taylor, who stood stiff with outrage. He said to Hayes in an even tenor, "Teddy, Doc and I are through."

Dempsey later backed down a bit and said Kearns could manage him again, but not for 50 percent; 35 percent. Kearns declined. He said, and even seemed to believe, that he had an unspoken lifetime agreement with Dempsey. Half the proceeds. Half the proceeds for all eternity. Informed that the champion was cutting him loose, Kearns, quite sober now, told Hayes, "When I found Dempsey, he was a bum. He'll end his days a bum. Broke and nowhere. He's nothing without me." Kearns subsequently fired off volleys of lawsuits. Following that night at Montmartre in late spring 1924, Kearns and Dempsey did not exchange a civil word for thirty-five years.

Sometime after that during a discussion with Estelle about setting a wedding date, Dempsey found himself startled. "Any date you want to name, darling Jack," Taylor said. "There's only one thing I have to do first."

"What's that?"

"Get divorced."

The husband turned out to be Malcolm Pencock of Philadelphia. (Whether this was Taylor's first or second husband remains unclear.)

When Dempsey was invited to judge the Miss America contest in Atlantic City in September 1924, Estelle joined him on the train. She wanted to find a Philadelphia lawyer to serve Pencock. By the time she did, her romance with Dempsey was splashing from gossip columns to sports pages. Pencock told reporters he was suing Dempsey "for alienation of my lovely wife's affections." When a judge learned that Pencock and Taylor had not lived together for five years, he threw out Pencock's suit and granted the divorce.

On February 7, 1925, Estelle and Dempsey married in an informal ceremony at the First Presbyterian Church in San Diego. She signed the church register as Estella Taylor. Joe Benjamin served as best man. Celia Dempsey came all the way from Salt Lake City to bless the couple.

A reporter shouted, "Champ, did you invite Doc Kearns?"

"I didn't ask him," Dempsey said, "because I knew he wouldn't come."

"I'm too happy to talk," Estelle said.

"We're going to honeymoon over in Europe," Dempsey said, "and listen, boys, I've always cooperated with you in every way, right?

"Now give us little break here, fellers. We need some privacy."

That came easily. The press and then the public became increasingly preoccupied with the ordeal of Floyd Collins, a young Kentuckian who prowled beneath the countryside looking for caverns to bring tourists into the hills. On a cold February day, Collins found a marvelous underground coliseum in Sand Cave, a few miles from Mammoth Cave. A sudden earth slide trapped him, a hundred feet from daylight, and pinned one of his feet beneath a six-ton boulder. Rocks, gravel, and mud covered him to the hips.

A small, agile reporter from the *Louisville Courier-Journal,* William Burke (Skeets) Miller, crawled on his belly down a black passage and reached the side of the trapped man. He brought in food and milk. When he crawled out, he wrote a harrowing story of the spelunker's agony. For seventeen consecutive days Miller reported on Collins. At one point water began dripping against Collins's forehead.

Miller wrote, "This reminded me of the old water torture used in ages past. I shuddered." He blocked the dripping with a piece of oil cloth. Obscure Floyd Collins suddenly became front-page news. Millions followed his suffering. As someone wrote, "Anyone who shared the dread of being buried alive could understand Floyd's torment and could feel his chest and lungs fighting for air."

On February 18, Collins was found dead. Extricating his body would have put scores of people at risk. Kentucky authorities filled in the cave with timbers and cement. In death Collins remained where the cave had trapped him. Skeets Miller's reporting won a Pulitzer Prize.

Walter Wanger fired Estelle Taylor from Paramount, some said because she had cut short their affair. Louella Parsons, the gossip columnist, wrote that Wanger felt so enraged at losing Estelle as a lover that he intended to seek out Dempsey and start punching, to settle the score. The publication of this item terrified Wanger, a skinny, dapper Englishman who had come to Hollywood with a background of directing plays at the Whitechapel Theatre in London. Wanger had no boxing experience. He now writhed, lest Dempsey seek him out, and immediately asked Hayes to visit him at Paramount.

Wanger told Hayes that the decision to release Estelle had been strictly business. "I'm supposed to cut down overhead. That means firing some contract players. We already have Bebe Daniels, Kathleen Williams, and Elsie Ferguson to play female leads. [Jesse] Lasky [the supreme head of Paramount] wants me to bring in European actresses. We think exotic European women are going to be all the rage. There is no place and no budget here anymore for Estelle Taylor."

He said Taylor pleaded with him to have dinner "so we can talk things over." Wanger declined. "Dinner with you? And have my face punched out by that boyfriend of yours? That wouldn't be very smart of me, Estelle." Although Wanger was a profligate womanizer, Hayes elected to accept his story. He told Dempsey that someone in

Wanger's position could have a hundred women, five hundred, all great looking. (Some years later the husband of another actress Wanger had seduced shot him, not fatally, in the groin.)

At length, Dempsey accepted Hayes's opinion, but told Estelle he didn't want her pleading with other men to buy her dinner. Estelle blew up. "That gave us," Hayes said, as though he were part of the marriage, "at least two very bad days."

Estelle was a good enough performer to move successfully from silent films to talking pictures. Elmer Rice's *Street Scene* is a brilliant, naturalistic play, in which all the characters reside in the same cramped slum tenement. The building throbs with hope and with hatred. When the director King Vidor turned *Street Scene* into a movie in 1931, he cast Estelle as a smoldering, desperate middle-aged housewife whose husband returns unexpectedly and catches her in bed with a lover. Long suspicious, the husband has been carrying a pistol. He shatters the heavy quiet with gunfire, shooting his adulterous wife to death.

If Estelle was capable of delivering a powerful performance as late as 1931, why did she panic when Paramount released her in 1925? The nature of acting—auditions, rehearsals, stage fright, flops—exacerbates anxieties. Jackie Cooper, once a multimillionaire child star, told me, "I was *always* insecure. How did I know I was an actor? How did I know I was any good? It wasn't as if I were a lawyer or a doctor with a big license framed on my wall. All actors are insecure and scared. The only difference among them is the degree of terror."

By the spring of 1925, eighteen months had passed since Dempsey defended his title. The sportswriters were growing restless. Here was a champion who said he liked to fight, who now appeared to have turned pacifist. He boxed easy exhibitions in Los Angeles and Mexico City for fees as high as ten thousand dollars, but the championship lay fallow. "Despite Dempsey's prolonged inactivity," Grantland Rice wrote in his syndicated column "The Sportlight," "he is in no danger of having his title stripped away. Talk about such a thing

happening is bagpipe music, wind. Dempsey will lose the title only when he officially retires or has it hammered off under fire." Rice proposed that Gene Tunney take on Tommy Gibbons and that Harry Wills fight Charlie Weinert. The two winners should meet and the winner of that bout, the third bout, "crowd our champion into a corner and force him either to battle or to retirement." Given Dempsey's position and reputation, "there will be no heavyweight championship fight with the heavyweight champion himself sitting outside looking in." For a columnist, Rice turned out to be a splendid matchmaker. Tunney knocked out Tommy Gibbons in the twelfth round at the Polo Grounds on June 5, 1925. Wills knocked out Weinert in two on July 2. But Rice's grand design stalled when Tunney refused to fight Wills.

W. O. McGeehan of the *Tribune* frequently referred to Wills as the "Senegambian," crafting the word from names of two West African territories, later nations, Senegal and Gambia. Wills was born in New Orleans and resided in New York. In terminology appropriate to the time, his ethnicity was American Negro. McGeehan's nickname was freighted with derogatory intent. His word, Senegambian, implied that Wills was a figure out of a jungle, probably half lowland gorilla. In the rampant American bigotry of the 1920s, *Senegambian* became a popular term.

James A. Farley, a newly appointed but influential New York boxing commissioner who became postmaster general under Franklin Roosevelt, wanted Tunney to fight Wills as a prelude to Dempsey (presuming, of course, that Dempsey resumed serious boxing). So did Nat Fleischer at *Ring* magazine. Tunney insisted that he alone was entitled to meet Dempsey. He had knocked out Gibbons. Dempsey in Shelby could not. Enthusiasm for Wills, Tunney believed, was prejudice in reverse. "Alas," Tunney wrote Tim Mara, one of his handlers, a shrewd bookmaker who owned the New York [Football] Giants, "I myself am not colored [like] the Senegambian. Politics makes strange bedfellows [Farley and Wills]." Later, scoring points for alliteration, Tunney referred to Wills as "James Farley's pampered panther."

Mara was too practical to antagonize Farley, a politician with such phenomenal recall that it was said he remembered the name of every individual he had ever met. To quiet Tunney, Mara composed a letter that built to a pointed postscript. "By the way, Gene, who have you fought that justifies your getting a Dempsey match?"

James Joseph Tunney had been boxing professionally since 1915, when he was eighteen. (A baby sister pronounced his first name "Jeem" and that evolved into the ring nickname.) He came out of an Irish neighborhood in Greenwich Village, a bright and rugged character who served in the Marine Corps in France—but did not see combat—and won the light-heavyweight championship of the A. E. F. in an elimination series of twenty bouts, staged throughout France for the amusement of generals. He next outpointed the A. E. F. heavyweight champion, Bob Martin, in a four-rounder.

An earnest, if ostentatious, reader, Tunney for a time took night classes in law at New York University. He won the American light-heavyweight championship in 1922 when he outpointed Battling Levinsky. Harry Greb beat him in 1923, but later that year Tunney met Greb again and regained his championship on a fifteen-round decision. Tunney put on bulk as he matured and by 1925, after more than seventy bouts, he weighed in at 190 pounds, just about the same fighting trim as Dempsey. He was no slugger, but he was a brilliant boxer and a clever, cutting puncher. He had become a formidable contender.

Mara's disparagement was a business tactic. He had convinced Tunney that he alone could deliver Dempsey for a fight at the Polo Grounds, and he wanted to be paid as much as possible for his services. Knocking Tunney was one of Mara's devices to stress his own worth.

No record shows how Mara proposed to produce Dempsey, but moving money under the table is a reasonable supposition. Rickard's secret payment to Boss Frank Hague to set up Dempsey–Carpentier was a model of how such things were done. Mara probably intended to offer cash to the boxing commissioners and to Governor Alfred E. Smith, if necessary, to forget about Harry Wills and license the Tunney fight. He would sprinkle gratuities among state legislators and

have them repeal the law that limited ringside prices to twenty-five dollars. Mara spoke warmly of a gate approaching $3 million. A third of that, a guarantee of a million dollars, would assure Dempsey's appearance.

This gilded picture impressed Tunney. He signed a contract promising Mara 10 percent of his purse for fighting Dempsey and, if he won as he believed he would, 25 percent of his future earnings as heavyweight champion. Tunney was already paying his manager, Billy Gibson, a third of his purses. If he did become champion, he would be responsible for most of his own training expenses and, in addition, he would have to give Mara and Gibson fifty-eight cents of every dollar he earned.

Stories persist of old-time boxers who were cajoled into selling 150 percent of themselves. Every time they fought they went deeper into debt. The 1920s boxing world, peopled by such characters as Kearns and Mara, makes those stories believable. Paul Gallico estimated that Dempsey in his lifetime gave away a fifth of everything he earned as gifts and handouts to old fighters whose handlers had abandoned them to poverty. It is a grave and tempered irony that one of Dempsey's late handouts, five hundred dollars in 1963, eased the final weeks of life for a destitute Jack Kearns.

Three thousand miles away from the boxing disorder in New York, Dempsey was trying to concentrate on his honeymoon. Neither he nor Kearns had talked publicly about their split. In fact, Kearns actually went ahead and signed a contract with a promoter named B. C. Clements for Dempsey to fight Harry Wills in Chicago. Dempsey had said he was interested only in fighting for Tex Rickard. He ran his increasingly complicated situation by Estelle Taylor. She looked at Dempsey's typed agreement with Kearns and saw that it did indeed provide for a fifty-fifty split. She also saw that it expired at the end of August 1926.

Her solution was direct. She told Dempsey not to put his championship on the line until September 1926. Then Kearns and his 50

percent would be history. Estelle frequently impressed others with her intelligence and her mordant wit. When Dempsey told her that he believed he had a Jewish great-grandmother, she tenderly called the champion "Ginsberg." But Estelle's wit and intelligence, and Dempsey's essential integrity, were scant armor against the cobra in Kearns.

The fairly newlywed couple sailed for Europe on May 6 aboard the Cunard liner *Berengaria*. Dempsey told the sporting press that he was happy to have such a beautiful wife. When they got to Europe, he said, they intended to "loaf around." Beyond that he had no plans. Estelle looked decorative. She was silent both because the reporters' questions were directed at Dempsey and because the ocean voyage filled her with dread. She knew the story of the *Titanic* and assurances that the *Berengaria* had mounted a huge searchlight to spot icebergs from afar were meager comfort.

Dempsey was the shipboard star, mixing easily with other passengers, signing autographs, and even boxing a gentle exhibition with one of the crew. Estelle remained in the cabin. "The seas were calm," Dempsey told me, "and there weren't any icebergs, but Miss Taylor retched her way across the Atlantic." He always referred to her as Miss Taylor, as if guarding the intimacy of the name Estelle. Ginsberg and Miss Taylor were one unusual couple.

Dempsey was feted in the capitals of Europe and offered fees of ten thousand dollars and fifteen thousand dollars a week to box more exhibitions. Happy to pick up paychecks that he thought would be out of Kearns's grasp, Dempsey pulled on trunks and gloves. A boxing honeymoon was not what Miss Taylor had in mind and she occupied herself with compensatory shopping. She purchased stoneware and antique furniture in England, fashions in Paris, Dresden china in Germany; which is where she found a new love.

Dempsey and Estelle stayed at Berlin's celebrated Hotel Adlon, and he boxed exhibitions at Luna Park for one thousand dollars a night. Any amateur boxer was eligible—and he would win a five-hundred-dollar

prize if he lasted three rounds. Professional fighters from all over Europe assumed new names and forged amateur credentials for a crack at the champion and five hundred dollars. He flattened them all, five on one night, three on several others. "Dempsey's punches," observed Nat Fleischer of *Ring,* "produced electric shocks." Fleischer ranked Dempsey as the best ever at punching to the heart, at infighting, at delivering a combination right to the heart and left to the chin. "He was the greatest two-hand puncher in history," Fleischer said, "and the roughest heavyweight champion of all time." Ordinary European heavyweights who dreamed they had a chance against Dempsey never remained vertical for long.

But Dempsey met his match in a 210-pound slate-gray dog named Castor. Dempsey called the animal a "Bismarck." Others referred to it as a boarhound. If I had been asked, and I wasn't, I believe I would have called the creature Baskerville.

"Like a Great Dane," Dempsey said, "only bigger. He weighed two hundred ten pounds, a hundred pounds more than Miss Taylor. On his hind legs he was maybe a foot taller than me." An old English lightweight named Joe Edwards, who was visiting Berlin, introduced Castor to Miss Taylor. She hugged the beast's outsize neck, purred into the outsize ears, and announced that Castor was the most beautiful creature she had ever seen. Dempsey simply had to buy Castor for her. She continued gushing until Dempsey paid Edwards $250. "If Miss Taylor had kept quiet," Dempsey said, "I could have gotten the mutt for a double sawbuck [twenty dollars]."

Dempsey got laughs with Castor stories for the rest of his life. Castor was prowling the mezzanine of the Hotel Adlon when Estelle walked into the lobby and gave him a friendly wave. To return the greeting Castor bolted down a flight of stairs. His walker, Lee Moore, neglected to let go of Castor's chain. Moore suffered a broken arm, a broken rib, and a concussion. Estelle demanded that Dempsey fire Moore.

"Why do you want to fire Lee?"

"Because," Estelle said, "after he came to, he called Castor a son of a bitch."

When the couple went sightseeing, Estelle insisted that Castor be included. Because of the dog's size, this meant arranging for a second car and a second driver. "Castor bit quite a collection of European chauffeurs," Dempsey said. "When we got to Paris he chewed up an Aubusson rug. Castor cost me ten thousand dollars in Europe. Like Miss Taylor, who loved to buy things provided they were expensive, Castor kept me working."

Castor was not present when Estelle and Dempsey met the press at the New York Customs House after returning on the liner *Homeric* in July 1925. Dempsey said he was ready to fight. Reporters noted that Doc Kearns was not on hand. Dempsey said their contract would expire next year and sidestepped specific questions. "I'll tell you this," he said. "Marriage has been terrific for me. My wife is one great kid." Estelle was wearing a blue suit, blue shoes, a black felt hat, and fawn stockings. Photographers asked her to show more leg. A reporter wondered if she'd answer questions. She said, "If you don't treat me like a moron the way that photographer just did."

She said that Jack was tactful and cared about her needs. European men seemed only to care about themselves. "In fact, the more European men I met, the more I loved my husband." Then, with the press looking on, customs men opened the luggage and carefully picked through Dempsey's underwear and Estelle's lingerie. Even the photographers seemed embarrassed.

Back in California, the couple moved into an estate on Los Feliz Boulevard in a then-fashionable semirural Los Angeles neighborhood called Laughlin Park, in the hills east of Hollywood. Their mansion was Hollywood Spanish and the grounds included a private eighteen-hole golf course. When a neighbor's Airedale ventured onto this enormous property, Castor jumped the other dog and killed it. This led to reports that Dempsey kept ferocious jungle creatures, or at least a black bear, on his grounds. When police investigated, Dempsey hid Castor in the basement. When the police left, Dempsey told Estelle that he was selling Castor. She hugged the dog and wept. Dempsey offered Castor to Damon Runyon and Gene Fowler. Neither was interested. At length Dempsey got Lee Moore, the injured

dog walker, to accept Castor, but Moore wouldn't buy the boarhound, either. He would accept Castor only if Dempsey paid *him* five hundred dollars.

Estelle insisted that she could not survive without a dog. Dempsey liked to end his arch accounts of the Castor saga by saying, "So I got her a Pomeranian. Weighed about four pounds."

The marriage was advancing to the stage of dueling dog stories. Estelle said that Dempsey was genuinely frightened by the thought of intruders. One night, she said, she heard a noise downstairs and asked Dempsey to investigate. According to Estelle he stayed in bed, repeatedly calling to the tiny Pomeranian, "Sic 'em! Sic 'em!"

"You should have heard Jack yelping to the dog in that high-pitched voice of his," she said. "It was hilarious."

Dempsey dismissed this tale and said the real problem was a Peeping Tom who climbed strategic trees to watch Estelle undress. Dempsey bought a shotgun, loaded it with rock salt, and resolved to blast the voyeur out of the trees. One night Estelle saw a figure in the branches. She called out and Dempsey reached under the bed for the gun. But the Pomeranian was under the bed as well and nipped Dempsey's hand. The gun spun and went off, a cannon in the boudoir, and a charge of rock salt hit the dog in the rear.

Estelle said, "You shot my dog. You deliberately shot my dog. How can you be so cruel to a defenseless little animal?" The Pomeranian recovered. Dempsey said it never again ventured into the master bedroom.

Estelle decorated the bedroom with silk draperies, pillows of taffeta and lace, and unusual dolls, a fashion of the time, with beige heads and long satin skirts—and nothing else—for bodies. In that silken dollhouse setting Dempsey reminded Paul Gallico of a circus tiger "dressed up for the show, in strange and humiliating clothes."

Old boxers visited the mansion, flat-nosed men with the hoarse, slurred, whispering speech that comes after too many blows to the

head. They upset Estelle, as they had upset Celia, but Dempsey would not turn away broken-down fighters. Estelle said they had to move in loftier circles; this was essential to Hollywood success. Lupe Velez, still angry, told Estelle that Dempsey was just a pug, not good enough for a gifted and sensitive woman. Estelle ought to divorce him, grab as much money as the courts would give her, and move on to a husband who could help her at the big studios. A great director, if she could land one, or even an agent.

But "Ginsberg" and Miss Taylor were in love. Perhaps he more than she. Dempsey was a Jack Mormon, but a devout romantic. Quite aside from the dog stories, the taffeta pillows, and the long-skirted dolls without bodies, you had two gifted people trying to make a life together under plush but difficult circumstances and jarring careers. Star actresses marry their stardom. A woman doesn't become a movie star without maintaining a consuming focus on the big screen. A generalization (with some basis in fact) holds that the greatest movie stars make the worst mates. A champion boxer, even a nonpracticing boxer, as Dempsey was in 1925, first of all has to be a modern gladiator. Everything else—home, hearth, passion for a wife—comes after the primal dedication to combat.

Dempsey did buy the screenplay Estelle liked, *Manhattan Madness,* from Fairbanks and Pickford, hired a director named John McDermott, and financed the movie with his personal funds. He played Steve O'Dare, a gentleman-cowboy, who comes East to collect money that the German government owes him. Since World War I the German government had been synonymous with villainy. Estelle's character was simply "the Girl."

According to Charles Silver of the Museum of Modern Art's Film Study Center, *Manhattan Madness* is a lost motion picture. No copies survive. An influential trade journal, *Harrison's Reports,* reviewed the film favorably in the autumn of 1925. The plot has Steve O'Dare boasting to college chums in New York about the thrills of the West. They organize what they take to be a capital joke. They kidnap the Girl, who calls out for Steve's help.

Harrison's reported, "Several fights are staged in which the hero engages many persons at one time." The grateful girl rewards him with a torrent of kisses and Steve falls in love with her. When the friends reappear and announce that the kidnapping was a hoax, Steve feels humiliated. He turns on his "friends," subdues them, and carries off the girl. She reveals that she too has fallen in love. As the film ends a parson is marrying the couple.

"Mr. Dempsey," *Harrison's* noted, "acts surprisingly well. Miss Taylor appears charming. The direction is good and the settings are beautiful." Unfortunately, *Manhattan Madness* was neglected by the public and lost money. That outcome depressed Estelle. Dempsey felt restless. He loved Estelle and acting was easy, but he missed the thrill of the ring.

While Dempsey and Estelle were shooting *Manhattan Madness,* across the summer of 1925, the country turned to the town of Dayton, Tennessee, where a high-school biology teacher named John Thomas Scopes broke a state law by teaching Darwin's theory of evolution. The law, which fundamentalists had rammed through the Tennessee legislature that March, made it a crime "to teach the theory that denies the story of the divine creation of man as taught in the Bible, and to teach instead that man has descended from a lower order of animals."

Scopes taught Darwin knowing that he would be arrested and also knowing that the American Civil Liberties Union would defend him. The celebrated agnostic lawyer Clarence Darrow, a pleader of unpopular causes who had recently saved Chicago's wealthy young "thrill killers," Richard Loeb and Nathan Leopold, from execution, agreed to serve as chief counsel to Scopes. William Jennings Bryan, the great commoner, fighter for free silver, thrice-defeated candidate for president, former secretary of state, and indefatigable champion of the Bible, volunteered his services to the prosecution. Borrowing Tex Rickard's phrase for Dempsey–Carpentier, newspapermen called Darrow–Bryan "the battle of the century." Like the original, this turned out to be an unequal struggle.

H. L. Mencken wrote in the *Baltimore Sun,* "Divine inspiration down here is as common as the hookworm. This is what the great heritage of mankind is reduced to in regions where the Bible is the beginning and the end of wisdom, and the mountebank Bryan, parading the streets in his seersucker coat, is pointed out to sucklings as the greatest man since Abraham." W. O. McGeehan abandoned sports to cover the trial for the *New York Herald Tribune.* (The *Tribune* and the *Herald* had recently merged.) In the midst of one booming peroration, McGeehan reported, "Mr. H. L. Mencken fell off his chair with a crash that startled the courtroom.

"'It's a jedgment,'" said one of the sisters [fundamentalist woman spectators]. 'The walls are falling in, and Mr. Mencken is the first to go, and he won't go to glory, either.'"

The final battle between Darrow and Bryan exploded on the seventh day of the trial. Because of the heat, the judge had moved his court to a lawn. There, under maple trees, fundamentalists and modernists formed cheering sections. The principals had removed their jackets. Bryan wore a pongee shirt. Darrow's suspenders were lavender. Darrow put Bryan on the stand and asked if he literally believed that a whale had swallowed Jonah.

"I believe," Bryan said, "in a God Who can make a whale and can make a man and make both do what He pleases."

"You don't know whether it was an ordinary mine-run of fish, or made for that purpose?"

"You may guess," Bryan said. He fanned himself with a palm leaf. "An evolutionist guess."

"You are not prepared to say whether that fish was made especially to swallow a man?"

"The Bible doesn't say, so I am not prepared to say."

"Had the earth actually once stood still? Wouldn't it have turned into a molten mass?"

"The God I believe in would have taken care of the earth, Mr. Darrow. You can testify to your own beliefs when you get on the stand." Bryan turned to the judge. "Let him have latitude. I am going to have some latitude myself when he gets through."

"You can have latitude and longitude," Darrow said.

He asked Bryan to fix the date of the biblical flood. Bryan suggested 2348 B.C. "Some fish may have survived," he said. "Everything else was destroyed."

"Don't you know there are any number of civilizations that are traced back to more than five thousand years?"

Bryan said some mortals might cipher that way. He himself believed the inspired word of God.

Darrow's manner moved from forceful questioning to ridicule. Bryan flushed. More and more of his answers said, directly or in effect, "The Bible states it. It must be so."

The *New York Times* reported: "Mr. Bryan's complete lack of interest in things connected with religious questions and the history of mankind was shown again and again by Mr. Darrow. He had never made a study of the ancient civilizations of China and Egypt." Bryan did not know that their origins predated his year of the flood. He knew nothing of the religions of Confucius or Buddha or Zoroaster, other than that "they were inferior to Christianity." Darrow asked if Bryan realized that libraries held thousands of books on ancient societies and comparative religions. Bryan said he did not, but would take Darrow's word. He threw in that Buddhism was really a religion of agnostics because in Rangoon once he had observed Buddhists preparing to send a delegation to a world convention on agnosticism in Rome.

As Darrow proceeded, Bryan slumped and perspired and seemed to grow disoriented. At length the judge asked if the defense team wished to file Bryan's testimony as part of the record for an appellate court. Bryan sat in confusion; the other defense lawyers said they did not.

"We will file it," Darrow cried.

Bryan sat straight. "File it from Dan to Beersheeba," he said in his deep rumble.

Scopes was convicted and fined one hundred dollars, which the Baltimore Sunpapers paid. Fundamentalism and Bryan drew world-

wide ridicule. Mencken described him as vague, unpleasant, and mangy.

Five days after the trial ended on August 2, 1925, Bryan died. His final public scene offered up his worst performance. The fierce populist, the idealistic pacifist who had quit Woodrow Wilson's cabinet because he thought Wilson was leading the country into war, came off as a semiliterate Bible salesman. He had returned to center stage one time too many, close to his final hour. Most judged him harshly, but Paul Y. Anderson wrote in the *St. Louis Post-Dispatch,* "In a rambling old white house on the outskirts of Dayton, where the maples rustle placidly and the fragrance of the harvest lingers in the air, rests today the majestic clay which was William Jennings Bryan...."

Inaction was costing Dempsey the press and a portion of the public. "We stepped into one of the largest Broadway motion picture houses," Grantland Rice wrote in the summer of 1925, "where a moment later Jack Dempsey was shown in a newsreel. There was first dead silence—followed a second later by a salvo of hisses. Dempsey has stepped into ground as rough as even Jack Johnson walked in. His continued statements that he is keen to fight and his continued refusal to do so have put him in the attitude of kidding the public. He now ranks with Jack Johnson as being the most unpopular of heavyweight champions....No other ring champion with as many possibilities for public favor has stumbled into as many ways of giving public offense—from the first mobilization of 1917 down to date."

McGeehan, safely returned from Tennessee, wrote in the *Herald Tribune,* "Mr. Dempsey seems to have emulated that other great resident of California, Mr. Luther Burbank, who after many years of experimenting produced the spineless cactus." Dempsey issued occasional statements. He was not retired. He intended to take on either Gene Tunney or Harry Wills, after fighting a warmup bout or two. He would put his championship on the line in every match. Specifically, he told an Associated Press reporter—he knew the AP serviced every significant newspaper in the country—"I will fight Harry Wills

for any promoter who can induce [Wills' manager] Paddy Mullins to sign a fair contract for a match."

The New York State Athletic Commission had decreed that a champion must defend his title every six months. In high summer 1925, James Farley, now chairman of the commission, asked Dempsey to attend an executive session to discuss his idleness and to explore a bout with Wills. At Estelle's urging, Dempsey ignored the request. The commission could have stripped him of his championship, at least in New York State, but Farley announced, "We have deemed it best not to take action at this time."

"This might lead one to believe," Jack Lawrence wrote in the *Herald Tribune,* "that Dempsey is afraid of Wills and the Boxing Commission is afraid of Dempsey."

McGeehan was angry. In his column "Down the Line," he wrote: "The three dumb dukes who stood upon their dignity against the world have received one raspberry apiece from the present heavyweight champion and have accepted the tokens of Mr. Dempsey's disesteem with smiling faces....As I recall, I deplored the fact that Mr. Dempsey could not get interested in the late World War, a combat open to everyone. I was reproached for hounding a lovable character, an ornament to society and a credit to the manly art of mauling. I have committed many crimes in the name of sport writing, but I am innocent of any part in making a popular idol out of Mr. Jack Dempsey."

It seemed to make small impact on Grantland Rice or Bill McGeehan that Dempsey had been acquitted of draft evasion. On the record they refused to consider the reasonable supposition that he stood trial because the spectacle pleased right-wing fanatics who called themselves patriots, and because an envious whore was playing out a shakedown. Criticism of Dempsey for not defending his championship was legitimate. His problems with Kearns, real though they may have been, were not the boxing public's problems. But along with legitimate criticism, Rice and McGeehan displayed a compulsion to raise the slacker issue again and again. That issue properly was

dead. If journalism had been a boxing match, Rice and McGeehan would have been disqualified for eye gouging, hitting below the belt, and probably ear biting as well.

Floyd Fitzsimmons, the midwestern promoter who had staged Dempsey–Miske, guaranteed Wills fifty thousand dollars down, against a percentage to be determined later, to fight Dempsey in Michigan City, Indiana. His guarantee to Dempsey was an even million dollars, with three hundred thousand dollars due on receipt of a signed contract. The rest, the full million, was to be paid before Dempsey entered the ring. Adjusting for inflation that equals almost ten million dollars today. Adjusting for the old laissez faire income-tax rates, it comes close to fifteen million, for a fight Dempsey believed he would win easily.

The parties convened on September 28, 1925, in South Bend, Indiana, where Fitzsimmons had organized "a syndicate of wealthy businessmen," headed by one Andrew Weissberg, who owned several hotels, to underwrite the fight. Fitzsimmons gave Paddy Mullins, who managed Wills, the check for fifty thousand dollars. Mullins announced, "Mr. Fitzsimmons and Mr. Weissberg, the men back of this show, are above reproach." Weissberg said, "No final date on the big fight yet, gentlemen, but it will be sometime after August 1926" (when Dempsey's lawyers said the Kearns contract would be history). Wills said, "Fighting's my business. The public has been courteous to me and since they want this match I'm happy to go ahead." Reporters said Wills sat down, looking cheerful, "and began to hum a little jazz tune."

Fitzsimmons said abruptly to Dempsey, "You'll get your money tomorrow." The gathering adjourned and Dempsey was driven to the Notre Dame campus, where Knute Rockne organized a special intrasquad football scrimmage for his benefit. Later Dempsey amiably signed autographs for awed halfbacks.

Dempsey had begun working as his own manager. The next day Fitzsimmons tendered a check for twenty-five thousand dollars and

said, "It's all I got right now, Jack, but there's plenty more [another $275,000 was due] where this came from. Don't you worry. I made you good money for fighting Miske, remember? Poor Billy. He was awful young to go." Dempsey forswore a eulogy and took Fitzsimmons to a Chicago bank where he could have the twenty-five-thousand-dollar check cashed. "I want to see this in green. For the time being, you can hold onto your money," Dempsey said. "I'll hold on to the contract. When you get the other two-seven-five and you give me my three hundred, I'll give you the contract. Signed."

The Chicago bankers knew Dempsey. A clerk began counting out twenty-five thousand dollars. "Boys," Dempsey said, "you better call the bank this is drawn on." The check was rubber. There wasn't a penny in the account. As Dempsey reported later, "I thanked my banker friends, I gave Floyd Fitzsimmons hell. I caught the next train back to Los Angeles and Miss Taylor."

At this point Dempsey really wanted to fight Wills. He said, "I always could lick those big, slow guys. Ask Willard. Ask Firpo. I liked the Wills fight because I figured it was an easy win. But I had to get paid." The one promoter whom Dempsey trusted, the one promoter who could raise necessary guarantees in cash (as opposed to bad checks), was Rickard. But Rickard told Dempsey, as he had been telling him for years, that he would never put a Negro into the ring to fight for the heavyweight championship.

Dempsey wanted his million-dollar purse. When he pressed, Rickard said vaguely and portentously, "Tremendously powerful figures in Washington insist that only white men can fight for the heavyweight championship. This isn't up to me. My hands are tied."

Why did the press not pursue hard-edged reporting that could have led them to turn their World War I howitzers away from Dempsey and onto Rickard? I asked that of "Coach" Stanley Woodward, a great sports editor and a successor to McGeehan at the *Herald Tribune*. "Your suspicion is that Tex was buying off the writers, am I right?" Woodward said. "Because they pressed Dempsey to fight Wills and they never pressed Rickard to book the bout, it strikes you

that Rickard was paying off the writers, even the big stars like Rice and McGeehan?"

"The thought had entered my mind, Coach."

"The truth is something worse," Woodward said. "When it came to grasping what was really going on in boxing, Rice and McGeehan weren't corrupt. They were ironheads."

Woodward swallowed some martini and laughed. "Rickard was lying. He barred Harry Wills on his own. There was a lot of the hookworm belt [the racist South] in Tex. What makes me laugh is his reference to Calvin Coolidge as a tremendously powerful figure. Now you have to pay for the next round."

Sports journalism in the 1920s was illuminated by the work of Gallico and Runyon, Broun and McGeehan, Lardner and Rice. These men excelled as descriptive writers. In their time the probing and often intrusive newspaper reporting that flourishes today did not exist (which is a reason why Warren Harding was not impeached). They were interested in painting vivid (sometimes crimson) scenes, arabesques, and offering commentary on what they had painted and on the characters they described. Judged as craftsmen of prose—*prose* is the term old-time journalists use for belletristic writing—the great sportswriters of the 1920s constitute a newspaper class that has not been equaled. But unraveling a story as complicated as Dempsey's inactivity required a willingness to intrude on Dempsey, the private person, and to scrutinize the manipulations of Tex Rickard, the sometime bigot. That was distasteful to Lardner, to Broun, and even to lesser journalists. When those customs agents publicly examined all the underwear and lingerie belonging to Dempsey and Estelle, not a single reporter, not one, described in print what he had seen, silken or dross.

The unfortunate boxing sabbatical that Dempsey took at his peak mixed private and public aspects of his life. Beyond the ring, Dempsey was his family's provider. When his parents separated for good, he bought each of them a house—at some remove—in Utah. His brother Johnny dreamed of a career as a movie actor. Dempsey

brought Johnny and his wife, Edna, to Los Angeles, set them up in an apartment, and introduced them to studio people. None of the other Dempseys was making a living. Jack sent everybody monthly checks.

People in his own family were the first to urge Dempsey to reconsider his relationship with Kearns. Celia said paying a manager 50 percent was "giving away too much." (It was also illegal under the rules of New York State Boxing Commission, which decreed that a manager's percentage could not exceed one-third of the gross.) The Dempsey relatives, I suppose, were afraid that Kearns would bankrupt their benefactor. From the Willard fight on, Kearns charged Dempsey extra random fees for expenses. He even held on to some of Dempsey's 50 percent to buy real estate for himself, saying, "We'll settle later."

When Dempsey asked for and got the five-hundred-thousand dollar Firpo check himself in 1923, he was beginning to declare financial independence. By 1924, he calculated, Kearns owed him "at least one hundred fifty thousand dollars." In later life, Dempsey said that whenever he pressed for his money, Kearns dodged and announced, "Kid, you don't understand how these things work." Being treated like a simpleton bothered Dempsey more than the bad debt. "Sure, the old Manassa Mauler had muscles," he told me once when he was in an expansive mood. "But tough as this may be to believe, he had more than just a muscle between the ears."

The team of Dempsey and Kearns has been widely cited as the best boxer–manager combination in history, but as Dempsey reached out for life and freedom and a beautiful movie-star wife, the partnership was doomed. Kearns would put up with anything in a fighter except maturity. He could not manage without dominating, and Dempsey, who reached the age of thirty in 1925, would no longer accept domination. Following Kearns's fancy stepping in the fiscal follies, his drunken attack on Estelle at the Montmartre was only the specific that produced the split.

Estelle, to be sure, detested Kearns. It was not surprising that she had slept around. That was common, and not necessarily cheap or

vulgar, in the Hollywood of that time or this. But no woman sitting in a public place beside her lover would want to hear herself called a tramp. After that, whenever Dempsey wavered and sentimentalized the old days when Kearns took care of everything, Estelle spoke, in effect, as Lady Macbeth: "Screw your courage to the sticking-place." Or, as she put it in her own plain Wilmington, Delaware, English, "Keep away from that lousy bastard, Jack."

It was not till December 1925 that Dempsey bluntly defined his new situation in public. He had fought exhibitions in Mexico City and Monterey, Mexico. Traveling by car, he stopped overnight in San Antonio on the way to Los Angeles. A young Associated Press reporter spotted him and asked about rumors that he was going to fight Wills for Tex Rickard in New York and that he had reconciled with Jack Kearns.

"I don't want to mislead you on Wills," Dempsey said. "That situation is up in the air. But the fight, if it happens, will not take place in New York. Any stories that I'm working with Kearns again are bunk. I'm through with Kearns. There's nobody managing Jack Dempsey or going to manage Jack Dempsey other than Jack Dempsey himself. And that's final."

Back in Los Angeles, after a good sleep among taffeta pillows, he set off on a brisk twenty-mile hike through the hills that rose above his estate. The champion was back in training.

Although the break with Kearns delighted Estelle, and in many ways pleased Dempsey, it created elements of chaos. Estelle was beginning to believe that she understood boxing. Hookworm-belt poison had leeched north to the Wilmington of her childhood and Estelle said, "Don't fight the nigger, Jack. Fight Tunney. He's more refined. Besides, Tunney will mean a bigger gate." It is fair to suggest that Dempsey had swapped one dominating partner for another. Estelle was prettier, but Kearns understood boxing.

Dempsey telephoned Rickard at Madison Square Garden. "I'm ready to fight. Get me a match for next September." Rickard said he

would see what he could do. Then he telephoned Teddy Hayes and asked if Hayes was managing the champion. Hayes said he had quit because Dempsey was being unfair to Kearns and, anyway, he wasn't sure that Dempsey would ever again be fit to fight. "All he's been doing for two years, Tex, is climbing on top of that dame. That ain't training. I hear he's gotten fat, something like two twenty-seven." That was at least forty pounds more than Dempsey's weight in the Willard fight.

Rickard checked out the essentials—Dempsey had *not* gone to fat. Then he returned Dempsey's call and laid out the situation. Jim Farley of the New York State Boxing Commission was insisting that Dempsey fight Harry Wills. That was the only Dempsey fight the commission would sanction. Rickard suspected that Farley and another important Democratic politician, Jimmy Walker, secretly owned a piece of Wills. They were talking about racial fair play, Rickard believed, but they were thinking about their wallets. Rickard intended to offer the New York commissioners Dempsey–Tunney and put it in that big new ballpark uptown, Yankee Stadium. He could place the fight in another town, but for now he wanted as little trouble as possible with Farley and his fellow commissioners. Giving them first crack was the way to go.

Dempsey simply could not manage himself, Rickard said. The rule in New York and in many other states specified that a boxer *had* to have a manager—not himself—who was in place to protect him from mismatches, from agreeing to fight while unfit or recuperating, from financial exploitation, and other perils of the trade. Practically, Dempsey had to hire a manager. Rickard suggested white-haired Leo P. Flynn, a solid, unspectacular character who had managed the late K. O. Bill Brennan. Dempsey said he had already engaged a business manager, Gene Normile, and he'd prefer to use Normile as boxing manager as well. That would save money. Rickard told him to suit himself.

Dempsey asked what sort of cut Rickard was offering. After expenses, Rickard said, Dempsey could have 50 percent of the gate.

"Work with me on this, Jack," he urged. "It's going to be your biggest purse ever." He would guarantee Tunney two hundred thousand dollars and no more. "He's just a boxer, Jack. I could lick him myself. He's not a puncher like you. This is an easy fight for you and a great deal for both of us." ("Like hell it was," Doc Kearns said. "First of all Dempsey should have gotten a million-dollar guarantee. Rickard knew Jack was a softer touch than me and he took advantage of that.")

Sometime after the Rickard conversation, one reporter observed a change in Dempsey's demeanor. "It used to be," he said, "that when you asked Jack about contract details, or future fights, he'd tell you, 'Talk to Doc.' Now he's started telling us, 'Take that question to Tex.'"

The problem, and it would prove catastrophic, came down to this: Rickard, increasingly Dempsey's friend, was *not* Dempsey's manager. His loyalty went to his promotions, his gross receipts, rather than to a fighter, even one he liked. Tunney had won thirty-one consecutive bouts. His speed and tactics troubled everyone he fought. You needed to plan very carefully to defeat him. A sound manager would have pointed that out to Dempsey. Rickard did not. With the departure of Kearns and the defection of Hayes, Dempsey was left without a solid fight man in his inner circle.

He wasn't fat, but he was rusty. He needed a warm-up bout, perhaps two. In 1919, to get Dempsey ready for Willard, Kearns sent him into battle five times. Dempsey won every fight with a first-round knockout, each a preparation for the demolition of Willard. Now, seven years later, two journeymen heavyweights, Bartley Madden and "Young Bob" Fitzsimmons, son of the Cornishman who knocked out Jim Corbett in 1897, were ready to face Dempsey, and take a pasting, for a purse. But without a real manager in place, Dempsey had no one to put together warm-ups. The rust on the veteran battler remained. Many years later Dempsey said, "Trying to manage myself was a mistake. Understandable after Kearns. But a mistake."

Tunney had been studying Dempsey. He fought a preliminary on the Carpentier card and after that, wearing a bathrobe over his boxing trunks, he crouched close to the ring and made notes. He obtained a prime ticket to the Firpo fight and analyzed that as well. He amassed a collection of Dempsey's fights on newsreel films. Scouting Dempsey, fighting Dempsey, and defeating Dempsey became the obsession of this disciplined young man's life. Tunney worked with a trainer to enlarge the size of his neck. He believed that would increase his capacity to take punches to the head. By heavyweight boxing standards, his hands possessed little natural strength. Tunney carried sponge balls, squeezing and releasing them night and day, until his hands became harder and more powerful. Whatever Rickard said, Tunney was no one to regard lightly.

In his old age Kearns talked often about how he believed Dempsey had been mishandled—mostly by Dempsey himself. "I had big-money people lined up for Jack and me to fight Wills in Chicago. Forget Rickard. I was working with B. C. Clements, who operated out of the Chicago Coliseum, which was their Madison Square Garden. Our end would have been a million guarantee, and that's the truth. Wills was strong and liked to bull people around. That was the only way he knew how to fight. But if you closed with Dempsey and shoved, Jack started throwing those short hooks that felt like they were crashing in your ribs. The fight wouldn't go on long after that. No one who went inside with Dempsey finished standing. No one ever."

Kearns said he would have booked "at least one, maybe two, tune-ups before Wills. I would have made Tunney wait until we had beaten Wills. Tunney was a master boxer. Tommy Gibbons was a very good boxer and he stayed away from a younger Dempsey for fifteen rounds. Tunney could be beaten—with care and planning and making sure we had the right referee. But what was the hurry to fight a master boxer? Tunney was no crowd pleaser. Without Dempsey he drew peanuts. My plan would have been two tune-ups, then Wills, then maybe an easy fight to keep Dempsey sharp. After that Tunney,

with the right ref and the right rules. Jack retires, the only undefeated heavyweight champion in history and a very wealthy man. And I don't go to the poorhouse myself. It's a damn shame that isn't the way things happened."

In the reality of 1926 Kearns hit Dempsey with three lawsuits, one for $333,333.33, another for $249,999.99, and then again for $333,333.33. Estelle swaggered with her champion into the Battle of Kearns. She had dealt with hustlers before and her own confidence blossomed when John W. Considine, Jr., the president of Feature Productions, Inc., offered her a long-term contract. Feature Productions had only one major asset, but it was considerable: the acting services of Rudolph Valentino. Considine intended to star Estelle opposite Valentino, the great lover of the silent screen for whom many maids panted and matrons sighed. That was in July. Valentino died of peritonitis at the end of August. He was thirty-one. Estelle's long-term contract perished with him. She wept and retreated to her bed.

The Kearns suits stressed Dempsey and appeared to take a toll on his health. He found himself chronically constipated and began treating himself with doses of olive oil. His bodyguard, Mike Trent, served up a small glass of olive oil every morning. Dempsey also suffered from recurrent boils. His once easy smile hung down like a torn pocket.

Dempsey began formal training in mid-August at his old lair alongside Saratoga Lake. Estelle went East with him. Valentino was touring the Orient and she would be at liberty until the star returned. Dempsey bought her a Rolls-Royce so that she could drive about upstate New York in prima donna comfort. On August 21, as Estelle was cruising the rural blacktop between Saratoga and Mechanicsville, deputy sheriff Benjamin W. Wilson of Saratoga pulled her over with a Valkyrie wail of sirens. Wilson was accompanied by a New York attorney who identified himself as "Abner Siegel from the offices of Arthur Hagen. We represent Mr. Jack Kearns. We are attaching this car."

Estelle produced a bill of sale that showed the car was registered in her name, not Dempsey's. Sheriff Wilson decided that the document was irrelevant. He put the Rolls under lock and key in a Saratoga garage, then proceeded with Mrs. Dempsey to the training camp, where he leaped a fence and tried to serve several legal papers One was a subpoena for Dempsey to appear in Brooklyn Supreme Court on August 26 "to account for all monies taken in through recent boxing exhibitions."

These activities proceeded from the most creative of Kearns's lawsuits, the first one for $333,333.33. The basis for the claim here was "Plaintiff Kearns' share" of the million-dollar purse for the Dempsey–Wills fight in Chicago. The purse did not exist. The fight never took place. Kearns claimed it should have, would have, had Dempsey dealt with him honestly. Kearns's lawyers convinced a remarkably cooperative Brooklyn judge named Louis Valente that there was enough merit in these claims to issue subpoenas and padlock a lady's grand touring sedan.

Dempsey did not learn the car was seized until he had finished his day's workout. "It's a good thing they didn't tell him earlier," one of his sparring partners, Jimmy Roberts, told a reporter for the *New York Times*. "If they had, he would have killed a couple of us."

Rickard continued to hold out hope for Dempsey–Tunney in New York. He booked Yankee Stadium for September 16 and announced that he would be scaling the house down from $27.50 ringside. He began parallel negotiations with officials in Philadelphia. The year 1926 was the Sesquicentennial, the 150th anniversary of the Declaration of Independence, and Philadelphia leaders organized an extended celebration. They constructed an enormous, cold concrete horseshoe on the south side of town, which they called, tossing syllables about like confetti, Sesquicentennial Stadium. Dempsey–Tunney was more than welcome there. On August 16, a national guard colonel named John Phelan, an underwear importer by trade but by avocation chairman of the New York State Boxing Licensing Commission, announced that Dempsey would not be licensed to fight in New York until he took on Harry Wills. (The licensing commission

was a bureaucratic creation, independent of the boxing commission—more fees for political appointees. Here it managed to throw a sledgehammer into Rickard's machinery. After that it was seldom heard from again.)

Fine, Rickard said, in effect. We'll miss September in New York. Give our regards to the Grand Concourse. Dempsey fights Tunney in Philadelphia on the night of September 23. Same top, $27.50. About 125,000 tickets will go on sale, but the whole world wants to see this one. Better hurry.

Despairing, Harry Wills told reporters, "I'll take on Dempsey at any time in any street he wants to name. I'll knock him out for nothing."

"I don't make a living fighting for free," Dempsey said, "and I don't fight in the streets. The only people who fight in the streets are hoodlums."

Tunney set up camp in Stroudsberg, Pennsylvania, and showed Richards Vidmer of the *Times* "a left that darted like a dangerous snake." Tunney never endured vilification in the newspapers as Dempsey did, but his press relations were uncomfortable, because reporters found him pretentious. In time he characterized newspapermen as "ungentlemanly fellows. That's why really nice people instinctively steer clear of [them]." But he understood the power of star writers. When Grantland Rice and Ring Lardner showed up at Stroudsberg with their families, Tunney invited them for lunch. Ring Lardner Jr. recounted what happened next.

"[Tunney] kept a small leatherbound book at his side at all times, even taking it to the table with him when the meal was served. Telling us about it later, my father said he was praying that no one would ask Tunney what the book was, but the Rices' nineteen-year-old daughter, Floncy, disappointed him by putting the question. 'Oh, just a copy of the *Rubaiyat* that I'm never without,' said the heavyweight contender. My father was unfavorably impressed."

It took years, but all of Kearns's lawsuits were dismissed. Court proceedings revealed that he never possessed a valid written contract with Dempsey. The so-called contract has long since been lost.

Dempsey said it was a hastily typed document, prepared only when the New York State Boxing Commission demanded that Kearns produce a contract. "I didn't sign my name to it," Dempsey testified under oath. "Kearns signed my name. Later he pleaded with me to ink over the signature he made so he couldn't be thrown in prison for forgery. I went along with him."

Aside from that, if Kearns admitted in his claims that he was taking 50 percent of everything Dempsey made, most states would have barred him from managing. That is why his lawsuits asked not for half, but for a third of Dempsey's proceeds.

At one point a judge asked Kearns directly how much Dempsey had paid him for the Firpo fight. The figure was $250,000 and change. Kearns, who was under oath, declined to answer. If he told the truth, he would admit to breaking boxing commission rules. If he lied, it would be perjury.

As Dempsey remembered it, the judge leaned over and said, "Did you file a tax return on that income from Mr. Dempsey?" Kearns again refused to respond.

The judge said, "Mr. Kearns, you answer my questions or get off the stand." Kearns exited. The Internal Revenue Service, more passive in those days, never pursued Kearns, but his days of febrile litigating against Dempsey were done. Dempsey offered a sharp comment on why Kearns' dealings with him had led to court in the first place. "Doc," Dempsey said, "mistook gratitude for stupidity."

The weakness of Kearns's legal positions did not prevent him from harassing Dempsey when the champion moved to Atlantic City for the final stages of training. More process servers descended ten days before the fight. Kearns's lawyers wanted Dempsey's purse frozen "to insure a fair settlement. Defendant has no assets in New Jersey or Pennsylvania." After workouts, when he preferred cards, reading, or banter, Dempsey had to closet himself with his defense attorneys.

Reporters asked if the constant litigations were bothering Dempsey or his wife.

"Let's talk boxing," Dempsey said.

"How about the new nose, champ? Is it going to stand up against Tunney's jabs?"

"I've urged my sparring partners to go for the nose and some of them have landed healthy socks. There's nothing to worry about. I breathe better through the nose now and it doesn't give under the strain of a hard punch. It hurts to get hit there, sure, but any nose hurts when it gets hit."

James Dawson reported in the *Times* that Dempsey was "raising havoc" with his sparring partners and looked again like "the great Dempsey of years gone by." On September 18, Tommy Loughran, who would win the world light-heavyweight championship in 1927, put a crisp right uppercut on Dempsey's nose. It bled. A trainer, Jimmy Luvadis, said, "That's enough, Champ."

Dempsey said, "No, no. That's all right. Another round and more." He began beating Loughran to the punch. At the end of the next sparring round, it was Loughran's nose that bled.

"He's in great shape," Loughran told reporters. "He's hitting snappy. His timing and balance are good. His punches are hard. He's on his toes all the time, crowding you all over the ring, not giving you a chance to get up an attack of your own."

Harry Greb, the Human Windmill, had been watching. He had fought Tunney five times, a total of sixty-five rounds, and beaten him once. "The champion looks like the winner to me," Greb said. "Tunney is no bargain to hit solid, but the champion is working splendidly."

Two teenage girls from Parkersburg, West Virginia, got close to Dempsey in a narrow runway leading to his dressing room and kissed him. They said they were schoolmates of Dempsey's West Virginia relatives.

"We're praying for you to win," one said.

"Give my regards to my relatives," Dempsey said. The champion's smile was beginning to return.

The *New York Times* assigned most of its sports staff to poll celebrities. Wilbert Robinson, who managed the Brooklyn Dodgers (then called the Brooklyn Robins, in his honor), said, "Dempsey by a mile. He's a bulldog." John McGraw of the New York Giants said, "Tunney is a good man, but the edge goes to Dempsey." Ty Cobb picked Dempsey and so did "Poosh 'Em Up" Tony Lazzeri and Lou Gehrig from the Yankees' slugging lineup, Murderers' Row. (Babe Ruth declined to pick. He was unhappy that Dempsey was richer and more famous than he.) Big Bill Tilden, the great tennis player, and Willie Hoppe, the world's billiards champion, both picked Dempsey. So did Battling Levinsky and Leo P. Flynn, the manager, and Lew Tendler, a great lightweight boxer. Kearns said, "Tunney has a chance, but I think Dempsey has enough left to win inside of five or six rounds."

Fewer than 10 percent of the people polled chose Tunney. One who did was Philadelphia Jack O'Brien, the retired lightweight champion. He said amid the babble, "I like the way Tunney moves and counters and thinks on his feet. I respect Dempsey but I like Tunney one hundred percent."

On the front page the *Times* bubbled in a headline: BIG BOUT THURSDAY/WILL SURPASS ALL. Coolidge was staying in Washington. He disliked crowds and he owned a radio. But, the *Times* reported, Vice President Charles Dawes was going to the fight, along with three members of the cabinet, six state governors, the mayors of New York and Philadelphia. "The renowned English noblewoman" Lady Nettleton would be the guest of Mr. and Mrs. William F. Carey. Condé Nast would be at ringside and Bernard Gimbel and William Randolph Hearst and Otto Kahn and W. Averill Harriman and Babe Ruth and Vincent Astor and Charlie Chaplin and the heads of most of the big brokerage houses.

"You know," Dempsey said to Teddy Hayes before the Kearns breakup, "Estelle is gonna get me in with high society."

Hayes thought, but did not say, "Yeah, but who the hell will get Taylor in?" In all the big fights, Carpentier, Firpo, Tunney, high soci-

ety (and high politics and high Wall Street) beat a path to the hutch that was Dempsey's ringside.

On the morning of the Philadelphia bout, Mike Trent, the bodyguard, gave Dempsey the usual small glass of olive oil. After that Trent disappeared. A few hours later, Dempsey began suffering from cramps. His intestines went hyperactive. Rumors spread that gamblers had paid Trent to add a nonlethal poison to Dempsey's olive oil. Nothing was substantiated. Dempsey might simply have eaten a bad clam. Whatever, his innards were chaotic and he looked pale at the weigh-in. "It's nothing," he said. "I just haven't been getting enough sun."

Tunney chartered a small plane to fly him from Stroudsberg to Philadelphia. He meant to demonstrate that he feared neither Dempsey nor flight in an open cockpit. But the weather was unsettled—a front was moving in—and the plane lurched about the sky. Tunney became airsick; he looked as pale as Dempsey at the weigh-in.

Federal tax records would put the paid attendance at 120,757. The *Times* estimated the crowd, including gate-crashers, ushers, reporters, and the rest, at 135,000. That may be generous, but not by much. This was, and still is, the greatest number of people ever assembled to see a boxing match. Gates receipts totaled $1,895,733. The *Times,* then two cents at the newsstand, proclaimed on its front page, "The biggest event in the history of sport."

One gets a measure of Dempsey's impact on boxing and on America by recalling that in 1919 paid attendance for Willard fell short of twenty thousand, and *that* was considered a pretty fair crowd. From 20,000 to 135,000 within eight years. From a gate of $450,000 to a gate of almost $2 million. From a sport scorned as immoral to a sport that had the leaders of the country tripping over one another in their rush for ringside seats. Neither before nor after has sport known a single individual attraction equal to the Mauler.

At introductions, the crowd cheered Tunney and hooted Dempsey. The jingoist press had turned a champion into a villain and

lauded Tunney—who never saw combat—as the heroic manly marine. At the center of the ring, before the referee's instructions, Tunney said, "Hello, champion." Dempsey said, "Hello, Gene."

It was beginning to rain. Ruskin's famous opinion on "valueless books" notes that inept authors always create weather to match their scenes. Good things happen in sunshine. Funerals proceed through rain. Ruskin called this convergence "the pathetic fallacy." It rained so hard in Philadelphia on September 23 that the *Times* later ran a headline: SOAKED FANS FLOOD/TAYLORS WITH SUITS. Ruskin is unassailable in literary theory, but as the drizzle built into a downpour, Dempsey suffered a terrible battering. Pathetic to some, but not a fallacy to Dempsey's admirers. Tunney won every one of the ten rounds.

Tunney fought erect, even leaning backward as if to keep his face away from punches. His strategy was to retreat, always retreat, and counter Dempsey's charges with that dangerous snake of a left. The retreat was clockwise so that when Dempsey landed a left hook, Tunney was moving away from the punch, lessening impact. Tunney had noticed something when Carpentier and later Firpo tagged Dempsey with right hands. Sometimes, not often but sometimes, as Dempsey charged, he let his left drop a bit, as he was getting ready to hook. A boxer with fast enough hands could slip a right cross over Dempsey's lowered left glove. That was how Carpentier connected to the cheekbone. That was how Firpo began the barrage that knocked Dempsey out of the ring.

Just describing this tactic diminishes it. You have to dare to get close to Dempsey and forget about pain and connect against a swarming, snorting, snarling roughhouse fighter. Miss the right, and Dempsey's hooks—swiveling from the hips, he could throw three or four in a seeming instant—will shatter you. Tunney, a ponderous fellow and a brave man, moved in close enough to shake Dempsey with a right to the cheekbone in each of the first two rounds. He could hit harder than Dempsey had imagined.

After that it was all pursuit, Dempsey pursuing as Tunney supposed

he would, but not as recklessly and dangerously as he had pursued before Tunney landed the rights. The younger man moved backward, sometimes trotting. Dempsey tried to corner Tunney without success. As Tunney executed his remarkable footwork, he slashed Dempsey with small, repetitive, cutting blows to the nose and to the eyes.

Doc Kearns was sitting in the first row with Gene Fowler and a Los Angeles sportswriter named Mark Kelly. In the sixth round, Kearns said, "He's gonna lose. His timing's off and his legs are gone. Still, there's something he could do." Over the moist and roaring crowd, Kelly said, "Get over to his corner and help him. The guys in there aren't any good at all."

Kearns shook his head. "No. Let him take it. That's the way he wanted it and that's the way it will have to be."

Kelly looked at Kearns. "Doc. You're crying."

"I am not. It's the rain on my face."

Kelly seized Kearns's arm. "You're not kidding me, you bum. You're crying. Get up in the corner and help the champion." Kearns would not. He watched Dempsey take a beating and cried into his right hand through the last four rounds. When the fight was over, Kearns dried his eyes. Then he found a speakeasy and drank himself into oblivion.

By most accounts, Dempsey landed only one good punch. His left hook in the sixth round caught Tunney in the Adam's apple and left Tunney hoarse. He even coughed up a little blood. But Dempsey could not land combinations. He said, "I was slower than I thought, or Tunney was faster. I was blaming the wet ring, but it didn't bother Tunney. He glided around like a great skater on ice." A twisting Tunney jab cut Dempsey over the right eye in the fourth round. By the eighth Tunney had punched Dempsey's left eye shut. Going out for the tenth, Dempsey was bleeding from the mouth and both his cheeks were bruised. The downpour continued and Dempsey's face was streaked with rain and smeared with blood. Still he kept coming. His stomach ached and his legs wobbled and his visage looked like the

thorn-raked face of a martyr. Still he kept coming. It was unforget-table, this raw and ghastly courage in the rain.

At the final bell, Dempsey fought back the pain and threw an arm over one of Tunney's shoulders. "Great fight, Gene," Dempsey said. "You won." He walked back to his corner. The judges gave Tunney all ten rounds. In the corner Dempsey heard cheering. People stood in the downpour and called his name. At last some of the people were beginning to realize what they'd had.

"You'll always be the champion," a man shouted. "You're our champion forever."

He had never heard words like that in the ring before. Rugged old Jack Dempsey blinked away tears. "I want you to get to the people," he told me forty-five years later, "that losing was the making of me."

"Not losing, Champ," I said. I was feeling proud for him. "Losing with guts."

He tapped a huge hand on my arm and looked embarrassed.

Estelle had skipped the fight. She said she loved Jack so much she could not bear to see him hit. Fight night she caught a train to Philadelphia and she was sitting in the living room of his hotel suite when Dempsey returned. Handlers walked with him, but only a few reporters. Most of the press was interviewing Tunney.

She gasped at the sight of his face, but recovered and gently touched his features, looking for a spot that was not bruised. She kissed him lightly and said, "What happened, Ginsberg?"

His answer was brief and droll and unforgettable. "Honey, I for-got to duck."

Dempsey earned $717,000. Kearns seldom failed to comment, "I woulda gotten him a million." Tunney made two hundred thousand dollars for the one fight, forty minutes, more than double Babe Ruth's salary for the year.

"Dempsey fought like the great champion he was," Tunney said. "He had the kick of a mule in his fists and the heart of a lion in his

breast. I never fought a harder socker nor do I hope to meet one. I'm content to rest a while with the ambition I have nourished for seven years finally realized."

Dempsey said, "I have no alibis to offer. I lost to a good man, an American. A man who speaks the English language. I have no alibis."

12 Loser and Still Champion

To the Dempseys, in the name of sportsmanship…

Unsigned note with flowers, from Al Capone

DISBELIEF SET IN AT ONCE. How could a powder-puff puncher have defeated the great champion? Ring Lardner wrote to Scott and Zelda Fitzgerald in Europe, "I bet $500 on Dempsey, giving 2 to 1. The odds ought to have been 7 to 1. Tunney couldn't lick David [Lardner's seven-year-old son] if David was trying. The thing was a very well done fake, which lots of us would like to say in print, but you know what newspapers are where possible libel suits are concerned.... The championship wasn't worth a dime to Jack; there was nobody else for him to fight and he had made all there was to be made (by him) out of vaudeville and pictures."

Lardner wrote about the fight under his own name and under the name of Grantland Rice, who had been laid low by a virus, bad Prohibition whiskey, or both. In one of the articles, Lardner recalled the way Dempsey had once thrown spine-rattling rabbit punches. "Against Tunney he didn't throw rabbit punches; he punched like a rabbit."

Lardner's annoyance and even cynicism may have proceeded

from his experiences covering the crooked Chicago baseball team the Black Sox, which dumped the World Series of 1919. The crowd in Philadelphia included the gambler Arnold Rothstein, who engineered the fix (and who appears in *The Great Gatsby* as Meyer Wolfsheim), and one of Rothstein's fellow conspirators, an old lightweight boxer named Abe Attell. Their presence was a nasty reminder of corruption. "After the White Sox went crooked," someone said, "all Ring really cared about in sport was the Notre Dame football team and Jack Dempsey. In Philadelphia he lost Dempsey and that bastard Rothstein was sitting right there. When Ring yelled 'fake,' it was not a considered judgment, but a cry of pain."

The possibly poisoned olive oil was never explained, nor seriously investigated. Dempsey, a realist, was impatient with speculation. "Tunney would have won anyway," he said.

Dempsey thought of retiring. He had been fighting for fourteen years and had seen what boxing does to those who fight on for too long. Sam Langford was punched blind. Battling Nelson went addlepated. Harry Greb had been developing vision problems, and on October 22 he died at the age of thirty-two of complications following eye surgery. If fans and movie people and sportswriters saw Dempsey as superhuman, Achilles and Samson in one, Dempsey himself was not delusional. He wondered if at thirty-one or thirty-two, he still had the legs to catch Tunney, and, should he catch him, would he still possess the punching power to finish him with dispatch? Tunney's slashing blows around the eyes gave Dempsey further pause. Was a rematch worth yet more risk to his health? Rickard at first was doubtful about a rematch. On a personal level, he didn't want to watch Dempsey absorb another pummeling. The businessman in Rickard felt that Dempsey had lost so badly in Philadelphia that a rematch could be hard to sell. Friendship and money made clangorous counterpoint. With time, both men reconsidered, and friendship and money modulated into harmony.

Dempsey agreed to hire a fine trainer named Gus Wilson to get him back into shape, and a new manager, Leo P. Flynn, that solid

boxing professional, to help with stratagems, press relations, and the rest. The following spring Rickard announced that he was sponsoring an elimination tournament. Joseph Paul Zukauskas out of Binghamton, New York, fought as "Sailor Jack Sharkey, the Boston Gob." Sharkey would fight one Jim Maloney in May and the winner would take on Dempsey. Harry Wills—again or still—was out of the mix. Sharkey had defeated Wills a month after Dempsey–Tunney by falling down, clutching his groin, and writhing. The foul was questionable, but the referee gave Sharkey the decision. Three men had to hold Wills back from clubbing, and possibly fouling, the referee.

Sharkey knocked out Maloney in the fifth round and Rickard immediately matched him against Dempsey for Yankee Stadium in July. The winner would fight Tunney. By this time Rickard recognized that Dempsey's appeal had not diminished and that if Dempsey did beat Sharkey and moved on to Tunney II, he, Rickard, was looking at back-to-back million-dollar gates. "You can take Sharkey, Jack," Rickard said. "Just be careful of his left."

The year 1927 generally was festive. "The ballyhoo year," Frederick Lewis Allen called it. Except for south Florida, where thousands discovered that the "prime building sites" they had purchased from afar lay under brackish water, the economy was robust. Under Alfred P. Sloan General Motors was booming with its slogan "a car for every purse and purpose." Chevrolets were becoming so popular that Henry Ford had to phase out his black Model T jalopy and introduce the Model A, with balloon tires and a choice of colors that included Florentine Cream. Ford hired Madison Square Garden to exhibit the Model A and posed proudly in front of one with his son Edsel, who looked haunted, and his landlord pro tem, Tex Rickard, who looked prosperous.

For the first time, people could have radios installed in their automobiles. The Philadelphia Storage Battery Company aggressively marketed its new product, the Philco Car Radio. (A radio! In your car! And it works!) Walter Gifford, the president of AT&T, called a

joint press conference with Herbert Hoover, the secretary of commerce, and in Hoover's Washington office demonstrated a new electronic wonder he called television. He hoped to be trampled by investors, but he was not, perhaps because the country was still getting used to radio. The new technologies overwhelmed many, but a few, including Gifford and Hoover, saw them as the basis for the abolition of poverty and the creation of an era of perpetual prosperity. People were humming "Blue Skies" and "'S Wonderful" and "My Blue Heaven." They read Sinclair Lewis's new novel, *Elmer Gantry,* debunking evangelical Christianity, and they discussed the dissolute expatriates who wandered through Ernest Hemingway's year-old hit, *The Sun Also Rises.* Why had Hemingway been so vicious in his portrait of Robert Cohn, the Princeton Jew who boxed? "Ernest was a little anti-Semitic," says one of Hemingway's old friends who is Jewish, "But so what? Everybody was a little anti-Semitic in those days."

On May 21, after nearly thirty-four hours of solo flight from Long Island, Charles Augustus Lindbergh Jr. landed his white single-engine monoplane, the *Spirit of St. Louis,* at Le Bourget Airport in Paris. While Lindbergh was aloft editors at the *New York Times* cabled Edwin L. James, their chief European correspondent, "Isolate Lindbergh." As James wrote, when Lindbergh landed "[a] movement of humanity swept over soldiers and by policemen and there was the wild sight of thousands of men and women rushing madly across half a mile of not-so-even ground. Soldiers and police tried for one small moment to stem the tide, then they joined it, rushing as madly as anyone else toward the aviator and his plane.

"'Well, I made it,' Lindbergh said."

James failed to isolate him, but after a dreadful beginning wrote a solid story. (James's lead: "Lindbergh did it." As generations of copyreaders have pointed out, there is no antecedent for the pronoun "it.") When Lindbergh returned to New York for a ticker-tape parade, police estimated the crowd that cheered along the route at four million. On its editorial page, the *Herald Tribune* commented, "Lindbergh is a work of art. Like a picture or a poem, he either thrills you or he

doesn't." No one anticipated the later Lindbergh who walked proud and smiling beside men wearing swastika armbands. His anti-Semitism was more virulent and chilling than the snide, shallow bigotry of Hemingway. It enabled Lindbergh to be comfortable among Nazis.

Dempsey told reporters in New York that he was coming back "because I want to fight. It's my business. I'm not dead by a jugful." He proceeded north for serious training beside Saratoga Lake and he enjoyed the routine, now carefully organized by Leo Flynn. He prepared himself to slip and counter Sharkey's left.

He seemed in such good shape on July 1 that Flynn told him to take the day away from sparring. Dempsey rose at 5:00 and was jogging at 5:30 on the sandy roads in back of Saratoga Lake. After the run he threw rocks, some the size of a fist, some small boulders. Flynn said this exercise "powers the quick-action muscles." Next Dempsey grabbed an axe and chopped down a good-sized maple. He returned to camp, jumped into a small boat, and rowed vigorously for an hour. All this before lunch. He spent the afternoon cheerfully receiving sightseers and reporters. The next afternoon, in a rooming house at 847 Emmet Street in Schenectady, just twenty miles away, Johnny Dempsey murdered his wife Edna, then put a pistol to his head and shot himself. The couple left a two-year-old son, Bruce, named after the youngest Dempsey sibling, the newsboy who was stabbed to death in Salt Lake City ten years before.

John Dempsey's heroin addiction had been becoming more acute. He suffered mood swings and threatened Edna, whom Jack called "one of the finest women I've ever met." Dempsey paid for unspecified surgery, probably a prefrontal lobotomy, then regarded as effective treatment for violent behavior. Sometime after that Dempsey told his brother there would be no more checks. He didn't want his money used to buy heroin.

Edna fled in fright, taking the baby to upstate New York, where she had relatives. At Jack's urging, Johnny checked himself into a

county hospital in Salt Lake City. A physician named George N. Roberts treated him there for more than a month. He discharged Johnny as "cured of his addiction" and said he seemed happy at the possibility of a reconciliation with Edna and a chance to see his son.

Johnny arrived in Schenectady in June and took up separate lodgings. According to Edna's landlady, Mrs. Frank Prievo, Johnny made only one or two visits. His life-style in Schenectady is not known, but Edna still felt uncomfortable with him. On the fatal day he and Edna argued loudly. Prievo heard three shots and rushed into the room. Johnny was dead. Edna lay groaning her life away; she died before an ambulance arrived.

Dempsey was summoned to identify the bodies. From the morgue he telephoned his mother in Salt Lake City. Celia collapsed. After a time, her oldest daughter, Effie, came on the line and said, "Can you please have the body sent to us in Salt Lake? Mother wants to see Johnny one last time." Dutifully, numbly, Dempsey made the arrangements. When he returned to the training camp, he went into seclusion in his dark-green cabin beside the lake.

Estelle did not come East. She was having trouble finding movie roles. Dempsey was left to grieve alone, without family, in the harsh setting of a fight camp. Rickard talked to Leo Flynn. "Jack's all busted up," Flynn said. "This is a crushing, terrible blow." Rickard did not want to intrude. "Just tell him I called with condolences, will you, Leo?"

Dempsey stayed in his bedroom for two days. As he recounted this stark time, he thought of death and young Edna's friendly smile. He could not believe it, Edna dead at twenty-one. He blamed himself for bringing his brother to Hollywood, where heroin came easy, and he thought of the times that Johnny had pleaded with him for money and he'd said, No, kid. You're just gonna use it to buy dope. In his mind he heard Johnny's voice, sometimes ranting, sometimes begging, and it was the last, the sound of dead Johnny begging, that made him cry.

Leo Flynn talked to him and later recounted the conversation to reporters. "I said we have to think this through. Maybe getting back to training will get your mind off this tragedy. But maybe the stress of training is too much. It could ruin you. We have to think this through. I don't have any final answer yet, gentlemen. That's where we are." On July 4, the eighth anniversary of Willard, Dempsey resumed training. The fight would take place as scheduled on July 21. But he did not want to be crowded. Only the press, not the public at large, would be permitted to watch him spar. The old Jack Dempsey training camp, full of fans and hangers-on and easy ladies, all consuming bootleg whiskey and making noise, the camp that Paul Gallico had found "vulgar, Rabelaisian and rather marvelous," was history, along with Dempsey's youth.

Sharkey, enthusiastic and confident, moved to Manhattan and held daily public sparring sessions on the roof of Madison Square Garden, at Eighth Avenue and Fiftieth Street. "This is great drama," Jim Dawson wrote in the *New York Times*. "A tough pro, Sharkey, against Dempsey, who only a little while ago was being described as 'a hollow shell.' This will be spectacular, thrilling, pulse-throbbing," Dawson concluded, crushing understatement beneath sturdy typing fingers.

Forty-eight radio stations, "the largest hook-up ever," would carry the fight to thirty million listeners from New York to California. This was larger than the "hook-up" for Lindbergh's return. New York State law still limited the price of ringside tickets to $27.50 ($25 plus a 10 percent federal tax). The *Times* reported, "The ticket brokers have obtained sizeable lots of choice seats and are reaping a golden harvest. Tickets in the first five rows, marked $27.50, are bringing $125 each. For tickets slightly farther back, the speculators are getting $120." Bookmakers quoted Sharkey as the favorite at odds fluctuating from 9 to 5 to 7 to 5.

On the way to his seat in the ringside press row Damon Runyon reported that, "he fell under the hurrying hoofs of fourteen kings of finance, twenty-nine merchant princes, six bootleggers and five ticket

speculators...all owners of Rolls-Royce cars." It was another rich, distinguished crowd. Tunney came and so did the now-crippled Franklin Delano Roosevelt. Attendance at Yankee Stadium reached eighty-five thousand, the record for a fight with no championship at stake. Beyond the bleachers thousands more looked on from the elevated station and the tops of stopped subway cars and roofs and even from water towers.

Unlike Tunney, Sharkey carried the fight to Dempsey. He had a snapping left hand and he moved far ahead through the first five rounds. Only Dempsey's great staying power saved him. Flynn shouted to Dempsey between rounds, "Go for his body. He doesn't like it in the guts." Sharkey had a special tactic to protect his middle. He wore the belt of his boxing shorts high.

Dempsey's body blows slowed Sharkey in the sixth and Dempsey continued body-punching in the seventh. One punch bounced off a Sharkey elbow and landed against a hip. Another seemed—the newsreels don't show this clearly—to land below the high beltline. Sharkey turned to the referee, Jack O'Sullivan, and dropped his hands. He started to complain, "He hit me low and——" He did not finish the sentence. No prudent man facing Jack Dempsey in a prize ring dropped his guard. *Ever.*

Dempsey threw his great left hook into Sharkey's jaw. Sharkey fell and rolled awkwardly so that he was lying face down. He clutched his groin and writhed and winced. But he didn't start wincing until after Dempsey's hook to the *jaw.* He was hooked to the jaw and fell clutching his groin. O'Sullivan counted Sharkey out.

Afterward O'Sullivan said he had seen one low blow—to the leg—but the punch did no damage and was not nearly enough to warrant disqualification. "Any other punches that looked low," Mayor James J. Walker said, "looked that way because Sharkey was wearing his tights so high." Tunney, Jim Corbett, Tommy Loughran, and Westbrook Pegler saw no foul. Pegler added from the safety of his typewriter that Sharkey was "a shade yellow." Later a reporter— his identity is lost—said to Dempsey, "How could you hit Sharkey

like that when he had his hands down and he was talking to the referee?"

"What was I supposed to do?" Dempsey said. "Write him a letter?" He grinned. He had just earned $350,000.

There was going to be a rematch against Tunney in September. Dempsey wanted Rickard to stage the bout in New York. "Did you hear the way the New York people cheered me, Tex, when I came into the ring against Sharkey? That's worth a million. This is my town." The Wills issue had gone away when the Basque heavyweight Paulino Uzcudun knocked out Wills in the fourth round at Ebbets Field, just a week before Dempsey knocked out Sharkey. But Rickard said there were other problems. The New York Boxing Commission was refusing to drop its $27.50 ringside ceiling. In Chicago they could get forty or fifty dollars for ringside. Besides, Chicago had an outdoor arena, Soldier Field, that could hold more than one hundred thousand for a fight. "It's economics, Jack. If we fight in Chicago, I can offer you a four-hundred-thousand-dollar guarantee. Maybe a little more. The most any challenger has ever made. I can't do that if we stay in New York." The fight was booked into Soldier Field for the evening of September 22.

A terrible ending stalked Bartolomeo Vanzetti, a fish peddler, and Nicola Sacco, a shoemaker, who had been charged with payroll robbery and murder in South Braintree, Massachusetts, seven years earlier. Throughout the country, and indeed the world, liberals and leftists of all shade rallied behind the two, arguing that they had been convicted "not by evidence but by atmosphere." The men were anarchists. Heywood Broun, who was leaving sportswriting for new horizons, spent the summer of 1927 trying to keep Sacco and Vanzetti alive. Walter Lippman wrote an editorial that filled an entire page in the *New York World*. Lippman had studied the evidence; he was afflicted, he wrote, by "doubts that will not down." Broun described

Sacco and Vanzetti as shining spirits and wrote that the sentence of electrocution was "death condemning life."

But the more hotly observers attacked "Massachusetts justice," the more obstinately did Massachusetts officials dig in their heels. Governor Alvan T. Fuller, who manufactured bicycles before becoming governor, asked President Abbott Lawrence Lowell of Harvard to chair a commission to examine the trial proceeding. Lowell gave the court, the prosecution, the jury, and the death sentence unqualified approval. "What more can these immigrants from Italy expect?" Broun wrote with gorgeous irony in the *World*. "It is not every prisoner who has a president of Harvard University throw on the switch for him."

Vanzetti (probably assisted by Sherwood Anderson) composed a farewell: "If it had not been for these things, I might have live [*sic*] out my life talking at street corner to scorning men....But now we are not a failure. This is our career and our triumph." Sacco and Vanzetti were electrocuted on August 23, 1927. The Pulitzer family, which owned the *World,* insisted that controversy now be ended. Heywood Broun then wrote an emotional, defiant column in which he said President Lowell's actions were outrageous. "From now on, I want to know, will the institution of learning in Cambridge, which we once called Harvard, be known as Hangman's House?"

The *New York World* fired him. The Pulitzers fired one of the greatest journalists America has known for writing his conscience. There have been many unfortunate Pulitzer prizes issued across the years amid stories of lobbying, infighting, backbiting, and favoritism. No prize was uglier than the one Ralph Pulitzer handed to Heywood Campbell Broun in the summer of 1927. Unemployment.

"There ought to be a place in New York for a liberal newspaper," Broun wrote afterward in the *Nation*. "Perhaps the first thing needed for a liberal paper is capital, but even more important is courage."

Carl Sandburg called an angular, clunky poem he composed "Chicago" and its rough-hewn lines seemed to define the Second City.

Hog butcher for the world,
Tool maker, stacker of wheat,
Player with railroads and the nation's
freight handler;
Stormy, husky, brawling,
City of the big shoulders.

When Sandburg published "Chicago" in 1916, a racket was "a device used to strike a ball or shuttlecock." By 1927, when Dempsey and his entourage assembled for the second Tunney fight, *racket* had developed another, darker meaning: "a dishonest business or practice, especially one using fraud or extortion." Chicago still butchered hogs, stacked wheat, and handled freight, but its growth industry now was racketeering. With bootlegging at the center of his underworld trade, Al Capone was said to be earning $100 million a year. Capone had henchmen running sidelines in brothels, heroin, and bookmaking. His massive presence mixed coarse good fellowship with menace. Capone favored, Damon Runyon wrote, "hats of pearly white, emblematic, no doubt, of purity."

To Dempsey's embarrassment, he remained Capone's great hero. Tunney, with his literary pretensions, his increasingly stilted speech, and his refined ring tactics, was everything Capone thought a heavyweight champion should not be. "A fucking pansy," Capone said in his gracious way.

Capone told his confederates and some newspapermen that he was personally going to make certain that this time the real champion, Mr. Jack Dempsey, won. He was betting fifty thousand dollars on Dempsey, and he was going to make certain that Dempsey would get—arch wink—a fair shake, if you know what I mean. The problem for Capone proceeded from the fact that Dempsey was indeed a real champion. When word of Capone's boasts reached him at Lincoln Fields Racetrack, outside Chicago, where he had begun training, Dempsey wrote a letter in longhand. "Please lay off, Al. Let the fight go on fair, in true sportsmanship. If I beat Tunney, or Tunney beats

me in true sportsmanship, it will prove who really deserves to be champion.... Your friend...*Jack Dempsey.*" This is the only instance in the annals of a boxer pleading against a fix that would have guaranteed him a championship. Jack Dempsey was blessed in equal measure with courage and with character.

Capone responded in his own way. The next day a delivery truck arrived at Dempsey's camp bearing great banks of flowers. The card accompanying the flowers was unsigned. The message read, "To the Dempseys, in the name of sportsmanship." Although it may have been overstated by three hundred pink blush roses, even Scarface Al knew a moment of earthly grace.

Having forestalled his preeminent underworld supporter, Dempsey turned his attention to Tunney's relationship with a Philadelphia hood called Max "Boo Boo" Hoff, whom Westbrook Pegler called "a sinister man." He sent an open letter to Tunney, via the *Chicago Herald and Examiner,* which seethed with distrust and anger. The *Herald and Examiner* ran a dramatic headline on September 19, three days before the fight:

TELL TRUTH ABOUT 1926 FIGHT,
DEMPSEY CHALLENGE TO TUNNEY
JACK LINKS $20,000
LOAN WITH GAMBLING
PLOT TO FIX REFEREE

Dempsey spun out an odd story, without disclosing its sources, which had Abe Attell, one of the Black Sox World Series fixers, "the tool of a big New York gambling clique," working with Hoff and Tunney's manager, Billy Gibson, to handpick a referee. Tunney had in fact borrowed money from Hoff, and Abe Attell had paid several visits to Tunney's Stroudsberg camp. They were trying to rig the fight, Dempsey wrote, "so that unless I hit [Tunney] on the top of the head, the referee would rule the punch was low." Actually, Dempsey conceded, the man who did referee in Philadelphia, Tommy Reilly,

did an honest job, but Reilly worked only because the Tunney–Hoff–Attell plot failed.

"How about making all the facts public," Dempsey wrote, "and telling the folks what happened when you chummed around with Attell and why you had to pay Boo Boo Hoff $200,000 [out of the winner's purse]? Does the public get that story—unvarnished and complete? If not—well, why not?" The open letter was signed "very truly yours, Jack Dempsey."

At his camp on the grounds of Cedar Crest Country Club, Tunney first said, "I will not dignify these charges with a denial. I have more important things to do. I am currently reading *Of Human Bondage* and I am going to return promptly to Mr. Maugham's excellent work."

"But what about the substance of the charges, Gene?" a reporter asked.

"Utter trash. At best, a cheap appeal for public sympathy. I have asked my attorney, Mr. Dudley Field Malone, to review these false allegations to see if they are actionable." (A lawsuit, *Tunney v. Dempsey,* could have been almost as interesting as their bouts.) At length Tunney responded with an open letter of his own:

> My Dear Dempsey:
>
> Your so-called open letter to me was brought to my attention. While my reaction is to ignore it and its evident trash completely, yet I cannot resist saying that I consider it a very cheap appeal for public sympathy. Do you think this sportsmanlike?
>
> Gene Tunney
> P.S.—I might add that I wrote this letter myself.

None of Tunney's statements did him much good in preserving his image as Clean Gene, the Manly Marine. Hoff had begun a lawsuit for $310,000 against Tunney claiming, for mysterious reasons, that that

was his fair share of Tunney's Philadelphia purse. Tim Mara, the bookmaker and "sportsman," was suing Tunney for another $410,000 as his share of the same Philadelphia money. Since Tunney's purse was two hundred thousand dollars the mathematics employed by Hoff, Mara, and their attorneys is, like so much lawsuit math, a bit confusing. But there it was. Tunney was mounting a Galahad defense in Chicago, but as the lawsuits indicated, his path from Greenwich Village to Philadelphia had not met the standards of a Galahadian quest.

He finally said, "Looking ahead to the fight that's coming up, there will be no feigning on my part."

A reporter asked Tunney about his right eyelid, which a sparring partner named Chuck Wiggins had split a few days before. "Fine now," Tunney said. "Excuse me, gentlemen. I have an appointment in the library."

Dempsey remembered the suspect olive oil in Philadelphia and now his trainer, Jerry Luvadis, became his official taster. No food or drink reached Dempsey's lips that Luvadis had not previously sampled. "As long as the Greek lived," McGeehan wrote, "Dempsey could eat."

After some threats, rumored and real, Dempsey had his base ringed with barbed wire, as Carpentier had done in Manhasset six years earlier. There were no carefree baseball games with actors and light heavyweights here. Sparring partners repeatedly tore scar tissue above Dempsey's eye from a cut Jack Sharkey had opened. Tired of bleeding in public, a few days before the fight Dempsey closed his camp to everybody but the sportswriters. He was worried about his eyes, the hoods, the press, and Estelle, who had retreated to a suite at the Edgewater Beach Hotel, an in-town resort on the North Side with tennis courts and a white sand beach. "*The Jazz Singer* with Joly [Al Jolson] came out in 1927," Teddy Hayes said. "Talking pictures were here. That flipped Estelle. A whole new movie era coming and she didn't have a contract with anybody. She needed medication for depression, but whenever she came out of it, she'd just about drive Jack nuts.

"She didn't start cheating on him right then. That came later."

Kearns steamed into Chicago and announced, "If Dempsey is kept out of the ring by all the lawsuits [most initiated by Kearns] my guy, Mickey Walker, is ready to step in for him on ten minutes notice." That hustle done—even Kearns himself didn't take it seriously—he began to wander the scene. He concluded quickly that Leo Flynn wasn't doing much of a job. Both sides were said to have agreed to a rule specifying that after a knockdown, the fighter who was standing had to move to "the farthest neutral corner." But, Kearns said, "there ain't no neutral corners during a round. I mean *every* corner is equal until the round ends and the seconds come in. What they're trying to do is give the guy on the canvas a chance to get up and set his guard before he gets hit again. But this is no way to do it. Let the boxer on his feet go to any corner. Three will always be clear. This rule gives the referee too much power. If I still had Dempsey, I wouldn't let him step into the ring with a rule like that. When I had Dempsey I paid attention to the dough, the rules, and the ref."

Illinois boxing regulations decreed that the ring itself could measure anywhere from sixteen feet to twenty feet along the ropes from corner to corner. "You want the small ring," Kearns said, "the sixteen-footer, because like I always tell people, inside is where Dempsey is Dempsey. If they fight in a broom closet, Tunney don't see the second round." Leo Flynn argued for the smaller ring, but he was ineffective. The Illinois Boxing Commission decreed that the ring at Soldier Field would be the twenty-footer. "If they hand me a bad rule and a bad ring," Kearns said, "I put Dempsey on a train for someplace very far away and I ask these Illinois characters, how are they gonna give back that two million bucks' worth of ticket money, in cash or certified checks? You'll see the rules flip my way pretty quick."

The *World* hired Benny Leonard, who had retired in 1924 as undefeated lightweight champion, to file analytical pieces, helped by Hype Igoe, the warbling writer, who kept his ukelele in his refriger-

ator to preserve its tonal quality. In one of the pieces Leonard described the importance of the referee. "When two fighters clinch, the referee breaks them," Leonard wrote, "but there's more to it than that. How long does he let them clinch and how does he break them? Dempsey likes to come out of a clinch and throw a short overhand right. That's a very powerful punch. But if the referee breaks the men with a hand on Dempsey's right arm, he takes away the punch. If he breaks them just by sticking his arms between them, Tunney has to watch out. Only if you've spent a lot of time inside the ring do you realize how many ways a referee influences a fight."

Leonard thought that the best available referee was one Dave Miller. But some suggested—including Doc Kearns, who was making a final bit of mischief—that Miller also was Al Capone's choice. Two days before the fight, the Illinois Boxing Commission issued a statement. Dave Barry would be the referee. According to Teddy Hayes, Barry ran a speakeasy, "but not one that worked under Scarface. Barry's 'speak' was tied up with the opposition." Where but in Chicago during the 1920s could a bootlegger, or a bootlegger once removed, a working criminal, so to speak, be hired to referee a heavyweight championship fight?

Igoe estimated that betting on the fight reached $10 million, with Tunney favored by odds that hovered around 7 to 5. With that much money at stake, suggestions arose that not everything was kosher in Mr. Sandburg's Hog Butcher for the World.

In a later time, after Dempsey and Tunney had retired, such mobsters as Blinkie Palermo and Frankie Carbo owned boxers outright. Fights were scripted and many bookmakers went bankrupt and had to get real jobs. (In a classic instance, Jake LaMotta, later middleweight champion, was ordered to lose a fight to Billy Fox in November 1947. Until then LaMotta had never been knocked off his feet, even by the great Sugar Ray Robinson, and that was his pride. "There ain't no son of a bitch alive can knock me off my feet." He made only token efforts to hit Fox and took a terrible beating until

the referee stopped the fight in the fourth round. LaMotta had lost as ordered, suffering but vertical. He had behaved honorably, according to his lights, dim though those lights were. But the vanity turned out to be wasted; Robinson hammered LaMotta to the canvas in a rough and honest bout on St. Valentine's Day in 1951.)

Mobsters had not begun buying boxers in the 1920s. Their first and most profitable priority was bootlegging. But for the Soldier Field fight, Capone was betting Dempsey heavily. The Philadelphia mob, run by Boo Boo Hoff, was betting Tunney. Dempsey remembered the violent death of K. O. Bill Brennan, after Brennan crossed the mob. He was certain that Hoff had tried to fix the Philadelphia fight.

Right up to the day of the Soldier Field bout, he pressed Tunney for a meeting, "so I can ask you man to man about Hoff." Tunney ducked him. Dempsey wrote Tunney another note. "You beat me fair in Philadelphia. I want to know we will have a fair fight in Chicago. I know you borrowed pretty good money from Hoff. I think you owe me an explanation." Tunney said Dempsey was trying to break his concentration, "but he cannot. He will get no reply, except for the boxing match itself."

The day before the battle Dempsey moved into a bungalow on the roof of the Hotel Morrison, forty-two stories above downtown Chicago. Tunney retreated to a library with his new friend Somerset Maugham and read until three in the afternoon. Then he moved on to a penthouse at the Hotel Sherman.

Everything was as it always was for Dempsey's major fights. The huge crowd; early and inflated estimates put the number at 150,000. The long lists of celebrities: Alfred Sloan of General Motors; Walter Chrysler of the rival auto company; Charles Schwab, president of Bethlehem Steel; and the usual suspects from Wall Street and Hollywood. Rickard celebrated his own promotion by telling Hype Igoe at ringside, "Kid, if the earth came up and the sky came down and wiped out my first ten rows, it would be the end of everything. Be-

cause I've got in those ten rows all the world's wealth, all the world's brains and production talent. Just in them ten rows, kid. And you and me never seed nothing like it."

Everything was as it had been, including Rickard's grammar, except—*except*—the mob. Hank Greenspun, the late savvy editor of the *Las Vegas Sun,* explained the way things were over drinks in the lounge of a vanished Las Vegas hotel called the Frontier.

"Essentially you had two sets of mob guys," Greenspun said. "The Italians ran Chicago, except for a few sections on the North Side. Then you had tough Jewish guys in Philadelphia and Detroit."

A beautiful young woman seemed to be eyeing me as she walked toward our booth and I could not help noticing that, save for a fishnet body stocking, she was naked.

Greenspun gave her a quick professional glance and said to me, "Forget it. A pro."

"How can you be sure, Hank?"

"No underwear," Greenspun said. "In this town only the amateurs put on underwear. But you were asking me about Dempsey in Chicago. Capone and his Chicago Italians were for Dempsey. Hoff and the Jewish hoods were trying to fix the fight for Tunney. Maybe they even had a piece of Tunney. They never told me. I know you heard that Dempsey himself told Capone to lay off, but Big Al was a bastard, the last American in my lifetime, except for Harding, that I would trust.

"What happened was this. You had Hoff and Attell trying to rig the fight for Tunney and you had Capone trying to rig things for Dempsey. The Jewish guys won. They got the ring size they wanted and the referee they wanted, a ref who made up the rules to help Tunney as he went along. I'm telling you this as a friend and, also as a friend, I tell you that I think Jack Dempsey was the greatest fighter who ever lived and one of the finest people I've ever known. I may be wrong, but I believe the Philadelphia mob stole Jack's championship in Chicago. I may be wrong. I don't believe I am."

Hank Greenspun flew army surplus B17s, Flying Fortresses, from Mexico to Palestine, ferrying arms when Israel was struggling

to be born. Mexico to the Azores to Palestine, in weary planes that had already ready seen their war. "You must be proud of that," I said.

"Nothing to boast about. After Auschwitz I *had* to fly those crates, and not just as a Jew. As a human being, as an American. Yeah, I guess I am a little proud." Even in the Las Vegas lounge I could see the squint lines on Greenspun's face, squint lines around the eyes that every hero pilot seems to have. He caught me studying his face and said, "You see those dark eyebrows and that flat nose. Here's something else I'm *really* proud of. Dempsey says I look a helluva lot like him."

Chicago began like Philadelphia, without the rain. Dempsey stormed forward. Tunney retreated and fought in short, damaging flurries. He bruised and cut Dempsey about the eyes. "He was outboxing Jack," Hype Igoe wrote in the *World*. "Dempsey had some tricky shuffles away from Tunney's lunging left, but when Tunney settled down to finer boxing, Dempsey became a mark. Until the seventh round. Then a thunderbolt came out of the sky."

Fifty seconds into the seventh round, Dempsey caught Tunney with a long left to the jaw. Igoe: "Tunney went into the ropes sideways and seemed stung. Few realized he had been badly hurt. But Dempsey knew."

Dempsey threw an overhand right. Then, closing, he drove the left hook. Both punches found Tunney's resolute jaw. Tunney's eyes went blank and he began to fall. "God, how I dreamed of this moment," Dempsey would say. "Seventeen rounds [counting the ten in Philadelphia]. And now I had him." As Tunney was sliding to the canvas, Dempsey hit him four more times. An overhand right. Two left hooks. A right hook.

Crashing four blows into a collapsing boxer taxes belief. Dempsey's punching speed was matchless, too fast for the reporters sitting under the white floodlights at Soldier Field. Too fast to follow in a newsreel run in real time. To get the sequence, I had to run a replay of a videotape made from the original newsreel, run it in slow motion and run it many times.

Dempsey stepped back toward a nearby corner. Barry said, "Go to the farthest corner." Dempsey said, "I stay."

Barry grabbed Dempsey's arm and walked him toward the distant corner. Now, at last, Tunney was regaining consciousness. "When I opened my eyes," he told Heywood Hale Broun, the gifted son of a gifted father, "I perceived herring bone, and I wondered where on earth I could be, with herring bone right before my eyes. It was some time before I realized that the herring bone before my eyes was the pattern of the canvas on the floor of the ring."

When Barry returned to Tunney, Paul Beeler, the official timekeeper, was shouting "Five!"

Barry refused to pick up the count. Instead he began, "One!"

When Barry reached five, leaning over Tunney and bellowing his count, Tunney looked at him vaguely. He arose at Barry's count of nine. He had been on the canvas for at least fourteen seconds, possibly eighteen. But still the fight continued.

On his feet, Tunney fled, scurrying away from Dempsey with speed and guile. He was three years younger than Dempsey and his quickness and his youth, as well as his superb conditioning, served him, if it did not serve the spirit of heavyweight boxing. Paul Gallico wrote: "At 32, Dempsey was pugilistically an old man. He was a fighter with the kill in front of him. [But] his legs failed him. He stopped. And over his swarthy, blue-jowled fighter's face there spread a look the memory of which will never leave me as long as I live....It was an expression of self-realization of one who knows that his race is run, that he is old and that he is finished. And then through it and replacing it there appeared such a glance of bitter, biting contempt for his opponent that I felt ashamed for the man who was running away."

Dempsey made little pawing motions with his gloves. *Stop running. This is a fight. Don't run, you son of a bitch. Come on and fight me, you gutless bastard.* That was what Dempsey would have done. He was always deaf to the bugles of retreat. But Tunney kept fleeing. He later told Harold Rosenthal of the *Herald Tribune,* "I honestly thought Dempsey was going to kill me." The words of a prudent man facing the champion.

By the eighth round, Tunney had recovered and he briefly dropped Dempsey, who was weary and off balance, with a left-right combination. Dave Barry sprang at Dempsey and shouted, "One!" Tunney had not gone to the farthest neutral corner. He had not gone to any corner. He was hovering nearby, as Dempsey had done the round before. Barry ignored him. Dempsey regained his feet before the count reached two. Watching this moment on videotape, one is consumed by outrage. Two knockdowns, one round apart, and two different sets of rules. The explanation, I believe, is not complicated. In my tape of Chicago 1927, I am looking at a crooked referee.

At the end of round ten, Dempsey's eyes were bloody and bruised. Tunney had won on points. The official paid attendance was 104,943. Gross receipts totaled $2,658,660. Adjusting for inflation, the gate was at least twenty-five million of today's dollars, by far the largest gate for a single event in the history of sport. Tunney earned $990,445. Dempsey's share was $450,000.

Legend has Dempsey stoically accepting Barry's officiating and the long count. Actually he filed a protest with the Illinois Boxing Commission. When that was turned down—was this suspect commission about to second-guess its handpicked referee?—Dempsey carried his protest to the National Boxing Association, a body that supervised athletic commissions in eighteen states including Illinois. Only after the N.B.A., his final court of appeal, turned him down did Dempsey assume his gallant stoicism. "What the hell," he said. "It was either that or alibi. The people loved me for saying, 'The long count was one of the breaks. Tunney fought a smart fight.' I've made a lot of mistakes in my life, but I've tried to tell the truth and I never alibi."

Working with a variable speed projector and two stopwatches, Hype Igoe and Benny Leonard spent a week getting the newsreel film into real time. Fight newsreels were sped up during the 1920s, so that the action would look faster in the movie houses. A three-minute round lasted about two minutes and fifteen seconds on film.

After they painstakingly adjusted the projector so that round seven lasted three minutes by one loudly clicking stopwatch, they used a second stopwatch to time Tunney down. Their conclusion: Eighteen seconds passed between the time Tunney hit the canvas and the time that he got up. Tapes today suggest it was between fourteen and fifteen seconds. But we are looking at reproductions that have been reshaped across many generations. The contemporary number offered by Leonard and Igoe is persuasive.

Could Tunney have gotten up at an honest nine? The answer is uncertain.

Could Tunney, rising at an honest nine, have avoided Dempsey's fists and survived the round? No, he could not. Dempsey would have regained his title by a knockout in the seventh round.

I sit considering Soldier Field, 1927, one more time, one last time, and then suddenly the film maker flashes forward and I am watching Soldier Field in 1957. A promoter has brought together Dempsey and Tunney thirty years later. Dempsey is sixty-two. Tunney is fifty-nine.

Workmen have set up a ring where the old ring stood, and Dempsey and Tunney sit on stools in their corners. They are impeccably attired in formal wear and they look relaxed, but in this odd, jerry-built ring they suddenly have become old men. For the athlete time marches a merciless march in quick time.

The former animosities are dead with Boo Boo Hoff and Scarface Al Capone. The old men in the prize ring stare at one another and then, at an unheard signal, rise.

Standing ten feet apart they paw the air with lefts and rights. They are handsome and vigorous old men. And then they close. I feel that clutch of terror one gets at ringside when great heavyweights come together. *Somebody is going to get hurt.*

But not now. Not Dempsey. Not Tunney. That would be terribly, terribly wrong.

They close. Dempsey clutches Tunney's hands. The two begin to waltz. They waltz, smiling lightly. They waltz with majestic grace.

At first you laugh, but laughter gives way to mist around the eyes, for what time does to all of us, even the mighty. Only a blockhead would fail to be moved to tears watching these old men dance their final, elegant dance of life.

The film returns to 1927 and there is Dempsey, the fighter, leaving a championship ring for the last time, standing very straight, bloody and bruised and uncomplaining. He is walking out of a blaze of light, not into obscurity but into history. He is moving toward his exalted place in the corridor of heroes.

In my mind's eye, others walk behind him: Willard and Carpentier; Rickard and Lardner; Firpo and Runyon and Gallico and Kearns and Neysa McMein and Maxine Cates and the jingoist Charles Thomas. Hemingway tramps sullenly, looking rude and angry, and some French show girls, very pretty, whose names we did not seem to catch. And Castor, the Hound of the Dempseys, and Clara Bow and Barbara Stanwyck and Charlie Chaplin and Al Jolson, who is pointing to the long scar under his chin. Calvin Coolidge is there and Al Capone and Rudolph Valentino and Estelle Taylor and Babe Ruth and the tramps and the miners and the nymphs and—how can one say this politely?—the former nymphs, now sensual and worldly. A battalion of humanity, a generation, marches behind the Champion.

Dempsey himself called me pal, and lied less than most and beat down the huge bullies the way we all wanted to do when we were children and the way the child in us still wants to do today.

Fight hard. Never alibi. Don't whine. No matter how slick it looks, it's still a hobo jungle underneath. Keep your guard up at all times.

The sooner the safer.

No matter how much I have, I'm for the poor people. The white poor and the black poor who have it worse. As long as I live, I'll never forget that I was poor.

And all the people who called me "Champ."

I loved the people.

History is all ragged edges. The extraordinary period that we have come to call the Roaring Twenties did not end when Dempsey stepped out of that Chicago ring. The stock-market crash was still two years away. Prohibition persisted until 1933. It is unbridled romanticism to say Dempsey all by himself symbolized the Roaring Twenties. Why not Henry Ford, or Charles Lindbergh, or that misbegotten go-getter Loy J. Molumby of Shelby, Montana? And yet, the old American frontier lived on uniquely in Dempsey, the high-country hobo who captured Hollywood and New York. He was rough and ready, and full of jazz. Was there ever a more remarkable American in Paris? He made millions but never forgot, nor did he want to forget, the sad gray visage that is poverty. Walking with kings, he kept the common touch. At least as I perceive it, Jack Dempsey *did* all by himself symbolize America in the Roaring Twenties. What's wrong with a little unbridled romanticism, anyway?

ROGER KAHN
Croton-on-Hudson, New York
1996–1999

Epilogue

A clamor rang throughout the country for Dempsey and Tunney to fight one more time. Tex Rickard wanted it. The sportswriters wanted it. The public wanted it. About the only two people who did not want another rematch were the principals.

Dempsey felt he had already taken enough physical punishment, particularly from Tunney's slashing chops at his eyes. He announced his retirement and quit the ring for Broadway, where the famous director David Belasco hired him to portray a character named Tiger in a drama called *The Big Fight.* Estelle Taylor played the leading lady. Following the script, Dempsey nightly flattened a 280-pound Jess Willard clone named Ralph Smith without having to endure the jolts of unpulled punches. Once, when Smith forgot his role and started serious scuffling, Dempsey actually did knock him out on stage with a left to the stomach and a right to the head. When Smith came to, he apologized. One of Dempsey's supposedly light taps had knocked him woozy, he said.

The drama critic in the *Herald Tribune* wrote, "Mr. Dempsey is a better actor than one might have expected." The same reviewer disliked Estelle Taylor's performance because of "her shrill and strident voice." *The Big Fight* ran for six weeks. "Not my worst effort in show business," Dempsey said. But not a new career, either.

In the great long-count round at Chicago Dempsey hit Tunney harder than he had ever been hit before. After that Tunney did not again want to share a ring with Dempsey. In an essay prepared for Isabel Leighton's stylish collection *The Aspirin Age,* Tunney referred to Dempsey not as the Manassa Mauler but as the Man Killer. This echoed words spoken by dashing Georges Carpentier decades before. Dempsey's fists were heavy with reminders of one's mortality. Even to such trained, conditioned, and gritty professionals as Carpentier and Tunney, they were as ominous as a cannon's mouth.

In the summer of 1928 Tunney ducked the logical contender, Jack Sharkey, and fought a walkover against Tom Heeney, a journeyman from New Zealand, at Yankee Stadium. He won with an eleventh-round technical knockout, pocketed five hundred thousand dollars, and retired unbeaten as heavyweight champion, and a wealthy man. He subsequently married an attractive heiress named Polly Lauder. Tunney spent the rest of his days—he lived until 1978—serving on corporate boards, granting chosen journalists polysyllabic interviews, and fighting off incipient alcoholism.

The 1928 Heeney fight drew only 45,890 fans in high summer, which meant that half the stadium tickets went unsold. "Dempsey," Bill McGeehan said, "drew more gate-crashers than that." Rickard and the Madison Square Garden Corporation lost $152,000, and several prominent Garden stockholders demanded that Rickard be fired. "With Dempsey fighting," Rickard said, "boxing was fun. Now it's just a business."

He decided to quit the Garden Corporation and form a partnership with Dempsey that would promote fights "and explore other enterprises." Dempsey and Rickard considering buying 51 percent of the New York Giants. Rickard talked about building a great gambling and sports center in south Florida. The two were interested

in oil exploration. Dempsey's passion for mining never waned; gold, silver, and copper were other areas to consider. For starters Rickard asked Dempsey to copromote a bout in Florida between Sharkey and a scrappy but smallish Georgia-born heavyweight named William Lawrence Stribling (who fought as "Young Stribling") early in 1929. Incidentally, just incidentally mind you, Rickard wondered if Jack would take on the winner. Dempsey said he would think about it. His lack of formal education was troubling him now. "Tunney had gone to college. He could do a lot of things. I was just a pug who never even went to high school."

By early 1929, Rickard and Dempsey were millionaires several times over. Rickard told reporters that he kept "about a million of what I got just lying around in New York banks, in case all of a sudden some gilt-edged investment comes up." Dempsey calculated that he was worth more than $3 million. No boxer before had ever become so prosperous.

On January 2, 1929, after a late New Year's Eve party in Florida, Rickard felt sharp stomach pain, first diagnosed as indigestion. When the pain worsened, his second wife, Maxine, a former show girl, moved him to Allyon Hospital in Miami Beach, where surgeons removed his appendix and diagnosed "a toxic gangrenous infection of the abdomen." Dempsey flew his own doctor, Robert E. Brennan, down from New York and Maxine Rickard's internist, S. W. Fleming, joined the medical team. The physicians consulted by telephone with Dr. Will Mayo, of the Mayo Clinic, who was vacationing in Cuba. Mayo refused to cut short his vacation and told an Associated Press reporter, "In my opinion, the patient's condition is such that my services would be of no benefit."

Rickard's infection today would be treated with a range of antibiotics, offering a good likelihood of recovery. There was no such treatment in 1929. Antibiotics lay in the future.

Seeing Dempsey standing beside his hospital bed, Rickard brightened. Then he grimaced at a stab of pain and said tightly, "You know where the dough is. Promise you'll take care of my wife and little kid."

Dempsey nodded and stroked Rickard's hands.

Rickard said, "Jack. You've been more than a son to me."

Dempsey wept.

Rickard died on January 6. The *New York Times* reported on its front page of January 9:

RICKARD'S BODY LIES IN STATE
IN GARDEN AS THOUSANDS MOURN
DEMPSEY LEADS FUNERAL PARTY FROM
MIAMI AND DIRECTS ARRANGEMENTS HERE

Ten months later, while lawyers were working on the Rickard estate, the stock market collapsed. (Typically, the hot growth stock, R.C.A., dropped from 101 to 28.) Some of the money Rickard said had been "lying around in banks" may have been deposited at the Bank of the United States, which folded. But Tex was a gambling man. He had put most of what he had into heavily margined securities in a stock market that went over the edge of Niagara. "I looked everywhere," Dempsey said, "but I couldn't find much." The estate finally came in at $166,662. To Rickard in his prime, that was nothing more than what Doc Kearns used to call "movement money."

The market crash and the ensuing Depression minced just about everyone except tenured civil servants and the long-entrenched rich. (No Harrimans or Biddles, no policemen or schoolteachers, had to sell apples.) Dempsey told Ray Arcel, "I lost almost everything myself. I dropped three million dollars."

Predictably, I suppose, but sadly, as Dempsey's money vanished, so did his beautiful Hollywood bride. He and Estelle divorced in 1930. She got a house worth $150,000 and $40,000 in cash—a settlement worth almost two million in today's dollars.

What money Dempsey himself retained was tied up in a trust fund that he could not touch for years. Practically, he told me, "I was just the same as everybody else in 1930 and '31. Broke. All of a sudden fancy

people, ladies in mink, men from the Social Register, were having dinner at Childs [a chain of brightly lit inexpensive Manhattan restaurants]. The dinner was all you could eat for sixty cents."

Dempsey had lost his championship career and his business partner and his wife and his fortune. He uttered no whimper. Enacting one more exercise in courage, he laced on his gloves and went back to work. Starting in August 1931, he began fighting exhibitions; by his own estimate he took on 175 opponents over the next three years, sometimes as many as five in a night. He found fighting chumps undignified, but he needed cash.

Everywhere people wanted to see Dempsey box just one more time. In a busy month, a single Depression month, taking on all comers in Reno, Spokane, Seattle, Tacoma, Portland, he earned $250,000. He began to wonder if he had retired too quickly, but his thoughts of returning to competitive boxing ended in Chicago on February 18, 1932, when a serious professional, a solid middle-level heavyweight who fought under the name of Kingfish Levinsky, cuffed him about for four rounds. Dempsey still could take out local strongboys, bullies, and amateur toughs, but he was no longer up to mixing it with ranked pros. He turned to officiating and on at least three occasions earned a then-record five thousand dollars to referee. Young boxers learned that Dempsey was no man to call borderline low blows. His prefight instructions ended: "All right, boys. Let's see a *fight!*"

He opened Jack Dempsey's Restaurant near Madison Square Garden in 1935 and stayed in business until 1974, after moving the restaurant to its best-remembered location, the west side of Broadway between Forty-ninth and Fiftieth streets. At lunch and dinner, he occupied a corner booth against a window on Broadway. "When I first came to New York," Bert Randolph Sugar, the former editor and publisher of *Ring,* told me, "I was walking up Broadway and I saw Dempsey in the window. Dempsey himself! I couldn't believe it. I thought it was a cut-out."

Paul Gallico described a restaurant visit during the 1930s.

[Dempsey's] hair is still blue-black, his chin faintly blue, and his movements still quick, restless, catlike.

If he knows you it will be: "Hello, pally" (in that high-pitched voice). "Glad to see you. Glad to see you. How's my old pardner? Sure I can find room for you."

He sweeps the rope aside, taking you by the arm. He grips the shoulder of the head waiter. No matter how crowded it is, he will say: "Find a nice table for my friend... and see that he gets taken care of. I'll be over later and have a chat with you, pardner."

And you march in proudly.

It feels like being presented in court.

Long afterward, when Dempsey was seventy-five, Robert Lipsyte of the *New York Times* paid a visit and found the champion "tall, gray-haired, bright-eyed...old-fashioned and courtly." Lipsyte's column won the E. P. Dutton Prize as the best feature sports story published in a newspaper during 1970.

After the Japanese attack on Pearl Harbor, Dempsey tried to enlist in the army, but he was turned down as overage. Following some high-level intervention, perhaps by Franklin D. Roosevelt, the Coast Guard accepted Dempsey, commissioned him, and put him in charge of physical training at its biggest base, Manhattan Beach, at the southern edge of Brooklyn. In time he was promoted to lieutenant commander.

As American forces slowly rallied and began the bloody Pacific counteroffensive—called, incongruously, as though it were a vacation cruise, "island hopping"—one of Dempsey's units was assigned to move in with the landing parties storming Okinawa. As the young warriors climbed into small boats for the assault on April 1, 1945, a line officer said, "You stay here with me, Jack. We can't afford to lose you."

Dempsey said, "Sir, I trained these boys and they look up to me. I go where they go." Which is how Jack Dempsey hit the beach at Okinawa when he was forty-nine years old.

"You know," he told me with great seriousness, "in World War I, they said I was a slacker. In World War II they said I was a hero." A hard look. "They were wrong both times."

His personal life had continued to be difficult. In 1933, he married another brunette, a popular singer named Hannah Williams, soon after her divorce from Roger Wolfe Kahn, a wealthy bandleader and test pilot who was the son of the Wall Street banker Otto Kahn. Williams bore Dempsey two daughters, Joan and Barbara—his only children—but the couple divorced in 1943. He was married for a fourth and final time in 1958 to Deanna Piattelli, who had been running a jewelry shop at the Hotel Manhattan. He was sixty-two. This would be the most tranquil of his marriages. After years of living in hotel suites, he settled into a penthouse on East Fifty-third Street. Although he never entirely got over Estelle Taylor, Dempsey said of Deanna, "She was my fourth. I wish she had been my first."

On June 17, 1970, Dempsey walked into a darkened ring at Madison Square Garden—later Jerry Quarry would box Mac Foster in a heavyweight bout—and two huge screens showed highlights of the fights with Willard and Firpo and Tunney II. Then the Garden crowd of more than sixteen thousand sang "Happy Birthday." Dempsey would turn seventy-five on June 24. It was, Dempsey said, an emotional moment. Harry Markson, the Garden fight promoter, said, "The way he still brings in the crowds, I wish we could have a birthday party for him every week."

Nine months later at the Garden, on the night Joe Frazier beat Muhammad Ali, the ring announcer, Johnny Addie, who was introducing celebrities, missed Dempsey. Only when people in the crowd chanted, "We want Dempsey" did Addie remember to invite the old champion into the ring for a bow. Dempsey was hurt. Trying to rally, he told his stepdaughter, Barbara, "After all, how long can one person stay in the spotlight before the bulb gets changed?"

He had to close the restaurant in 1974. The Broadway–Times

Square area was turning grim. Fear of muggers and purse snatchers, discomfort at roaming prostitutes and pimps, kept evening crowds away and his dinner business dwindled. Broadway was becoming as rowdy as old Commercial Street in Salt Lake City—as rowdy and probably more dangerous. Beyond the nasty changes on the street, the company operating the building that housed the restaurant, 1619 Broadway, let things slide. A burst water pipe damaged James Montgomery Flagg's mural of Dempsey fighting Willard against a backdrop of pastel sky and bright white clouds. Shortly after that, the building manager asked for what Dempsey described as "a huge increase in rent." Using his many sources, Dempsey tried to locate the landlord—not the building manager but the landlord—and thought he finally found her overseas. She was, he believed, Elizabeth II of England. A spokesman in Buckingham Palace denied that the building was one of the queen's properties and that Her Majesty doubled as a rent gouger. Even as he had to close down, Dempsey was unconvinced. Doesn't royalty thrive by squeezing the wallets of commoners, even, as in this case, an uncommon commoner?

During the late 1970s, Dempsey suffered a number of small strokes. When last I saw him, in the Fifty-third Street penthouse, he was using a cane. The dazzling memory for people and places, fights and follies, had dimmed. He seemed happy enough being waited on by Deanna and his stepdaughters, but the restless, questing Dempsey, the nomad of the brake beams, was no more. After that his stout heart began to fail and doctors implanted a pacemaker. He died on a mild spring afternoon, May 31, 1983, at the age of eighty-seven. Better than most, he had reached out and seized life with two strong hands.

It is a tribute to his generosity that his gross estate amounted to only $517,615. He had given away more than that to needy people, mostly broken-down fighters. The doles were always described as loans. Almost never was one repaid.

Deanna Dempsey interred the champion in the cemetery at Southampton, New York, a summer playground for the rich and so-

cial. The sea was close by; the mountains of his boyhood stood more than half a continent away.

The burial plot is bordered on three sides by a hedge of yew. A granite headstone bears the word "Dempsey." The only other name carved into the champion's gravestone is "Jack"—not William Harrison, just Jack. A mason has sculpted boxing gloves on the stone and carved an epitaph supplied by his widow: "A gentleman and a gentle man."

On the day I visited flowers someone had left by the headstone were withering, and I thought of Gertrude Stein's sad line, "the flowers of friendship faded." Stein and Dempsey had several things in common. Paris in the 1920s and a dislike for Ernest Hemingway.

It is a lovely, touching grave. Remembering the champion's distaste for emotional excess, I simply tapped the gravestone when it was time to go and said, "See ya."

Comparing Dempsey with other heavyweight champions is probably foolish and unquestionably irresistible. "I don't think," wrote Mickey Walker, the great middleweight champion, "that the world will ever again see a man who releases such ferociousness, strength and viciousness in the ring." My own judgment of him inside the ropes necessarily comes from films, but my judgment of his character comes from life. He stood up against punches the way he stood up against disasters, with great manliness and courage. His own blows were fierce and incredibly accurate. At his peak, I think Dempsey was the greatest fighter who ever lived.

When the solid television reporter Barry Tompkins asked Ray Arcel how Dempsey might have fared against such later champions as Joe Frazier and Muhammad Ali, Arcel seemed surprised at the question. Then he said, "Those are fine young men, but Jack would have had a picnic."

I admired Ali's fortitude in the ring and he moved almost as well as the incomparable middleweight Sugar Ray Robinson. But Ali was not much of a puncher. His knockouts of Sonny Liston are suspect. (We know Ali was trying, but was Liston?)

Many have praised the tormented Jack Johnson—few clear films of him survive—but Jess Willard simply wore Johnson down one very hot day in Havana and took away his championship in the twenty-sixth round.

My favorite fighters of the century are the great punchers, Jack Dempsey and Joe Louis, and the boxing question of the century asks how would they have fared against one another. Gene Tunney supplied a fascinating answer in a 1940 issue of *Look* magazine. He imagined a twenty-five-year-old Dempsey coming into the ring at Soldier Field, Chicago, weighing 192½, and taking on a twenty-five-year-old Louis who weighed just over 200. This would be, Tunney wrote, "the most thrilling and savage short fight in modern history. One has to go back to the Homeric contest between Ulysses and Irus, the Beggar, to find its equal.

"Most experts," Tunney continued, "said Louis's boxing skill and terrific straight punching would conquer the bobbing, weaving, hooking Dempsey. They cited Louis's victories over cumbersome [Primo] Carnera, amateurish [Max] Baer, unorthodox [Two-Ton Tony] Galento, light hitting Bob Pastor, et al." Tunney described Dempsey as "the young White Hope" and Louis as "the great colored fighter." The bout he imagined lasted exactly two minutes and thirty seconds.

Dempsey and Louis, in Tunney's fantasy, advanced cautiously toward one another. Each knew his opponent hit hard. "Great caution here!" wrote Tunney. Dempsey forced the battle and suddenly Louis crashed a right into the side of Dempsey's face. (Dempsey's jaw, as always, was tucked safely inside his left shoulder.) Louis's right knocked down Dempsey, who moved to one knee and took a count of nine, clearing his head.

When Dempsey got up, Louis missed a left hook and Dempsey clinched. "As they broke, Dempsey landed a vicious left hook on Louis's temple. The blow had an amazing effect. It seemed as though the color of Louis's skin changed, the pigment took on a lighter hue. They clinched again with Louis doing the holding. Dempsey reached

his right hand around Louis's shoulder and started raining deadening rabbit blows on the back of his neck."

More hard punching followed. Dempsey dropped Louis with a left hook. Louis got up at the count of three, "woefully woozy." He appeared confused. "It has been our belief," Tunney wrote, "that no opponent of Dempsey's could ever become confused and expect to remain vertical long."

The end, as Tunney imagined it: "Dempsey locked Louis's right arm with his own left, and pulling him forward, rained a series of vicious blows on the back of Louis's neck. Louis stumbled badly and only a great fighting heart kept him from falling. The referee stepped in and pushed Jack back. As soon as the referee was out of the way, Dempsey leaped in with an overhand right that landed behind Louis's left ear. With the landing of that blow 'the call of the wild' in Louis was silenced, and the abysmal urge in Dempsey was gratified. Louis fell face down, where he was counted out exactly two and a half minutes after the historic contest began.

"To Jack Dempsey must go all the credit and all the laurels."

At his death, fifty-seven years after he lost his championship, Dempsey was still so prominent that the *New York Times* reported his passing on page one. A week or so afterward, the late Jim Murray of the *Los Angeles Times* composed a ringing tribute.

> Whenever I hear the name Dempsey, I think of train whistles on a hot summer night on the prairie. I think of a tinkling piano coming out of a kerosene-lit saloon in a mining camp. I think of an America that was one big roaring camp of miners, drifters, bunkhouse hands, con men, hard cases, men who lived by their fists and their shooting irons and the cards they drew. It was the America of the Great Plains Buffalo, the cattle drive, the fast draw, the jailhouse dirge, America at High Noon.
>
> More than a man died with Dempsey. He took an era

with him. Dempsey was part of our heritage like Dan'l Boone, Davy Crockett and Honest Abe....His fight style was modeled after the timber wolf's, although he was as gentle outside the ring as he was savage in it.

Dempsey retired the word "Champ!" with him. "Dempsey" meant "Champ!"

When he went down, he got up. When he got hit, he hit back. When he bled, he laughed. When he got hurt, he attacked. When he got beat, he shrugged. If that doesn't mean Champ, would you tell me what does?

Not every question requires an answer.

A Word on Sources

The Dempsey literature is extensive and uneven. Two successful books are Toby Smith's *Kid Blackie* and *Championship Fighting,* the boxing text that Dempsey put together with editorial help from Jack Cuddy. Smith roamed Colorado during the 1980s, when a few of Dempsey's contemporaries survived, and effectively set down their memories of the young Rocky Mountain boxer. Should you want to learn ring footwork, or how to throw left hooks and overhand rights, *Championship Fighting* is a source without peer.

Dempsey appears vividly as a character in several more general books. John Lardner's *White Hopes and Other Tigers* sweeps from the reign of Jack Johnson to the retirement of Gene Tunney when, Lardner wrote, "the golden age ended." Lardner's themes were rascality and racism. His touch with such benign scoundrels as Kearns is remarkable and his quiet loathing of bigotry illuminates elegant pages of this neglected classic. I worked with John at *Newsweek* and for more than three years we had drinks every Thursday and lunch every

Saturday. Among other gifts and attributes, John commanded an extraordinary knowledge of boxing and its technicalities. ("A wild left swing may be a larrup," he once said. "But a wild left swing is not a hook.")

He regarded Dempsey's Toledo July as an episode of major historical consequence. (Subsequently he said, "Dempsey later overshadowed both Harding and Coolidge. Of course, Harding's shadow was a little crooked.") I knew Lardner before I knew Dempsey. Through John I learned a good deal about his father, Ring, and Ring's era, which broadly coincided with Dempsey's boxing prime. My friendship with John is a root source of *A Flame of Pure Fire*.

On the spring night in 1959, when Floyd Patterson defended his heavyweight championship against lightly regarded Ingemar Johansson of Sweden, I sat with Lardner at Yankee Stadium. For two rounds Patterson cuffed Johansson in the ribs and kidneys and appeared to be cruising toward an unexciting victory. Then in the third Johansson drove a mighty overhand right between Patterson's gloves. The punch landed above Patterson's nose and knocked him down and dizzy. When he got up he walked across the ring, holding his nose, like a small boy who didn't want to fight anymore. Johansson spun him and knocked him down again. Patterson's wife rushed to ringside and screamed at referee Ruby Goldstein, "Stop it, please stop it." Patterson kept staggering up and Johansson kept knocking him down. It was some time before Goldstein waved his arms over Patterson's fallen body, ending the fight.

"Wasn't that something?" I said to Lardner.

"Seven," he said.

"What?"

"Seven knockdowns." Amid the screaming and the punching, Lardner, with outwardly calm professionalism, had penciled a line on his notepaper each time Patterson fell. Seven lines. Seven knockdowns. Dempsey, sitting nearby, had gotten up and started out of the stadium to beat the crowds at knockdown number three. With another kind of professionalism, Dempsey realized before any of the rest of us that the fight was over.

In Joyce Carol Oates's spirited volume *On Boxing,* she comes up shaky on Johansson–Patterson I, which she describes as "three wholly one-sided rounds." (Patterson was well ahead on points when Johansson knocked him down.) She also confuses Dempsey, the disciplined champion, with Dempsey, the young saloon fighter. She refers to Dempsey as "reckless," which does not accurately describe a champion who protected his jaw so carefully that no one ever knocked him out with a blow to the chin. But much of her research is sound, and I enjoy the verve that runs through *On Boxing.* What carries Oates's work is not reporting or unique inside knowledge, but enthusiasm and flair. Boxing excites Joyce Oates and she conveys her excitement as intensely as an ardent woman unashamedly in love.

In *Farewell to Sport* Paul Gallico wrote a wonderful chapter on Dempsey. It is called, after the cry with which wild-swinging schoolboys taunted one another, "Who Do You Think You Are— Dempsey?" This is where Gallico says he could go on and on writing and never exhaust "the incredibly fascinating" Dempsey story. But for the best account of Gallico in the ring against the champion, one has to turn to Jerome Holtzman's *No Cheering in the Press Box,* taped reminiscences of eighteen sportswriters lovingly edited by Holtzman, long a star sportswriter himself. Gallico's conversation on his dreaded boxing date with Dempsey, filtered through Holtzman, is vivid and droll.

Dempsey wanted his story told and began trying to set it down in 1920 with the anonymous "Eyewitness" of the *Chicago Tribune* syndicate. That was necessarily incomplete. During the 1950s, he agreed to work with the prolific Hearst columnist Bob Considine, a good journalist and one of the fastest writers of his generation. But Considine had overbooked himself. To meet the deadline, he turned to another Hearst columnist, Bill Slocum, for help. "I found myself ghosting for a ghost," Slocum said.

In this book, simply called *Dempsey,* certain taped passages of Dempsey's words and stories work exceedingly well. But overall *Dempsey* seems a bit short and slight for the subject, a splendid long magazine piece rather than a full-scale book. That is not only my

judgment; it was Dempsey's. It was soon after the publication of *Dempsey* that the champion asked me about doing a work on a larger scale. I think his bringing up Hemingway as my potential rival for the assignment was a hustle. Dempsey's dislike for the writer ran deep and besides, by 1960, mental illness dominated Hemingway. (His suicide came the next year.) Not a bad hustle, but a hustle still. Dempsey had, after all, worked for a long time with Doc Kearns.

I don't for the life of me know why I didn't get back to Dempsey and work up a formal proposal. I was busy; not as overbooked as Bob Considine, but busy. There was an assignment in Hollywood and some work for *Esquire* and, most rewarding, a visit with Robert Frost. As Frost reminds us in "The Road Not Taken," "way leads on to way." At any rate, I did not see Dempsey again for many years. By that time he had composed a final version of his life, working with his stepdaughter, Barbara Piattelli Dempsey. That book, also called *Dempsey,* appeared in 1977. It contains good stories. *Dempsey,* 1977, is best regarded as an earnest family project.

An academic press published Randy Roberts's biography, *Jack Dempsey,* in 1979. Roberts lists himself as a PhD and the book is extensively footnoted, but unlike Lardner, Oates, Gallico, and Considine, Roberts possesses little feel for the scenes and stirring beat of boxing. He repeatedly has sportswriters covering big fights from a press *box.* The press box is baseball. When I covered championship bouts at Yankee Stadium, the Polo Grounds, Madison Square Garden, and Comiskey Park, not to mention working fights in such defunct small clubs as Ridgewood Grove, I sat at or near ringside in a press *row.* Roberts refers to the Dempsey–Considine work as "a popular biography." That book obviously was not a biography but an autobiography, and it is hard to escape the conclusion that Roberts is trying to dismiss it in a mean-spirited way. Roberts lists Ring Lardner, Jr.'s wonderful memoir, *The Lardners,* in his own bibliography but carelessly mangles Gene Tunney's pompous comment on the *Rubaiyat,* which appears accurately in the Lardner book. Dempsey deserved a higher level of work. Fortunately, he got it from various contemporaries.

The so-called Golden Age of Sport, the 1920s, is identified with athletic stars—Dempsey, Babe Ruth, Bill Tilden, Bobby Jones. Reading newspapers from the twenties, I began to see the time as first a Golden Age of Sportswriting. After World War I, a gorgeous flowering burst forth in American newspapers: Heywood Broun, Paul Gallico, Ring Lardner, W. O. McGeehan, Westbrook Pegler, Grantland Rice, Damon Runyon. The general approach was tough-guy romantic, as "when Homer smote his bloomin' lyre," and their best work is belletristic—writing that is not merely informative but also beautiful to read.

"In those days," the late columnist Red Smith told me in the 1970s, "the hacks were semiliterate and corrupt, and the best were better than anything we have today." Smith, a journalism major, graduated from Notre Dame in 1927. Now, more than seventy years later, the great old sportswriting still fairly leaps off a page.

Acknowledgments

The best source on Jack Dempsey was Jack Dempsey. Indeed, for certain matters, such as his early years and the terrible end of his first wife, he became the only source. Newspapers in El Paso and Juarez took no notice of Maxine Cates Dempsey's death, according to two researchers who recently contacted papers in the area. We can't even be certain what name she was using when she perished, obscure, unknown, in a fire in the forgotten brothel that employed her.

Was Dempsey, as he claimed, partly Jewish? For reasons unknown, some deny the claim. Finding complete birth and marriage records among backwoods people scattered in northwestern Virginia, c. 1800, is daunting, if not impossible. Besides, unrecorded common-law marriage and common-law copulation thrived. Dempsey told Bob Considine: "I am basically Irish, with Cherokee blood from both parents, plus a Jewish strain from my father's great-grandmother, Rachel Solomon." I see no reason to question Dempsey's word.

I met with him frequently during the 1950s, when I worked as

the sports editor of *Newsweek*. This was an interesting time for boxing. The three heavyweight champions of the period, Rocky Marciano, Floyd Patterson, and Ingemar Johansson, made for frequent stories and I took to calling on Dempsey for insight before major fights. (The lighter divisions were equally vital, with such talented boxers as Archie Moore, Ray Robinson, and Carmen Basilio.) Dempsey did not like to make predictions for publication. He said, "A former champion shouldn't take sides." But he seemed most comfortable when I stopped by with questions on a working visit, since that furnished a sense of usefulness to our meetings. He was always friendly, but the champion enjoyed talking most when the conversation went toward some purpose, such as an article that would be published.

He gave me background information on fights and fighters, but more than that, he provided lectures, often with demonstrations, on the falling step, the shovel hook, the overhand right, all his tools of war. I still fantasize this: Had I known as a child the ring technique I learned listening to Dempsey, my childhood would have been more adventurous. I could have ruled my block, my neighborhood, and in summertime, the dandelion fields. In Budd Schulberg's stirring line from *On the Waterfront,* "I coulda been a contender." That's how Dempsey made me feel; that was one touch of his magic.

He helped out, mostly anonymously, on a number of short *Newsweek* boxing stories. When I drew assignments to write full-length profiles of him for two magazines, *SPORT* and the now-vanished men's publication *Saga,* he offered me as much time as I needed and showed me some of the longhand notes that were the basis for his text called *Championship Boxing.* He also refused ever to let me pay for a drink or a meal in his place. He was as generous as he was prosperous, very generous indeed.

In 1958 I wrote of him in *SPORT,* "Only he is in a position to testify about long passages of his life, and his memory of himself, like every man's, is imperfect. Nor do I believe that this is notably significant. The exact size of a purse in a mining town half a century ago,

the precise date of a boyhood brawl are footnotes to an epic. More important, an age demanded and Jack Dempsey arose."

He had a remarkable intelligence, a sure sense of right and wrong, and a compassionate streak that would have graced Mother Teresa. He seemed to care very much for writers, and his grasp of details helped any writer who could listen and remember. Some of his quotes were unforgettable, as when he told me that he had been a hobo but never a bum, and how, in the icy clutch of poverty, he had begged on the streets, but never once, for all his raw strength, never once had he stolen. I have a few crumbling notes from these meetings and seeing them, and looking at my old Dempsey pieces, brought back much more: the high voice, the steady gaze, and the manner, gentle and without pretension. You began by talking with an icon and you finished talking with a friend.

According to Dempsey, Fireman Jim Flynn knocked him out in Murray, Utah, on February 13, 1917, because he had neglected to warm up properly and he had hurt a hand in a bowling alley. He walked into the ring cold, he said, and Flynn flattened him three times within two minutes of the first round. Bernie Dempsey, working as a second for his brother, threw in the towel and said later, "I did it because another punch might have killed you." This episode followed close upon Jack's first and unhappy visit to New York and his impetuous marriage to striking, dark-haired Maxine Cates, the harlot of Commercial Street, in Salt Lake City. Maxine told others that Dempsey actually threw the Flynn fight for either three hundred dollars or five hundred dollars. This, she said, provided the newlywed couple with needed cash and coincidentally provided Utah fight fixers with a betting coup. Before Dempsey's 1920 draft-evasion trial in San Francisco, she repeatedly threatened "to give the authorities the real lowdown on you and Flynn."

At that point Dempsey said in effect, Do what you damn please. In a rematch on February 14, 1918, he knocked Flynn senseless in one round. During that one year, 1918, he scored eleven first-round knockouts. But the first Flynn bout remains memorable. It is the only

occasion during Dempsey's fifteen years of competitive boxing when anyone knocked him out. Long after all the principals died, the fix story persisted. Throwing a fight was not in the presiding character of Dempsey, and as the draft trial demonstrated, Maxine was no slave to truth. Still, some speculate that a young Dempsey, strapped for the cash needed to make a marriage work, might have thrown one. I doubt it, but we cannot be sure.

What I can say with certainty is that across years of encounters with Dempsey, I came away with a strong feel for the man. As these pages testify, I liked what I found—the candor, the quiet pride, the kindness, the wit, the fists like boulders, and the rousing horseplay, as when he insisted that I spar with him. Gentle he was, but he never let you quite forget that he was Jack Dempsey, who in his prime could lick any son of a bitch in the world.

Here is a rare thing: close up, as from afar, he was a hero.

I am particularly grateful for assistance provided by Heywood Hale Broun, journalist, author, and actor, an exemplar of the triple-threat man; Ed Fitzgerald, a Gene Tunney scholar who formerly edited *SPORT*; Ring Lardner, Jr., an author and screenwriter who has twice won Oscars; Harold Rosenthal, an outstanding sportswriter with the late *New York Herald Tribune*; and Bert Randolph Sugar, a renowned boxing historian. Harold Rosenthal died at eighty-five, just as I was completing this book. He was crusty and sensitive, earthy and proud, a friend of mine for fifty years and, now, for the ages.

Gerald Astor, a former managing editor of *Look* and a former photo editor of *Sports Illustrated,* did his customary stellar job of finding and selecting the pictures. He also lit some fires a few years back by remarking to me, "I think too much has been written about Babe Ruth and not enough about Jack Dempsey."

Robert Shepard of New York City possesses a splendid collection of Dempsey memorabilia. Although few knew it, Dempsey subscribed to a clipping service. Bob Shepard purchased every clipping Dempsey saved from the champion's estate. His factual expertise on

Dempsey is unmatched, his support was most welcome, and his cooperation was invaluable.

At a UCLA seminar on sportswriting as literature, Bill Dwyre, sports editor of the *Los Angeles Times,* read aloud from Jim Murray's farewell to Dempsey. I'd known Jim Murray at least since we covered a Patterson–Liston fight in Chicago early in the 1960s, but I had not seen his Dempsey piece. My thanks to Bill and his deputy, Kelly Burgess, for supplying a copy.

This work benefits from the indefatigable research efforts of Carol J. Ryan and the splendid copy-editing of Anne Lunt. During long library sieges, Ms. Ryan's exceptional eye for telling details from long ago did not blur. Anyone dangling a participle near Ms. Lunt is in clear and present danger.

Owen Findsen of the *Cincinnati Enquirer* provided rich detail on Dempsey the vaudeville trouper, working the banks of the Ohio. Maury Povich and Lynn Povich Shepard furnished copies of some of the late Shirley Povich's fine writing on Dempsey. Shirley himself had provided the author with vivid background pictures of the Washington, D.C., he knew as a young newspaperman in the days of Harding and Coolidge.

Seymour Rothman, a former sports reporter for the *Toledo Blade,* proved to be an invaluable source on Jess Willard and Toledo 1919. Jim Walsh led me to descendants of the murdered boxer K. O. Bill Brennan. Georgie Papalski helped research Dempsey's will and estate. Jana and Randy Tyler of the *Glenrock (Wyoming) Independent* assisted with details on the unhappy ending that befell John "Bull" Young.

Generous library help was provided by May Stone of the New York Historical Society and Stephan Sacks of the New York Public Library, two organizations that are national treasures. I am also grateful to Martha Campbell, Martha Taylor, and Judy Malatino of the Croton Free Library; John Hawkins of the Ossining Public Library; and Kate Ray and Mary Loomba of the Westchester (County, N.Y.) Community College Library. Angel Morales in the *Sports Illustrated*

editorial library graciously lent his assistance. Charles Silver and Ron Magliozzi of the Museum of Modern Art Film Study Center provided screenings of pertinent 1920s movies.

I also received help from Patty Patterson at the Netrona County (Wyoming) Public Library; John Lloyd of the Ocean County (New Jersey) Public Library; and Greg Miller at the Toledo-Lukas Library.

Terrence Ryan furnished charts that provided a sensible approach to the slippery question, What would a 1920 dollar be worth today?

Finally, I am profoundly grateful to Dan Farley, president of the general book division of Harcourt Brace, for his faith in this work from the outset, and for the support, enthusiasm, and splendid editorial counsel offered by Walter Bode. Although great editors may well be an endangered species, Walt Bode is breathing proof that some survive.

I don't believe I have left anyone out. If I have, my apologies.

The editorial help and research assistance were splendid. The responsibility for any errors that may have invaded this book, in the despicable, sidewinding way that errors have, is mine alone.

R.K.

Bibliography

Adams, Samuel Hopkins. *Incredible Era: The Life and Times of Warren Gamaliel Harding.* New York: Houghton Mifflin, 1939.

Allen, Frederick Lewis. *Only Yesterday: An Informal History of the Nineteen-Twenties.* New York: Harper & Brothers, 1931.

Anderson, Dave. *In the Corner: Great Boxing Trainers Talk about Their Art.* New York: William Morrow & Co., 1991.

Anger, Kenneth. *Hollywood Babylon II.* New York: E. P. Dutton, 1984.

Anthony, Carl Sferrazza. *Florence Harding: The First Lady, The Jazz Age and the Death of America's Most Scandalous President.* New York: William Morrow, 1998.

Asinof, Elliot. *1919. America's Loss of Innocence.* New York: Donald I. Fine, 1990.

Baker, Carlos. *Ernest Hemingway.* New York: Scribner, 1969.

Boylan, James R., ed. *The World and the 20s.* New York: Dial Press, 1973.

Breslin, Jimmy. *Damon Runyon.* New York: Ticknor & Fields, 1991.

Britton, Nan. *The President's Daughter.* New York: Elizabeth Ann Guild, Inc., 1927.

Broun, Heywood. *The Collected Edition of Heywood Broun.* New York: Harcourt Brace, 1941.

Broun, Heywood. *Seeing Things at Night.* New York: Harcourt Brace, 1921.

Broun, Heywood Hale. *Tumultuous Merriment.* New York: R. Marek, 1979.

Brown, Gene, ed. *The New York Times Encyclopedia of Sports: Boxing.* New York: Arno Press, 1979.

Brownlow, Kevin. *The Parade's Gone By.* New York: Knopf, 1968.

Cherington, Ernest Hurst. *Standard Encyclopedia of the Alcohol Problem.* Westerville, Ohio: American Issue Publishing.

Culhane, John. *The American Circus.* New York: Henry Holt, 1990.

Daniels, Jonathan. *The Times Between the Wars: Armistice to Pearl Harbor.* Garden City, NY: Doubleday, 1966.

Dartnell, Fred (Lord Melford). *"Seconds Out!" Chats about Boxers, Their Trainers and Patrons.* London: T. W. Laurie, Ltd, 1924.

Dempsey, Jack. *Championship Fighting: Explosive Punching and Aggressive Defense,* edited by Jack Cuddy. New York: Prentice-Hall, 1950.

Dempsey, Jack, with Bob Considine, and Bill Slocum. *Dempsey: By the Man Himself.* New York: Simon and Schuster, 1960.

Dempsey, Jack, with Barbara Piattelli. *Dempsey.* New York: Harper & Row, 1977.

Durso, Joe. *Madison Square Garden: 100 Years of History.* New York: Simon and Schuster, 1979.

Elder, Donald, *Ring Lardner.* Garden City, NJ: Doubleday, 1956.

Ellis, Richard N., and Duane A. Smith. *Colorado: A History in Photographs.* Niwot, CO: University Press Colorado, 1991.

Evensen, Bruce J. *When Dempsey Fought Tunney: Heroes, Hokum and Storytelling in the Jazz Age.* Knoxville, TN: University of Tennessee Press, 1996.

Everson, William K. *American Silent Film.* New York: Oxford University Press, 1978.

Farr, Finis. *Black Champion: The Life and Times of Jack Johnson.* New York: Macmillan, 1964.

Fleischer, Nat. *The Ring Record Book and Boxing Encyclopedia.* Norwalk, CT: O'Brien Suburban Press, Annual.

Fleischer, Nat, and Sam André. *A Pictorial History of Boxing.* New York: Bonanza Books, 1959.

Fleischer, Nat. *Fifty Years at Ringside.* New York: Fleet Publishing, 1958.

Fowler, Gene. *Good Night, Sweet Prince.* New York: Viking, 1944.

Fried, Robert K. *Corner Men: Great Boxing Trainers.* New York: Four Walls Eight Windows, 1991.

Fritz, Percy Stanley. *Colorado*. New York: Prentice-Hall, 1941.

Furnas, J. C. *Great Times: An Informal Social History of the United States, 1914–1929*. New York: Putnam and Sons, 1974.

Furnas, J. C. *The Life and Times of the Late Demon Rum*. New York: Putnam, 1965.

Gallagher, Brian. *Anything Goes: The Jazz Age Adventures of Neysa McMein and her Extravagant Circle of Friends*. New York: Times Books, 1987.

Gallico, Paul. *Farewell to Sport*. New York: Knopf, 1938.

Graham, Billy. *Approaching Hoofbeats: The Four Horsemen of the Apocalypse*. Waco, TX: Word Books, 1983.

Graham, Frank, Jr. *A Farewell to Heroes*. New York: Viking Press, 1981.

Greever, William S. *The Bonanza West: The Story of the Mining Rushes, 1848–1924*. Norman, OK: University of Oklahoma Press, 1963.

Grombach, John V. *The Saga of the Fist: The 9000-Year Story of Boxing*. South Brunswick, NJ: A. S. Barnes, 1977.

Hayes, Teddy. *With the Gloves Off*. Lancha Books, 1977.

Heimer, Mel. *The Long Count*. New York: Atheneum, 1969.

Heinz, W. C. *The Professional*. New York: Arbor House, 1958.

Heinz, W. C., ed. *Fireside Book of Boxing*. New York: Simon and Schuster, 1961.

Hogan, Richard. *Class and Community in Frontier Colorado* (Studies in Historical Social Change). Lawrence, KS: University Press of Kansas, 1991.

Hollender, Zander, ed. *Madison Square Garden, A Century of Sport*. New York: Hawthorn Books, 1973.

Holtzman, Jerome. *No Cheering in the Press Box*. New York: Holt, Rinehart and Winston, 1974.

Kearns, Jack, with Oscar Fraley. *The Million Dollar Gate*. New York: Macmillan, 1966.

Kluger, Richard A. *Ashes to Ashes*. New York: Knopf, 1996.

Kobler, John. *Capone: The Life and World of Al Capone*. New York: Putnam, 1951.

Lardner, John. *White Hopes and Other Tigers*. Philadelphia, PA: Lippincott, 1951.

Lardner, John, ed. Kahn, Roger. *The World of John Lardner*. New York: Simon and Schuster, 1961.

Lardner, Ring, Jr. *The Lardners: My Family Remembered*. New York: Harper & Row, 1976.

Leighton, Isabel, ed. *The Aspirin Age: 1919–1941*. New York: Simon and Schuster, 1949.

Lender, Mark Edward, and James Kirby Martin. *Drinking in America: A History.* New York: Free Press, 1982.

Letis, M. *Al Capone.* London: Wayland Press, 1974.

London, Jack. *John Barleycorn.* New York: The Century, 1913.

Marsh, Irving, and E. Ehre. *Best Sports Stories, 1971.* New York: Dutton, 1971.

Means, Gaston. *The Strange Death of President Harding, From the Diaries of Gaston B. Means as Told to May Dixon Thacker.* New York: Guilt Publishing Corporation, 1930.

Oates, Joyce Carol. *On Boxing.* Garden City, NY: Dolphin Doubleday, 1987.

Oberfirst, Robert. *Rudolph Valentino, The Man Behind the Myth.* New York: Citadel Press, 1962.

Randisi, Robert J. *The Ham Reporter: Bat Masterson in New York.* Garden City, NY: Doubleday, 1986.

Rice, Grantland. *The Final Answer and Other Poems.* South Brunswick, NJ: A. S. Barnes, 1955.

Rice, Grantland. *The Tumult and the Shouting: My Life in Sport.* South Brunswick, NJ: A. S. Barnes, 1954.

Roberts, Randy. *Jack Dempsey: The Manassa Mauler.* Baton Rouge, LA: Louisiana State University Press, 1979.

Sammons, Jeffery T. *Beyond the Ring: Boxing in American Society.* Urbana, IL: University of Illinois, 1988.

Samuels, Charles. *The Magnificent Rube: The Life and Gaudy Times of Tex Rickard.* New York: McGraw-Hill, 1957.

Scagnetti, Jack. *The Intimate Life of Rudolf Valentino,* Middle Village, NY: Jonathan David, 1975.

Schulberg, Budd. *The Harder They Fall.* New York: Random House, 1947.

Silverman, Al. *The World of Sport.* New York: Holt, 1962.

Smith, Duane A. *Horace Tabor: His Life and the Legend.* Niwot, CO: Colorado University Press, 1989.

Smith, Toby. *Kid Blackie: The Colorado Days of Jack Dempsey.* Ridgway, CO: Wayfinder Press, 1987.

Snyder, Louis, and Richard Morris. *A Treasury of Great Reporting.* Simon and Schuster, 1949.

Sugar, Bert Randolph. *100 Greatest Boxers of All Time*. Galley Press, 1981.

Sugar, Bert Randolph. *100 Years of Boxing*. Galley Press, 1982.

Sugar, Bert Randolph. *100 Greatest Athletes of All Time*. Citadel Press, 1995.

Tunney, Gene. *A Man Must Fight*. Boston: Houghton Mifflin, 1932.

Ubbelohde, Carl A. et al. *A Colorado History*. Boulder, CO: Pruett, 1995.

Van Every, Edward. *Muldoon: The Solid Man of Sport*. New York: Frederick A. Stokes, 1929.

Voynick, Stephen M. *Leadville: A Miner's Epic*. Missoula, MT: Mountain Press, 1986.

Walker, Alexander. *Rudolf Valentino*. Harmondsworth, Eng.: Stein and Day, 1976.

Walker, Mickey. *Will to Conquer*. Hollywood, CA: House-Warven, 1953.

Walker, Mickey, with Joe Reichler. *Mickey Walker: The Toy Bulldog and His Times*. New York: Random House, 1961.

Wolfe, Muriel Sibell. *Stampede to Timberline: The Ghost Towns and Mining Camps of Colorado*. Denver, CO: Sage Books, 1962.

MEDIA AND FILM SOURCES

Art News

Baltimore Sun

Film, *Call Me Savage* (Featuring Estelle Taylor, 1932)

Chicago Tribune

Cincinnati Enquirer

Film, *Daredevil Jack* (Featuring Jack Dempsey, 1923)

Glenn Rock Independent

Look

Los Angeles Times

Louisville Courier-Journal

National Police Gazette

New York American

New York Sun

New York Tribune

New York Herald Tribune

Newsreels of Dempsey vs. Willard, Carpentier, Gibbons, Firpo, Tunney, provided by ESPN

The New Yorker

Ring magazine

San Francisco Chronicle

Saga

SPORT

Sports Illustrated

Film, *Street Scenes* (Featuring Estelle Taylor, 1931)

St. Louis Post Dispatch

The New York Daily Mirror

Film, *The Ten Commandments* (Featuring Estelle Taylor, 1923)

The New York Times

The Toledo Times

Washington Post

The [New York Morning and Evening] World

Toledo Blade

Index

Note: Reference to Jack Dempsey in subheadings is indicated by "JD."
Family members are identified parenthetically.

Adams, Annette A., 127, 145
Adams, Charles Francis, 171
Adams, Franklin Pierce, 230
Addie, Johnny, 433
Adler, Alfred, 114
Aiken, Conrad, 23–24
Albuquerque Journal, 193
Alexandra, czarina of Russia, 244
Ali, Muhammad, 433, 435
Allen, Frederick Lewis: *Only Yesterday,*
 114, 229, 331, 404
Altoona, Pennsylvania, 48, 72
American Civil Liberties Union, 378
American Legion, 142–43, 205, 304, 307
 California chapter, 127
American People's League, 236
Anderson, André, 17
Anderson, Maxwell, 123
Anderson, Paul Y., 381
Anderson, Sherwood, 411
 Winesburg, Ohio, 30
Anthony, Carl S., 332

Anti-Saloon League, 27
Aquitania (Cunard liner), 279, 281, 282
Arbuckle, Roscoe ("Fatty"), 113
Arcel, Ray, 192, 232, 300–301, 362, 430, 435
Arizona, U.S.S. (battleship), 140
Armstrong, Bob, 288
Army and Navy War Activities Fund, 162
Associated Press, 262, 314–15, 328, 381,
 387
Astor, Vincent, 255, 262, 396
Atlantic City, New Jersey, 237, 240, 247,
 254, 333, 334, 339, 367, 394
Atlantic Monthly, 113
Attell, Abe, 403, 413–14, 419
Auerbach, A. J., 146

Baer, Max, 260, 291, 436
Baker, Carlos, 291
Baldwin, Roger, 24
Baltimore Sun, 123, 265, 379, 380
Balzac, Billy, 293
Banky, Vilma, 113

Bannon, Joe, 264
Bara, Theda (born Theodosia Goodman), 112
Barbour, W. Warren, 88, 92, 95–96
Barnum, P. T., 36
Barry, Dave, 86, 417, 421, 422
Barrymore, Ethel, 59
Baruch, Bernard, 179
Basilio, Carmen, 446
Baton Rouge State Times, 111
Bay View Park (Toledo, Ohio), 54, 55
Beckett, Joe, 45, 199, 224, 239, 247, 254, 265, 282
Beeler, Paul, 421
Beery, Wallace, 361
Belasco, David, xiv, 427
Bell, Tommy, 76
Bellows, George Wesley, 321, 323
Benjamin, Joe, 44, 248, 281, 282, 284, 342, 347, 364, 367
Benton Harbor, Michigan, 207–10
Berardinelli, Giuseppe Antonio (a.k.a. Joey Maxim), 76
Berengaria (Cunard liner), 373
Berger, Meyer, 76
Berlin, Germany, 294–96, 373–74
Berlin, Irving, 292
Bettison, Benny, 254, 255
Biddle, Maj. Anthony J. Drexel, 88–89, 204, 236, 277
"Big Ed" (wrestler), 14
Big Fight, The (play), xiv, 427–28
Bingham County, Utah, 193
Black Hand Society, 152, 166
Blanchard, Maria, 96
Bliss, Charles H., 107–8
Bloom, Phil, 44
Bodkin, Thomas V., 60, 62
Bolitho, William, 25
Bond, Joe, 16
Borah, William E., 151
"Boston Bearcat," 15, 16, 190
Bow, Clara, 359–60, 424
Boyle's Thirty Acres (Jersey City, New Jersey), 235, 247, 258, 261, 262, 310, 325, 328, 348

Brady, William A., 133, 232, 323–24
Brandeis, Alice Goldmark, 123
Branstetter, Eddie, 364
Braque, Georges, 290
Brazzo, Jack, 44
Breadon, Sam, 349
Brennan, "K. O." Bill (born William Shanks), 45, 72, 158, 215–21, 227, 269, 300, 324, 359, 418
Brennan, Mary, 220, 221
Brennan, Mary Shirley, 221
Brennan, Robert E., 429
Breyer, Victor, 254
Bridger, Jim, 173
Britton, Elizabeth Anne, 251
Britton, Nan, 251, 332
Broun, Heywood Hale
 in Algonquin Roundtable, 230
 coverage of Dempsey-Carpentier fight, 223, 231, 247–48, 252–53, 259–60, 263, 264, 265
 coverage of Dempsey-Firpo fight, 345, 347
 coverage of Dempsey-Gibbons fight, 312, 314, 316, 317
 coverage of Dempsey-Tunney fight, 421
 coverage of Leonard-Kansas fight, 243
 coverage of Republican National Convention (1920), 139, 151–52
 as sportswriter, xiv, 385, 443
 support for Sacco and Vanzetti, 123, 410–11
Brown, Betty, 95
Brown, Ned, 17
Brown, Warren, 211
Brownlow, Kevin: *The Parade's Gone By,* 112
Bryan, William Jennings, 22, 37, 123, 180, 378–81
Buffalo, New York, 21, 226
Burbank, Luther, 381
Burke, Martin, 250, 353
Burns, Tommy (born Noah Brusso), 40, 289, 303

Burton, R. W., 155
Butler, Dr. Nicholas Murray, 146, 151, 161

Cameron, Lucy, 41
Camp Robinson Crusoe (Sturbridge, Massachusetts), 79–82
Campbell, Anamas (boxer), 195
Cannon, Jimmy, 301
Cantor, Eddie, 237, 256
Cantor, Mortimer, 246
Capone, Al, 86, 111, 140, 208, 214, 215, 306, 402, 412–13, 418, 419, 424
Carbo, Frankie, 417
Carey, Mr. and Mrs. William F., 396
Carlyle, Thomas, 185
Carnegie, Andrew, 268
Carnera, Primo, 436
Carpentier, Georges, 424
 fight with Joe Beckett (1919), 199
 fight with JD (1921), 223–69, 276, 326, 398, 428
 fight with Ted "Kid" Lewis (1922), 285
 as possible opponent for JD, 45, 98, 127, 137, 156, 198, 199–200
 and possible rematch with JD, 296, 300
 as tour guide for JD, 293
Carson, Kit, 173
Carter, John F., 113
Caruso, Mr. and Mrs. Enrico, 152, 161, 166, 268
Casey, Hugh, 291
Casper (Wyoming) Press Weekly, 57
Castor (dog), 374–76, 424
Cates, Adeline, 167
Cates, Maxine. See Dempsey, Maxine Cates
Cavell, Edith Louisa, 8, 11
Championship Fighting (Dempsey and Cuddy), 439, 446
Chaney, Lon, 115
Chaplin, Charlie, 115, 355, 361, 364, 396, 424
Chase, William, 348
Chester Park and Vaudeville Theater (Cincinnati, Ohio), 105

Chicago, Illinois. See also Capone, Al
 fights in, 16, 208, 390, 410, 411–17, 431
 Republican convention in, 139, 140–41, 142, 150–52, 156–57, 161
 vaudeville in, 110
Chicago Coliseum (Chicago, Illinois), 390
Chicago Daily News, 61, 225
Chicago Herald and Examiner, 413
Chicago Sun-Times, 336
Chicago Tribune, 187
 "Eyewitness," 441
Chipman, William, 334
Chrysler, Walter, 418
Cincinnati, Ohio, 101, 104, 105–7
Cincinnati Enquirer, 105
Clark, Dane, 73
Clarkson, Effie Dempsey (widowed sister), 24, 136, 144, 146, 158, 176, 407
Cleghorn, Sarah Northcliffe, 189
Clemenceau, Georges, 255
Clements, B. C., 372, 390
Cleveland, Grover, 178
Cleveland, Ohio, 16
Coast Guard, U.S., 432–33
Cobb, Irvin S., 262
Cobb, Ty, 138–39, 396
Coffey, Nannie, 148–49
Cohan, George M., 237, 262
 "Over There," 21–22, 23
Colbert, Claudette, 118
Collins, Floyd, 367–68
Collins, Michael, 309
Colma, California, 75
Colorado
 economic crisis in, 179–80
 settlement of, 171–75, 179
Coney Island (New York City), 203
Connelly, Marc, 230, 293
Considine, Bob, 197, 225, 356, 441, 445
Considine, John W., Jr., 391
Coolidge, Calvin, 53, 146, 151, 157, 228, 332–33, 353, 385, 396, 424
Cooper, Jackie, 369
Corbett, James J. ("Gentleman Jim"), 32–33, 106, 204, 236, 323, 348, 389, 409

Cort, David, 320–21
Coué, Emile, 247
Covey, George, 281
Cowl, Jane, 237
Cox, James M., 52–55, 228
 Journey Through My Years, 53
Crafts, Wilbur F., 236, 268
Creede, Colorado, 182
Cuddy, Jack, 439
Cullen, James, 220
cummings, e. e., 140

Dalrymple, A. V., 141
Daniel, Dan M., 352
Daniels, Bebe, 117, 118, 297, 359, 368
Daniels, Josephus, 165
Daredevil Jack (serial, 1923), xiv, 106,
 114–15, 117, 121, 128, 143, 167
Darrow, Clarence, 122–23, 378–81
Daugherty, Harry, 250–51, 252
Davies, Marion, 117, 364
Davis, Elmer, 314, 315
Davis, Richard Harding, 8
Dawes, Charles, 396
Dawson, James, 76, 395, 408
Dearborn (Michigan) Independent, 244–46
Debs, Eugene V., 22–23, 228
DeCosta, Manuel, 233, 234
DeForest, Jimmy, 64, 72, 73, 89, 323
Delevan, Frank, 66
Delta, Colorado, 185
DeMille, Cecil B., 6, 117
 The Call of the North, 116
 The Ten Commandments, 6, 327
 Why Change Your Wife?, 117
Dempsey, Andrew ("Big Andrew,"
 paternal grandfather), 175
Dempsey, Barbara (daughter), 433
Dempsey, Barbara Piattelli (stepdaughter),
 175, 433, 442
Dempsey, Bernie ("Barney," brother), 6,
 136, 144, 176, 186–87, 447
Dempsey, Bruce (brother), 158, 183
Dempsey, Bruce (nephew), 406
Dempsey, Deanna Piattelli (fourth wife),
 433, 434

Dempsey, Edna (sister-in-law), 386, 406–7
Dempsey, Effie (widowed sister). *See*
 Clarkson, Effie Dempsey
Dempsey, Elsie (sister), 183, 354
Dempsey, Estelle Taylor (Ida Estelle
 Boylan, second wife), 6, 175, 292,
 327–28, 354, 356–58, 360–62, 363–69,
 372–78, 386–87, 391, 396, 400, 407,
 415–16, 424, 427–28, 430
Dempsey, Florence (sister), 181, 183
Dempsey, Hannah Williams (third wife),
 433
Dempsey, Hyrum (father), 24, 59–60, 110,
 136, 144, 146, 157, 167, 175–77,
 181–83, 184–85, 189, 190–91, 312, 385
Dempsey, Jack ("the Nonpareil," John
 Kelly, d. 1895), 4–6
Dempsey, Jack (William Harrison,
 "Harry")
 as actor, xiv, 106, 111–17, 128, 167,
 326, 354–56, 364–65, 427–28
 background of, xiii, 171, 175–91
 birth of, 177, 178
 break with Kearns, 327, 349, 364–66,
 372, 375, 383, 386–87, 390–92,
 393–94, 399
 commercial endorsements by, 103–5,
 133, 135–36
 death of, 434–35, 437–38
 diary of, 282–84, 296
 education of, 185–86
 fighting style of, xiv, 4, 13, 20, 21,
 69–70, 71, 73–79, 83–86, 192–93,
 218–19, 248, 309, 343, 352, 374,
 398–99, 402, 436, 438, 446
 fights
 with André Anderson (1916), 17
 with "Big Ed" (1915), 14
 with the Boston Bearcat (1916),
 15, 16, 190
 with "K. O." Bill Brennan (1918,
 1920), 45, 158, 214–19, 227, 359
 with Martin Burke (1924), 353
 with Campbell (1915), 195
 with Georges Carpentier (1921),
 223–69, 276, 326, 398, 428

with Jack Downey (1915), 195
with Luis Angel Firpo (1923),
 321, 323–49, 351–52, 362, 384,
 390, 394, 398
with "Fireman" Jim Flynn (1917,
 1918), 45, 121, 162, 343,
 447–48
with Fred Fulton (1918), xiv, 64,
 109, 116, 155, 226, 242
with Tommy Gibbons (1923),
 304–17, 328, 370
with Dick Gilbert (1916), 20, 120
with "One-Punch" Hancock
 (1914), 12
with John Lester Johnson (1916),
 17–18, 72, 120
with Terry Keller (1916), 120
with "Wild" Bert Kenny (1916),
 17
with Dan Ketchell (1916), 15
with Cyril Kohn (1916), 15
with "Battling" Levinsky, 45
with "Kingfish" Levinsky (1932),
 431
with Joe Louis (imagined), 219,
 322, 436–37
with Andy Malloy (1915), 13
with Tommy Marvin (1924), 353
with Bob McAllister (1917), 162
with Willie Meehan (1917), 162
with Billy Miske (1919), 206–11,
 227, 384
with Carl Morris (1917), 125, 162,
 226
with Al Norton (1917), 162
with Dutch Seifert (1924), 353
with Jack Sharkey (1927), 404,
 408–10
with "Gunboat" Smith, 45, 125,
 162, 226, 339
with Johnny Sudenberg (1915,
 1916), 15, 195–96, 197
with Gene Tunney (1927), xii, 86,
 387–401, 410, 412–24, 428
with "Two-round Gillian" (1915),
 15

with Jess Willard (1919), xii, 7,
 21, 31–32, 45–48, 49–50,
 69–99, 158, 384, 389, 397
with Freddy Woods (1913),
 193–94
with Bob York (1916), 15
with "Young Hector" (1916), 120
health of, 434
as heavyweight champion, 3,
 100–168, 270, 339, 352, 360,
 369–70, 400
incriminating letters by, 124–68
injuries of, xiv, 218–19, 250, 316, 317,
 346, 399–400, 415, 420, 422
looks (and plastic surgery) of, 6, 115,
 357–58, 395, 420
marriages, xiv
 to Maxine Cates (first wife),
 19–20, 46, 102, 108–9, 118–22,
 124–68, 362, 424, 445, 447
 to Estelle Taylor (second wife), 6,
 175, 292, 327–28, 354, 356–58,
 360–62, 363–69, 372–78,
 386–87, 391, 396, 400, 407,
 415–16, 424, 427–28, 430
 to Hannah Williams (third wife),
 433
 to Deanna Piattelli (fourth wife),
 433, 434
military deferment for (alleged draft
 evasion by), 24, 122, 126–27, 129,
 131–66, 382–83, 447
military service by, 432–33
as Mormon, xiii, 181
nicknames of
 "Ginsburg," 175, 373
 "Kid Blackie," 12, 191–93
 "Manassa Mauler," 386
 "Salt Lake City Tiger," 15, 70, 71
non-boxing jobs held by, xiii–xiv,
 12–13, 19, 20, 71, 121, 145, 161,
 164, 188, 189–90, 191, 193
obituary of, 437–38
officiating by, 431
as practical joker, 116
retirement of, 403, 427

Dempsey, Jack (William Harrison, "Harry") (*continued*)
 seventy-fifth birthday party for, 433
 social conscience of, 123, 179, 424–25, 434
 training of, 43–44, 59–60, 64, 71–72, 186–88, 195, 196, 201–2, 216–17, 237, 239, 240–41, 247, 249–50, 252–53, 284, 311, 313–14, 333, 335, 361, 387, 389, 391–92, 394–95, 403–4, 406, 408, 412, 415
 on vaudeville circuit, 101, 104, 105–7, 109–11, 299–300, 353
Dempsey, Joan (daughter), 433
Dempsey, Joe (brother), 6, 158, 283
Dempsey, Johnny (brother), 116–17, 158, 186, 187, 342–43, 354, 385–86
 death of, xiv, 117, 406–7
Dempsey, Mary Celia Smoot (mother), xiii, 24, 46, 120, 136, 144, 146, 154, 157–59, 167, 175, 176, 177–78, 183, 184, 188, 267, 283, 297, 354, 355–56, 367, 385, 386, 407
Dempsey, Maxine Cates (first wife), 19–20, 24, 25, 46, 102, 108–9, 118–22, 124–68, 362, 424, 445, 447
Dempsey (Dempsey, with Barbara Piattelli Dempsey), 442
Dempsey: By the Man Himself (Dempsey, with Considine and Slocum), 441–42
Dempsey v. Dempsey, 131–66
Denver, Colorado, 173–74, 183–84
Deschamps, François, 199, 227, 232, 233, 237–39, 241, 247, 253, 262, 265
Dodge, Earl, 292
Doheny, Edward, 252
Dolly Sisters, 281, 285, 292–93, 297
Dolores (show girl), 201
Dooling, Maurice J., 145, 147–48, 152, 153, 165–66
Dorgan, Ike, 276–77
Dougherty, Jack (actor), 327
Dougherty, Jim (referee), 309, 317
Downey, Hardy, 12

Downey, Jack, 195
Dreamland Arena (San Francisco, California), 125
Dunn, Robert, 54
Durango, Colorado, 13
Durango Herald Evening Democrat, 13

E. P. Dutton Prize, 432
Easton, Pennsylvania, 48
Ebbets, Charles, 207
Ebbets Field (New York City), 253, 324, 410
Echo du Sport (Paris), 254, 294
Edgren, Bob, 225
Edwards, Edward I., 236
Edwards, Joe, 374
Einstein, Albert, 296
Eliot, Jimmy, 203
Eliot, T. S., 230
Elizabeth II, queen of England, 434
Ely, Nevada, 120, 197, 352
Emke, John, 205
Emporia (Kansas) Gazette, 151
English, "Wop," 88
Eppstein, Solly, 88
Ertle, Harry, 266
Evans, Madge, 201
Excelsior Springs, Missouri, 202, 205

Fairbanks, Douglas, 115, 116, 270, 355, 364, 365
Fairmont Fight Club (New York City), 17
Fall, Albert, 252
Farley, James A., 370–71, 382, 388
Farman, Jack, 341
Farnol, Jeffrey, 254
Farnsworth, Bill, 276–77
Farnsworth (*Journal* reporter), 37
Fassbinder, Arthur, 13
Feature Productions, Inc., 391
Ferguson, Elsie, 368
Field, Marshall, 179
Fife, Dr. Joseph, 109, 152
Fight and Win (serial, 1923), 326, 354, 364
Fink, Louis, 56

Firpo, Luis Angel, 424
 fight with JD (1923), 321, 323–49,
 351–52, 362, 384, 390, 394, 398
 fight with "Sailor" Tom Maxted
 (1922), 279
 fight with Jess Willard (1922), 310,
 325–26, 328–30
 fight with Harry Wills, 269, 348
 as possible opponent for JD, 282, 310,
 317
Fisher, Irving, 333
Fitzgerald, C. F., 238, 241, 248
Fitzgerald, F. Scott, 213, 230, 402
 This Side of Paradise, 30, 290
Fitzgerald, George, 166
Fitzgerald, Tommy, 159
Fitzgerald, Zelda Sayre, 290, 402
Fitzsimmons, Bob, 4, 33, 64, 190, 203, 288,
 323, 389
Fitzsimmons, "Young Bob," 389
Fitzsimmons, Floyd, 207, 383–84
Flagg, James Montgomery, 201, 434
Flammarion, Camille, 238
Flanner, Janet, 256
Fleischer, Nat, 50, 204, 210, 301, 352, 370,
 374
 Ring Record Book, 191
Fleming, S. W., 429
Floto, Otto, 110
Flournoy, Frank B., 45, 87, 276–77
Flynn, "Fireman" Jim (born Andrew
 Chiariglione), 45, 121, 162, 343,
 447–48
Flynn, Leo P., 388, 396, 403, 406–9, 416
Ford, Edsel, 23, 404
Ford, Henry, 30, 244–46, 255, 404, 425
Foster, Mac, 433
Fowler, Gene, 357, 360, 375, 399
Fox, Billy (boxer), 417
Fox, William (producer), 234, 245
Fraley, Oscar, 89–90, 210
France, Anatole, 123
Frazier, Joe, 433, 435
French, Mitti, 292
Freud, Sigmund, 113–14
Friedrich, Otto: *Before the Deluge,* 296

Frost, Jeanie, 23
Frost, Robert, 230, 442
Frunier, Maurice, 293
Fuchs, Richard ("Dick"), 34–38
Fuller, Alvan T., 123, 411
Fulton, Carrie, 251
Fulton, Fred ("the Giant of the North"),
 xiv, 64, 75, 109, 116, 155, 226, 242

Gainford, George, 37
Galento, "Two-Ton" Tony, 436
Gallagher, Jack, 343, 346
Gallico, Paul, 320, 372, 376, 408, 424, 431–32
 coverage of Dempsey-Tunney fight,
 421
 sparring with JD, 4, 335–38, 352
 as sportswriter, 385, 443
 works
 Farewell to Sport, 441
Gallivan, James A., 235
Gandhi, Mohandas, 274
Gans, Joe, 39, 276
Garvin, Pierre, 236
Gasko, Nellie (a.k.a. Nellie Hurley), 272,
 275
Gehrig, Lou, 396
George V, king of England, 286–87
George VI, king of England, 286
Georgetown, Colorado, 179
Getty, J. Paul, 111
Gibbons, Floyd, 9
Gibbons, Tommy, 268, 304, 307–17, 318,
 328, 370, 390
Gibson, Billy, 372, 413
Gifford, Walter, 404–5
Gilbert, Dick, 20, 120
Gimbel, Bernard, 396
Gleason, Mrs. J. C., 160–61
Gloria, George, 257
Gluck, Alma, 281
Goff, Charles, 108
Goldfield, Nevada, 61, 72, 195–96, 276, 352
Goldstein, Ruby, 440
Gompers, Samuel, 33–34
Goodman, Rudolph, 145
Goodrich, Helen, 148

Gould, Jay, 179, 262
Grange, Red, 214, 245
Granite State, U.S.S., 216
Grant, Ulysses S., 179
Great Lakes Naval Training Station, 137, 164, 209
Great Northern Railway, 306, 307
Greb, Harry ("the Human Windmill"), 209, 282, 296, 307, 363, 371, 395, 403
Greenspun, Hank, 419–20
Griffith, D(avid) W(ark), 281, 282–83
Grigsby, John, 50–52
Grogan, Perry, 346
Grupp's Gymnasium (New York City), 16, 72
Guest, Edgar, 29–30
Guggenheim family, 179

Hagen, Arthur, 391
Hague, Frank, 235, 236, 371
Hampton, Hope, 256
Hancock, "One-Punch," 12
Harbut, Will, 212
Harding, Florence Kling DeWolfe, 229, 250, 332
Harding, Warren G., 53, 131, 151, 156–57, 161, 166, 228–29, 240, 250–52, 278–79, 298, 385
 death of, 299, 331–33
Harlem Sporting Club (New York City), 18
Harriman, Joseph W., 255
Harriman, W. Averill, 396
Harrisburg, Pennsylvania, 48
Harrison, "Kid," 195
Harrison, New Jersey, 64, 226, 242
Harrison's Reports, 377–78
Havana, Cuba, 33, 42, 57, 233, 324
Hawthorne, Fred, 258
Hayes, Helen, 230
Hayes, Teddy
 defense of JD by, 133–35, 136, 164
 as fight trainer, 90, 103–4, 110, 111, 114, 125, 128, 167, 198, 201–2, 205, 239
 as JD's agent and manager, 354, 366, 388

in JD's entourage, 281, 326, 352–53, 359, 360–61, 364–66, 368–69, 396
on vaudeville circuit, 297
Haywood, Maize, 251
Hearst, William Randolph, 117, 364, 396
Heeney, Tom, 428
Heifetz, Jascha, 230, 293
Heinz, W. C.: "They Die in the Dressing Room," 260
Hemingway, Ernest, 36, 130, 424
 in Algonquin Roundtable, 230
 JD's refusal to spar with, 271, 290–92, 435
 as possible JD biographer, xv, 442
 works
 The Sun Also Rises, 405
Heppenheimer, Gen. William G., 259
Herman, Jack, 324
Herron, Charles E., 277
Hess, Anna, 272–73
Hibbard, Jim, 324
Hitler, Adolf, 246
Hoff, Max ("Boo Boo"), 413–15, 418, 419
Hollywood, xiv, 106, 111–17, 167, 354–58
Holtzman, Jerome: *No Cheering in the Press Box,* 336–37, 441
Holyfield, Evander, 74
Home Sector magazine, 127
Homeric (ocean liner), 375
Hoover, Herbert, 151, 332, 405
Hoppe, Willie, 396
Hopper, James, 249
Horbetch, Mary, 272
Hornsby, Rogers, 338, 349–50
Housman, A. E., 192
Howard, Hubert, 140–41
Howard, Leslie, 237
Hubert's Museum and Flea Circus (New York City), 42
Hudson, Henry, 26
Hughes, Charles Evans, 146–47, 267
Hughes, Leonora, 292
Hugo, Victor, 293
Humphrey, Joe, 264

Igoe, Hype
 coverage of Dempsey-Firpo fight, 346
 coverage of Dempsey-Gallico
 sparring, 336
 coverage of Dempsey-Gibbons fight,
 312, 314, 318
 coverage of Dempsey-Tunney fight,
 416, 417, 418, 420, 422
 coverage of Dempsey-Willard fight,
 64
 coverage of JD's bon voyage, 281
Illinois, boxing law in, 416
Illinois Boxing Commission, 416, 422
International Reform Bureau, 236, 268

Jack Dempsey, Inc., trial expenses of, 138
Jack Dempsey's Restaurant (New York
 City), 431–32, 433–34
Jackson, George, 173
Jackson, "Shoeless Joe," 212, 213
Jacobs, Mike, 207, 234
James, Edwin L., 405
Jamison, Ted, 42
Jeannette, Joe, 248
Jeffries, James J. ("the California
 Grizzly"), 40–41, 50, 276, 288, 289,
 323, 330
Jersey City, New Jersey, 235, 247, 258, 261,
 262, 310, 325
Jewish Relief Fund Bank, 275
Jocelyn, Sylvia, 297
Joel, Solly, 235
Johansson, Ingemar, xi, xii, 199, 238,
 358–59, 440, 446
Johnson, Hiram, 139, 146, 151–52, 157
Johnson, Jack, 21, 33, 39–40, 41, 42, 50, 56,
 57–58, 72, 75, 93, 97, 186–87, 226, 276,
 289, 301, 303, 381, 436
Johnson, James A., 307, 313, 318, 319
Johnson, John Lester, 17–18, 72, 120, 334
Johnson, Katharine Colt, 168
Jolson, Al, 201, 216, 262, 270–71, 415, 424
Jones, Blossom, 251
Jones, Bobby, 443
Jones, Lenich and Schaeffer (vaudeville
 troupe), 109–10

Jones, Samuel Milton ("Golden Rule"
 Jones), 51
Jones, "Soldier," 249
Jones, Tom, 56
Journée, Paul, 238, 241, 253
Joyce, James, 290
Joyce, Peggy Hopkins, 117, 294, 297
Jung, Carl Gustav, 114

Kahn, Gordon J., 35, 157, 214
Kahn, Otto, 396
Kahn, Roger Wolfe, 433
Kane, Eddie, 308, 309
Kansas, Rocky (born Rocco Tozze), 44,
 242–43, 258
Kansas City, Missouri, 16, 299
Kaufman, George S., 230
Kearns, Jack "Doc" (John Leo McKernan)
 article by, 89–90
 break with JD, 327, 349, 364–66, 372,
 375, 383, 386–87, 390–92, 393–94,
 399
 defense of JD by, 132–35, 137,
 144–45, 168
 as fight promoter, 207, 210, 231–34,
 304–7, 308, 309–11, 315, 317–18
 in JD's Hollywood entourage, 114,
 118, 128
 as JD's manager, 20–21, 24–25, 45–48,
 52–53, 59–60, 61, 72, 73, 86–87,
 95, 96, 100–101, 103, 167, 198,
 205, 206, 210, 214–15, 216, 217,
 228, 264, 284, 287, 301, 333,
 335–36, 342, 344, 347, 354, 424
 plastic surgery of, 357
 on vaudeville circuit, 101, 104, 105,
 297, 299–300, 353
 as Mickey Walker's manager, 362–63,
 416
 on women, 109, 118, 124–25, 216, 237,
 294, 358, 359, 361–62, 364–66
Keller, Terry, 120
Kelly, Mark, 399
Kelly, R. J., 139
Kennedy, Lt. John F. ("Jack"), 137, 145,
 164–65

Kenny, "Wild" Bert, 17

Ketchel, Dan, 15

Kiecal, Stanislaus (a.k.a. Stanley [or Steve]
 Ketchel), 75, 190, 196

Kilmer, Joyce, 23

Kilrain, Jake, 77, 177–78

King Features, 288

Kinsella, Walter, 281

Klondike gold rush, 38–39

Knight, Irene, 339

Knights of Columbus War Relief Fund, 162

Kohn, Cyril, 15

La Rocque, Rod, 113

Laconia (Cunard liner), 9

Laemmle, Carl, 354

LaFollete, Robert, 22, 151

LaGuardia, Fiorello H., 151

LaHiff, Billy, 201, 297

Lakeview, Utah, 189, 191

LaMotta, Jake, 76, 417–18

Landis, "Kenesaw Mountain," 213

Lane, J. E., 312

Langford, Sam ("the Boston Tar Baby"),
 16, 17, 45, 75, 209, 300, 403

Langlen, Suzanne, 246

Lardner, David, 402

Lardner, John, ix, 4, 20, 26, 31, 38, 63, 78,
 199, 214, 238, 306, 315, 323, 329, 358
 White Hopes and Other Tigers, 269,
 325, 439–40

Lardner, Ring, 106, 229, 424, 440
 coverage of Dempsey-Carpentier
 fight, 233, 238
 coverage of Dempsey-Firpo fight, 347
 coverage of Dempsey-Tunney fight,
 393, 402–3
 coverage of Dempsey-Willard fight,
 31–32, 60, 63–64, 67–68, 98
 on "Tex" Rickard, 38
 as sportswriter, xiv, 321, 385, 443
 on tennis scoring system, 160
 on White Sox scandal, 213–14
 works
 "The Battle of the Century,"
 223–28
 You Know Me, Al, 63

Lardner, Ring, Jr., 393

Las Vegas Sun, 419

Lasky, Jesse, 368

Lawes, Lewis E., 221

Lawrence, Jack, 342, 346, 382

Lazzeri, "Poosh 'Em Up" Tony, 396

Leadville, Colorado, 171, 183

Leadville (Colorado) Chronicle, 171

League of Nations, 134, 142, 151, 228

League of Women Voters, 141

Lehman, Howard, 273

Leighton, Isabel: *The Aspirin Age,* 428

Lenin, Vladimir I., 11, 114, 157, 274

Leonard, Benny (born Benjamin Leiner,
 "the Ghetto Wizard"), 24, 44, 204,
 224, 242–44, 257–58, 334, 416–17, 422

Leonardo da Vinci: *Mona Lisa,* 290

Leopold, Nathan, 378

Levinsky, "Battling" (born Barney
 Lebrowitz), 45, 190, 206, 232, 254,
 265, 371, 396

Levinsky, "Kingfish," 431

Lewis, Harry, 330

Lewis, Johnny, 88

Lewis, Mary, 280

Lewis, Sinclair
 Babbitt, 306
 Elmer Gantry, 405
 Main Street, 30

Lewis, Ted "Kid" (born Gershon
 Mendeloff), 285, 293

Lincoln Fields Racetrack (Chicago,
 Illinois), 412

Lindbergh, Charles A., Jr., 405–6, 425

Lippman, Walter, 410

Lipsyte, Robert, 432

Liston, Sonny, 435

Lodge, Henry Cabot, 139, 141–42, 146, 150

Loeb, Richard, 378

Logan County, West Virginia, 175, 176,
 190–91

London, England, 285–89

London, Jack, 40

London Daily Mail, 287

London Daily Telegraph, 254

London Prize Ring rules, 177–78

Long, Huey, 23

Long, Tommy, 88
Longworth, Alice Roosevelt, 141, 262, 332
Look magazine, 322, 436
Loos, Anita, 198
Los Angeles, California, 56–57, 114, 354, 369, 375. *See also* Hollywood
Los Angeles Times, 437–38
Loughran, Tommy, 395, 409
Louis, Joe ("the Brown Bomber"), 38, 40, 101, 196, 209, 219, 260, 291, 301, 321, 322, 436–37
Louisiana Purchase, 172
Lowden, Frank Q., 151, 156
Lowell, Abbott Lawrence, 123, 411
Lundgren, Birgit, 358
Luvadis, Jimmy, 395, 415
Lyons, Bill, 315

Macauley, Thomas Babington, 243
Macbeth, W. J. "Bunk," 161, 243, 257–58, 265
MacMahon (poet), 6
Madden, Bartley, 389
Madden, Owney, 140
Madison Square Garden (New York City), 36–37, 205–6, 207, 214–19, 272, 324, 404, 408, 428, 433
Malloy, Andy, 13–14
Malone, Dudley Field, 414
Maloney, Jim, 404
Man o' War (racehorse), 161, 211–12, 214, 245
Manassa, Colorado, 72, 177, 181, 182
Manchester Guardian, 255
Manhattan Madness (film), 365, 377–78
Mara, Tim, 370–72, 415
Marciano, Rocky, 38, 101, 321, 322, 446
Markson, Harry, 433
Marquette, Sgt. Joseph, 65–66
Marquis, Don, 265
Marquis of Queensberry rules, 74, 96, 346
Martin, "Fightin' [Fighting] Bob," 43, 300, 371
Marvin, Tommy, 353
Marx, Harpo, 230
Marx, Karl: *Das Kapital,* 114
Mary, queen of England, 286

Masterson, William B. ("Bat"), 63
Mata Hari (born Gertrud Zelle), 9–11
Mathews, T. S., 63
Mathewson, Christy, 110, 213
Matisse, Henri, 290
Maurice (French dancer), 292
Maxted, "Sailor" Tom, 279
Mayo, Dr. Will, 429
McAllister, Bob, 162
McAuliffe, Jack, 324
McCabb, Joe, 334
McCahill, Edith, 349
McCann, H. S., 146
McCarney, "Professor" Billy, 60, 62, 88–89
McCloud, J. B., 155
McCormack, John, 299–300
McDermott, John, 377
McGeehan, W(illiam) O('Connell) (Bill), 70, 127, 255, 357–58, 381, 415
 on boxing laws and regulations, 203, 204, 274, 382
 coverage of Dempsey-Brennan fight, 218
 coverage of Dempsey-Firpo fight, 340, 343
 coverage of Dempsey-Gibbons fight, 314
 coverage of Dempsey-Miske fight, 211
 coverage of Dempsey-Willard fight, 32, 33, 60, 66–67, 87, 98
 coverage of Scopes trial, 379
 coverage of Yankees, 138
 on Firpo-Wills fight, 348
 racism of, 370
 on "Tex" Rickard, 326, 428
 as sportswriter, 385, 443
McGraw, John J., 133, 279, 342, 396
McIntosh, Hugh, 40
McKenney, Charles, 279
McKernan, John Leo. *See* Kearns, Jack "Doc"
McKinley, William, 180
McLarnin, Jimmy, 244
McLaughlin, James P., 54, 55, 68
McLean, Edward ("Ned"), 298

McNab, Gavin, 134–37, 144–45, 147–50, 152–53, 155–56, 165
McPartland, Billy "Kid," 346
Meehan, Willie, 162
Meeker, Colorado, 185
Mello, Louis P., 105
Memphis, Tennessee, 72, 353
Mencken, H. L., 123, 249, 264, 379, 381
Mendoza, Daniel, 83
Mercer, Sid, 211
Mexico City, Mexico, 324, 369, 387
Meyer, Louie, 295
Michigan City, Indiana, 383
Millay, Edna St. Vincent, 123
Miller, Alice Duer, 230
Miller, Dave, 417
Miller, Nathan L., 232
Miller, William Burke ("Skeets"), 367–68
Million Dollar Gate, The (Kearns, with Fraley), 210, 286
Mills, Ogden L., 151
Milwaukee, Wisconsin, 72, 215
Miske, Billy, 72, 206–11, 219, 227, 307, 384
Mix, Tom, 355
Mizner, Wilson, 190
Molumby, Loy J., 304–5, 307, 308, 309, 313, 425
Monahan, Walter, 64
Monet, Claude, 290
Monroe, James, 172
Monroe, Marilyn, 357
Montana, "Bull," 254
Monterey, Mexico, 387
Montmartre Club (Los Angeles, California), 364
Montreal, Canada, 303
Montrose, Colorado, 72, 185, 188–89, 193–94
Moore, Archie, 446
Moore, Lee, 374–76
Moore, Owen, 135
Moore, Roy, 195–96
Moose Hall (Montrose, Colorado), 194
Moran, Frank, 72
Moran, Vic, 44
Mormon Church, xiii, 176, 177, 181, 182, 189, 355

Morris, Carl, 125, 162, 226
Moynahan, Walter, 89, 91
Muldoon, William, 236, 273–74, 302–4, 333
Muldoon Hygienic Institute, 302
Mullins, Paddy, 382, 383
Murphy, Thomas, 277
Murray, Jim, ix, 437–38
Murray, Peggy, 155
Murray, Utah, 120, 343, 447

Napoleon Bonaparte, 157, 172, 250
Nast, Condé, 396
Nation, 321, 411
National Boxing Association, 422
National Police Gazette, 39, 190, 301
National Press Club, 251
Negri, Pola, 113
Neil, Eddie, 346
Nelson, "Battling" ("the Durable Dane"), 39, 61–62, 68, 276, 403
Nesbit, Evelyn, 36–37, 272
Ness, Elliott, 90
Nettleton, Lady, 396
New Haven, Connecticut, 48, 72
New Jersey, boxing laws in, 243
New Orleans, Louisiana, 21, 33, 72, 226, 353
New York (city)
 corruption and vice in, 51
 JD's arrival in, 16, 72, 447
 JD's fights in (1916), 16–19, 72, 120
New York (state)
 boxing banned in, 303–4
 boxing laws in, 43, 46, 55, 202–5, 304, 382, 386, 408
New York American, 231, 249, 280–81, 282, 285, 288, 292
New York Daily News, 335
New York Evening Post, 252
New York Herald Tribune, 37, 379, 381, 382, 405, 421, 428
New York Life Insurance Company, 206
New York Morning Telegraph, 63
New York Society for the Prevention of Cruelty to Children, 271, 272
New York State Athletic Commission, 382

New York State Boxing Commission, 386, 394, 410
New York State Boxing Licensing Commission, 392–393
New York Times, 76, 137, 140, 216–17, 218, 219, 221, 257, 262, 271, 275, 278, 313, 314, 315, 325, 329–30, 380, 392, 395, 396, 397, 405, 408, 430, 432, 437
New York Tribune, 18, 31, 33, 66–67, 87, 102–3, 139, 151, 152, 157, 161, 209, 210, 211, 231, 236, 238, 239, 241, 243, 248, 249, 252–54, 255–56, 257–59, 267, 334, 357–58
New York World, 18, 25–26, 63–65, 160, 249, 251, 267, 279, 281, 289, 312, 314, 340–41, 342, 345, 410–11, 416–17, 420
Evening World, 198, 246–47
Morning World, 17
Newark, New Jersey, 279
Newsweek magazine, 320, 322, 439, 446
Nicholas II, czar of Russia, 11, 41, 244
"Nonpareil's Grave, The" (poem), 5–6
Normand, Mabel, 113, 117
Normile, Gene, 388
Northcliffe, Lord, 287
Norton, Al, 162
Nuxated Iron, JD's endorsement of, 103–5

Oakes, D. C., 174
Oakland, California, 21, 72, 107
Oates, Joyce Carol: *On Boxing,* 441
O'Boyle, Tommy, 88
O'Brien, Charles, 341
O'Brien, "Philadelphia" Jack, 35, 89, 190, 252, 396
Ochs, Adolph, 314
O'Donnell, Steve, 288
Ogden, Utah, 15, 72, 128–29
Ohio, boxing laws in, 52–55
Okinawa, 432
Olathe, Colorado, 13–14
Olympic Club (New Orleans, Louisiana), 33
O'Malley, Walter, 300
"101 Ranch" Wild West show, 45
O'Neill, Terrence (a.k.a. James Hughes), 221

O'Rourke, Tex, 65
Orr, O. O., 143
Osborne, Susie, 193
O'Sullivan, Jack, 409
Overland Swimming Club (Toledo, Ohio), 59, 60

Palermo, Blinkie, 417
Palmer, A. Mitchell, 27–28
Palmer, Bea, 297
Pantages Vaudeville Circuit, 297, 353
Paris, France, 72, 269, 270–71, 289–94, 296
Parker, Dorothy, 230–31, 245, 259
Parsons, Louella, 368
Pastor, Bob, 436
Pathé Studios, 106, 114–15, 117
Patterson, Floyd, xi, xii, 238, 358–59, 440, 446
Patterson, Joseph, 337
Pearl Harbor, attack on, 140, 432
Pecora, Ferdinand, 274–78
Pecord, Ollie, 91–92, 93, 94, 95, 96
Pegler, Westbrook, 238, 321, 409, 413, 443
Pencock, Malcolm, 361, 366–67
Pendergast, Tom, 299–300
Pensacola, Florida, 353
People of the State of New York v. George L. Rickard, 274–78
Pepys, Samuel, 230
Pershing, Gen. John J., 24, 42, 43, 146, 166
Phelan, Col. John, 392
Philadelphia, Pennsylvania, 21, 392, 393, 398
Piattelli, Deanna. *See* Dempsey, Deanna Piattelli
Picart, Bianca Lourdes, 348
Picasso, Pablo, 290
Pickford, Mary, 116, 135, 355, 365
Pike, Col. Zebulon Montgomery, 172–73
Pioli, Joseph (a.k.a. Frank Rossi), 220–21
Pipp, Wally, 212
Pitts, Tommy, 189
Planck, Max, 296
Plearra, Vincent D., 272
Poincaré, Raymond (president of France), 10, 25
Police Gazette. See National Police Gazette

Polo Grounds (New York City), 302, 310,
 321, 341–42, 363, 370, 371
Portland, Oregon, 431
Povich, Maury, 298
Povich, Shirley, 298–99
Preston, John W., 146, 157–58, 161–65
Price, Jack, 15–17
Priddy, Bessie Leach, 279
Prievo, Mrs. Frank, 407
Prizefighter and the Lady, The (film), 199
Prohibition, 26–28, 33–34, 90, 110, 122,
 140–41
 bootlegging during, 61, 116, 137, 140,
 150, 330, 412, 418
 repeal of, 425
Protestant Bible Society, 204–5
Protocols of the Elders of Zion, 244
Proust, Marcel, 290
Provo, Utah, 72
Pulitzer, Ralph, 237, 411
Pulitzer family, 411

Quarry, Jerry, 433
Quick, Lt. Raymond B., 65
Quimby, Margaret, 364

Raleigh, North Carolina, 353
Randall, Charles H., 55
Reading, Pennsylvania, 48
Reagan, Ronald, 200
Reed, John, 11
Reese, Miller, 268
Reid, Wallace, 116
Reilly, Tommy, 413–14
Reisler, John ("the Barber"), 17, 21, 46, 72,
 120
Renault, Jack, 250
Reno, Nevada, 41, 195, 352, 432
Renzi, Elvira, 272
Reza Khan, 240
Rice, Bandsman, 259
Rice, Elmer: *Street Scene* (1931), 369
Rice, Floncy, 393
Rice, Grantland ("Granny"), 84, 229,
 369–70, 381
 coverage of Dempsey-Brennan fight,
 219

coverage of Dempsey-Carpentier
 fight, 250, 258, 266
coverage of Dempsey-Firpo fight,
 334, 339, 344, 347, 348
coverage of Dempsey-Gallico
 sparring, 337
coverage of Dempsey-Tunney fight,
 393
coverage of Dempsey-Willard fight,
 30–32, 60, 62, 66, 67, 94, 95, 98
on JD's military deferment, 102–3, 382
Ring Lardner writing for, 402
as sportswriter, xiv, 138, 385, 443
works
 "The Two Sides of War," 29
Richburg, Mississippi, 77, 177–78
Rickard, Edith Mae, 273
Rickard, George Lewis ("Tex")
 broadcast rights negotiated by, 240
 child abuse charges against, 271–78
 death of, 429–30
 defense of JD by, 133, 137, 138, 168,
 200
 as fight promoter, 34, 35, 36, 37–39,
 41, 42, 45–48, 49–50, 52–54, 55,
 59, 60, 61, 62, 68, 74, 87, 88, 101,
 200, 205–6, 207, 208–9, 214–15,
 217, 226, 231–35, 236, 241–42,
 246, 255, 257–58, 262, 263, 269,
 284, 287, 302, 303, 310, 325–26,
 328, 330–31, 333–34, 335, 340,
 349, 371, 372, 384–85, 387–89,
 392, 403–4, 410, 418, 424, 428–29
Rickard, Maxine, 429
Rickey, Branch, 349–50
Riddle, Samuel D., 161
Rifle, Colorado, 185
Rigler (National League umpire), 139
Ring magazine, 209, 210, 301
Ringling, John, 36, 37, 137, 138
Roberts, George N., 407
Roberts, Jimmy, 392
Roberts, Randy: *Jack Dempsey,* 442
Robinson, Mrs. Douglas, 141
Robinson, Edward Arlington, 171
Robinson, "Sugar" Ray, 75–77, 417, 418,
 435, 446

Robinson, Wilbert, 396
Rockefeller, John D., 255
Rockefeller, John D., Jr., 263
Rockne, Knute, 214, 383
Rockwell, Helen, 297
Rodriguez, Juan, 233, 234
Rolland, Romain, 123
Roosevelt, Archibald, 342
Roosevelt, Eleanor, 111
Roosevelt, Franklin Delano, 53, 123, 179,
 228, 409, 432
Roosevelt, Kermit, 277, 342
Roosevelt, Theodore, 21, 37, 157
Rosenthal, Harold, 318, 326, 420
Ross, Harold, 230
Rothman, Seymour, 57, 58
Rothstein, Arnold, 138, 403
Ruck, Alice, 272–73
Runyon, Damon, 90, 375, 412, 424
 on boxing laws and regulations, 203
 coverage of Dempsey-Carpentier
 fight, 233, 238
 coverage of Dempsey-Firpo fight,
 310, 321
 coverage of Dempsey-Gibbons fight,
 314
 coverage of Dempsey-Kenny fight,
 17
 coverage of Dempsey-Sharkey fight,
 408
 coverage of European tour, 281, 282,
 284, 287, 288, 292–93, 295
 on JD's training, 186–87
 as sportswriter, 385, 443
Ruppert, Jake, 263
Rush, Benjamin, 27
Ruskin, John, 398
Ruth, Babe, 24, 130–31, 138, 212, 214, 263,
 289, 338, 342, 343, 349–50, 396, 400,
 424, 443
Ryan, John "Get Rich Quick," 86–87

Sacco, Nicola, 123, 410–11
Saga magazine, 446
St. Louis, Missouri, 16
St. Louis Post-Dispatch, 381
Salmon, Patsy, 311

Salt Lake City, Utah, 12, 15, 19–20, 72,
 163, 195, 196
Salvation Army, 162
Sampson, Sam, 307
San Francisco, California, 20, 33, 51, 72,
 106–7, 108–9, 163
San Francisco Chronicle, 107–8, 122,
 125–27, 129–30, 137, 149, 154, 158,
 159, 167
Sanchez, John, 233
Sandburg, Carl: "Chicago," 411–12
Sapulpa, Oklahoma, 56
Sartre, Jean-Paul, 111
Saturday Evening Post, 63
Sawyer, Charles E., 332
Schoenfeld, Sarah, 272, 275
Schreiber, Cornell, 52, 54
Schwab, Charles, 418
Scopes, John Thomas, 122–23, 378–81
Scott, Sir Walter: The Legend of Montrose,
 185
Seattle, Washington, 109, 164, 431
Sedgwick, Josie, 115
Seeger, Alan, 23
Seeman, Billy, 201
Segal, Vivienne, 201
Seifert, Dutch, 353
Sells-Floto Circus Troupe, 110–11
Service, Robert W.: "The Harpy," 100
Sharkey, "Sailor" Jack (born Joseph Paul
 Zukauskas, "the Boston Gob"), 227,
 404, 408–10, 428, 429
Sharkey, Tom, 203
Sharpless, Casper, 361
Shaw, George Bernard, 199, 223, 224, 231,
 249, 259–60
Shelby, Montana, 304, 305–19, 325, 330,
 370
Shelby, Peter P., 306
Sherman, Mary, 280
Sherman, Shirley, 220
Sherry, Louis, 237
Shevlin, Peggy, 339
Shor, Toots, 201
Siegel, Abner, 391
Silver, Charles, 377
Sinclair, Harry ("Sinco"), 252

Sinclair, Upton, 123
Sisler, George, 212, 338
Slade, Dave, 363
Sloan, Alfred P., 404, 418
Smith, Alfred E., 166, 204, 205, 371
Smith, "Gunboat," 45, 56, 125, 162, 226, 339
Smith, Harry B., 125–27, 129–30, 132
Smith, Ralph, 427
Smith, Red, 75, 443
Smith, Toby: *Kid Blackie,* 193, 439
Soldier Field (Chicago, Illinois), 410, 416, 418
Solomon, Rachel (paternal great grandmother), 175, 176, 445
Southampton, New York, 434–35
Speaker, Tris, 139
Spellman, Frank, 117, 128–29
Spirit of St. Louis (airplane), 405
Spokane, Washington, 431
SPORT magazine, 446
Sports Illustrated, 89
Sprague, Marshall, 172
Spring, Muriel, 292
Sproul, William, 151
Stalin, Josef, 12, 260, 274
Stanton, George H., 307, 313, 315
Stanwyck, Barbara, 261, 359, 424
Steamboat Springs, Colorado, 184, 185
Stein, Gertrude, 290, 435
 Sacred Emily, 30
Stengel, Casey, 196
Steuer, Max D., 273, 275–78
Stoneham, Charles, 207
Stribling, William Lawrence ("Young Stribling"), 429
Stroudsberg, Pennsylvania, 393
Studebaker, P. E., 179
Stutz, Harry, 104
Sudenberg, Johnny, 15, 195–96, 197
Suez Canal, 274
Sugar, Bert Randolph, 431
Sullivan, John L. ("the Boston Strong Boy"), 33, 42, 77, 83, 101, 106, 177–78, 191–92, 203, 204, 261, 289, 302
Summit, New Jersey, 237
Sunday, Billy, 110

Sutherland, Eddie, 359–60
Swope, Herbert Bayard, 237

Tabor, "Baby Doe," 180–81
Tabor, Horace A. W., 175, 180
Tacoma, Washington, 431
Tate, "Big Bill," 64, 90, 105, 110, 111, 114, 209, 226
Tate, Sarah, 114
Taylor, Beulah, 128, 155–56, 159, 160, 164
Taylor, Estelle. *See* Dempsey, Estelle Taylor
Taylor, W. A., 128
Teapot Dome scandal, 252
Tendler, Lew, 396
Thatcher, Addison Q., 52
Thaw, Harry, 37
Thomas, Col. Charles W., 122, 127–28, 132, 143, 145, 147–50, 153–54, 156, 165, 424
Thomas, Evan, 24
Thompson, E. B., 155
Tilden, William Tatem, II, 24, 212, 214, 246–47, 396, 443
Toledo, Ohio, 31–32, 33, 34, 49, 50–52, 53, 54, 77, 86, 102
Toledo Athletic Club (Toledo, Ohio), 52
Toledo Blade, 50–51, 57, 98
Toledo Ministerial Union, 54
Toledo News Bee, 95
Toledo Times, 6, 95
Tompkins, Barry, 435
Tonopath, Nevada, 72, 352
Trent, Mike, 391, 397
Trotsky, Leon, 11, 157
Trowbridge, Frank Parker, 257
Truman, Harry S., 300
Tumulty, Joe, 133–36, 142, 145, 164, 166
 Woodrow Wilson as I Know Him, 134, 135
Tunney, Gene (James Joseph Tunney, "the Manly Marine"), 219, 322
 on Dempsey-Firpo fight, 362
 fight with JD (1927), xii, 86, 352, 370–72, 381, 387–401, 410, 412–24, 428
 fight with "Soldier" Jones, 249

rating of, 209
training of, 42, 371
on women, 358
Tunney, Polly Lauder, 428
"Two-round Gillian" (boxer), 15
Tyson, Mike, 74

"Uncle Bill" (counselor, Camp Robinson
 Crusoe), 79–82
Uncompahgre, Colorado, 183, 193
Underhill, Harriette, 255–56, 263
Universal Studios, 354, 355
Uzcudun, Paulino, 227, 410

Valente, Louis, 392
Valentino, Rudolph, 113, 115, 391, 424
Van Dyke, W. S. ("Woody"), 115, 117
Van Every, Edward, 303–4
Van Kelton's Handball Courts (New York
 City), 216
Vanderbilt, William, 255
Vanzetti, Bartolomeo, 123, 410–11
Velez, Lupe, 357, 359, 377
Vidmer, Richards, 393
Vidor, King, 369
Volstead, Andrew J., 140

Walcott, "Jersey" Joe, 38
Wales, Henry G., 10–11
Walker, Edward Patrick ("Mickey," "the
 Toy Bulldog"), 362–63, 416, 435
Walker, James J., 203–4, 388, 409
Walker, Mickey, 343
Walker (ringside doctor), 346
Walsh, Christy, 289, 338
Walsh, George, 361
Walton, Florence, 280–81, 297
Wanger, Walter, 361, 368–69
Washington, George, 26–27
Washington Post, 298
Watson, James, 151
Weaver, Buck, 13
Weinert, Charlie ("the Newark Adonis"),
 253, 370
Weissberg, Andrew, 383
Wells, "Bombardier" Billy, 45, 224, 247,
 254, 265, 282

Welsh, Freddie, 237
Wendt, "Whirlwind," 88
West, Mae, 118
Wharton, Edith, 230
White, Stanford, 36–37, 214, 272
White, William Allen, 151
White Sox scandal, 212–14, 403
White Sulfur Springs, New York, 333,
 391, 406
Whitney, Henry Payne, 342
Whitney, Payne, 237, 262
Widmer, Guillermo, 324
Wiggins, Chuck, 209, 415
Wilde, Oscar: Impressions of America, 119
Willard, Jess ("the Pottawatomie Giant"),
 342, 424
 fight with JD (1919), xii, 7, 21, 31–32,
 45–48, 49–50, 55–60, 64, 65, 68,
 69–99, 158, 276, 384, 389, 397
 fight with Luis Angel Firpo (1922),
 310, 325–26, 328–30
 fight with Jack Johnson (1915), 33,
 42, 44, 190, 436
 fighting style of, 56
 as movie actor, 106
 rematch with JD, 198, 231, 269, 282,
 296, 300
 training of, 55–56, 58–59
Williams, Hannah. See Dempsey, Hannah
 Williams
Williams, Kathleen, 368
Williams, Ken, 338
Williams, Larry, 250
Wills, Harry ("the Brown Panther")
 fight with Luis Angel Firpo, 269,
 330–31, 348
 fight with Jack Sharkey, 227
 fight with Paulino Uzcudun (1927),
 227, 410
 as possible opponent for JD, 45,
 226–27, 269, 271, 282, 288, 296,
 298, 300–301, 302, 311, 351, 372,
 381–82, 383–85, 387, 388, 390,
 392, 393, 404, 410
 as possible opponent for Charlie
 Weinert, 370
Wilson, Benjamin W., 391–92

Wilson, Edith Bolling Galt, 134
Wilson, Edmund, 63
Wilson, Gus, 403
Wilson, "Tommy," 121–22, 124, 129, 159
Wilson, Woodrow, 11, 22, 25, 133–34, 139, 166, 381
Wintz, George, 71
Witwer, H. C., 91
Wolcott, Colorado, 184
Women's Christian Temperance Union, 27
Wood, Gen. Leonard, 139, 146, 151, 156, 161
Woods, Freddy, 189, 193–94
Woodward, "Coach" Stanley, 107, 249, 384–85
Woollcott, Alexander, 230
World War I, xiv, 7–12, 21–25
 aftermath of, 29–30
 armistice for, 25, 27, 165
 peace between Germany and the U.S., 236, 267
World War II, 140, 432–33
Worthing, Helen, 297
Wray, Ben, 311

Yankee Stadium (New York City), 76, 358, 388, 392, 404, 409, 428, 440
York, Bob, 15
Young, John ("Bull"), 56–57, 88
Young, Noah, 56
"Young Hector" (boxer), 120

Zelle, Gertrud (a.k.a. Mata Hari), 9–11
Ziegfeld, Florenz, 342